STUDIES IN BRITISH ART

THE PAINTINGS OF

J. M.W. TURNER

MARTIN BUTLIN and EVELYN JOLL

Text

Published for
The Paul Mellon Centre for Studies in British Art
and
The Tate Gallery
by
YALE UNIVERSITY PRESS
NEW HAVEN AND LONDON · 1977

Copyright © 1977 by The Tate Gallery and Yale University

Designed by John Nicoll and set in Monophoto Ehrhardt

Text filmset and printed in Great Britain by
BAS Printers Limited, Over Wallop, Hampshire

Monochrome illustrations originated and printed in Great Britain by
BAS Printers Limited, Over Wallop, Hampshire

Colour illustrations originated and printed in Great Britain by
Westerham Press, Westerham, Kent

Published in Great Britain, Europe, Africa, the Middle East,
India and South-East Asia by Yale University Press, Ltd., London

Distributed in Latin America by Kaiman & Polon, Inc., New York City;
in Australiasia by Book & Film Serices, Artarmon, N.S.W., Australia;
in Japan by Harper & Row, Publishers, Tokyo

Library of Congress Cataloging in Publication Data

Butlin, Martin.
 The paintings of J. M. W. Turner.

 (Studies in British art)
 Bibliography: p.
 Includes index.
 1. Turner, Joseph Mallord William, 1775–1851.
I. Joll, Evelyn, 1925– joint author. II. Paul
Mellon Centre for Studies in British Art. III. Tate
Gallery, London. IV Title. V. Series.
ND497.T8B83 759.2 77-76297
ISBN 0-300-02130-5

List of Contents

Acknowledgements

THIS catalogue has been a joint enterprise and we have not forborne from making suggestions regarding each other's entries. However, we are each finally responsible for our own entries and, while in some cases acknowledgements are due from both authors equally, in others we have individual debts of gratitude to pay.

To deal first with those whom we wish to thank jointly: we owe an incalculable debt to Frances Butlin who has done the reseach into contemporary reviews of Turner's work. A glance at practically any entry for a picture which Turner exhibited will reveal the extent of her contribution to the catalogue. We also owe a great deal to the diligence of Dudley Snelgrove who searched the mass of material in the Turner Bequest for drawings related to the oil paintings.

We have also had unstinted co-operation from Turner scholars, particularly Fred Bachrach, Gerald Finley, John Gage, Lawrence Gowing, Luke Herrmann, Adele Holcomb, Michael Kitson, John McCoubrey, Graham Reynolds, Conal Shields, Charles Stuckey and Andrew Wilton. All have helped in ways even more numerous than can be deduced from the plenitude of references to them in the text.

A constant flow of encouragement has emanated from the Mellon Centre, starting with the late Basil Taylor who first proposed the idea of this catalogue and got it under way, and later from Jules Prown, Angus Stirling, Ellis Waterhouse and the present Director, Christopher White, who has provided a gentle touch of the spur when most needed. Iain Bain has put the full resources of the Tate Gallery Publications Department behind the project. Finally, John Nicoll of the Yale University Press has shown himself to be both the most professional and the most relaxed of publishers.

As I have catalogued all the pictures outside the Turner Bequest, I have necessarily been in contact with a great many more people than Martin Butlin has; hence the list of those to whom I owe thanks will be much longer. Obviously my first debt is to the owners of Turners, both private and public, for without their co-operation this book would not exist. I hope that these owners, who have been kindness itself at all times, will accept being thanked *en bloc* and will understand that gratitude is no less sincere for being offered collectively. I owe a special debt to St John Gore for his help over pictures owned by the National Trust. In particular, my entries for the twenty paintings at Petworth rely very heavily on his material.

Although I have tried to thank all those who have helped over individual pictures in the catalogue entries concerned, a number of people have given me help of a more general nature. In this category I am extremely grateful to the following: John Brealey, Peter Cannon Brookes, David Brown, Beverly Carter, Rollo Charles, Kenneth Garlick, Bob Hubbard, Oliver Millar, Edward Morris, John Murdoch, Kurt Pantzer, Charles Parkhurst, Joseph Rishel, Colin Thompson, Robert Wark, Clovis Whitfield and Selby Whittingham.

Among colleagues in the trade, Tim Bathurst, Ernest Johns, Hugh Leggatt, Charles Morley-

Fletcher, John Quilter and David Somerset have all helped me either with their firms' records or in gaining access to their clients' pictures. Jeremy Maas has most kindly allowed me to consult his Joseph Gillott material, which provides such an important record of early changes of ownership among Turner's pictures.

The Chairman of Christie's, Jo Floyd, generously allowed me to go through their sale records and Mark Wrey has proved a wizard at finding the required catalogues. At Sotheby's Paul Thomson and Janet Green provided vital information while Judith Landrigan, in the New York Office, went to great trouble to trace pictures sold at auction in America.

I must also thank my partners at Agnew's who agreed to my taking six weeks off in 1974 in order that the catalogue should get properly under way. They have been very indulgent when Turner threatened to preoccupy my energies to an unreasonable extent.

Pat Barnden of the Mellon Centre has undertaken the considerable task of obtaining photographs from all over the world with the greatest efficiency and good humour. My secretary, Susan Valentine, has typed and re-typed catalogue entries with constant cheerfulness. I owe her and Betty Pearsse, who also helped with the typing, an enormous debt of gratitude.

Last to be thanked, but first in every other respect, is my wife. Not only did she suffer uncomplainingly while more and more of our house became a Turner reserve, but her enthusiasm for the project even survived an endorsement for speeding, collected when trying to reach a Turner before the gallery in question closed.

Martin Butlin would also like to acknowledge the helpfulness of many of those mentioned above, including both private owners and museum curators who have enabled him to see their works under optimum conditions and have readily discussed them with him. He is similarly indebted to other art-historians and to friends in the trade. His colleagues at the Tate Gallery have proved a great support. In particular he wishes to thank the members of the Conservation Department under its Keepers, Stefan Slabczynski and the Viscount Dunluce, for their help over problems of conservation and technique; also Judy Egerton for much painstaking research and checking, and the successive secretaries who have struggled to read his writing. He owes a particular debt to Mary Chamot whose work on the Turners at the Tate provided the foundation for much of this catalogue.

Finally we must both thank Ruth Rattenbury for gallantly volunteering to take over much of the job of indexing the catalogue.

Evelyn Joll
January 1977

Introduction

IT IS now seventy-five years ago since Sir Walter Armstrong's *Turner* was published. It remains the only serious attempt at providing a catalogue raisonné of the artist's work but, inevitably, it is now badly in need of revision, excision and expansion.

Much of the information about Turner's oil paintings that has come to light since 1902 has already been published, either in books, articles, in the catalogues of museums that own works by Turner, or in the catalogues of a number of Turner exhibitions that have taken place since the war, notably those held in Indianapolis in 1955, at Agnew's in 1967 and, above all, at the Royal Academy in 1974–5. Yet there remains a considerable amount of material which has never been published; hence this book. Its purpose is twofold: to collate all the information at present available about Turner's oil paintings, and to try to establish as precisely as possible exactly what he did and did not paint. As a catalogue of Turner's work in oil, it may be regarded as a preliminary to the far greater task of a complete survey of his entire oeuvre.

The result of the dispute over Turner's will was that the contents of his studio became the property of the nation. In practical terms, this means today that the oil paintings are now in the Tate Gallery, apart from a handful of top quality works permanently on show in the National Gallery. The watercolours, with which are included a few oil sketches done on paper or board, are in the Print Room of the British Museum. There are 318 paintings in the Turner Bequest (283 pictures in the Tate and National Galleries and 35 oil sketches in the British Museum), about sixty per cent of Turner's total output in oil, while the remaining 210 or so pictures, which he sold during his lifetime, are now scattered over the world, although the vast majority are in Great Britain and the U.S.A.

In effect, therefore, the pictures in the Turner Bequest are those which the artist failed to sell and were thus still in his possession when he died. This statement needs considerable qualification, for many unfinished canvases were of course never shown to prospective buyers, while, towards the end of his life, Turner refused to sell certain key pictures such as *Crossing the Brook* and *The Fighting Temeraire*, although the latter could have been bought for 250 guineas at the Royal Academy exhibition in 1839. In 1845, however, Turner refused a blank cheque for it. In other cases, Turner actually bought back his own pictures at auction, notably at the de Tabley sale in 1827 (*Sun Rising through Vapour* and *A Country Blacksmith Disputing upon the Price of Iron*), showing that by this date he may well already have had it in mind to leave a considerable portion of his work to the nation. At the same time, in this as in other matters, Turner was not consistent, for he certainly made no attempt to buy back other pictures which were sold publicly in the 1830s and 1840s, although he sometimes left wholly unrealistic bids for them as, for instance, at the H. H. Dobree sale at Christie's in 1842. Furthermore, with the publication in 1843 of the first volume of *Modern Painters*, the demand for Turner's pictures grew appreciably and his dealer, Thomas Griffith, urged Turner to put some of his less recent pictures into a proper state of repair, so that

there was something for prospective customers to buy when they visited his studio in Queen Anne Street. It was in 1844 that his patrons Elhanan Bicknell and Joseph Gillott both made 'bulk' buys in this way, amounting between them to fourteen pictures, while B. G. Windus and Munro of Novar continued to buy Turner's work in the 1840s, and there were other new purchasers of his exhibited pictures, especially of his Venetian paintings. All the evidence seems to show that Turner himself wholeheartedly approved of these transactions.

Finally, therefore, Turner's often quoted remark about his pictures: 'What is the use of them but all together?' cannot have been intended by him to be taken too literally. He had in his studio a sufficient cross-section of pictures to demonstrate to posterity his range and development, and he may well have calculated that interest in his pictures would wane rather than increase if there were not enough pictures which could circulate after his death, and thus rekindle enthusiasm for him and his work. After all, if the 'Bridgewater' and 'Egremont' seapieces were sold, Turner still had *Calais Pier* and *The Shipwreck*; if *Petworth from the Lake: Dewy Morning* and *Somer Hill* were gone, *Dorchester Mead (Abingdon)* and *Frosty Morning* were still in the studio, and so on throughout his oeuvre: pictures which had been sold had their counterparts in his possession. Only perhaps in the case of the short period between 1834 and 1836 which produced such masterpieces as *Wreckers off the Coast of Northumberland*, the two versions of *The Burning of the Houses of Parliament*, *Keelmen*, *Mercury and Argus* and *Juliet and her Nurse*—which were all sold by 1845—could one say that no paintings of the same date and of equal stature were left in the studio. Indeed, it may have been in order to compensate for these losses that Turner retained *The Fighting Temeraire*. Similarly, the group of unfinished landscapes, painted *c*. 1835–40, most of which are based on engravings in the *Liber Studiorum* series, may also owe their origin to a desire on Turner's part to leave in his studio a selection of canvases which would illustrate the more tranquil and idyllic aspect of landscape, whereas at the same time his exhibited work showed his increasing preoccupation with the images of disaster so central to the oeuvre of a Romantic painter.

It is not the intention of this Introduction to trace Turner's development as a painter, for this has already been done by a number of others more able than I. There have been four recent and admirable books on Turner's art, the most concise being Michael Kitson's *Turner* (Blandford Press, 1964). More detailed surveys are provided by Sir John Rothenstein and Martin Butlin's *Turner* (Heinemann, 1964) to which should be added Butlin's prefatory essay 'J. M. W. Turner: Art and Content' in the catalogue of the Turner Bicentenary Exhibition; by Graham Reynolds' *Turner* (Thames and Hudson, 1969); and, more recently, by Luke Herrmann's *Turner* (Phaidon, 1975).

However, it is perhaps worth making the point to those who think first, when Turner's name is mentioned, of *The Slave Ship* or *Snowstorm—Steam-Boat off a Harbour's Mouth* that, when Turner entered the Royal Academy Schools in 1789, Sir Joshua Reynolds was still President and the pictorial hierarchy of the late eighteenth century was still very much in force. In one sense Turner's career can be seen as a sustained attempt to transform this hierarchy and to raise the role of landscape, which featured so low in it, to a level of importance which placed it beside paintings of historical, allegorical, mythological and religious subjects—and of portraits. It is only when this ambition is kept in mind that Turner's attitude towards the old masters—and the use he made of them—becomes clear.

Of course, there are instances in Turner's art when his ambition to tackle 'sublime' themes led him into territory where he was not fully at ease. This occurs mainly in pictures of historical or allegorical subjects in which the human figure features on a fairly large scale. At the time of the Bicentenary Exhibition, the uneven quality of Turner's figure-painting was clearly apparent. It cannot be said to have been his *forte* and, with the exception of *Jessica*, when on a large-scale it sometimes verges on the ludicrous. In such paintings as *Medea* or *War: The Exile and the Rock Limpet*, for example, an element of the grotesque in the central figure immediately alienates one's sympathies.

When in London in 1799 Turner saw the two great paintings by Claude, which W
Beckford had just bought from the Altieri collection, he said that they 'were beyond the pow
imitation.' This remark is of central importance but, like many of Turner's sayings, his e
meaning is unclear. It certainly does not mean that Turner regarded the Claudes as so far beyond
what he himself could do, that he could learn nothing from them. His attitude towards Claude,
towards other old masters and indeed towards his own contemporaries among painters was
compounded of emulation and competition, but his object was to derive from them what Michael
Kitson has called 'a vocabulary of style which he could then apply to compositions of his own
invention.' That Turner's study of the old masters was intensive is attested both by the way in
which he occupied his time in the Louvre in 1802 and by a study of the text of his lectures on
perspective. Indeed the work of certain artists became so well-known to him that, when he first
visited their native countries, he felt himself at once on familiar ground. 'Quite a Cyp' he scrawled
in a notebook when visiting Holland in 1817, and when he finally reached Italy in 1819 and saw
Loreto, he wrote at the bottom of a drawing 'the first bit of Claude'. He relied on this 'vocabulary',
although decreasingly so, until almost the end of his life—from his Wilsonian oils of the late 1790s
until the final echoes of Claudian seaports in *Regulus* and *Ancient Italy* in the late 1830s, and, even
as late as the early 1840s, exhibited works such as *Bacchus and Ariadne* and *The Dawn of
Christianity* reveal Turner's continuing interest in Titian and the Venetian School.

Furthermore, Turner's work was often judged by contemporary critics precisely in its
relationship to the old masters. Whereas Constable's admiration for 'The Bridgewater Seapiece'
was tempered by his 'knowing the picture by Van der Velde on which it was formed', for West and
Fuseli it was because the picture reminded them of Rembrandt that they esteemed it so highly.
When Turner's colour became more individual, however, his work began to attract criticism, so
that the *Macon*, exhibited in 1803, reminded Sir George Beaumont of 'Claude with the colouring
forgotten'—and these criticisms multiplied as Turner's colours became ever more daring.

If the old masters provided Turner with his 'vocabulary of style', the *Liber Studiorum* gave him
the opportunity to explore the full range open to a landscape painter. His division of the *Liber* into
six categories, and the variations he suggested within them, enabled him to transmit to a wide
public his view that the scope which landscape might encompass could become almost limitless.
The fact that one of the categories was EP (which almost certainly stands for 'Elevated Pastoral'),
shows that the wish was never far from Turner's mind to stress the noble and uplifting role that
landscape painting could play.

But Turner was far from relying solely on the old masters as the source for his pictures. His own
powers of invention were enormous and his readiness to explore new avenues led him to
experiment in all sorts of ways, including direct transcriptions from nature, the most notable
example of which occurs in the series of Thames sketches executed *c.* 1807.

These sketches, which are discussed more fully in the main body of the catalogue, are, however,
if not unique, certainly an exceptional feature in Turner's oeuvre. Apart from the series of small oil
sketches executed in Devon in 1813, studies in oil, made out of doors, occur very rarely thereafter
so far as we know, but Turner was prepared to employ any methods that lay to hand in order to
capture an effect, so that one must be wary of being too dogmatic about this.

Indeed to approach Turner's art in too dogmatic a spirit is simply to invite error and in no area
is this more true than in the question of dating. Dates have been proposed for all the pictures
in the catalogue but, in certain instances, the very wide limits suggested reflect the quandary
which confronted the compilers and in the face of which they have proceeded with a caution
which, it is hoped, will be considered wise rather than irresolute. For Turner experimented not
only in his compositions but also in his technical methods, employing different means at the same
time or similar means at different times. This, coupled with the use he made of material gathered
on his sketching trips, which often involved the lapse of many years before a quick notation in
pencil was taken up again and used as the basis for a finished oil, provides a possible range in the
dating of some pictures which it would be foolhardy not to recognize. Paintings may be based on

drawings made on a recent visit, or again they may go back to sketches made many years earlier, and Turner was by no means consistent in the way he used his material. To give an example: if asked to date the two versions of *The Burning of the Houses of Parliament*, one would naturally incline to consider the version in Cleveland as the earlier, for it corresponds more closely to the watercolour sketches which Turner made on the spot on the night that the fire broke out—but one would be wrong. In fact the margin for error here is small, for both pictures were exhibited within seven months of the fire, but there are other cases in Turner's work where the possible outer limits of the dating bracket, to judge solely on the evidence of the preparatory material, could be measured in decades rather than in months.

But, although Turner's preparatory sketches are sometimes of little help in dating a picture, the cataloguer is faced with equal, or more difficult problems where no such material exists. To date Turner's work on stylistic grounds alone is often a very inexact exercise, in which the cataloguer may end up by relying as much on intuition as on any evidence which is either remotely firm or easily explicable. This applies particularly to the second half of Turner's career when, relying less and less on the exemplar of the old masters, he finally found full freedom of expression. The compositions which resulted show little trace of being constructed on classical lines; instead they are loosely put together in a series of interlocking arcs and curves which tend more and more to fuse the ingredients—whether they be sea and sky, or buildings in Venice and the Grand Canal— into a single image of harmonious light and colour.

These problems of dating are of course magnified when confronted with canvases which are clearly unfinished or, at most, simply 'laid in', conditions which apply to a sizeable proportion of pictures in the Turner Bequest. The temptation to date freely-painted, sketchy works too late is one that the cataloguer frequently confronts in Turner's work, particularly in the 1820s and 1830s, when so many sketches or unfinished works have seemingly much in common with pictures exhibited ten years later. Paradoxically, it is not until the 1840s that the problem becomes simplified to some extent (but by no means altogether), when the distinction between Turner's exhibited and unexhibited work diminishes appreciably. Indeed, it is at this period also that Turner's technique in his oils comes very close to his practice in watercolour, so that his work in both media seems, in Constable's phrase, to be painted 'in tinted steam'.

Nevertheless, the long list of Turner's exhibited works provides a basis on which to analyse his development, and has also been used here as a framework in the arrangement of the catalogue, which is set out in the List of Contents. The entries are divided into sections based on the main periods of Turner's career as it was punctuated by his principal journeys abroad. Within each section the normal rule is for works exhibited by Turner in his lifetime to be given first, in chronological order, followed by unexhibited works. In all but the last section, works after 1829, the unexhibited pictures are also arranged more or less chronologically; certain groups such as the Thames sketches or works associated with Petworth, form further distinct sub-sections. In the last section, the unexhibited works, which are especially difficult to date, are roughly grouped together according to subject, for instance stormy seas or Venetian scenes. An appendix is devoted to border-line attributions and works formerly attributed to Turner.

It is frequently remarked that Turner was 'the first impressionist'. This judgement would appear to have the support both of Turner himself and of Ruskin. Turner advised a fellow-artist that he ought 'to paint his impressions,' while Ruskin wrote 'the truth of impression . . . was something he [Turner] was always anxious to preserve.' Yet Turner and the Impressionists differed radically in their approach to landscape, for Turner had no wish to place on immediate record a scene he had observed under specific conditions of light or weather. Indeed, no doubt this is why he seems to have given up painting out of doors in oils—or watercolour except rarely. His pictures were rather a synthesis of recollection for, although he wrote 'Every look at nature is a refinement upon art', his paintings show clearly that he intended every work of art to be a refinement upon nature.

After about 1830, Turner's complete technical mastery, combined with his understanding of

light and his extraordinarily bold colour sense, finally enabled him to paint a series of pictures that truly were 'beyond the power of imitation'. His debt to the old masters finally absolved, Turner's originality now had full scope. His imaginative powers seemed to expand as he grew older, so that, in pictures such as *The Slave Ship* or *Peace: Burial at Sea*, he produced images at once so powerful and so moving that they eclipse anything painted by any other English artist before or since. In 1844 the critic of the *Spectator* wrote of Turner's *Approach to Venice*: 'beautiful as it is, it is but a vision of enchantment.' Although at the time these words were meant to imply a lack of substance—and perhaps also of 'high seriousness'—it is hard to think of a phrase which sums up more perfectly the overwhelming beauty of Turner's finest work.

Turner's oil paintings fall naturally into two categories: those pictures which were left to the nation as part of the Turner Bequest, and those which were sold during the artist's lifetime. Since Turner's death in 1851, eight pictures have been added by gift, purchase or bequest to the national collections, and these are now the property of the Tate Gallery.

All the pictures in the National and Tate Galleries and in the British Museum have been catalogued by Martin Butlin. All Turner's other paintings have been catalogued by Evelyn Joll. Although we have consulted together fully in preparing the catalogue, the entries have been individually rather than jointly compiled and each of us is entirely responsible for his own section. Occasional differences of opinion between the compilers have been noted in the individual entries.

In so far as the individual entries go, these are set out in the form usually followed in such catalogues. In the case of exhibited pictures, we have quoted freely from the exhibition notices which appeared in the newspapers and journals of the day. Although reviewers in Turner's day were far more outspoken than they are today, and although he was subject to much abuse, the critics soon realised that they were confronted by a painter of quite exceptional talents. Apart from *Blackwood's Magazine*, which remained implacably hostile to Turner throughout, few critics failed to find something—and often much—to praise in Turner's work, although this praise was usually tempered with criticism. Many of them admitted their bewilderment, especially in front of Turner's later works, as, for example, Thackeray did when he wrote of *The Slave Ship*: 'Is the picture sublime or ridiculous? Indeed, I don't know which.'

Turner himself affected to be little impressed by criticism of his work, hence his advice to Ruskin not to publish the latter's reply to the criticism of Turner's 1836 exhibits which had appeared in *Blackwoods*; 'I never move in such matters' wrote Turner. But there are also indications that he could be greatly put out by insensitive criticism, as on the occasion, for instance, when his painting of the sea in *Snowstorm—Steam-Boat off a Harbour's Mouth* had been likened by one critic (so far untraced) to 'soapsuds and whitewash'; Ruskin came upon Turner muttering angrily to himself: ' "Soapsuds and whitewash!" What would they have? I wonder what they think the sea's like? I wish they'd been in it.'

These newspaper criticisms have been included in the catalogue not only because they provide valuable evidence of how Turner's work struck his contemporaries, but also because, in turn, they may give us a clue as to whether such criticism had any effect on Turner himself—either on his personality in general or, more specifically, on the kind of pictures that he sent to exhibitions. Although, on the whole, the available evidence seems to show that Turner was sufficiently self-confident not to be seriously affected by criticism, information on the subject is generally so scarce that any scrap is to be welcomed. For, although Turner was quickly recognised by his contemporaries as an artist of outstanding gifts, and was therefore in the limelight of the art world in England for over fifty years, we know surprisingly little about him, apart from what can be pieced together from his tours in Britain and to the Continent, based on a study of his sketchbooks, and from such sources as the minutes of the Council meetings at the Royal Academy. These facts are all admirably gathered together in Finberg's *Life*, and are rounded out with more revealing glimpses of the artist when staying at houses where he felt at ease, such as Farnley or Petworth—or by anecdotes from old friends such as the Rev. Trimmer or Clara Wheeler, William Wells' daughter. Nonetheless the result can be fairly described as the bare bones of biography rather than

a fully-fleshed portrait. Finberg's portrait of Turner, which carefully avoids all speculation about the artist's relationships with women, is corrected by Jack Lindsay's biography (1966), which does tackle this question and provides as well a convincing portrayal of Turner in his social setting. Yet great gaps in our knowledge of Turner still remain; of course Turner himself was largely responsible for this, for his love of secrecy was generally remarked upon and, if this self-mystification was often playfully intentional rather than pathological, the result was the same. A fresh biographical source, therefore, such as Robert Cadell's diary, recently discovered by Gerald Finley in the National Library of Scotland, is of the greatest value. Extracts have been published in Finley's article 'J. M. W. Turner and Sir Walter Scott: Iconography of a Tour', *Journal of the Warburg and Courtauld Institutes* XXXV 1972, pp. 359–85. This diary records, in particular, the visit that Turner made to Sir Walter Scott's house at Abbotsford from 4–9 August 1831, for the purpose of choosing subjects that were to illustrate a new edition of Scott's poems. The narrative, which records the events of the six-day visit in some detail, is easily the most sustained account of Turner that exists. It confirms much that one might expect: Turner's affability when in company that he found congenial (also his tendency to take a drop too much in the evenings), and his willingness to oblige a patron over the choice of subject-matter to be drawn; but it also emphasizes, in a way that only an eye-witness account can, what phenomenal energy and industry Turner possessed, and what trouble he took in selecting his material. No other source gives us such a vivid picture of Turner at work in the field.

Similarly, although Turner cannot be accounted a great letter-writer, as so many of his surviving letters are concerned with mundane business matters or are brief replies to social invitations, nevertheless new information of great interest will be revealed by John Gage's forthcoming edition of Turner's letters, which I have most generously been allowed to consult in typescript. So far as this catalogue is concerned, the importance of Turner's letters is that they reveal that a number of paintings, hitherto thought merely to have been sent to exhibitions in the 1830s and '40s for sale in the normal way, were actually painted on commission; incidentally, it is interesting to note that Turner reduced his prices if a work was commissioned. This not only extends the list of patrons known to us who were prepared to order work directly from the artist, but it also further discredits the once widely accepted picture of Turner in old age, which portrayed him living as a recluse, misunderstood by his contemporaries and surrounded by unsold and unsaleable canvases.

All these pieces of evidence are of help in the preparation of a catalogue raisonné of Turner's paintings, and in time no doubt our knowledge will be further increased by the emergence of lost pictures, or of pictures at present untraced. No fewer than thirteen oils, exhibited by Turner, have disappeared (in one or two of these cases there is doubt whether the works were oils or watercolours). There also remain untraced a further fourteen paintings which are either clearly documented or were lent to exhibitions while Turner was still alive, or which belonged to patrons whose relationship with Turner make the authenticity of anything owned by them beyond question. However, even if all these twenty-seven pictures were to appear, although they would doubtless provide us with a surprise or two, it seems unlikely that our view of Turner's art would be altered to any marked extent.

Ideally, the compiler of a catalogue such as this should have seen every picture listed in it, or rather every picture of which the present location is known. However, I must confess that I have included four pictures which I have never seen and this is noted in the individual entries concerned.

It is perhaps advisable at this stage to say something about the physical condition of Turner's paintings, and to explain why this is not treated in more detail in the individual catalogue entries which follow. The whole question has been greatly bedevilled by Ruskin, who was an alarmist to a quite unnecessary degree on this subject. Ruskin described Turner's paintings as being 'wrecks of dead colours', or as 'ghosts' of what they had once been, and further claimed that '*no* Turner looked the same after a month as it had done when it left the easel'. Ruskin refers again and again to

pictures which had deteriorated markedly in condition, and describes in detail many of the possible causes for this in his account of *Childe Harold* (see No. 342). Yet, although some of Ruskin's concern was undoubtedly justified, it is undeniable that he had a bee in his bonnet on this subject which clouded his judgement, and his opinions thereon should be treated with scepticism. In fact, there is a good deal of evidence which points to Turner's paintings having suffered less from the artist's allegedly unsound materials and methods than, subsequently, at the hands of ignorant restorers who failed to understand either Turner's technique or his intentions.

Turner's technique does demand and deserve detailed study, but in the absence of such a study it seemed wise to confine our comments on condition to the minimum. In the case of the pictures in the Turner Bequest, some observations on condition have been included in instances where they either assist our understanding of the picture or help in grouping together certain canvases as, for instance, with the sketches painted at Cowes in 1827, or those done on Turner's second visit to Italy in 1828–9.

In dealing with the pictures outside the Turner Bequest, the question of condition has barely been mentioned, because it has not been possible to examine the great majority of pictures concerned under conditions which would justify authoritative judgements. Anyone who has looked at pictures in private collections (especially in the kind of light available in many English houses in winter) will know what I mean. Even in public collections, full conservation reports are not always available or differ widely in both the amount and the quality of information they provide. Judgements about condition, made before a picture is cleaned, can prove very fallible, and as a good many Turners in private hands are in need of cleaning, and as the condition of a picture has become an increasingly important factor in recent years in determining its market value, this was an additional reason against publishing comments which were not based on detailed investigation.

In only a very few cases therefore, where comment on a picture's condition seemed essential in order to explain its present appearance, have such observations been included. Otherwise the problem has been shelved—and I hope this will not be considered an euphemism for shirked—until a detailed study can be devoted to Turner, or at any rate to the paintings in the Turner Bequest.

The catalogue ends with a small section entitled 'Works no longer attributed to Turner'. This is mainly composed of pictures in public collections which have either been displayed until recently as being by Turner, or in some cases are still so exhibited, in our opinion erroneously.

Throughout his life, but especially towards the end of it, Turner's pictures fetched high prices: Bicknell paid 1,000 guineas in 1844 for *Palestrina* and John Naylor bought two large seapieces (Nos. 236 and 372) from Turner for £1,260 each in the last year of the artist's life. These were big sums and the terms of Turner's will, which had the result that only those pictures sold in Turner's lifetime could ever become available on the market, inevitably meant that the price of Turner oils began to rise still further after 1851. This in turn provided an obvious incentive for forgery and there were soon imitations in circulation. Most of these are lamentably bad and are usually pastiches of Turner's later style, consisting of an amalgam of Turnerian motifs, thrown together more or less anyhow. Thus one comes across pictures which are obviously derived from one of Turner's Carthaginian subjects on one side of the composition while, on the other, one faces Santa Maria della Salute and the Grand Canal, Venice. The imitators who produced such pictures failed to grasp one of the hallmarks of Turner's style. His training in early life as an architectural and topographical draughtsman meant that, even in his most diffuse and diaphanous late works, there is an underlying sense of structure which the pasticheurs failed totally either to understand or to reproduce. Such worthless imitations fortunately have no place in this catalogue (although Martin Butlin claims to distinguish, besides the inevitable crop of copies and misattributions, three hands among Turner's habitual imitators, dubbed Hands A, B, and C in the absence of any evidence for their names).

The last section also contains, however, one or two pictures which remain real puzzles, and the

decision to exclude them from the main body of the catalogue was a border-line one. It is after all one of the purposes of a catalogue such as this to air such problems—there are also a few others in the main corpus where the decision went the other way—in the hope that further study will eventually resolve them. It is invariably the case that the accepted oeuvre of a painter undergoes quite sharp variations of expansion and contraction after his death. In Turner's case, for instance, Armstrong's catalogue contains 193 pictures outside the Turner Bequest of which twenty-one are not accepted as genuine in our catalogue. On the other hand our catalogue lists about two hundred pictures which were either not known to Armstrong or not considered genuine by him. These vagaries in the accepted oeuvre of a painter, which occur over a prolonged period of time, have been most shrewdly described by Christopher White in his review of Seymour Slive's catalogue of Frans Hals' work (*Times Literary Supplement*, 28 November 1975): 'An initial period of discovery is accompanied by a spirit of optimistic expansionism; this is followed eventually by a mood of deep retrenchment, in which it almost becomes a matter of honour to reach negative conclusions, so that much of the baby as well as the bathwater tends to be thrown out. Finally a balanced assessment arrives at a solution somewhere between the two extremes.'

It is our hope that in the catalogue which follows, the baby is not only sufficiently well grown to stand no danger of disappearing down the plug, but is at the same time not so overweight as to need much in the way of slimming in the foreseeable future.

Evelyn Joll

The Turner Bequest

THE fate of Turner's will and its various codicils is fully discussed in A. J. Finberg's *Life of J. M. W. Turner, R.A.* (1961, pp. 329–31, 415, 424, 441–55). The texts, together with a condensation of the report of the Select Committee of the House of Lords appointed to look into the Turner Bequest in 1861, are reprinted in Walter Thornbury's *Life of J. M. W. Turner R.A.* (1862, ii, pp. 409–22; 1877, pp. 620–33). This is not the place to go fully into the confused history of the Bequest, or into exactly what Turner's intentions for his pictures and drawings were. Briefly, Turner's intentions changed radically between, on the one hand, his first two wills of 1829 and 1831 and a codicil of 1832, and on the other hand three codicils of 1848 and 1849. At first he planned that a gallery should be built as part of 'Turner's Gift', a charitable institution to be set up at Twickenham for the support of 'Poor and Decayed Male Artists'. Late in his life Turner changed this; all his 'finished Pictures' were to go to the National Gallery on condition that 'a room or rooms', to be called 'Turner's Gallery', were added to the existing Gallery. In either case the pictures were to remain at Turner's own gallery in Queen Anne Street until the provisions of his will could be met; eventually, should these not be fulfilled, the works were to be sold. The space available in either event would have been relatively limited; Turner envisaged a changing display. From the beginning Turner specified that two paintings (one was changed in 1831, see catalogue Nos. 69, 131 and 135) were to go to the National Gallery to hang next to works by Claude.

The qualification in the later codicils, 'my finished Pictures', is interesting and seems to represent a narrowing of intent as compared with the words, 'my pictures', of the 1832 codicil, in which he also states that his first object is 'to keep my Pictures together'. However, Turner may well have relied on the assumption that a 'Picture' meant, in common parlance, a finished work worthy of being exhibited in public. In addition, at that time, 1832, he may not yet have amassed the quantity of unfinished oils that are now among the most highly appreciated of his works; at least, he may have assumed that he would complete and exhibit those already under way. This distinction of finished works from unfinished was maintained by the ex-Lord Chancellor, Lord St Leonards when defending the concept of a distinct Turner Gallery in 1857 (Finberg, *op. cit.*, p. 446), and by the authorities of the National Gallery when giving inventory numbers to the oil paintings from the Bequest (see below).

In the event all the works remaining in Turner's possession at his death that were adjudged by Turner's executors to be by the artist, 'without any distinction of finished or unfinished', were handed over to the National Gallery in 1856. A supplementary order stipulated that all pictures, drawings and sketches 'into which figures or objects have been introduced by other Artists shall belong to the Crown', but that all works 'painted drawn or sketched by other Artists which have been retouched by the Testor [Turner] or into which figures or objects have been introduced by the Testor shall belong to the next of Kin'.

The selection was based on the 'Schedule of Pictures and Drawings mentioned or referred to in

an Agreement bearing the date 21st June 1854 and made Between The Reverend Henry Scott Trimmer Clerk, and others the acting Executors named in the Will of Joseph Mallord William Turner late of Queen Ann Street Cavendish Square in the County of Middlesex Esquire R.A. decease of the one part and The Most Noble George Granville Sutherland Levison Duke of Sutherland, Knight of the Most Noble Order of the Garter, and others, the Trustees of a certain Society or Institution in London called "The National Gallery" of the other part.' This formed the basis for a second 'Schedule of Pictures, Drawings and Sketches Selected by Sir Charles Lock Eastlake, Knight, President of the Royal Academy, and John Prescott Knight, Royal Academician, in pursuance of an Order of the Court of Chancery dated 19th March 1856, as being in their opinion, by the hand of the late Joseph Mallord William Turner, Royal Academician, and as coming under the description specified in the Order referred to, Such pictures, drawings and sketches so selected by the Referees above named, being the property of the Nation.' Numbers corresponding to those given in the two schedules were chalked on the back of each picture and in some cases can still be seen. The 1854 schedule is reprinted in so far as it concerns the oil paintings, with annotations identifying many of the works listed with known pictures, in Martin Davies' *National Gallery Catalogues: The British School* (1946 edition only, pp. 185–91; the original schedules are still at the National Gallery). Martin Davies' identifications, together with further identifications made subsequently, are given under each catalogue entry for a Turner Bequest picture: the number, title and measurements given in the Schedule are noted, together with a reference to the chalk number where this still exists or has been recorded; the measurements are given as in the Schedule in feet and inches, the larger dimension first.

When the National Gallery received the pictures in 1856 only 106 of the approximately 285 oils were inventoried immediately, following the distinction between 'finished pictures' and the rest (one of the works accepted as by Turner is now thought to be by Richard Wilson or his studio, see No. 547; in addition thirty-six oil sketches on paper or board, included in this catalogue, were treated as part of the collection of watercolours and drawings). Of the 106, only about fifteen, so far as one can tell, had never been exhibited by Turner, and even these are relatively conservative in style. The numbers of this first group ran from 458 to 562. It was not until the twentieth century that any further oils were numbered: inventory numbers between 1857 and 1890 were allocated in 1901, between 1980 and 2068 in 1905, between 2302 and 2707 in 1908, between 2857 and 3557 at intervals between 1911 and 1920, between 4445 and 4665 in 1929 and 1932, and from 5473 to 5546 in 1944. After the opening in 1897 of the Tate Gallery (until 1955 an offshoot of the National Gallery under the overall direction of the same Trustees) most of Turner's works were transferred there, the new discoveries being moved as they were unearthed. In the catalogue entries the inventory numbers are given immediately after the name of the gallery where the picture is now housed.

The last batch of unnumbered oils was discovered in the cellars of the National Gallery at the beginning of the Second World War. Some of these, as Lord Clark has described, were 'in a small and remote vault, some twenty rolls of canvas, thick with dust, which I took to be old tarpaulins' (Kenneth Clark, *Another Part of the Wood* 1974, pp. 276–7), though others were on panel or old stretchers still bearing the chalk numbers of the 1854 schedule. Even now the Conservation Department at the Tate Gallery is still faced with about fifteen works remaining to be freed from over a hundred years of dirt and neglect, despite the special efforts that have been made to concentrate on the Turner collection since the Department was established in 1954. The unsatisfactory appearance of these uncleaned works is perhaps exaggerated by the reproductions in this catalogue. In fact the condition of such works, despite the quantity of dirt and actual damages, is often more satisfactory than works that have been restored, often more than once, in the past; No. 241 in this catalogue is a prime example of the ravages caused by well-meaning but over-drastic treatment. It is hoped to complete the restoration of this group of pictures over the next few years.

Martin Butlin

Authors' Note

1. In the case of exhibited pictures, we have followed the titles as they originally appeared even though this means repeating Turner's idiosyncratic spelling e.g. Rosllyn for Roslin (No. 110), San Georgio for San Giorgio (Nos. 390, 391), etc. It should be noted however that Royal Academy catalogues were often corrected during the course of printing (see, for example, No. 368); these entries have been checked by the compilers against two sometimes differing sets.

2. Similarly we have not corrected the spelling in contemporary newspaper reviews, etc., but give them as printed and usually without resorting to (*sic*).

3. The medium of all pictures is oil unless otherwise stated. Dimensions are given in inches, followed by centimetres in brackets; height precedes width.

Bibliography of Publications Referred to in Abbreviated Form

1793–1821 Joseph Farington, *Diary*, typescript in British Museum, Department of Prints and Drawings.

1819 William Carey, *A Descriptive Catalogue of a Collection of Paintings by British Artists, in the possession of Sir John Fleming Leicester, Bart.*, 1819.

1821 John Young, *A Catalogue of Pictures by British Artists, in the Possession of Sir John Fleming Leicester, Bart.*, 1821.

1837 Petworth Inventory. *See* 1856.

1838 Dr Waagen, *Works of Art and Artists in England*, 2 vols., 1838.

1843 John Ruskin, *Modern Painters*, i, 1843 (for subsequent volumes see 1846, 1856 and 1860; references are given to the Library Edition of 1903–12).

1846 John Ruskin, *Modern Painters*, ii, 1846 (references are given to the Library Edition of 1903–12).

1850 S. C. Hall, *The Vernon Gallery of British Pictures*, first series, 1850.

1851 S. C. Hall, *The Vernon Gallery of British Pictures*, second series, 1851.

1851² S. C. Hall, *Catalogue of the Vernon Gallery of Paintings by British Artists . . .*, 1851.

1851 John Ruskin, *Pre-Raphaelitism*, 1851 (references are given to the Library Edition of 1903–12).

1852 John Burnet, *Turner and his Works*, 1852 (second edn 1859).

1852 Peter Cunningham, 'The Memoir' in Burnet 1852.

1853 S. C. Hall, *The Vernon Gallery of British Pictures*, third series, 1853.

1853 John Ruskin, *The Stones of Venice*, 1853 (references are given to the Library Edition of 1903–12).

1854–57 Dr Waagen, *Treasures of Art in Great Britain*, 3 vols., 1854; with a supplementary volume *Galleries and Cabinets of Art in Great Britain*, 1857.

1856 John Ruskin, *Modern Painters*, iii and iv, 1856 (references are given to the Library Edition of 1903–12).

1856 The Rev. Thomas Socket, *Inventory of the Petworth Collection of Pictures* (all those pictures which were in the collection at Lord Egremont's death in 1837 are marked with an asterisk), privately printed 1856.

1857 John Ruskin, *Notes on the Turner Gallery at Marlborough House 1856*, 1857 (references are given to the Library Edition of 1903–12).

1857² John Ruskin, *Catalogue of the Sketches and Drawings by J. M. W. Turner, R.A.,*

exhibited in Marlborough House in the Year 1857–8, 1857 (references are given to the Library Edition of 1903–12).

1860 Charles Robert Leslie, *Autobiographical Recollections*, 1860.

1860 John Ruskin, *Modern Painters*, v, 1860 (references are given to the Library Edition of 1903–12).

1862 Walter Thornbury, *The Life of J. M. W. Turner, R.A.*, 2 vols., 1862 (second edn 1877).

1865 W. Frost, A.R.A., revised by Henry Reeve, *A Complete Catalogue of the Paintings, Water-Colour Drawings, Drawings and Prints in the Collection of the late Hugh Andrew Johnstone Munro Esq of Novar, at the time of his Death deposited in his House Nᵒ. 6 Hamilton Place London with some Additional Paintings at Novar*, 1865.

1875 R. N. Wornum, *The Turner Gallery, with a Memoir and Illustrative Text*, 1875.

1877 Walter Thornbury, *The Life of J. M. W. Turner, R.A.*, second edn of 1862 work, in one volume, 1877.

1878 W. G. Rawlinson, *Turner's Liber Studiorum, a Description and a Catalogue*, 1878 (second edn 1906).

1879 Philip Gilbert Hamerton, *The Life of J. M. W. Turner, R.A.*, 1879 (new edn with more reproductions 1895).

1879 W. Cosmo Monkhouse, *Turner*, 1879.

1886–9 John Ruskin, *Praeterita*, 1886–9 (references are given to the Library Edition of 1903–12).

1895 Charles Eastlake Smith (ed.), *Journals and Correspondence of Lady Eastlake*, 1895.

1899 C. W. Carey, 'The "Van Tromp" Pictures of J. M. W. Turner, R.A.', *Magazine of Art*, 1899, pp. 173–5.

1900 F. Wedmore, *Turner and Ruskin*, 2 vols., 1900.

1901 C. F. Bell, *A List of the Works contributed to Public Exhibitions by J. M. W. Turner, R.A.*, 1901.

1902 Sir Walter Armstrong, *Turner*, 1902.

1902 A. G. Temple, *Catalogue of Pictures forming the Collection of Lord and Lady Wantage*, 1902.

1903–12 E. T. Cook and Alexander Wedderburn, *The Works of John Ruskin*, Library Edition in 39 vols., 1903–12.

1906 W. G. Rawlinson, *Turner's Liber Studiorum, a Description and a Catalogue*, second edn, revised, of 1878 work, 1906.

1908 C. J. Holmes, 'Three Paintings by Turner', *Burlington Magazine* xiv 1908, pp. 17–25.

1908 W. G. Rawlinson, *The Engraved Work of J. M. W. Turner, R.A.*, i, 1908 (vol. ii appeared in 1913).

1909 A. J. Finberg, *The National Gallery: A Complete Inventory of the Drawings in the Turner Bequest: with which are included the Twenty-three Drawings bequeathed by Mr. Henry Vaughan*, 2 vols, 1909.

1909 John Ruskin, *Letters i, 1827–69; ii 1870–89* (references are given to the Library Edition of 1903–12).

1909 W. G. Rawlinson and A. J. Finberg, *The Water-Colours of J. M. W. Turner*, 1909.

1910 A. J. Finberg, *Turner's Sketches and Drawings*, 1910 (reissued, with introduction by

Lawrence Gowing, 1968).

1912 A. J. Finberg, *Turner's Water-Colours at Farnley Hall*, n.d. (1912).

1912 Algernon Graves, *Summary of and Index to Waagen*, 1912.

1913 W. G. Rawlinson, *The Engraved Work of J. M. W. Turner, R.A.*, ii, 1913 (vol. i was published 1908).

1913–15 Algernon Graves, *A Century of Loan Exhibitions 1813–1912*, 5 vols., 1913–15.

1920 C. H. Collins Baker, *Catalogue of the Petworth Collection of Pictures in the Possession of Lord Leconfield*, 1920.

1920 D. S. MacColl, *National Gallery, Millbank: Catalogue; Turner Collection*, 1920.

1924 Alexander J. Finberg, *The History of Turner's Liber Studiorum with a New Catalogue Raisonné*, 1924 (this retains the numbering of W. G. Rawlinson, *Turner's Liber Studiorum*, 1878 and 1906).

1925 Christopher Hussey, 'Turner at Petworth', *Country Life* lviii 1925, pp. 974–8.

1928 William T. Whitley, *Art in England 1800–1820*, 1928.

1928[2] William T. Whitley, *Artists and their Friends in England 1700–1799*, 2 vols., 1928.

1930 A. J. Finberg, *In Venice with Turner*, 1930.

1930 William T. Whitley, *Art in England 1821–1837*, 1930.

1938 Bernard Falk, *Turner the Painter: His Hidden Life*, 1938.

1939 A. J. Finberg, *The Life of J. M. W. Turner, R.A.*, 1939 (second edn 1961).

1939 Camille Mauclair, *Turner*, 1939.

1946 Martin Davies, *National Gallery Catalogues: The British School*, 1946 (second edn 1959).

1947 R. B. Beckett, '"Kilgarran Castle": A Link between Turner and Wilson', *Connoisseur* cxx September 1947, pp. 10–15.

1949 Kenneth Clark, *Landscape into Art*, 1949 (enlarged edn 1976).

1949 John Rothenstein, *Turner (1775–1851)*, 1949.

1951 Charles Clare, *J. M. W. Turner, his Life and Work*, 1951.

1951 Hilda F. Finberg, 'Turner's Gallery in 1810', *Burlington Magazine* xciii 1951, pp. 383–6.

1952 C. C. Cunningham, 'Turner's Van Tromp Paintings', *Art Quarterly* xv 1952, pp. 323–9.

1952 John Steegman, *National Museum of Wales: Catalogue of the Gwendoline E. Davies Bequest of Paintings, Drawings and Sculpture*, 1952.

1953 Hilda F. Finberg, 'Turner to Mr. Dobree', *Burlington Magazine* xcv 1953, pp. 98–9.

1955 National Museum of Wales, *Catalogue of Oil Paintings*, 1955.

1957 Ann Livermore, 'J. M. W. Turner's Unknown Verse Book', *The Connoisseur Year Book* 1957, pp. 78–86.

1957 Hilda F. Finberg, 'With Mr. Turner in 1797', *Burlington Magazine* xcix 1957, pp. 48–51.

1959 T. S. R. Boase, 'Shipwrecks in English Romantic Painting', *Journal of the Warburg and Courtauld Institutes* xxii 1959, nos. 3–4, pp. 334–46.

1959 Martin Davies, *National Gallery Catalogues: The British School*, second edn 1959 (first edn 1946).

1961 A. J. Finberg, *The Life of J. M. W. Turner, R.A.*, second edn of work of 1939 revised

by Hilda F. Finberg, 1961.

1962 Martin Butlin, *Turner Watercolours*, 1962 and subsequent edns.

1962 Douglas Hall, 'The Tabley House Papers', *Walpole Society 1960–1962* xxxviii 1962, pp. 59–122.

1963 Luke Herrmann, *J. M. W. Turner 1775–1851*, 1963.

1964 Mary Bennett, *The Emma Holt Bequest, Sudley*, Liverpool 1964.

1964 Michael Kitson, *J. M. W. Turner*, 1964.

1964 John Rothenstein and Martin Butlin, *Turner*, 1964.

1965 John Gage, 'Turner and the Picturesque', *Burlington Magazine* cvii 1965, pp. 16–26, 75–81.

1966 Lawrence Gowing, *Turner: Imagination and Reality*, 1966 (catalogue of the Museum of Modern Art, New York exhibition).

1966 Jack Lindsay, *J. M. W. Turner, His Life and Work, A Critical Biography*, 1966.

1966² Jack Lindsay, *The Sunset Ship; The Poems of J. M. W. Turner*, 1966.

1967 Leslie Parris, *The Loyd Collection of Paintings and Drawings*, 1967.

1968 John Gage, 'Turner's Academic Friendships: C. L. Eastlake', *Burlington Magazine* cx 1968, pp. 677–85.

1968 Luke Herrmann, *Ruskin and Turner*, 1968.

1968 Bernice Davidson, *Paintings in the Frick Collection*, 2 vols., 1968.

1969 Frederick Brill, *Turner's 'Peace—Burial at Sea'*, 1969.

1969 John Gage, *Colour in Turner: Poetry and Truth*, 1969.

1969 Michael Kitson, 'Un nouveau Turner au Musée du Louvre' in *La Revue du Louvre* nos. 4–5, 1969, pp. 247–56.

1969 Graham Reynolds, *Turner*, 1969.

1969² Graham Reynolds, 'Turner at East Cowes Castle', *Victoria and Albert Museum Yearbook* i 1969, pp. 67–79.

1970 Adele M. Holcomb, 'The Vignette and the Vertical Composition in Turner's Oeuvre', *Art Quarterly* xxxii 1970, pp. 16–29.

1970 Kenneth Woodbridge, *Landscape and Antiquity: Aspects of English Culture at Stourhead, 1718–1838*, 1970.

1971 Mary Bennett and Edward Morris, *Catalogue of the Emma Holt Bequest, Liverpool: Sudley*, 1971.

1971 William Gaunt, *Turner*, 1971.

1971 Hardy George, 'Turner in Venice', *Art Bulletin* liii 1971, pp. 84–7.

1971 Michael Kitson, 'Nouvelles Precisions sur le "Paysage" de Turner', *La Revue du Louvre*, no. 2, 1971, pp. 89–94.

1971 Jerrold Ziff, review of Gage 1969 in *Art Bulletin* lii 1971, pp. 125–6.

1972 John Gage, *Turner: Rain, Steam and Speed*, 1972.

1972 Louis Hawes, 'Turner's *Fighting Témérarie*', *Art Quarterly* xxxv 1972, pp. 23–48.

1972 Harold I. Shapiro (ed.), *Ruskin in Italy, Letters to his Parents 1845*, 1972.

1972 Gerald Wilkinson, *Turner's Early Sketchbooks 1789–1802*, 1972.

1973 Kenneth Clark, *The Romantic Rebellion*, 1973.

1973 Victoria and Albert Museum, *Summary Catalogue of British Paintings*, 1973.

1974 A. G. H. Bachrach, *Turner and Rotterdam 1817, 1825, 1841*, 1974.

1974 John Gage, 'Turner and Stourhead: The Making of a Classicist?', *Art Quarterly* xxxvii 1974, pp. 59–87.

1974 Adele M. Holcomb, 'The Bridge in the Middle Distance: Symbolic Elements in Romantic Landscape', *Art Quarterly* xxxvii 1974, pp. 31–58.

1974 Gerald Wilkinson, *The Sketches of Turner, R.A., 1802–20*, 1974.

1974–5 Edward Morris, 'John Naylor and other Collectors of Modern Paintings in 19th Century Britain', *Walker Art Gallery Liverpool Annual: Report and Bulletin* v 1974–5, pp. 72–9.

1975 David Brown, 'Turner, Callcott and Thomas Lister Parker: New Light on Turner's "Junction of the Thames and Medway" in Washington', *Burlington Magazine* cxvii 1975, pp. 719–22.

1975 Malcolm Cormack, *J. M. W. Turner, R.A., 1775–1851; A Catalogue of Drawings and Watercolours in the Fitzwilliam Museum, Cambridge*, 1975.

1975 Gerald Finley, 'J. M. W. Turner's Proposal for a "Royal Progress"', *Burlington Magazine* cxvii 1975, pp. 27–35.

1975 Luke Herrmann, *Turner: Paintings, Watercolours, Prints and Drawings*, 1975.

1975 Gerald Wilkinson, *Turner's Colour Sketches 1820–34*, 1975.

Exhibitions Referred to in Abbreviated Form

ALL exhibitions took place in London or Great Britain unless otherwise indicated. For annual summer exhibitions of contemporary art, and winter exhibitions of Old Masters, the following abbreviations are used:

B.I.	British Institution
R.A.	Royal Academy
R.H.A.	Royal Hibernian Academy, Dublin
R.S.A.	Royal Scottish Academy, Edinburgh
S.B.A.	Society of British Artists

Other institutions, such as the Birmingham Society of Artists, the Liverpool Academy and the Royal Manchester Institution, which held annual exhibitions, are referred to in brief form without the title of the exhibition, e.g. Royal Manchester Institution 1829.

A similar practice has been adopted for dealers' stock exhibitions, e.g. Agnew 1910, Tooth 1931, Leggatt 1958 etc.

1834	Society of British Artists 3rd Winter Exhibition; opened December 1834.
1854	Town Hall, Liverpool, *Pictures exhibited at a Soirée given by John Buck Lloyd Esq, Mayor of Liverpool, at the Town Hall on Saturday evening September 23*, 1854
1857	Manchester, *Art Treasures of the United Kingdom collected at Manchester in 1857*, Section 2, Paintings by Modern Masters.
1862	South Kensington, London, *International Exhibition*, Fine Art Department, British Division Section 38, Painting, 1862.
1868	Leeds, *National Exhibition of Works of Art*, Section 2, British Deceased Painters in Oil, 1868.
1876	Wrexham, *Art Treasures Exhibition*, 1876.
1878	Corporation Galleries, Glasgow, *Fine Art Loan Exhibition*, October 1878.
1881	Liverpool Art Club, *Loan Collection of Oil Paintings by British Artists born before 1801*, October 1881.
1886	Corporation of Liverpool, Walker Art Gallery, *Pictures from Lancashire Collections and Exhibitions of the Liverpool Society of Painters in Water-Colours and Liver Sketching Club*, 1886
1887	Fine Art Galleries, Manchester, *Royal Jubilee Exhibition*, 1887.
1888	The Grosvenor Gallery Winter Exhibition, *A Century of British Art from 1737 to 1837*, 1888.

1888 Kelvingrove Park, Glasgow, *Fine Arts Section, International Exhibition, 1888.*

1889 The Grosvenor Gallery Winter Exhibition, *A Second Series of a Century of British Art from 1737–1837,* 1889.

1892 Corporation of London Art Gallery, Guildhall, *Loan Collection of Pictures,* 1892.

1894 Corporation of London Art Gallery, Guildhall, *Loan Collection of Pictures,* 1894.

1898 Public Hall, West Ham, *Free Picture Exhibition,* opened April 1898.

1899 Corporation of Birmingham Museum and Art Gallery, *Loan Collection of Pictures and Drawings by J. M. W. Turner, R.A.,* 1899.

1899 Corporation of London Art Gallery, Guildhall, *Loan Collection of Pictures and Drawings by J. M. W. Turner, R.A., and of a Selection of Pictures by some of his Contemporaries,* April–July 1899.

1900 Paris Exhibition, *Loan Collection and Exhibits in the British Royal Pavilion,* 1900.

1901 Kelvingrove Park, Glasgow, *International Exhibition, Fine Art Section,* 1901.

1902 Wolverhampton, *Art and Industrial Exhibition: Fine Art Section,* May–November 1902.

1902 Messrs. Lawrie & Co., 159 New Bond Street, *The Farnley Hall Collection of Pictures and Drawings by J. M. W. Turner, R.A., etc.,* May 1902

1908 Fine Art Palace, Shepherd's Bush, *Franco–British Exhibition,* British Section, Oil Paintings by Deceased Artists, 1908.

1908 Copenhagen, Det Kongelige Academi For De Skønne Kunster, *Udstilling af Ældre Engelisk Kunst I Ny Carlsberg Glyptotek MDCCCVIII.*

1909 Manchester, *Loan Exhibition of Works by Early British Masters,* Winter 1909.

1910 Fine Art Palace, Shepherd's Bush, *Japan British Exhibition,* Fine Arts Part I, British Section.

1911 Rome, *International Fine Arts Exhibition,* 1911.

1912 Laing Art Gallery, Newcastle, *Original Drawings in Water Colour, etc., by J. M. W. Turner, R.A.,* 1912.

1913 National Museum of Wales, Cardiff, *Loan Exhibition of Paintings,* February–March 1913.

1914 Knoedler, New York, *Loan Exhibition of Paintings by Thomas Gainsborough and J. M. W. Turner, R.A.,* January 1914.

1914–15 Grosvenor Gallery, *III National Loan Exhibition: Pictures from the Basildon Park and Fonthill Collections,* 1914–15.

1924 Laing Art Gallery, Newcastle, *Special Loan Collection of Paintings in Oil, Water Colour, etc., by J. M. W. Turner, R.A.,* 1924.

1927 Vienna, *Meisterwerke Englischer Malerei aus Drei Jahrhunderten,* September–November 1927.

1928 Olympia, *1928 International Exhibition of Antiques and Works of Art organized by The Daily Telegraph,* July–August 1928.

1929 Musée Moderne, Brussels, *Exposition Rétrospective de Peinture Anglaise (XVIII & XIX Siècles),* October–December 1929.

1931 Tate Gallery, *Turner's Early Oil-Paintings (1796–1815),* July–September 1931.

1933 Walker Art Gallery, Liverpool, *Autumn Exhibition,* 1933.

1934 Royal Academy, *Exhibition of British Art c. 1000–1860,* January–March 1934.

1934 City Art Gallery, Manchester, *British Art Exhibition*, April–May 1934.

1935 Brussels, *Exposition Internationale de Cinq Siècles d'Art*, May–October 1935.

1936 Stedelijk Museum, Amsterdam, *Twee Eeuwen Engelsche Kunst*, July–October 1936.

1936–9 Empire Loan Collections Society tour to New Zealand, Australia and South Africa, *British Masters from the National and Tate Galleries, London*, 1936–9.

1938 Louvre, Paris, *La Peinture Anglaise, XVIIIᵉ & XIXᵉ Siècles*, 1938 (with illustrated souvenir volume).

1938 Palazzo dell'Esposizione, Venice (sala 12, Gran Bretagna), *XXIᵃ Esposizione Biennale Internazionale d'Arte*, 1938.
 (Because of the vagueness of some of the titles, it has not been possible to identify all of the six Turners included).

1944 Council for the Encouragement of Music and the Arts tour, *British Narrative Paintings from the Tate Gallery*, 1944.

1946 Museum of Fine Arts, Boston, *An Exhibition of Paintings Drawings and Prints by J. M. W. Turner, John Constable, R. P. Bonington*, March–April 1946.

1946 National Library of Wales, Aberystwyth, *Seventy-Two Pictures from the Gregynog, Dulwich College and other Collections*, July–August, September–October 1946.

1946–7 Metropolitan Museum, New York; Art Institute, Chicago; and Toronto; *Masterpieces of English Painting: William Hogarth, John Constable, J. M. W. Turner*, 1946–7.

1947 Arts Council tour to Temple Newsam House, Leeds; Ferens Art Gallery, Hull; Harrogate Public Library; Derby Museum and Art Gallery; National Museum of Wales, Cardiff; and City Art Gallery, Bristol, *English Romantic Art*, May–November 1947.

1947 National Library of Wales, Aberystwyth, *Fifty-Seven Pictures from the Gregynog, Dulwich College and other Collections*, from July 1947.

1947–8 British Council tour to Stedelijk Museum, Amsterdam; Berner Kunstmuseum; Orangerie, Paris; Palais voor Schone Kunst, Brussels; Museum voor Schone Kunst, Liege; British Pavilion, XXIV Venice Biennale; and Palazzo Venezia, Rome, *Turner 1775–1851*, 1947–8.

1948–9 Museum and Art Gallery, Birmingham and Tate Gallery, *Richard Wilson and his Circle*, November 1948–January 1949.

1949 British Council tour to Lisbon and Madrid, *A Hundred Years of British Painting*, 1949.

1949–50 British Council tour to Kunsthalle, Hamburg; Kunsternernes Hus, Oslo; Nationalmuseum, Stockholm; and Statens Museum for Kunst, Copenhagen, *British Painting from Hogarth to Turner*, 1949–50.

1951 National Museum of Wales, Cardiff, Celebration of the Centenary of Turner's Death, February–March 1951 (no catalogue issued).

1951 Tate Gallery, *The Turner Collection from Petworth*, May–July 1951.

1951 National Library of Wales, Aberystwyth, *An Exhibition of 61 Pictures from the Gregynog Collection*, July–October 1951.

1951 Art Gallery of Toronto and National Gallery of Canada, Ottawa, *Paintings by J. M. W. Turner*, October–December 1951.

1951–2 Royal Academy, *The First Hundred Years of the Royal Academy*, December 1951–March 1952.

1952 British Council, Van Riebeeck Festival, National Gallery of South Africa, Cape Town, *Some Paintings of the British School, 1730–1840*, 1952.

1952–3 Arts Council Tour, *J. M. W. Turner, R.A. 1775–1851, A Selection of twenty-four oil paintings from the Tate Gallery*, 1952–3.

1953 Orangerie, Paris, *Le Paysage Anglais*, February–April 1953.

1953 Whitechapel Art Gallery, *J. M. W. Turner, R.A. 1775–1851*, February–March 1953.

1953–4 The loan of a group of Turner's to the Antwerp Museum in exchange for loans to the Royal Academy's Flemish exhibition, winter 1953–4.

1954 Wildenstein, *Pictures and Works of Art from Petworth House*, February–March 1954.

1955 British Council, Museum Boymans, Rotterdam, *Engelse landschapschilders von Gainsborough tot Turner*, 1955.

1955 John Herron Art Museum, Indianapolis, *Turner in America*, November–December 1955.

1956–7 Museum of Modern Art, New York; City Art Museum of St. Louis; and the California Palace of the Legion of Honor, San Francisco, *Masters of British Painting 1800–1950*, October 1956–May 1957.

1957 Brighton Art Gallery, *The Influence of Wales in Painting*, Summer 1957.

1959 Council of Europe, Tate Gallery (and Arts Council Gallery), *The Romantic Movement*, July–September 1959.

1960 Pushkin Museum, Moscow, and Hermitage Museum, Leningrad, *British Painting 1700–1960*, Summer 1960.

1960 National Gallery of South Australia, Adelaide; Art Gallery of New South Wales, Sydney; National Gallery of Victoria, Melbourne; Queensland National Art Gallery, Brisbane; and Art Gallery of Western Australia, Perth, *Paintings by J. M. W. Turner, R.A. 1775–1851, Lent by the Tate Gallery, London*, March–September 1960.

1960 Leggatt Brothers, *Autumn Exhibition 1960: J. M. W. Turner R.A.*, October–November 1960.

1962 Royal Academy, Winter Exhibition, *Primitives to Picasso: An Exhibition from Municipal and University Galleries in Great Britain*, January–March 1962.

1963 Virginia Museum of Fine Arts, Richmond, *Painting in England 1700–1850: Collection of Mr. and Mrs. Paul Mellon*, April–August 1963.

1964 Glynn Vivian Art Gallery, Swansea, *Art in Wales: A Survey of Four Thousand Years to AD 1850*, July–August 1964.

1964 Arts Council, *Ruskin and his Circle*, January–February 1964.

1964–5 Royal Academy, Winter Exhibition, *Painting in England 1700–1850 from the Collection of Mr. and Mrs. Paul Mellon*, December 1964–February 1965.

1965 Yale University Art Gallery, New Haven, *Painting in England 1700–1850 from the Collection of Mr. and Mrs. Paul Mellon*, 1965.

1965 Petit Palais, Paris, *Trois Millénaires d'Art et de Marine*, March–May 1965.

1966 Museum of Modern Art, New York, *Turner: Imagination and Reality* (catalogue by Lawrence Gowing), March–June 1966.

1966–7 British Council tour to Wallraf-Richartz-Museum, Cologne; Palazzo Venezia, Rome; and Muzeum Narodowe, Warsaw, *Painting from Hogarth to Turner*, October 1966–March 1967.

1967 Thos. Agnew & Sons, Ltd., *Paintings and Watercolours by J. M. W. Turner, R.A.*, November–December 1967.

1968 National Gallery of Scotland, Edinburgh, *J. M. W. Turner (1775–1851)*, 1968.

1968 Detroit Institute of Arts and Philadelphia Museum of Art, *Romantic Art in Britain: Paintings and Drawings 1760–1860*, January–April 1968.

1968 Leicester Museums and Art Gallery, *The Victorian Vision of Italy 1825–1875*, October–November 1968.

1968–9 National Gallery of Art, Washington, D.C., *J. M. W. Turner, a Selection from the Collection of Mr. and Mrs. Paul Mellon*, October 1968–April 1969.

1968–9 Royal Academy, *Bicentenary Exhibition 1768–1968*, December 1968–March 1969.

1969 National Gallery, Prague; National Gallery of Slovakia, Bratislava; and Volkerskünde Museum, Vienna, *Two Centuries of British Paintings*, April–October 1969.

1969–70 Norwich Castle Museum and Victoria and Albert Museum, *A Decade of English Naturalism 1810–1820*, November 1969–February 1970.

1970–1 National Museum of Western Art, Tokyo, and Kyoto National Museum of Modern Art, *English Landscape Painting of the 18th and 19th Centuries*, October 1970–January 1971.

1970–1 Mauritshuis, The Hague, and Tate Gallery, *Schok der Herkenning/Shock of Recognition*, November 1970–February 1971.

1972 Petit Palais, Paris, *La Peinture Romantique Anglaise et les Préraphaélites*, January–April 1972.

1972 Wildenstein, *Venice Rediscovered*, November–December 1972.

1972 Gemäldegalerie Neue Meister, Dresden, and Nationalgalerie Staatliche Museen Preussischer Kulturbesitz, Berlin, *William Turner 1775–1851*, July–November 1972.

1973 Palais des Beaux-Arts, Brussels, *Europalia*, September–November 1973.

1973 Fundação Calouste Gulbenkian, Lisbon, *Turner (1775/1851)*, June–July 1973.

1973–4 British Council tour to Bridgestone Gallery, Tokyo; Fine Arts Museum, Osaka; and City Hall Art Gallery, Hong Kong, *J. M. W. Turner 1775–1851: Watercolours, Influence in Britain*, February–April 1974.

1973–4 Tate Gallery, *Landscape in Britain c. 1750–1850*, November 1973–February 1974.

1974 Royal Academy, Diploma Galleries, *Impressionism: Its Masters, its Precursors and its Influence in Britain*, February–April 1974.

1974 Victoria and Albert Museum, *Byron*, May–August 1974

1974–5 Tate Gallery and Royal Academy at the Royal Academy, *Turner 1775–1851*, November 1974–March 1975.

1975 Palazzo Reale, Milan, *Pittura Inglese 1660/1840*, January–March 1975.

1975–6 Department of Prints and Drawings, British Museum, *Turner in the British Museum: Drawings and Watercolours*, May 1975–February 1976.

1975–6 Hermitage Museum, Leningrad, and Pushkin Museum, Moscow, *Turner 1775–1851*, October 1975–January 1976.

1976 Kunsthalle, Hamburg, *William Turner und die Landschaft seiner Zeit*, May–July 1976.

1976–7 Kunsthaus, Zurich, *Turner und die Schweiz*, October 1976–January 1977.

Chronology

1775
23 April: Joseph Mallord William Turner born at 21 Maiden Lane, Covent Garden, London, the eldest son of a barber and wig-maker.

1786
Probably went to live with his uncle at Brentford, Middlesex, in this year. First signed and dated drawings.

1789
Probable date of first extant sketchbook from nature, made in London and the neighbourhood of his uncle's house in Sunningwell, near Oxford (the 'Oxford' sketchbook, T.B.11).
11 December: Admitted as a student of the Royal Academy Schools after a term's probation. Probably began to study with Thomas Malton, the watercolour painter of architectural subjects, at about the same time.

1790
First exhibit, a watercolour, at the Royal Academy.

1791
September: Sketched at Bristol, Bath, Malmesbury and elsewhere in Somerset and Wiltshire.

1792
Summer: First sketching tour in South and Central Wales.

1793
27 March: Awarded the 'Greater Silver Pallet' for landscape drawing by the Society of Arts.

1794
May: Publication of the first engraving after one of his drawings.
His watercolours at the Royal Academy attract the attention of the press for the first time.
First Midland tour, largely to make drawings for engraving.
His employment in winter evenings, together with Girtin, Dayes and others, by Dr Monro to copy drawings by J. R. Cozens and other artists probably began in this year; it lasted for three years.

1795
Toured in South Wales June–July and the Isle of Wight August–September, in part to execute private commissions for topographical drawings as well as for engravings.

1796
Exhibited first oil painting at the Royal Academy (No. 1).

1797
Summer: First tour in the North of England, including the Lake District.

1798
Summer: Trip to Malmesbury, Bristol and thence, almost certainly for the first time, to North Wales.

1799
April: Recommended to Lord Elgin to make topographical drawings at Athens. Failed to agree on salary.
August–September: Stayed for three weeks with William Beckford at Fonthill.
Autumn: To Lancashire and North Wales.
4 November: Elected an Associate of the Royal Academy.
November–December: Moved to 64 Harley Street.

1800
Some of the verses in the Royal Academy catalogue possibly by Turner himself for the first time (see No. 12).
27 December: Turner's mother admitted to the Bethlem Hospital for the insane.

1801
June–August: First tour of Scotland, returning through the Lakes.

1802
12 February: Elected a full member of the Royal Academy.
15 July–October: First visit to France and Switzerland, possibly with Walter Fawkes; made sketches and notes after pictures in the Louvre.

1804
15 April: Death of Turner's mother, probably at Bethlem Hospital.
April: Completed a gallery in Queen Anne Street, contiguous with 64 Harley Street, for the exhibition of twenty to thirty of his own works.
Had a *pied-à-terre* on the Thames, at Sion Ferry House, Isleworth, by this year or 1805.

1806
Exhibited two oils at the first exhibition of the British Institution.
Late summer and autumn: Stayed at Knockholt, Kent, with W. F. Wells, who suggested the *Liber Studiorum*.
October (?): Took a house at 6 West End, Upper Mall, Hammersmith, retaining his London home.

1807
11 June: First volume of the *Liber Studiorum* published.
2 November: Elected Professor of Perspective at the Royal Academy.

1808
Summer: Stayed at Sir John Leicester's seat, Tabley House, Cheshire (see Nos. 98–9, 208). Also sketched on the River Dee (see No. 92).

1809
Summer: First visit to Petworth House, the home of Lord Egremont, probably this year (see No. 113).

1810
Late summer: First recorded visit to Walter Fawkes at Farnley Hall, Yorkshire; repeated nearly every year till 1824.

Before 12 December: His town address changed to 47 Queen Anne Street West, round the corner and attached to 64 Harley Street.

1811

7 January: First lecture as Professor of Perspective of the Royal Academy.

July–September: Tour of Dorset, Devon, Cornwall and Somerset in connection with *The Southern Coast*, his first big series of topographical engravings, to be issued in parts.

Gave up Hammersmith home, and had a temporary residence at Sion Ferry House, Isleworth, while building a house at Twickenham.

1812

First quotation in the Royal Academy catalogue from the *Fallacies of Hope* (see No. 126).

1813

Solus (later Sandycombe) Lodge, Twickenham, completed from his designs.

Summer: Toured Devon (see Nos. 213–25).

1816

July–September: Visited Farnley Hall and travelled in the North of England, in part collecting material for Whitaker's *History of Richmondshire*.

1817

August–September: First visit to Belgium, the Rhine between Cologne and Mainz, and Holland. Returned via County Durham, and stayed at Farnley Hall in November.

1818

Commissioned to do watercolours of Italian subjects after drawings by James Hakewill for Hakewill's *Picturesque Tour in Italy*.

October–November: Visited Edinburgh in connection with Walter Scott's *The Provincial Antiquities of Scotland*.

1819

March: Eight of his oils on view in Sir John Leicester's London gallery; also in subsequent years.

April–June: Sixty or more watercolours on view in Walter Fawkes' London House, and again in 1820.

August–February 1820: First visit to Italy: Turin, Como, Venice, Rome, Naples; returned from Rome via Florence, Turin and the Mont Cenis pass.

1819–21

Enlarged and transformed his Queen Anne Street house, building a new gallery.

1821

Late summer or autumn: Visit to Paris, Rouen, Dieppe, etc.

1822

1 February–August: A number of watercolours included in an exhibition organised by the publisher W. B. Cooke, and again in 1823 and 1824.

August: Visited Edinburgh for George IV's State Visit, going by sea up the east coast (see Nos. 247–8).

1823

Sketched along the south-east coast.

Commissioned to paint *The Battle of Trafalgar* for St James' Palace (see Nos. 250–2).

1824

Summer and autumn: Toured east and south-east England.

1825
28 August: Set out on tour of Holland, the Rhine and Belgium.
25 October: Death of Walter Fawkes.

1826
The series of *Picturesque Views in England and Wales* begun for Charles Heath.
The Ports of England mezzotints issued this year, and in 1827 and 1828.
10 August–early November: Visited the Meuse, the Moselle, Brittany and the Loire.

1827
18 June: Death of Lord de Tabley (Sir John Leicester).
Late July–September: Stayed with John Nash at East Cowes Castle, Isle of Wight (see Nos. 242–3, 260–8), probably returning via Petworth, where he was a regular visitor until 1837 (see Nos. 282–91, 444–9).

1828
January–February: Turner's last lectures as Professor of Perspective.
August–February 1829: Second visit to Italy (see Nos. 292–328); Paris, Lyons, Avignon, Florence, Rome, returning via Loreto, Ancona, Bologna, Turin, Mont Cenis, Mont Tarare and Lyons.

1829
Early June–18 July; About forty watercolours for the *England and Wales* engravings exhibited at the Egyptian Hall; some later shown at Birmingham.
August–early September: visited Paris, Normandy and Britanny.
21 September: Death of Turner's father.

1830
Late August–September: Toured the Midlands.
Roger's *Italy* published with vignettes by Turner.

1831
July–September: Toured Scotland, staying at Abbotsford in connection with his illustrations to Scott's poems (see No. 347, 524).

1832
March: Twelve illustrations to Scott exhibited at Messrs. Moon, Boys and Graves, Pall Mall; further watercolours were shown there in 1833 and 1834.

1833
Turner's Annual Tour – Wanderings by the Loire and *by the Seine* published this year, 1834 and 1835.
August: Visited Paris; it was probably on this occasion that he went to see Delacroix.
September: Almost certainly in Venice, travelling via the Baltic, Berlin, Dresden, Prague and Vienna.

1834
Illustrations to Byron's poems exhibited at Colnaghi's.
Late July: Set off on a tour of the Meuse, Moselle and Rhine.
Winter: Four of his early oils on view at the Society of British Artists (Nos. 91, 108, 149, 536).

1836
Summer: Toured France, Switzerland and the Val d'Aosta with H. A. J. Munro of Novar (see Nos. 371, 520).
October: Ruskin's first letter to Turner, enclosing a reply to an attack in *Blackwood's Magazine* (see No. 365).

1837

One oil in the British Institution 'Old Masters' Exhibition (No. 14)

11 November: Death of Lord Egremont.

28 December: Resigned post of Professor of Perspective.

1840

22 June: Met Ruskin for the first time.

Early August–early October: Third visit to Venice, going via Rotterdam and the Rhine and returning through Munich and Coburg.

1841

August–October: Visited Switzerland: Lucerne, Constance, Zurich, etc.

1842

August–October: Visited Switzerland.

1843

May: Publication of the first volume of Ruskin's *Modern Painters*, intended largely as a defence of Turner.

June (?)–September: Visited Switzerland.

1844

August–early October: Last visit to Switzerland; also Rheinfelden, Heidelberg and the Rhine.

1845

Walhalla shown at the 'Congress of European Art' at Munich (see No. 401).

May: Short visit to Boulogne and neighbourhood.

14 July: As eldest Academician, chosen to carry out duties of President during Shee's illness.

September–October: Visit to Dieppe and the coast of Picardy (his last trip abroad).

1846

Last firm date for a finished watercolour, though further Swiss views may have been executed in 1848 or even later.

Took a cottage on the corner of Cremorne Road and Cheyne Walk, Chelsea, at about this time.

1848

January: One painting hung in the National Gallery to represent the Vernon Gift (No. 396).

1851

No works at the Royal Academy.

19 December: Died at his cottage, 119 Cheyne Walk, Chelsea. Buried at St Paul's on 30 December.

1. Early Works, up to Turner's First Visit to the Continent, *c.* 1793–1802

Nos. 1–19: Exhibited Pictures

1. Fishermen at Sea Exh. 1796 (Plate 2)

THE TATE GALLERY, LONDON (T. 1585)

Canvas, 36 × 48⅛ (91·5 × 122·4).

Coll. Purchased 1796 by 'General Stewart'; . . .; by descent from the mid nineteenth century to F. W. A. Fairfax-Cholmeley, sold through Thos. Agnew and Sons Ltd to the Tate Gallery 1972.

Exh. R.A. 1796 (305); Tate Gallery 1931 (1, repr.); on loan to the Tate Gallery, with interruptions, 1931–72; R.A. 1951–2 (180); Tate Gallery 1959 (342, repr. pl. 46); Paris 1972 (258, repr.); R.A. 1974–5 (19); Leningrad and Moscow 1975–6 (4).

Engr. By Turner for his *Liber Studiorum* but not published (repr. Finberg 1924, p. 340; the preliminary pen and sepia drawing from the Vaughan Bequest, now with works from the Turner Bequest in the British Museum, CXVIII-V, repr. *ibid.*).

Lit. Cunningham 1852, p. 7; Thornbury 1862, i, p. 75; 1877, p. 44; Bell 1901, p. 30; A. J. Finberg, 'Turner's First Exhibited Oil Painting', *Burlington Magazine* lviii 1931, pp. 262–7, repr. p. 266 fig. B; Rothenstein 1949, p. 24, colour pl. 1; Finberg 1961, pp. 33–4, 458 no. 22; Herrmann 1963, p. 10; Rothenstein and Butlin 1964, pp. 7–8, 15, pl. 5; Gage 1964, pp. 22–3, repr. p. 20 fig. 30; Lindsay 1966, pp. 27–8, 120, 223 no. 24; Lindsay 1966², p. 17; Gage 1969, pp. 33–5, 78, pl. 22; Wilkinson 1972, pp. 35, 38, repr. p. 39; Herrmann 1975, pp. 12, 226, pl. 18.

The identification of this picture with the work exhibited at the R.A. in 1796 as 'Fishermen at Sea', though not absolutely certain, is very probable. The R.A. picture was exhibited in the 'Anti Room' together with portraits, landscapes and subject paintings at least some of which, such as portraits by Hoppner and Beechey, must have been in oils, whereas Turner's watercolour exhibits were in the Antique Academy and the Council Room. Two contemporary accounts describe the exhibited work in terms that fit the Tate Gallery picture. According to the *Companion* to the exhibition, 'As a sea-piece this picture is effective. But the light on the sea is too far extended. The colouring is, however, natural and masterly; and the figures, by not being more distinct and determined, suit the obscure perception of the objects, dimly seen through the gloom of night, partially illumined.' John Williams ('Anthony Pasquin') in the *Critical Guide* follows his praise of the picture with the comment, 'the boats are buoyant and swim well, and the undulation of the element is admirably deceiving.'

Furthermore, Thornbury, on the basis of MS notes written by the engraver E. Bell (according to which Bell had first met Turner in 1795) says that 'The same valuable record mentions also that Turner's first oil picture of any size or consequence [following 'his first attempt in oil, from a sketch in crayon, of a sunset on the Thames, near the Red House, Battersea'] was a view of flustered and scurrying fishing-boats in a gale of wind off the Needles, which General Stewart bought for £10.' The Needles are prominent in the middle distance on the left of the painting, and Turner had toured the Isle of Wight, including the westernmost point, in 1795 (see the sketchbook, labelled '95, Isle of Wight' by Turner himself and watermarked 1794, in the British Museum, XXIV).

Though none of the sketches in the 'Isle of Wight' sketchbook is directly related to the painting, the larger watercolour apparently from the 'Cyfarthfa' sketch-book is fairly close (XLI-37, also watermarked 1794; Finberg 1909, i, p. 99, disputes the traditional title of 'The Needles', suggesting '(?) Oxwich Bay, Gower', but the former identification seems to be correct). John Gage suggests a dependence on a drawing of 1794 by P. J. de Loutherbourg (repr. *Burlington Magazine* cvii 1965, p. 20, fig. 31, and Wilkinson 1972, p. 39; see also Gage 1969, *loc. cit.* and p. 229 n. 53) but the relationship is not close. Gage has, however, convincingly

demonstrated that Turner's interest in the Isle of Wight reflected Picturesque fashion in the 1790s. In style *Fishermen at Sea* is in the tradition of Joseph Vernet, Wright of Derby and de Loutherbourg, particularly in the contrasting of the cold natural light of the moon with the ruddier glow of the lantern in the boat. Turner developed this style in one of his R.A. exhibits of the following year, *Moonlight, a Study at Millbank* (No. 2).

In the R.A. catalogue *Fishermen at Sea* was not marked with the asterisk that distinguished works 'to be disposed of'. It had presumably been bought already by the 'General Stewart' of Bell's account, of whom nothing is known. How it passed to the Fairfax-Cholmeley family is unclear.

2. Moonlight, a Study at Millbank Exh. 1797
(Plate 17)

THE TATE GALLERY, LONDON (459)

Mahogany, $12\frac{3}{8} \times 15\frac{7}{8}$ ($31 \cdot 5 \times 40 \cdot 5$).

Coll. Turner Bequest 1856 (96, 'River Scene Moonlight' $1'4'' \times 1'0\frac{1}{2}''$); transferred to the Tate Gallery 1910.

Exh. R.A. 1797 (136); Tate Gallery 1931 (2); R.A. 1974–5 (20); Hamburg 1976 (6, repr.).

Lit. Thornbury 1862, i, pp. 258, 261; ii, p. 331; 1877, pp. 92, 417–18; Hamerton 1879, p. 50; Bell 1901, p. 71 no. 82; Armstrong 1902, pp. 31, 225; Finberg 1910, pp. 28–9; Davies 1946, p. 187; Clare 1951, p. 18; Finberg 1961, pp. 42, 459 no. 33; Rothenstein and Butlin 1964, pp. 8–10, pl. 6; Gaunt 1971, p. 4, colour pl. 2

For a long time, until the identification of the 1796 *Fishermen at Sea* (No. 1), regarded as Turner's 'first exhibited oil-picture' (Thornbury 1862, i, p. 258). It is perhaps just possible that this picture is imperfectly remembered in a note by the engraver Bell, as given by Thornbury (1862, i, p. 75) of how 'Mr. Bell stood by in the little room in Maiden-lane when Turner made his first attempt in oil, from a sketch in crayon, of a sunset on the Thames, near the Red House, Battersea.'

Unlike the other oil exhibited in 1797 (No. 3) this picture does not seem to have attracted any critical attention.

3. Fishermen coming ashore at Sun Set, previous to a Gale Exh. 1797
(Plate 18)
known as *The Mildmay Seapiece*

PRESENT WHEREABOUTS UNKNOWN

Canvas, 36×48 ($91 \cdot 5 \times 122$). The size is given as 3 ft by 4 ft on the lettering of the first state of the *Liber Studiorum* engraving

Coll. Perhaps painted for Sir John Mildmay, Bt; G. R. Burnett; sale Christie's 24 March 1860 (82) as

'Autumnal Sunset at Sea' bought Shepherd (the catalogue stated 'This grand work was painted for Sir John Mildmay'. If true, this must have been Turner's earliest commissioned oil of any importance); no subsequent history is known.

In fact Sir John Mildmay must be a mistake for Sir Henry St John-Mildmay (1746–1808). This mistake is perpetuated in the letterpress on the *Liber* engraving (1812) which states that it is taken from the picture 'in the possession of Sir John Mildmay Bart.' By this date the picture must have passed to the fourth Baronet, also Sir Henry St John-Mildmay (1787–1848).

Exh. R.A. 1797 (344).

Engr. By W. Annis and J. C. Easling in the *Liber Studiorum*, published 11 February 1812 (Rawlinson 40).

Lit. Farington *Diary* 28 April 1797; Burnet and Cunningham 1852, pp. 19, 21–2, 110 no. 34; Thornbury 1877, pp. 415, 568, 608; Monkhouse 1879, pp. 34, 35; Bell 1901, p. 71 no. 83; Armstrong 1902, p. 229; Finberg 1924, pp. 159–60; Whitley[2] 1928, ii, p. 215; Clare 1951, p. 20; Finberg 1961, pp. 41–2, 459 no. 34; Gaunt 1971, p. 4.

This picture, now untraced, was enthusiastically received when shown at the R.A. as the following accounts show:

The Times for 3 May thought 'Mr. Turner . . . has strayed from the direct walk of his profession [i.e. as an architectural draughtsman] to paint the sickly appearance of the setting sun at sea, preparatory to a storm, as it is described in Falconer's poem of *The Shipwreck*; and in this he has succeeded in an astonishing degree. We never beheld a piece of the kind possessing more imagination or exciting more awe and sympathy in the spectators.'

The reference to the poem *The Shipwreck* by William Falconer (1732–69) attests to its continuing popularity. It consisted of three Cantos and first appeared in 1762, revised versions being published in 1764 and 1769. By 1796 no fewer than nine editions had appeared.

The *Morning Post*, 5 May, reported as follows: '279. [A mistake for 344] Fishermen coming ashore at sunset, previous to a gale. We have no knowledge of Mr. Turner, but through the medium of his works, which assuredly reflect great credit upon his endeavours; the present Picture is an undeniable proof of the possession of genius and judgement, and what is uncommon, in this age, is, that it partakes but very little of the manner of any other master: he seems to view nature and her operations with a peculiar vision, and that singularity of perception is so adroit, that it enables him to give a transparency and modulation to the sea, more perfect than is usually seen on canvas:—he has a grace and boldness in the disposition of his tints and handling, which sweetly deceive the sense; and we are inclined to approve him the more, as all our marine Painters have

too servilely followed the steps of each other, and given us pictures more like Japanned tea-boards, with boats on a smooth and glossy surface, than adequate representation of that inconstant, boisterous, and ever changing element.'

This criticism was reprinted in a pamphlet *A Critical Guide to the Present Exhibition at the Royal Academy,* 1797, by John Williams 'whose public appellation is Anthony Pasquin'.

Thomas Green, the younger (1769–1815), the author of *The Diary of a Lover of Literature,* published in 1810, mentions his visit to the R.A. on 2 June 1797 (p. 35): 'Visited the Royal Exhibition. Particularly struck with a sea view by Turner—fishing vessels coming in, with a heavy swell, in apprehension of tempest gathering in the distance, and casting, as it advances, a night of shade; while a parting glow is spread with fine effect upon the shore. The whole composition, bold in design, and masterly in execution. I am entirely unacquainted with the artist; but if he proceeds as he has begun, he cannot fail to become the first in his department.'

Furthermore, Hoppner, later to be sternly critical of Turner's work, who was a member of the Council of the R.A., reported on the exhibition before it opened to Farington, praising 'Turner's Evening sea view'.

4. Winesdale, Yorkshire, an Autumnal Morning Exh. 1798

PRESENT WHEREABOUTS UNKNOWN

Size unknown

Exh. R.A. 1798 (118).

Lit. Burnet and Cunningham 1859 (not in the 1852 edn), p. 96 no. 39; Thornbury 1862, i, p. 150; 1877, pp. 93, 568; Ruskin 1878 (1903–12, xiii, p. 406); Bell 1901, p. 71 no. 84; Armstrong 1902, p. 46 (but not in his catalogue); Finberg 1961, pp. 48, 460 no. 39.

This picture is known only through its original appearance at the R.A. To judge from where it hung at the R.A., and from its neighbours there, it seems quite certainly to have been an oil. It is mentioned in the *St. James's Chronicle* for 1–3 May 1798, which gives the title as 'Winnesdale' and describes it as consisting of 'a beautiful variety of tints, all in perfect harmony'. The critic of the *London Packet, Or, New Lloyd's Evening Post* also refers to the picture, 30 April–2 May, saying: 'This is a very aspiring artist, but he appears rather too much inclined to shackle Nature in the magic bonds of Poetry, than give her chaste beauties their full and unaffected display. Mr. T's drawings in general much surpass his pictures.'

There is no such place as Winesdale in Yorkshire, but Finberg points out that there were an unusual number of misprints in the R.A. catalogue that year and that probably 'Wensleydale' was intended. (Ruskin certainly refers to the picture under this title.) The subject presumably derived from Turner's sketching

tour of the summer of 1797 when he passed through Wensleydale on his way from Lancaster to Harewood.

5. Morning amongst the Coniston Fells, Cumberland Exh. 1798 (Plate 1)

THE TATE GALLERY, LONDON (461)

Canvas, $48\frac{3}{8} \times 35\frac{5}{16}$ (123 × 89·7); about 1 (2·5) made up at top and $\frac{1}{4}$ (0·7) at sides and along bottom.

Coll. Turner Bequest 1856 (74 'Waterfall' 4′0″ × 3′0″); transferred to the Tate Gallery 1910.

Exh. R.A. 1798 (196); Tate Gallery 1931 (5); Amsterdam, Berne, Paris, Brussels, Liege (1), Venice and Rome (2) 1947–8.

Lit. Farington *Diary* 5 January 1798; Cunningham 1852, p. 6; Thornbury 1862, i, pp. 258, 264; ii, 332; 1877, p. 92, 419, 530; Bell 1901, p. 27 no. 85; Armstrong 1902, p. 220; Davies 1946, p. 187; Clare 1951, p. 20, repr. p. 19; Finberg 1961, pp. 45, 48–9, 460 no. 40; Rothenstein and Butlin 1964, p. 10, pl. 10; Lindsay 1966, p. 60.

Exhibited in 1798, the first year verses were allowed in the R.A. catalogue, with the lines:

————'Ye mists and exhalations that now rise
'From hill or streaming lake, dusky or gray,
'Till the sun paints your fleecy skirts with gold,
'In honour to the world's great Author, rise'.
Milton Par. Lost, Book V
(In line two Milton's original word is 'steaming'.)

The picture represents Coniston Old Man in Lancashire, which Turner had visited during his tour of the north of England, including the Lake District, in the Summer of 1797; there is a pencil drawing, inscribed 'Old Man', in the 'Tweed and Lakes' sketchbook (XXXV-57). This is close to the painting in general composition, though Turner has altered the trees and introduced such details as the flock of sheep in the centre of the picture; the whole feeling of atmospheric depth at the top of the picture is also new. In addition the Turner Bequest includes one or two watercolour beginnings of the Coniston Old Man in oblong format (XXXVI-L and ?U).

A watercolour of *c.* 1797, 10 × 14¼ in., belongs to the Clonterbrook Trustees. The composition, oblong in format, is much less dramatic.

Thornbury, after correctly identifying this picture as the work exhibited in 1798, goes on to mention it again with the works of 1802.

Farington, on 5 January 1798, recorded a conversation with Hoppner who, having visited Turner's studio and seen this picture and No. 7, 'mentioned 2 pictures by Turner—Rainbow and Waterfall—a timid man afraid to venture'.

For the *Whitehall Evening Post* of 10–12 May 1798 the picture was 'A beautiful and well-executed

landscape. The distance is so admirably preserved, as to induce a momentary deception, and appears as if the Spectator might actually walk into the picture.' Speaking of Turner's works at the 1798 R.A. Exhibition in general the *Oracle* wrote, 23 April 1798: 'W. Turner has a variety of Picture worthy the attention of the *Cognoscenti*. He takes a distinguished lead in the present Exhibition, and rises far superior to our expectation on forming an opinion of his previous works.' Similarly the *Monthly Magazine* for July 1798: 'TURNER.—This artist's works discover a strength of mind which is not [*sic*] often the concomitant of much longer experience: and their effect in oil or on paper is equally sublime. He seems thoroughly to understand the mode of adjusting and applying his various materials; and, while *colours* and *varnish* are deluding one half of the profession from the path of truth and propriety, he despises these ridiculous superficial expedients, and adhers to nature and the original and unerring principles of the art.'

There are minor losses of paint along the top and sides and also where the picture has been slightly overcleaned in the past.

6. Dunstanborough Castle, N.E. Coast of Northumberland. Sun-Rise after a Squally Night
Exh. 1798 (Plate 4)

NATIONAL GALLERY OF VICTORIA, MELBOURNE

Canvas, $36\frac{1}{4} \times 48\frac{1}{2}$ (92 × 123).

Coll. W. Penn of Stoke Poges by 1808; almost certainly Granville Penn of Stoke Poges Court; sale Christie's 10 July 1851 (69) as 'Corfe Castle from the Sea'; bought Gambart; M. T. Birchall by 1857 from whom bought by Agnew's in 1870 and sold to John Heugh; sale Christie's 24 April 1874 (184) bought Mayne (a *nom de vente* for the Duke of Westminster or his agent—see below); Duke of Westminster sale Christie's 10 May 1884 (99) bought in; presented to the National Gallery of Victoria by the first Duke of Westminster in 1888 (Inventory no. 313/1).

Exh. R.A. 1798 (322); Manchester 1857 (198, lent by Birchall); International Exhibition 1862 (350); R.A. 1873 (16); Wrexham 1876 (253); Grosvenor Gallery 1888 (69); *Centennial International Exhibition* Melbourne 1888.

Engr. In the *Liber Studiorum* (Rawlinson 14) published 10 June 1808 ('The picture in the possession of W. Penn Esq.'). The engraving is in fact closer to a drawing on p. 45 of the 'North of England' sketch-book (XXXIV) than to the Melbourne picture.

Lit. Burnet and Cunningham 1852, pp. 20, 110 no. 41; Thornbury 1862, i, pp. 258, 282 (with incorrect size); 1877, pp. 415, 568; Ruskin 1878 (1903–12, xiii, p. 406); *Catalogue of the Collection at Grosvenor House* 1882, no. 133 ('purchased in 1874 from Mr. Heugh'); Bell 1901, p. 72 no. 86; Armstrong 1902, pp. 46, 221; Finberg 1924, pp. 55–6; Clare 1951, pp.

21–2; Finberg 1961, pp. 48, 460 no. 41; Ursula Hoff, *National Gallery of Victoria: Catalogue of European Paintings before Eighteen Hundred* 1961, pp. 132–3; Rothenstein and Butlin 1964, pp. 8–10, pl. 9; Lindsay 1966, p. 58; Reynolds 1969, pp. 36, 61–2; Holcomb 1974, p. 45, fig. 7.

Exhibited at the R.A. with the following lines from Thomson's *Seasons*:

> 'The precipice abrupt,
> 'Breaking horror on the blacken'd flood,
> 'Softens at thy return,—The desert joys,
> 'Wildly thro' all his melancholy bounds,
> 'Rude ruins glitter; and the briny deep,
> 'Seen from some pointed promontory's top,
> 'Far to the blue horizon's utmost verge,
> 'Restless, reflects a floating gleam'

In the summer of 1797 Turner made a sketching tour of the north of England. On his way from Durham to Berwick, he visited Warkworth, Dunstanborough and Bamborough Castles. There are a number of drawings and watercolours of Dunstanborough in the Turner Bequest. In the 'North of England' sketchbook (XXXIV) p. 45 shows the original pencil drawing for the exhibited oil and there are other views of the castle on pp. 46 and 46 verso. A broad sketch on rough brown paper (XXXVI-S) is also virtually identical with the oil and is slightly reminiscent of the drawings of the Rev. William Gilpin (1724–1804). XXXIII-S ('Water Colours: Finished and Unfinished 1796–7') shows the same composition again but with colour added. These numerous studies show how carefully Turner prepared the way for his exhibited oil paintings at this early stage in his career.

This view is taken from the south. For a smaller view of Dunstanborough in oils, taken from the opposite side of the castle, see No. 32. Turner returned to the subject in a watercolour in the *England and Wales* series. This watercolour, engraved by R. Brandard in 1830, is now in the City Art Gallery, Manchester. In general it follows the composition of the Melbourne oil quite closely but differs in omitting the rocks in the foreground.

At the R.A. the picture was well received. The *St. James's Chronicle* for 1–3 May described it as being 'in the broad style of Wilson; nor is the colouring very different; the water is finely painted.' The *London Packet, Or, New Lloyds Evening Post*, 9 May, wrote: 'This is a really good picture—The phenomenon of Nature which the painter has given charmingly, is that of the sun rising on the coast after a squally night. The idea is sublime and we here excuse his giving a quotation of eight lines from his favourite Thompson.'

Dr Holcomb suggests that between 1793 and 1800 Turner was indebted to Girtin's example for the 'image of the heroic castle' in general and, in this connection, she points out that Girtin painted three watercolours of Dunstanborough between 1794 and 1797.

The compiler has not seen the original.

7. Buttermere Lake, with part of Cromackwater, Cumberland, a Shower Exh. 1798 (Plate 5)

THE TATE GALLERY, LONDON (460)

Canvas, 36⅛ × 48 (91·5 × 122).

Coll. Turner Bequest 1856 (80 'Landscape with Rainbow' 4′0″ × 3′0″); transferred to the Tate Gallery 1929.

Exh. R.A. 1798 (527); Tate Gallery 1931 (4); Tate Gallery 1959 (343); New York 1966 (1, repr. p. 6); R.A. 1974–5 (30, repr.).

Lit. Farington *Diary* 5 January 1798; Thornbury 1862, i, p. 261; 1877, p. 418; Bell 1901, pp. 61, 73 no. 90 (as exh. R.A. 1799); Armstrong 1902, p. 219; Rawlinson and Finberg 1909, pp. 30–31; Finberg 1910, p. 35; Davies 1946, p. 187; Clark 1949, p. 104; Clare 1951, pp. 22–3, repr.; Finberg 1961, pp. 45, 49, 461 no. 47, pl. 6; Rothenstein and Butlin 1964, p. 10. pl. 7; Gowing 1966, p. 7, repr. p. 6; Lindsay 1966, p. 36; Gage 1969, pp. 56, 135; Reynolds 1969, p. 36, pl. 23; Gaunt 1971, p. 5, colour pl. 1; Ziff 1971, p. 126; Wilkinson 1972, pp. 47–9, repr. p. 49; Herrmann 1975, pp. 12, 225, colour pl. 10.

First exhibited with the following verses, a conflation of Thomson's 'Spring', ll. 189–205:

'Till in the western sky the downward sun
'Looks out effulgent—the rapid radiance instantaneous
 strikes
'Th'illumin'd mountains—in a yellow mist
'Bestriding earth—The grand ethereal bow
'Shoots up immense, and every hue unfolds.'
 Vide Thompson's [*sic*] Seasons.

Turner omits many of Thomson's images and, more interestingly in view of his later interest in colour-theory, the immediately following lines which refer to Newton and his 'showery prism'. Gage suggests that the verses, which do not altogether fit the subdued colouring of the picture, and in particular of the rainbow, were an afterthought occasioned by the new permission in 1798 to include quotations in the R.A. catalogue. Ziff on the other hand sees the discrepancy merely as the result of the relatively dark tonality characteristic of Turner's early style: Turner's altera-tion of the position of the rainbow in the preliminary watercolour in the 'Tweed and Lakes' sketchbook (XXXV, p. 84; repr. in colour Wilkinson, *op cit.*) shows that he had Thomson's text in mind from the beginning. In the oil Turner added the reflection of the rainbow in the lake.

Other features added in the oil are the little rowing boat and foreground branches, though the boat and its two passengers does appear in another watercolour from the same sketchbook (XXXV, p. 87; repr. in colour Wilkinson, *op. cit.*, pp. 46–7). In addition Turner strengthened the feeling of volume enfolding the rainbow by making the distant hills less ethereal.

For Hoppner's judgement, recorded by Farington, and two favourable reviews, see No. 5.

8. Fishermen becalmed previous to a Storm, Twilight Exh. 1799

PRESENT WHEREABOUTS UNKNOWN

Size unknown

Exh. R.A. 1799 (55).

Lit. Burnet and Cunningham 1852, pp. 19, 110 no. 49; Thornbury 1877, pp. 415, 569; Bell 1901, pp. 72–3 no. 87; Finberg 1961, pp. 56–7, 461 no. 49.

All trace of this picture has disappeared, although it is mentioned by two visitors to the exhibition. Thomas Green of Ipswich (see also No. 3) records in his *Diary of a Lover of Literature* that he visited the R.A. Exhibition on 3 June '. . . and was again struck and delighted with Turner's landscapes, particularly with fishermen in an evening—a calm before a storm, which all nature attests is silently preparing, and seems in death-like stillness to await . . .'

The critic of the *London Packet, Or, New Lloyds Evening Post*, 29 April–1 May, wrote: 'This young Gentleman is an enthusiast:—he conceives grandly, but when he commits his thoughts to canvas, he is apt to forget that the tablet of his imagination is not visible to any but himself; hence it is his pictures are often little better than charcoal sketches varnished up to some-thing like an oily effect. This observation, however, does not generally apply, some of his designs of the present year, of which we shall have occasion to speak hereafter, are among the best in the Exhibition, and indeed this before us only required more finishing to establish its claim as a work of considerable merit.'

Finberg suggests that this picture may possibly be identified with the one still in the artist's possession when engraved in the *Liber Studiorum* and published under the title 'Calm' on 23 April 1812 (see plate 540). If so, the size of the original is given as 14 × 27 in the lettering of the first state (see Finberg 1924, p. 175–6). This appears rather small for an exhibited picture (although *Moonlight at Millbank* (No. 2), shown two years previously, is even smaller), and this is a point that one of the reviewers quoted above might have been expected to mention. There are, moreover, two other possible pictures which may have been engraved as 'Calm': two oils shown in Turner's gallery in 1809 with the same title, 'Fishing Boats in a Calm' (see Nos. 93 and 94), but here again the dimensions of the engraved picture seem on the small side for an exhibited picture to judge from the sizes of the other pictures shown in 1809.

It is interesting to note that the charge of a lack of finishing was made against Turner so early in his career as a painter in oils.

9. Harlech Castle, from Twgwyn Ferry, Summer's Evening Twilight Exh. 1799 (Plate 6)

YALE CENTER FOR BRITISH ART, PAUL MELLON COL-LECTION

Canvas, $34\frac{1}{4} \times 47$ (87×119.5).

Coll. The fifth Earl Cowper (1778–1837; he succeeded to the title in 1799) who acquired it from the artist; the Hon. H. Finch-Hatton by 1903; Sir Donald Currie; by descent to his grand-daughter Mrs. M. D. Fergusson from whom bought by Agnew 1961; sold to the present owners in the same year.

I have been unable to trace a connection between the Cowper and Finch-Hatton (Winchelsea) families, but the Hon. Harold Finch-Hatton (1856–1904) was High Sheriff for Merionethshire, which includes Harlech, in 1903, the year in which he lent this picture to the Winter Exhibition at the R.A. The subject was therefore likely to appeal to him and he may have bought it direct from the seventh (and last) Earl Cowper (*d.* 1905).

Exh. R.A. 1799 (192); R.A. 1903 (29); Richmond 1963 (130); R.A. 1964–5 (183); Yale 1965 (200); Washington 1968–9 (3).

Lit. Burnet and Cunningham 1852, p. 110 no. 50; Ruskin 1860 (1903–12, vii, p. 391); Thornbury 1877, p. 569; Bell 1901, p. 73 no. 88; Armstrong 1902, p. 48 (but not listed in his catalogue); Whitley² 1928, ii, p. 235; Finberg 1961, pp. 56, 461 no. 50; Jerrold Ziff, 'J. M. W. Turner on Poetry and Painting', *Studies in Romanticism* iii, Summer 1964, pp. 201–2; Gage 1969, p. 135; Reynolds 1969, p. 38.

Exhibited with the following lines from Book iv of *Paradise Lost*:

'Now come still evening on, and twilight grey,
'Had in her sober livery all things clad.'
 '————Hesperus that led
'The starry host brightest 'till the moon
'Rising in clouded majesty unveiled her peerless light.'

Based on the watercolour on p. 95 of the 'North Wales' sketchbook (XXXIX) which is inscribed on the reverse in Turner's hand: '117 Harlech Study for Ld. Cooper's picture'. The watercolour differs from the oil in having two additional figures wading on the foreground and another standing by the woman with the basket on the far left. It lacks, however, the two small sailing boats which appear in the oil. Other pencil studies of Harlech appear on pp. 21–2 of the same sketchbook.

At the R.A., the picture had a mixed reception. The *London Packet, Or, Lloyds New Evening Post* for 6–8 May criticised Turner for 'excessive vanity' in attempting to translate such beautiful verse onto canvas although it admitted that 'of the picture itself much may be said in commendation'. The critic of the *Sun*, 13 May, was more laudatory: 'This Landscape, though it combines the style of CLAUDE and of our excellent WILSON, yet wears an aspect of originality, that shows the painter looks at Nature with his own eyes. We advise MR. TURNER, however, with all our admiration of his works, not to indulge a fear of being too accurately minute, lest he should get into a habit of *indistinctness* and *confusion*.'

As noticed under No. 8, it is of interest that 'indistinctness', a fault found with Turner's work throughout his carrer, is raised for the first time in this year. It is also interesting to note, as Gage points out, that later Turner himself came to agree with the critic of the *London Packet* that such lines were not suitable for pictorial representation. Turner discusses the quotation to this picture in the 'Poetry and Painting' lecture of 1812 and it is clear that by then Turner felt that, although Milton can suggest colour in the phrase 'twilight grey', it was beyond his powers to do the same in paint without running the risk of his colour becoming monotonous and, to use his own definition, too 'passive'. It is significant therefore, that it was at this date—1812—that Turner began to append quotations from his own fragmentary poem *Fallacies of Hope* to his exhibited pictures.

10. Battle of the Nile, at 10 o'clock when the L'Orient blew up, from the Station of the Gun Boats between the Battery and Castle of Aboukir Exh. 1799

PRESENT WHEREABOUTS UNKNOWN

Size unknown.

Coll. No history for this picture is known for certain but according to Bell it was in the collection of L. Huskisson of Frith Street, Soho, and was bought in at his sale at Christie's 27 April 1864 (91), but the very low price of 10 guineas argues against its being the R.A. picture. In the 1961 edition of Finberg, the picture is stated to belong to Hugh Cholmondeley in Paris, but this picture (canvas $30\frac{1}{2} \times 39$ in.), although of a sea battle, is not by Turner. A picture claiming to be the lost original was sold at Parke-Bernet, New York, 2 March 1950 (41) with the provenance that it came from the collection of Joseph Prior, fellow of Trinity College, Cambridge, but the photograph in the Witt Library makes it clear that it cannot have been the exhibited picture.

Exh. R.A. 1799 (275); (?) XIX Century Art Society, July 1886. (According to Bell, but Graves gives the date as 1888 and identifies the owner as W. Cox, adding 'This picture was not in the Catalogue of this Exhibition, but was shown in the Conduit Street Gallery, during the time the exhibition was open.')

Lit. Burnet and Cunningham 1852, p. 110 no. 51; Ruskin 1860 (1903–12, vii, p. 391); Thornbury 1877, p. 569; Monkhouse 1879, p. 49; Bell 1901, p. 73 no. 89; Armstrong 1902, p. 48 (but not in his catalogue); Finberg 1961, pp. 56, 462 no. 51; Rothenstein and Butlin 1964, pp. 11, 14; Gage 1965, pp. 23–5; Lindsay 1966, pp. 41, 59, 70–71, 87–8; Reynolds 1969, p. 40.

Exhibited with the following quotation from Book vi of *Paradise Lost*:

————'Immediate in a flame,
'But soon obscured with smoke, all heav'n appear'd
'From these deep-throated engines belch'd whose roar
'Imbowel'd with outrageous noise the air,
'And all her entrails tore, disgorging foul
'Their devilish glut, chain'd thunderbolts and hail
'Of iron globes.'

One of the most tantalising and baffling problems in Turner's oeuvre, as clues to the appearance of this important picture, Turner's first exhibited oil which recorded a contemporary event, are elusive. At the R.A., it was strongly criticised by the *London Packet* for 29 April–1 May: 'Mr. Turner has compleatly failed in producing the grand effect which such a spectacle as the explosion of a ship of the line would exhibit. He has moreover altogether mistook the colouring of such an eruption—the reflection should be red, but the vitreous flame should be bright and prismatic in its tints.'

The *Morning Post* for 11 May also mentions the picture among five paintings of the subject in the exhibition, two by Nicholas Pocock and two by Cleveley as well as Turner's.

An additional problem in connection with Turner's *Battle of the Nile* is provided by a notice which appeared in the *Morning Chronicle* on 17 June 1799: 'Blowing up L'Orient with the representation of the whole of the Battle of the Nile, aided by the united Powers of Merchants, Paintings and Optics, is now exhibiting at the Naumachia, Silver-Street, Fleet-Street ... The whole designed and executed by and under the direction of Mr. Turner.'

The question is: who is the Mr Turner referred to in this advertisement? The answer is complicated by the appearance of a picture *The Battle of the Nile* at the R.A. Exhibition in 1800 (38) by G. Turner which was praised in the *Whitehall Evening Post*, 29 April–1 May.

If this is George Turner (*op.* 1782–1820), his work seems to have consisted mainly of genre scenes of cottage life in the manner of Francis Wheatley and a picture of a naval battle seems wholly outside his normal repertoire.

On the other hand, J. M. W. Turner is known to have been interested in displays and spectacles of this kind and would perhaps have been induced to attempt something along these lines, influenced by de Loutherbourg's *Eidophusikon*. All the available evidence as to whether J. M. W. Turner was the artist connected with the enterprise has been thoroughly investigated by Gage and is set out in detail in his article in the *Burlington Magazine*. The case for Turner's participation, although considerable, remains circumstantial, for in none of the references is any initial or christian name attached to the surname 'Turner'. On the other hand, if George Turner did stray so far from his usual subject-matter as to paint a picture of *The Battle of the Nile*, it seems quite reasonable to accord him an equal chance of being the 'Mr. Turner' concerned with the *Naumachia*.

There remain the further possibilities either that the

G. Turner who exhibited the picture in 1800 is a different painter from the George Turner discussed above, or that the 'Mr. Turner' who 'designed and executed the exhibition at the *Naumachia*' was a completely different person again, whose identity remains untraced. The name 'Turner' is unfortunately too common to make a definite judgment about the matter worthwhile, until some fresh evidence appears. By 1969, when Gage's *Colour in Turner* was published, the only new evidence he had (p. 255 n. 14) was that a 'Mr. Turner' had been one of de Loutherbourg's assistants on the decor of *Omai* in 1785 but this does not really get us any further. It is perhaps just worth adding that the *Daily Advertiser and Oracle* for 30 April 1802 carried a review of two large transparencies, exhibited by Mr G. Turner of Hemmings Row (the same artist that exhibited the painting in 1800 of *The Battle of the Nile*; his address is given as 19 Hemmings Row from 1799 onwards), the first of which showed Britannia receiving Neptune's trident, in recognition of her naval triumphs, etc. Although in no way to be compared with a moving exhibition such as the *Naumachia* was, it does perhaps press a little further G. Turner's claims as a possible participant in the *Naumachia*.

11. Kilgarran Castle on the Twyvey, Hazy Sunrise, previous to a Sultry Day Exh. 1799

(Plate 7)

THE NATIONAL TRUST (on loan to Wordsworth House, Cockermouth)

Canvas, 36 × 48 (92 × 122)

Coll. Probably William Delamotte the painter (1775–1863); Sir John Leicester (later Lord de Tabley) who bought it in Oxford before 1808; Lord de Tabley sale (by Christie's in Lord de Tabley's London house, 24 Hill Street) 7 July 1827 (17) bought Butterworth; William Cave; sale Christie's 29 June 1854 (61) bought Wallis; anon. sale Foster's 3 February 1858 (106) bought in; Joseph Gillott; sale Christie's 27 April 1872 (305) bought H. L. Bischoffsheim; bequeathed to his daughter, Lady Fitzgerald, wife of Sir Maurice Fitzgerald; by descent to Lady Mildred Fitzgerald who bequeathed the picture to the National Trust in 1970.

Exh. R.A. 1799 (305); Sir John Leicester's Gallery 1819 (27); ? Greenock 1861 (39 lent by James Tennant Caird but this may refer to one of the other versions); R.A. 1881 (173); Guildhall 1899 (1); Tate Gallery 1931 (15); R.A. 1951–2 (179); Agnew 1967 (1); Paris 1972 (259); R.A. 1974–5 (47).

Lit. Farington *Diary* 13 March 1799; *Catalogue of Sir John Leicester's Collection* 1808, no. 27; Young 1821 (27 engraved); Burnet and Cunningham 1852, p. 111 no. 52; Thornbury 1877, p. 569; Bell 1901, pp. 74–6 no. 91; Armstrong 1902, pp. 47–8, 223, repr. facing p. 40; Beckett 1947, pp. 10–15, repr.; Finberg 1961,

pp. 56–7, 302, 462 no. 52, 478 no. 205; Hall 1960–62, p. 120 no. 95; Lindsay 1966, pp. 40, 162; Woodbridge 1970, p. 177, pl. 39a; Gage 1974, p. 62.

Turner visited Cilgerran (as it is now spelled, although the number of variations are legion) on his tour of South Wales in 1798 and there are a number of watercolours and pencil drawings of the subject in the 'Hereford Court' sketchbook (XXXVIII pp. 28–9, 88 (the study for this picture), 100). There is also a finished watercolour of $c.$1799 in the Manchester City Art Gallery ($10\frac{1}{2} \times 14\frac{1}{8}$) which shows the same viewpoint as the R.A. picture. He returned to the subject thirty years later in a watercolour in the *England and Wales* series (Coll. Marquess of Lansdowne; engraved by J. T. Willmore 1829).

Douglas Hall quotes an undated letter from Brian Broughton in Oxford to Mrs Langford Brooke, 12 Albemarle Street, who was a friend and neighbour of Sir John Leicester's in Cheshire. This letter gives the price of *Kilgarran* as 30 guineas and states that Turner sold it to 'a drawing master of this place [Oxford], and from him it came to its present possessor.' The writer asks Mrs Brooke to mention the matter to Sir John as 'another gentleman, Mr. Loveden wishes to be the purchaser, because the subject of the picture, Kilgerran Castle, is on one of his Estates'. The letter also mentioned that 'Mr. Oldfield Bowles, who is an Amateur himself and a pupil of Wilson's has, I understand, pronounced it to be as good a picture as the Artist ever painted.'

The exact date of Sir John Leicester's purchase is not known. William Delamotte, who was probably the drawing master mentioned above, was working in Oxford from 1797 to 1803 before he moved to Great Marlow. The very modest price asked for the picture, coupled with the wording of the letter which refers to Delamotte as 'a drawing master of this place', make it seem possible that the transaction took place before Delamotte left Oxford.

Farington records in his *Diary* that he called on Turner and saw this picture being prepared for the forthcoming R.A. Exhibition. It is not however mentioned in any of the reviews of the exhibition which concentrated on the other three oils shown and on the watercolours.

Turner painted several pictures of Cilgerran which are fully discussed by R. B. Beckett (see Nos. 36, 37, 541 and 550). The problem of unravelling the histories of the various versions is aggravated by the fact that Gillott owned two of them and that both of these were reported as having been bought at his sale in 1872 by the New York Museum (now the Metropolitan Museum), whereas in fact neither was.

Turner may have been drawn to Cilgerran by knowing Wilson's painting of the subject (repr. W. G. Constable, *Wilson* 1953, pl. 30a) or an engraving of it. Although Wilson's influence is still visible in Turner's painting, the bold handling and dramatically raised

viewpoint show Turner already stamping the subject with his own individual approach; it is however difficult to agree with Lindsay that the V of light has 'its meaning as a birth-tunnel, a vaginal passage of rhythmic convulsion'. A further inducement to visit Cilgerran may well have been provided by the enthusiastic recommendation of Sir Richard Colt Hoare, as Gage has shown. Colt Hoare had visited Cilgerran in 1793 and wrote in his journal 'I was so delighted with this enchanting spot that I visited it three times, and visited it in every possible direction — it can only be seen to advantage by water . . .' Moreover Cilgerran was a supreme example of the image of 'the castle on a hill' which was to acquire exceptional symbolic value in English landscape painting in the mid 1790s and which first Girtin and then Turner were to develop during the following decade (see Holcomb 1974, p. 33 ff).

When shown at the Turner Bicentenary Exhibition, hanging opposite the watercolour *Caenarvon Castle* (exh. R.A. 1799 (340)), the similarities in Turner's technique in oil and watercolour at this time were very apparent, especially in the way the reflections in the water were painted.

12. Dolbadern Castle, North Wales Exh. 1800
(Plate 22)

ROYAL ACADEMY OF ARTS, BURLINGTON HOUSE

Canvas, $47 \times 35\frac{1}{2}$ ($119\cdot5 \times 90\cdot2$)

Coll. Turner's Diploma Work deposited by the artist after his election as an Academician on 12 February 1802. After sending the *Dolbadern*, Turner apparently thought the Council might prefer another picture and therefore submitted a second work (it is not known what this was), asking the Council to choose whichever they preferred. However, the first painting was 'approved unanimously'.

Exh. R.A. 1800 (200); B.I. 1854 (155 as 'Landscape with Banditti'); Manchester 1857 (232); Philadelphia International Exhibition 1876; R.A. 1951–2 (172); Brighton 1957 (31); R.A. *Treasures of the Royal Academy* 1963 (40); R.A. 1974–5 (48); Leningrad and Moscow 1975–6 (5).

Lit. Ruskin 1843 (1903–12, iii, p. 190); Burnet and Cunningham 1852, pp. 23, 44, 111 no. 60; Thornbury 1862, i, p. 258; 1877, pp. 220, 416, 569 (wrongly assigned to 1799); Hamerton 1879, pp. 55, 56, 57; Bell 1901, pp. 76–7 no. 92; Armstrong 1902, pp. 48, 221; Whitley 1928, p. 29; Clare 1951, p. 27; Finberg 1961, pp. 67, 77, 463 no. 60; Rothenstein and Butlin 1964, pp. 10, 11, pl. 11; Lindsay 1966, pp. 60, 75; Gage 1969, p. 56; Reynolds 1969, p. 38, fig. 25; Wilkinson 1972, pp. 94–5, repr.; Holcomb 1974, pp. 43–4, fig. 3; Herrmann 1975, pp. 12, 226, pl. 22.

Based on sketches Turner made on his trips to Wales in 1798 and 1799. Drawings of Dolbadern occur in the 'North Wales' (XXXIX), 'Hereford Court' (XXXVIII) and 'Dolbadarn' (XLVI) sketchbooks of 1798 and there are six studies of the castle in the 'Studies for Pictures' sketchbook of 1799 (LXIX). Four of these are reproduced in Wilkinson (pp. 94–5); that on p. 112 of the sketchbook is closely related to the finished painting. These studies are in coloured chalks and are much more highly coloured than the oil, being in a style that anticipates the work of Henry Bright (1814–73). There is also a large, very free watercolour in the Turner Bequest (LXX-O) of *c.* 1799 which may represent a preliminary idea for the oil. In the watercolour the castle is shown fairly low down surrounded by mountains, a viewpoint which Turner altered in the oil in order to gain the maximum dramatic effect.

Exhibited with the following quotation:

How awful is the silence of the waste,
Where nature lifts her mountains to the sky.
Majestic solitude, behold the tower
Where hopeless OWEN, long imprison'd, pined
And wrung his hands for liberty, in vain.

In the catalogue of the Turner Bicentenary exhibition it was suggested that these lines are by Turner himself, but they seem altogether too fluent.

At the R.A., most of the reviewers concentrated, among Turner's exhibits, on *The Fifth Plague* (see No. 13) and on the watercolours of Fonthill. However, the *St. James's Chronicle*, 29 April–1 May, described *Dolbadern* as: 'a picture of the first merit; which the Gentlemen who draw for tours in Wales might very profitably study.'

Gage has pointed out that *Dolbadern* shows how much sympathy Turner felt for Gilpin's conception of the 'Sublime' palette. The mood certainly foreshadows that of the large watercolours of 1804 such as *The Great Falls of the Reichenbach* (Cecil Higgins Art Gallery, Bedford) and the *Passage of the St Gothard* (Abbot Hall, Kendal) while the small figures, reminiscent of Salvator Rosa (and therefore no doubt responsible for the strange title at the British Institution exhibition of 1854), illustrate a theme recurrent throughout Turner's work, that of man being dwarfed by the immensity of nature. As Dr Holcomb suggests, the composition which all but encloses the castle mirrors the allusion in the verses to Owen's imprisonment. Owain Goch, a Welsh prince, was imprisoned in Dolbadarn by his brother Llewelyn from 1254–1277, when he was released by the Treaty of Conway that followed Edward I's defeat of independent Wales. Dr Holcomb believes that Turner may be illustrating a twofold allusion in the last two lines of the verse: Owen's grief at both the personal injustice he has suffered and the subjugation of his country.

A small panel (17¾ × 13), alleged to be a study for the picture, was sold from Percy Moore Turner's collection at Sotheby's 26 November 1952 (107) bought Dent; it is at present untraced. From a photograph in the Witt Library, it looks unlikely to be genuine although there are differences between the sketch and the Diploma picture, especially in the figures, and the sketch can be traced back to Munro of Novar's collection. In Frost and Reeve's catalogue of the Munro collection, published in 1865, it is listed as no. 937 on p. 94 and is described as 'Two men with prisoner in foreground; castle in background—this picture was for many years at Novar.' If this is so, it seems curious that the correct title was not known, although other instances of pictures becoming detached from their titles are not unknown in Turner's work. The sketch was included in the Munro sale at Christie's, 11 May 1867 (181) among those 'Removed from the Mansion of Novar, N.B', as 'A Mountain Pass—a small early sketch', bought Smith, but the very low price it fetched, 46 guineas, in comparison with the high figures obtained for the other Turners, suggests that doubts about its authenticity must have been widely held. It was later in the collection of Gerard Craig Sellar and belonged to P. M. Turner by 1937, when he lent it to an exhibition, held to mark the centenary of Constable's death, at Wildenstein's (19, as 'A Mountain Pass').

13. The Fifth Plague of Egypt Exh. 1800 (Plate 10)

THE INDIANAPOLIS MUSEUM OF ART, INDIANA

Canvas, 49 × 72 (124 × 183)

Coll. William Beckford of Fonthill who bought it at the R.A. for 150 guineas (his purchase was known by 29 April 1800 when it was mentioned by the *St. James's Chronicle*); sold at Fonthill sale 24 August 1807 (581) bought Jeffrey; George Young by 1853; sale Christie's 19 May 1866 (26) bought Lord Grosvenor, later Marquess of Westminster; Sir J. C. Robinson; bought from him by Sir Francis Cook, Bt, in 1876; remained in the Cook Collection until 1952 when bought by Agnew and sold to Sir Alexander Korda 1953, who resold it through E. Speelman Ltd in 1955 to the John Herron Art Museum, Indianapolis (now called The Indianapolis Museum of Art) (gift in memory of Evan F. Lilly).

Exh. R.A. 1800 (206); B.I. 1853 (164 lent by George Young); International Exhibition 1862 (268); B.F.A.C. 1871 (49); R.A. 1871 (140); Guildhall 1899 (9); R.A. 1903 (66); Brighton Art Gallery, on loan 1948–51; R.A. 1951–2 (167); Indianapolis 1955 (7); Seattle World Fair 1962 (21); New York 1966 (2); R.A. 1974–5 (70).

Engr. by C. Turner in the *Liber Studiorum*, published 10 June 1808. (Rawlinson 16 'The picture late in the possession of W. Beckford Esq.')

Lit. Farington *Diary* 10 July 1800, 13 April 1801, 27 August 1807; Ruskin 1843, 1860, 1878 (1903–12, iii, pp. 240–41; vii, p. 391; xiii, p. 407); Burnet and Cunningham 1852, pp. 22, 30, 111 no. 61; Waagen

1854, ii, p. 257; Thornbury 1862, i, pp. 277, 284, 355; ii, p. 400; 1877, pp. 415, 570, 598; Hamerton 1879, p. 64; Monkhouse 1879, p. 49; Bell 1901, p. 77 no. 93; Armstrong 1902, pp. 48, 221; Cook and Brockwell, *Catalogue of the Paintings at Doughty House* i 1913, p. 4; iii 1915, pp. 22–3, pl. 407; Finberg 1924, pp. 63–4; Whitley 1928, pp. 7, 129; Mauclair 1939, p. 38, repr.; Clare 1951, p. 51; Finberg 1961, pp. 66, 71, 195, 463 no. 61; Boyd Alexander, *William Beckford, England's Wealthiest Son* 1962, p. 25; Jerrold Ziff, 'Turner and Poussin', *Burlington Magazine* cv 1963, pp. 315–21, fig. 42; Rothenstein and Butlin 1964, pp. 14–15, 16, pl. 14; Kitson 1964, p. 13; Lindsay 1966, pp. 72, 77, 87; Gowing 1966, p. 9; Gage 1969, p. 136; Reynolds 1969, pp. 41, 44–5, 61, 64, 78, 88, 94, 165, fig. 28; Indianapolis Museum of Art, *A Catalogue of European Paintings* 1970, pp. 155–7, repr. in colour; Holcomb 1974, pp. 47–8, fig. 11; Herrmann 1975, pp. 12, 226–7, pl. 23.

Exhibited with the following quotation:

'And Moses stretched forth his hands toward heaven,
'and the Lord sent thunder and hail, and the fire
'ran along the ground.'

Exodus, chap ix. ver 23

The title is in fact incorrect: the picture represents the seventh plague, that of hail and fire, and not the fifth, which was the murrain. This perhaps argues against Gage's tentative suggestion that the picture may have been a direct commission from Beckford, who was unlikely to have missed such an error. Nonetheless, the note on p. 1 of the 'Smaller South Wales' sketchbook (XXV) definitely links Beckford with a picture of 'The Plague of Egypt' (which plague is not stated) as early as 1796 or 1797, as Gage has pointed out, and there is also the evidence quoted by Boyd Alexander that the 1807 Fonthill sale included an early Turner commissioned by Beckford. This would seem to be contradicted by the evidence from the *St. James's Chronicle* already cited. However, even if the painting was not a specific commission from Beckford, he may very well have suggested the subject to Turner.

There is a pen and ink study for part of the foreground on p. 79 of the 'Dolbardarn' sketchbook (XLVI) which shows additional figures between the dead horse and the man standing on the right which do not occur in the oil. Page 117, a study in watercolour of a dead body, may also be connected. In the 'Studies for Pictures' sketchbook (LXIX), p. 22 shows a man with outstretched hands very like the figure of Moses in the oil and pp. 23, 24, and 25 also contain related drawings. Finberg also suggests that a damaged fragment (LXX-S) is a study for part of the composition but this seems questionable.

The picture was at once recognised at the R.A. as Turner's most imaginative to date, and his first treatment of an historical subject was welcomed with general acclaim, as the following extracts from contemporary reviews show:

The *General Evening Post* for 26–29 April thought that 'This landscape is without a rival in the rooms', while the *St. James's Chronicle*, 29 April–1 May, considered it 'The grandest and most sublime stile of composition, of any production since the time of *Wilson*. The whole of the conception is that of a great mind', and the picture was also warmly praised in rather similar terms in the *Whitehall Evening Post* for 26–29 April, and in the *Morning Chronicle* and *Morning Herald*, both for 28 April. The *Sun*, 3 May, was also generally laudatory but suggested that 'Perhaps the effect would have been stronger, if the figure of Moses had been rendered more conspicuous, and if there had been more spectators of the tremendous scene, and more victims of Almighty vengeance. But we forget that the artist is a landscape Painter, and is therefore naturally most solicitous to signalize his powers in his immediate province.' A note of caution was introduced by the *London Packet* for 25–28 April which, after commenting that 'This is indisputably the best landscape in the Exhibition', continued '... but we are apprehensive these grand effects are produced by means not sufficiently stable to give that fame to the artist which such a production might otherwise secure for him. The colouring does not appear to be of that kind which will stand.'

Ruskin, however, considered it 'a total failure' and commented that 'the pyramids look like brick kilns, and the fire running along the ground like the burning of manure'.

Ziff has pointed out that despite the fact that the picture was to hang at Fonthill with the two great Claudes from the Altieri Collection, which Beckford had bought in 1799, the catalogue of the Indianapolis Exhibition is surely wrong in suggesting that Turner painted *The Fifth Plague* as 'a first competitive effort against Claude'. As the critics of the day recognised, the two painters whose influence is most clearly visible in this picture are Richard Wilson and Nicolas Poussin. Wilson's *Niobe* was well known to Turner from Sir George Beaumont's collection and Turner made a sketch of Poussin's *Landscape with a Snake*, then in the collection of Sir Watkyn Williams Wynn (now in the National Gallery), on p. 114 verso of the 'Dolbadarn' sketchbook (XLVI, which also contains a study for *The Fifth Plague*); indeed this picture is the earliest manifestation of Turner's admiration for Poussin which was to become still more marked after Turner's visit to the Louvre in 1802. As Dr Holcomb points out, a further source for Turner may have been the etchings of Piranesi, of which Turner's patron, Sir Richard Colt Hoare, owned a collection at Stourhead. In particular, the pyramid in *The Fifth Plague* may derive from Piranesi's etching *The Pyramid of Caius Cestus* from the series *Views of Rome*, 1755 (Holcomb, fig. 13).

14. Dutch Boats in a Gale: Fishermen endeavouring to put their Fish on Board Exh. 1801

known as *The Bridgewater Seapiece*　　(Plate 11)

PRIVATE COLLECTION, ENGLAND

Canvas, $64 \times 87\frac{1}{2}$ ($162 \cdot 5 \times 222$)

Coll. Painted for Francis Egerton, third and last Duke of Bridgewater; on his death, in 1803, bequeathed with a life interest to his nephew, the first Marquess of Stafford, with reversion to his nephew's second son, Lord Francis Leveson Gower, later created first Earl of Ellesmere; thence by descent until sold by the Trustees of the Ellesmere 1939 Settlement at Christie's 18 June 1976 (121, repr. in colour) bought Hazlitt, Gooden and Fox for the present owner.

Exh. R.A. 1801 (157); B.I. 1837 (145); R.A. 1951–2 (157); Leggatt 1958 (10); R.A. 1968–9 (681); R.A. 1974–5 (71).

Engr. By J. Fittler for the *British Gallery of Pictures—Stafford Gallery* 1812; by J. Young for the *Stafford Gallery* 1825 and by J. C. Armytage in the *Turner Gallery* 1859.

Lit. Farington *Diary* 18, 19, 25, 26 April 1801, 5 May 1802, 3 January 1803, 1 April, 17 July 1804, 11 July 1806; W. Y. Ottley, *Engravings of the Marquess of Stafford's Collection* 1818, iv, p. 142 no. 7; Waagen 1838, ii, p. 80; *Quarterly Review* lxii 1838, p. 144; Ruskin 1843, 1851, 1856 (1903–12, iii, pp. 568, 646–7; xii, p. 373; xiii, pp. 47, 147); Burnet and Cunningham 1852, pp. 23, 27, 29, 44, 57, 76–7, 111 no. 62; Waagen 1854, ii, p. 53; Thornbury 1862, i, p. 262; ii, pp. 184–5, 400; 1877, pp. 291, 325, 418–9 (but here Thornbury confuses it with *Boats carrying out Anchors*), 570, 598; Monkhouse 1879, p. 50; Bell 1901, pp. 77–8 no. 94; Armstrong 1902, p. 229; Rawlinson i 1908, pp. 35–6; ii 1913, pp. 207, 210, 357, 375; *Catalogue of the Collection of Pictures and Statuary of the Rt. Hon. John Francis Granville Scrope, Earl of Ellesmere, at Bridgewater House, Cleveland Square, St. James's, London* privately printed 1926, no. 251; Whitley 1928, p. 20; Boase 1959, pp. 337–8; Finberg 1961, pp. 69–71, 113, 367, 397, 464 no. 68, 501 no. 476; Rothenstein and Butlin 1964, pp. 15–16, pl. 15; Lindsay 1966, p. 74; Gage 1969, pp. 171–2, 231; Reynolds 1969, p. 45; Clark 1973, p. 230; Bachrach 1974, p. 13; Herrmann 1975, pp. 13, 44.

Painted as a pendant to a seascape, *A Rising Gale* by Willem Van der Velde the younger (1633–1707), in the Bridgewater Collection (sold Christie's 2 July 1976 (92) bought Leger). In fact the Van der Velde is smaller ($51 \times 74\frac{1}{2}$; $129 \cdot 5 \times 189$; see Plate 541).

Turner received 250 guineas for this commission and later tried unsuccessfully to obtain a further 20 guineas for the frame. This story was recounted by Henry Edridge to Farington. It was the established custom at that time that frames were extra—'charged at cost' as Turner wrote to a customer much later—but Edridge was amazed at Turner's shortsightedness in trying to dun such an influential client.

Thornbury's statement that 'the same evening Turner received the order he went home, stretched a canvas, and had it all in dead colour before he left it' is disproved by the considerable number of studies for the picture in the 'Calais Pier' sketchbook (LXXXI) which testify to the importance which Turner attached to this commission. Drawings for the picture occur on pp. 106–7, 108–9, 122–3, 126–7 and the lower half of p. 129. Those on pp. 104–5 may also be connected but this seems doubtful. Several of these drawings are inscribed in Turner's hand: 'Duke's Picture' or 'Duke's'. They contain a number of differences from the exhibited picture and even the drawing on pp. 106–7 inscribed 'Last Study to the Dutch Boats D of B' shows more ships in the background than appear in the final version. Turner's inscriptions on these drawings were added when he went through the 'Calais Pier' sketchbook in 1805 (see No. 16).

The Bridgewater Seapiece (as it is generally known) became, as Finberg points out, the picture of the year at the R.A. This caused the *Monthly Mirror* for June 1801 to sound a note of warning: 'This picture has with the justest claims, become a peculiar favourite of the spectators. The artist's good sense will teach him to be on his guard against the effects of public favour.'

While admitting that the picture contained great merits, the critics found that it lacked finish and attention to detail, and showed signs of carelessness, affectation and indistinctness.

The *Porcupine*, 7 May, after allowing that 'Nothing little appears from his hand, and his mind seems to take a comprehensive view of Nature', continued 'It must be confessed, however, that his desire of giving a *free touch* to the objects he represents betrays him into *carelessness* and *obscurity* so that we hardly ever see a firm determined outline in anything he does . . .'

The *Star* for 4 May took much the same view: 'This *liberal* stile of painting may fascinate for a while but the sober observer of Nature requires more to satisfy him fully of the pre-eminent claims of an artist than can be found in a picture totally without outlines . . .'

Among Turner's fellow artists, however, the picture received high praise. Fuseli considered it the best picture in the exhibition and both he and West compared it to Rembrandt, West saying that it was 'what Rembrandt thought of but could not do'. The reference to Rembrandt is interesting, although it is difficult to know whether West and Fuseli intended the comparison to refer in general terms or to a specific picture. If the latter, they must surely have had in mind, as Mr Evan Maurer has pointed out (in a paper delivered to the Turner Symposium at Johns Hopkins University, Baltimore on 17 April 1975), the *Christ in the Storm on the Lake of Galilee* of 1633, now in the Isabella Stewart Gardner Museum in Boston, but

which appears to have entered the Hope Collection at Deepdene near Dorking in the late eighteenth century. The position of the nearest boat in the Turner is certainly close to that of Rembrandt's storm-tossed boat on Galilee but this is probably coincidence. The number and variety of preliminary drawings for the composition (West and Fuseli would have been unaware of their existence) argue against Turner having used any model but the Van der Velde. Even Sir George Beaumont, while 'considering the sky too heavy and water rather inclined to brown,' told Farington that he thought very highly of the picture. Farington records that Constable also praised the picture, 'although he says he knows the picture of W. Van der Velde on which it is formed'. Three years later, in 1804, when discussing the pictures in the Bridgewater Gallery, Farington noted that West said that the Turner made a fine picture by Van der Velde in the same room 'look like glass bottles (*brittle*)'. Sir George Beaumont said in reply 'that Vandervelde's picture made Turner's *sea* appear like pease soup'.

In 1837 Lord Francis Egerton lent both the Van der Velde and the Turner to the British Institution, thus giving the critics a chance of comparing the pictures directly. As might be guessed, *Blackwood's Magazine*, July–December 1837, considered the Dutch master superior. Although it admitted that the Turner was also a fine picture and 'very forcible', it was criticised for sacrificing everything for effect and the writer even went so far as to complain that 'the water is certainly not liquid'!

However, the *Literary Gazette* for 3 June asked 'whether there is a single point in which the old Dutch painter has the advantage of the modern English one?' and patriotically concluded 'that, at least, in one department of the fine arts, there is in this country living merit, as high as that which is attached to the greatest name, in that department, of former days.'

Waagen (1838) considered that, compared to the Van der Velde, Turner's picture 'appears like a successful piece of scene-painting. The great crowd of amateurs, who ask nothing more of the art, will always prefer Turner's picture'. This judgment provoked Ruskin to write in his *Diary*: '21 Nov. 1843—Not so much done to-day, except that I have had the satisfaction of finding Dr. Waagen—of such mighty fame as a connoisseur—a most double-dyed ass . . .' Ruskin's own comment on the picture is also bizarre, for he claimed that it was one of those of Turner's pictures which 'are free from the Dutch infection, and show the real power of the artist'. In writing this, however, Ruskin probably had in mind that marine painting in England, during the second half of the eighteenth century, as practised by artists such as Whitcombe, Swaine, Pocock and the Cleveleys, had been unadventurous enough, carrying on in the main the tradition of the Dutch painters of the previous century in a rather enfeebled form. This commission gave Turner an opportunity to challenge this tradition, and to paint the first of a great series of seascapes which were to eclipse it.

As noted by Rothenstein and Butlin, the composition of the Turner is similar to that of the Van der Velde, but in reverse, and Turner has been at pains to reproduce certain features of the earlier picture: for instance, the small figures shown on the deck of the man-of-war which is preparing for sea in the Van der Velde are echoed by those shown on the deck of the three-master shown in silhouette on the right of Turner's picture. There are, however, significant differences in detail between the two pictures, as was pointed out in the catalogue of the Turner Bicentenary Exhibition. In particular, the recession, which is suggested in the Dutch picture by the angle of the ships leading into the distance, is achieved by Turner with the fall of light on the waves, by the band of light on the horizon and by the silhouette of the second ship against a light patch of sky. The contrast and variety of light and shade is much more marked in the Turner and it is this that gives it a far greater sense of movement. In addition, as Professor Bachrach has pointed out, Turner has added a typically romantic touch to his composition by setting his ships on a collision course.

Bachrach considers the picture fully in his book *Turner's Holland* which is to be published shortly, the opening chapters of which have, however, already appeared in the *Dutch Quarterly Review of Anglo-American Letters* (6 1976/2, p. 88 ff.). In particular Bachrach analyses the changes that the composition underwent by means of a detailed survey of the preparatory drawings, seven of which he illustrates. He also sets the commission for the picture in its historical perspective, by drawing attention to some of the recent events in the relationship between Britain and Holland which might have been recalled by those who saw Turner's picture.

15. The Army of the Medes destroyed in the Desert by a Whirlwind—foretold by Jeremiah, chap. xv. ver 32, and 33 Exh. 1801

PRESENT WHEREABOUTS UNKNOWN

Size unknown

Exh. R.A. 1801 (281).

Lit. Burnet and Cunningham 1852, pp. 22, 111 no. 65; Thornbury 1877, p. 570; Hamerton 1879, p. 64; Monkhouse 1879, p. 49; Bell 1901, p. 78 no. 95; Armstrong 1902, p. 48 (but not in his catalogue); Whitley 1928, pp. 19–20; Livermore 1957, p. 84; T. S. R. Boase, *English Art 1800–1870* 1959, pp. 101–2; Finberg 1961, pp. 71–2, 464 no. 69; Jerrold Ziff, 'Proposed Studies for a Lost Turner Painting', *Burlington Magazine* cvi 1964, pp. 328–33; Lindsay 1966, p. 74; Wilkinson 1972, p. 71.

All trace of this picture has been lost since its appearance at the R.A. in 1801. In his article in the *Burlington Magazine* Ziff quotes two contemporary criticisms:

The *Porcupine*, 28 April, wrote: 'Mr. Turner has doubtless heard that obscurity is one source of the sublime, and he has certainly given to the picture a full measure of this kind of sublimity. Perhaps his work may be best described by what a lady said of it—that it is all flags and smoke.'

For the *Star*, 8 May, 'This is a very masterly sketch but there is so much trick in the execution that we doubt much if its chief beauties could be retained in a print. To save trouble the painter seems to have buried his whole army in the sand of the Desert with a single flourish of his brush; thus reminding us of an itinerant Raphael, who, undertaking the delineation on a staircase of the story of the Children of Israel passing the Red Sea, contented himself with covering the whole with a coat of yellow ochre, and when it was demanded of him by his patron what had become of the Israelites, he observed that they had all gone to the promised land and that Pharaoh and his host were all drowned.'

Ziff quotes a third account published ten years later in the first issue of the *Reflector* (1811), probably written by Robert Hunt, art critic of the *Examiner*: '... Our first landscape-painter is Mr. Turner, who has the same fault in his drawing as Sir Joshua, that of indistinctness of outline; but this fault, which is so obnoxious in human subjects, and baffles Mr. Turner's ragged attempts at history, becomes very different in the mists and distances of landscape; and he knows how to convert it into a shadowy sublimity. Mr. Turner's invention generally displays itself through this medium, whether disturbed or placid. His *Whirlwind in The Desert* (*sic*) astounded the connoisseurs, who after contemplating at proper distance an embodied violence of atmosphere that seemed to take away one's senses, found themselves, when they came near, utterly at a loss what to make of it, and as it were smothered in the attempt. Of his calmer style, there are two exquisite specimens in Sir John Leicester's Collection ...'

It appears that Turner may have made a characteristic mistake in his reference to Jeremiah, unless this was a misprint in the R.A. catalogue. He must have meant verses 32–3 of chapter xxv, rather than xv:

'Thus saith the Lord of hosts, Behold, evil shall go forth from nation to nation, and a great Whirlwind shall be raised up from the coasts of the earth.

'And the slain of the Lord shall be at that day from one end of the earth even unto the other end of the earth; they shall not be lamented, neither gathered, nor buried; they shall be dung upon the ground.'

Ziff's suggestion that four drawings ('Calais Pier' sketchbook LXXXI pp. 165 and 163 and 'Dinevor Castle' sketchbook XL pp. 58 verso—59 and 60 verso—61) are studies for this picture is, on the whole, convincing, especially the latter two which seem to fit the description of the picture (so far as we can interpret it) reasonably well. The presence of the word 'Whirlwind', written in Turner's hand on p. 165 of the 'Calais Pier' sketchbook, also provides convincing proof that this study must be connected with the composition (see Plates 542–4).

Finberg suggests that the drawing on p. 163 may be a study for *The Deluge* but on the whole Ziff's proposal that it, too, is probably connected with *The Army of the Medes* seems more convincing. It also seems possible that the drawing on p. 161 may be a further study but this is only conjecture.

As Ann Livermore points out, Turner may have been drawn to this subject by a reference to the prophet Jeremiah by Thomson in a note to the third stanza of the *Ode on Aeolus's Harp* (1748). Thomson refers to him as 'the sacred Bard, who sat alone in the drear waste and wept his people's woes'. But Lindsay also suggests that Turner intended a contemporary reference to Napoleon's unsuccessful campaign in Egypt.

Mr Lynn Matteson, in a paper delivered at the Turner Symposium held at Johns Hopkins University in April 1975, made the very interesting suggestion that Turner may have also had a passage from Gilpin in mind when he came to paint this picture. In his *Observations on the Western Parts of England* (1798, pp. 283–4), Gilpin notes that dust, like mist, can act 'as a harmonizing medium but that this effect is seldom imitated on canvas'. The one artist, de Loutherbourg, who has attempted to do so must be considered to have failed. Gilpin continues that 'the only circumstance which can make a cloud of dust an object of imitation is *distance*', and he illustrates his point by quoting an episode from Xenophon's *Anabasis* where Cyrus summons his army to his side. This was scarce done, when 'a white cloud was seen in the distant horizon spreading far and wide, from the dust raised by so vast a host. As the cloud approached, the bottom of it appeared dark and solid. As it still advanced, it was observed, from various parts, to gleam and glitter in the sun; and soon after, the ranks of horse and foot, and armed chariots, were distinctly seen.'

Mr Matteson suggests that Gilpin's observations provided Turner both with ideas and with a challenge. The drawings already cited in LXXXI and XL show how Turner set about depicting the 'gleam and glitter' of an army emerging through the dust and how he also responded to Gilpin's dictum that 'the only circumstance that can make a cloud of dust an object of imitation is distance', even though Turner's attempt to render this was considered by one critic to be 'all flags and smoke'. Furthermore de Loutherbourg had exhibited at the R.A. in 1799 (15) a picture entitled *A Distant Hailstorm coming on, and the March of Soldiers with their Baggage*, now in the Tate Gallery, London (no. 5389). This may have been an attempt on de Loutherbourg's part to override the criticism of his work published by Gilpin in the previous year. Turner, however, may well have felt that de Loutherbourg's new picture still failed to 'imitate the effect of dust on canvas' and so painted *The Army of the Medes* to show how it should be done. Unfortunately, the loss of this key picture in Turner's early work makes it impossible for us to judge how far he succeeded or whether we, too, would have had our senses taken away by the picture's 'embodied violence of atmosphere'.

16. Fishermen upon a Lee-Shore, in Squally Weather Exh. 1802 (Plate 12)

SOUTHAMPTON ART GALLERY

Canvas, 36 × 48 (91·4 × 122)

Coll. Bought from Turner by Samuel Dobree (1759–1827); by descent to his son H. H. Dobree; sale Christie's 17 June 1842 (11) described as follows: 'A fishing boat pulling off from the shore, among the breakers, near a wooden pier, which another boat is approaching, under a grand stormy sky in a fresh breeze' 47 × 36 bought by E. S. Ellis of the Oriental Club; his sale Christie's 16 April 1853 (84) described as 'A Seashore with a fishing boat pushing off and a lugger making for the mouth of a harbour, a fine gleam of sunshine breaking through the clouds above' bought Gambart; Charles Birch; Francis T. Rufford by 1857; T. Horrocks Miller by 1889; by descent to Thomas Pitt Miller; sale Christie's 26 April 1946 (111) bought Agnew; D. V. Shaw-Kennedy (*d.* 1950); sold for his executors by Agnew to the Southampton Art Gallery in 1951.

Exh. R.A. 1802 (110); Manchester 1857 (264 as 'Coast Scene' lent by F. T. Rufford); R.A. 1889 (181); Agnew *English Landscape* 1926 (17); Manchester *Art Treasures Centenary* 1957 (225); Wildenstein *Pictures from Southampton* 1970 (22). In all these exhibitions except the first, the picture is called 'The Wave' or 'A Boat on the Crest of a Wave' (a title Turner would never have attached to a picture that he sent to the R.A.).

Engr. By J. Cousen in the *Turner Gallery* 1859 as 'Fishing Boats; a Coast Scene'.

Lit. Burnet and Cunningham 1852, pp. 23, 111 no. 68; Thornbury 1862, i, p. 266, who states it was bought by Rufford in 1853; 1877, pp. 98, 423, 570; Bell 1901, p. 78 no. 96; Armstrong 1902, pp. 53, 229; Rawlinson ii 1913, pp. 207, 357; Clare 1951, pp. 27–8; Boase 1959, p. 338; Finberg 1961, pp. 78, 109, 465 no. 74; Lindsay 1966, pp. 77, 87, 160; Reynolds 1969, p. 46; Herrmann 1975, pp. 13, 227, pl. 31. (N.B. Many of these references refer to this picture under its exhibited title but also assume that it is to be identified with the *Iveagh Seapiece* at Kenwood.)

At the H. H. Dobree sale at Christie's in 1842 Turner left a bid for the picture of 80–100 guineas. This was unsuccessful as the picture fetched 160 guineas.

The arguments for identifying this picture, rather than the *Iveagh Seapiece* at Kenwood, as that exhibited at the Royal Academy in 1802 as 'Fishermen upon a Lee-Shore, in Squally Weather' are given below, although certain reasons which tell against the claims of the Kenwood picture to be accepted as the R.A. picture are given in the entry for that picture (see No. 144).

Studies for this picture are in the 'Calais Pier' sketchbook (LXXXI) pp. 84–5 and 96–7. The former is inscribed in Turner's hand 'Mr. Dobree's Lee Shore' (see Plate 545) and from Turner's inscriptions on other drawings in the book we know that he must have gone through it in 1805 and annotated it. A number of drawings are inscribed 'Study not painted 1805' and the picture of *Macon* (No. 47) which was bought by Lord Yarborough in 1804 is identified as belonging to him. A number of drawings in the sketchbook are studies for pictures exhibited at the R.A. 1801–3 (e.g., the *Bridgewater* and *Egremont* Seapieces (Nos. 14 and 18) as well as the *Macon*).

A further slight pen and ink study which may be connected is on p. 77 (inside cover) of the 'Chester' sketchbook (LXXXII) as the figure in the stern fixing the rudder is clearly visible.

Drawings of waves breaking on the shore in the 'Dunbar' sketchbook (LIV pp. 109, 110 verso, 116 and 116 verso which are reproduced in Wilkinson 1972, pp. 118–19) are cited by Wilkinson as almost certainly studies for the Kenwood picture but in fact the angle of the waves to the beach is much closer to this picture, and it is possible that they are connected with it. The 'Dunbar' sketchbook was in use in 1801.

The inscription noted above in Turner's writing proves that the Southampton picture belonged in 1805 to Samuel Dobree and that the words 'Lee Shore' were certainly attached to the title. There are several instances of Turner's pictures losing their exhibited titles even when they were sold straight from an exhibition into a collection where they have remained ever since (e.g., *The Forest of Bere* (No. 77) and *The Confluence of the Thames and the Medway* (No. 75), both at Petworth). Although the Southampton picture remained in the Dobree family, its correct title was evidently forgotten by the time of the 1842 sale, if my identification is right.

Obviously, the drawing in the 'Calais Pier' sketchbook is the strongest and most important piece of evidence for connecting the Southampton picture with the exhibited 'Fishermen upon a Lee Shore'. It is, however, certainly not the only argument in favour of this theory, which can be seen to receive strong corroboration from a careful reading of the Press notices about the 1802 Exhibition which mention 'Fishermen upon a Lee Shore'.

On 6 May the *Star* wrote: 'No. 110. *Fishermen upon a Lee Shore*—J. M. W. Turner, R.A. This is a very admirable sketch, but we have doubts whether Mr. Turner could himself make it a good finished picture. The drawing is spirited, the general touch masterly and the distribution of light and shade very effective, but the water has a stony appearance, and the colouring of the picture is cold and even dirty. The best part of it is the beach, and the returning wave.'

Although this notice does little to clarify the problem, the words 'the colouring of the picture is cold and even dirty' apply with slightly less inaccuracy to the Southampton than to the Kenwood picture.

The *True Briton* for 4 May commented as follows: '. . . There is an appearance of *Scotchy* force in this

work, but it is much too indeterminate and wild. The water is by no means a representation of the elements; it wants transparency throughout, and the waves are all *chalky*. The sky is not in harmony with the general tone of colouring. The best part of the piece is the beach, and that is admirable.' This notice is too indeterminate (to use its own word) to draw any conclusions from. It could apply equally to either picture.

The *St. James's Chronicle*, 18–20 May, and *Lloyds Evening Post*, 19–21 May, wrote in identical terms that 'it exhibits, in a terrific manner, the dangers of a lee-shore'.

Surely there is no one in the Kenwood picture in any danger as the great majority of the figures are safely on dry land, whereas the occupants of the boat in the Southampton picture *are* in danger of being overturned by the waves through which they are endeavouring to put to sea.

The *Monthly Mirror* for June wrote: 'No. 160 [*sic*] Fishermen upon a Lee Shore Turner, R.A. A masterly performance, remarkable for its comprehensive and distinct divisions of large parts. The massive roll of the waves, and the precision of aerial tints in the objects beyond them, impress and delight the spectator. The scene is likewise connected with interest. We wish to feel it for men, whose necessary and daily occupations of livelihood expose life to such imminent peril, and we regret that the precision, so admirable in the painter's imitation of the large parts of nature, is not equally to be found in the minute particulars which fill up his story. *The boat and its tenants* [my italics] conveys but a faint idea of the *action* either of a boat or of men. If this arises from want of diligence in the painter, it is eminently his interest to correct the *creeping vice*; if from any other cause it is only to be lamented in talents that promise to their possessor so much celebrity.'

It seems inconceivable to me that this description can be applied to the Kenwood picture. The phrase 'the boat and its tenants' alone would seem to disbar it, especially when followed by the criticism of the *action* of the boat. On the other hand, this description does draw attention to some of the features in the Southampton picture.

Last, although this is perhaps more disputable ground, the Kenwood picture does not depict a lee shore in the accepted sense of the term, which is that the wind should be blowing directly on shore. If one examines the line of the shore in relation to the direction of the wind as evidenced by the flag and by the sail of the boat offshore, they are clearly not at right angles. On the other hand, the Southampton picture does truly portray a lee shore. Although Turner's titles sometimes show a weakness in historical or Biblical knowledge, his knowledge of the sea was such that a seapiece exhibited by him is likely to have been accurately described and titled.

It will be noticed that in not one of these newspaper criticisms is there any reference to an identifiable feature in the Kenwood picture, although the numerous figures, the fish on the beach and the boat being hauled

ashore might all seem to be worthy of comment in any notice as long as a number of those which mentioned 'Fishermen upon a Lee Shore'.

The sum of the above evidence seems to me to show conclusively that the Southampton picture should be rechristened and restored once more to the title under which it was originally exhibited by Turner in 1802.

17. The Tenth Plague of Egypt Exh. 1802

(Plate 19)

THE TATE GALLERY, LONDON (470)

Canvas, $56\frac{1}{2} \times 93$ (142×236)

Coll. Turner Bequest 1856 (24, 'The 10th Plague' $7'9'' \times 4'9\frac{1}{2}''$); transferred to the Tate Gallery 1910.

Exh. R.A. 1802 (153); Tate Gallery 1931 (10).

Engr. By W. Say for the *Liber Studiorum*, R. 61, published 1 January 1816 with the classification 'H' for Historical (repr. Finberg 1924, p. 243; the preliminary pen and sepia drawing, CXVIII-H, and etching repr. p. 242). The composition, though containing the same elements, is compressed laterally and a shaft of lightning introduced.

Lit. Farington *Diary* 1 May, 15 June 1802, 12 October 1812; Ruskin 1843 (1903–12, iii, pp. 240–41); Cunningham 1852, pp. 8–9; Thornbury 1862, i, p. 264; 1877, pp. 345, 419; Monkhouse 1879, p. 49; Bell 1901, pp. 61, 78–9 no. 97; Armstrong 1902, pp. 48–9, 221; Finberg 1924, p. 243; Davies 1946, p. 186; Clare 1951, pp. 29–30, repr. p. 28; Finberg 1961, pp. 77, 80, 171, 195, 465 no. 75; Rothenstein and Butlin 1964, pp. 11–12, 16, pl. 19; Lindsay 1966, p. 77.

Accompanied in the 1802 R.A. catalogue by the following lines from *Exodus* xii, 29–30:

> Ver. 29. 'And it came to pass, that at midnight the Lord smote all the first-born in the land.
> Ver. 30. 'And Pharoah rose, he and all the Egyptians; and there was a great cry in Egypt; for there was not a house where there was not one dead.'

Farington, on 1 May 1802, mentions that 'Turners Murder of the Innocents', presumably this picture in the absence of any more likely candidate, was among those works 'noticed by many', and on 3 May he included Turner's 'Tenth Plague of Egypt' in a short list of five 'favourite pictures'. On 15 June he records Smirke's opinion: 'He thought the large picture by Turner "The [Plague] in Egypt", an extraordinary production.—He was surprised at it.'

The picture was singled out by the *Monthly Mirror* for June 1802: '. . . it aspires to the *ideal* imitation of nature . . . Forests, cities, and storms, are combined to excite the idea of grandeur.' The critic went on to warn that 'There is a false as well as a true sublime, and both

present the same surface to the first glances of the eye. The merits of this picture are, however, many and great.'

This picture was priced at £400 in a note, probably of *c*. 1810, in Turner's 'Finance' sketchbook (CXXII-36; for the date see Nos 53 and 56).

18. Ships bearing up for Anchorage Exh. 1802
known as *The Egremont Seapiece* (Plate 20)

H.M. TREASURY AND THE NATIONAL TRUST (Lord Egremont Collection) PETWORTH HOUSE

Canvas, 47 × 71 (119·5 × 180·3)

Signed 'J M W Turner pinx' lower right

Coll. Bought from Turner by George, third Earl of Egremont (1751–1837) possibly in 1802 at the R.A. but in any case he owned it by 1805 (see below); by descent to the third Lord Leconfield who in 1947 conveyed Petworth to the National Trust; in 1957 the contents of the State Rooms were accepted by the Treasury in part payment of death duties.

Exh. R.A. 1802 (227); R.A. 1892 (131); Tate Gallery 1951 (5); R.A. 1951–2 (182); Agnew *English Pictures from National Trust Houses* 1965 (30); Brussels 1973 (63); R.A. 1974–5 (72).

Engr. By Charles Turner in the *Liber Studiorum*, published 20 February 1808, entitled 'Ships in a Breeze'. (Rawlinson 10. There are considerable differences from the original, which no doubt account for the alteration in the title as the ships are no longer 'bearing up for anchorage' in the print, the composition of which is a good deal more concentrated. There is a drawing for the print in the Turner Bequest CXVI-M.)

Lit. Petworth inventories 1837, 1856 (North Gallery); Burnet and Cunningham 1852, p. 111 no. 70; Waagen 1854, ii, p. 37; Thornbury 1862, ii, pp. 5, 397; 1877, pp. 98, 199, 200, 570, 594; Bell 1901, p. 79 no. 98; Armstrong 1902, p. 230; Collins Baker 1920, p. 123 no. 33; Finberg 1924, p. 39; 1961, pp. 79, 465 no. 76; Rothenstein and Butlin 1964, p. 16 pl. 18; Reynolds 1969, p. 46; Wilkinson 1972, pp. 143, 154.

There are a great number of studies for this picture, some of them of great beauty, in the Turner Bequest, mainly in the 'Calais Pier' sketchbook (LXXXI): pp. 64–5, 66–7 (left-hand part of composition only), 72–3 (the most finished study, reproduced inside the front covers of Wilkinson), 88–9, 112–13, 115. Some of these are inscribed in Turner's hand 'Ld. Egremont's Picture' when he evidently went through the sketchbook in 1805 (a number of drawings are inscribed: 'Study not painted 1805' which fixes the date). There are also some much slighter studies in the 'Studies for Pictures' sketchbook (LXIX) pp. 29–32, 40 verso–41, 91. In some cases the connection is clear, in others more tenuous. These drawings emphasise the care Turner

took over the composition which, in its finished state, does perfectly illustrate the title, showing in detail ships sailing, coming up into the wind, shortening sail and dropping anchor. Professor Bachrach has drawn my attention to the similarity between the ship at anchor (although Turner has shown it as greatly elongated) and a model of a ship which Turner owned (now in the Tate Gallery).

This picture attracted almost no attention when at the R.A., the critics concentrating mainly on *The Tenth Plague* (No. 17) and after that on *Fishermen on a Lee-Shore* (No. 16) and the watercolours of Scotland. The only paper to mention it was the *Daily Advertiser and Oracle* for 5 May which wrote: 'That which struck us amidst the crowd and bustle which prevail at the first opening of the Academy as the best, is a scene with ships beating up to gain anchorage. It is indeed a most forcible and judicious performance, well drawn and admirably coloured.'

Such neglect seems extraordinary after the attention paid to the *Bridgewater Seapiece* the previous year (see No. 14), especially as this great early masterpiece goes even beyond its predecessor in its dramatic rendering of a stormy sky and turbulent sea.

19. Jason Exh. 1802 (Plate 21)

THE TATE GALLERY, LONDON (471)

Canvas, 35½ × 47⅛ (90 × 119·5)

Coll. Turner Bequest 1856 (72, 'Jason' 4′0″ × 3′0″); transferred to the Tate Gallery 1910.

Exh. R.A. 1802 (519); B.I. 1808 (394, 'Jason, from Ovid's Metamorphosis'); Plymouth 1815; Tate Gallery 1931 (11); Liverpool 1933 (22); Arts Council tour 1952 (2); R.A. 1974–5 (73).

Engr. By Charles Turner for the *Liber Studiorum*, R. 6 (the preliminary pen and sepia drawing, CXVI-E, repr. Finberg 1924, p. 22; the etching and engraving repr. pp. 22–3).

Lit. Ruskin 1857 (1903–12, xiii, pp. 104–5); Thornbury 1862, i, pp. 257, 263–4; 1877, p. 419; Monkhouse 1879, p. 74; Bell 1901, pp. 61, 79–80 no. 99; Armstrong 1902, p. 223; Finberg 1910, p. 38; MacColl 1920, pp. 4–5; Finberg 1924, p. 23; Davies 1946, p. 187; Finberg 1961, pp. 80, 141, 229, 465 no. 80, 468 no. 113, 513 no. 194a; Gage 1969, pp. 137–9.

Turner's source was probably Apollonius Rhodius (*Argonautics* iv, trans. Fawkes in R. Anderson's *A Complete Edition of the Poets of Great Britain* 1792–5, xiii, p. 302) rather than the short account in Ovid's *Metamorphoses*; Fawkes' translation gave the dragon as a 'serpent' as shown by Turner (and which tied up with the Python killed by Apollo, Turner's picture of which was already in his mind at this time—see No. 115). Turner omits the Golden Fleece in which lay the

subject's alchemical significance, though in his choice of subject he may well have been influenced by de Loutherbourg, whose interest probably was alchemical; de Loutherbourg's *Jason enchanting the Dragon* was in the Bryan collection up to 1798 and his sale included *Cadmus destroying the Dragon*, Cadmus often being associated with Jason.

There is a possible sketch in the 'Jason' sketchbook of *c*. 1801 (LXI-60 verso) and another possible sketch, for the centre of the composition only, in the 'Rhine, Strassburg and Oxford' sketchbook of 1802 (LXXVII-44); the latter may however be for *The Garden of the Hesperides* like that on the next page, 45 (see No. 57). There is also a drawing of Jason himself in the 'Calais Pier' sketchbook (LXXXI-7).

The picture does not seem to have been individually reviewed when it was exhibited in 1802 but in 1808, when it was shown again at the British Institution, it was given a long account in the *Review of Publications of Art*, probably by John Landseer, who began by describing it as 'a scene of romantic and mysterious solitudes, of a highly poetical character'. The reviewer questioned the subtitle 'from Ovid's Metamorphosis' but went on, 'It may be the more what Ovid would have done, had he expressed himself in another art, and painted, instead of writing, his story of Jason . . . The

spectator can discover but a single coil of the dragon-serpent, but having already seen him in his dreadful effects, is led to imagine much. It is . . . a feature of immensity! while the few human bones which lay about the fore-ground terribly indicate the fearlessness of the hero, and the favourite prey of the monster.' The reviewer concludes, of this and *The Battle of Trafalgar* (No. 58), 'Both Mr. Turner's performances—Poems, we had nearly called them, are calculated to display the vast power which he possesses over the imaginations of his *readers*. In comparison with him, some other painters, and particularly of the modern French School, appear but as *geometers* of painting, making their appeal directly through the medium of sense to the judgement. His art is of more persuasively-commanding influence,

And without passing through the judgement, gains
The heart, and all its end at once attains.'

That this picture and No. 87 were exhibited at Plymouth in 1815 is shown by Turner's letter to Ambrose Johns of 4 November 1815 explaining that he had sent these two rather than the 'Dido' and 'Frostpiece' (Nos. 131 and 127) that Johns had suggested in a letter that had crossed with his (see Finberg 1961, p. 229).

Nos. 20–45: Unexhibited Works

Nos. 20–42: Miscellaneous

20. Self-Portrait *c*. 1793 (Plate 24)

THE INDIANAPOLIS MUSEUM OF ART, INDIANA

Canvas, 20½ × 16½ (52 × 42)

Coll. Said to have been given by Turner to his housekeeper, Hannah Danby and bequeathed by her in 1854 to John Ruskin; bequeathed by Ruskin to Arthur and Joan Severn; the picture remained at Brantwood until Arthur Severn died in February, 1931 when it was sent to Sotheby's for sale 20 May 1931 (132) bought Sir Arthur Russell, Bt (1878–1964); Marjorie, Lady Russell (his widow); sale Christie's 21 March 1969 (76) bought Agnew for Kurt Pantzer of Indianapolis and given to the Indianapolis Museum in 1972 in memory of Dr and Mrs Hugo O. Pantzer by their children.

Exh. Fine Art Society 1878 (121); Arts Council 1964 (90).

Lit. Ruskin 1856, 1878, 1884 (Conversation with M. H. Spielmann at Brantwood), 1900 ('Dilecta') (1903–12,

xiii, pp. 156, 473–4, repr. as frontispiece; xxxiv, p. 668; xxxv, p. 601); Thornbury 1862, i, p. 7; 1877, p. 10; L. Cust, 'The Portraits of J. M. W. Turner R.A.', *Magazine of Art* 1895, p. 245; C. Monkhouse, 'Some Portraits of J. M. W. Turner', *Schribner's Magazine* xx 1896, p. 93; Finberg 1961, p. 27; Sheila Birkenhead, *Illustrious Friends* 1965, p. 381; Lindsay 1966, pp. 29, 221, n. 22.

The frame is inscribed J M W TURNER SUA MANU LUSTRO ETATIS QUARTO which suggests that the portrait shows Turner aged between fifteen and twenty. The origin of the inscription is to be found in a letter from Ruskin to the Rev. W. Kingsley in Mr Pantzer's collection. Ruskin describes the portrait and continues 'Will you please send me good latin for the title of it—to go on the frame below—you are in for that at any rate as you stand for philology

Himself Painted
J M W Turner
Aetat 16–19

They say 16. But the painting is impossibly firm and fine for that age—and yet this boy can't be more than 19—His old servant bequeathed it to me—he gave it *her* himself.'

Further evidence about the date is provided by a reference to it in the posthumous *Notes and Reminiscences* of W. H. Harrison, Ruskin's friend and editor, in the *Dublin University Magazine* May 1878, pp. 546–7 (kindly communicated by Dr Harold Shapiro). In a section devoted to Turner, Harrison wrote: 'He painted two portraits of himself; one at the age of, I think, sixteen, which, when he was about to destroy it, was begged of him by his housekeeper, who left it by will to Mr. Ruskin.'

If Harrison is correct about the date, this would mean the picture was painted in 1791–2, Turner's earliest recorded oil by at least two years. However, Turner certainly appears to be older than in the watercolour self-portrait in the National Portrait Gallery (dated in the Turner Bicentenary Exhibition catalogue, p. 175, *c.* 1791–3, although the latter date would seem to be too late) but the difference in scale and medium of the two portraits makes it difficult to be dogmatic about this.

Later, Ruskin himself suggested it was painted 'at about the age of 17.' Turner certainly appears a good deal younger than in the Tate self-portrait of *c.* 1798 (No. 25) and perhaps *c.* 1793 is the most convincing date after considering all the factors. Ruskin considered that it 'shows the broad and somewhat clumsy manner [e.g., the left hand] of his painting in the school days' but that also 'it is to me who know him in his age, entirely the germ and virtually capable contents of the man I know.' Ruskin also thought that the portrait was fit to bear comparison with those of Watson (whose portrait of Ruskin's father hung next to the Turner in the dining room at Brantwood) and Raeburn; it certainly shows signs of being formed on earlier models, with Hoppner perhaps as another and even stronger influence. This derivative aspect, coupled with the rather idealized features, makes it difficult for us to discern 'the germ' of Turner in maturity which Ruskin observed.

According to Thornbury, the Rev. Trimmer thought it 'strikingly like the nose and eyes, but otherwise defective'. Thornbury also relates that Turner was dissatisfied with it to the extent of knocking his fist through it, resulting in 'a fracture visible on the left side of the picture'. This damage is no longer discernible today, and the story seems unlikely to be true in view of Turner's attitude to his pictures. Furthermore, Thornbury states that it was Turner's father who gave the portrait to Hannah Danby but this is refuted by the evidence given in Ruskin's letter already quoted.

21. Rochester Castle with Fishermen drawing Boats ashore in a Gale *c.* 1794

PRESENT WHEREABOUTS UNKNOWN

Size unknown

Coll. Dr Nixon, Bishop of Tasmania, in 1854; according to Thornbury it was finished at Foot's Gray Parsonage, 'the residence of the father of Dr. Nixon'; no further history is known unless this is possibly the same picture as was sold from the collection of Thomas Ball at Christie's 14 May 1860 (168) *Rochester Castle* as 'Painted for the Rev. E. T. Douglas'. It was bought in for 37 guineas. However no connection is known between 'the father of Dr. Nixon' and the Rev. E. T. Douglas. The latter is described in Christie's catalogue as 'one of the artist's earliest patrons' and the picture appears certainly to have been an oil and not a drawing as described by Thornbury who also states that the vendor in 1860 was W. Herring.

Lit. Thomas Miller, *Turner and Girtin's Picturesque Tours* 1854, p. xxvii and n.; Thornbury 1862, i, pp. 77, 155; 1877, pp. 45, 96; Gage 1969, p. 229 n. 53.

Turner was in Rochester in 1793 and according to Miller's account this oil would have been painted in the following year, which makes it Turner's earliest recorded oil painting, except for the self-portrait now in Indianapolis (No. 20). Also according to Miller, it bore a strong resemblance to the work of de Loutherbourg and was 'carefully but thinly painted, in just the manner one might suppose a water-colour artist would paint'.

22. Limekiln at Coalbrookdale *c.* 1797 (Plate 3)

YALE CENTER FOR BRITISH ART, PAUL MELLON COLLECTION

Panel, $11\frac{3}{8} \times 15\frac{7}{8}$ (29 × 40·3)

Coll. J. J. Chalon, R.A. (1778–1854), by 1825 (when engraved in that year, the picture was in the possession of Mr J. J. Chalon and the Potter sale catalogue of 1886 identifies him as the painter John James Chalon); perhaps John Clow; sale Winstanley's 3 December 1852 (89) as ' "Lime Kilns by Night" drawing, engraved', bought in; Wallis; sale Christie's 16 April 1853 (108) bought in; C. G. Potter sale Christie's 6 March 1886 (167) bought in (wrongly listed as a drawing in Graves' *Art Sales* 1911, iii, p. 240); C. V. Bagot sale Christie's 1 July 1905 (112) bought in (although it seems difficult to explain how the picture got into the Bagot collection when it would appear to have remained in the possession of the Potter family, see below, Lot 112 is described as the picture formerly in the Chalon collection which was engraved by F. C. Lewis); P. Potter; bought from Mrs Potter by Agnew's in 1909; sale Christie's 18 March 1911 (93) bought in; W.

Lockett Agnew sale Christie's 7 June 1918 (70) bought Walford; D. F. Ward sale Sotheby's 23 November 1966 (86) bought Patch; bought by the present owners from Agnew, 1967.

Exh. Washington 1968–9 (2).

Engr. By F. C. Lewis, 1825.

Lit. Thornbury 1862, i, p. 296; 1877, pp. 431–2; Armstrong 1902, pp. 66, 220; Rawlinson, ii, 1913, pp. 210, 374; F. D. Klingender, *Art and the Industrial Revolution* 1968, p. 90, pl. 27.

Thornbury (and, following him, Armstrong) dates this picture *c.* 1814 which makes no sense at all. The subdued tonality points to an early work and comparison with *Moonlight: a Study at Millbank* (No. 2) exhibited in 1797, reveals close parallels between the two pictures. In particular, the foliage and the reflections in the water are painted in an identical manner and both panels, incidentally, are of almost identical size. They clearly owe a debt to Dutch painting and the lighting in *Coalbrookdale* may derive from Turner's study of Rembrandt's small night scene of *The Flight into Egypt* (now in the National Gallery of Ireland) which Turner must have seen in the collection of his patron Sir Richard Colt Hoare at Stourhead. Turner may have visited Stourhead as early as 1795 and the Rembrandt there seems also to have influenced one of Turner's R.A. exhibits of 1797: the watercolour of *The Trancept of Ewenny Priory* (National Museum of Wales). Furthermore, the elongated figures of the two drovers are typical of figures in Turner's watercolours of about this date, reflecting the influence of Edward Dayes. Although one of Turner's earliest known oil paintings, the way in which the branches of the pollard willows on the left are seen through the drifting smoke shows how far Turner had already mastered the medium.

Coalbrookdale in Shropshire was famous for its iron works and was an early centre of the Industrial Revolution. Although no Turner drawings of Coalbrookdale are known, he may easily have passed through it on his way either to or from Wales in 1795 and he was certainly in Shropshire in 1794. Two drawings of kilns in the 'South Wales' sketchbook (XXVI pp. 18, 96) attest to Turner's interest in subjects of this kind and a watercolour *c.* 1796–7 of an iron foundry (XXXIII-B) provides further evidence of this. An equally important source for this picture may be a series of small watercolours and drawings in pen and ink done on card by de Loutherbourg which include several of Coalbrookdale. These belonged to Dr Monro, with whom Turner was, of course, in contact at this date. Turner's interest in them is proved by his purchase of 53 of them at the Monro sale in 1833 and they are now in the British Museum as part of the Turner Bequest (CCCLXXII).

23. Interior of a Romanesque Church *c.* 1795–1800
(Plate 23)

THE TATE GALLERY, LONDON (5529)

Mahogany, $24 \times 19\frac{3}{4}$ (61×50)

Coll. Turner Bequest 1856 (283, one of '37 Pictures various'; identified by chalk number on back); transferred to the Tate Gallery 1947.

Lit. Davies 1946, pp. 166, 191 n. 27.

In the 1856 copy of the Schedule the '37 Pictures various' of 1854 were cut down to seven.

The picture is still awaiting cleaning and is covered by a heavy layer of dirt. Turner seems to have used a panel from a door or piece of furniture. His painting is over several other layers of paint of single colours, and pin holes round the edges, in the surface, suggest that the main area of the panel was originally framed with wooden beading.

Stylistically the picture seems to be early, recalling such ecclesiastical, selectively-lit interiors as the watercolours of *Ely Cathedral: looking towards the North Transept and Chancel*, probably exhibited in 1796 (Aberdeen Art Gallery; repr. exh. cat., R.A. 1974–5, p. 34 no. 13) and *Trancept of Ewenny Priory, Glamorganshire*, exhibited the following year (National Museum of Wales, Cardiff; repr. Finberg 1961, pl. 5; *c.f.* also the interior of Ewenny Priory in the 'Swans' sketchbook, dated by Finberg to *c.* 1798, XLII-58 and 59). Compare also the equally dirty *Interior of a Gothic Church*, which is related to watercolours of 1797 (No. 24).

24. Interior of a Gothic Church *c.* 1797 (Plate 26)

THE TATE GALLERY, LONDON (5536)

Mahogany, $10\frac{15}{16} \times 16$ (28×40.5)

Coll. Turner Bequest 1856; transferred to the Tate Gallery 1947.

Engr. By Turner for the *Liber Studiorum*, R.70, published on 1 January 1819, the date altered from the '1816' of the third state (repr. Finberg 1924, pp. 278–9; the preliminary etching repr. p. 278).

Lit. Davies 1946, p. 167.

The figures in the engraving are absent from the painting and there are other variations as if the interior was seen from a slightly different viewpoint. The painting does not show the sharply delineated shaft of light falling diagonally on the end wall at the right of the first two states of the engraving ('the daylight effect'; see Finberg, *loc. cit.*). The composition is close to a group of watercolours in the sketchbook, used in 1797, labelled by Turner 'Studies for pictures—copies of Wilson', particularly XXXVII—26/7 and 34/5 (the latter repr. in colour, as '36, 37', in Wilkinson 1972, p. 53), though again there are differences in detail.

All the edges of the panel have been bevelled at the back and it is probable that it originally came from a door or panelling. Turner used the reverse as a palette and a considerable amount of paint remains. The surface of the painting is very dirty and damaged by scratching and abrasion, largely done before the paint had fully dried.

25. Self-Portrait *c*. 1798 (Plate 25)

THE TATE GALLERY, LONDON (458)

Canvas, $29\frac{1}{4} \times 23$ ($74 \cdot 5 \times 58 \cdot 5$)

Coll. Turner Bequest 1856 (92, 'Portrait of J. M. W. Turner' $2'5'' \times 1'11''$); transferred to the Tate Gallery 1910.

Exh. National Portrait Exhibition 1868 (94); Tate Gallery 1931 (13); Venice and Rome 1948 (1, repr.); R.A. 1974–5 (B1, repr. as frontispiece); Leningrad and Moscow 1975–6 (88).

Lit. Thornbury 1862, i, pp. 45, 63; ii, p. 320; 1877, pp. 25, 36, 42, 392, 419; Hamerton 1879, p. 38; Armstrong 1902, pp. 28–9, 227, repr. facing p. 8; MacColl 1920, p. 2; Davies 1946, p. 187; Rothenstein and Butlin 1964, p. 76, pl. 1; Herrmann 1975, p. 225, pl. 1.

Datable *c*. 1798 for reasons of style and the age of the sitter.

26, 27. Two Views of Plompton Rocks *c*. 1798
(Plates 28, 29)

THE EARL OF HAREWOOD

Canvas, each $48 \times 54\frac{1}{4}$ ($122 \times 137 \cdot 5$)

Coll. Painted *c*. 1798 for Edward Lascelles, first Earl of Harewood (1740–1820) or possibly for his son Edward, later Viscount Lascelles (1766–1814), for the library at Harewood. They have remained *in situ* ever since.

Exh. R.A. 1974–5 (31 & 32).

Lit. Tancred Borenius, *Catalogue of Pictures and Drawings at Harewood House* 1936, p. 186, nos. 467 and 468, pls. LXVIII and LXIX; Gage 1969, p. 148, pl. 32.

Two connected drawings are in the Turner Bequest. CXCVII-L (catalogued by Finberg under 'Colour Beginnings 1802–1820') is a partly finished watercolour study for No. 27 and LI-Y ('Miscellaneous 1799–1801') is a general view of the scene in pencil but differing in details from both pictures.

This pair of pictures represent what seems very likely to have been Turner's first commission for oil paintings. (*The Mildmay Seapiece* No. 3 predates them but it is by no means certain that this was painted on

commission.) They hang under—and are the same width as—a set of four landscapes of local Yorkshire views by Nicholas Thomas Dall (*d.* 1777) which were painted for the room. According to the guidebook to Harewood by Richard Buckle, the Turners were commissioned to replace two mahogany doors, shown in Adam's original design, which it must have been decided to abolish. The date of the pictures is not documented but a watercolour of *Harewood from the South East*, presumably commissioned as a result of Turner's visit to Harewood in 1797, is signed and dated 1798.

Gage points out that Turner was at pains to tone in the skies in his pictures with the delicate shades of pink of the Adam decoration. Indeed, the lightness of key throughout the two pictures is quite unlike Turner's palette in oil at this date, although it is possible that the tonality has been influenced not only by the pictures' surroundings but by a pair of pictures by Richard Wilson of *Dinas Bran* and *View near Wynnstay* which Turner would have seen in Sir Watkyn Williams Wynn's collection. They are now in the Yale Center for British Art and are illustrated in W. G. Constable, *Richard Wilson* 1953, pls. 36a and 62b.

Gage also observes that the pictures have 'a viewing distance which is wholly calculated in relation to the scale of the setting'. Certainly the somewhat summary, almost coarse, handling reinforces the view that Turner did not expect these pictures to be examined at close range. It may also derive from a study of the texture of certain landscapes by Joseph Wright of Derby.

Plompton Rocks is the name of a well-known beauty spot, about four miles south-east of Harrogate, which, in the early nineteenth century, was 'open every Tuesday in the summer months to the Nobility and gentry who frequent Harrogate etc. on account of its beautiful pleasure grounds' (*The Tourist's Companion or the History and Antiquities of Harewood*, second edn, Leeds, 1822, p. 30).

28. Caernarvon Castle *c*. 1798 (Plate 27)

THE TATE GALLERY, LONDON (1867)

Pine, $5\frac{15}{16} \times 9\frac{1}{16}$ ($15 \cdot 1 \times 23$); a bevelled edge along the bottom leaves a painted surface of $5\frac{13}{16} \times 9\frac{1}{16}$ ($14 \cdot 8 \times 23$)

Coll. Turner Bequest 1856; transferred to the Tate Gallery 1905.

Exh. *Welsh Landscape in British Art* Arts Council Welsh tour, August 1947–February 1948 (40); Cardiff 1951; Brighton 1957 (33); Swansea 1964 (154); R.A. 1974–5 (45).

Lit. Gage 1969, pp. 29–30, colour pl. 6.

A watercolour of the same view is in the 'Academical' sketchbook (Turner Bequest XLIII-39 verso, repr. in colour Gage, *op. cit.*, pl. 5; for rather more accurate colour reproductions of three of the other related

sketches of Caernarvon Castle in the same sketchbook, XLIII-42 verso, 43 verso and 44 verso, see Wilkinson 1972, pp. 82–3). This was used for the large finished watercolour *Caernarvon Castle* exhibited at the R.A. in 1799 (340). There are similar views of Caernarvon Castle in pencil in the 'Lancashire and North Wales' sketchbook (XLV-24 verso, 25 verso and 26 verso; 24 verso and 26 verso are repr. Wilkinson, *op. cit.*, p. 86); these were dated *c.* 1799 by Finberg but should probably be dated, like the watercolour sketches and this oil painting, to 1798, the year before the finished watercolour was exhibited.

29. View in Wales: Mountain Scene with Village and Castle—Evening *c.* 1798 (Plate 30)

THE TATE GALLERY, LONDON (466)

Canvas, $22\frac{7}{8} \times 28\frac{5}{8}$ (58 × 72·5)

Coll. Turner Bequest 1856 (? 93, 'Welsh Castle' $2'4\frac{1}{4}'' \times 1'1\frac{1}{2}''$); transferred to the Tate Gallery 1929.

Exh. Newcastle 1912 (54); Newcastle 1924 (158); Tate Gallery 1931 (8); *Welsh Landscape in British Art* Arts Council Welsh tour, August 1947–February 1948 (41); Cardiff 1951; Arts Council tour 1952 (1); Brighton 1957 (32); Swansea 1964 (155); Milan 1975 (148, repr.).

Lit. Ruskin 1857 (1903–12, xiii, pp. 102–3); Armstrong 1902, p. 236; MacColl 1920, p. 3; Davies 1946, p. 187.

One of a group of small Wilsonian canvases of *c.* 1798 and more conventionally Wilsonian in composition than Nos. 30 and 31. The identification with Wales dates back to the painting entering the National Gallery, if not to the Inventory of the Turner Bequest, though the exact site cannot be located; nor are there any directly comparable drawings. On the other hand, Andrew Wilton has suggested a more direct influence from Wilson: the skyline and tower are very close to the right-hand side of Wilson's *Landscape with Bathers, Cattle and Ruin*, no. 1209 in the Tate Gallery (another version, in the Huntington Art Gallery, San Marino, is repr. W. G. Constable, *Richard Wilson* 1953, pl. 99b). Turner copied this, or another version of the composition, in a watercolour in the Turner Bequest (XXXIII-I).

30. Mountain Scene with Castle *c.* 1798 (Plate 31)

THE TATE GALLERY, LONDON (465)

Canvas, $17\frac{1}{4} \times 21\frac{1}{4}$ (44 × 54)

Coll. Turner Bequest 1856 (94, 'Mountain Scene with Castle' $1'9'' \times 1'5\frac{1}{2}''$); transferred to the Tate Gallery 1910.

Exh. *Richard Wilson* Tate Gallery, 1925 (67); Tate

Gallery 1934 (6); Amsterdam, Berne, Paris, Brussels, Liege (2), Venice and Rome (3), 1947–8; Cardiff 1951; R.A. 1974–5 (35).

Lit. Thornbury 1862, i, p. 262; 1877, p. 418; Armstrong 1902, p. 225; MacColl 1920, p. 3; Davies 1946, p. 187; Rothenstein and Butlin 1964, p. 10, pl. 8, Wilkinson 1972, p. 72, repr.

Related to sketches in the 'Dinevor Castle' sketchbook, which Turner was using in 1798, especially those tentatively identified by Finberg as Caer Cennen (XL-37 verso and 38, repr. Wilkinson, *loc. cit.*, and 39 verso and 40; see also XL-84 verso, repr. Wilkinson, p. 73, and XLVI-107 from the 'Dolbadarn' sketchbook of 1798–9).

31. View of a Town *c.* 1798 (Plate 32)

THE TATE GALLERY, LONDON (475)

Canvas, $9\frac{1}{2} \times 12\frac{3}{4}$ (24 × 32·5)

Coll. Turner Bequest 1856 (797, 'Town View' $1'1'' \times 4'3\frac{1}{2}''$); transferred to the Tate Gallery 1910.

Exh. *Richard Wilson* Tate Gallery, 1925 (68); Tate Gallery 1931 (3); Birmingham (171) and Tate Gallery (164) 1948–9; Australian tour 1960 (1); R.A. 1974–5 (34).

Lit. Armstrong 1902, p. 233; MacColl 1920, p. 5; Davies 1946, p. 187.

A small but finished picture, close to Wilson in style and technique, particularly the large rock in the foreground, but perhaps derived, like No. 30, from one of Turner's Welsh tours. The dimensions given in the Schedule of 1854 must be an error, as the larger dimension is normally given first regardless of whether it represents height or width.

32. Dunstanborough Castle *c.* 1798 (Plate 33)

DUNEDIN PUBLIC ART GALLERY, NEW ZEALAND

Canvas, $18\frac{1}{2} \times 26$ (47 × 69)

Coll. Sims; A. Andrews (not included in his sale at Christie's on 14 April 1888); Messrs Dowdeswell; A. G. Temple from whom bought by Agnew in 1899 and sold to E. F. Milliken, New York; anon. (Milliken) sales Christie's 3 May 1902 (43) and 23 May 1903 (79) bought in on both occasions; Mrs C. M. de Graff; sale Christie's 21 February 1930 (75) bought Meatyard from whom bought by Leggatt, who sold it to Dunedin in 1931.
 The early section of the provenance is taken from Armstrong. I can find out nothing about Sims or his collection.

Exh. Guildhall 1899 (2, lent by Messrs. Dowdeswell); Auckland 1959.

Lit. Armstrong 1902, p. 222, repr. facing p. 215; Finberg 1961, p. 48.

A charcoal drawing (XXXVI-T, 'Subjects connected with North of England Tour'), although very damaged, is certainly a study for this picture and also for a watercolour, $13\frac{3}{4} \times 19$ in., which formerly belonged to Sir Donald Currie and is now in the collection of Mr N. E. Hurst. The compositions of the oil and the watercolour are virtually identical.

Armstrong confuses this picture with the much later watercolour in the *England and Wales* series in stating that it was engraved by Brandard.

The compiler has not seen the original. However, despite a saleroom record scarcely calculated to inspire confidence (it fetched 30 guineas at Christie's in 1930), it looks genuine from a photograph, although it should be said that to pass judgements on Turner's work on the basis of photographs alone is well known to be a fallible exercise.

Also from the photograph, it would appear to be very close in date to No. 6 and therefore *c.* 1798, although Armstrong suggests *c.* 1800. The marked influence of Wilson would seem to support the earlier date, and it seems possible that this version may have been a try-out on a small scale for a 36×48 picture, which Turner finally brought to fruition in the version in Melbourne, having in the meantime decided on a different viewpoint. There seem also to be similarities of style between this version and the *Shipping by a Breakwater* (No. 33) which was dated *c.* 1798 in the catalogue of the Turner Bicentenary Exhibition (p. 41).

33. Shipping by a Breakwater *c.* 1798 (Plate 48)

THE TATE GALLERY, LONDON (469)

Mahogany, $11\frac{7}{8} \times 7\frac{5}{8}$ (30·3 × 19·4)

Coll. Turner Bequest 1856 (98, 'Marine Subject' $1'0'' \times 0'7\frac{1}{2}''$); transferred to the Tate Gallery 1910.

Exh. Tate Gallery 1931 (7); R.A. 1974–5 (33).

Lit. Thornbury 1862, i, p. 262; 1877, p. 418; Armstrong 1902, p. 231; MacColl 1920, p. 4; Davies 1946, p. 187.

Not so far as is known directly related either to a watercolour sketch or drawing on the one hand, nor to a larger oil painting on the other; this picture seems to be an independent composition in its own right. Formerly dated *c.* 1802, it seems very tentative by the side of the sea studies in the 'Calais Pier' sketchbook of that year (LXXXI) and is close to watercolours or gouaches in the 'Wilson' and 'Academical' sketchbooks (XXXVII and XLIII; examples repr. Wilkinson 1972, pp. 57 and 82–3); these sketchbooks can both be dated *c.* 1798.

34. Æneas and the Sibyl, Lake Avernus *c.* 1798
(Plate 8)

THE TATE GALLERY, LONDON (463)

Canvas, $30\frac{1}{8} \times 38\frac{3}{4}$ (76·5 × 98·5)

Coll. Turner Bequest 1856 (88, 'Æneas and the Sibyl' $4'0'' \times 3'0''$); transferred to the Tate Gallery 1929.

Exh. Tate Gallery 1931 (9); Birmingham (172) and Tate Gallery (165) 1948–9; R.A. 1974–5 (46).

Lit. Thornbury 1862, i, p. 263; 1877, p. 418; Armstrong 1902, p. 218; MacColl 1920, p. 3; Davies 1946, p. 187; Clare 1951, p. 27, pl. 26; Herrmann 1963, p. 10; Rothenstein and Butlin 1964, pp. 14, 18, pl. 12; Lindsay 1966, p. 72; Kenneth Woodbridge, 'The Sacred Garden, Painters and the Lake-garden of Stourhead', *Apollo* lxxxviii 1968, pp. 213–14, repr. pl. 12; Reynolds 1969, p. 40, pl. 26; Woodbridge 1970, pp. 89, 183–4; Gage 1974, pp. 72–5, pl. 12; Herrmann 1975, pp. 12, 226, pl. 20.

Based on a drawing of Lake Avernus made by Sir Richard Colt Hoare on 4 February 1786 (repr. Woodbridge 1968, pl. 11, and 1970, pl. 29b, and Gage 1974, pl. 10). A drawing by Turner, presumably made during a visit to Stourhead in the later 1790s (see Woodbridge 1970, p. 178; repr. Gage 1974, pl. 11), is in the Turner Bequest (LI-N): this introduces a path and Antique masonry into the foreground and was fairly closely followed, save for the introduction of the figures, in the painting, which can be dated *c.* 1798.

For a later version painted for Colt Hoare in 1815, see No. 226. That this replaced the earlier version, with which Colt Hoare could have become dissatisfied, is a possibility, but there is no evidence that he ever owned any other version than that of 1815. John Gage has suggested (1974, pp. 38–40) that Colt Hoare could have suggested the subject in the 1790s partly to replace, as it were, a Wilson in his collection which had turned out to show not Lake Avernus but Lake Nemi with Diana and Callisto.

The subject, taken from the sixth book of Virgil's *Æneid*, is Æneas being told by the Cumaean Sibyl that he can only enter the Underworld, where he seeks the shade of his father, with a golden bough from a sacred tree as an offering to Proserpine. The subject is related to that of *The Golden Bough*, exhibited at the R.A. in 1834 (see No. 355) in which Lake Avernus and the distant landscape reappear.

In both versions of *Æneas and the Sibyl* Turner enlarged Colt Hoare's foreground to serve as a stage for the figures of the Cumaean Sibyl, Æneas and his followers, also adding the monumental fragments of Antique masonry. Lake Avernus and the ruined temple on its edge are more prominent, but he diminished the effect of the trees on the strip of land dividing that lake from the Lucrine Lake beyond. The sharp facets of the

Miseneum in Colt Hoare's drawing are veiled by the effect of distance. In the earlier version, though not in the other, he balanced the framing trees on the right with others on the left.

35. Wild Landscape with Figures, Sunset
c. 1799–1800 (Plate 36)

THE BRITISH MUSEUM, LONDON (XCV(a)-G)

Oil and ink on paper, irregular, $10\frac{5}{16} \times 15\frac{1}{4}$ ($26\cdot1 \times 38\cdot8$)

Coll. Turner Bequest 1856.

Exh. British Museum 1975 (26, repr.).

Lit. Finberg 1909, i, p. 248.

This oil study was inventoried by Finberg together with the oil studies executed by Turner while staying with W. F. Wells at Knockholt, Kent, Nos. 154–9, but there is no direct connection, and the style seems rather earlier, say the *c.* 1799–1800 suggested by Andrew Wilton in the 1975 exhibition catalogue. The figures, perhaps illustrating the parable of the Good Samaritan, are still reminiscent of Wilson, as is the general treatment; a parallel in the dramatic composition, lighting and handling is *The Fifth Plague of Egypt*, exhibited in 1800 (No. 13).

36. Cilgerran Castle *c.* 1799 (Plate 34)

THE VISCOUNT ALLENDALE

Canvas, 22×27 ($55\cdot8 \times 68\cdot5$)

Coll. Wynn Ellis; sale Christie's 6 May 1876 (117) bought Beaumont; Wentworth B. Beaumont; sale Christie's 30 May 1891 (86) bought in; by descent to the present owner.

Exh. Brussels 1935 (1133).

Lit. Bell 1901, p. 76; Armstrong 1902, p. 224; Beckett 1947, pp. 10–15.

Painted from a viewpoint close to that shown in the watercolour on p. 73 of the 'Hereford Court' sketchbook (XXXVIII).

This picture, in common with some of the other versions of Cilgerran, presents something of a problem. It has certainly not been cleaned for many years and the surface has become very dry. Yet even in its present condition it appears to be authentic and the painting of the water and, in particular, of the sky comes very close to the version of the subject exhibited in 1799 (No. 11).

A complication is provided, however, by virtually identical versions being in existence, one in oil and one in watercolour, by William Havell (1782–1857). William Havell was certainly influenced as a young man by Turner and in 1806 Sir George Beaumont told

Farington that Havell 'speaks of Turner as being superior to Claude, Poussin or any other'.

Havell's oil of Cilgerran is almost certainly that now in the National Museum of Wales (no. 277, canvas, 22×28) which can probably be identified with the picture exhibited at the R.A. in 1805 (158) as 'View of Kilganan Castle on the Tyoi, near Cardigan'.

The watercolour version, which is signed, was shown the following year at the Old Water Colour Society's exhibition (284: $19\frac{3}{8} \times 27\frac{1}{2}$) and is now in the Victoria and Albert Museum (no. 3057–76, William Smith Bequest). Havell later exhibited another version, with slight differences, at the O.W.C.S. in 1812 (162: $27\frac{1}{2} \times 36\frac{1}{2}$). This watercolour is also now in the Victoria and Albert Museum (no. 1932–00 Carr Bequest.)

On first consideration it seems highly improbable that Havell would exhibit publicly in London two works so exactly based on a Turner and therefore the possibility that Lord Allendale's picture was also painted by Havell appeared a very strong one. Yet a comparison between it and the Havell oil at Cardiff reveals that the former is of higher quality and has subleties of tone which seem beyond the power of the younger artist. In particular the shadows in the Cardiff picture are much more harshly modelled. Therefore the seemingly unlikely explanation that Havell copied Turner's picture appears to be correct. This suggests some sort of private arrangement between the two artists which seems so very uncharacteristic of Turner's usual practice—unless there there was some kind of elaborate joke at the bottom of it—that, in the absence of any evidence, it seems fruitless to speculate how such a situation came about. The only other possible explanation is that the Turner was bought by a collector who then either allowed or commissioned Havell to paint a version of it. It is a case wherein a solution appears to be suggested by all the factors save the most important one: the quality of Lord Allendale's picture.

37. Cilgerran Castle *c.* 1799–1800 (Plate 35)

THE LEICESTERSHIRE MUSEUM AND ART GALLERY

Canvas, $23\frac{3}{4} \times 29\frac{1}{4}$ ($60\cdot3 \times 74\cdot2$)

Coll. Joseph Gillott who bought it from Turner according to his sale catalogue; sale Christie's 27 April 1872 (303) bought Léon Gauchez, a dealer in Brussels; John W. Wilson, Brussels; sale Hotel Drouot, Paris, 27–8 April 1874 (13) bought M. Outran; anon (L. Gauchez) sale Christie's 10 May 1879 (58) bought Levy; executors of Albert Levy, sale Christie's 3 May 1884 (14) bought in; Martin H. Colnaghi; Arthur Sanderson, Edinburgh; sale Christie's 3 July 1908 (46) bought in; G. Beatson Blair, Manchester; R. B. Beckett from whom purchased by the Leicester Museum in 1955 (Accession no. 71A 1955).

Exh. Brussels *Cercle Artistique et Littéraire de*

Bruxelles; Collection de John Waterloo Wilson 1873
repr. in cat, facing p. 27; R.A. 1891 (18); Manchester
City Art Gallery *Richard Wilson Loan Exhibition*
1925 (37a lent by G. B. Blair).

Engr. By Gustave Greux for the J. W. Wilson
Exhibition catalogue, 1873.

Lit. Charles Tardieu, *Gazette des Beaux-Arts* 1873, viii,
p. 401; Bell 1901, pp. 75–6; Armstrong 1902, p. 223;
Julien Leclerc, *Gazette des Beaux-Arts* 1904, xxi,
p. 490; *Cicerone* April 1909, p. 251, repr.; Beckett
1947, pp. 10–15, repr.; *Catalogue of Paintings in the
Leicester Museum* 1958, pp. 53–4, no. 153, repr.;
Gage 1969, p. 269 n. 9.

See also Nos. 11 and 36. As with No. 11 the buyer at the
Gillott sale was reported to be the New York (now the
Metropolitan) Museum. The confusion arose ap-
parently because Léon Gauchez had been involved in
buying pictures for the New York Museum and
continued to do so in their name in the saleroom
throughout 1872. In this case, however, the transaction
fell through as Gauchez' commission was confined to
the purchase of old masters, a status which Turner had
not yet attained. Beckett, in discussing the date of the
Leicester picture, disagrees with Armstrong's dating of
c. 1799 and prefers 1804, relying on the statement in the
Wilson catalogue of 1873 and the fact that Gillott may
have had the information from Turner himself. Beckett
claims corroboration for this view from the fact that in
the 'Dinevor Castle' sketchbook (XL) the word
'Kilgarron' appears in Turner's writing with the figure
'3' after it, which Beckett takes to mean that Turner had
orders for three pictures of this subject. However, it is
clear that 'Kilgarron' here really refers in some way to
Turner's itinerary. Beckett links this reference to one
on p. 67 verso of the 'Academies' sketchbook of *c.* 1804
(LXXXIV) where there occurs a further entry for
'Kilgarron' for the Duke of Bridgewater, a commission
which must have been interrupted by the Duke's death.
This occurred on 8 March 1803, which surely
contradicts Beckett's argument for 1804. In any case a
number of other oils and watercolours mentioned on
these pages in the 'Academies' sketchbook are con-
nected with the 1802 trip to the Continent, even if a link
between the Duke of Bridgewater and this version of
Cilgerran could be established. Furthermore, although
it may be slightly later than No. 11, it is too dark in tone
and too Wilsonian in lighting to admit 1804 as a
possibility. On stylistic grounds 1799–1800 seems more
convincing.

A drawing on p. 28 of the 'Hereford Court'
sketchbook (XXXVIII), while not a study for this
picture, shows the castle painted from a similar
viewpoint, although at much closer range.

38. Mountain Landscape with a Lake *c.* 1799–1800
formerly known as *In the Trossachs* (Plate 37)

THE FITZWILLIAM MUSEUM, CAMBRIDGE

Canvas, $25\frac{1}{4} \times 38\frac{7}{8}$ (64·1 × 98·8)

Coll. H. A. J. Munro of Novar by 1857; anon. sale
Christie's 15 June 1861 (96) as 'Loch Katrine'
bought in; Munro sale Christie's 11 May 1867 (180
as 'Loch Katrine or the Trossachs', 'Painted in the
style of Gaspard Poussin') bought White; bought
from White by Agnew in 1869 as 'Loch Katrine' and
sold in 1870 to K. D. Hodgson; bought back from
him by Agnew in 1893 and sold to James Orrock; sale
Christie's 27 April 1895 (308) bought in; bought
from Orrock by Agnew in 1901 and sold in the same
year to Humphrey Roberts; sale Christie's 21 May
1908 (102) bought Agnew who sold it to W. B.
Paterson, the dealer, immediately after the sale;
bought from the Marlay Fund by the Fitzwilliam
Museum in 1925 through Paterson from an
anonymous owner (Accession no.: Marlay Additions
17).

If this is the picture sold at Christie's on 15 June
1861 then the vendor on this occasion must have
surely been Munro of Novar, which means that the
title 'Loch Katrine' must have become attached to it
after 1857, when it is described in the *Art Journal* in
Munro's collection simply as 'Landscape'. In
Christie's 1861 catalogue the vendor is not specifi-
cally identified but a capital 'M' in the margin against
this picture (and two others by Romney and Wilson)
makes it seem virtually certain that Munro was the
seller for, in addition, the catalogue refers to the
entry on p. 135 of the *Art Journal* for 1857. On the
other hand, in the fifth edition of *Modern Painters*
published in 1851, Ruskin describes a picture on
exhibition at the dealer Grundy's in Regent Street as
follows:

'The worst picture I ever saw of this period
[Ruskin is discussing pictures of 1810–12], "The
Trosachs," has been for some time exhibited at Mr.
Grundy's in Regent Street; and it has been much
praised by the public press, on the ground, I
suppose, that it exhibits so little of Turner's power or
manner as to be hardly recognisable for one of his
works.'

If Munro acquired it at this time, the shedding of
its title by 1857 is hard to explain, although similar
instances among Turner's works can be cited (e.g.,
Ostend, No. 407). Nevertheless, in view of the title
attached to the picture in the 1867 sale catalogue, the
possibility that Munro's picture was the same as
that exhibited at Grundy's cannot be ruled out.

Exh. R.A. 1894 (10 lent by James Orrock as 'The
Trossachs').

Lit. Ruskin 1843 (1903–12, iii, p. 245); *Art Journal*
1857, p. 135; Thornbury 1862, ii, p. 400; 1877,
p. 597; Frost 1865, p. 94 no. 705 as 'Loch Katrine'

(the catalogue states that the picture was formerly in the collection of Sir John Swinburne but this is almost certainly untrue and must be due to a confusion as to who was the vendor at Christie's in June 1861); Armstrong 1902, p. 233 (who repeats the error about the Swinburne provenance); W. G. Constable, *Catalogue of Pictures in the Marlay Bequest, Fitzwilliam Museum*, Cambridge 1927, pl. xxxi.

Dated by Armstrong *c*. 1810, this is clearly much too late. Finberg's notes suggest 'about 1802' which is more acceptable. If the traditional title is correct it would seem likely that this is a product of Turner's trip to Scotland in the summer of 1801.

If this dating is correct, then it seems there is an outside chance that this picture may be identified with that exhibited at the R.A. in 1802 (862) as *Ben Lomond Mountain, Scotland—the Traveller—vide Ossian's War of Caros* as has been suggested by Gage (1974, pp. 86–7 n. 51), who points out that Turner may have had his attention directed to Ossian by Sir Richard Colt Hoare who owned a picture by Cooper, the subject of which was taken from Ossian. There do, however, seem to be some fairly strong arguments in favour of accepting that no. 862 at the R.A. was a watercolour rather than an oil (see entry for No. 40).

However, in the catalogue of the English Pictures in the Fitzwilliam Museum which is at present being compiled by Mr J. W. Goodison (and which he has kindly allowed me to see in draft), he suggests that the title 'Loch Katrine' was mistakenly given to the picture by Frost in his 1865 catalogue of Munro's collection and that the additional alternative 'or the Trossachs' was added in the 1867 sale catalogue, possibly through a confusion with the picture exhibited at Grundy's which, however, Mr Goodison considers was probably another picture altogether. (If so, it is still untraced.) Mr Goodison believes that stylistically the picture is earlier than Turner's visit to Scotland in 1801 and that topographically it resembles Welsh scenery more closely than Scottish. Furthermore, Mr Goodison points out that Turner's route in 1801, as given by Finberg (1961, pp. 73–4), ran at a distance from the Trossachs and Loch Katrine. This is a valid point, although as Turner passed within a few miles of Loch Katrine, it may be unwise to make too much of this in view of Turner's well-known readiness to make a detour in search of material.

Mr Goodison proposes, therefore, that the picture should be rechristened 'Welsh Mountain Landscape', and dated 1799–1800. He considers that the picture closely resembles the *Mountain Scene* in the Tate Gallery (No. 30) painted *c*. 1798 and a number of watercolours in the sketchbooks which Turner used on his tour of north Wales in that year.

Until recently I felt that Mr Goodison had been misled by the fact that the paint has undoubtedly darkened with time into dating it rather too early. However, a further careful study of the picture recently

has made me change my mind and I would certainly now agree that a dating after 1800 seems most unconvincing. If this is accepted, then a Scottish title must also be discarded as Turner's visit to Scotland in 1801 was his first.

If Frost was responsible for the addition of the Scottish title in 1865 (Munro having died before Frost's catalogue was printed), it may have been pure conjecture on his part, along the lines that Munro, being a Scot, would have been attracted to a Scottish subject.

If this seems implausible, it is equally strange that Munro, who was such a close friend of Turner's, should have an unidentified landscape in his collection.

On balance, therefore, although a number of problems remain unsolved, I would follow Mr Goodison in rejecting the traditional title and agree with a dating of *c*. 1800 or possibly a little earlier.

39. Landscape with Lake and Fallen Tree *c*. 1800?
(Plate 38)

THE TATE GALLERY, LONDON (3557)

Canvas, $15\frac{3}{8} \times 23\frac{7}{8}$ (39 × 60·5)

Coll. Turner Bequest 1856 (? 166, 1 unspecified $2'1'' \times 1'4''$); transferred to the Tate Gallery 1919.

Exh. New Zealand (3), Australia and South Africa (54) 1936–9; Paris 1953 (70, repr. pl. 35).

Formerly called 'Lake Scene: A Fallen Tree'. Apparently left unfinished and also rather worn, this picture is probably rather earlier than it at first appears. The composition and particularly the reclining figure with raised leg still reflect the influence of Wilson, and the picture lacks the classicising tendencies of the works following Turner's studies in the Louvre in 1802.

40. A Storm in the Mountains *c*. 1801–2 (Plate 39)

LADY KLEINWORT

Canvas, $9\frac{1}{2} \times 12$ (24 × 30·5)

Coll. Wynn Ellis; sale Christie's 6 May 1876 (110) bought Agnew; H. Crossley; H. Darell-Brown by 1899; sale Christie's 23 May 1924 (43) bought Agnew; Miss A. G. Bickham; sale Christie's 25 November 1927 (49) bought Agnew; H. L. Fison Dec. 1927; sale Christie's 6 November 1959 (28) bought Agnew for Mrs E. A. Leavett-Shenley; sale Christie's 17 March 1967 (67) bought Agnew for the present owner.

Exh. Guildhall 1899 (4 lent by Darrell-Brown); Leggatt 1956 (22) and 1958 (16); Agnew 1967 (2).

Lit. Armstrong 1902, p. 228 as 'Rocky Landscape with Cattle'; Charles Holme, 'The Genius of J. M. W. Turner, R.A.', *Studio* 1903, repr. in colour facing p. viii; Finberg 1961, pp. 80, 465 no. 81.

Finberg's suggested identification of this picture with no. 862 at the R.A. in 1802 entitled *Ben Lomond Mountains, Scotland; the Traveller—vide Ossian's 'War of Caros'* is not convincing and rests mainly on the argument that no watercolour of this subject is known. Bell, while agreeing that it is difficult to conjecture whether no. 862 was an oil or a watercolour, points out that it was hung in the Library of the R.A. together with oils, engravings, enamels and even an ivory model of a ship, and thinks it improbable that an oil by an Academician would have been hung in such mixed company. It certainly seems improbable that Turner would have exhibited such a small oil at the R.A. Furthermore, the critic of the *St. James's Chronicle* refers to several drawings of views from nature in Scotland while the *Morning Chronicle* refers to Turner's three landscapes in oil (Turner had four oils in the exhibition, leaving aside no. 862). However, this picture must date from *c.* 1802 as first proposed by Armstrong. The suggestion, made by Gage (1974, pp. 86–7 n.51), that no. 862 at the R.A. in 1802 may be identified with the picture in the Fitzwilliam Museum, Cambridge, known until recently as 'In the Trossachs', must also be borne in mind when considering this picture, although I now believe the Fitzwilliam picture to be earlier than 1802 (see No. 38).

In Finberg's manuscript notes in the British Museum he expressed doubt about the picture's authenticity, an opinion shared by Martin Butlin.

41. Tummel Bridge, Perthshire *c.* 1802–3

(Plate 40)

YALE CENTER FOR BRITISH ART, PAUL MELLON COLLECTION

Panel, $11 \times 18\frac{1}{4}$ (28 × 46·5)

Coll. R. Nicholson of York, sale Christie's 13 July 1849 (207) as 'Dummel Bridge' bought Wallis; anon. sale Christie's 1 April 1852 (84) again as 'Dummel Bridge, Fifeshire, Painted in 1812' bought Gambart (Graves gives the vendor in 1852 as Agnew but this would seem to be a confusion with the three lots preceding no. 84 which were sold by Agnew. Lot 84 has no vendor identified beside it in Christie's catalogue but only the initial 'F' which may well stand for the dealer 'Flatow' and certainly does so on other occasions in Christie's records); John Miller of Liverpool; sale Christie's 22 May 1858 (244) bought Gambart; bought by Agnew in 1858 from Rought and sold to R. P. Grey; bought back from him by Agnew in 1863 and sold to James Fenton; sale Christie's 28 February 1880 (405) bought Wertheimer; Sigismund Rucker (sold before 1902); Mrs Tempest Hicks; sale Christie's 26 November 1926 (116) bought in; bought after the sale by Pawsey and Payne and from them by Agnew and sold to R. W. Lloyd, 1927; bought by Mr. Paul Mellon from Oscar and Peter Johnson Ltd in 1963.

Exh. Manchester 1857 (245) as 'A Highland Bridge' lent by John Miller; R.A. 1964–5 (164); Yale 1965 (193); Washington 1968–9 (4).

Engr. By J. Barnard 1852.

Lit. Thornbury 1877, p. 428 (?); Armstrong 1902, p. 233; Rawlinson ii 1913, pp. 214, 408; Holcomb 1974, p. 51, fig. 19.

Based on a drawing in the group listed by Finberg as 'Scottish Pencils' (LVIII no. 39). Turner visited Scotland between 18 July and 5 August 1801 and one of the sketchbooks he used on the tour appears in Finberg's inventory under the name 'Tummel Bridge' (LVII). It contains a number of pencil drawings of Tummel Bridge which were identified as such by Ruskin. They are so slight as to be barely discernible, but nos. 38, 40 and 42 of the 'Scottish Pencils' show other views of the subject.

Armstrong's dating of this panel to 1812 seems to be without foundation. On stylistic evidence there seems every reason to accept that it was painted soon after the Scottish journey, perhaps *c.* 1802–3. It resembles quite closely the panel of similar size of *Old Margate Pier* (see No. 51) which Turner gave to Samuel Dobree in 1804. Martin Butlin accepts the impossibility of 1812 as a date but has very strong doubts about the picture's authenticity.

Dr Holcomb discusses the role of the bridge in English landscape and points out that 'its elevation to the status of a major pictorial device accorded with neoclassical taste around the turn of the century'. She cites as the classical example of the type Cotman's *Greta Bridge* of 1805–6, which was preceded by watercolours by Girtin such as his *Ouse Bridge, York* and by Turner's *Tummel Bridge*. Dr Holcomb agrees in dating this around 1803 although her statement that it was 'apparently reworked later' seems, on careful investigation, to be unfounded.

42. View on Clapham Common *c.* 1800–05

(Plate 9)

THE TATE GALLERY, LONDON (468)

Mahogany, $12\frac{5}{8} \times 17\frac{7}{16}$ (32 × 44·5)

Coll. Turner Bequest 1856 (95, 'Study of Trees' $1'5'' \times 1'0''$); transferred to the Tate Gallery 1910.

Exh. Amsterdam, Berne, Paris, Brussels, Liege (3), Venice and Rome (4), 1947–8 (repr.).

Lit. Ruskin 1857 (1903–12, xiii, pp. 103–4, 135, 142–3); Armstrong 1902, pp. 49, 220, repr. facing p. 46; MacColl 1920, p. 4; Davies 1946, p. 187; Herrmann 1963, p. 12, pl. 3.

Apparently painted partly when already framed, a strip $\frac{5}{8}$ in. along the bottom edge being only roughly laid in.

Ruskin however attributes this to the picture's having been left unfinished.

The title and a dating of *c*. 1802 first appear in Ruskin's account of the Turners exhibited at Marlborough House in 1856. Much less Wilsonian than paintings of the late 1790s the painting yet lacks the freedom and atmosphere of the Thames oil sketches and watercolours of *c*. 1806–7 (see Nos. 160–94 and, e.g., the watercolour from the Turner Bequest, XCV-

46, repr. exh. cat., B.M. 1975, p. 40 no. 34 and, in colour, Wilkinson 1974, p. 77). A closer parallel is *Chevening Park* painted in oil and gum on paper, one of the studies done when Turner was staying with W. F. Wells at Knockholt (No. 156); Finberg dated these *c*. 1806 but Andrew Wilton suggests that they may have been done as early as 1800, which seems, however, rather too early (see exh. cat., B.M. 1975, pp. 36–7 nos. 24 and 25).

43–45: Copies after Other Artists

43. Diana and Callisto *c*. 1796 (Plate 41)

THE TATE GALLERY, LONDON (5490)

Canvas, 22¼ × 36 (56·5 × 91·5)

Coll. Turner Bequest 1856; transferred to the Tate Gallery 1951.

Lit. Davies 1946, p. 159; Gage 1974, p. 72, pl. 15.

This is a copy or variant of Richard Wilson's much repeated composition (see W. G. Constable, *Richard Wilson* 1953, pp. 164–5, pls. 23a and b, 24a.). John Gage has suggested that, as it is closest in certain details to J. Wood's engraving of 1764 of a picture described as being in the collection of Henry Hoare (repr. Gage, *op. cit.*, pl. 14), it reflects Turner's knowledge of the original, which he could have seen at Stourhead. However, a version by Wilson still in the Hoare collection (but unknown to Gage when he wrote his article) is in the reverse direction to both the engraving and to the Turner and differs in several particulars from both (as Constable points out, neither the dimensions nor the format of Wood's engraving match those of the Wilson still in the Hoare collection). Turner is as likely, therefore, to have worked from the engraving as from the painting.

Nevertheless, in so far as one can tell from the dirty and damaged condition of the Turner, it is crudely enough handled to justify Gage's dating of *c*. 1796, some two years earlier than Turner's most Wilsonian period. The main damages are in the sky and in the tree on the left.

44. Tivoli: Temple of the Sibyl and the Roman Campagna *c*. 1798 (Plate 42)

THE TATE GALLERY, LONDON (5512)

Canvas, 29 × 38 (73·5 × 96·5)

Coll. Turner Bequest 1856 (298, with marginal note '(copy from Wilson)', identified 1946 by chalk

number on back); transferred to the Tate Gallery 1947.

Lit. Davies 1946, pp. 163, 191 n. 27.

This is based on a Wilson that exists in a number of versions at Cardiff, Philadelphia, the Tate Gallery and elsewhere (the Tate version and one in a private collection repr. W. G. Constable, *Richard Wilson* 1953, pls. 115a and 116b); the composition was also engraved in reverse by W. Byrne in 1765. Turner omits both the large tree and the figures that appear in varied forms in the Wilsons, thus making his copy more of a direct transcript of the view, though he does retain the large rocks that also seem to have been introduced into the foreground by Wilson.

For three pictures formerly thought to be copies of Wilson by Turner see Nos. 545–7.

45. Landscape with Windmill and Rainbow *c*. 1795–1800 (Plate 43)

THE TATE GALLERY, LONDON (5489)

Canvas, 27¾ × 35½ (70·5 × 90)

Coll. Turner Bequest 1856 (?); transferred to the Tate Gallery 1947.

Lit. Davies 1946, pp. 168–9.

Martin Davies, who accepted this picture as being by Turner with reservations, added that, although there was now no chalk number on the back to link it with the Schedule of the Turner Bequest, 'there can be little doubt that this picture forms part of the Turner Bequest, and was accepted by Eastlake and Knight [who drew up the Schedule] as being an early work'. The central part of the picture is based on a Gainsborough, now lost but known from an engraving and an old sale catalogue reproduction (Ellis Waterhouse, *Gainsborough* 1958, p. 108 no. 846, as repr. Robert Cluett sale, New York, 26 May 1932, lot 90); the

Gainsborough lacks the windmill and the rainbow. It looks therefore as if Turner may have begun this work as a straight copy but developed the composition in accord with his own taste: the rainbow in particular would seem to reflect his especial interests. That Turner was interested in Gainsborough's work is shown by his copy of the older artist's etching of a 'Wooded Landscape with Church, Cow and Figure' in the sketchbook now at Princeton University Art Museum inscribed 'The Sketch Book—/of J.M.W. Turner—London/as it was left at—/M͞r Narraways—Bristol/about 1790 or 1791—' (exh. R.A. 1974–5 (B8); see John Hayes, *Gainsborough as Printmaker* 1971, p. 35, the Gainsborough repr. pl. 30, the Turner pl. 32); here the original composition is again modified, though less drastically. (The compiler is indebted to Dr John Hayes for advice on this entry.)

2. From 1803 until Turner's First Visit to Italy, 1819

Nos. 46–140: Exhibited Pictures

46. Bonneville, Savoy, with Mont Blanc Exh. 1803
(Plate 14)

PRIVATE COLLECTION, SCOTLAND

Canvas, 36 × 48 (91·5 × 122)

Coll. John Green; sale Christie's (at Green's house in Blackheath) 26 April 1830 (72) as 'A View in Switzerland with Mont Blanc in the distance' bought Munro; Henry Webb from whom bought by Agnew in 1861; John Heugh from whom bought back by Agnew in 1863 and sold to Thomas Miller; by descent to Thomas Pitt Miller of Singleton Park, near Blackpool; sale Christie's 26 April 1946 (109) bought Agnew for the father of the present owner.

Exh. R.A. 1803 (24); R.A. 1889 (173); Tate Gallery 1931 (16); R.A. 1951–2 (188); Musée d'art et d'histoire, Geneva *Genève et le Mont Blanc* 1965 (120); Agnew 1967 (4).

Lit. Ruskin 1843 (1903–12, iii, p. 245); Burnet and Cunningham 1852, pp. 24, 111 no. 76; Thornbury 1877, pp. 300, 571; Monkhouse 1879, p. 53; Bell 1901, pp. 80, 82 nos. 100 and 104 with incorrect size for picture of this title; Armstrong 1902, pp. 51, 219; Finberg 1961, pp. 98 ff., 360, 465 no. 82; Rothenstein and Butlin 1964, p. 18; Herrmann 1975, pp. 14, 228, pl. 40.

As noted in the entry for No. 50, the histories of the two pictures of *Bonneville*, both exhibited in 1803, are not always easy to disentangle. To judge from pp. 66 verso and 67 in the 'Academies' sketchbook (LXXXIV), this picture was bought or commissioned from Turner by Mr Green, with also possibly a watercolour of the subject. This must be the John Green of Blackheath whose sale by Christie's in 1830 also included the *Venus and Adonis* (No. 150) and who is described as 'the well-known amateur of Blackheath'. For Munro of Novar's account of the sale at Blackheath in 1830, see the entry for No. 150. Munro stated that Turner 'was willing to let *Beauville* [Bonneville] take its chance but was

anxious about the other'. In the event, Munro bought both pictures for the same price: 83 guineas.

Ruskin mentions two versions of the subject, one 'in the collection of Abel Allnutt' (but here Ruskin must mean John Allnutt as no Abel appears in the Allnutt family tree), and the other belonging to 'a collector near Birmingham'. However, it is not certain to which two of the three versions (see also Nos. 50 and 124) Ruskin was referring. One of the pictures he mentions may have been acquired from Munro although there is no evidence for this, nor is it known if Henry Webb and the 'collector near Birmingham' were one and the same person. On balance, however, it seems unlikely that Munro owned *Bonneville* for long.

As with No. 50 based on sketches made on Turner's trip to the Continent in 1802; a drawing on p. 7 of the 'St Gothard and Mont Blanc' sketchbook (LXXV) is a study for the composition. A finished watercolour of *c.* 1808 which was at Farnley until 1912 and is now in a private collection in London (it has only one girl on the rock in the foreground, and she wears a straw hat), and another similar watercolour, now in the Salting Bequest in the British Museum (1910-2-12-284; signed), attest the popularity of the subject with both Turner and his patrons.

Bonneville was also engraved in the *Liber Studiorum* (Rawlinson 64, published 1 January 1816), using the general composition of this picture but, in details, the engraving comes closer to the Philadelphia version (No. 124).

Besides a brief notice in the *St. James Chronicle* for 10–12 May, this less classical of the two *Bonnevilles* received a sympathetic notice as part of a lengthy survey of Turner's work in the *British Press*, 9 May: 'No. 24 is a grand mountainous scene at Bonneville, Savoy, with the Mont Blanc. It is a fine landscape, with rich deep and forcible colouring, and the remote and second distances are managed and furnished with great excellence and effect. Had the foreground been equally finished, it would not only be a more perfect but be

almost an unexceptionable picture. By attempting great force and depth, this master appears to exhaust the power of his tones on the *distances* of his pictures, and the foregrounds are consequently left undetailed and undefined, and deficient of corresponding force . . .' Later in the review Turner was urged to take a lesson from Wilson and Gainsborough in this respect.

47. The Festival upon the Opening of the Vintage of Macon Exh. 1803 (Plate 13)

SHEFFIELD CITY ART GALLERIES

Canvas, $57\frac{1}{2} \times 93\frac{1}{2}$ (146 × 237·5)

Coll. Bought from Turner by the Lord of Yarborough in 1804; by descent until Yarborough sale Christie's 12 July 1929 (106) bought Agnew; sold in 1938 to Gooden and Fox on behalf of E. E. Cook; bequeathed to Sheffield through the National Art-Collections Fund by E. E. Cook in 1955.

Exh. R.A. 1803 (110); probably Turner's gallery 1804 (see below); B.I. 1849 (43); R.S.A. 1851 (158); Manchester 1857 (229); R.A. 1875 (122); Glasgow 1888 (302); Grosvenor Gallery 1888 (121); R.A. 1934 (619); R.A. 1962 (64); Agnew 1967 (5); Tokyo and Kyoto 1970–71 (31); R.A. 1974–5 (76).

Lit. Farington *Diary* 2 and 3 May 1803, 22 May 1804; Burnet and Cunningham 1852, pp. 24, 44, 78–9, 111 no. 77; Waagen 1854, ii, p. 87; 1857, iv, p. 70; Thornbury 1862, i, pp. 265–6, 355; ii, p. 397; 1877, pp. 420–21, 571, 594; Hamerton 1879, p. 92; Monkhouse 1879, p. 53; Bell 1901, pp. 80–81 no. 101; Armstrong 1902, pp. 51, 52, 224; Whitley 1928, p. 59; Falk 1938, p. 57; Finberg 1961, pp. 98 ff., 107, 167, 425–6. 465 no. 83, 511 no. 585, 516 no. 595; Rothenstein and Butlin 1964, pp. 18, 28, pl. 18; Kitson 1964, p. 15, repr. p. 26; Lindsay 1966, pp. 82–3; Gage 1969, pp. 152, 171, 229 n. 64; Reynolds 1969, pp. 67, 120, fig. 36; Herrmann 1975, pp. 14, 228, 233, pl. 41.

The view is overlooking a bend of the river Saone between Chalons and Macon. Turner passed through Macon on his way from Paris to Lyons in the second half of July 1802. Drawings for the picture occur in the 'Calais Pier' sketchbook (LXXXI). Page 54 has three preliminary sketches, mostly concerned with the placing of the trees which frame the composition and, in the bottom one of the three, with their relation to the bridge. It is inscribed: 'Macon Ld Yarborough's picture'. Pages 116–17 show a small study without any figures on the lower half of p. 117 and a study of the whole composition which runs across the top half of both pages and is inscribed 'The last study for the picture of Macon Lord Yarborough bought'.

There is also a drawing in the Vaughan Bequest in the British Museum (CXVIII-Y) catalogued as 'View from a Terrace (Macon?)', probably a preparatory drawing

for the *Liber Studiorum* which was never published (Rawlinson 92). The suggested identification of the scene seems at first sight convincing, but there are several differences: for example, in the drawing there is no sign of the buildings shown on the left of the bridge in the oil, and the spit of land at the bend in the river, which is bare in the oil, is covered by bushes in the drawing. On the whole the compiler considers that the drawing probably does not represent Macon.

Burnet, who saw the painting soon after 1849, reported that it was marked on the back by Turner 'this picture not to be taken off the canvas'. He was told by William Seguier that Turner had the greatest horror of the picture being relined as he had 'commenced it with size colour on an unprimed canvas'. (Gage points out that, at that time, to begin a picture in distemper was believed to be following the technique usually employed by Claude.) Although by 1849 it was of 'a deep rich tone', Seguier reported that 'when it was first painted it appeared of the most vivid greens and yellows.'

Farington records that Sir John Leicester, who had offered 250 guineas for *Macon* in 1803, offered 300 guineas for it in 1804, the price Turner had originally asked for it; but Turner 'now demanded 400 guineas, on which they parted'. Burnet and Cunningham, however, report that Lord Yarborough bought the picture for 300 guineas. These reports about the price suggest that it was again on exhibition in Turner's gallery in 1804, although no catalogue of what was shown has survived.

It is interesting to note that this most overtly Claudian of Turner's paintings to date (and for some years to come) should follow his visit to the Louvre during the preceding year, although the Claudes in Paris do not appear to have attracted Turner's notice on that occasion. Gage explains this convincingly by showing that the lighting in the Grande Galerie was so poor at that time that Claude's subtle effects may have been almost invisible, and certainly suffered by comparison with the stronger and more colourful work of other artists which did engage Turner's attention.

At the R.A. Exhibition, Farington noted that Opie considered the large landscape (*Macon*) 'very fine — perhaps the finest work in the room' and that Fuseli also commended it. However, Sir George Beaumont said that 'the subject was borrowed from Claude but the colouring forgotten.'

On the whole the critics devoted more attention to *Calais Pier* (No. 48) than to *Macon*, which did, however, receive two sharply contrasting reviews:

The *British Press*, 6 May, considered it 'is, without comparison; the first landscape of the kind that has been executed since the time of Claude Lorain, on whose works, indeed, Mr. Turner, has evidently and usefully fixed his eye; and we are bold to say, he has even surpassed that master in the richness and forms of some parts of his picture. The scene is singularly fine, and the figures, which are many, are drawn and grouped in a style far superior to any of this Artist's

productions.' Later on, however, the picture is criticised for 'the blues being rather too powerful in the distance, especially when we consider that the time chosen is when the sun is near the Horizon.'

The *True Briton* for 16 May, on the other hand, thought that 'The magnitude of this picture, rather than its intrinsic merit, has rendered it an object of peculiar attraction, and there is an imposing dignity in the general impression, which has deluded many shallow critics ... What we understand to be a *tambourine*, seems to be a *broken pan*, and what we are told is a *white robe* upon the ground, seems to be *spilt milk* ... the whole is a composition of *bastard grandeur*.'

48. Calais Pier, with French Poissards preparing for Sea: an English Packet arriving Exh. 1803
(Plate 16)

THE NATIONAL GALLERY, LONDON (472)

Canvas, $67\frac{3}{4} \times 94\frac{1}{2}$ (172 × 240)

Coll. Turner Bequest 1856 (56, 'Calais Pier' $8'0'' \times 5'8\frac{1}{2}''$); transferred to the Tate Gallery 1949, returned to the National Gallery 1956, to the Tate Gallery 1961, and to the National Gallery 1968.

Exh. R.A. 1803 (146); New York, Chicago and Toronto 1946–7 (45, repr. pl. 39); Tate Gallery 1931 (19); Paris 1938 (140, repr.); Moscow and Leningrad 1960 (51, repr.); R.A. 1974–5 (75, repr.).

Engr. By T. Lupton, unpublished mezzotint, 1827.

Lit. Farington *Diary* 17 April, 2 May, 3 May and 13 May 1803, and 1 April 1804; Ruskin 1851 and 1857 (1903–12, xii, p. 378; xiii, pp. 105–7, 111 n.); Cunningham 1859, p. 10; Thornbury 1862, i, pp. 264–5, 367, 413–16; 1877, pp. 196–8, 420; Hamerton 1879, pp. 92, 153–4, 167; T. Lupton, letter in *Pall Mall Gazette* 4 April 1884 (reprinted in Ruskin 1903–12, xxxiv, p. 668 n. 5); Bell 1901, p. 81 no. 102; Armstrong 1902, pp. 47–8, 51–2, 229; Finberg 1910, pp. 47–8; Whitley 1928, pp. 58–9, repr.; Falk 1938, pp. 55–7; Davies 1946, pp. 147, 186; Clare 1951, pp. 31–3, repr. p. 30; Davies 1959, pp. 94–5; Finberg 1961, pp. 82, 97–101, 134, 171, 465 no. 84; Herrmann 1963, p. 12, pl. 2; Rothenstein and Butlin 1964, pp. 18–19, 76, colour pl. i; Gowing 1966, p. 10, repr. with detail; Lindsay 1966, pp. 82, 88; Gage 1969, p. 40; Reynolds 1969, pp. 49, 62, 64–5, colour pl. 54; Gaunt 1971, pp. 4–5, colour pl. 4; Wilkinson 1974, pp. 25–6, repr. in colour; Herrmann 1975, pp. 13, 15, 227, colour pl. 11.

Based on Turner's experiences on his first journey abroad in 1802, but despite its title (not Turner's own) the 'Calais Pier' sketchbook only seems to contain one sketch directly related to this picture, for the light-sailed boat in the middle distance (LXXXI-151; similar drawings are on pp. 146–150). There are, however, other drawings in the book with inscriptions such as

'Landing at Calais. Nearly swampt' and 'Our Situation at Calais Bar' (LXXXI-58 verso and 59, 70, 71, 74 verso and 75, 76 verso and 77, 78 verso and 79). The pseudo-French word 'Poissards' in the title in the 1803 R.A. catalogue seems to have been made up by Turner from *poissarde*, which can mean a fish-wife.

The critic of the *British Press*, almost certainly John Britton, who had already singled Turner out for special mention on 3 May 1803 and for a long review of *The Festival upon the Opening of the Vintage of Macon* on 6 May (see No. 47), returned to Turner's other exhibits on 9 May in a long passage the opening words of which reasserted the high reputation Turner held in many quarters: 'To animadvert on the production of genius is a very easy task ...' He goes on, 'We have long observed and admired the improving execution of Mr. Turner. His early performances evinced the possession of an eye to see, and mind to feel the beauties of nature and art.' The works in the 1803 exhibition 'present a singular and studied variety of subjects and effects'. Of *Calais Pier* he writes that it 'combines many great excellencies, and some defects. The former will be found in the vessel which is moving off, in the grouping, action, and character of the numerous figures which are scattered over the pier, and on the decks, and more particularly the distance and right hand corner of the picture, where the colouring and management are most singularly fine and clear. But the clouds are certainly too material and opake [*sic*]; they have all the body and consistence of terrestrial objects, more than fleeting vapours of unsubstantial air.'

Farington records a number of examples of qualified praise from the leading artists and connoisseurs of the day. On 17 April 1803 he notes West's opinion: 'He said the "Harbour of Calais", by Turner was clever in his manner but would have been better had more time been employed upon it.' On 2 May 'Fuseli commended both the "Calais Harbour" and the large Landscape [No. 47], thinking they shewed great power of mind, but perhaps the foregrounds too little attended to,—too undefined.'

On 3 May Farington records Sir George Beaumont's strictures: 'Turner finishes his distances and middle distances upon a scale that requires *universal precission* throughout his pictures,—but his foregrounds are comparatively *blots*, & faces of figures witht. a feature being expressed ... The water in Turner's Sea Piece (Calais Harbour) like the veins on a Marble slab.'

Farington also recorded, on 13 May 1803, that 'Lord Gower asked the price of the "Calais Harbour", & Turner signified that it must be more than that for which He sold a picture to the Duke of Bridgewater (*250 guineas*)' (see No. 14). The painting remained in Turner's possession and was engraved much later, in 1827, by Thomas Lupton as a companion to the print of *The Shipwreck* (No. 54), but this was left unfinished because Turner insisted, on account of the change of scale, on enlarging and adding to the boats.

This picture was priced at £400 in a note, probably of *c.* 1810, in Turner's 'Finance' sketchbook (CXXII-36; for the date see Nos. 53 and 56).

49. Holy Family Exh. 1803 (Plate 44)

THE TATE GALLERY, LONDON (473)

Canvas, $40\frac{1}{4} \times 55\frac{3}{4}$ (102 × 141·5)

Coll. Turner Bequest 1856 (69, 'A Holy Family' 4'10" × 3'6"); transferred to the Tate Gallery 1910.

Exh. R.A. 1803 (156); Tate Gallery 1931 (18); Whitechapel 1953 (72); R.A. 1974–5 (77).

Lit. Farington *Diary* 2 May 1803; Thornbury 1862, i, p. 264; 1877, p. 420; Hamerton 1879, p. 98; Bell 1901, pp. 61, 81 no. 103; Armstrong 1902, p. 223; Whitley 1928, p. 59; Davies 1946, p. 187; Finberg 1961, pp. 98–9, 171, 465 no. 85; Rothenstein and Butlin 1964, p. 16; Lindsay 1966, p. 230 n. 6; Gage 1969, p. 140, pl. 64; Reynolds 1969, p. 56, pl. 37; Herrmann 1975, pp. 14–15, 228, pl. 43.

This picture and *Venus and Adonis* (No. 150), both influenced strongly by Titian, are interrelated in composition. The *Holy Family* may have been inspired in general terms by Titian's *Holy Family and a Shepherd*, sold with the W. Y. Ottley collection in London in January 1801 and now in the National Gallery (see Cecil Gould, *National Gallery Catalogues: The Sixteenth Century Venetian School* 1959, pp. 97–8), while *Venus and Adonis* owes a still closer debt to Titian's now destroyed *St Peter Martyr* altarpiece. This painting from SS. Giovanni e Paolo in Venice (where Turner was later, in 1819, to copy a detail of the foreground foliage and the Martyr's leg) had been looted by Napoleon and was seen by Turner in the Louvre during his visit in 1802; his notes on the picture cover three pages of the 'Studies in the Louvre' sketchbook (LXXII-28 verso, 28 and 27 verso). Well known in England already through engravings, it was eulogised by Turner in his 1811 lecture as Professor of Perspective at the R.A.: 'the highest honour that landscape has as yet, she received from the hand of Titian; ... the triumph even of Landscape may be safely said to exist in his divine picture of St. Peter Martyr' (see Jerold Ziff, ' "Backgrounds, Introduction of Architecture and Landscape": A Lecture by J.M.W. Turner', *Journal of the Warburg and Courtauld Institutes* xxvi 1963, p. 135). (For Martino Rota's engraving after the Titian see Plate 549.)

The *Holy Family* was also originally based on the composition of Titian's *Peter Martyr*. A drawing in the 'Calais Pier' sketchbook shows the Holy Family in the setting, complete with flying putti above, of the Titian (LXXXI-63, repr. with both the Turners under discussion by Gage 1969, pls. 61–4; see also LXXXI-62). However, Turner decided on an oblong format, close even in size to the Ottley Titian, apparently following another drawing in the 'Calais Pier' sketchbook (LXXXI-60; there are further related drawings on LXXXI-44 and 47). The *St Peter Martyr* setting he then used for *Venus and Adonis*, datable for stylistic reasons to *c.* 1803–5.

The serpent that slides away on the right of the *Holy Family* is presumably a traditional allusion to the Redeemer striking the serpent's head, though Gage also finds a connection with the confrontation of *Apollo and the Python* (No. 115) of *c.* 1803–11, and the nature symbolism of Jacob Boehme (*op. cit.*, pp. 139–40).

The *Holy Family* was not well received in the press. The *True Briton* for 6 May, attacking the figures, concluded that 'unless the artist can produce something better, we advise him to take an eternal farewell of History', and John Britton in the *British Press* for 9 May, while noting 'a bold and daring effort', agreed with 'a man of great taste, that Mr. Turner has ... spoilt a fine landscape by very bad figures.' Farington recorded, on 2 May, Fuseli's judgment: 'His Historical Picture "A Holy Family" He also thought like an embrio, or blot of a great Master of colouring.'

This picture was priced at £400 in a note, probably of *c.* 1810, in Turner's 'Finance' sketchbook (CXXII-36); for the date see Nos. 53 and 56).

50. Châteaux de St. Michael, Bonneville, Savoy Exh. 1803 (Plate 15)

YALE CENTER FOR BRITISH ART, PAUL MELLON COLLECTION

Canvas, 36 × 48 (91·5 × 122)

Coll. Bought from Turner in 1804 by Samuel Dobree (1759–1827); William Young Ottley (*d.* 1836) from whom bought by the first Earl of Camperdown (1785–1867); Camperdown sale Christie's 21 February 1919 (159) bought Agnew; Captain R. A. Tatton, Cuerdon Hall, Preston; sale Christie's 14 December 1928 (59) bought Agnew for S. L. (later Sir Stephen) Courtauld; sale Sotheby's 27 June 1973 (55) bought Agnew.

Exh. R.A. 1803 (237); ?Turner's gallery 1804; R.A. 1895 (134); Agnew *English Landscape* 1926 (11); Brussels 1929 (178); Tate Gallery 1931 (17); R.A. 1934 (648); R.A. 1951–2 (190); Agnew 1974; R.A. 1974–5 (74); Hamburg 1976 (15); Zurich 1976–7 (18).

Lit. Farington *Diary* 4 May 1803; Ruskin 1843 (1903–12, iii, p. 245); Burnet and Cunningham 1852, pp. 24, 112 no. 80; Thornbury 1877, p. 571; Monkhouse 1879, p. 53; Bell 1901, pp. 80, 82, nos. 100 and 104; Armstrong 1902, pp. 51, 219; H. F. Finberg 1953, pp. 98–9; Finberg 1961, pp. 98 ff., 360, 466 no. 86; Rothenstein and Butlin 1964, p. 18, pl. 21; Wilkinson 1972, p. 55; Clark 1973, pp. 228–30, pl. 173; E. Joll, *J.M.W. Turner R.A.: Bonneville, Savoy* (pamphlet printed to coincide with exhibition at Agnew's July 1974).

In 1803 Turner exhibited two pictures of Bonneville at the R.A.; this picture and no. 24 *Bonneville, Savoy, with Mont Blanc* (see No. 46). The histories of the two pictures have been confused in the past (e.g., by Bell)

but the strongest evidence for identifying this picture with no. 237 at the R.A. is found in a letter, written by Turner on June 30 1804 to the purchaser Samuel Dobree: . . . 'and may I ask once more "am I to put out the cloud in the Picture of Bonneville?" If you can drop me a line decide[d]ly yes or no this Evening or tomorrow morning it shall be as you wish.'

Evidently, Turner's letter did not reach Dobree in time for him to reply as a second letter from Turner states that he has not heard from Dobree. Therefore the cloud was presumably left 'in' and it is certainly much more prominent in this picture than in the other picture of *Bonneville* (No. 46). Furthermore in Turner's 'Academies' sketchbook (LXXXIV), in use about 1804, there is a list of pictures and their purchasers in Turner's writing on page 66 verso. Bonneville subjects are recorded as belonging to Mr Green and Mr Dobree but on the next page Mr Green's name occurs again with 'Mt Blanc' against it.

Mrs Finberg suggests that this picture may well have been exhibited by Turner again in 1804 at his newly built gallery in Harley Street, and bought by Dobree during the exhibition.

The pictures of Bonneville result from Turner's first trip to the Continent in the summer of 1802 during the Peace of Amiens. He arrived in Upper Savoy probably in early August and the area round Bonneville was the first part of the Alps to which he gave concentrated attention. His preliminary pencil sketches are in the 'France, Savoy and Piedmont' sketchbook (LXXIII) which include on p. 46 verso a quick notation of the mountains in the background of this picture. There is also a watercolour study for the oil in the British Museum (LXXX-H; $15 \times 19\frac{1}{2}$ in.) which, although fairly summary in treatment, has something of the bright local colours of the finished picture. A later and more finished watercolour, which is more subdued in colour, was once in Ruskin's collection, later belonged to Sir Stephen Courtauld, and was given in his memory to the Courtauld Institute in 1974. A much later watercolour, signed and dated 1817, was engraved for *The Bijou* in 1828 and formerly belonged to Miss Julia Swinburne. Its present whereabouts is not known but it testifies to the continuing impact of Bonneville on Turner's imagination.

On Turner's way back to England, he stopped in Paris and spent some days studying the pictures on exhibition in the Louvre. We know from his notebooks (e.g., 'Studies in the Louvre' LXXII) that he paid particular attention to the paintings of Nicolas Poussin, an artist who had already influenced his pictures (e.g., No. 13). However, a source for *Bonneville* was nearer at hand in Poussin's *Landscape with a Roman Road* (now at Dulwich) which belonged to Noel Desenfans, whom Turner probably met through Sir Francis Bourgeois, R.A. The Desenfans Poussin was exhibited for sale in Berners Street, London in 1802 (no. 55). Turner was subsequently to refer to the Desenfans picture in his 'Backgrounds' lecture (first delivered in February 1811) as a 'powerful specimen of

Historic landscape, in which the rules of parallel perspective produce propriety even in Landscape . . . where a road terminates in the middle of the picture and every line in it tends to that centre.'

This picture reflects both these sources of inspiration for Turner. He has given full rein to his enthusiastic response to the wild grandeur of the scenery round Mont Blanc but he has tempered it with something of the classicism of Nicolas (and perhaps also Gaspard) Poussin. Although, as Kenneth Clark has noted, the picture 'contains failures of pictorial logic that Poussin could never have tolerated . . . after a few minutes' analysis we recognize that the point of the picture does not lie in the design at all, but in the effect of light and observation of nature.' It was Turner's observation of nature that led him to become increasingly aware of how rude and disordered it was. Thus his watercolours of Switzerland, done in the years following *Bonneville*, abandon any attempt to impose a logical pattern upon the landscape but emphasize instead the imbalance inherent in such scenery.

Ruskin, writing in 1843 at a time when his acquaintance with Turner's early work was very limited, considered that the two pictures of Bonneville were 'in every respect magnificent examples of his early style'.

At the R.A. in 1803, most critics concentrated on the *Calais Pier* (No. 48) among Turner's exhibits but the *St. James's Chronicle*, 10–12 May, described no. 237 as 'The design spirited, the colouring clear and the execution masterly.' It was also praised by Lawrence to Farington when they met at Mrs Opie's 'Musick party'. Farington records that 'Lawrence observed to me that in Turner's pictures there are his usual faults, but greater beauties. His picture in the Anti-room [no. 237] he thought remarkably fine.'

51. Old Margate Pier Exh. 1804? (Plate 45)

ERNEST H. GASKELL ESQ.

Panel, $10\frac{7}{8} \times 16$ ($27 \cdot 5 \times 40 \cdot 7$)

Coll. Given by Turner to Samuel Dobree (1759–1827) in 1804; by descent to his son H. H. Dobree (1787–1841); sale Christie's 17 June 1842 (10) bought by his younger brother Bonamy Dobree (1794–1863); Holbrook Gaskell; sale Christie's 11 June 1920 (41) bought in; inherited from Sir Holbrook Gaskell's estate by the present owner in 1951.

Exh. ?Turner's gallery 1804; Manchester 1857 (254 lent by Bonamy Dobree).

Lit. Armstrong 1902, p. 224; H. F. Finberg 1953, p. 99.

This picture is mentioned in a letter from Turner to Samuel Dobree, undated but evidently written on Sunday 1 July 1804 (it follows a letter dated 30 June). The letter concerns arrangements for Turner's father to

deliver some pictures to Dobree on the following
morning:

'You will find that I have sent you *all* and have added
the small picture of Margate, which you appeared to
like—your acceptance of it, and to allow it always to
remain in your Eye as a small remembrance of respect
will be very pleasant to me, and altho' it accompanies
the "Boats Going out with Cables", consider it not as its
make-weight...'

Mrs Finberg conjectures quite plausibly that Samuel
Dobree had admired the *Margate* while on exhibition in
Turner's gallery in Harley Street, the first held there,
although no catalogue of the exhibition exists.

In Christie's catalogue of the 1842 sale, this picture is
described as follows: 'A Fishing-Boat off Margate Pier,
on which are numerous figures; a vessel seen in the
distance, grand effect of storm—small'. A manuscript
note in Christie's own copy of the catalogue says
'Painted for Mr. D.' Turner himself left a bid of £10 for
it which was unsuccessful, the picture fetching 50
guineas.

Although Turner first visited Margate as early as
1792 no drawings belonging to this period have been
identified in the Turner Bequest. However, two pages
in the 'Wilson' sketchbook of 1797 (XXXVII
pp. 82–3), tentatively identified by Finberg as of
Ramsgate, may in fact show Margate Pier from a
different angle. They are reproduced in Wilkinson
1972, p. 56.

Similarities between this picture and other early sea
pictures make a date of 1801–3 seem convincing,
despite differences in scale. On stylistic grounds it must
be close in date to the seapiece in the Malden Public
Library (No. 143) where the handling is very similar in
certain passages.

52. Boats Carrying Out Anchors and Cables to Dutch Men of War, in 1665 Exh. 1804 (Plate 46)

THE CORCORAN GALLERY OF ART (W. A. Clark Collection),
WASHINGTON D.C.

Canvas, 40 × 51½ (101·5 × 130·5)

Coll. Bought from Turner by Samuel Dobree
(1759–1827) in 1804; acquired after Dobree's death
by Thomas, Lord Delamere, *d.* 1855; anon. (exec-
utors of Lord Delamere) sale Christie's 24 May 1856
(128) bought in; acquired after the sale by W. Benoni
White; sale Christie's 24 May 1879 (280) bought
White (a member of the family?); W. Houldsworth;
sale Christie's 23 May 1891 (57) bought in; sale
Christie's 16 May 1896 (53) bought McLean; Sir
Horatio Davies, Bt, M.P., by 1899; Sir George
Donaldson by 1903; bought from him by W. A. Clark,
Senator for Montana, in 1907 and bequeathed with
the rest of his collection to the Corcoran Gallery of Art,
April 1926.

Exh. R.A. 1804 (183); Glasgow 1888 (331); Birming-
ham 1899 (6); Guildhall 1899 (8); R.A. 1903 (12);
R.A. 1974–5 (79).

Lit. Farington *Diary* 9, 16, 17 and 20 April 1804;
Burnet and Cunningham 1852, p. 112 no. 83;
Thornbury 1877, pp. 418–19 but confused with *The
Bridgewater Seapiece*, 571; Bell 1901, p. 82 no. 105;
Armstrong 1902, pp. 53, 229, repr. facing p. 56;
Whitley 1928, p. 71; H. F. Finberg 1953, pp. 98–9;
Finberg 1961, pp. 108–9, 466 no. 89; Lindsay 1966,
p. 87; Gage 1969, pp. 166, 262 n. 111; Reynolds
1969, p. 65; Bachrach 1974, p. 14.

We learn from Farington (quoted by Gage) that
Turner painted most of this picture in one of the
Keeper's rooms at the R.A., probably because his own
studio in Harley Street was still occupied by builders.
During the exhibition Farington reported that Turner
was concerned about his seapiece being hung under the
white drapery of Copley's portrait of *Mrs Derby as St
Cecilia* (R.A. 184). However, Turner sold the picture to
Samuel Dobree and actually arranged for it to be
delivered to Dobree on 2 July 1804. This is recorded in
a letter from Turner to Dobree published by Hilda
Finberg although the price seems not to have been
agreed upon before the picture was sent. Hilda Finberg
suggests that criticisms of the picture during the
exhibition may have encouraged Dobree to try to get a
reduction. The date of delivery means that Turner
must have removed the picture before the end of the
exhibition, which may have been one cause of his
disagreement with the Council that year. (The exhi-
bition opened on 30 April and ran for approximately
three months.)

On the whole, the picture was not favourably
received at the R.A. although the *Star* for 7 May, the
Morning Post for 5 May and the *Monthly Mirror* for
July all had something to say in its favour. The *St.
James's Chronicle*, 12–15 May, called it 'a fine seascape'
but added 'but the sailors in the boats are all bald, and like
Chinese'.

Farington records that Opie said the water in
Turner's seapiece looked like a 'Turnpike Road' over the
sea. Northcote said he should have supposed Turner
had never seen the sea. The *Sun*, 10 May, also had some
harsh things to say: 'Why the scene before us should be
placed so far back as in 1665, it is difficult to conceive,
except by referring to that affectation which almost
invariably appears in the work of the Artist. There is
nothing in the subject to excite an interest. The figures
are very indifferently formed, and the *Sea* seems to have
been painted with *birch-broom* and *whitening*.'

The Turner Bicentenary Exhibition catalogue
suggested that Turner had made a mistake in the date in
his title and that the scene he portrayed refers to the end
of 'The Four Days' Battle of 1–4 June 1666. On this
occasion the British fleet came upon the Dutch fleet at
anchor seven leagues from Ostend. Admiral de Ruyter's
journal records, 'We saw the English fleet, about 70 sail
in strength bearing down upon us. Owing to the heavy
seas we could not weigh our anchors. At noon we all had
to cut our cables, some losing a cable and a half, and
some two whole ones...'

My suggestion was that Turner had painted the scene after the battle when the Dutch fleet had returned and, because of the precipitate way in which they had had to leave their anchorage, were now in the process of having additional anchors and cables rowed out to them so that they could moor safely.

This view has been challenged by Professor Dr A. G. H. Bachrach of Leiden, who suggests that the date of 1665 in the title is correct and that the Dutch fleet are here seen at anchor but taking on additional anchors and cables as a precaution before going into action. Professor Bachrach also suggests that Turner intended to suggest a comparison between the situation in 1665 and in 1804. Professor Bachrach believes that after the defeat of the Dutch fleet at the Battle of Lowestoft in June 1665, the English felt so secure and complacent that they were quite unaware of how hard the Dutch were working to refit their fleet, efforts which were crowned with a number of successes culminating in their invasion of the Medway in June 1667. Turner may therefore have felt in 1804 that the threat of invasion from France was being met with a similar lack of foresight and preparation, and meant this picture to be interpreted as a warning by analogy. Professor Bachrach's interpretation seems more convincing than mine which therefore means that Turner's title was in fact accurate.

53. Narcissus and Echo Exh. 1804 (Plate 47)

H.M. TREASURY AND THE NATIONAL TRUST (Lord Egremont Collection) PETWORTH HOUSE

Canvas, 34 × 46 (86·3 × 116·8)

Coll. Bought from Turner by the third Earl of Egremont after 1810 but before 1819 (see below); by descent to the third Lord Leconfield who in 1947 conveyed Petworth to the National Trust; in 1957 the contents of the State Rooms were accepted by the Treasury in part payment of death duties.

Exh. R.A. 1804 (207); B.I. 1806 (258); R.A. 1888 (11); Tate Gallery 1951 (6).

Engr. A soft ground etching by Turner himself for the *Liber Studiorum* but unpublished (Rawlinson 90).

Lit. Farington *Diary* 18 May 1804, 16 February 1806; Petworth Inventories 1837, 1856 (North Gallery); Burnet and Cunningham 1852, pp. 44, 112 no. 84, 121 no. 1; Waagen 1854, iii, p. 37; Ruskin 1860 (1903–12, vii, p. 391); Thornbury 1862, i, p. 355; ii, pp. 5–6, 397; 1877, pp. 199–200, 571, 594; Monkhouse 1879, p. 48; Bell 1901, p. 83 no. 106; Armstrong 1902, p. 225; Collins Baker 1920, p. 124 no. 46; Finberg 1924, p. 361; 1961, pp. 109, 122, 171–2, 466 no. 90, 467 no. 95; Rothenstein and Butlin 1964, p. 11; Gage 1965, p. 79 n. 33; Lindsay 1966, pp. 127, 309; Gage 1969, pp. 141, 259 n. 71.

Echo, a daughter of the Air and Tellus, was once one of

Juno's attendants and became the confidant of Jupiter's amours. Her loquacity, however, displeased Jupiter; and she was deprived of the power of speech by Juno and only permitted to answer the questions which were put to her. After she had been punished by Juno, Echo fell in love with Narcissus and on being despised by him she pined away, and was changed into a stone, which still retained the power of voice.

Exhibited with the following lines:

"So melts the youth, and languishes away;
His beauty withers, and his limbs decay;
And none of those attractive charms remain
To which the slighted Echo sued in vain.
She saw him in his present misery,
Whom, spite of all her wrongs, she griev'd to see:
She answer'd sadly to the lover's moan,
Sigh'd back his sighs, and groan'd to every groan:
'Ah! youth beloved in vain!' Narcissus cries;
'Ah! youth beloved in vain!' the nymph replies.
'Farewell!' says he. The parting sound scarce fell
From his faint lips, but she reply'd 'Farewell!' "

Rothenstein and Butlin suggest the quotation which accompanied the picture at the R.A. may possibly be by Turner himself. They were evidently unaware, as Gage points out, that Turner had in fact made use of Addison's translation of Ovid's *Metamorphoses* (Book iii ll. 601–12). That the quotation was a translation from Ovid was, however, noticed by the critic of the *Star* (see below).

The picture was still in Turner's possession *c.* 1810, for in the 'Finance' sketchbook (CXXII) it is listed with its value apparently written down, presumably because it was still unsold. The list is on a page opposite one which refers to a date in November 1809 but it must have been drawn up rather later (the sketchbook includes references to dates as late as 1814) as the *Narcissus* is lumped together with 'Cows' (*Abingdon/Dorchester Mead?*) 'Richmond' and 'Ploughing' (presumably *Slough* (No. 89)). As *Slough* and *Dorchester Mead* (No. 107) were exhibited in 1809 and 1810 respectively, it seems unlikely that Turner would have written down their value straightaway. Finberg interprets Turner's notes, which bracket these four pictures together for £200, to mean that Turner had revalued them for 'stock-taking' purposes at £50 each, but it is also possible (although I consider it less likely after studying Turner's calculations) that he meant to indicate that this quartet belonged to the category which was normally priced £200 each. If Finberg's theory is correct, then it seems that Egremont may have been tempted to buy it by the reduction in price.

To judge from another note in the 'Farnley' sketchbook (CLIII) about engravings to be published in the *Liber Studiorum* on 1 January 1819, Lord Egremont must have owned the picture by this date if Finberg is correct in identifying 'Lord Egremont's picture' with the *Narcissus*. The note shows that it was intended that W. Say should engrave it but in fact only three out of the eight titles listed by Turner as 'Liber

Studiorum Plates out Jan 1 1819' were in fact published on that date.

Ruskin described it as the first classical subject painted by Turner but Gage suggests that another source may have been an idea of George Field's, that reflection in colour might be compared to 'echo in sound', and 'it is agreeable to this analogy, that *Echo* was feigned to have pined for *Narcissus*'. In any case the influence of Gaspard Poussin is paramount in the picture's composition, although the experience of the large Welsh watercolours is also evident.

When the picture was shown at the R.A. the critic of the *British Press* for 3 May wrote 'We acknowledge the great beauty of this picture is the landscape . . . yet the story is gracefully told . . . This picture will bear much critical examination; while its general effect is extremely beautiful, and ranks it in a very high class.'

The *Star* for 10 May also praised it with reservations, although it said the picture was 'too affectedly imitative of the manner of a foreign school' and also that 'Here again we have another long translation from Ovid, to point out that in the picture which without it would never have been found.'

The *Sun* for the same date, however, found the picture full of faults, saying that if the artist had not told us the subject 'it would have been impossible for the most penetrating intellect to have discovered it. There are more figures introduced than might be expected in such a scene and, except Narcissus, they all appear like *Statues* that had fallen from their places. The general aspect of the colouring is like *clay* and the *trees* are much of the same hue as *boiled vegetables*. A part of the mountain is so strangely detached from the body, that it seems to be *flying stone* which dropped some years ago in Yorkshire.'

When discussing the exhibition at the British Institution in 1806, Thomas Daniell told Farington that the room was too dark and that 'Turner's *Echo* and *Hesperian Fruit* [see No. 57] looked like old tapestries.'

It seems likely that Turner was attracted to the subject by seeing Claude's picture of *Narcissus and Echo* (dating from 1644 and now in the National Gallery, London, no. 19). The Claude belonged to Sir George Beaumont by 1790 and hung in his house in London from then until being taken to Coleorton, Beaumont's house in Leicestershire, in 1808. Although Beaumont was later to become a hostile critic of Turner's work, he and Turner seem to have been on reasonably friendly terms in the late 1790s and Turner would certainly have known Beaumont's collection.

54. The Shipwreck Exh. 1805 (Plate 49)

THE TATE GALLERY, LONDON (476)

Canvas, $67\frac{1}{8} \times 95\frac{1}{8}$ ($170 \cdot 5 \times 241 \cdot 5$)

Coll. Bought 1806 by Sir John Leicester, Bt; exchanged 1807 for *Fall of the Rhine at Schaffhausen* (No. 61); Turner Bequest 1856 (54, 'Shipwreck'

$8'0'' \times 5'8\frac{1}{2}''$); transferred to the Tate Gallery 1910.

Exh. Turner's gallery 1805; Tate Gallery 1931 (21); Tate Gallery 1959 (344, repr. pl. 47); R.A. 1974–5 (82).

Engr. By Charles Turner in mezzotint in 1806, published 1 January 1807 (Rawlinson ii 1913, pp. 362–3 no. 751); by T. Fielding in aquatint 1825.

Lit. Ruskin 1857 (1903–12, xiii, pp. 107–13); Burnet 1852, p. 101 as 'Fishing-Boats saving the Crew of a Wreck', engr. as frontis.; Cunningham 1852, p. 13; Thornbury 1862, i, pp. 266–7, 410; 1877, pp. 193–4, 423–4; Hamerton 1879, p. 167; Monkhouse 1879, p. 50; Armstrong 1902, pp. 52–3, 231; Finberg 1910, pp. 49–51; Rawlinson ii 1913, p. 363; Whitley 1928, p. 106; Davies 1946, p. 186; Finberg 1961, pp. 116–19, 124–5, 134, 171, 467 no. 94, pl. 9; Hall 1962, pp. 93, 120; Kitson 1964, p. 18, repr. in colour p. 25; Rothenstein and Butlin 1964, p. 19, pl. 23; Lindsay 1966, pp. 90–91; Brill 1969, pp. 11–12, repr.; Gage 1969, pp. 40, 89; Reynolds 1969, pp. 60–62, 68, 75–6, pl. 42; Adele M. Holcomb, 'John Sell Cotman's *Dismasted Brig* and the Motif of the Drifting Boat', *Studies in Romanticism* xiv 1975, pp. 34, 36–7, pl. 5.

Purchased by Sir John Leicester, Bt, for £315; the receipt is dated 31 January 1806. A note in Turner's hand of 9 February (?) 1807 at Tabley House records an agreement to take it back in exchange for *The Falls of the Rhine at Schaffhausen* (No. 61, *q.v.*): 'The picture of the fall of the Rhine—to be Sir John Leicesters in Exchange for the Storm for 50 Guineas'. This was endorsed by Sir John Leicester, 'Pd. Febr. 9 [?] 1807 Mr. Turner 50 Gs. & Storm in exchange for ye Rhine'.

A possible stimulus to Turner's choice of subject was the highly successful republication in 1804, with illustrations by Nicholas Pocock, of William Falconer's poem *The Shipwreck*, first published in 1762. Cotman made a watercolour copy of the foremost boat, now in a private collection (repr. Holcomb *loc. cit.*, pl. 6).

This picture was priced at £400 in a note, probably of *c.* 1810, in Turner's 'Finance' sketchbook (CXXII-36; for the date see Nos. 53 and 56).

There are drawings for the composition in the 'Calais Pier' sketchbook (LXXXI-2, 6, 132–3, 136–7, 140–41) and slighter sketches, probably from actual wrecks, in the 'Shipwreck No. 1' sketchbook (LXXXVII-11, 16, repr. Kitson 1964, p. 41 and Reynolds 1969, pl. 41 respectively, as well as other sketches related in more general terms). This was the first of Turner's oil paintings to be engraved. The prospectus makes it clear that the picture could be seen in Turner's gallery 'until July 1, 1805'.

55. The Deluge Exh. 1805? (Plate 65)

THE TATE GALLERY, LONDON (493)

Canvas, 56¼ × 92¾ (143 × 235)

Coll. Turner Bequest 1856 (61, 'The Deluge'
7′10″ × 4′10½″); transferred to the Tate Gallery 1929.

Exh. ?Turner's gallery 1805; R.A. 1813 (213); Tate
Gallery 1931 (23); R.A. 1974–5 (81).

Engr. By J. P. Quilley 1828 (perhaps significantly only
two years after John Martin exhibited the first of his
two large pictures of the subject); also, with
considerable variations, by Turner or H. Dawe for
the *Liber Studiorum*, R. 88, but not published (repr.
Finberg 1924, p. 352; Turner's preliminary pen and
sepia drawing from the Vaughan Bequest, CXVIII-
X, is also repr. *loc. cit.*).

Lit. Farington *Diary* 21 February 1805; Ruskin 1843
(1903–12, iii, p. 519); Thornbury 1862, i, p. 295;
1877, p. 431; Bell 1901, p. 93 no. 129; Armstrong
1902, p. 220; Finberg 1924, p. 353; Whitley 1928,
pp. 88, 210–11; Davies 1946, p. 187; Finberg 1961,
pp. 113, 117–18, 171, 195–6, 304, 475 no. 184, 512
no. 94a; Lindsay 1966, p. 87, 230 n. 9; Reynolds
1969, p. 61.

A note in the *British Press* for 8 May 1804 stated that
'Mr. Turner is engaged upon a very large picture of the
Deluge, which he intends for the exhibition next year'.
By 'the exhibition' is probably meant that at the R.A.,
but, apparently owing to some dispute in the Academy
Council, Henry Thomson told Farington on 21
February 1805 that 'Turner will not exhibit at the Royal
Academy but at his own house'. It is likely therefore
that *The Deluge*, like *The Shipwreck*, was on view in
Turner's own gallery from early May to the beginning
of July 1805.

When exhibited again at the R.A. in 1813, the same
year as *Frosty Morning* (No. 127), it must have looked
rather conservative, but the *Morning Chronicle* for 3
May praised it as 'a good composition, and treated with
that severity of manner which was demanded by the
awfulness of the subject'. The catalogue contained the
following lines from Milton:

'Meanwhile the south wind rose, and with black wings
Wide hovering, all the clouds together drove
From under heaven —————
————— the thicken'd sky
Like a dark cieling [*sic*] stood, down rush'd the rain
Impetuous, and continual, till the earth
No more was seen.'

 Milton's Paradise Lost.

As in the case of his Plague pictures Turner may have
been spurred on by the example of Poussin, whose own
picture of the subject he had studied closely in the
Louvre in 1802 (for his notes see the 'Studies in the
Louvre' sketchbook, LXXII-41 verso, 42). But
Turner's main inspiration, particularly in the vivid

colouring of the figures on the right, came from Titian
and Veronese.

The drawing inscribed 'Study for the Deluge' in the
'Calais Pier' sketchbook shows an alternative com-
position, and that inscribed 'Whirlwind' is also related
(LXXXI-120, 121, 163). The group of a negro
supporting a girl on the right is close to a figure study in
the 'Studies for Pictures' sketchbook of *c.* 1800–02
(LXIX-66).

This picture was priced at £300 in a note, probably of
c. 1810, in Turner's 'Finance' sketchbook (CXXII-36;
for the date see Nos. 53 and 56).

56. The Destruction of Sodom Exh. 1805?
 (Plate 66)

THE TATE GALLERY, LONDON (474)

Canvas, 57½ × 93½ (146 × 237·5)

Coll. Turner Bequest 1856 (64, 'Destruction of
Sodom' 7′10″ × 4′10″); transferred to the Tate
Gallery 1910.

Exh. ?Turner's gallery 1805; Tate Gallery 1931 (22);
Tate Gallery 1959 (345).

Lit. Thornbury 1862, i, p. 266; 1877, p. 423; Arm-
strong 1902, p. 232; MacColl 1920, p. 5; Davies 1946,
p. 187; Finberg 1961, pp. 113, 118, 171; Kitson
1964, pp. 13–5, detail repr. in colour p. 24; Lindsay
1966, p. 87.

An illustration to Genesis xix, 24–6. On the right Lot
and his daughters are shown fleeing the city; MacColl
also identifies Lot's wife as a pillar of salt behind them.

The picture was possibly exhibited at Turner's own
gallery in 1805 though there is no evidence of this; no
list of his exhibits in this year had been traced. In a note
of *c.* 1810 *Sodom* is included in a list of unsold pictures
and valued at £400 (CXXII-36). The sketchbook is
watermarked 1804 or 1801 but contains notes dated
1809, 1810, 1812, 1813 and 1814; the list referred to
faces a page apparently dated 1809 (see also No. 53).
Thornbury dates the picture 'about 1805' and the style
fits such a dating.

**57. The Goddess of Discord choosing the Apple
of Contention in the Garden of the Hesperides**
Exh. 1806 (Plate 54)

THE TATE GALLERY, LONDON (477)

Canvas, irregular 61⅛ × 86 (155 × 218·5)

Coll. Turner Bequest 1856 (66, 'The Garden of the
Hesperides' 7′2″ × 5′1″); transferred to the Tate
Gallery 1910.

Exh. B.I. 1806 (South Room 55); Turner's gallery
1808; Tate Gallery 1931 (24).

Lit. Farington *Diary* 16 February and 5 April 1806;
Ruskin 1857 and 1860 (1903–12, xiii, pp. 113–19; vii,
pp. 376, 392–408); Thornbury 1862, i, pp. 267–8;
1877, pp. 424–5; Hamerton 1879, pp. 98–9, 153–4;
Monkhouse 1879, pp. 52, 72–4; Bell 1901, pp. 61,
83–4 no. 108; Armstrong 1902, pp. 59, 223; MacColl
1920, p. 6; Davies 1946, p. 187; Rothenstein 1949,
p. 10, colour pl. 5; Clare 1951, pp. 35–6, repr.;
Finberg 1961, pp. 122–3, 134, 148–9, 171, 467
no. 96, 469 no. 126; Rothenstein and Butlin 1964,
pp. 11, 19, pl. 27; Lindsay 1966, p. 98; Lindsay
1966², p. 103, 131–2; Gage 1969, pp. 137–9, pl. 60;
Herrmann 1975, pp. 15, 228, pl. 44.

There are a number of sketches with some relation to
the picture in the 'Hesperides' (1) sketchbook, though
none for the whole composition (XCIII-1, 3 (the same
background, but the figures seem to be for another
subject), 3 verso (the dragon, again with different
figures), 8–10).

No verses were included in the catalogue of this the
first exhibition of the British Institution, but there is a
related 'Ode to Discord' in the Verse Notebook
belonging to C. W. M. Turner:

'Discord, dire Sister of Etherial Jove
Coeval, hostile even to heavenly love,
Unask'd at Psyche's bridal feast to share,
Mad with neglect and envious of the fair,
Fierce as the noxious blast thou cleav'd the skies
And sought the hesperian Garden's golden prize.

The guardian Dragon in himself an host
Aw'd by thy presence slumberd at his post
The timid sisters with prophetic fire
Proffered the fatal fruit and fear'd thy wrathful ire
With vengfull pleasure pleas'd the Goddess heard
Of future woes: and then her choice preferred
The shining mischief to herself she took
Love felt the wound and Troy's foundations shook . . .'

There are also versions of the first two lines in the
'Windsor, Eaton' sketchbook, which is usually dated
c. 1807 but may well, because of the relationship to this
picture exhibited early in 1806, have been begun a year
or two earlier (XCVII-83 and 83 verso).

The apple chosen by Discord and claimed at the
bridal feast was that eventually awarded by Paris. In the
sources the bridal feast was that of Peleus and Thetis, not
Psyche, who was introduced, Gage suggests, as a
symbol of mercurial water, this picture being, it would
seem, like *Jason* and *Apollo killing Python* (Nos. 19 and
115), in part an alchemical allegory. The Hesperides,
the nymphs of sunset and daughters of night, would
represent air. Ruskin points out that two of them, Ægle
and Erytheia, represent Brightness and Blushing (the
other two are Hestia the spirit of the Hearth, and
Arethusa, the Ministering spirit) while the fruit they
guard is Juno's fruit, the wealth of the earth. The
dragon is Ladon, brother of the dragon slain by Jason;
almost merging with the mountain ridge, it embodies
the elements of fire and earth.

Gage also points out the similarity between the last
two lines of Turner's Ode and Milton's description of
Eve plucking the Apple in *Paradise Lost* ix, thus linking
the theme with the Biblical Fall. This echoes Ruskin's
conclusion, in the fifth volume of *Modern Painters*
(nearly a whole chapter of which, 'the Nereid's Guard',
is devoted to this picture), that this 'is our English
painter's first great religious picture . . . the Assump-
tion of the Dragon; . . . the fair blooming of the
Hesperid meadows fades into ashes beneath the
Nereid's Guard'. The picture was thus, for Ruskin, the
first of the long series of works in which Turner
portrayed the moral and physical decline of his country.

Ruskin also, in his notes on the Turners shown at
Marlborough House in 1856, pointed to the combined
influence of Poussin and the Alps in this picture. Later,
in the manuscript for *Modern Painters*, he described the
picture as 'much spoiled by cleaning', but this note was
not published.

There seems to have been no comment in the press
on Turner's contribution to the 1806 British Institution
exhibition, but Farington, on 5 April 1806, records that
he dined with Beaumont and that 'Turner's pictures at
the British Institution were spoken of. —Sir George said
they appeared to him to be like the works of an *old man*
who had ideas but had lost his power of execution. —He
said Havil [William Havell, the painter, 1782–1857]
speaks of Turner as being superior to Claude, —Poussin,
or any other'. Thomas Daniell, also there, 'sd. that
Turner's pictures appeared to him to resemble tapestry'.
Farington had already recorded on 16 February that
'Daniell has seen the pictures now arranged at the
British Institution . . . The room in which the
landscapes are hung is too dark, and all the pictures
suffer from it, his own included . . . Turner's pictures of
'*Echo*' [No. 53] and the 'Hesperian Fruit' look like old
Tapestry as to general color & effect.'

In 1808, when Turner exhibited the picture again in
his own gallery, it was on the whole praised by John
Landseer(?) in the *Review of Publications of Art*. 'We
have no where seen more loftiness of thought displayed
in landscape painting than in the middle ground and
distant mountains of this picture. Its rocks and rolling
clouds, and dreadful precipices, and romantic cataract;
and the dragon which guards the pass, are all conceived
and executed in a style which may justly entitle it to be
called sublime: and its grey obscurity and golden light,
are in full harmony with the general wild aspect of the
scene, and with the terror which its towering rocks and
ever-watchful dragon inspires.

'The idea of the situation of this dragon appears to
have been suggested by that of the Polyphemus of
Nicolas Poussin [repr. Anthony Blunt, *Nicolas Poussin*
1966, plates vol., pl. 190; the picture was in Russia from
1772 but there were copies in England early in the
nineteenth century, see Blunt, *op. cit.*, Critical Cat-
alogue, p. 125] . . . Yet the dragon and its sublime
accompaniments are his own; and there is a spirit of
enterprise and loftiness of enthusiasm in this part of the
picture which may justify the connoisseur, if not the

critic, in calling it inspiration . . . But the vale below, notwithstanding that it has many very beautiful parts, conveys, on the whole, more the idea of being the approach to the garden of the Hesperides, than the garden itself . . . It is however a highly poetical scene, and its terrible acclivities, its lofty trees, its crystal fountains, and its golden fruits, cannot fail to delight those minds which Mr. Turner here means to address.'

This picture was priced at £400 in a note, probably of c. 1810, in Turner's 'Finance' sketchbook (CXXII-36; for the date see Nos. 53 and 56).

58. The Battle of Trafalgar, as seen from the Mizen Starboard Shrouds of the Victory
Exh. 1806; reworked 1808 (Plate 50)

THE TATE GALLERY, LONDON (480)

Canvas, 67¼ × 94 (171 × 239)

Signed 'J M W Turner' incised on bulwark bottom centre. (Plate 538)

Coll. Turner Bequest 1856 (3, 'Death of Nelson' 7'10" × 5'8"); transferred to the Tate Gallery 1910.

Exh. Turner's gallery 1806; B.I. 1808 (359); Tate Gallery 1931 (25); R.A. 1974–5 (84, repr.); on loan to the National Maritime Museum from 1975.

Lit. Farington *Diary* 3 June 1806; Ruskin 1857 (1903–12, xiii, p. 170); Thornbury 1862, i, p. 291; 1877, p. 428; Eastlake 1895, i, p. 189; Bell 1901, p. 86 no. 112; Armstrong 1902, p. 233; Finberg 1910, pp. 53–4; MacColl 1920, p. 7; Davies 1946, p. 185; Clare 1951, pp. 38–40, repr. p. 43; Finberg 1961, pp. 121, 125, 141–2, 171, 414, 467 no. 99, 468 no. 112, pl. 12; Rothenstein and Butlin 1964, p. 30, pl. 31; Reynolds 1969, p. 66, pl. 46; Gaunt 1971. p. 9.

The Battle of Trafalgar took place on 21 October 1805 and the *Victory*, bearing Nelson's body, anchored off Sheerness on 22 December. Turner made a special trip to sketch the *Victory* as she entered the Medway and subsequently made a large number of detailed studies on board the ship in the 'Nelson' sketchbook (LXXXIX). There are also two larger studies of the deck of the *Victory* in the British Museum (CXX-c, and the Vaughan Bequest CXXI-S, repr. exh. cat. R.A. 1974, p. 60 no. 96).

Farington recorded on 3 June 1806 that 'Turner's I went to and saw His picture of the Battle of Trafalgar. It appeared to me to be a very crude, unfinished performance, the figures miserably bad.'

Perhaps because he had been so keen to show the picture as soon as possible after the event Turner seems to have felt the need to work on it further before exhibiting it again in 1808. According to the writer, probably John Landseer, of a long review in the *Review of Publications of Art* for 1808, 'The picture appears more powerful both in respect of chiaroscuro and colour than when we formerly saw it in Mr. Turner's gallery, and has evidently been since revised and very much improved by the author'. Describing the picture as 'a *British epic picture*' the writer called it 'the *first* picture of the kind that has ever, to our knowledge, been exhibited'. 'Mr. Turner . . . has detailed the death of *his* hero, while he has suggested the whole of a great naval victory, which we believe has never before been successfully accomplished, if it has been before attempted, in a single picture.'

This picture was priced at £400 in a note, probably of c. 1810, in Turner's 'Finance' sketchbook (CXXII-36; for the date see Nos. 53 and 56).

59. The Victory returning from Trafalgar
Exh. 1806? (Plate 51)

YALE CENTER FOR BRITISH ART, PAUL MELLON COLLECTION

Canvas, 26⅜ × 39½ (67 × 100·3)

Coll. Walter Fawkes of Farnley who bought it from Turner; Fawkes sale Christie's 27 June 1890 (61) bought Agnew for Sir Donald Currie; by descent to his granddaughter Mrs L. B. Murray, from whom bought by Agnew in 1960 and sold to the present owners.

Exh. ?Turner's gallery 1806; R.A. 1892 (22); Birmingham 1899 (8); Guildhall 1899 (10); Richmond 1963 (132); R.A. 1964–5 (167); Yale 1965 (195); Washington 1968–9 (5) repr. on cover.

Engr. A drawing in the British Museum (CXVIII-C Vaughan Bequest) is listed by Finberg as among subjects to be engraved in the *Liber Studiorum* (Rawlinson 99) but it was not published. The drawing differs from the picture in minor details in the foreground and in the fact that the left-hand view of the *Victory* is not broadside on but shows her heading at an oblique angle towards the spectator.

Lit. Thornbury 1862, ii, pp. 85, 393; 1877, pp. 237, 589; Armstrong 1902, pp. 56, 232, repr. facing p. 56; Finberg 1912, pp. 20, 21; Clare 1951, p. 38; Finberg 1961, pp. 125, 467 no. 102.

Finberg suggests that this was shown in Turner's gallery in 1806 as well as *The Battle of Trafalgar, as seen from the Mizen Starboard Shrouds of the Victory* (No. 58) which we know from Farington was definitely exhibited in Harley Street that year although in an unfinished state. If Fawkes acquired it as early as 1806, the *Victory* may have been his first oil by Turner. (No. 148, *Bonneville* may possibly have been a still earlier purchase.) In the watercolour by Turner of the drawing room at Farnley painted 1818–19, which shows the *Dort* (No. 137) hanging in the room, the *Victory* can be seen on one side of the *Dort* with No. 95 on the other.

As it is known that Turner actually sketched the *Victory* as she entered the Medway (see his letter written to J. C. Schetky quoted in the entry for No.

252), it is strange that in this picture he has transposed the scene to the Isle of Wight. In the background the Needles are visible and the south-west coast running towards Freshwater Bay. (In fact, therefore, the *Victory* is shown heading towards the south-west tip of the Island rather than up the Solent.) It would seem almost as if Turner had chosen this scene in order to underline, or perhaps to defy, Gilpin's strictures on the Island, published in his guidebook of 1798, which he had condemned as unpicturesque partly on account of the cliffs which were 'one long monotonous white' (see Gage 1965, pp. 22–3). Turner seems to have been at pains to emphasise the whiteness of the cliffs in the background here.

In view of the fact that this picture was bought direct from Turner by Fawkes, the traditional title: *The Victory returning from Trafalgar, in three positions* must be accepted as correct. Authorities on naval history have however pointed out that in fact the ship portrayed by Turner is by no means readily identifiable as the *Victory* and that furthermore, as Nelson's body was still on board, it would seem unthinkable that she should not be flying her ensign at half mast at such a moment.

60. Walton Bridges Exh. 1806? (Plate 52)

THE LOYD COLLECTION

Canvas, $36\frac{1}{2} \times 48\frac{3}{4}$ (92·7 × 123·8)

Signed 'J M W Turner R A' lower right

Coll. Bought by Sir John Leicester for £280 and paid for in January 1807 (although the receipt is endorsed for *Walton Bridges* the sum is greater than Turner usually got for his 36 × 48 canvases at this time. Indeed, 200 guineas would appear to have been his normal price until at least 1810 (see notes of amounts owing to Turner recorded by him in his 'Hastings' (CXI) and 'Finance' (CXXII) sketchbooks) so that it seems possible that this sum included another picture. Sir John seems either to have sold or exchanged it before 1819 as it does not appear in William Carey's catalogue of the Leicester collection printed in that year); Thomas Wright of Upton; sale Christie's 7 June 1845 (58) bought Pennell; Joseph Gillott by 1847; sale Christie's 27 April 1872 (307) bought Agnew for H. W. F. Bolckow; sale Christie's 2 May 1891 (105) bought Agnew, from whom bought by Lord Wantage; by descent to the present owner.

Exh. ?Turner's gallery 1806; Birmingham Society of Artists 1847 (129 lent by Joseph Gillott); Manchester 1857 (266); R.A. 1892 (140); Agnew 1897 (17); Guildhall 1899 (19); Paris 1900 (46); Tate Gallery 1931 (50); Whitechapel 1953 (73); Agnew 1956 (10); R.A. 1968–9 (150); R.A. 1974–5 (131).

Lit. Thornbury 1862, i, p. 305 (where he dates it in the 1820s); 1877, pp. 438–9; Armstrong 1902, pp. 59, 236, repr. facing p. 58; Temple 1902, pp. 160–61 no. 241; Holmes 1908, p. 17 where he dates it 1815

and detects the influence of Rubens' *Château de Steen*, which was in England by 1802 and was seen by Constable at Benjamin West's in 1804; Finberg 1961, pp. 125, 132, 302, 467 no. 100, 510 no. 581; Hall 1960–62, p. 93; Parris 1967, pp. 39–40 no. 58 repr.; Reynolds 1969, p. 74.

As Finberg suggests, although the only picture certainly recorded by Farington as being shown in Turner's gallery in 1806 is the *Battle of Trafalgar* (No. 58), the likelihood that this picture was included in the exhibition is quite strong; there is however some evidence that the other picture of *Walton Bridges* may not have been shown until 1807 (see No. 63).

Drawings for this picture occur in the 'Hesperides (2)' sketchbook (XCIV) pp. 4, 6, and possibly 7, 7 verso and 8, and in the 'Thames from Reading to Walton' (XCV) sketchbook pp. 22–3 (p. 22 repr. Wilkinson 1974, p. 75). Turner painted another full-scale picture of the subject (see No. 63) as well as two later oil sketches (Nos. 184 and 185) and there are other drawings in sketchbooks in use about 1806–7.

Walton Bridges also appear in an engraving in the *Liber Studiorum* entitled 'The Bridge in the Middle Distance', published in June 1808 (Rawlinson 13) which Turner used as the basis for an oil painting in the late 1830s (see No. 511).

Armstrong's dating of *c.* 1812 in his catalogue and of 1815 in the text of his book, the former of which is followed in the catalogue of the Whitechapel Exhibition, is, of course, invalidated by the evidence of payment in the Tabley House papers.

It is worth noting that, when exhibited in 1847, the *Birmingham Advertiser*, 21 October, commented: 'This picture is a forcible illustration of the fate of most of Turner's pictures. The original brilliant colour has faded, and where a magic sunlight effect should have been displayed, nothing is seen but a mass of faint yellow colour ... If the colours of the picture retain their present body (but we fear they will not) the work will still be a good specimen of the master.'

The *Birmingham Journal* for 4 September wrote that 'without a positive assurance of the fact, it would require a considerable exercise of faith to believe that No. 129 was the production of that master of brilliant colour J.M.W. Turner R.A.'

The subject was a favourite among artists in the eighteenth and nineteenth centuries. The old wooden bridge had been painted by Canaletto a number of times, the most famous version now being at Dulwich.

61. Fall of the Rhine at Schaffhausen Exh. 1806

MUSEUM OF FINE ARTS, BOSTON, MASS. (Plate 67)

Canvas, 57 × 92 (144·7 × 233·7)

Coll. Bought by Sir John Leicester in February 1807, Sir John returning *The Shipwreck* (No. 54) in part exchange and paying an additional 50 guineas; not

included in the 1827 sale of Lord de Tabley's pictures, but remained in the Tabley collection until 1912 when it was bought from Lady Leicester Warren by Agnew and Sulley and sold by Sulley to the Boston Museum in 1913 (Accession number 13.2723. Bequest of Alice Marian Curtis and special picture Fund).

Exh. R.A. 1806 (182); Sir John Leicester's gallery 1819 (58); Manchester 1857 (297); International Exhibition 1862 (332); R.A. 1879 (169); Boston 1946 (2).

Lit. Farington *Diary* 27 April, 5 May 1806, 16 March 1807; Carey 1819, no. 57; Young 1821, no. 58 (engr. size given as 78 × 94 in.); Burnet and Cunningham 1852, pp. 24, 112 no. 86; Thornbury 1862, i, p. 268; 1877, pp. 425, 571; Monkhouse 1879, p. 53; Bell 1901, p. 83 no. 107; Armstrong 1902, pp. 57, 228; Whitley 1928, p. 104; Hall 1960–62, pp. 93, 120 no. 91; Finberg 1961, pp. 124–6, 134, 302, 467 no. 97, 478 no.207; Rothenstein and Butlin 1964, p. 31, pl. 30; Lindsay 1966, pp. 96, 231 n. 1; Gage 1969, p. 161.

Hall publishes a note in Turner's hand in the Tabley House papers agreeing to the form of exchange. Sir John Leicester gave Turner a note of authority to collect *The Shipwreck*, and then another as Turner mislaid the first. Thornbury gives as a reason for the exchange that Lady Leicester had lost a favourite nephew at sea, and was 'unable to bear the associations called up by the scene'. However this explanation seems impossible as Sir John and Lady Leicester were not married until nearly four years after the exchange took place.

Sketches connected with this picture occur on pp. 29 and 31 of the 'Fonthill' sketchbook (XLVII). The subject was to remain a favourite of Turner's; a quite different view of the Falls was obviously drawn with the *Liber Studiorum* in mind (CXVIII-Z) but was never engraved, and a number of watercolours of the Falls date from Turner's Swiss journeys in the early 1840s.

Rothenstein and Butlin draw attention to the close compositional similarities between this picture and *The Garden of the Hesperides* (No. 57), also exhibited in 1806 at the British Institution; cf. also No. 435.

As Finberg records, Turner seems to have expected this picture to be badly hung at the R.A. (it was the first he had sent since his unfortunate experience with No. 52 in 1804) for he originally sent it in without a title. While the exhibition was being arranged, Turner went to see Edmund Garvey, one of the Hanging Committee, and told him that he had not sent a title as he had intended withdrawing the picture if it was not hung to his satisfaction. Garvey led Turner to believe that it was hung to advantage, whereupon Turner delivered the title for the catalogue. Garvey was apparently proud of the way he had deceived Turner, for he called on Farington on 27 April to tell him what he had done.

Turner's fears seem to have been justified for the *St. James's Chronicle*, 24–27 May, noted that it was unfortunately hung and impossible to view from a proper distance, especially when the room was full.

The picture was praised in the *Monthly Magazine* for May 1806 but on the whole it was savagely attacked both in the press and by the older among Turner's fellow artists. Farington records a number of hostile comments: West said Turner had become 'intoxicated and produced extravagances' while a Mr Dashwood of Cley, Norfolk, denounced this picture as 'a wild incoherent production, the froth of the water being like a brush of snow'. And at an evening at Farington's house in June 'the vicious practice of Turner and his followers was warmly exposed' by a group including Sir George Beaumont, William Alexander, Edridge and Thomas Daniell. Farington also records that on 5 May at the opening of the R.A. he met two journalists, James Boaden of the *Oracle* and John Taylor, editor of the *Sun*. On looking at the *Schaffhausen* Boaden said 'That is Madness' and Taylor agreed 'He is a madman'. Later in the month, on 21 May, the critic of the *Sun* remembered a finer rendering of the scene exhibited many years before by de Loutherbourg (R.A. 1788 (227); now in the Victoria and Albert Museum) and wrote that, although the subject ought to have brought out the best in Turner 'we cannot compliment him on his success. Instead of boldness and grandeur, his picture, in our opinion, is marked by negligence and coarseness, and the prevailing features of the colouring seem to have been produced by *sand* and chalk'. The *Star* for 8 May reproached Turner for neglecting Nature and Truth and compared him unfavourably with Wilkie whose *Village Politicians*, R.A. (145), it praised highly. It considered the figures looked as though they were 'dressed from a book of Swiss costumes' and the colouring 'is not that of German Nature. The spray from the cataract more resembles a cloud of stone dull than water, the body of the current itself being the block from which it is made to fly.'

62. Sheerness and the Isle of Sheppey, with the Junction of the Thames and the Medway from the Nore Exh. 1807 (Plate 68)
usually known as *The Junction of the Thames and the Medway*

NATIONAL GALLERY OF ART, WASHINGTON D.C.

Canvas, 42¾ × 56½ (108·6 × 143·5)

Coll. Bought by Thomas Lister Parker (1779–1858) in 1807, almost certainly from Turner's gallery; Parker sale Christie's 9 March 1811 (29) bought in; John Newington Hughes of Winchester; sale Christie's 15 April 1848 (147) bought Thomas Rought, from whom bought by Joseph Gillott 3 May 1848; sale Christie's 27 April 1872 (306) bought Agnew; Richard Hemming of Bentley Manor, Bromsgrove; bought by Agnew from Mrs Hemming in 1892 and sold in 1893 to Wallis and Co. who sold it to P. A. B. Widener of Philadelphia (*The Times*, 12 May 1894, in

reviewing the exhibition at the French Gallery (Wallis and Son) reported that 'It is said that this splendid masterpiece has been sold to America'); passed to the National Gallery, Washington, with the rest of the Widener Collection in 1942 (no. 683).

Exh. Turner's gallery 1807; Royal Birmingham Society of Artists 1852 (37) as 'Shipping the Rudder—the Junction of the Thames and the Medway from the Nore Buoy, with a distant view of Sheerness and the Isle of Sheppey'; Manchester 1857 (288); Leeds 1868 (1107); The French Gallery, 120 Pall Mall, London 1894 (26).

Engr. By J. Fisher as 'Sheerness and the Isle of Sheppey, with the Junction of the Thames and the Medway from the Nore' (Rawlinson 168a). The plate is unfinished and there is no clue as to its date. Rawlinson suggests it may have been engraved for the original owner of the picture.

Lit. Thornbury 1877, p. 617; Armstrong 1902, pp. 53, 231, repr. facing p. 54; Rawlinson i 1908, pp. xcii, 88; W. Roberts, *Pictures in the Collection of P. A. B. Widener: British and Modern French Schools* 1915, no. 20; Finberg 1961, p. 421; Rothenstein and Butlin 1964, p. 24; Brown 1975, pp. 721–2, fig. 37.

Parker's purchase was recorded in the *Morning Post* for 6 May 1807: 'Mr T. Lister Parker has purchased a fine seapiece by Turner which is in his best manner.' But the identification of the Parker seapiece with the Washington *Junction of the Thames and the Medway* was not established until David Brown discovered a copy of it by Callcott at Browsholme Hall in the West Riding of Yorkshire, still the home of the Parker family. Mr Brown subsequently found that the Turner was listed in a catalogue of Parker's collection, compiled in 1808, as 'View off Sheerness' and there is a possibility that it was included in a sale of paintings at Browsholme in 1808 when it must have been bought in, as the seller at Christie's in March 1811 is firmly identified as 'Parker' in Christie's copy of the sale catalogue. It is not known when John Newington Hughes acquired the picture but, as his other Turner oil *Whalley Bridge* (see No. 117) was exhibited at the Royal Academy in 1811, it seems likely that he may have bought both Turners at about this time. If Parker 'often bought for investment', as Mr Brown suggests, his Turner must be accounted a failure in this respect, for he apparently paid £200 for it, as this figure is mentioned in the entry for the picture in the 1808 catalogue and is perfectly consistent with Turner's prices at this date, but it was bought in for only 79 guineas at Christie's.

Since Mr Brown wrote his article, he has made the interesting suggestion to the compiler that Parker may have originally commissioned *Whalley Bridge* (No. 117) from Turner but that his unfortunate experience in the saleroom with this seapiece may have led to a decision to sell both pictures to Newington Hughes. In this way he may have obtained a price for this picture which came reasonably close to what he had originally paid for it.

It seems almost certain that, in reporting Parker's acquisition, the *Morning Post* is referring to a sale from Turner's gallery, as similar sales from it in 1808 are recorded in the *Examiner* and the exhibitions held there annually were clearly considered to be worthy of notice. It is likely that the picture was originally exhibited with its full title, as given later both in the Newington Hughes sale catalogue and on the engraving.

A pen and ink study for the composition is on p. 16 of the 'Hesperides (1)' sketchbook (XCIII, dated 1805–7 by Finberg). A drawing on pp. 90–91 of the 'Calais Pier' sketchbook (LXXXI) may also be related. It is inscribed in Turner's hand 'Do' (Ditto) which probably refers to the inscription 'Study not painted 1805' on p. 94 (it seems that Turner was going through the pages backwards in this part of the book). The angle of the rowing boats and its relation to the light-coloured sails of the ship behind do seem to contain the germ of the final composition. If this connection is accepted, a *terminus ante quem* is provided for the dating of the picture, but in fact there is no reason to think that it was not painted immediately before being exhibited in 1807.

Mr Brown suggests convincingly that two copies on a smaller scale were also done by Callcott: one is now in the Tate Gallery (see No. 542) and the other is in the Ashmolean Museum, Oxford (see No. 543). A third copy of part of the composition is also in the Tate Gallery but this is considerably weaker and certainly not by Callcott (see No. 544).

63. Walton Bridges Exh. 1807? (Plate 53)

NATIONAL GALLERY OF VICTORIA, MELBOURNE

Canvas, $36\frac{1}{4} \times 48\frac{1}{8}$ (92·2 × 122·4)

Coll. Bought by the Earl of Essex (1757–1839), possibly from Turner's gallery in 1807 (see below); sale 'Modern Pictures from Cassiobury Park collected early in the century by George, 5.th Earl of Essex' Christie's 22 July 1893 (47) bought in; bought by James Orrock sometime before the winter of 1899–1900; sale Christie's 4 June 1904 (139) bought Agnew; bought back again by Orrock in 1905; Sir Joseph Beecham by 1910; sale Christie's 3 May 1917 (75) bought Duncan; acquired by Frank Rinder in 1919/20 for the Felton Bequest, National Gallery of Victoria (Accession no. 981/3).

Exh. ?Turner's gallery 1807; R.A. 1878 (131); New Gallery 1899–1900 (189 lent by James Orrock); B.F.A.C. 1910 (10 lent by J. Beecham); Rome 1911 (98); R.A. 1974–5 (132).

Engr. By Chauvel, published by A. Tooth and Sons.

Lit. Farington *Diary* 5 July 1809; Armstrong 1902, p. 236; Falk 1938, p. 250; Finberg 1961, pp. 125, 467 no. 101; Ursula Hoff, *National Gallery of Victoria: Catalogue of European Painting before Eighteen Hundred* second edn 1967, p. 135.

The provenance as given in Dr Hoff's catalogue is incorrect in saying that Lord Essex sold the picture to Agnew's in 1893. In Finberg's inventory of the Turner Bequest drawings, published in 1909, he refers to 'Mr. Orrock's Walton Bridges', so presumably it was not acquired by Sir Joseph Beecham until shortly before he lent it to the exhibition at the Burlington Fine Arts Club in 1910.

A slight study for the composition is on p. 5 verso of the 'Hesperides (2)' sketchbook (XCIV), and a drawing on p. 71 of the 'River and Margate' sketchbook (XCIX) may also be connected.

A much later watercolour, which follows this composition in all its essentials, was engraved by J. C. Varrall for the *England and Wales* series in 1830.

As with the other picture of *Walton Bridges* (No. 60), Finberg conjectures that this picture was shown in Turner's gallery in 1806. However, a letter preserved in the Turner Bequest (CXX-l), written by Lord Essex to the artist on 10 June 1808 about arrangements for collecting *The Purfleet and the Essex Shore* (No. 74) begins 'I have sent a packing case for the picture, the same as the other picture came in last year . . .' This must refer to *Walton Bridges* and fixes the year of purchase as 1807. It is, of course, possible that the picture was exhibited by Turner in his gallery in 1806 and then again in 1807 as there are other instances of this. Alternatively, Turner may have exhibited No. 60 in 1806 and then the Melbourne picture in the following year as he was to do at the Royal Academy in 1826 and 1827 with the two pictures of Mortlake Terrace (Nos. 235 and 239).

Lord Essex was one of Turner's earliest patrons and Turner painted a number of watercolours for him of his two houses, Hampton Court in Herefordshire and Cassiobury Park near Watford in Hertfordshire. The Hampton Court watercolours are based on sketches made in 1795 and Turner seems to have made two groups of drawings of Cassiobury, the first between 1796 and 1800 and the second in 1807 when Farington records Turner's visit there. However, Lord Essex does not appear to have bought an oil painting by Turner before this one, although he followed it up with further purchases in 1808 and 1809 (Nos. 74 and 92).

64. The Thames near Windsor Exh. 1807?

(Plate 71)

H.M. TREASURY AND THE NATIONAL TRUST (Lord Egremont Collection) PETWORTH HOUSE

Canvas, 35 × 47 (89 × 119·4)

Coll. Bought by Lord Egremont, possibly in 1807; by descent to the third Lord Leconfield, who in 1947 conveyed Petworth to the National Trust; in 1957 the contents of the State Rooms were accepted by the Treasury in part payment of death duties.

Exh. ?Turner's gallery 1807; Tate Gallery 1951 (4).

Lit. Petworth Inventories 1837, 1856 (North Gallery); Burnet and Cunningham 1852, p. 44?; Waagen 1854, iii, p. 38; Thornbury 1862, ii, p. 379; 1877, pp. 199, 200, 594; Collins Baker 1920, p. 123 no. 21; Finberg 1961, pp. 134, 467 no. 105; Reynolds 1969, p. 74.

This is one of the pictures which Finberg suggests were shown at Turner's gallery in 1807 on the strength of West's report to Farington that the pictures he saw there were 'views on the Thames, crude blotches, nothing could be more vicious'. The evidence is only circumstantial although the fact that pictures of Thames scenery had been exhibited by Turner previously is confirmed by John Landseer's (?) review of the 1808 exhibition (*Review of Publication of Arts*) in which he says 'The greater number of the pictures at present exhibited are views on the Thames, whose course Mr. Turner has now studiously followed . . . almost from its source to where it mingles its waters with those of the German Ocean, including the pictures of Thames scenery which Mr. Turner has formerly exhibited.'

In any case, a dating of *c.* 1807 would seem perfectly acceptable on stylistic grounds although it is difficult to be certain about this in view of the picture's present condition. The paint has certainly darkened with time and the surface has suffered maltreatment from a past relining. The left-hand lower corner in the area of the two boats has suffered particularly but the water is also restored in a number of areas. Waagen noted that the picture 'breathes a soft melancholy, and gives an effect which may be classed between Claude and Van der Neer'. Much of this atmospheric effect has now sadly disappeared.

65. Newark Abbey on the Wey Exh. 1807?

(Plate 55)

YALE CENTER FOR BRITISH ART, PAUL MELLON COLLECTION

Canvas, 36 × 48½ (91·5 × 123)

Coll. Sir John Leicester (later Lord de Tabley); sale conducted by Christie's in Lord de Tabley's London house in Hill Street, 7 July 1827 (19) as 'Thames Lighter at Teddington' bought Sir Thomas Lawrence; sale Christie's 15 May 1830 (117) as 'Canal Scene with Barges' bought Penney; Pall Mall Gallery; sale Christie's 20 March 1838 (214) as 'The Lock—Glowing effect of Sunlight. From Lord de Tabley's Collection'—bought in; John Allnutt; Charles Macdonald of Cressbrook, sale Christie's 29 May 1855 (77) as 'Newark Castle' bought in; sale Christie's 5 June 1858 (51) bought Gregory; anon. sale Christie's 22 May 1868 (86) as 'Newark Abbey on the Vey' (the catalogue stated that it had been bought at Lawrence's sale by John Allnutt) bought Agnew and sold to Thomas Wool-

ner, R.A.; Kirkman Hodgson, M.P., from whom bought back by Agnew in 1893 and sold to James Orrock; bought back from him by Agnew in 1901 and sold to Sir Charles Tennant, Bt; by descent to the Hon. Colin Tennant from whom bought by Agnew in 1961 and sold to the present owners in 1962.

Exh. ?Turner's gallery 1807; Sir John Leicester's gallery 1819 (69); R.A. 1872 (145 lent by Woolner); R.A. 1894 (33 lent by Orrock); Guildhall 1899 (18); New Gallery 1900 (191); R.A. 1903 (31); Richmond 1963 (131); R.A. 1964–5 (182); Yale 1965 (199); Washington 1968–9 (6).

Lit. Young 1821 (no. 69, engr.); Ruskin 1843 (1903–12, iii, p. 267 as 'Sunset behind Willows'); Armstrong 1902, p. 226 (with incorrect measurements); Finberg 1961, pp. 134, 302, 468 no. 106, 478 no. 209; Hall 1960–62, pp. 120–21 nos. 98 and 99.

The view is painted from Pyrford Mill. A pencil study for the picture is in the 'Thames: from Reading to Walton' sketchbook (XCV) p. 27; other sketches of Newark Abbey, drawn from the other side, occur in the 'Wey, Guildford' sketchbook (XCVIII). For other oils of the subject, see nos. 191, 192 and 201.

The provenance of this picture contains a number of puzzles, deriving mainly from the different titles by which it has been known. In the 1821 catalogue of Sir John Leicester's collection, it is simply called 'On the Wey'. No such title occurs in the 1827 sale catalogue but Lot 19 is described as 'Thames Lighter at Teddington'. No such picture occurs in any of the catalogues of the Leicester collection. There seems no reason for this change of title but nonetheless it seems probable that they are one and the same picture.

Armstrong states that it was painted for Sir John Leicester but there seems to be no evidence for this and Armstrong's date of 1815 is certainly too late. Finberg conjectures that it may have been shown at Turner's gallery in 1807. This is certainly about the time that Sir John was most active as a buyer of Turner's work although there is no record of payment among the Tabley House papers, as there is for a number of his other purchases at this time. However, as noticed under the entry for *Walton Bridges* (see No. 60), the receipt of £280 for this picture seems too much for one picture of Turner's usual 36 × 48 size, so it may include a second picture. On the other hand, it seems too little for two 36 × 48 canvases, unless Sir John got a reduction as he may have done later with the two views of Tabley. The receipt for *Walton Bridges* does not mention another picture, however, and although stylistically *Newark* fits in quite well with other oils of this date, affinities with the *Windmill and Lock* (No. 101) of 1810, especially in the way the sky is painted, suggest the possibility that the *Newark* may be slightly later than 1806–7. Another picture relevant for purposes of comparison is the *Barge on the River* in the Tate Gallery (see No. 168), which is assigned to c. 1806–7 but which may also be a year or two later. For the dating of the '1807' Thames sketches, see pp. 104, 108.

66. Cliveden on Thames Exh. 1807? (Plate 70)

THE TATE GALLERY, LONDON (1180)

Canvas, 15⅛ × 23 (38·5 × 58·5)

Coll. . . .; Mrs E. Vaughan, bequeathed 1885 to the National Gallery; transferred to the Tate Gallery 1912.

Exh. ?Turner's gallery 1807; Tate Gallery 1931 (30).

Lit. Armstrong 1902, p. 220; Finberg 1961, pp. 134, 468 no. 107; Rothenstein and Butlin 1964, p. 26; Gage 1969, p. 38, pl. 41.

Benjamin West visited Turner's gallery on 5 May 1807 and told Farington that he 'was disgusted with what he found there; views on the Thames, crude blotches, nothing could be more vicious'. The Thames views shown in Turner's gallery the following year are known (see Nos. 70–73) and the relative immaturity of *Cliveden* supports Finberg's 'guess' that it was among the works shown in 1807. However, the frontality of the composition and the still slightly conventional Titianesque sky suggest that it could be even earlier, nearer in date to the Petworth *Windsor Castle from the Thames* of c. 1804–6 (No. 149) and before the two pictures of Walton Bridges probably exhibited in 1806 and 1807 (Nos. 60 and 63). The nearest parallel is *Hurley House on the Thames* (No. 197, q.v.); c.f. also the still smaller panel of *Newark Abbey* (No. 201).

67. The Mouth of the Thames Exh. 1807?
(Plate 69)

DESTROYED DURING 1939–45 WAR

Canvas (?), 12⅛ × 18 (30·8 × 45·7)

Coll. Bought by Agnew from Pennell in February 1864 and sold to William Holmes in September; L. Flatow; sale Christie's 9 June 1865 (53) bought Colnaghi; Hugh Lupus Grosvenor, first Duke of Westminster (1825–99) by 1868; by descent in Grosvenor family until destroyed by enemy action during Second World War.

Exh. ?Turner's gallery 1807; Leeds 1868 (1226); B.F.A.C. 1871 (43); R.A. 1871 (145); Wrexham 1876 (243); Grosvenor Gallery 1888 (111); *Centennial International Exhibition* Melbourne 1888; West Ham 1898.

Engr. In mezzotint by Frank Short, R.A.

Lit. *Catalogue of the Collection of Pictures at Grosvenor House* 1882, no. 120; Armstrong 1902, p. 231, where he states incorrectly that the picture was no longer in the Westminster collection; Finberg 1961, pp. 134, 464 no. 108.

The view showed the Isle of Sheppey in the distance. Finberg conjectures that this may have been

exhibited in Turner's gallery in 1807. There is no solid evidence for this beyond a report by Farington (*Diary* 5 May 1807) of a visit to Turner's gallery by Benjamin West as noted in the entry for No. 66.

68. A Country Blacksmith disputing upon the Price of Iron, and the Price charged to the Butcher for shoeing his Poney Exh. 1807 (Plate 56)

THE TATE GALLERY, LONDON (478)

Oil, $21\frac{5}{8} \times 30\frac{5}{8}$ (55×78), on pine $22\frac{5}{8} \times 31\frac{5}{8}$ (57.5×80.5)

Signed 'J M W Turner RA' lower left

Coll. Bought 1808 by Sir John Leicester, Bt, later first Lord de Tabley, sold Christie's 7 July 1827 (14) bought Turner; Turner Bequest 1856 (46, 'Blacksmiths Shop' $2'6\frac{1}{2}'' \times 1'10''$); transferred to the Tate Gallery 1910.

Exh. R.A. 1807 (135); Sir John Leicester's gallery 1819 and subsequent years (19); Tate Gallery 1931 (27); R.A. 1974–5 (133, repr.).

Lit. Farington *Diary* 7 April, 8 May, 11 May, 2 June and 19 June 1807; Carey 1819, pp. 56–7 no. 19; Young 1821, p. 9 no. 19 engr.; Allan Cunningham, *Life of Wilkie* 1843, i, pp. 143–4; Ruskin 1857 and 1857² (1903–12, xiii, pp. 156, 274–5 n.); Cunningham 1859, pp. 10–11; Thornbury 1862, i, p. 289; 1877, pp. 425–6; Bell 1901, p. 84 no. 109; Armstrong 1902, p. 218; MacColl 1920, p. 6; Whitley 1928, pp. 120–21, repr.; Falk 1938, pp. 83–4; Davies 1946, p. 186; Clare 1951, pp. 36–7, pl. 38; Finberg 1961, pp. 134–6, 302, 468 no. 110, 478 no. 204, pl. 10; Rothenstein and Butlin 1964, p. 20, pl. 29; Lindsay 1966, p. 100; Gage 1969, p. 243 n. 95; Reynolds 1969, pp. 62–4, pl. 43; Herrmann 1975, pp. 19, 228–9, pl. 52.

In this picture Turner was almost certainly inspired by the success of the young David Wilkie, ten years his junior, with his first exhibit at the R.A. the year before, *Village Politicians*, which is also in the Teniers manner. In 1807 Wilkie exhibited *The Blind Fiddler* (Tate Gallery; repr. illustrated souvenir *David Wilkie* R.A. 1958, pl. 5), also an interior, and visitors to the exhibition drew the obvious comparisons, some favouring Turner, others Wilkie.

Farington, apparently reporting Westall, who had seen the picture on 7 April 1807, noted that the 'small picture of the inside of a Farrier's Shop, is a very clever picture'. On 2 June he notes Marchi's opinion that 'Turner's *Forge*' was 'flimsy'. However Jameson told Farington on 11 May that he admired Turner's '*Forge*, which he thought finer colouring than the picture by Wilkie—warmer', and Smirke told him on 19 June that he thought the picture 'excellent'.

The *St. James Chronicle* for 9–12 May described the picture as displaying a 'Considerable share of humour. The attitudes of the disputants are highly natural'. On

the other hand the *Monthly Magazine*, 1 June, felt that the full title was 'rather too much to express in picture, nor is it reasonable to expect that such a story should be clearly told on canvas.' Nevertheless, according to the *Cabinet or Monthly Report of Polite Literature* for February–June, 'In this picture, art is certainly carried to a very considerable extent; to succeed in rendering such a scene so highly picturesque, must be attended with no little difficulty. There is a great variety of appropriate forms managed with infinite skill; and had the characters and expressions been sufficiently defined and varied to be equal to the colouring and effect, we should have pronounced it a perfect work.'

On 8 May Farington recorded that Sir George Beaumont 'sd. Sir John Leicester had told him that He had asked Turner the price of His picture of a Forge. Turner answered that He understood Wilkie was to have 100 guineas for *His Blind Fiddler* & He should not rate His picture at a less price.' Turner, as his receipt of 9 January 1808 shows, got his price. The painting returned to Turner's possession in 1827 when he bought it back for 140 guineas at the sale following the death of Sir John Leicester, later 1st Lord de Tabley.

There are a number of drawings of figures engaged in various indoor activities in the 'Hesperides (1)' sketchbook of *c.* 1805–7, one being used for this picture (XCIII-22 verso). A rebate round the edge shows that the picture was finished in its frame.

69. Sun rising through Vapour; Fishermen cleaning and selling Fish Exh. 1807 (Plate 57)

THE NATIONAL GALLERY, LONDON (479)

Canvas, $53 \times 70\frac{1}{2}$ (134.5×179); $\frac{1}{4}$ (1.0) is turned over on the left but there is the same amount of unpainted canvas on the right

Coll. Bought 1818 by Sir John Leicester, Bt, later Lord de Tabley, sold Christie's 7 July 1827 (46) bought Turner; Turner Bequest 1856.

Exh. R.A. 1807 (162); B.I. 1809 (269, 'Sun-rising through vapour, with fishermen landing and cleaning their fish'); Turner's gallery 1810 (1, 'Dutch Boats'); Sir John Leicester's gallery 1819 (7); Chicago, New York and Toronto 1946–7 (46, pl. 38); Moscow and Leningrad 1960 (52).

Lit. Farington *Diary* 7 April, 11 May, 19 June 1807 and 16 January 1819; Carey 1819, pp. 21–5 no. 7; Young 1825, p. 3 no. 7 engr.; Cunningham 1852, p. 24; Thornbury 1862, i, pp. 266, 270, 289–90; 1877, pp. 369–70, 375, 491; Hamerton 1879, pp. 98–100, 306–10; Bell 1901, pp. 84–5 no. 110; Armstrong 1902, pp. 104, 232; Whitley 1928, pp. 120–21; 1930, pp. 136–7, 282–3; Falk 1938, pp. 63, 94, 111–12; Davies 1946, pp. 147–8; Clare 1951, p. 37, repr. p. 40; H. F. Finberg 1951, p. 384; Davies 1959, pp. 95–6; Finberg 1961, pp. 125, 134–6, 172–3, 255, 302, 321, 331, 441, 468 no. 111, 478 no. 202, 512

nos. 149a and 157a, pl. 11; Hall 1962, pp. 93, 120; Rothenstein and Butlin 1964, pp. 10, 22, 26, pl. 28; R. B. Beckett (ed.), *John Constable's Correspondence* iii 1965, p. 58; Gage 1965, pp. 18 n.12, 23; Lindsay 1966, p. 100; Brill 1969, pp. 12–13, repr. p. 12; Herrmann 1975, pp. 13, 19, 227, pl. 27.

This is one of the four pictures offered to Sir John Leicester in a letter, accompanied by slight pen sketches, of 12 December 1810, where it was described as 'Dutch Boats. This (6ft. long, 5 ft. high) wants cleaning' (see Plate 194), but not sold to him until 1818, when, in a letter to Sir John Leicester of 16 December, Turner acknowledged receipt of £100 in part payment of 350 guineas and mentioned that he would arrange for W. R. Bigg to clean the picture, then already in Sir John's London home. On 16 January 1819 Bigg confirmed this transaction, and that he had cleaned the picture, in conversation with Farington. John Constable, writing to C. R. Leslie on 17 January 1832, mentions what may have been this picture, though his description suggests that his memory of the composition could not have been very accurate: 'I remember most of Turner's early pictures, as they came occasionally to be *rubbed out* at Mr. Biggs: I must say however, some of them came to him in a most miserable state of filth, shined on in haste for the exhibition. Amongst them was one of singular intricacy and beauty, it was a canal with numerous boats, making thousands of beautiful shapes, and I think the most complete work of genius I ever saw' (the identification is Beckett's; Finberg, on the other hand, suggests that the picture was the *Dort*, No. 137, *q.v.*).

Turner, in his letter to Sir John Leicester, continued, 'The description of the Picture was as follows. Dutch Boats and Fish Market—Sun Rising thro' Vapour— but if you think dispelling the Morning Haze or Mist better pray so name it.' Turner's original title for the R.A. in 1807 is that used for this entry, that for the 1809 B.I. is given above. Carey calls the picture 'Sun-rise, through a Mist', adding, 'This scene is supposed to represent a harbour on the coast of Holland; although the artist has not confined himself to the particulars of a local view. The shipping are built like those which were used by the Dutch towards the close of the sixteenth century.' Young's title is 'Dutch Fishing Boats: The Sun rising through Vapour', to which he adds, 'Being a View of a Harbour on the Coast of Holland.'

Farington, 7 April 1807, apparently reporting that Westall had seen the pictures submitted for the R.A. Exhibition, notes, 'Turner's large picture, a Sea piece is inferior to His former productions.' On the same day West told him that 'Turner has greatly fallen off in a large Sea piece. He seems to have run wild with conceit.' On 11 May 1807, however, 'Jameson called having been at the exhibition. He admired the picture of Boats by Turner', and on 19 June Farington reports of Smirke that 'Turner's picture of Boats . . . He thought excellent.'

The press was on the whole favourable, though the praise was sometimes qualified. For the *Monthly Magazine* for 1 June 1807 this picture and the *Blacksmith's Shop* (No. 68) were 'admirably painted, but not the better for their resemblance to Dutch pictures, which Mr. Turner has no occasion to imitate'. The critic of the *Cabinet or Monthly Report of Polite Literature*, February–June 1807, wrote that 'The general effect . . . is soft, harmonious, and beautiful; it does not possess quite so much rigour as we have observed in some other of this master's works, but it has a great deal of very excellent colour.' For the *St. James's Chronicle*, 9–12 May, 'This picture is without doubt one of the very best Mr. Turner has ever produced.'

In 1831, in his second will, Turner substituted this picture for *The Decline of the Carthaginian Empire* (No. 135) as one of the two works he bequeathed to the National Gallery to hang next to pictures by Claude (see No. 131).

There is a sketch, inscribed 'Study Calm', in the 'Calais Pier' sketchbook (LXXXI-40, repr. Herrmann 1975, pl. 26), as well as a number of other related drawings (LXXXI-24, 26 and 34). Also related is the study used for *Lake of Geneva* (No. 103) in the same sketchbook (LXXXI-20, repr. Wilkinson 1974, p. 58). For another, probably slightly later, picture entitled *The Sun rising through Vapour* see No. 95.

70. Union of the Thames and Isis Exh. 1808

THE TATE GALLERY, LONDON (462) (Plate 72)

Canvas, $35\frac{3}{4} \times 47\frac{3}{4}$ (91 × 121·5)

Insc. 'JMW Turner RA' lower left.

Coll. Turner Bequest 1856 (86, 'Cattle in Water' 4'0" × 3'0"), transferred to the Tate Gallery 1912.

Exh. Turner's gallery 1808; Turner's gallery 1809 (5); Tate Gallery 1931 (37); *The Thames in Art* Henley and Cheltenham, June–July 1967 (21); *Paintings of the Thames Valley* Reading Museum and Art Gallery, February–March 1968 (23).

Lit. Armstrong 1902, p. 224, as 'Landscape, with Cattle in Water'; MacColl 1920, p. 3; Whitley 1928, p. 140; Davies 1946, p. 187; Clare 1951, pp. 41–2; Finberg 1961, pp. 144, 468 no. 115, 469 no. 132.

This is the first of the pictures mentioned in the long account of Turner's gallery in the *Review of Publications of Art* for 1808, probably by John Landseer. It is described as 'a scene of Claude-like serenity, which is much to be admired for its exquisite colouring, picturesque groups of cattle, and the delicate management of the air tint which intervenes between the several distances. The negative grey by means of which this beautiful sweetness of gradation is accomplished, is with great art insensibly blended with, and in parts contrasted to, the positive and even rich colouring of the cows, . . . the plumage of the ducks and other

subjects on the foreground . . . That continuity of line which so often contributes to the *grandeur* of Mr. Turner's pictures, is here, in the wooden bridge, and in the ridge of distant hill, made subservient to a milder sentiment . . .'

71. The Thames at Eton Exh. 1808 (Plate 73)

H.M. TREASURY AND THE NATIONAL TRUST (Lord Egremont Collection) PETWORTH HOUSE

Canvas, $23\frac{1}{2} \times 35\frac{1}{2}$ (59·5 × 90)

Coll. Bought by Lord Egremont perhaps from the exhibition in Turner's gallery in 1808; by descent to the third Lord Leconfield, who in 1947 conveyed Petworth to the National Trust; in 1957 the contents of the State Rooms were accepted by the Treasury in part payment of death duties.

Exh. Turner's gallery 1808; Eton College *Quincentenary Exhibition* 1947 (28); Tate Gallery 1951 (8); Brussels 1973 (65).

Lit. Petworth Inventories 1837, 1856 (North Gallery); Burnet and Cunningham 1852, p. 44; Waagen 1854, iii, p. 38; Thornbury 1862, ii, pp. 5, 397; 1877, pp. 199, 200, 594; Armstrong 1902, p. 221 (with incorrect size) repr. p. vii; Collins Baker 1920, p. 124 no. 108; Finberg 1961, pp. 144, 149, 468 no. 116; Kitson 1964, p. 78, repr. p. 43; Rothenstein and Butlin 1964, p. 26, pl. 37; Reynolds 1969, p. 74.

We owe our knowledge that this picture was shown by Turner in his gallery in 1808 to a lengthy review of the exhibition by John Landseer (?) in the *Review of Publications of Art* for June 1808. Twelve pictures are described in some detail, of which this is the second, referred to as 'Eton College'. Landseer stresses the 'stately dignity' of the picture and says this effect is maintained by the introduction of a group of swans. Not surprisingly the review quotes from Thomas Gray's *Ode on a Distant Prospect of Eton College*. Landseer ends his discussion of this picture by referring to the recently issued Prospectus for the *Liber Studiorum* and asking into which classification of landscape Mr Turner would assign this picture.

On 8 May the *Examiner* announced the purchase by Lord Egremont of *The Forest of Bere* (No. 77) from Turner's gallery but, as Finberg points out, the exhibition had then only been running for a little over two weeks, and there is no reason why Lord Egremont should not have bought further pictures later in the course of the exhibition. Indeed, as four pictures in all of those shown in 1808 are now at Petworth, it seems more likely that he bought the other three during the course of the exhibition rather than after it closed, but there is no evidence about this either way.

A number of drawings of Eton occur in the 'Windsor, Eaton' sketchbook (XCVII) but none is closely connected with this composition.

The figures in the punt on the left have a markedly Dutch look about them, deriving perhaps from the figures in Van Goyen's 'riverscapes'. Turner was to introduce Van Goyen into the title of one of his exhibited pictures twenty-five years later (see No. 350).

72. Pope's Villa at Twickenham Exh. 1808
 (Plate 60)

TRUSTEES OF THE WALTER MORRISON PICTURE SETTLEMENT

Canvas, $36 \times 47\frac{1}{2}$ (91·5 × 120·6)

Signed 'I M W Turner RA PP' lower left (Plate 538)

Coll. Bought by Sir John Leicester (created Lord de Tabley in 1826) from Turner's gallery in 1808; sale by Christie's in Lord de Tabley's house in Hill Street, 7 July 1827 (24) bought James Morrison (he paid 5 guineas more for it than it had cost Sir John Leicester in 1808); by descent to the present owners.

Exh. Turner's gallery 1808; Sir John Leicester's gallery 1819 (17); International Exhibition 1862 (334); R.A. 1882 (175); Grosvenor Gallery 1889 (41) and 1914–15 (72); *Country Life* Exhibition, 1937 (uncatalogued); R.A. 1974–5 (148).

Engr. By John Pye (figures by C. Heath), for Britton's *Fine Arts of the English School* 1811.

Lit. Carey 1819 (17); Young 1821 (17, engr.); Waagen 1857, iv, p. 302; Thornbury 1862, ii, pp. 235–6; 1877, p. 333; Armstrong 1902, p. 227; C. F. Bell, 'Turner and his Engravers', *The Genius of Turner* 1903, p. iv; Rawlinson i 1908, pp. xxv–vi, 33; Clare 1951, p. 82; Livermore 1957, pp. 78–86; Finberg 1961, pp. 144–5, 149, 157, 184, 302, 468, 478 no. 203; Hall 1960–62, pp. 93, 120 no. 93; Lindsay 1966, p. 128; Gage 1969, p. 42, pl. 43 (engraving).

Sir John Leicester's purchase of this picture is recorded in the *Examiner* for 8 May 1808. Turner's receipt for 200 guineas for 'Pope's House' is dated 1 September 1808 and is among the Tabley House papers.

The picture refers to the demolition of Pope's villa which took place in 1807 on the orders of Baroness Howe who built a new house in its place.

In the *Review of Publications of Art*, June 1808, John Landseer (?) describes and praises this picture at length on pp. 155–9. He adds as if by way of a sub-title: 'during its dilapidation, and as seen from the Middlesex bank of the river, or perhaps (as we conjecture) from one of the Twickenham ayts: probably that which lies off the grounds of Strawberry Hill'. It is clear from his notice that he perceived—and was in sympathy with—the reasons which led to Turner's choice of this subject. He calls it 'serenely pensive: "far from all resort of mirth" yet still farther from gloom . . . At such a time the mind willingly enthralled by a certain feeling of melancholy pleasure, is instinctively led to compare the permanency of Nature herself with the fluctuations of

fashion and the vicissitudes of taste . . . and not even the taste, the genius and the reputation of Pope could retard the operations of Time, the irksomeness of satiety, and the consequent desire of change!' Landseer continues by reflecting that 'At least it should mitigate our regret, that the pencil of Turner has rescued the Villa of Pope from the oblivion in which other mansions which have from time to time adorned the borders of the Thames, have been suffered to sink.' The review concludes: 'In adding this picture to his collection Sir John Leicester has added much to his former reputation as a tasteful collector of modern art.'

There is a poem by Turner 'On the demolition of Pope's villa at Twickenham' which occurs in Turner's verse-book of 1808 and which is published in full by Ann Livermore and Jack Lindsay (1966² p. 117). It begins:

'Dear Sister Isis tis thy Thames that calls
See desolation hovers o'er those walls
The scatter'd timbers on my margin lays
Where glimmering Evening's ray yet lingering plays.'

An earlier and less complete draft, 'Invocation of Thames to the Seasons—upon the Demolition of Pope's House', occurs in the 'Greenwich' sketchbook (CII p. 11 verso et seq.). For a picture on a similar theme, see No. 86.

In his biography of Turner, Lindsay suggests that the 'pastoral lovers' in the left foreground of this picture were the forerunners of Turner's *Dido and Æneas* (1814, see No. 129) and that Pope's Grotto, mentioned frequently in a later poem of 1812–13, becomes merged in Turner's imagination with the cave where, according to Virgil, the lovers met.

This later poem may owe its origins to the correspondence Turner had late in 1811 with John Britton about the letterpress which was to accompany the publication of the engraving of *Pope's Villa*. Britton ended his caption by quoting some lines from Robert Dodsley's (1703–1764) poem 'The Cave of Pope. A Prophesy', and Turner asks in his letter 'Why say the Poet and Prophet are not often united? for if they are not they ought to be. Therefore the solitary instance of Dodsley acts as a *censure*'.

This was the first engraving made for Turner by John Pye. When Turner saw the proof, he said to Pye 'You can see the lights; had I known there was a man living could have done that, I would have had it done before'.

Turner was elected Professor of Perspective at the R.A. in December 1807, so this picture must be one of the first with 'PP' added to his usual signature.

73. View of Richmond Hill and Bridge Exh. 1808
(Plate 74)

THE TATE GALLERY, LONDON (557)

Canvas, 36 × 48 (81·5 × 122)

Coll. Turner Bequest 1856 (87, 'Richmond Bridge' 4′0″ × 3′0″); transferred to the Tate Gallery 1929.

Exh. Turner's gallery 1808; Tate Gallery 1931 (32); Venice and Rome 1948 (15, repr.); Rotterdam 1955 (52, repr.); *Historic Richmond* Town Hall, Richmond, Surrey, August–September 1959 (53); Australian tour 1960 (5).

Lit. Thornbury 1862, i, p. 349; 1877, p. 467; Armstrong 1902, p. 227; Whitley 1928, p. 140; Davies 1946, p. 187.

There are general views of the same scene in the 'Shipwreck (No. 2)' and 'Thames from Reading to Walton' sketchbooks (LXXXVIII-14, running onto 15, and XCV-24). The 'Hesperides (1)' sketchbook contains two composition sketches for the picture, and a figure study related to that closest to the final picture (XCIII-35 verso, 37 verso and 38 respectively).

John Landseer (?) described this picture among those shown by Turner in his gallery in 1808 in the *Review of Publications of Art* for that year: Turner's 'view of *Richmond Hill and Bridge* is taken from the Surry [*sic*] bank, looking up the Thames . . . The most conspicuous feature in the picture is Richmond Bridge, of which, the sun being low in the horizon, the Surry end is faintly overshadowed. By obscuring the detail of Richmond itself in the mistiness of the morning; by introducing some sheep, and the simple incident of women bathing a child near the foreground—an incident which we deem worthy of the pastoral Muse of painting, and which, had it been met with in the morning pastorals of Theocritus, would have called forth general admiration—Mr. Turner has given a pastoral character to a scene of polished and princely retirement . . . We feel delighted with the effects which we here behold "of incense breathing morn". The indistinct distance of mingled groves and edifices with which Mr. Turner here presents us, leaves the imagination to wander over Richmond, and finish the picture from the suggestions of the painter, where another artist would have exhausted his subject, and perhaps the patience of his observers, by the attention which he would have required to the minute accuracy of his distant detail.'

Finberg, in a note now in the British Museum, suggested that the centre of the picture was worked on by Turner at a later date, and indeed the sky does seem to have been painted up to the edges of the more thinly painted trees, but Landseer's review suggests that the effect of the rising sun low over the hills was already there in 1808.

This picture was priced at £200 in a note, probably of *c*. 1810, in Turner's 'Finance' sketchbook (CXXII-36; for the date see Nos. 53 and 56).

74. Purfleet and the Essex Shore as seen from Long Reach Exh. 1808 (Plate 75)

PRIVATE COLLECTION, BELGIUM

Canvas, 36 × 48 (91·4 × 122)

Signed and dated 'J M W Turner RA PP 1808' bottom right

Coll. Bought by the Earl of Essex from Turner's gallery in 1808; sale, 'Modern Pictures from Cassiobury Park collected early in the century by George, 5th Earl of Essex', Christie's 22 July 1893 (48) bought in; John H. McFadden, Philadelphia by 1899; George J. Gould, Lakewood, New Jersey by 1900; Alister McDonald sale Christie's 1 June 1945 (65) bought Goris; Baron C. E. Janssen, Brussels, from whom purchased by the present owner.

Exh. Turner's gallery 1808; Manchester 1857 (609 as 'Seapiece'); R.A. 1884 (212); Agnew 1895 (19); Guildhall 1899 (15); Paris 1900 (47 lent by George Gould).

Lit. Farington *Diary* 5 July 1809; Armstrong 1902, p. 230, repr. facing p. 76; Finberg 1961, pp. 145, 149, 173n., 469 no. 119.

Lord Essex' purchase of this picture was reported in the *Examiner* for 8 May 1808: 'At Mr. Turner's private Gallery . . . the *Purfleet* has been bought by Lord Essex . . . We think his *Purfleet* and *View of Sheerness* the finest sea-pieces ever painted by a British Artist.' A letter from Lord Essex to Turner, written from Cassiobury on 10 June 1808 and preserved in the Turner Bequest (CXX-l), states that Lord Essex has sent a packing case for the picture 'and I will send for it tomorrow Sennight to your house'.

In the *Review of Publications of Art* for June 1808 John Landseer (?) discusses this picture together with two other seapieces also exhibited, *Sheerness as seen from the Nore* (No. 76) and the *Confluence of the Thames and Medway* (No. 75). Landseer writes that those who have sailed down the Thames will probably remember the strips of land which appear in the background of these three pictures 'as little more than mere threads of distance: yet in Mr. Turner's pictures of these subjects, they answer important purposes. They serve, by identifying the several spots represented, to give names to the pictures, and connect them with a series; their horizontal lines impart a certain degree of steadiness which the painter values in his composition; they contrast the upright lines of his masts and rigging, and the undulating forms of his wide-weltering waves, and they serve as a foundation for the rolling clouds of his gathering tempests or the raving zigzaggery of those which the tempest has broken over the landscape.

'. . . Gloomy, deep-toned shadows, sweep across the Purfleet picture, and that of the Union of the Thames and the Medway, and with so much of the truth of Nature as awakens kindred recollections, and causes the spectator to imagine he hears the attendant gusts of wind; and it may be remarked of the former picture, that Long Reach is so known to be exposed to every wind of the compass, that rough water is a marked characteristic of the scene.'

As in the case of other Turner paintings, the title of this picture when first exhibited seems to have been forgotten, and in subsequent sales and exhibitions it was called either simply 'Seapiece' (1857 Exhibition) or 'The Nore' (1884, 1899, 1945). This led Armstrong to confuse it with the *Shoeburyness* now in the National Gallery of Canada (No. 85). Finberg suggested the identification of Mr Gould's seapiece 'The Nore' with this picture which is confirmed by the description in the catalogue of the winter exhibition at the R.A. in 1884.

Farington records a visit which he paid to Cassiobury on 5 July 1809 in the company of Hearne and Edridge. It was on this occasion that Hearne said that Turner's seapiece was 'raw'.

The compiler has not seen the original.

75. The Confluence of the Thames and the Medway Exh. 1808 (Plate 58)

H.M. TREASURY AND THE NATIONAL TRUST (Lord Egremont Collection) PETWORTH HOUSE

Canvas, 35 × 47 (89 × 119·4)

Signed 'J M W Turner RA fe' lower right

Coll. Bought by the Earl of Egremont probably from Turner's gallery in 1808; by descent to the third Lord Leconfield who in 1947 conveyed Petworth to the National Trust; in 1957 the contents of the State Rooms were accepted by the Treasury in part payment of death duties.

Exh. Turner's gallery 1808; Tate Gallery 1951 (17 as 'Sheerness').

Lit. Petworth Inventories 1837, 1856 (London House); Collins Baker 1920, p. 126 no. 665; Clare 1951, p. 41; Finberg 1961, pp. 145–6, 149, 469 no. 120.

Although described as 'Sheerness' as early as 1837, this seems to be another example of Turner's pictures soon losing the titles under which they were originally exhibited. Further confusion has arisen because *The Junction of the Thames and the Medway* (No. 62) has virtually the same title and is of much the same date. However, the description of the picture (exhibited in 1808 under the above title) given by John Landseer (?) in *Review of Publications of Art*, pp. 163–4, fits this picture exactly and there can no longer be any reasonable doubt that the identification is correct.

Landseer devotes some space to a general description of the three Thames seapieces exhibited, as noted in the entry for No. 74. Writing specifically about this picture, he praises the 'considerable technical knowledge of marine affairs' displayed in the painting of the ships and their rigging. 'This *Knowledge* is always traceable in

Mr. Turner's pictures, and we wish we could more frequently say the same of his *care*.' He goes on to describe it as being 'altogether much more carefully painted than *Sheerness from the Nore* [No. 76] . . . and its prevailing freshness, and cool and silvery tone, form an agreeable contrast with the rich, golden-toned *View in the Forest of Bere* [No. 77] which hangs alongside.' It is interesting that Landseer comments upon the picture's freshness as it is certainly painted in a higher key than other seapieces of this date and is unusual in having patches of green pigment, of quite a light tone, among the waves.

A watercolour on p. 41 in the 'Hesperides (1)' sketchbook (XCIII) shows a hoy crossing and partly masking a man of war in the same way as shown in this picture although the watercolour contains additional boats that do not appear in the oil. A drawing of fishing boats on p. 32 of the 'River and Margate' sketchbook (XCIX) may also possibly be connected.

76. Sheerness as seen from the Nore Exh. 1808
(Plate 59)

THE LOYD COLLECTION

Canvas, 41½ × 59 (105·4 × 149·8)

Coll. (?) Samuel Dobree (1759–1827), see below; H. H. Dobree; sale Christie's 17 June 1842 (12) bought Crockford, who sold it to Bryant (according to a note in the Dobree sale catalogue in the Courtauld Institute) for whom bought by Sir Thomas Baring; sale Christie's 2 June 1848 (61) bought William Wells of Redleaf; sale Christie's 10 May 1890 (72) bought Agnew from whom bought by Lord Wantage; by descent to the present owner.

Exh. Turner's gallery 1808; B.I. 1852 (145 as 'A Seapiece'); Manchester 1857 (228, as 'Sunrise, Men-of-War at the Mouth of the Thames'); R.A. 1875 (91) and 1891 (36); Agnew 1897 (20); Guildhall 1899 (16); R.A. 1910 (138); Tate Gallery 1931 (38); Birmingham City Art Gallery (on loan) 1945–52; Agnew 1956 (3).

Lit. Armstrong 1902, pp. 53, 230, repr. facing p. 52; Temple 1902, pp. 155–6 no. 238; Finberg 1910, pp. 52–4, 96; *Guide to the Pictures at Lockinge House* 1928, p. 12; H. F. Finberg 1953, p. 99; Finberg 1961, pp. 145–6, 149, 421, 469 no. 121; Rothenstein and Butlin 1964, pp. 24, 28, colour pl. iv; Parris 1967, p. 42 no. 60 repr.; Gage 1969, p. 57.

Praised in the *Examiner* 8 May (together with *Purfleet*, see No. 74) as 'the finest sea-pieces ever painted by a British Artist'. This was included in a notice reporting the sale of three pictures 'at Mr. Turner's private gallery'. Finberg seems to have been mistaken in inferring that this picture was also sold at the same time 'to an unknown buyer' as I cannot discover any evidence for this. Going a stage further, Mrs Finberg

suggests that the buyer may well have been Samuel Dobree (1759–1827). The fact that the picture was included in H. H. (Samuel's son) Dobree's sale in 1842 points strongly to the assumption that he inherited the picture from his father who was certainly an important early patron of Turner and who acquired a number of other seascapes by the artist in and around 1804 (Nos. 52 and 144).

Nevertheless, the evidence for Samuel Dobree owning this picture is at present only circumstantial. According to Mrs Finberg, Turner left a bid for the picture at the 1842 sale but it was unsuccessful. However, Christie's catalogue of the sale has no record of such a bid as, for instance, it has in the case of Lot 10 (*Margate Pier*, see No. 51).

The picture is mentioned in John Landseer's (?) notice of the exhibition at Turner's gallery in the *Review of Publications of Art* for June 1808. After some general remarks on the three pictures of Thames subjects (see No. 74), Landseer remarks that beside the carefully painted *Confluence of the Thames and Medway* (No. 75) the *Sheerness* seems 'almost everywhere to want finishing' with a note appended, 'Unless its representing a sunrise should be thought sufficiently to account for this unfinished appearance, which in our estimation it does not.'

Armstrong's dating of 1808–10 is perhaps due to confusion with *The Guardship at the Nore* (No. 91) shown at Turner's gallery in both 1809 and 1810. Nor is Armstrong's comparison with the lost *Leader Seapiece* (No. 205), through the engraving in the *Liber Studiorum* (Rawlinson 20), really relevant, as the compositions have several marked differences.

77. The Forest of Bere Exh. 1808
(Plate 61)

H.M. TREASURY AND THE NATIONAL TRUST (Lord Egremont Collection) PETWORTH HOUSE

Canvas, 35 × 47 (88·9 × 119·4)

Signed '. . . Turner R A' at bottom, right of centre

Coll. Bought by Lord Egremont from Turner's gallery in 1808; by descent to the third Lord Leconfield who in 1947 conveyed Petworth to the National Trust; in 1957 the contents of the State Rooms were accepted by the Treasury in part payment of death duties.

Exh. Turner's gallery 1808; R.A. 1871 (235) and 1888 (7); Agnew 1967 (7); R.A. 1974–5 (149).

Lit. Petworth Inventories 1837, 1856 (North Gallery); Waagen 1854, iii, p. 37 as 'Landscape, Cows and Water'; Thornbury 1862, i, p. 14; ii, p. 397; 1877, pp. 199, 202, 594; Armstrong 1902, p. 227 as 'Pool with Willows—Evening'; Collins Baker 1920, p. 124 no. 39 as 'Evening—the Drinking Pool'; Whitley 1928, p. 140; Finberg 1961, pp. 146, 149, 469 no. 122; Herrmann 1975, pp. 19, 229, pl. 54.

A study of a grey pony in the 'River' sketchbook (XCVI

p. 45 verso) is probably connected with this picture.

The Forest of Bere is a few miles north of Havant. Turner had passed through it on his way to Portsmouth in October 1807 to watch the arrival of Stanhope's squadron after the surrender of the Danish fleet at Copenhagen (see No. 80, also exhibited at Turner's gallery in 1808 but in an unfinished state).

The figures in the left foreground are engaged in barking chestnut branches for caulking and tanning, an activity that was practised on Lord Egremont's estates, which included the Forest of Bere. In introducing these figures engaged thus into his picture, Turner may have hoped that this would recommend it to Lord Egremont. If so, his ingenuity succeeded, for the purchase of this picture by Lord Egremont was reported in the *Examiner* on 8 May 1808. Despite the painting going straight from Turner's gallery to Petworth, it was soon shorn of its exhibition title but there can be no doubt at all of its identification after reading John Landseer's (?) detailed description of it in the *Review of Publications of Art* for June 1808.

Landseer praised the picture warmly, writing that 'Though it is nothing as a subject, it is everything as a picture', relying for its effect on 'the rich and harmonious union of its parts'. He concluded 'Cuyp has long enjoyed a well-deserved celebrity, for making a few cattle and a setting sun the subject of an admirable picture. The pride of Cuyp . . . would be humbled, we conceive, by a too near approach to this picture of Turner'.

In fact, the picture shows signs of the influence of Rubens' landscapes, which Turner was to criticise in one of his lectures as taking liberties with lighting which destroyed 'the simplicity, the truth, the beauty of pastoral nature'. As well as Rubens, there are echoes of both Gainsborough and Crome in the picture, which, however, remains one of Turner's most unaffected (as well as his most sylvan) paintings. It is thus characteristic of the moment it was painted, when landscape painting in England was on the threshold of a more naturalistic phase, which was to last throughout the coming decade. And, as the catalogue of the Turner Bicentenary Exhibition suggested, this 'return to nature' in Turner's case may well have been the result of the experience of painting out-of-doors, an activity which Turner had recently been practising in his series of sketches of Thames subjects (see Nos. 160–94).

78. Margate Exh. 1808 (Plate 76)

H.M. TREASURY AND THE NATIONAL TRUST (Lord Egremont Collection) PETWORTH HOUSE

Canvas, $35\frac{1}{2} \times 47\frac{1}{2}$ (90·1 × 120·6)

Coll. Bought by Lord Egremont perhaps from Turner's gallery in 1808; by descent to the third Lord Leconfield who in 1947 conveyed Petworth to the National Trust; in 1957 the contents of the State Rooms were accepted by the Treasury in part payment of death duties.

Exh. Turner's gallery 1808; Tate Gallery 1951 (18) as 'Seapiece, probably Hastings'.

Lit. Petworth Inventories 1837, 1856 (London House); Armstrong 1902, p. 237; Collins Baker 1920, p. 126 no. 672; Finberg 1961, pp. 147, 469 no. 123.

This is another example of Turner's title for a picture getting lost. In the 1856 Petworth Inventory it was listed simply as 'Seapiece'. Armstrong catalogued it as 'Whitby (?) from the Sea' and Collins Baker, misled no doubt by the fishing smack on the left having 'Hastings' on its stern, assumed that the scene represented was Hastings.

The identification of this picture with the 'Margate' exhibited in 1808, rests on John Landseer's (?) description of it in the *Review of Publications of Art*, June 1808. Landseer writes as follows:

'We had not imagined that any VIEW of MARGATE, under any circumstances, would have made a picture of so much importance as that which Mr. Turner has painted of this subject: but, by introducing a rising sun and a rough sea; by keeping the town of Margate itself in a morning mist from which the pier is emerging; and by treating the cliffs as a bold promontory in shade, he has produced a grand picture; and (while he contrasts the prevailing horizontal forms of the composition by the lines of upright masts and rigging) has given a special interest to his fore-ground by introducing the local incident of Margate wherries hailing and stopping a Hastings boat on her way to the London market, to purchase fish . . . The detail of the town and cliffs, being lost at the early hour which is represented, in the mistiness of the morning, and only the bolder forms being discernible, Margate acquires a grandeur we should in vain look for at any other time and under any other circumstances. The mill and brewery on the summit of the cliff behind which the sun is rising, from their general forms alone being visible become objects of great interest in the landscape—appearing like magnificent temples.'

The main discrepancy between this description and the picture itself is that in the latter no pier is discernible 'emerging from the morning mist' but there is perhaps the suspicion of a projecting quay which may have misled Landseer. Nor could the sea be fairly described as rough; Armstrong calls it 'fresh' which seems more accurate. Against this, the incident in the foreground of the Hastings fishing smack and the Margate wherries surely provides the crucial evidence which must override all reasonable doubts about identifying this picture with the 'Margate' exhibited in 1808. The picture must have darkened a good deal, especially in the water, since it was painted, and this may account for certain features mentioned by Landseer being less easily discernible today.

79. A Subject from the Runic Superstitions (?); Reworking of 'Rispah watching the Bodies of her Sons' Exh. 1808? (Plate 77)

THE TATE GALLERY, LONDON (464)

Canvas, $36\frac{1}{4} \times 48$ (91·5 × 122)

Coll. Turner Bequest 1856 (82, 'Rizpah' 4′0″ × 3′0″); transferred to the Tate Gallery 1910.

Exh. ?Turner's gallery 1808 (see text); Tate Gallery 1931 (12); R.A. 1974–5 (85).

Engr. By R. Dunkarton for the *Liber Studiorum*, R. 46, and published 23 April 1812; the preliminary pen and sepia drawing from the Vaughan Bequest is catalogued with the Turner Bequest as CXVII-U and repr. Finberg 1924, p. 182; the etching and engraving repr. pp. 182–3.

Lit. Ruskin 1856, 1860 and 1857 (1903–12, v, p. 399; vi, p. 26; vii, p. 386; xiii, p. 119); Thornbury 1862, i, pp. 262, 277–8; ii, p. 332; 1877, pp. 418, 497, 530–31; Armstrong 1902, p. 228; MacColl 1920, p. 3; Finberg 1924, p. 183; Davies 1946, p. 187; Finberg 1961, pp. 142, 147; Gage 1969, p. 56, pl. 46.

This picture seems originally to have shown 'Rispah watching the Bodies of her Sons' (2 Samuel xxi, 9–10) and was engraved under this title for the *Liber Studiorum*. In the engraving Rispah is shown protecting the bodies of her two sons by Saul from predatory birds and beasts 'in the days of the harvest, in the first days, in the beginning of the barley harvest' (see Plate 546).

Subsequent to the preparation of the *Liber Studiorum* engraving, which could have been at least begun any time after the scheme was first mooted in 1806, Turner overpainted the oil painting, replacing the bodies of Rispah's sons by enormous insects dragging off the bodies of other creatures, adding another female figure behind that of Rispah and introducing several spectral figures and a mysteriously glowing light on the right. The subject now seems to be a scene of incantation, possibly suggested by the encounter of Saul and the Witch of Endor during which the ghost of Samuel foretold the death of Saul and his sons (1 Samuel xxvii, 8–20). However, though one of the apparitions could well be Samuel, 'covered with a mantle', and the others include a soldier about to slay with a sword a child held by another, the putative Saul is a woman with bare breasts.

What was almost certainly this picture was shown at Turner's gallery in 1808 when it was described in the *Review of Publications of Art* ii, pp. 166–7. The reviewer, who seems to have been John Landseer, was obviously baffled by the subject which had presumably already been altered by Turner: 'Of an unfinished picture which hangs at the upper end of the room, the subject of which is taken from the Runic superstitions, and where the artist has conjured up mysterious spectres and chimeras dire, we forbear to speak at present.

'At the lower end of the room is a larger picture of two of the DANISH SHIPS which were seized at COPENHAGEN [see No. 80] . . .'

80. Spithead: Boat's Crew recovering an Anchor Exh. 1808 (Plate 63)

THE TATE GALLERY, LONDON (481)

Canvas, $67\frac{1}{2} \times 92\frac{5}{8}$ (171·5 × 235)

Coll. Turner Bequest 1856 (62, 'Boat's Crew running an anchor' 7′7″ × 5′9″ —see below); transferred to the Tate Gallery 1949.

Exh. Turner's gallery 1808; R.A. 1809 (22); Turner's gallery 1810 (16); Tate Gallery 1931 (26, repr.).

Lit. Thornbury 1862, i, pp. 292–3; 1877, p. 429; Bell 1901, pp. 86–7 no. 113; Armstrong 1902, pp. 56, 231, repr. facing p. 66; Finberg 1910, pp. 53–4, 60; Whitley 1928, pp. 144, 146; Davies 1946, pp. 148, 187; H. F. Finberg 1951, pp. 384, 386; Finberg 1961, pp. 138, 147–8, 158–9, 171, 469 no. 125, 471 no. 146, 513 no. 157l; Rothenstein and Butlin 1964, p. 30, pl. 39; Lindsay 1966, p. 101; Gaunt 1971, p. 9.

In the 1854 Schedule of the Turner Bequest the size was first left blank and subsequently entered in pencil. In the 1856 Schedule 'running' was replaced on the manuscript by Wornum by 'recovering'.

Described, almost certainly by John Landseer, in the *Review of Publications of Art* 1808 as 'a larger picture [than that of 'Runic superstitions', No. 79] of two of the DANISH SHIPS which were seized at COPENHAGEN, entering Portsmouth Harbour, where Mr. Turner again displays with his powers as a painter, his great and various knowledge, and talent for marine composition'. The Danish fleet had surrendered on 7 September 1807 and on 14 October the first detachment set sail for England with an English escort. Turner went especially to Portsmouth to witness the arrival of the squadron, but unfortunately it was dispersed by bad weather, some ships arriving on 30 October, others on 1 November. Turner shows the two ships that arrived on the latter date, the *Three Crowns* and the *Denmark*. There are a number of on-the-spot drawings in the 'Spithead' sketchbook (C-1 to 18, 27 to 30).

By 1809, when the picture was exhibited at the R.A., there was such a political outcry against the Danish operation that Turner seems to have thought it expedient to change the title of the picture to 'Spithead: Boat's crew recovering an anchor'. Nobody seems to have noticed the original subject, or the Dutch flags flown below the English as a sign of submission, and indeed Robert Hunt, writing in the *Examiner*, referred to the ships as being English (Finberg 1961, p. 159, gives the date of the review as June 1809, but it cannot now be traced). In 1810 the picture was exhibited once again at Turner's gallery as 'Spithead'. On this last

occasion it aroused no critical interest in the press, but in 1809 it was generally praised by 'Anthony Pasquin' (John Williams): 'This is one of the most perfect performances in the Exhibition, and in every point of view worthy of the Artist who traced it . . . Mr. Turner appears to have taken Backhysen as his model; at any rate, his manner, if not imitative of that great naval painter, possesses a similar direction both in composition and colouring. When Mr. Turner first became noticeable for his talents, he seemed more desirous of surprising us, by his bold eccentricities, than of pleasing us by the chastity of his arrangements . . . but he now seems disposed to reform those excesses and flights of imagination, and fall back, like a true soldier, into the ranks of reason. We cannot dismiss this subject without observing that the transparency of the water, in this view, is beautifully managed; and Mr. Turner may become, if he pleases, the first marine painter in the world; he has more correctness, though less brilliancy, than Vernet, and appears to regard nature with an eye so keenly inquisitorial, that his representations must be valuable, provided that his fancy is not permitted to neutralize the effort' (*Morning Herald*, 4 May 1809). On the other hand Farington, dining with Mr Augustus Phipps on 30 April 1809 recorded Mrs Phipps' opinion: 'The water in His [Turner's] large sea piece she thought not like water, not liquid, and in all His pictures there is a want of finishing.'

This picture was priced at £400 in a note, probably of *c*. 1810, in Turner's 'Finance' sketchbook (CXXII-36; for the date see Nos. 53 and 56).

81. The Unpaid Bill, or the Dentist reproving his Son's Prodigality Exh. 1808 (Plate 64)

DENNIS LENNOX ESQ.

Panel, 23⅜ × 31½ (59·4 × 80)

Coll. Painted for Richard Payne Knight (1750–1824) as a pendant to his Rembrandt of *The Cradle* (which is also on panel, and of virtually identical size and which was lent in 1808 to the British Institution for copying, see Plate 547); the Turner has remained in the possession of Payne Knight's heirs ever since.

Exh. R.A. 1808 (116); R.A. 1882 (30).

Lit. Burnet and Cunningham 1852, p. 112 no. 90; Thornbury 1877, p. 571; Bell 1901, p. 85 no. 111; Armstrong 1902, p. 234; Whitley 1928, p. 140; Finberg 1961, pp. 150, 468 no. 114; Gage 1965, pp. 76–7; Lindsay 1966, p. 133; Gage 1969, pp. 89, 136, 271; Reynolds 1969, pp. 62, 127; Gage 1972, p. 49, fig. 28.

Below the open medicine cabinet on the wall on the left is pinned a sheet of paper on which is written 'College of physici[ans]. This is to certify . . .' (the rest is unfortunately illegible apart from the word 'duty'). The certificate has two signatures, both followed by 'M.D.'

Among a folder of papers on the floor behind the dentist's chair and next to the stool with a round top is a sheet, half pulled out, on which the words 'Tooth drawn' are visible.

Preparatory drawings exist in the 'River and Margate' sketchbook (XCIX pp. 73, 74, 75 verso, 77 verso), and CXCV(a)-I. They show that Turner originally intended the boy to stand on the right of his parents but later altered his position to standing between them. Turner also experimented with different poses for the mother. CXCV(a)-I, although now bound in the same sketchbook as the others, is less certainly connected with this picture, although it does show the saw hanging on the wall in the same place as in the drawing on p. 77 verso.

Richard Payne Knight was one of the leading connoisseurs and arbiters of taste of his time (despite his advice to the Government, happily unheeded, not to purchase the Elgin marbles).

Farington records in his *Diary* on 11 February 1808 that it was Payne Knight's ambition to build up a collection of contemporary paintings to show 'that the moderns can stand up to the Old Masters'. It was no doubt a challenge that Turner welcomed, for Rembrandt was an artist whom Turner had long admired, and indeed would continue to do so all his life.

Apart from relishing the honour of being accorded almost Old Master status by this commission, Turner must also have enjoyed the opportunity to try to outshine a contemporary rival, David Wilkie, in tackling a subject which required the portrayal of an interior in a manner which Wilkie had made his especial province.

The commission was noted in the *Examiner* for 15 May 1808 and seems to have been conceived by Payne Knight in terms of providing a 'ridiculous' companion to his 'sublime' Rembrandt, although the true subject of the latter—*The Holy Family*—seems not to have been recognised at the time and it was known simply as *The Cradle* (now in the Rijksmuseum, Amsterdam). The fullest discussion of the picture occurs in Gage's article in the *Burlington Magazine*. He argues that although Payne Knight considered that 'the ridiculous seems . . . to be always lying in wait on the extreme verge of the sublime', the 'idea of antithesis was unlikely to have been in Knight's mind in this case'. Evidence that Turner did not accept Payne Knight's view that the ridiculous and the sublime are so closely related is provided by a passage on p. 1 verso of the 'Cockermouth' sketchbook (CX of 1809) in which Turner criticises Tom Paine's definition of the sublime, which is similar to Payne Knight's. It is difficult to know how far Turner was allowed freedom to express his own ideas in this picture, or whether he was made to follow Payne Knight's wishes pretty closely. From evidence of other commissioned works, Turner seems to have gone out of his way to accommodate his patrons. However, apart from the triangle of figures which approximates to those in the Rembrandt, the contrast between the two interiors is so marked that it is difficult

not to suspect that the intention to present antitheses *was* here uppermost in Turner's mind, whatever his patron's wishes were. Turner's picture is the epitome of clutter and confusion, as opposed to the tranquillity of the Rembrandt, thus illustrating the difference between the joys and the cares of parenthood: the innocent delight in a new-born child which is afterwards exchanged for the tribulations brought upon his parents by a teenage son.

As Gage points out, the fact that Turner here also echoes many features to be found in Teniers' pictures of alchemists' shops reflects Turner's interests at the time and raises again the question to what extent Turner was free to express his own ideas. However, it is also true that the clutter of objects in the room is essentially 'picturesque' and that this feature of the painting is likely to have been approved, if not actually suggested, by Payne Knight, who was an acknowledged expert on the theory and pictorial application of the picturesque.

It was perhaps a feeling on Turner's part that this commission had inevitably meant that his ideas had had to some extent to be tailored to Payne Knight's suggestions that led Turner to restate in his own terms the relationship of the ridiculous and the sublime. The result was *The Garreteer's Petition* (see No. 100) and *The Amateur Artist*, although the latter got no further than a drawing (CXXI-B).

When exhibited at the R.A., *The Unpaid Bill* was considered by the *Examiner*, 15 May, as 'worthy of its destination as a companion for the candle-piece of Mr. P. Knight's Rembrandt'. The critic found fault with the figures which were 'wretchedly drawn' but 'for a picture of colouring and effect, it is not only unexceptionable but inestimable'.

The critic of the *Beau Monde* (iii, p. 350) acknowledged that 'artists recognise the excellence of the picture' but added that the 'unskilled spectator' was offended by the air of indistinctness which pervaded the whole work.

The *Sun* for 17 May considered that such a work wasted Turner's powers and saw it merely as an unsuccessful attempt on his part to rival Wilkie's dexterity, and the *Cabinet* for December 1807–June 1808 agreed that it added nothing to Turner's reputation.

82. Sketch of a Bank, with Gipsies Exh. 1809?

(Plate 78)

THE TATE GALLERY, LONDON (467)

Canvas, $24\frac{1}{8} \times 33$ ($61 \cdot 5 \times 84$)

Coll. Turner Bequest 1856 (?89, 'Cows on a Hill' $4'9\frac{3}{4}'' \times 3'0\frac{1}{2}''$); transferred to the Tate Gallery 1910.

Exh. ?Turner's gallery 1809 (1); Tate Gallery 1931 (41); Amsterdam, Berne, Paris, Brussels, Liege (14), Venice and Rome (16) 1947–8; Arts Council tour 1952 (8).

Engr. Etched by Turner for the *Liber Studiorum* R.91,

but not published (two impressions repr. Finberg 1924, pp. 364–5).

Lit. Thornbury 1862, i, p. 262; 1877, p. 418; Armstrong 1902, p. 228; MacColl 1920, p. 4; Finberg 1924, p. 365, repr. p. 364; Rothenstein and Butlin 1964, p. 27; Gage 1965, p. 79; Lindsay 1966, p. 106.

Probably the work of this title exhibited at Turner's gallery in 1809. Perhaps in part based on sketches in the 'Cows' sketchbook (LXII, especially pp. 10 and 13 for the left-hand cow).

83. The Quiet Ruin, Cattle in Water; a Sketch, Evening Exh. 1809?

(Plate 79)

THE TATE GALLERY, LONDON (487)

Mahogany, $24\frac{1}{8} \times 30\frac{1}{8}$ ($61 \times 76 \cdot 5$)

Coll. Turner Bequest 1856; transferred to the Tate Gallery 1910.

Exh. ?Turner's gallery 1809 (2, as 'Sketch of Cows, &c.'); Tate Gallery 1931 (52); on loan to the Ulster Museum 1964–9.

Lit. Ruskin 1857 (1903–12, xiii, p. 121); Thornbury 1862, i, p. 294; 1877, p. 430; Armstrong 1902, p. 219; MacColl 1920, p. 8; Gage 1965, p. 79 n. 35.

For an alternative candidate for the picture exhibited in 1809 see No. 84. Ruskin dates the painting 1811 with a query; Thornbury 1811 *tout court*. However it seems likely that this was the work listed by Turner in about 1810 in his 'Finance' sketchbook (CXXII-36; for the dating see Nos. 53 and 56); the relatively low price set for it of £200 again suggests this picture rather than the larger No. 84.

Ruskin imagined 'this to be one of the very few instances in which Turner made a *study* in oil. The subject was completed afterwards in a careful, though somewhat coarse drawing, which defines the Norman window in the ruined wall, and is one of many expressions of Turner's feeling of the contrast between the pure rustic life of our own day, and the pride and terror of the past.' If, however, the watercolour he refers to is the *St Agatha's Abbey, Easby, Yorkshire* in the Whitworth Art Gallery, Manchester, the oil is almost certainly the later of the two versions of the composition. The watercolour, which measures 20×30 in. and is signed 'W. Turner', the form only used by Turner up to about 1800, shows a group of cows, fairly close to that in the oil, against the ruined abbey, which occupies most of the background, though there is a bank of earth on the left. In the oil all of the background is shown as earth and rocks with the exception of an architectural feature similar to that in the watercolour on the skyline on the right. The main forms are the same as in the watercolour, however, and pentimenti suggest that the background of the oil could

originally have been much more architectural. In addition the grouping of the cows has been modified in the oil, two sheep added on the right, and the foreground detail inserted.

84. River Scene with Cattle Exh. 1809? (Plate 80)

THE TATE GALLERY, LONDON (1857)

Canvas, $50\frac{1}{2} \times 68\frac{1}{2}$ (128·5 × 174)

Coll. Turner Bequest 1856; transferred to the Tate Gallery 1919.

Exh. ?Turner's gallery 1809 (2, as 'Sketch of Cows, &c.'); Tate Gallery 1931 (36).

Lit. Armstrong 1902, p. 228; MacColl 1920, p. 28; Gage 1965, p. 79 n. 35.

For an alternative candidate for the work exhibited by Turner in 1809 see No. 83; the fact that the latter, rather than this work, was included in the batch of works to be given numbers immediately they were aquired by the National Gallery makes it marginally the more likely to have been the exhibited picture. The fact that this *River Scene* is rather more of a finished picture than the other paradoxically supports the claims of the other to have been exhibited as a 'Sketch'.

The picture is based on sketches in the 'Tabley No. 2' sketchbook, probably of 1808 (the closest is CIV-47 verso; there are variations on pages 46 verso and 47 (in which the shipping is closer to the final painting), and 48 verso and 49). These follow a series of river scenes identified by Finberg (1909, p. 273) as showing the Dee in North Wales, which may therefore also be the scene of this painting.

85. Shoeburyness Fisherman hailing a Whitstable Hoy Exh. 1809 (Plate 62)
also known as *The Pilot Boat* and *The Red Cap*

THE NATIONAL GALLERY OF CANADA, OTTAWA

Canvas, 36 × 48 (91·5 × 122)

Signed 'J M W Turner R A' lower right

Coll. Bought from Turner by Walter Fawkes of Farnley; it remained in the Fawkes collection until 1912 when bought by Agnew and Knoedler; sold by the latter in 1916 to J. Horace Harding; exhibited for sale at 654 Madison Avenue, New York, 1939 (Collection of the late J. Horace Harding); bought by the National Gallery of Canada in 1939 (no. 4423).

Exh. Turner's gallery 1809 (4) and 1810 (11 as 'Shobury-ness, Essex'); Liverpool Academy 1810 (42 as 'Fishermen hailing a Whitstable Hoy,' and marked as for sale); R.A. 1886 (156); Lawrie and Co., 1902 (11); R.A. 1906 (77); Knoedler, New York 1914 (29); Toronto Art Gallery *Great Paintings* 1940 (63); Winnipeg Art Gallery *Turner* 1952.

Lit. Thornbury 1862, ii, pp. 85, 89, 393; 1877, pp. 237, 240, 589; Wedmore 1900, i, repr. facing p. 132; Armstrong 1902, p. 230 where he confuses it with the *Purfleet and Essex Shore* (see No. 74); Charles Holme, 'The Genius of J. M. W. Turner R.A.', *Studio* 1903, pl. o–7 where he dates it 1812; Finberg 1910, p. 52; *International Studio* xlvi 1912, p. 312, repr. in colour p. 313; Finberg 1912, pp. 3, 19, 20, 21; Whitley 1928, p. 150; R. H. Hubbard, *European Paintings in Canadian Collections* i 1956, p. 154; *National Gallery of Canada Catalogue* ii 1959, p. 158; Finberg 1961, pp. 156–7, 425, 469 no. 131, 513 no. 157h; Rothenstein and Butlin 1964, p. 24.

As the only years for which we possess a list of what Turner showed in his own gallery are 1809 and 1810 (although Landseer's (?) review of the gallery in 1808 us a fairly clear picture of what was shown then) it is interesting to note that Turner believed in persevering with pictures which did not sell one year by showing them again the next; in some cases the titles are not identical but it is impossible to say whether this is by accident or design.

It was Edward Dillon, writing in the *Athenaeum*, 27 January 1906, who identified the picture, then on exhibition at Burlington House as 'The Pilot Boat', with the picture shown in Turner's gallery in 1809 and noted that 'the Hoy has Whitestable on its sails' (there is no longer any trace of this).

Walter Fawkes evidently decided against this picture in 1809 when he bought *London from Greenwich* (No. 97) which he subsequently returned to the artist, possibly in exchange for one of the two pictures which he owned which had been included in the 1810 exhibition, either this picture or the *Lake of Geneva* (No. 103). If, however, it was exchanged for this picture, the transaction must have taken place after the exhibition at the Liverpool Academy.

A pencil drawing on p. 16 of the 'Farnley' sketch-book (CLIII), in use *c.* 1818, shows this picture hanging over the fireplace in the library at Farnley (repr. in Wilkinson 1974, p. 153).

86. Thomson's Æolian Harp Exh. 1809 (Plate 81)

THE TRUSTEES OF THE WALTER MORRISON PICTURE SETTLEMENT

Canvas, $65\frac{5}{8} \times 120\frac{1}{2}$ (166·7 × 306)

Coll. Probably bought by James Morrison in the 1820s, although no firm evidence for this exists (but see below); it is first documented in the Morrison collection by Waagen in 1857; by descent to the present owners.

Exh. Turner's gallery 1809 (6); International Exhibition 1862 (330) entitled 'Italy'; R.A. 1882 (41); Grosvenor Gallery 1914–15 (75) as 'Autumnal Morning'.

Lit. Waagen 1857, iv, p. 301; Armstrong 1902, pp. 218, 233 (listed both as 'Autumnal Morning' 1805–08 and as 'Italy'); Livermore 1957, pp. 78–86; Finberg 1961, pp. 157, 470 no. 133; Rothenstein and Butlin 1964, p. 11; Lindsay 1966, p. 104–5.

The obvious connection between this picture and *Pope's Villa at Twickenham* (No. 72) makes it unsurprising that they have been together in the same collection for several generations. We know that James Morrison (1789–1857) came to London in 1809 without means but soon made a very large fortune. In 1827 he bought *Pope's Villa* at the de Tabley sale and his other Turner, the large watercolour *Rise of the River Stour at Stourhead* (known as 'The Swan's Nest'), which was exhibited at the R.A. in 1825 (465), was presumably acquired about then or soon after. Whether these purchases preceded or followed Morrison's acquisition of *Thomson's Æolian Harp* it is impossible to say, but it seems likely that all three were made in the 1820s.

Exhibited with the following lines:

To a gentleman at Putney, requesting him to place one in his grounds.

On Thomson's tomb the dewy drops distil,
Soft tears of Pity shed for Pope's lost fame,
To worth and verse adheres sad memory still,
Scorning to wear ensnaring fashion's chain.
In silence go, fair Thames, for all is laid;
His pastoral reeds untied, and harp unstrung,
Sunk is their harmony in Twickenham's glade,
While flows the stream, unheeded and unsung
Resplendent Seasons! chase oblivion's shade,
Where liberal hands bid Thomson's lyre arise;
From Putney's height he nature's hues survey'd,
And mark'd each beauty with enraptur'd eyes.
The kindly place amid thy upland groves
Th' Æolian harp, attun'd to nature's strains,
Melliferous greeting every air that roves
From Thames' broad bosom or her verdant plains,
Inspiring Spring! with renovating fire,
Well pleas'd, rebind those reeds Alexis play'd,
And breathing balmy kisses to the Lyre,
Give one soft note to lost Alexis' shade.
Let Summer shed her many blossoms fair,
To shield the trembling strings in noon-tide ray;
While ever and anon the dulcet air
Shall rapturous thrill, or sigh in sweets away.
Bind not the poppy in the golden hair,
Autumn! kind giver of the full-ear'd sheaf;
Those notes have often echo'd to thy care
Check not their sweetness with thy falling leaf.
Winter! thy sharp cold winds bespeak decay;
Thy snow-fraught robe let pity 'zone entwine,
That gen'rous care shall memory repay,
Bending with her o'er *Thomson's* hallow'd shrine.

James Thomson's poem *An Ode on Æolus's Harp* was first printed in 1748. In Turner's unpublished verse-book, the longest poem is on 'Thomson's Æolian Harp' at which there are no fewer than six attempts with many variations of individual lines. The verses printed in the 1809 exhibition catalogue were not necessarily Turner's definitive version as there are further drafts in the 'Plymouth, Hamoaze' sketchbook (CXXXI, watermarked 1812 and in use 1812–13). For instance on p. 189:

'O'er Thomsons tomb soft Piety's tears distill
Shed in remembrance sad for Pope's lost fane'.

That the second line in the 1809 catalogue misprints 'fame' for 'fane' is proved by the drafts in both Turner's verse-book and in the 'Plymouth' sketchbook. Fane is a poetical word for temple, a reference in this case to Pope's villa which had been demolished in 1807.

Dr Adele Holcomb has, however, kindly drawn my attention to the fact that Turner's choice of subject was probably suggested to him by reading William Collins' *Ode occasion'd by the death of Mr Thomson* which was written in 1749. The theme of Collins' (1721–59) ode, in which a poet's sylvan grave is decorated by nymphs, is clearly shown in Turner's picture and does not occur anywhere in Thomson's poetry to my knowledge (the pedestal of the tomb is inscribed 'THOMSON'). Collins' ode also mentions Thomson's 'airy harp' which a footnote explains is the harp of Æolus and Turner introduces the buildings of Richmond along the Thames, again following the advertisement for Collins' poem: 'The Scene of the following stanzas is suppos'd to lie on the Thames near Richmond' (where Thomson lived shortly before his death). Turner's lines, invoking the four seasons, not only make an obvious reference to Thomson's famous poem, but also suggest that the figures in his picture are meant to represent the four seasons.

This was the largest picture in the exhibition in Turner's gallery. Recent cleaning reveals it to be both a superb picture and a key work in Turner's development. It is certainly in a rather different vein to the other pictures—views on the Thames and seascapes—which Turner exhibited in 1809. Here Turner has been more ambitious and has set out to reinterpret the scenery of the Thames in Claudian terms in a composition which harks back to the *Macon* of 1803 (No. 47) and which indeed it resembles closely in general layout. However, in this case the specific reference to the buildings along the riverfront at Richmond shows that Turner was at pains here to fuse naturalistic with Claudian elements, in a way which goes beyond his treatment of similar elements in *Macon*. No doubt the more refined powers of observation shown here owe something to the experience which Turner gained in making his direct transcriptions from nature in the Thames sketches.

This was the only picture mentioned by name by Robert Hunt in his review of Turner's gallery in the *Examiner*. He wrote that it was 'a masterly exemplification of some rapturous lines of Thomson's poem The Seasons', and was seemingly unaware of either Thomson's or Collins' odes.

Æolus was the King of storms and winds, the inventor of sails and a great astronomer. An Æolian Harp is a musical instrument which produces sounds when the wind blows through the strings.

87. Fishing upon the Blythe-Sand, Tide setting in Exh. 1809 (Plate 82)

THE TATE GALLERY, LONDON (496)

Canvas, 35 × 47 (89 × 119·5)

Coll. Turner Bequest 1856 (11, 'Bligh Sands' 4′0″ × 3′0″); transferred to the Tate Gallery 1919.

Exh. Turner's gallery 1809 (7); Turner's gallery 1810 (4, 'Blyth Sand'); R.A. 1815 (6, 'Bligh Sand, near Sheerness: Fishing boats trawling'); Plymouth 1815; Tate Gallery 1931 (39); Amsterdam (repr.), Berne (repr.), Paris, Brussels (repr.), Liege (repr.) (15), Venice and Rome (17) 1947–8; R.A. 1974–5 (155, repr.).

Lit. Ruskin 1857 (1903–12, xiii, p. 123); Thornbury 1862, i, pp. 179, 297; ii, p. 155, 173; 1877, pp. 304, 317, 432; Bell 1901, p. 95 no. 132; Armstrong 1902, p. 229; Davies 1946, p. 185; H. F. Finberg 1951, p. 384; Finberg 1961, pp. 157, 172, 218–19, 229, 470 no. 134, 476 no. 187, 512 no. 157d; Rothenstein and Butlin 1964, p. 30, pl. 44; Lindsay 1966, p. 108.

Blyth Sands are in the Thames Estuary above Sheerness, facing Canvey Island. There is a related oil sketch among the large Thames sketches (No. 176) but with no precise details in common. There is also a wash drawing at the British Museum, closer in the placing of the nearest sailing boat but again not exactly the same (CXX-Q).

The picture is one of the four mentioned, presumably as available for sale, in a letter to Sir John Leicester of 12 December 1810, accompanied by slight pen sketches (see Plate 194). According to Thornbury Turner also had 'the proud pleasure of refusing to sell' this picture 'to his old enemy Sir John [*sic* for George] Beaumont' (1862, i, p. 297). For the evidence that this picture was sent for exhibition in Plymouth late in 1815 see No. 19.

Also according to Thornbury, 'An artist who professionally examined the picture for me tells me that the sky was painted with perishable sugar of lead, and has quite altered' (1862, i, p. 297). No evidence for this statement remains today. The canvas has been torn in five places, the most serious and extensive damage running down from the centre of the foreground boat almost to the lower edge of the picture; these have now been restored.

88. Near the Thames' Lock, Windsor Exh. 1809 (Plate 97)

H.M. TREASURY AND THE NATIONAL TRUST (Lord Egremont Collection) PETWORTH HOUSE

Canvas, 35 × 46½ (88·9 × 118)

Signed 'J M W Turner RA' bottom right

Coll. Bought by the third Earl of Egremont perhaps from Turner's gallery in 1809; by descent to the third Lord Leconfield, who in 1947 conveyed Petworth to the National Trust; in 1957 the contents of the State Rooms were accepted by the Treasury in part payment of death duties.

Exh. Turner's gallery 1809 (8); Tate Gallery 1951 (14).

Lit. Petworth Inventories 1837, 1856 (London House); Thornbury 1862, ii, p. 397; 1877, p. 594; Armstrong 1902, p. 237; Collins Baker 1920, p. 125 no. 649; Whitley 1928, pp. 150–51; Clare 1951, pp. 42–3; Finberg 1961, pp. 156, 470–71 no. 135; Reynolds 1969, pp. 74, 106.

Exhibited with the following quotation from Gray:

> Say, Father Thames, for thou hast seen
> Full many a sprightly race,
> Disporting on thy margin green,
> The paths of pleasure trace,
> Who foremost now delight to cleave
> With pliant arms thy glassy wave.

In 1809 the exhibition at Turner's gallery opened on 24 April. Sir Thomas Lawrence must have been among the early visitors, as Finberg prints a letter that he wrote on 26 April to a Mr Penrice of Yarmouth, a collector who had consulted him about buying old masters:

Dear Sir,

While you are meditating on the purchase of pictures of the Old Masters, what say you to setting an example to your rich friends of patronage to living artists? I have just been at the gallery of Mr. Turner (indisputably the first landscape painter in Europe) and there seen a most beautiful picture which in my opinion would be very cheaply purchased at two hundred guineas—the price at which I understand it may be bought. The subject is 'A scene near Windsor', with young Etonians introduced . . . If the expression can apply to landscape it is full of sentiment, and certainly of genius. If you dare hazard the experiment you must do it quickly and authorize me to secure it for you. It would give me very great pleasure, from my respect for the powers of the artist, my admiration of the work, and (may I say it on so slight an acquaintance?) my esteem for you.

The size of the picture is (by guess) about three feet in length and a little less in height. It is in his own peculiar manner, but *that* at its best; no Flemish finishing, but having in it fine principles of art, the essentials of beauty, and (as far as the subject admits it) even of grandeur.

I remain, Dear Sir, etc
THO. LAWRENCE

Despite this very warm recommendation, Mr Penrice did not buy the picture. Perhaps, as Lawrence's letter seems to imply, he was more attracted to pictures which showed 'Flemish finishing' and would have preferred Wilkie to Turner. Whether Lord Egremont bought the picture during the exhibition or later is not known but the former seems very possible. He had bought four pictures from the previous year's exhibition and the subject was one which obviously attracted him as he was finally to own three views by Turner of Windsor Castle and its surroundings (Nos. 64 and 149 besides this picture), as well as *The Thames at Eton* (No. 71).

89. Ploughing up Turnips, near Slough Exh. 1809
(Plate 85)

THE TATE GALLERY, LONDON (486)

Canvas, $40\frac{1}{8} \times 51\frac{1}{4}$ (102 × 130)

Coll. Turner Bequest 1856 (71, 'Windsor' $4'3\frac{1}{2}'' \times 3'4\frac{1}{2}'''$); transferred to the Tate Gallery 1919.

Exh. Turner's gallery 1809 (9); Tate Gallery 1931 (44); Paris 1972 (260, repr.); Lisbon 1973 (4, repr. in colour); R.A. 1974–5 (156); Leningrad and Moscow 1975–6 (15).

Lit. Thornbury 1862, i, p. 294; Armstrong 1902, p. 237; Finberg 1910, pp. 63–8; Davies 1946, p. 187; Finberg 1961, pp. 156, 171, 471 no. 136, pl. 13; Rothenstein and Butlin 1964, p. 26, pl. 41; Gage 1969, p. 89; Reynolds 1969, p. 106, pl. 49.

Formerly known as 'Windsor': the Castle is prominent in the background. The present title is that used in the catalogue of the 1809 exhibition in Turner's gallery. There are several related drawings in the sketchbook labelled by Turner '46, Windsor, Eaton', XCVII; this is dated *c.* 1807 by Finberg (1909, i, p. 251) and 1806 by Gage (exhibition catalogue, Paris 1972); see also No. 57. Page 2 shows the same general view, while there are also related sketches of cows, particularly on pp. 22, 87 and 89, and similar but not identical human figures particularly on pp. 27, 81 verso and 82 verso. The unusual size of the picture is shared by No. 107.

This picture was priced at £200 in a note, probably of *c.* 1810, in Turner's 'Finance' sketchbook (CXXII-36; for the date see Nos 53 and 56).

90. Harvest Dinner, Kingston Bank Exh. 1809
(Plate 98)

THE TATE GALLERY, LONDON (491)

Canvas, $35\frac{1}{2} \times 47\frac{5}{8}$ (90 × 121)

Signed '. . . MW Tur . . .' bottom right

Coll. Turner Bequest 1856 (14, 'Kingston Bank' $4'0'' \times 3'0''$); transferred to the Tate Gallery 1919.

Exh. Turner's gallery 1809 (10); Turner's gallery 1810 (5, 'Harvest Dinner'); Turner's gallery 1835; Tate

Gallery 1931 (43); on loan to the National Museum of Wales since 1964.

Engr. By Turner for the *Liber Studiorum*, R. 87, but not published (repr. Finberg 1924, p. 348; the preliminary pen and sepia drawing from the Vaughan Bequest, CXVIII-W, repr. *loc. cit.*).

Lit. Thornbury 1862, i, p. 295; 1877, p. 431; Armstrong 1902, p. 224; Finberg 1924, p. 349; S. D. Kitson, *Life of John Sell Cotman* 1937, p. 129; Davies 1946, p. 185; H. F. Finberg 1951, pp. 384–5; Finberg 1961, pp. 471 no. 137, 512 no. 157e; Rothenstein and Butlin 1964, p. 24.

When it was shown in Turner's gallery in 1809 this picture was the subject of a furtive copy in pencil by Cotman, but it does not seem to have attracted the attention of the critics. In 1835, however, this picture was one of 'the few of Mr. Turner's splendid paintings that enrich the walls of his gallery' where they were seen and described by the critic of the *Spectator* for 26 April 1835. After discussing *Frosty Morning* (No. 127) he goes on, 'What a contrast does it present to this river-scene at harvest-time! It does not need the man stooping to wash his face, to convey an idea of the sultry heat of a summer morn. Nothing can be more simple than this composition; nor more broad, quiet, and true than its effect.' For an oil sketch see No. 160.

91. Guardship at the Great Nore, Sheerness, &c
Exh. 1809 (Plate 83)

MAJOR-GENERAL E. H. GOULBURN, D.S.O.

Canvas, 36 × 49 (91·4 × 124·5)

Signed 'I M W Turner RA [PP]' lower right.

(Plate 538)

Coll. James Wadmore by 1834; sale Christie's 5 May 1854 (186) bought Rought acting for W. O. Foster of Stourbridge; by descent to Major A. W. Foster of Apley Park, Bridgnorth, from whom it passed to the present owner.

Exh. Turner's gallery 1809 (11) and 1810 (7 as 'Sheerness from the Great Nore'); S.B.A. 1834 (33 lent by James Wadmore); International Exhibition 1862 (331); Birmingham City Art Gallery *Works of Art from Midland Houses* 1953 (73); Agnew 1967 (9); R.A. 1974–5 (153); Hamburg 1976 (21).

Engr. By J. and G. P. Nicholls in the *Art Journal* 1 October 1856, p. 297.

Lit. Burnet and Cunningham 1852, pp. 29, 44; Thornbury 1862, ii, p. 400; 1877, p. 598; Armstrong 1902, p. 230 (dated *c.* 1805); *The Reminiscences of Frederick Goodall R.A.* 1902, p. 58; H. F. Finberg 1951, p. 385; Finberg 1961, pp. 156, 173 n., 350–51, 471 no. 138, 499 no. 455, 513 no. 157f.

This picture was still in Turner's studio in December

1810 as Turner made a slight sketch of it in a letter he wrote on the 12th to Sir John Leicester. It sounds as if Sir John had enquired of Turner what seascapes he had available. Turner's letter runs:

Sir John,

Perhaps the above slight mema of the only four subjects I have near the size may lead your recollection in regard to their fitness or class, and if I know when you would favour me with a call I would most certainly remain at home.

The second of the four sketches is described by Turner as 'Old Sandwich. G. Ship at the Nore 4 ft. long 3 high' and clearly depicts this picture. (This sketch is reproduced on Plate 194; see also Nos. 69, 89 and 206.)

A very slight drawing on p. 39 verso of the 'River and Margate' sketchbook (XCIX) which is inscribed by Turner 'Guardship at the Nore' has no connection beyond the title. Finberg suggests that a pen, ink and wash drawing on p. 17 of the 'Hesperides (1)' sketchbook (XCIII) may possibly be a study for the picture. The composition is, however, not closely enough connected to support this, even if one allows for considerable modification in the finished version.

As the catalogue of the Turner Bicentenary exhibition pointed out, Turner painted a number of seapieces of the Thames Estuary *c.* 1808–10, and some were exhibited at his gallery in successive years but with different titles, which makes it difficult to be certain which picture is referred to. However, the suggestion made in the catalogue that the *Sheerness from the Great Nore*, exhibited in 1810, may possibly refer to the *The Junction of the Thames and the Medway*, No. 62, now in Washington D.C., rather than to this picture has since been shown to be incorrect by the publication of an article by Mr David Brown in the *Burlington Magazine* (cxvii 1975, pp. 721–2) which proves that the Washington picture was in the collection of Thomas Lister Parker from 1807–11.

It also seems possible, as the catalogue of the Turner Bicentenary exhibition suggested, that Turner made use of his models of ships, as well as relying on his sketches, in painting this series of seapieces.

92. Trout Fishing in the Dee, Corwen Bridge and Cottage Exh. 1809 (Plate 84)
also known as *The Trout Stream*

THE TAFT MUSEUM, CINCINNATI, OHIO

Canvas, 36 × 48 (91·5 × 122)

Signed 'J M W T . . .' lower right (it looks as if the picture was originally signed: 'J M W Turner R A' and that the signature would reappear if the picture were cleaned)

Coll. Bought by the Earl of Essex, presumably from Turner's gallery in 1809; sale, 'Modern Pictures

from Cassiobury Park collected early in the century by George, 5th Earl of Essex' Christie's 22 July 1893 (46) bought A. Nattali for Abel Buckley; Arthur Sanderson by 1902; bought by Agnew from Sanderson in 1905 and sold to Scott and Fowles, New York, from whom bought by C. P. Taft, Cincinnati in the same year; given with the rest of the Taft Collections to the citizens of Cincinnati in 1931 (Accession no. 1931. 459).

Exh. Turner's gallery 1809 (13); Manchester 1857 (621 as 'Landscape'); R.A. 1878 (134) and 1895 (8); Birmingham 1899 (11); Guildhall 1899 (12); Glasgow 1901 (98 still belonging to Abel Buckley); Boston 1946 (3); Toronto and Ottawa 1951 (4).

Lit. Farington *Diary* 5 and 7 July 1809; Armstrong 1902, pp. 59, 233, repr. facing p. 58; M. W. Brockwell, *Catalogue of the Taft Museum* 1939, pp. 23–4 no. 105; Finberg 1961, pp. 151, 156, 471 no. 140.

A drawing on p. 28 verso of the 'Tabley No. 2' sketchbook (CIV) is a rough study for this picture and there are other drawings of the Dee at Corwen in the same book (e.g., pp. 44 verso, 45 verso–46). Both of these are taken from nearer the bridge and have cattle as a more prominent feature than in the finished picture.

In the summer of 1808 Turner was invited to stay at Tabley House near Knutsford in Cheshire, by the owner, Sir John Leicester. While there he painted two views of Tabley (Nos. 98 and 99) which he exhibited at the R.A. the following year. It seems that either before or after this visit he made a trip into Wales, as the drawing connected with this picture and others of Welsh scenery occur in a sketchbook labelled 'Tabley' by Turner.

Among the other visitors at Tabley was Henry Thomson, R.A., and it was he who reported to Callcott, who in turn told Farington, that Turner had 'begun another picture' (besides the two views of Tabley) while he was staying there. Finberg suggests that this was the picture in question, which seems quite possible, provided Turner's Welsh excursion took place before or during his stay at Tabley rather than on the way back.

The picture was certainly at Cassiobury by 5 July 1809 when it was seen by Farington, Hearne and Edridge. Hearne described the picture of 'Corwen' as 'Vapour' and, while discussing with the others what might be considered a fair price for one of Turner's pictures for which Lord Essex had given 200 guineas, said 'For a person a full admirer of his pictures 50 guineas, but for myself I would not give fifteen.'

93, 94. Fishing Boats in a Calm (2) Exh. 1809

PRESENT WHEREABOUTS UNKNOWN

Sizes unknown

Exh. Turner's gallery 1809 (14 and 17).

Lit. Finberg 1961, p. 471 nos. 141 and 144.

No trace of either picture exists beyond their appearance in the 1809 exhibition, for which a catalogue exists. In the catalogue of the Barber Institute, it has been suggested that No. 95, *Sun rising through Vapour*, now in the Institute, may have been exhibited under the above title, but this is only surmise. There is no sign of either picture in the 1810 exhibition, when a number of pictures, shown in 1809 but unsold, were exhibited again. It is therefore possible that one or both pictures were sold in 1809.

It also seems possible that one of these was engraved in the *Liber Studiorum* (Rawlinson 44) as 'Calm', published on 23 April 1812, 'Picture in the possession of J. M. W. Turner 1 ft 2 by 2 ft 3', but no further history of this picture is known. An alternative candidate which may have been engraved as 'Calm' is No. 8 (see Plate 540). Finberg (1924, p. 174) draws attention to an oil of this subject sold in the G. R. Burnett sale at Christie's 13 February 1875 (135) but the size is given as 17 × 13 in., which makes it seem rather small to be considered as a candidate for one of the pictures exhibited in 1809, although this is, of course, a possibility. It was bought by L. Harrison at Burnett's sale but is at present untraced.

95. The Sun rising through Vapour Exh. 1809?

(Plate 99)

THE BARBER INSTITUTE OF FINE ARTS, UNIVERSITY OF BIRMINGHAM

Canvas, $27\frac{1}{2} \times 40$ (69 × 102)

Signed 'J M W Turner RA' lower right

Coll. Bought from Turner by Walter Fawkes of Farnley; Fawkes sale Christie's 27 June 1890 (62) bought McLean from whom bought by Mrs Johnstone Foster; Dowager Lady Inchiquin (Mrs Johnstone Foster's daughter); sale Christie's 23 July 1937 (142) bought Alexander; bought by the Barber Institute from the Leicester Galleries, 1938.

Exh. ?Turner's gallery 1809; Berlin 1972 (5, repr. in colour).

Lit. Thornbury 1862, ii, p. 393; 1877, p. 589 as 'Coast Scene—Sunset, with men-of-war at anchor; fine weather'; Armstrong 1902, pp. 85?, 232; Finberg 1912, p. 20; A. C. Sewter, 'Four English Landscapes', *Burlington Magazine* lxxvii 1941, p. 13, repr. p. 15; *Catalogue of the Barber Institute of Fine Arts* 1952, pp. 114–15 repr.; Davies 1959, p. 95.

There is a pencil drawing, a study for this picture, on p. 70 of the 'Spithead' sketchbook (C), known to have been in use in the autumn of 1807.

Armstrong is incorrect in describing this as a 'small replica of the picture in the National Gallery' (see No. 69). The link between the pictures is in subject only and not in composition.

This picture is shown in a Turner watercolour of the drawing room at Farnley, painted 1818–19 (the dating is secure as the watercolour was included in the 1819 exhibition at Grosvenor Place of Walter Fawkes' collection of watercolours and it shows the *Dort* (No. 137), bought in 1818, hanging over the fireplace at Farnley). On the right is the *Victory* (No. 59) and this picture hangs as a pendant to it on the left. The fact that this picture and the *Victory* are of almost identical size raises the question whether they were commissioned by Walter Fawkes. It seems possible that Fawkes, having bought the *Victory*, and having also seen the National Gallery version of *Sun rising through Vapour*, either at the R.A. in 1807 or in Turner's studio, may have suggested to Turner that he should paint a similar subject for him of the same size as the *Victory*.

The Barber Institute catalogue suggests that this picture may be identified with one of two pictures exhibited with the same title, *Fishing Boats in a Calm*, by Turner at his gallery in 1809 (14 and 17, Nos. 93 and 94). Certainly, there has been absolutely no trace of either picture since, and there is abundant evidence that the titles of Turner's pictures often change with the years. Walter Fawkes did buy the *London from Greenwich* (No. 97), exhibited at Turner's gallery in 1809 (16), although he later exchanged or returned it. At present the evidence for this picture being exhibited in 1809 is only circumstantial but the suggestion is certainly plausible, although it is perhaps surprising that Turner did not include a reference to the fish-market in his title.

96. Bilsen Brook Exh. 1809

PRESENT WHEREABOUTS UNKNOWN

Size unknown

Exh. Turner's gallery 1809 (15).

Lit. Finberg 1961, p. 471 no. 142.

There is no record of this picture at all since the 1809 exhibition. Furthermore, the location of the scene represented is uncertain and seems likely to remain so unless the picture itself should reappear. A letter of inquiry to *Country Life* elicited two suggestions: first, that it was connected with a small hamlet called Bilsen, about three quarters of a mile south-west of Arundel, which is close to a number of streams. This hamlet is now called Bilsham. The second suggestion was that 'Bilsen' was a mistake for 'Bisham', a long-established flood ditch in Hurley. This might seem less likely but for the fact that Turner painted a picture of *Hurley House on Thames* c. 1807–9 (see No. 197) which is very close to Bisham Brook. Bisham is also the name of a village near Marlow, Bucks. (I am indebted for this suggestion to Judy Egerton).

97. London Exh. 1809 (Plate 86)

THE TATE GALLERY, LONDON (483)

Canvas, 35½ × 47¼ (90 × 120)

Inscribed '1809' and 'JMW Turner RA PP [?]' lower left centre. (Plate 539)

Coll. Walter Fawkes by 1811; returned to the artist by exchange (Thornbury) at an unknown date; Turner Bequest 1856 (13, 'Greenwich Hospital' 4'0″ × 3'0″), transferred to the Tate Gallery 1910.

Exh. Turner's gallery 1809 (16); Tate Gallery 1931 (45); Liverpool 1933 (24); R.A. 1974–5 (152, repr.); Leningrad and Moscow 1975–6 (13, repr.).

Engr. By Charles Turner for the *Liber Studiorum*, R. 26, and published 1 January 1811 as 'In the possession of Walter Fawkes, Esq, of Farnley'. The preliminary pen and sepia drawing, CXVII-D, repr. Finberg 1924, p. 102; the etching and engraving repr. pp. 102–3.

Lit. Ruskin 1857 (1903–12, xiii, pp. 119–20); Thornbury 1862, i, p. 293; 1877, p. 429; Armstrong 1902, p. 222; Finberg 1910, pp. 63, 80; 1924, p. 103; Davies 1946, p. 185; Finberg 1961, pp. 471 no. 143; Rothenstein and Butlin 1964, pp. 26–7, pl. 40; Lindsay 1966, p. 240.

Exhibited in Turner's gallery in 1809 with the following verses:

> Where burthen'd Thames reflects the crowded sail,
> Commercial care and busy toil prevail,
> Whose murky veil, aspiring to the skies,
> Obscures thy beauty, and thy form denies,
> Save where thy spires pierce the doubtful air,
> As gleams of hope amidst a world of care.

The signature is inscribed in brown; the date, to the left and slightly higher, more carefully in black, perhaps on the picture's return to Turner; it is painted on a distinctly thinner area of paint. The letters 'PP', of which traces seem to remain at the end of the signature, would stand for Professor of Perspective at the Royal Academy, a post to which Turner was elected in December 1807. Unevenly discoloured retouchings in the sky were removed in 1973; in particular the heavy plume of smoke rising just to the right of the right-hand dome of Greenwich Hospital was found not to be original.

There is a preliminary drawing for the whole composition, CXX-N (repr. Finberg 1910, pl. 30), and also some related studies of deer on XCV-43/44.

98. Tabley, the Seat of Sir J. F. Leicester, Bart.: Windy Day Exh. 1809 (Plate 88)

THE VICTORIA UNIVERSITY OF MANCHESTER

Canvas, 36 × 47½ (91·5 × 120·6)

Signed 'J M W Turner R A' bottom right

Coll. Painted in 1808 for Sir John Leicester who was created Lord de Tabley in 1826; the picture remained in the possession of his heirs at Tabley until bequeathed to the present owners by Lieut. Colonel J. L. B. Leicester-Warren on his death in 1975.

Exh. R.A. 1809 (105); Liverpool Academy 1811 (9, this may refer to No. 99, the companion picture); Sir John Leicester's Gallery 1819 (68); Manchester 1857 (292); R.A. 1881 (178); Whitechapel 1953 (76); Manchester *Art Treasures Centenary* 1957 (223); Agnew 1967 (8); Tate Gallery 1973–4 (206); R.A. 1974–5 (150).

Lit. Farington *Diary* 11 February, 2 August 1809; Carey 1819 (61); Young 1821 (68 engr.); Burnet and Cunningham 1852, p. 112 no. 92; Thornbury 1862, i, p. 303 (as exhibited in 1819); 1877, pp. 164, 436, 571; Bell 1901, p. 87 no. 114; Armstrong 1902, pp. 60, 233; Clare 1951, p. 43; Finberg 1961, pp. 151, 158–9, 302, 471 no. 147, 478 no. 208, 513 no. 169a?; Hall 1960–62, p. 121 no. 97, pl. 32b; Gage 1969, p. 36; Reynolds 1969, pp. 67, 68, 96, fig. 47; Herrmann 1975, pp. 19, 229, pl. 61.

Turner stayed at Tabley in the summer of 1808 to paint this and its companion (No. 99) for Sir John Leicester, who already owned half a dozen paintings by Turner.

There are a number of drawings connected with these paintings in the 'Tabley No. 1' (CIII pp. 15 verso, 16, 17) and 'Tabley No. 3' (CV pp. 7, 17) sketchbooks.

Callcott told Farington that the pictures were 'of Turner's 250 guineas size', but there are no receipts among the Tabley House papers. (In fact there is abundant evidence, both before and after this date, that Turner's price for a 36 × 48 in. canvas was 200 guineas.) Henry Thomson, R.A. (1773–1843), who was also staying at Tabley (and while there painted a view of the House and lake still in the collection) reported that Turner seemed to spend all his time fishing rather than painting. Finberg, however, suggests that Thomson was misled by Turner's normal practice of getting up very early to work on his pictures before anyone else was awake, which left him with free time later in the day to enjoy his favourite pastime.

Tabley House near Knutsford in Cheshire was built in 1761 by Carr of York for Sir Peter Leicester, Bt (Sir John's great-grandfather). It was painted by a number of other artists besides Turner, notably Richard Wilson c. 1774, now in the collection of Lord Ashton of Hyde, and James Ward, 1813–18, a view of the lake and tower, now in the Tate Gallery (385).

The two views of Tabley were on the whole well received when shown at the R.A. although the critic of the *St. James's Chronicle* for 16–18 May preferred the calm view as 'Mr. Turner is uniformly more happy in representing still than agitated scenery. His water in motion has a want of transparency . . .'

The *Monthly Magazine* for June considered that No.

98 'has an effect that ravishes as much by the novelty of its effect as by its genuine representation of truth.'

The *Repository of Arts* (i, p. 490) wrote: 'The Fleet at Spithead [No. 80] is a most majestic picture, and the views of Sir John Leicester's seat, which in any other hands would be mere topography, touched by his magic pencil have assumed a highly poetical character. It is on occasions like this that the superiority of this man's mind displays itself; and in comparison with the production of his hands, not only all the painters of the present-day but all the boasted names to which collectors bow sink into nothing.'

99. Tabley, Cheshire, the Seat of Sir J. F. Leicester, Bart.: Calm Morning Exh. 1809

(Plate 89)

H.M. TREASURY AND THE NATIONAL TRUST (Lord Egremont Collection) PETWORTH HOUSE

Canvas, 36 × 46 (91·5 × 116·8)

Signed 'J M W Turner R A' bottom right

Coll. Painted for Sir John Leicester, later Lord de Tabley, together with No. 98, in 1808; sale, conducted by Christie's in Lord de Tabley's house in London, 24 Hill Street, 7 July 1827 (34) bought by the third Earl of Egremont; by descent to the third Lord Leconfield who in 1947 conveyed Petworth to the National Trust; in 1957 the contents of the State Rooms were accepted by the Treasury in part payment of death duties.

Exh. R.A. 1809 (146); Liverpool Academy 1811 (9, this may refer to the companion picture); Sir John Leicester's gallery 1819 (43); Tate Gallery 1951 (3); Agnew *English Pictures from National Trust Houses* 1965 (31); R.A. 1968–9 (154); R.A. 1974–5 (151).

Lit. Farington *Diary* 11 February, 30 April, 2 August 1809; Carey 1819 (42); Young 1821 (43, engr.); Petworth Inventories 1837, 1856 (North Gallery); Waagen 1854, iii, p. 37; Burnet and Cunningham 1852, p. 44, 112 no. 93; Thornbury 1862, ii, p. 397; 1877, pp. 164, 199, 571, 594; Bell 1901, p. 87 no. 115; Armstrong 1902, pp. 60, 232; Collins Baker 1920, p. 123 no. 8; Whitley 1930, p. 135; Finberg 1961, pp. 151, 158–9, 302, 472 no. 146, 478 no. 206, 513 no. 169a?; Hall 1960–62, p. 120 no. 96; Reynolds 1969, pp. 67, 68, 96; Herrmann 1975, p. 19.

For the circumstances connected with the painting of this picture and its companion, for related drawings and for the critics' opinion of them when shown at the R.A., see the entry for No. 98. For an oil sketch for this picture, probably sent by Turner to Sir John Leicester to gain his approval of the viewpoint, see No. 208.

Finberg states that the picture fetched more at the de Tabley sale (165 guineas) than Sir John Leicester had paid for it, which seems to contradict Farington's report

that Callcott had told him that the Tabley views were 'of Turner's 250 guineas size'. It seems probable, however, that Turner charged a reduced price, perhaps 300 guineas for the pair, as it was his custom to charge less for pictures painted on commission (see note to companion picture about Turner's prices and also entry for No. 403).

Sir Francis Bourgeois, the artist, told Farington that Turner's views of Tabley were 'gaudy but not brilliant'. At the R.A. this picture received a separate notice in the *Morning Herald* for 4 May: 'In this felicitous imitation of a calm morning, the Artist has evidently taken Cuyp for his study; and it is but just to aver, that he has preserved the aerial perspective better than any other Artist within our remembrance, at least in this country. There is such *repose* in the whole composition, each part harmonizes with its adjunct object so happily, that a troubled spirit might dwell upon this picture in contemplation, until the nervous system were re-attuned by quietude, receiving an imperceptible anodyne through the operations of sympathy.'

Besides reminiscences of Cuyp (which make this picture a precursor of the *Dort*, No. 137) the pale tonality also perhaps reflects the influence of Turner's friend and follower Callcott, a number of whose pictures were bought by Sir John Leicester.

Reunited at the Turner Bicentenary exhibition, it was easy to see why this superb pair brought Turner further commissions of the same kind from Lord Egremont and Lord Lonsdale in the following year (see Nos. 108 and 113, and 111 and 112). In fact Turner was also to receive commissions of a somewhat similar nature much later in his career when he painted the two views of Mr Moffatt's house at Mortlake terrace (Nos. 235 and 239, exhibited in 1826 and 1827) and in the following year, 1828, when he exhibited the two pictures of East Cowes Castle painted for John Nash (Nos. 242 and 243).

100. The Garreteer's Petition Exh. 1809

(Plate 100)

THE TATE GALLERY, LONDON (482)

Mahogany, $21\frac{3}{4} \times 31\frac{1}{8}$ (55 × 79); painted surface $20\frac{7}{8} \times 30\frac{3}{4}$ (53 × 78)

Coll. Turner Bequest 1856 (17, 'The Garreteer's Petition' 2'6″ × 1'9½″); transferred to the Tate Gallery 1910.

Exh. R.A. 1809 (175); Turner's gallery 1810 (17, 'Poet's Garrett'); Tate Gallery 1931 (28); *British Narrative Paintings* C.E.M.A. tour 1944 (36); R.A. 1974–5 (134).

Lit. Thornbury 1862, i, p. 293; 1877, pp. 429–30; Eastlake 1895, i, p. 189; Bell 1901, p. 87 no. 116; Armstrong 1902, p. 222, repr. p. 17; Whitley 1928, p. 144; Davies 1946, p. 185; H. F. Finberg 1951, pp. 384, 386; Finberg 1961, pp. 159, 472 no. 149,

513 no. 157m; Rothenstein and Butlin 1964, pp. 20–22; Gage 1965, p. 79, repr. p. 77, fig. 30; Gage 1969, p. 136.

Exhibited in 1809 with the following verses:

'Aid me, ye Powers! O bid my thoughts to roll
In quick succession, animate my soul;
Descend my Muse, and every thought refine,
And finish well my long, my *long-sought* line.'

These verses, with the possible exception of those for *Dolbadern Castle* and *Caernarvon Castle* in the 1800 R.A., are the first of his own by Turner in an exhibition catalogue. There are drafts on the back of the study in pen and watercolour for the picture, CXXI-A, which is itself inscribed with references to Vida's 'Art of Poetry', 'Translations, &c', 'Hints for an Epic Poem', 'Paraphrase of Job', etc.

There is a companion sketch of an artist's studio, CXXI-B (repr. Gage 1965, fig. 29, and Gage 1969, pl. 31), again with draft verses on the back. Whereas *The Garreteer's Petition* somewhat ennobles its model, Hogarth's *Distressed Poet* (Birmingham City Art Gallery, repr. in colour Ronald Paulson, *Hogarth: His Life, Art, and Times* 1971, i, pl. 154a), Turner makes fun of the artist in his verses:

'Pleased with his work he views it o'er & o'er
And finds fresh Beauties never seen before'

while his apprentice cares not 'for taste beyond a butter'd roll'. Turner had already exhibited a somewhat similar subject the year before in *The Unpaid Bill* (No. 81).

This seems to have been painted on a panel already covered with what is apparently ordinary household paint. This extends beyond Turner's paint on the top and bottom edges. On the left there is a narrow strip of uncovered panel; on the right Turner's paint extends right up to the edge, which may have been cut after the painting was completed. In any case the panel seems to have been trimmed before Turner used it and after reinforcing battens and strips of canvas were added to the back.

Pasquin, writing in the *Morning Herald* (4 May 1809) followed his praise of *Spithead* (No. 80) with an attack on Turner for, in this work, attempting a genre to which he was not suited, concluding with 'the insulted Garrateer thus indignantly admonishing the Royal Academician . . .

'Avaunt! presumptuous, proud R.A.
What wouldst thou here, so pert, so gay?
May thine own Gods forsake thee:
You've spoil'd the tadpole of a thought,
Which Genius from Apollo caught,
For wich the Devil take thee!'

101. Grand Junction Canal at Southall Mill

Exh. 1810 (Plate 87)
also known as *Windmill and Lock*

PRIVATE COLLECTION, ENGLAND

Canvas, $36\frac{1}{4} \times 48$ (92 × 122)

Coll. J. Hogarth, a printseller and the publisher of Willmore's print after Turner of *The Temeraire* in 1845; sale Christie's 14 June 1851 (89) as 'The Lock, Evening' bought Bicknell; Charles Birch of Edgbaston; sale Foster's 15 February 1855 (16, repr.) bought Leo Redpath; sale Christie's 23 May 1857 (354) bought Gant or Gaut; Thomas Birchall by 1862 from whom bought by Agnew in 1870 and sold to John Heugh; sale Christie's 5 April 1874 (185) bought Cox; Sir Francis Cook, Doughty House, Richmond by 1899; by descent to his great-grandson; trustees of the Cook Collection sale Christie's 19 March 1965 (102) bought Agnew from whom bought by the father of the present owner.

Exh. Turner's gallery 1810 (2); International Exhibition 1862 (351 lent by T. Birchall); R.A. 1873 (69); Guildhall 1899 (13); Bradford *Exhibition of Fine Arts* 1904 (65); Grafton Galleries *Old Masters* 1911 (66); Agnew 1967 (11); Tokyo and Kyoto 1970–1 (37); Hamburg 1976 (34).

Engr. By W. Say in the *Liber Studiorum* published 1 June 1811 (Rawlinson 27) 'from a picture in the possession of J. M. W. Turner, R.A.'

Lit. Burnet and Cunningham 1852, pl. v (described as a companion to *Saltash*); Ruskin 1856, 1860, 1873 (1903–12, vi, pp. 16–19, pl. 19; vii, p. 432; xxxiv, p. 510); Thornbury 1862, i, pp. 178–9; ii, p. 38; 1877, pp. 127, 224; Armstrong 1902, pp. 56–7, 59, 237; Finberg 1910, pp. 57–8, 61; M. W. Brockwell, *A Catalogue of the Paintings in the Collection of Sir Herbert Cook* 1915, iii, pp. 24–5 no. 408, pl. 11; Finberg 1924, p. 107; H. F. Finberg 1951, pp. 383–6; Finberg 1961, p. 512 no. 157b; Gage 1972, pp. 61–2, fig. 40.

Ruskin mentions this picture in a letter written to his father on 21 February 1852. He refers to it being in a dealer's hands and says 'now it is cleaned, it comes out a real beauty—I believe Turner loved it.' From this it appears that Bicknell only kept the picture for a few months, but see the entry for *The Whale Ship* (No. 415) for a possible business arrangement between Bicknell and Hogarth over the three Turners in the 1851 sale.

Thornbury says that Turner sketched the mill (long since pulled down, but which was between Brentford and Hanwell) one evening on his way back from visiting his friend the Rev. Trimmer at Heston. Later Thornbury contradicts this and says that Turner used a sketch of Trimmer's, but the first story is more likely, in view of two small pencil drawings in the 'Windmill and Lock' sketchbook (CXIV) which clearly served as the basis for the oil; pp. 71 verso and 72 show a rapid sketch

of the mill which is taken from further away than the drawing on pp. 72 verso–73 (repr. Finberg 1910 pl. xxvii) which is a study for the oil, although the position of the horse is altered considerably in the painting. Thornbury also states that the picture was bought by one of Turner's executors, but there seems to be no corroboration for this.

Although the Cook catalogue is wrong in saying that Turner's picture is based on Rembrandt's *The Mill*, this must in fact be one of those fortuitous occasions when an artist came upon a subject in nature which reawakened an aesthetic stimulus recently received from another painter's picture. Rembrandt's *The Mill* (now in the National Gallery, Washington D.C. and no longer accepted as by Rembrandt) was among the pictures from the Orleans Collection smuggled out of Paris and exhibited in London in 1799 and again at the British Institution in 1806 and Turner must have seen it at any rate on the second occasion. He first refers to the picture in a note on reflected light on pp. 17 and 19 of the 'Greenwich' sketchbook (CII) of about 1808 ('Rembrandt is a strong instance of caution as to reflected light' and goes on to cite the celebrated picture of *The Mill* as an 'instance of the strongest class'), and he mentions it again in his lecture on 'Backgrounds', first delivered on 12 February 1811, but presumably prepared somewhat earlier. (See Jerrold Ziff, *Journal of the Warburg and Courtauld Institutes* xxvi 1963, pp. 124, 145, n. 78.)

In 1873 a Mr John Holmes wrote to Ruskin pointing out that 'the lock was made to open the wrong way, i.e. with instead of against the stream'. Ruskin replied on 13 December . . . 'Turner is assuredly wrong; unless we can imagine the stream to run the other way (up hill) and that would imply other wrongness. He simply has not been minding what he was about.'

102. View of the High-Street, Oxford Exh. 1810

(Plate 90)

THE LOYD COLLECTION

Canvas, 27 × 39½ (68·5 × 100·3)

Signed 'I M W Turner RA' bottom right. (Plate 539)

Coll. Commissioned by the Oxford picture dealer and frame maker James Wyatt (1774–1853) to be engraved; the picture was not in Wyatt's sale at Christie's 4–6 July 1853 although a copy of it apparently was (546); Jesse Watts Russell; sale Christie's 3 July 1875 (30) bought Agnew, from whom bought by Lord Overstone; by descent to the present owner.

Exh. Turner's gallery 1810 (3); R.A. 1812 (161); Grosvenor Gallery 1889 (34); B.F.A.C. *The Empire and Regency Period* 1929–30 (55); Tate Gallery 1931 (54); Oxford 1934 (8); Birmingham City Art Gallery (on loan) 1945–52; R.A. 1951–2 (171); Agnew 1967 (10); R.A. 1974–5 (159).

Engr. By J. Pye and S. Middiman, with figures by C. Heath, published by James Wyatt on 14 March 1812. In fact the plate was not quite finished by that date. A small replica, engraved by W. E. Albutt, was published in 1828.

Lit. Burnet and Cunningham 1852, p. 113 no. 108; Thornbury 1862, i, p. 179; 1877, pp. 127, 164–9, 174–6, 572; G. Redford, *Descriptive Catalogue of the Pictures at Lockinge House* 1875 (supplementary), no. 75; Monkhouse 1879, p. 86; Bell 1901, pp. 63, 91–2 no. 125; Armstrong 1902, pp. 109, 226; Temple 1902, pp. 158–9 no. 240 repr.; Rawlinson i 1908, pp. xxvi–xxviii, 36–9; ii 1913, p. 190; Finberg 1910, p. 5; *Guide to the Pictures at Lockinge House* 1928, p. 11; Clare 1951, pp. 47–8, 82; H. F. Finberg 1951, p. 384; Finberg 1961, pp. 160–66, 186–9, 474 no. 178, 512 no. 157c; Lindsay 1966, p. 106; Parris 1967, pp. 43–4 no. 61 repr.; Gage 1969, pp. 19, 51, 161.

This picture is one of the most closely documented of all Turner's works, as much of the correspondence between the artist and Wyatt still exists. Wyatt, who intended to publish an engraving of it, seems originally to have been uncertain whether to commission a drawing or a painting but finally chose the latter, for which he paid 100 guineas in March 1810. Turner's correspondence with Wyatt began in November 1809 and Turner went to Oxford at the end of December to make a drawing of the subject, which he is said to have done from inside a hackney coach. On 4 February 1810 he wrote to Wyatt from London to tell him that the picture was 'very forward' and a further letter of 14 March reported that it was finished and 'in a day or two can be varnished for the last time.' It was sent down to Oxford before 6 April and then returned to Turner in time for it to be included in the exhibition in his gallery which opened on 7 May. When the exhibition closed, it was handed over to the engravers and then exhibited again at the R.A. in 1812, with the companion picture No. 125.

The drawing which Turner used as the basis for his oil has disappeared but is referred to in Turner's letter, postmarked 25 December 1809, in which he asks Wyatt 'to get me a sheet of paper pasted down on a Board in readiness about 2 feet by 19'. Earlier in their correspondence, Turner mentions that he already has a sketch of the subject and this must be the pencil drawing in the Turner Bequest (CXX-F, 16⅛ by 20 in.), which is drawn from a point slightly further to the west than that of the painting, so that University College on the left and part of All Souls College on the right are omitted. The painting shows Robert Boyle's house on the left after University College; this has now been demolished.

The correspondence (which is published in part by both Thornbury and Finberg and will be given in its entirety by Gage) shows that a few alterations were made at Wyatt's request both before and after the

picture was sent to him at Oxford. A pair of clerical figures, attended by beadles, mentioned in Turner's letter of 28 February had been removed by 14 March and, instead, some women introduced 'for the sake of colour'. In a letter postmarked 6 April, Turner agreed to alter the spire of St Mary's which Wyatt thought too low. (The painting of this spire is reminiscent of some of Girtin's watercolours and, indeed, the whole picture recalls earlier Turner watercolours such as the Oxford Almanack drawings of c. 1802–5, and the even earlier Salisbury series of 1797–8.) Turner seems to have been very ready to comply with these suggestions and in general to do everything he could to meet Wyatt's wishes. Indeed, throughout the transactions, Turner's conduct seems to have been wholly obliging and he clearly went to great pains to make sure that he depicted such details as the figures in academical dress correctly, asking in a postscript to one letter: 'A Proctor's gown has I think you said velvet sleeves?'

As may be imagined Turner took the greatest interest in the choice of engraver and suggested a number of candidates, while leaving the final selection with Wyatt. However, in his letter of 23 November, he adds characteristically . . . 'but you must decide and all I can do respecting *advice etc.* to whomsoever you may ultimately choose, shall be at his or your service.'

The result obviously pleased Wyatt for he not only sent Turner a present of some sausages, but he commissioned a companion picture *Oxford from the Abingdon Road* (see No. 125). Turner refers to the possibility of painting a second picture as early as 6 April 1810 and at that time seems to have contemplated a view at the other end of the High Street.

At the R.A. exhibition, the critics concentrated their attention on *Hannibal* (No. 126) and there is no mention at all of the Oxford pictures by name, but this may be because they were hung, in Turner's words, 'in situations as unfortunate as could possibly be allotted them (from the Pictures close to them)'. Turner consulted Wyatt in a letter about the advisability of withdrawing them and showing them instead in his own gallery or at the British Institution the following year. He told Wyatt that if, in the latter's opinion, the advantages of the pictures being exhibited at the R.A. outweighed the disadvantages of their being so poorly hung—'*there they shall remain*' and, requesting an answer by return, begged Wyatt to think of himself '*first* and afterwards'. Wyatt evidently decided that the presence of the pictures at the R.A. might stimulate the sale of the engravings and the pictures remained in the exhibition.

103. Lake of Geneva, from Montreux, Chillion, &c Exh. 1810 (Plate 101)

LOS ANGELES COUNTY MUSEUM, CALIFORNIA

Canvas, $41\frac{1}{2} \times 65$ (105·4 × 165)

Coll. Bought by Walter Fawkes of Farnley, perhaps

from Turner's gallery in 1810; Ayscough Fawkes sale Christie's 27 June 1890 (59) bought in; bought by Sir Donald Currie 1891; by descent to his granddaughter Mrs L. B. Murray from whom bought by Agnew, 1950; Mrs Mildred Browning Green 1951; presented by her and her husband, Judge Lucius P. Green, to the Los Angeles County Museum in 1956.

Exh. Turner's gallery 1810 (6); R.A. 1877 (8) and 1892 (108); Agnew 1950 (22).

Lit. Thornbury 1862, ii, p. 393; 1877, p. 589; Armstrong 1902, p. 222; Finberg 1912, p. 20; H. F. Finberg 1951, pp. 384–5; Finberg 1961, pp. 167, 472 no. 157.

The view is taken looking across the lake towards the mouth of the Rhône. A drawing on p. 128 of the 'Calais Pier' sketchbook (LXXXI), identified by Finberg as a small study for this picture, does not seem in fact to be related. However, there is a pen and ink drawing which is identical with the picture, although not listed as such by Finberg. In this drawing (CXX-E, 'Miscellaneous Black and White (2)'), the figures are exactly the same as in the finished picture and a similar drawing also exists for the *Linlithgow Palace* (CXX-P), also exhibited in 1810 (No. 104). It seems, therefore, that both these drawings are records of the oils rather than studies for them, and may indicate that Turner intended these drawings as possible subjects to be engraved in the *Liber Studiorum*.

Dated by Armstrong 1805–10, it may well have been started a year or two before it was exhibited. The handling has points of similarity with the *London from Greenwich* (No. 97) of 1809 while the painting of the mountains goes back to the two oils of Bonneville (Nos. 46 and 50) of 1803. There are a number of sketches of Lake Geneva dating from the 1802 tour in the Turner Bequest as well as at least two finished watercolours but in these the viewpoint is taken from the shore of the lake.

This is one of three pictures known to have been shown in 1810 even before the discovery of the exhibition catalogue, because it is mentioned in the *Sun* for 12 June: 'In Mr. Turner's Gallery there is a rich display of taste and genius. A picture of the Lake of Geneva is particularly beautiful.'

104. Linlithgow Palace, Scotland Exh. 1810 (Plate 102)

THE WALKER ART GALLERY, LIVERPOOL

Canvas, 36 × 48 (91·4 × 122)

Coll. Painted for Sir George Phillips (1789–1883); this commission is noted by David Wilkie in his *Diary* for 7 and 8 May 1810: 'Had a call from a Mr. Phillips (now Sir George), who commissioned me to paint him a picture, for he was making a Collection of the English School; he resides in Lancashire.—(8th)

went to see Turner's Gallery: he has ... and a view of Linlithgow Castle; the latter painted for the Mr. Phillips who called on me yesterday. I thought this one of his best pictures'; by descent to Sir George Phillips' eldest daughter, Juliana, who married the second Earl of Camperdown in 1839; Camperdown sale Christie's 2 February 1919 (158) bought Agnew; F. J. Nettlefold who presented it to the Walker Art Gallery in 1948.

Exh. Turner's gallery 1810 (8); Royal Manchester Institution 1829 (271); R.A. 1888 (37); Tate Gallery 1931 (47); R.A. 1934 (643); Agnew *Selected Acquisitions from the Walker Art Gallery Liverpool 1945–1955*, 1955 (19).

Lit. Allan Cunningham, *The Life of Sir D. Wilkie* 1843, i, p. 295; Bell 1901, p. 111 no. 163; Armstrong 1902, p. 224; Falk 1938, p. 251; Clare 1951, p. 43; H. F. Finberg 1951, p. 385; Finberg 1961, pp. 167, 170–71, 472 no. 150, 513 no. 325a.

The title in the catalogue of Turner's gallery exhibition was misprinted as 'Lintithgow'. It was one of three pictures mentioned in the *Sun* in a notice of the exhibition, published on 12 June 1810 (three days after the exhibition had closed to the public). 'In Mr. Turner's gallery there is a rich display of taste and genius ... Another [picture] of Linlithgow Palace, Scotland has all the higher qualities of the art.'

In one of the account books belonging to Turner's stockbroker Mr William Marsh, preserved with Turner's sketchbooks in the British museum, there is a record of Turner's account with Marsh from January–July 1810. This includes two sums received on 16 and 18 May, against which Turner has pencilled the name 'Phillip'. In Turner's 'Hastings' sketchbook (CXI) the same figures occur again with the name 'Phillips' opposite them, and inside the cover of the same book, Turner has written 'Money received of Phillips 210'. Finberg suggested quite plausibly that this might refer to Sir George Phillips, Bt, M.P., as the price of this picture is likely to have been 200 guineas, and his connection through marriage with the Camperdown family has already been noted. This conjecture on Finberg's part was confirmed when Gage noticed the reference in Cunningham's biography of Wilkie which shows that the picture was actually commissioned by Phillips.

There are a number of drawings of Linlithgow Palace and Church in the 'Scotch Lakes' sketchbook (LVI), which is inscribed by Turner inside the front cover '18 of July left Edinburgh and on the 5 of August finished this book at Gretna Green.' This refers to Turner's visit to Scotland in 1801. Linlithgow is about fifteen miles north-west of Edinburgh. Most of the Linlithgow drawings in the sketchbook are of architectural details of the castle but that on p. 20 is a more general view relating to the oil. A pencil drawing of Linlithgow in the Fogg Museum, Harvard, may be a page out of the dismembered 'Smaller Fonthill'

sketchbook (XLVIII), in use from 1799–1802. A watercolour ($9\frac{1}{2} \times 16$ in.) of *c.* 1801, once in Ruskin's collection, taken from the opposite side of the castle, shows it nevertheless framed between trees in a similar manner to the oil and may represent Turner's original choice of viewpoint which he later modified, perhaps at Phillips' request.

There is also a pen and ink drawing of the composition (CXX-P) among the 'Miscellaneous Black and White Drawings (2)' dated by Finberg 1802–10, which includes the figures as they appear in the finished picture and which therefore appears to have been done after the picture was painted. This may be a projected drawing for the *Liber Studiorum* which Turner then set aside, as seems to be the case with a similar drawing of *The Lake of Geneva* (No. 103).

When exhibited at the Royal Manchester Institution in 1829, the critics united in praising it, obviously welcoming an opportunity of seeing such a good example of Turner's earlier style. Their general comments were summed up in the *Manchester Guardian* on 29 August which wrote 'Ah, Turner, Turner! why will you not paint thus now? Why will you not leave gamboge, maguilp, and quackery, and return to nature ...?'

105. Hastings—Fishmarket on the Sands
Exh. 1810 (Plate 103)

THE WILLIAM ROCKHILL NELSON GALLERY AND ATKINS MUSEUM OF FINE ARTS, KANSAS CITY, MISSOURI

Canvas, $35\frac{3}{4} \times 47\frac{1}{2}$ (91 × 120·6)

Signed and dated 'J M W Turner RA 1810' lower left

Coll. Bought by John Fuller, M.P. (*d.* 1834) of Rosehill Park, Sussex, probably in 1810; by descent to Sir Alexander Acland-Hood; sale Christie's 4 April 1908 (98) bought Agnew; Pandeli Ralli; bought by Kansas Museum through Sulley in 1933.

Exh. Turner's gallery 1810 (9) as 'Fish Market'; International Exhibition 1862 (333); R.A. 1882 (179); Agnew 1908 (20); Agnew 1926 (15); Vienna 1927 (86); Detroit Institute of Arts 1942 (63); Boston 1946 (4); Toronto and Ottawa 1951 (17); Indianapolis 1955 (12).

Lit. Burnet and Cunningham 1852, p. 34 (?); Armstrong 1902, p. 222; *Handbook of the William Rockhill Nelson Gallery of Art* 1933, pp. 57, 60 (repr.); H. F. Finberg 1951, pp. 384–5; Finberg 1961, pp. 167, 171, 472 no. 155.

Finberg's conjecture, in the first edition of his *Life*, that this picture may have been exhibited in Turner's gallery in 1810 was proved to be correct when the catalogue of the exhibition was discovered by Mr (now Sir) Francis Watson. Turner's exhibition ran from 7 May until 9 June.

In Turner's 'Hastings' (CXI) and 'Finance'

(CXXII) sketchbooks there is a record of a payment received from Fuller on 26 July 1810 which probably refers to this picture, although there is also a note of a further payment of a lesser amount on 26 November 1810, and Fuller seems to have owed Turner a further £200 at the end of the year. The question of sorting out these payments is complicated by the fact that we learn from Farington (*Diary* 21 April 1810) that 'Mr Fuller, member for Suffolk, has engaged Turner to go into that County to make drawings of three or four views. He is to have 100 guineas for the *use* of his drawings, which are to be returned to him.'

John Fuller was in fact the member for Sussex, not Suffolk, from 1801–12. Turner later painted for him a series of large watercolours of the countryside round his seat, Rosehill Park, near Battle, Sussex, which were to be engraved and published at his expense; Turner also painted an oil of Rosehill (see No. 211).

A watercolour version of the subject (signed and dated 1818, 11 × 15 in.) was in the Fawkes Collection at Farnley until 1912 (repr. in colour in Finberg 1912, pl. xxviii). It is perhaps possible that Turner was originally attracted to the subject by seeing the large and ambitious watercolour *Fishmarket on the Beach at Hastings* by Joshua Cristall (1768–1847), which was exhibited at the Society of Painters in Water Colours in 1808 (37) and is now in the Victoria and Albert Museum, although Turner treats the subject in an entirely different manner.

A number of very small drawings in the 'Hastings' sketchbook (CXI) of figures on a beach, identified by Finberg as 'probably on beach at Hastings', may be connected, especially p. 25, but this is not certainly so.

This may be the picture about which Burnet and Cunningham tell the story that Turner delivered it by coach to Fuller's house, received his cheque and went away, only to return a few minutes later to ask for 'three shillings for the cab fare'. The catalogue of the Turner Bicentenary exhibition noted, however, that a similar story was attached by tradition in the Meyrick family to *Rosehill* which Turner is said to have taken all the way to Anglesey in about 1849 where he sold it to Fuller's son (see the entry for No. 211), but there are so many improbabilities about this that it is much more likely that Burnet was right.

106. Calder Bridge, Cumberland Exh. 1810

(Plate 104)

PROFESSOR HAMILTON EMMONS

Canvas, 36 × 48 (91·5 × 122)

Coll. Bought from Turner by Elhanan Bicknell, probably among a group of six Turner oils purchased in March 1844; sale Christie's 25 April 1863 (110) bought H. Bicknell; bought by Agnew from Smith in 1868 and sold to Thomas Ashton; bought from S. E. Ashton in 1917 jointly by Agnew, Knoedler and Sulley; Sulley sale Christie's 1 June 1934 (36) bought

Agnew; sold in 1937 to R. V. B. Emmons; by descent to the present owner.

Exh. Turner's gallery 1810 (10) and 1812; Grosvenor Gallery 1888 (60); Olympia *Daily Mail Exhibition* 1930; Tate Gallery 1931 (48 lent under the name of F. S. Graham Menzies, a partner in Knoedler's).

Lit. Ruskin 1843 (1903–12, iii, p. 244); Thornbury 1862, i, p. 151; ii, p. 401; 1877, pp. 93, 599; Armstrong 1902, p. 219; H. F. Finberg 1951, p. 384–5; Finberg 1961, pp. 190–91, 474 no. 171, 513 no. 157g; Rothenstein and Butlin 1964, pl. 43.

Based on a pencil sketch in the 'Cockermouth' sketchbook (CX p. 33, repr. by Wilkinson 1974, p. 101) inscribed with the title in Turner's hand and a number of other notes including one about 'wheelwrights . . .' which must refer to the activities in the barn on the right of the picture. This sketchbook was in use in the summer of 1809, and Turner must have passed through Calder Bridge on his way to fulfil his commission to paint the picture of *Cockermouth Castle* for Lord Egremont (No. 108).

A notice in the *Sun* on 9 June 1812 refers to the exhibition in Turner's gallery which had just closed. The writer maintains that several pictures had been shown previously but 'there are seven additional landscapes, all of which display extraordinary merit. Indeed, we are almost disposed to say that they even excel his former productions except in two or three instances. Among the new works are *The River Plym* [No. 118], *Calder Bridge, Cumberland* . . . all these pictures are painted with a boldness, vigour and truth which entitle the artist to a very high station among the landscape painters of any period.'

The writer of this notice, who Finberg suggests was the *Sun*'s editor John Taylor, was wrong in saying that this picture had not been previously exhibited, although it is the only one, among those mentioned as new exhibits, which was not.

In composition this stems from some of the Thames sketches on canvas in the Tate Gallery (e.g., Nos. 166 and 172) and resembles them in having no far distance, but it looks forward, in both colour and arrangement, to the Wharfedale watercolours of *c.* 1815, as Ruskin recognised: 'Among the earlier *paintings* of Turner, the culminating period, marked by the Yorkshire series in his *drawings* is distinguished by great solemnity and simplicity of subject, prevalent gloom in chiaroscuro, and brown in the hue, the drawing manly but careful, the minutiae sometimes exquisitely delicate. All the purest works of this period are, I believe, without exception, views, or quiet single thoughts. The Calder Bridge, belonging to E. Bicknell Esq., is a most pure and beautiful example.'

107. Dorchester Mead, Oxfordshire Exh. 1810

(Plate 91)

THE TATE GALLERY, LONDON (485)

Canvas, 40 × 51¼ (101·5 × 130)

Coll. George Hibbert, sold Christie's 13 June 1829 (24) for £120.15.0 bought Turner; Turner Bequest (70, 'Abingdon' 4′3½″ × 3′4½″); transferred to the Tate Gallery 1910.

Exh. Turner's gallery 1810 (12); Tate Gallery 1931 (42); British Council tour, Cologne (56, repr.), Rome (57, repr.) and Warsaw (56, repr.) 1966–7; Hague (45, repr.) and Tate Gallery (43, repr.) 1970–71; R.A. 1974–5 (157).

Lit. Ruskin 1857 (1903–12, xiii, pp. 120–21); Thornbury 1862, i, p. 293; 1877, p. 430; Armstrong 1902, p. 217; Davies 1946, p. 187; Clare 1951, pp. 43–5, repr. in colour p. 17; H. F. Finberg 1951, pp. 384, 386; Finberg 1961, pp. 167, 171, 472 no. 154, 513 no. 157i; Rothenstein and Butlin 1964, p. 91, pl. 47; Lindsay 1966, p. 107; Gage 1969, p. 89.

Catalogued in the George Hibbert sale at Christie's on 13 June 1829 (24) as 'Abingdon, taken from the River — Cattle cooling themselves, Group of Lighters in half-distance, figures loading a Timber Waggon in right Bank, Sultry Sun in Mist', and listed in the schedule of the Turner Bequest as 'Abingdon', this picture nevertheless seems to be the otherwise lost 'Dorchester Mead' exhibited by Turner in his own gallery in 1810. The title is somewhat misleading in that Dorchester Mead is some two miles from Abingdon church, the spire of which is seen in the distance, but not much more perverse than the full title of the picture to which it may well have been intended as the companion, *Slough*, exhibited the year before (No. 89).

There are related drawings in the 'Hesperides (1)' and '(2)' sketchbooks (XCIII-21 verso, and XCIV-4 verso and, less close, 40 verso).

108. Cockermouth Castle Exh. 1810 (Plate 92)

H.M. TREASURY AND THE NATIONAL TRUST (Lord Egremont Collection) PETWORTH HOUSE

Canvas, 23¾ × 35½ (60·3 × 90·2)

Coll. Painted for the third Earl of Egremont; by descent to the third Lord Leconfield who in 1947 conveyed Petworth to the National Trust; in 1957 the contents of the State Rooms were accepted by the Treasury in part payment of death duties.

Exh. Turner's gallery 1810 (13); S.B.A. 1834 (122); Tate Gallery 1951 (15).

Lit. Petworth Inventories 1837, 1856 (London House); Waagen 1854, iii, p. 38; Armstrong 1902, p. 220, repr. p. v; Collins Baker 1920, p. 126 no. 653; Hussey 1925, p. 975 repr.; H. F. Finberg 1951,

p. 386; Finberg 1961, pp. 159, 167, 171, 350, 472 no. 153, 499 no. 457.

The success of Turner's two views of Tabley (see Nos. 98 and 99), painted for Sir John Leicester and shown at the R.A. in 1809, brought him further orders of this sort from Lord Egremont and Lord Lonsdale. These involved Turner in journeys in the summer of 1809 to gather material for these commissions. This material can be seen in the 'Petworth' (CIX) and 'Cockermouth' (CX) sketchbooks. In the former are a group of drawings of Cockermouth Castle; p. 24 shows a careful study for the oil and is much closer to the composition of the picture than the drawing on p. 14 which Finberg identifies as the sketch for it. There is also a related drawing on p. 16 of the 'Cockermouth' sketchbook among other views of the castle (in particular those on pp. 17 and 21). These drawings are much slighter and more rapidly executed than the detailed studies in the 'Petworth' sketchbook.

Cockermouth Castle was originally in the possession of the Earls of Northumberland and passed in 1750 with the Egremont title and Petworth to Sir Charles Wyndham (d. 1763), nephew of the seventh Duke of Somerset and the father of Turner's patron.

In the 'Hastings' sketchbook (CXI), pp. 57–9 contain details of Turner's accounts, which include a note of payment from Lord Egremont on 15 June 1810. This probably refers to the *Petworth from the Lake* (No. 113) and to this picture. Finberg gives the price of the former as 200 guineas and of this picture as 100 guineas.

It is interesting to note that although both pictures depict houses belonging to Lord Egremont and were painted in the same year, they were obviously not conceived as pendants as in the case of the two views of Lowther Castle (Nos. 111 and 112) or the two pictures of Tabley already mentioned. As this picture is the same size as *The Thames at Eton* (No. 71), acquired by Lord Egremont in 1808, it seems likely that it was painted to these dimensions in order to hang as a pendant to the *Eton*.

109. The Fall of an Avalanche in the Grisons
Exh. 1810 (Plate 116)

Also known as *Cottage destroyed by an Avalanche*

THE TATE GALLERY, LONDON (489)

Canvas, 35½ × 47¼ (90 × 120)

Coll. Turner Bequest 1856 (9, 'Avalanche' 4′0″ × 3′0″); transferred to the Tate Gallery 1910.

Exh. Turner's gallery 1810 (14); Tate Gallery 1931 (56); Amsterdam 1936 (158); Amsterdam, Berne, Paris (repr.), Brussels, Liege (16), Venice (repr.) and Rome (repr.) (18) 1947–8; Rotterdam 1955 (50); Tate Gallery 1959 (346); *Romantic Art in Britain: Paintings and Drawings 1760–1860* Detroit and Philadelphia, January–April 1968 (116); Paris 1972

(261, repr.); R.A. 1974–5 (87); Hamburg 1976 (16, colour pl. 3).

Lit. Ruskin 1843 and 1857 (1903–12, iii, p. 239; xii, pp. 122–3); Thornbury 1877, p. 378; Armstrong 1902, p. 218; MacColl 1920, p. 9; Whitley 1928, p. 177; Davies 1946, p. 185; H. F. Finberg 1951, pp. 384, 386; Finberg 1961, pp. 167, 472 no. 151; Rothenstein and Butlin 1964, p. 31, pl. 48; Lindsay 1966, pp. 106–7; Lindsay 1966², p. 21 n.; Reynolds 1969, p. 83, colour pl. 63; Gaunt 1971, p. 5, colour pl. 10; Herrmann 1975, pp. 20–21, 229, colour pl. 56; John Russell and Andrew Wilton, *Turner in Switzerland* 1976, pp. 17–18.

Exhibited with the following lines, which anticipate those attributed by Turner to his *Fallacies of Hope*, first quoted in connection with *Hannibal crossing the Alps* (No. 126):

'The downward sun a parting sadness gleams,
Portentous lurid thro' the gathering storm;
Thick drifting snow on snow,
Till the vast weight bursts thro' the rocky barrier;
Down at once, its pine clad forests,
And towering glaciers fall, the work of ages
Crashing through all! extinction follows,
And the toil, the hope of man—o'erwhelms.'

As Jack Lindsay has pointed out, these verses and the reference to the Grisons recall a passage from 'Winter' in Thomson's *Seasons*. John Gage suggests that the verses may also echo Job xiv, 18–19.

It is not known if Turner visited the Grisons when he was in Switzerland in 1802. In any case it is probable, as Dr. Amstutz has pointed out, that Turner had heard about the avalanche that took place at Selva in the Grisons in December 1808, a disaster in which 25 people were killed in one cottage alone (see Russell and Wilton, *loc. cit.*).

Turner was probably also inspired by two paintings of avalanches by de Loutherbourg in the collections of his patrons, one, of *c.* 1800, in the collection of Lord Egremont (still at Petworth, repr. illustrated souvenir *The First Hundred Years of the Royal Academy*, R.A. 1951–2, p. 53), the other, dated 1803, exhibited at the R.A. in 1804 and sold to Sir John Leicester in 1805 (now Tate Gallery; see *The Tate Gallery Report 1965–66*, pp. 19–20, repr.; also Herrmann 1975, repr. pl. 55). However, as Ruskin noted in his *Notes on the Turner Gallery at Marlborough House* 1857, 'No one ever before had conceived a stone in flight'; de Loutherbourg's pictures and the verses of Thomson deal only with the power of falling snow. A contemporary review of Turner's gallery in the *Sun* of 12 June 1810 noted that the picture 'is not in his usual style, but is not less excellent'.

110. Rosllyn Exh. 1810

PRESENT WHEREABOUTS UNKNOWN

Size unknown

Exh. Turner's gallery 1810 (15).

Lit. H. F. Finberg 1951, pp. 384–6; Finberg 1961, p. 513 no. 157k.

Mrs Finberg suggests that this may not have been an oil. If it was a watercolour, then it was the only one exhibited, and in the 1809 exhibition catalogue the only watercolour shown (*King's College Chapel*) was described as such, and was the last item in the list, whereas two oils follow no. 15 in the 1810 catalogue. In either case, no subsequent trace of this exhibit has ever been found.

On balance, therefore, it seems more likely that this was an oil. There are drawings of Roslin Castle and Roslin Chapel in the 'Dunbar' sketchbook (LIV pp. 39 verso–41) and in the 'Edinburgh' sketchbook (LV pp. 61 verso–68 verso), dating from the 1801 visit to Scotland. Sketches made on the same trip were used as the basis for an oil of *Linlithgow Palace* (No. 104), also exhibited by Turner in his gallery in 1810.

111. Lowther Castle, Westmorland, the Seat of the Earl of Lonsdale: North-West View from Ulleswater Lane: Evening Exh. 1810 (Plate 106)

PRIVATE COLLECTION, ENGLAND

Canvas, $35\frac{1}{2} \times 48$ (90.2 × 122)

Coll. Painted for William, first Earl of Lonsdale (1757–1844); by descent to the present owner.

Exh. R.A. 1810 (85); R.A. 1891 (131).

Lit. Burnet and Cunningham 1852, p. 112 no. 95; Thornbury 1877, pp. 165, 572; Bell 1901, p. 88 no. 117; Armstrong 1902, pp. 60, 224; Finberg 1961, pp. 159, 168, 171, 472 no. 158; Reynolds 1969, p. 69; Herrmann 1975, p. 227.

According to Finberg, Turner's commission to paint this and a companion picture for Lord Lonsdale and pictures of Cockermouth Castle and Petworth for Lord Egremont, followed the success of his two views of Tabley, exhibited at the R.A. in 1809. Turner gathered material in the summer of 1809 but, although there is a 'Lowther' sketchbook (CXIII) which contains some small sketches of architectural details of the castle, inscribed 'Lowther' in Turner's hand, there are no known drawings directly connected with the finished pictures in the Turner Bequest. There are, however, three drawings of Lowther in the Ashmolean Museum, Oxford (Ruskin School Collection), two of which are connected with the oils, in one case closely. These two drawings are reproduced in Herrmann 1968, pls. XV and XLVa and are nos. 72 and 73 in his catalogue.

No. 73 is virtually identical with this picture in the disposition of the main features of the composition; the oil differs only in having some cattle and vegetation introduced in the foreground which is left blank in the drawing. Professor Herrmann was not aware of this connection when he wrote his earlier book, as photographs of the oils were not then available.

Turner has, however, used considerable licence: he has greatly reduced the distance of the castle from the river and made the slope up to the castle much steeper. He has also moved a clump of pine trees on the near bank downhill nearer the river so that they split the foreground in two, thus producing a two-pronged lead into the middle distance, a favourite compositional device of Turner's at this time.

The pictures are unusual in having no human figures in them, although other instances of this do occur in Turner's work at about this time (e.g., in *Somer Hill* of 1811, No. 116). On the whole, the pictures were well received at the R.A. although Turner's other exhibit, *Petworth from the Lake* (No. 113), was generally recognised as finer.

Of this picture the critic of the *Morning Herald*, 1 May, wrote that 'One of the most indubitable proofs of the genius of Mr. Turner is that he has formed a manner of his own; if it partakes of the style of any preceding painter, it is Cuyp, whose aerial perspective Mr. Turner seems in some sort to copy; yet it is doing but common justice to our countryman to notice, that he is, in almost every other respect, very much superior to Cuyp.'

The *Repository of Arts, Literature, etc.* for June 1810 was less laudatory. The colouring of this picture was agreed to be 'clear, beautiful and natural but the execution is slovenly and indistinct. The cattle in the foreground ill drawn and poorly grouped.' Its companion was considered to have the same defects and the same charms of colour but it was noted that 'the sky [was] rather dirty, owing to a profusion of Naples or patent yellow'.

The *Monthly Magazine*, 1 July, considered this picture to be 'one of those enchanting scenes that England alone can boast, executed in a most transcendant style of effect.'

Lowther Castle, about five miles south of Penrith in Cumberland, was built for Lord Lonsdale between 1806 and 1811, and was thus still under construction at the time the pictures were exhibited. Turner shows the house as seen from the Celeron Road, Ullswater Lane.

112. Lowther Castle, Westmorland, the Seat of the Earl of Lonsdale (the North Front), with the River Lowther: Mid-Day Exh. 1810 (Plate 107)

PRIVATE COLLECTION, ENGLAND

Canvas, $35\frac{1}{2} \times 48$ (90·2 × 122)

Coll. As for No. 111.

Exh. R.A. 1810 (115); R.A. 1867 (33) and 1891 (135).

Lit. Burnet and Cunningham 1852, p. 112 no. 96; Thornbury 1877, pp. 165, 572; Bell 1901, p. 88 no. 118; Armstrong 1902, pp. 60, 224; Finberg 1961, pp. 159, 168, 171, 473 no. 159; Reynolds 1969, p. 69; Herrmann 1975, p. 227.

See No. 111 for the circumstances which led to this commission.

The view is taken from a point a little to the north-east of that in the companion picture.

A drawing in the Ashmolean Museum, Oxford, *Distant View of Lowther Castle* (no. 72 and pl. XV in Herrmann's catalogue, see No. 111) is taken from a viewpoint further down the Lowther Valley than this oil and there is no sign of the river in the drawing. However, the oil does include the thistle which features so prominently in the right foreground of the drawing, although here it reappears in the bottom left-hand corner.

For press criticisms of the two pictures when they were exhibited at the R.A., see No. 111.

113. Petworth, Sussex, the Seat of the Earl of Egremont: Dewy Morning Exh. 1810 (Plate 94)

H.M. TREASURY AND THE NATIONAL TRUST (Lord Egremont Collection) PETWORTH HOUSE

Canvas, $36 \times 47\frac{1}{2}$ (91·4 × 120·6)

Signed and dated 'J M W Turner R A 1810' lower left

Coll. Painted for the third Earl of Egremont in 1810; by descent to the third Lord Leconfield who in 1947 conveyed Petworth to the National Trust; in 1957 the contents of the State Rooms were accepted by the Treasury in part payment of death duties.

Exh. R.A. 1810 (158); R.A. 1892 (133); Tate Gallery 1951 (13); R.A. 1951–2 (174); Victoria and Albert Museum *Going Going Gone*, 1974 (un-numbered).

Lit. Petworth Inventories 1837, 1856; Burnet and Cunningham 1852, p. 112, no. 97; Thornbury 1862, i, p. 381; 1877, pp. 165, 572; Bell 1901, p. 88 no. 119; Armstrong 1902, pp. 60, 109, 226; Collins Baker 1920, p. 125 no. 636, repr. as frontispiece; Whitley 1928, p. 170; Finberg 1961, pp. 168, 171, 473 no. 160; Rothenstein and Butlin 1964, pp. 27, 44, 48, pl. 46; Lindsay 1966, p. 107; Gage 1969, p. 89; Reynolds 1969, pp. 69, 106; Herrmann 1975, p. 19, pl. 62.

Based on a pencil sketch (repr. in Wilkinson 1974, p. 98) on p. 4 of the 'Petworth' sketchbook (CIX), in use in the summer of 1809. Besides drawings of Petworth, this book has a number of studies of Cockermouth Castle, also belonging to Lord Egremont who had commissioned Turner to paint him views of both Petworth and Cockermouth Castle (No. 108). A payment from Lord Egremont on 14 June 1810,

recorded in Turner's 'Finance' sketchbook (CXXII), probably refers to these two pictures.

As Rothenstein and Butlin have pointed out, following on his experiments of using a white ground for the sky and the water in his Thames studies on canvas, Turner now began to explore the possibilities of attaining a high key in his finished oils by using a white ground throughout (although the catalogue of the Wantage collection claims that the first picture Turner painted on a white ground was *Whalley Bridge* exhibited in 1811 (see No. 117)). Turner's experiments in watercolour, in which he used the white paper as the means of lightening the tone of his drawings by allowing it to show through transparent washes, may have encouraged him to try a similar process in oil. At any rate, the result was sufficiently novel to make the critic of *La Belle Assemblée* (1810, i, p. 250) doubt that the picture was by Turner if it had not been 'for the information in the catalogue'. He wrote: '. . . it was manifestly Mr. Turner's design to express the peculiar hue and pellucidness of objects seen through a medium of air, in other words to express the clearness of atmosphere. To effect this purpose it was necessary to select those dark material objects which serve as a foil to aerial lights and to produce atmosphere by their contrast. Mr. Turner has neglected to use these necessary foils and has thus made a confusion between aerial lights and the appropriate gloom of objects. Failing in this forcible opposition, without which a painter can never express atmosphere, the appearance of the picture is that of a mere flimsy daubing without substance or distinction, without either shape or colour. A man of Mr. Turner's experience should have understood better the principles of his art.'

However, other critics were more appreciative: the *Public Ledger and Daily Advertiser* for 9 May wrote:

'The chief excellence in this picture is the execution of the water, and the dewy vapour that floats through the vallies; the latter effect is most happily expressed and, apparently, by a very simple process, that of a kind of light scumbling and glazing; but we think some of the more prominent objects in the foreground want force, and a richer variety of tint.'

This notice was repeated, almost word for word, in the *St. James's Chronicle* for 8–10 May while the *British Press*, 13 June, considered it 'Another most beautiful landscape, in which the water is pre-eminent, for the excellence with which it is finished. In clearness and brilliancy, we have never seen it excelled.' Later on, however, Turner is criticized for 'a remarkable blemish . . . in the shadow of the boat in the water, which is stronger than the boat itself; thus, contrary to nature, making the shadow the object, and the object the shadow.'

114. Mercury and Herse Exh. 1811 (Plate 96)

PRIVATE COLLECTION, ENGLAND

Canvas, 75 × 63 (190·5 × 160)

Signed 'JMW Turner RA PP' bottom centre

Coll. Sir John Swinburne (1762–1860) who bought the picture from Turner early in 1813 for 550 guineas; it remained in the possession of the Swinburne family until after 1862; Sir John Pender by 1872; sale Christie's 29 May 1897 (82) bought Tooth; Sir Samuel Montagu, Bt. (created Lord Swaythling in 1907) by 1899; Swaythling sale Christie's 12 July 1946 (38) bought in; sale Christie's 16 June 1961 (65) bought Betts; sold by Leggatt to the present owner in 1962.

Engr. By J. Cousen 1842 (plate dedicated to Sir John Swinburne).

Exh. R.A. 1811 (70); Turner's gallery 1812; International Exhibition 1862 (292 lent by Miss Swinburne); R.A. 1872 (131 lent by Sir John Pender) and 1891 (133); Guildhall 1899 (20); R.A. 1907 (90); Shepherd's Bush 1908 (66); R.A. 1934 (692); Leggatt *English Painting c. 1750–1850* 1963 (31).

Lit. Farington *Diary* 8 June 1811, 5, 24 February 1813; Burnet and Cunningham 1852, p. 112 no. 98; Thornbury 1862, i, p. 383; 1877, pp. 162, 572; Bell 1901, p. 89 no. 120; Armstrong 1902, pp. 59, 105, 225, repr. facing p. 60; Clare 1951, p. 47; Finberg 1961, pp. 179–80, 190, 208, 386, 473 no. 161, 474 no. 176; Michael Kitson 'The English Genius for Landscape', *Country Life*, 10 October 1963 p. 868 repr.; Rothenstein and Butlin 1964, pp. 28, 32; Lindsay 1966, p. 115; Gage 1969, pp. 89–90, pl. 19; Reynolds 1969, p. 186.

Exhibited with the following quotation from Ovid's *Metamorphoses*:

'Close by the sacred walls in wide Munichia's plain, The God well pleas'd beheld the virgin train.'

One of the Greek myths about Herse (a daughter of Cecrops, King of Athens) relates that Mercury fell in love with her while she was carrying a sacred basket up to the Acropolis in the annual procession in honour of Demeter.

It seems certain that the idea for this picture was suggested to Turner by seeing Paolo Veronese's *Hermes (Mercury), Herse and Aglauros*, at that time in Earl Fitzwilliam's collection at Richmond and now in the Fitzwilliam Museum, Cambridge. Turner analyses the colour of the Veronese in the last of his series of lectures on perspective which was first delivered on 12 February 1811. The fact that Turner has added 'PP' (Professor of Perspective) to his signature may be a reference to this, although it occurs elsewhere in Turner's *oeuvre*, most frequently in 1808, the year following his election to the Professorship.

Gage quotes Turner on the Fitzwilliam Veronese and observes of this picture:

'Although it has nothing to do with Veronese in its interpretation of the theme, it carries into a Claudian landscape his keynote of blue in the vivid sky, mirrored in the lake, tinging delicately the distant hills, and drawn into the foreground by the drapery to the left. Only the square of figures and fallen masonry on the left, veiled in diaphanous shadow, provides a warm middle-tone to the picture; and the distant landscape to the right has a cool, grey delicacy that looks forward to *Crossing the Brook* which, like it, makes a truly Claudian use of English motifs. In this, Turner has abstracted a principle from Veronese's practice and used it in his own way.'

As Kitson pointed out in his review of Leggatt's exhibition in 1963, although the picture is 'permeated by the influence of Claude, the outcome is Claude translated into early 19th-century terms; that is to say, it is Claude with the classical precision left out, and a Romantic love of the sublime put in its place.'

There are a number of drawings related to the composition in the Turner Bequest although in some cases the connection is less than certain, and they may rather be ideas for other classical subjects which Turner never painted. I would agree with Finberg that p. 57 in the 'Studies for Pictures; Isleworth' sketchbook (XC) is almost certainly a study for the picture and I believe also that the drawing on p. 60 is probably another but I am much less certain about those on pp. 57 verso–58 and 58 verso–59, the former of which is tentatively connected by Finberg with the oil. In the 'Woodcock Shooting' sketchbook (CXXIX) p. 20 verso seems probably connected, but on p. 21 a drawing of a piece of masonry overgrown by weeds, identified by Finberg as a study for the foreground, does not correspond closely with any feature in the oil. Page 4 of the 'Hesperides (1)' sketchbook (XCIII), which is torn, may also be a study for part of the composition.

Gage also suggests that the broken bridge in this picture may be based on the oil beginning in the Tate (see No. 169) which may help to date the sketch 1810–11. The two bridges do not appear to be sufficiently similar to confirm this suggestion with any certainty.

When, in his speech at the Academy banquet, the Prince Regent spoke of 'landscapes which Claude would have admired', it was assumed that he was alluding to this picture in particular, and it was generally expected that he intended to buy it.

The Prince Regent's praise of *Mercury and Herse* caused Turner some embarrassment. According to a paragraph in the *Sun* on 15 May, two of his earliest and warmest patrons became so eager to buy the picture that, rather than offend one of them, Turner resolved not to part with it at all. Farington's story is somewhat different. He tells us, on 8 June, that Earl Grey was understood to be willing to pay 500 guineas for the picture when the report was circulated that the Prince had bought it, 'which not being the case, Turner was

embarrassed about it, and under these circumstances with His usual caution, will not name a price when asked by His acquaintance.'

As will be noted in connection with the other oils exhibited at the R.A. in 1811 (Nos. 115, 116, and 117) the critics concentrated almost exclusively on this picture.

On April 30 the *Sun* published an enthusiastic notice of it, written by the editor, John Taylor: 'Highly as we thought of Mr. Turner's abilities, he has far exceeded all that we or his most partial admirers could expect from his powers . . .' Turner was so pleased with this eulogy that he copied the whole of it into his 'Hastings' sketchbook (CXI) and wrote Taylor a letter of thanks. The eulogy was repeated verbatim in the *Morning Post* on 2 May. In the *Monthly Magazine* the picture is described in the June issue (no. 213) as 'a master-piece', and in the July issue (no. 214) as 'such a brilliant example of poetical composition, in landscape, as is not excelled in the English School'.

The fullest account is given in the *Repository of Arts* for June 1811 where, after remarking that 'it has been said of this picture that it is too monotonous in its tones', the picture is described as 'very fine (we were near saying perfect)' and the various component parts are described in some detail and highly praised. The review ends 'We must not omit to notice the figures, which are so perfectly accordant with the scenery, that they form with it a consistent and harmonious whole, very rarely to be found among compositions of this class.'

Whatever the true story about the prospective buyers at the Academy in 1811, the picture did not sell and was shown again in Turner's gallery in 1812, when Taylor again wrote praising it, but lamenting that it was still in the possession of the artist, who had been 'the victim of etiquette and delicacy'. Luckily it did not remain unsold for much longer, for on 24 February 1813 Callcott told Farington that Sir John Swinburne had bought it.

Even Hazlitt, who did not always praise Turner's work, referred to it in the *Morning Chronicle* on 5 February 1814 as the 'never-enough-to-be-admired picture of Mercury and Herse'.

115. Apollo and Python Exh. 1811 (Plate 105)

THE TATE GALLERY, LONDON (488)

Canvas, $57\frac{1}{4} \times 93\frac{1}{2}$ (145·5 × 237·5)

Coll. Turner Bequest 1856 (58, 'Apollo and Python' 7'10½" × 4'10"); transferred to the Tate Gallery 1910

Exh. R.A. 1811 (81); Tate Gallery 1931 (46).

Lit. Ruskin 1857 and 1860 (1903–12, xiii, p. 122; vii, pp. 409–22); Thornbury 1862, i, p. 294; 1877, p. 430; Hamerton 1879, p. 122; Monkhouse 1879, pp. 67–74; Bell 1901, pp. 61, 89 no. 121; Armstrong 1902, p. 218; Davies 1946, p. 186; Finberg 1961,

pp. 180, 473 no. 162; Gage 1969, pp. 55, 139–40, 193, pl. 44.

Exhibited in 1811 with the following lines:

'Envenom'd by thy darts, the monster coil'd
Portentous horrible and vast his snake-like form:
Rent the huge portal of the rocky den,
And in the throes of death he tore,
His many wounds in one, while earth
Absorbing, blacken'd with his gore.'

 Hymn of Callimachus.

The Python was a huge dragon living at Crissa near Delphi, which Apollo chose as a site for his oracle. The name 'Python' is said to have been derived from the Greek word 'rot' used by Apollo as he killed it. Turner seems to have used two eighteenth-century English translations of the Callimacchus *Hymn to Apollo*, those by Christopher Pitt in R. Anderson's *Complete Edition of the Poets of Great Britain* viii 1794, and by William Dodds, *The Hymns of Callimacchus* 1755; Turner's own drafts, partly based on these, occur in the 'Hastings' sketchbook of *c.* 1809–11 (CXI-17, 26 verso, 39 verso–40, 52 verso–53, 70 verso, 78, 82 verso and 83 verso). Cook and Wedderburn, in the Library Edition of Ruskin's *Works* vii, p. 409 n. 1., suggest that the verses in the R.A. catalogue were also based on the description of dragons in Ovid's *Metamorphoses* Book 1, the Python and the dragon killed by Cadmus. They also suggest that Turner originally intended to show the latter, with what appears to be Cadmus' javelin, later overpainted, being shown sticking into the dragon. In some of his draft verses, though not in those finally printed, Turner stresses the contrast between the dark setting of the Python's lair and Apollo's 'golden arms', a contrast recognised in the painting itself by John Ruskin in *Modern Painters* v (see below).

Turner seems to have had the picture in mind for some years; some of the sketches are closely juxtaposed with ones for *The Garden of the Hesperides* (No. 57) and, perhaps, *Jason* (No. 19). A composition sketch appears in the 'Rhine, Strassburg and Oxford' sketchbook, used by Turner as early as 1802, but is perhaps itself rather later (LXXVII-43 verso; repr. Wilkinson 1974, p. 52). Another, inscribed 'Death of Python', very different from the final picture and therefore presumably Turner's first idea, is in the 'Calais Pier' sketchbook of *c.* 1800–05 (LXXXI-68 and 69). A third, also differing from the painting, is in the 'Hesperides (1)' sketchbook of *c.* 1805–7 (XCIII-28 verso). There are two studies for the figure of the Apollo in the 'Studies for Pictures: Isleworth sketchbook of *c.* 1804–5 (XC-3). The picture could have been exhibited in Turner's own gallery before appearing at the R.A. in 1811, no catalogues having survived for the years 1804 to 1808 (though the exhibits for 1808 are almost certainly given in full in John Landseer's (?) account in the *Review of Publications of Art*). Certainly the picture, though very dirty, looks as if it could have been painted considerably earlier than 1811.

Press reports of the 1811 R.A. exhibitions concentrated on *Mercury and Herse* (No. 114), though the *Monthly Magazine* for July did say that *Apollo and Python* was 'also ... such a brilliant example of practical composition, in landscape, as is not excelled in the English School', echoing its praise for No. 114.

The picture was, however, singled out by Ruskin in 1857 as 'one of the very noblest of all Turner's work', and in *Modern Painting* v he devoted several pages to the picture, which he regarded as a sequel to *The Garden of the Hesperides*. He saw it as 'the first experience of a great change which was passing in Turner's mind' in which he became 'the painter of the loveliness and light of the creation', displaying 'light seen pre-eminently in colour'.

116. Somer-Hill, near Tunbridge, the Seat of W. F. Woodgate, Esq. Exh. 1811 (Plate 95)

THE NATIONAL GALLERY OF SCOTLAND, EDINBURGH (no. 1614)

Canvas, $36 \times 48\frac{1}{2}$ ($91 \cdot 5 \times 122 \cdot 3$)

Coll. James Alexander; sale Christie's 24 May 1851 (38) bought in, (described in the catalogue as 'painted for Mr. Alexander' who, however, did not buy the estate from Woodgate until 1816. It is not known whether Woodgate ever owned the picture. If so, he presumably sold house and picture together to Alexander; if not, Alexander must have bought it from Turner after he had acquired the house); Wynn Ellis; sale Christie's 6 May 1876 (120) bought Agnew (not Williams as stated by Graves); sold to Ralph Brocklebank 1878; Brocklebank sale Christie's 7 July 1922 (71) bought Agnew for the National Gallery of Scotland (purchased with funds from the Cowan Smith bequest).

Exh. R.A. 1811 (177); R.A. 1880 (11); Liverpool 1886 (1230); Grosvenor Gallery 1888 (64); Guildhall 1899 (17); Wolverhampton 1902 (36); Manchester 1909 (32); Tate Gallery 1931 (53); R.A. 1934 (451); Brussels 1935 (1135); R.A. 1951–2 (177); R.A. 1974–5 (158).

Lit. Burnet and Cunningham 1852, p. 112 no. 100; Thornbury 1877, p. 572; Hamerton 1879, p. 122; Wedmore 1900, i, repr. facing p. 144; Bell 1901, pp. 63, 90 no. 122; Armstrong 1902, pp. 60, 105, 232, repr. facing p. 61; Falk 1938, p. 251; Clare 1951, p. 47; National Gallery of Scotland *Catalogue of Paintings and Sculpture* 1957, p. 276; Finberg 1961, pp. 169, 180, 238, 473 no. 163; Rothenstein and Butlin 1964, pp. 27–8, colour pl. v; Lindsay 1966, pp. 107–8; Reynolds 1969, p. 106; Gage, *A Decade of English Naturalism 1810–1820* (exhibition catalogue 1970), p. 24; Gaunt 1971, p. 5; Clark 1973, p. 248; Herrmann 1975, pp. 20, 229, pl. 63.

A pencil sketch on pp. 3 verso and 4 of the 'Vale of

Heathfield' sketchbook (CXXXVII) is a careful study for this picture. This book was in use from 1810 onwards, and Turner's visit to Somer Hill probably took place on the same trip that he made to Rosehill Park in Sussex to paint some watercolours of the house for the owner, John Fuller. Farington records Fuller's commission in his *Diary* for April 1810. Somer Hill is in Kent, a mile and a half to the south-east of Tonbridge.

Gage considers that the new naturalism of *Somer Hill* stems from the Thames sketches painted outdoors, according to him, at about the same time (but see p. 104) as a number of those canvases, now in the Tate Gallery, show signs of having been worked up later in the studio towards pictures. He suggests that it was 'perhaps on this sort of basis that Turner's masterpiece of naturalism, the *Somer Hill* was developed into a exhibitable work' and argues that it was precisely this attempt to close the gap between outdoor sketch and finished picture that was the distinguishing feature of the naturalistic movement at this date. It is certainly true that it was at this time that Turner and Constable came closest to treading common ground.

Rothenstein and Butlin draw attention to the pentimento which shows that Turner raised the height of the bank in the left foreground with the intention of drawing the spectator's eye gradually across the water and so on up the slope to the house, the focal point of the picture. They point out that Turner, while placing the focus of interest in the far distance, at the same time pays particular attention to the overall design so that the recession is achieved by a most subtle combination of alternating bands of light and shadow together with the tunnel-like effect of the converging trees.

Such was the stir caused at the R.A. Exhibition by *Mercury and Herse* (No. 114) that the critics wrote about it almost exclusively, hardly mentioning any other of Turner's exhibits (he showed four oils and five watercolours) and ignoring entirely this most beautiful picture.

Somer Hill and *Petworth: Dewy Morning* (No. 113) were among Turner's pictures which were criticised by Sir George Beaumont and other connoisseurs on the grounds that they were much too light. In 1813, Beaumont told Farington that 'much harm had been done by Turner endeavouring to make his oil paintings appear like water-colours', Turner and his followers were spoken of as 'the white painters', a classification which it is not now easy to understand when in front of *Somer Hill* or any other works of this period.

117. Whalley Bridge and Abbey, Lancashire: Dyers washing and drying Cloth Exh. 1811

(Plate 93)

THE LOYD COLLECTION

Canvas, 24⅛ × 36¾ (61·2 × 92)

Coll. J. Newington Hughes; sale Christie's 15 April 1848 (145) bought Brown; Wynn Ellis by 1850–51, when seen by Waagen, and in his sale Christie's 6 May 1876 (118) bought Agnew from whom bought by Lord Overstone; by descent to the present owner.

In the copy of the Newington Hughes sale catalogue belonging to the Courtauld Institute, it states that the picture was bought by Lord Charles Townsend. In the Wynn Ellis sale catalogue however, it says that he bought it at the 1848 sale. In any case, Wynn Ellis certainly owned it by 1850–51.

Exh. R.A. 1811 (244); Grosvenor Gallery 1899 (38); Tate Gallery 1931 (55); R.A. 1934 (640); Birmingham City Art Gallery, on loan 1945–52; Birmingham and Tate Gallery 1948–9 (173); Agnew 1967 (12).

Lit. Burnet and Cunningham 1852, pp. 24, 112 no. 101; Waagen 1854, ii, p. 298; G. Redford, *Descriptive Catalogue of the Pictures at Lockinge House* 1875 (supplementary), no. 76; Thornbury 1877, p. 572; Hamerton 1879, p. 122; Bell 1901, pp. 63, 90 no. 123; Armstrong 1902, pp. 109, 237; Temple 1902, p. 157 no. 239 repr.; Finberg 1961, pp. 180, 421, 473 no. 164; Parris 1967, p. 45 no. 62 repr.; Herrmann 1975, pp. 20, 229, pl. 66.

Based on a drawing on p. 8 of the 'Tabley No. 1' sketchbook (CIII), which must have been made in 1808 when Turner was either staying at, or was on his way to or from, Sir John Leicester's seat, Tabley House, near Knutsford in Cheshire. This drawing is reproduced in Finberg 1910, pl. xxix. There are other drawings of the bridge and abbey, taken from different viewpoints, in the same sketchbook.

As noted in the entry for No. 62, Mr David Brown has suggested that a number of reasons point to the possibility that Thomas Lister Parker may have originally commissioned this picture. In particular there is the likelihood that the preparatory drawing mentioned above was made by Turner on a visit to Parker made during the course of the artist's longer visit to Sir John Leicester. Besides this, Whalley Bridge and Abbey are very close to Parker's home and the subject was one which would surely have appealed to his antiquarian interests; indeed he had earlier collaborated with Whitaker over the *History of Whalley*, published in 1800–01.

In view of the fact that Newington Hughes seems very likely to have bought this picture and *The Junction of the Thames and the Medway* (No. 62 which Parker had owned from 1807–11) in 1811 it seems too much of a coincidence to assume that *Whalley Bridge* had no connection with Parker. Although the evidence is only circumstantial, it surely suggests that Parker was unwilling or unable to take delivery of *Whalley Bridge* at the end of the 1811 R.A. Exhibition but that he managed to arrange instead to sell both pictures to Newington Hughes in a package deal.

According to Temple's catalogue of the Wantage Collection, this 'is believed to be the first picture he

[Turner] painted upon a groundwork of white paint.' It seems probable, however, that Turner had first used this method a little earlier—for instance, in *Petworth from the Lake* (No. 113).

One can see why this picture was chosen to represent Turner in an exhibition devoted to Richard Wilson and his Circle, held at Birmingham and at the Tate Gallery in 1948-9. In fact, however, this picture reveals the twin strains that occur in Turner's work at this period: the influence of Claude which points forward to *Crossing the Brook* (No. 130) and the naturalism which is at its most evident in pictures such as *Somer Hill* (No. 116) and (two years later) *Frosty Morning* (No. 127). This combination of classical and naturalistic elements results, in this case, in making the scenery appear curiously un-English. Indeed the picture has points in common with Corot's views of the Roman Campagna painted a decade or so later.

It was not mentioned in any of the notices of the R.A. Exhibition in 1811, the critics concentrating almost exclusively on *Mercury and Herse* (No. 114).

118. The River Plym Exh. 1812

PRESENT WHEREABOUTS UNKNOWN

Size unknown, but probably 36 × 48 (91·5 × 121·8)

Exh. Turner's gallery 1812

Lit. Finberg 1961, pp. 190, 191, 474 no. 170.

We owe our knowledge of the existence of this picture to a review of the exhibition at Turner's gallery in 1812, published in the *Sun* on 9 June. The reviewer mentions 'seven new landscapes' but gives the titles of only six of them, of which *The River Plym* is mentioned first. All the new works listed were clearly the result of Turner's visit to Devon and Cornwall in 1811. (The exception was *Calder Bridge, Cumberland* (see No. 106) but this in fact had already been shown in 1810.) There has been no trace whatever of *The River Plym* since 1812 and Finberg suggests that its original title may have got forgotten and that it may be identified with *Hulks on the Tamar* (see No. 119) at Petworth. There are certainly other instances of pictures by Turner bought directly from him by Lord Egremont which subsequently became separated from their exhibited titles (e.g., Nos. 75 and 77), so that Finberg's theory must be regarded at the very least as plausible. On the other hand, it remains possible that *Hulks on the Tamar* was also exhibited as such in 1812, thus being the one picture among the seven new works which was not listed by the writer in the *Sun*.

119. Hulks on the Tamar Exh. 1812? (Plate 108)

H.M. TREASURY AND THE NATIONAL TRUST (Lord Egremont Collection) PETWORTH HOUSE

Canvas, 35½ × 47½ (90·2 × 120·6)

Signed 'JMW Turner RA' bottom right

Coll. Bought by the third Earl of Egremont, perhaps from Turner's gallery in 1812 (see below); by descent to the third Lord Leconfield who in 1947 conveyed Petworth to the National Trust; in 1957 the contents of the State Rooms were accepted by the Treasury in part payment of death duties.

Exh. ?Turner's gallery 1812; Tate Gallery 1951 (16).

Lit. Petworth Inventories 1837, 1856 (London House); Armstrong 1902, pp. 109, 233, repr. facing p. 75; Collins Baker 1920, p. 126 no. 656; Hussey 1925, p. 976 repr.; Finberg 1961, pp. 190-91, 474 no. 170.

Repr. Rothenstein and Butlin 1964, pl. 50.

Drawings of this subject occur on pp. 6 and 7 in the 'Ivy Bridge to Penzance' sketchbook (CXXV) in use in the summer of 1811. However, they are not really at all close to the composition of the picture, and the connection between them, suggested by Finberg, seems most doubtful. Other drawings of hulks on a river are in the 'Devon Rivers' sketchbook (CXXXIII), dated 1812-15 by Finberg. That on p. 28 verso, listed by Finberg as 'Hulks in Plymouth Sound', resembles the oil more closely than the others, but cannot claim to be a study for it. A watercolour in the Turner Bequest, although catalogued as 'Hulks on the Tamar' (CXCVI-E, repr. in colour by Wilkinson 1974, p. 135), is also only marginally related, as Finberg recognised.

Dated *c.* 1811 by Collins Baker, there are traces of what may be a date following the signature, but they are now indecipherable. Finberg suggests that this picture may be identified with the picture exhibited in Turner's gallery in 1812 as 'The River Plym', one of the seven new landscapes mentioned in the review of the exhibition in the *Sun* of 9 June (see No. 118). There is no evidence for this, and the traditional title may be thought to gainsay it. On the other hand, there is no trace at all of the picture *The River Plym* since 1812 and the titles of Turner's pictures are often confused or changed with the passage of time. Instances of this among the Turners at Petworth have already been noted under No. 118. Lord Egremont would certainly have been familiar with the pictures exhibited in 1812 as he bought the *Teignmouth* (No. 120) shown that year. In any case, whether exhibited or not, this picture must date from *c.* 1812 on stylistic grounds. Similarities in the painting of the figures with those in *St Mawes* (No. 123), for instance, are very close.

According to the National Trust records, the condition of this picture 'must be assumed to be irrecoverable' since it fell into the hands of an over-zealous restorer in 1931. The surface is certainly now very much flattened and the subtle gradations of tone and colour are no longer more than faintly discernible.

120. Teignmouth Exh. 1812 * (Plate 114)

H.M. TREASURY AND THE NATIONAL TRUST (Lord Eg-remont Collection) PETWORTH HOUSE

Canvas, $35\frac{1}{2} \times 47\frac{1}{2}$ (90·2 × 120·7)

Signed 'J M W Turn . . .' lower left

Coll. Bought by the third Earl of Egremont probably from Turner's gallery in 1812; by descent to the third Lord Leconfield who in 1947 conveyed Petworth to the National Trust; in 1957 the contents of the State Rooms were accepted by the Treasury in part payment of death duties.

Exh. Turner's gallery 1812; Agnew *English Pictures from National Trust Houses* 1965 (32).

Lit. Petworth Inventories 1837, 1856 (London House); Armstrong 1902, p. 233; Collins Baker 1920, p. 126 no. 658; Hussey 1925, p. 976 repr.; Finberg 1961, pp. 190–91, 474 no. 172; Gage 1969, p. 89, pl. 47.

A study for the picture occurs on pp. 36–7 of the 'Corfe to Dartmouth' sketchbook (CXXIV) in use in the summer of 1811; this carries the composition further on the right and includes a row of trees fringing the bay. Another drawing on p. 35 shows the view looking back from beyond the boat under construction which appears in the oil.

A watercolour of *Teignmouth* (Collection: Mr and Mrs Paul Mellon) which is similar in composition to the oil, but which differs in details, was engraved by W. Cooke in 1815 for *Picturesque Views of the Southern Coast* and again in 1828 in aquatint for *A Selection of Facsimiles of Watercolour Drawings by British Artists* (Rawlinson ii 1913, p. 401 no. 829).

This was one of a group of 'seven additional landscapes, all of which display extraordinary merit' which were noted by the *Sun* in a review of Turner's gallery published on 9 June 1812.

As Gage has pointed out: '. . . in the magnificent *Teignmouth Harbour* at Petworth, Turner produced a profoundly original design of astounding economy, and of the reverse order to his earlier *Shipwreck*, by raising the overall tone of the composition, and restricting the greatest lights and the greatest darks to the single small area of the girl and cows. It is perhaps the first example of a principle of chiaroscuro which Turner continued to develop in the 1820s and 1830s as peculiarly his own; and it is an early, possibly the earliest, example of an overall spread of light of the type recognised by Turner in Veronese's *Marriage at Cana*.' It was just at this moment that Turner was preparing his 'Backgrounds' lecture, in the series he delivered in 1812 as Professor of Perspective, in which he pays especial attention to an analysis of Veronese's colour (see also No. 114). Gage's observations about Turner developing 'the principle of chiaroscuro', shown in *Teignmouth*, in the 1820s and 1830s, are also applicable to the colour and handling in certain areas, notably the foreground, where there are passages which come close to much later canvases such

as *The Evening Star* (see No. 453).

Collins Baker transcribed the signature as 'J M W Turner 1812' but this is no longer legible. The picture suffered badly when the original and lining canvases became detached about 1957, causing blistering and corrugations. The work of recovery and restoration undertaken by Mr John Brealey, although involving a good deal of repainting in the sky, has done much to reveal anew the picture's extraordinary beauty.

121. Saltash with the Water Ferry Exh. 1812

(Plate 109)

THE METROPOLITAN MUSEUM OF ART, NEW YORK

Canvas, $35\frac{3}{8} \times 47\frac{3}{4}$ (89·3 × 120·6)

Coll. J. Hogarth (see entry for No. 415); sale Christie's 13 June 1851 (50a) bought Bicknell; John Miller of Liverpool by 1853; sale Christie's 22 May 1858 (249) bought Gambart; Miss Maria C. Miller by 1868 and until after 1885; Henry G. Marquand who gave it to the Metropolitan Museum in 1889. (Accession no. 89.15.9)

Exh. Turner's gallery 1812; R.H.A. 1846 (106) when it still belonged to Turner, and was marked in the catalogue as being for sale; R.S.A. 1853 (72 lent by John Miller); Manchester 1857 (239); Leeds 1868 (1155 lent by Miss Miller); Liverpool Art Club 1881 (160); R.A. 1885 (54 lent by Miss Miller); Boston 1946 (5); Toronto and Ottawa 1951 (6).

Lit. Burnet and Cunningham 1852, p. 104; Thornbury 1862, i, p. 290; 1877, pp. 427–8; Armstrong 1902, p. 228, who was in error in stating that it had belonged to the Metropolitan since 1886; Finberg 1961, pp. 190–91, 579 no. 173.

Saltash is in Cornwall, across the river Tamar from Devonport and Plymouth. On the building on the right appear the words: 'England expects every man to do his duty'. Also legible are the words 'Beer' and 'Saltash'.

No preparatory drawing is known amongst the sketchbooks in the British Museum connected with Turner's journey to the west of England in the summer of 1811.

A much later watercolour *Saltash*, signed and dated 1825, and engraved by W. R. Smith in the *England and Wales* series in 1827, is now in the British Museum (R. W. Lloyd Bequest 1958; exh. British Museum 1975 (90)). The view is quite different and is taken looking back over the harbour towards the town.

Saltash was one of the six titles named in the *Sun* for 9 June 1812 among 'seven additional landscapes' noted as being on exhibition in Turner's gallery.

Burnet and Cunningham state that the *Windmill and Lock* (see No. 101, exhibited in 1810) and *Saltash* were painted as companions but this is clearly impossible. Apart from the two years which separate them, they have no common ground, although Burnet's miscon-

ception may have arisen because both pictures belonged to Hogarth in 1851. The picture which has most in common with *Saltash* is *St Mawes* (No. 123), also exhibited in 1812, but there is absolutely no evidence that they were conceived as being complementary.

This picture has not, so far as I am aware, been on exhibition at the Metropolitan for many years. It badly needs cleaning but, although the sky has suffered from maltreatment in the past, other parts of the picture, notably the reflections in the water, appear to be well preserved.

122. Ivy Bridge Mill, Devonshire Exh. 1812
(Plate 110)

PRIVATE COLLECTION, ENGLAND

Canvas, 35 × 47 (89 × 119·4)

Coll. Elhanan Bicknell who bought it probably in the Spring of 1844 as one among 'five others' which he bought from Turner at the same time that he bought *Palestrina* (No. 295) (this purchase was recorded in Ruskin's *Diary* on 27 March); sale Christie's 25 April 1863 (104) bought in; H. S. Bicknell; sale Christie's 9 April 1881 (462) bought Vokins; William Hollins by 1888; bought from Mrs Hollins by Agnew in 1897 and sold in 1899 to Pandeli Ralli; with Sulley 1928; Lt. Col. Innes by 1935, from whom it passed to the present owner.

Exh. Turner's gallery 1812; R.S.A. 1846 (414 lent by Bicknell); R.A. 1873 (12) and 1888 (41 lent by W. Hollins); Glasgow 1888 (116); Guildhall 1899 (21 lent by Agnew's); Whitechapel Art Gallery *Spring Exhibition* 1901 (247); Brussels 1935 (1134); Leggatt 1960 (27).

Lit. Ruskin 1843, 1856 (1903–12, iii, pp. 244–5, 559; v, p. 166); Waagen 1854, ii, p. 353; Thornbury 1862, ii, pp. 217, 400, 401; 1877, pp. 163 (engraving repr.), 474, 511, 534, 599; Armstrong 1902, p. 223, repr. facing p. 78; Finberg 1961, pp. 190–91, 397–8, 474 no. 174, 515 no. 579b; Gage 1969, p. 171.

Based on a pencil sketch on p. 47 of the sketchbook (CXXV) inscribed 'Ivy Bridge to Pensance' by Turner in the centre of the cover. This sketchbook was in use during Turner's trip to the West Country during the two months from mid-July 1811.

This picture is referred to by Turner in a letter written on 1 February 1844 to his dealer Griffith. It concerns the state of the pictures in his gallery and the problems connected with putting them into sufficiently good order for Griffith to be able to offer them for sale. Turner is anxious to find 'a young man acquainted with Picture cleaning and [who] would help *me* to clean accidental stains away ... To get any lined is made almost an obligation confer'd and subject to all remarks. The Stormy Picture you saw in the Parlour for Mr. Foord's *Hero* to advise with about cleaning and lining,

but cannot find out who was emply'd for the Ivy Bridge—so well done.'

This is one of the 'seven additional landscapes, all of which display extraordinary merit', which are mentioned in the review of the exhibition at Turner's gallery in 1812 in the *Sun* on 9 June. This notice is the only clue as to the contents of the exhibition but the titles mentioned show that nearly all the new pictures were the result of the visit to the West Country the previous summer.

Ruskin considered that the painting of the 'rock foreground is altogether unrivalled, and remarkable for its delicacy of detail; a butterfly is seen settled on one of the large brown stones in the midst of the torrent, a bird is about to seize it, while its companion, crimson-winged, flits idly on the surface of one of the pools of the stream, within half an inch of the surface of the water, thus telling us its extreme stillness.'

When exhibited at the R.S.A. in 1846 the critic of the *Scotsman*, 18 February, thought it 'dusky in colouring, like some of the Old Italian works', but agreed that, viewed from the distance, 'it has a certain force and impressiveness'.

123. St Mawes at the Pilchard Season Exh. 1812
(Plate 111)

THE TATE GALLERY, LONDON (484)

Canvas, 35⅞ × 47½ (91 × 120·5)

Coll. Turner Bequest 1856 (85 'Saint Mawes' 4′0″ × 3′0″); transferred to Tate Gallery 1910.

Exh. Turner's gallery 1812; Tate Gallery 1931 (51).

Lit. Thornbury 1862, i, p. 293; 1877, p. 430; Armstrong 1902, p. 288; MacColl 1920, p. 8; Whitley 1928, p. 203; Davies 1946, p. 187; Clare 1951, pp. 48–50; Finberg 1961, pp. 190–91, 474 no. 175.

St Mawes on Falmouth Harbour, with Pendennis Castle in the distance. According to Thornbury the picture was painted in 1809, but it may alternatively be a result of Turner's visit to the West Country in the summer of 1811 in connection with W. B. Cooke's *Picturesque Views of the Southern Coast of England*, published between 1814 and 1826. St Mawes and Pendennis appear in a list of subjects for this publication in the 'Devonshire Coast No. 1' sketchbook (CXXIII-5) and there are drawings in the same book of Falmouth, Pendennis and perhaps St Mawes (CXXIII-104, 108 verso, ?111, 217 verso; 198; and 133 respectively); there are further drawings in the 'Ivy Bridge to Penzance' sketchbook (CXXV-24 verso, 27, 27 verso, 29–30. ?45 verso). There were two engravings in the *Southern Coast*, 'St. Mawes, Cornwall' by J. C. Allen 1824, and 'Falmouth Harbour, Cornwall' by W. B. Cooke 1816. A later engraving, closer to this painting however, is that done by J. H. Kernot in 1830 of 'St. Mawes, Cornwall' for *Picturesque Views in England and Wales*, 1827–38.

124. A View of the Castle of St Michael, near Bonneville, Savoy Exh. 1812 (Plate 113)

JOHN G. JOHNSON COLLECTION, PHILADELPHIA

Canvas, $36\frac{1}{4} \times 48\frac{1}{2}$ (92 × 123·2)

Coll. John Gibbons of Hanover Terrace, London (*d.* 1851); The Rev. B. Gibbons; sale Christie's 26 May 1894 (61) bought Agnew; sold in July 1894 to John G. Johnson of Philadelphia, by whom bequeathed to the City of Philadelphia in 1917; the Johnson collection has been installed in the Philadelphia Museum of Art since the early 1930s but remains the property of the City.

Exh. R.A. 1812 (149); Boston 1946 (6); Toronto and Ottawa 1951 (5); Indianapolis 1955 (13); Indianapolis *The Romantic Era 1750–1850* 1965 (40).

Engr. By H. Dawe in the *Liber Studiorum*, R. 64 published 1 January 1816 (the pen and sepia drawing for the engraving, CXVIII-J, is more closely related to this version in oils than to No. 46 especially in the placing of the figures).

Lit. Burnet and Cunningham 1852, p. 113 no. 107; Thornbury 1877, pp. 168, 572; Monkhouse 1879, p. 54; Bell 1901, p. 91 no. 124; Armstrong 1902, p. 219; Wyllie *J. M. W. Turner, R.A.* 1905, pp. 36, 55, 166 no. 124; *Catalogue of the John G. Johnson Collection, Philadelphia* 1941, no. 848; Finberg 1961, pp. 189, 360, 474 no. 177.

As with the other two oil paintings of Bonneville (Nos. 46 and 50), based on studies made in 1802. See the entry for No. 46 for related sketches and watercolours. The differences in composition between this and No. 46 are in detail only, but the tone of the Philadelphia picture is considerably darker. The existence of two such similar pictures is extremely unusual in Turner's work and it is difficult to guess why he painted the Philadelphia version unless it was commissioned either as a result of the version exhibited in 1803 or from the later watercolour and why, even allowing for the interval of nine years, he sent another *Bonneville* to the R.A. It was clearly a subject which held a particular fascination for Turner, and it may be that, in planning the programme of the *Liber Studiorum*, he decided to paint the scene again in oil with a rather different emphasis. The Philadelphia version is certainly more Claudian than No. 46 but it is not a specific restatement of the subject in Claudian terms as, for instance, the Yale Center's *Lake Avernus: Æneas and the Sybil* (No. 226) is of the earlier Wilsonian version (No. 34) in the Tate Gallery.

There remains the possibility that the Philadelphia version was painted considerably earlier, perhaps not long after the other *Bonneville* pictures, but comparison with the handling in *Ivybridge* (No. 122), exhibited in 1811 (and documented to that year), shows similarities which indicate that it must have been painted only

shortly before being exhibited. Perhaps the reason why Turner painted a third version was mainly commercial: having sold the other two, he decided to reinforce success by offering still another painting of Bonneville to the public. As the date that this picture was first sold is not known, it is impossible to tell if Turner's scheme met with immediate success or not.

At the R.A. the picture was praised by the critic of the *Examiner* for 7 June who wrote: 'No. 149 . . . exhibits a perfect simplicity of style. The chiaro-scuro is efficient without the opposition of strong shade. The pencilling is neat, free and tasteful and the grey and warm colours, beautifully balanced and adjusted.'

125. View of Oxford from the Abingdon Road Exh. 1812 (Plate 112)

PRIVATE COLLECTION, ENGLAND

Canvas, $26 \times 38\frac{1}{2}$ (66 × 97·7)

Coll. Commissioned by James Wyatt of Oxford as a companion to the *High Street, Oxford* (No. 102) and painted between Christmas 1811 and April 1812; J. Watts Russell; sale Christie's 3 July 1875 (31) bought Agnew; John (later Sir John) Fowler; sale Christie's 6 May 1899 (80) bought Tooth; bought by Agnew from Tooth, 1915; Victor Reinaecker 1922; C. Morland Agnew 1924; bought by Agnew from the executors of C. M. Agnew in 1949; H. P. F. Borthwick Norton; bought from his widow by Agnew in 1953 and sold to Leggatt who sold it to the present owner.

Exh. R.A. 1812 (169); Agnew 1934 (15) and 1947 (15); Leggatt 1960 (6); R.A. 1974–5 (160).

Engr. By J. Pye, 1818, with figures by C. Heath.

Lit. Burnet and Cunningham 1852, p. 113 no. 109; Thornbury 1877, pp. 168–9, 174, 572; Monkhouse 1879, p. 86; Bell 1901, p. 92 no. 126; Armstrong 1902, pp. 109, 226; Rawlinson i 1908, pp. xxvii n., xxviii, 36–9; ii 1913, p. 190; Clare 1951, pp. 47–8; Finberg 1961, pp. 186–9, 204, 276, 474 no. 179; Gage 1969, p. 161.

For the circumstances which led to this commission, see No. 102. The correspondence between Turner and Wyatt is to be published by Gage. The picture was finished in time for the R.A. exhibition in 1812. After the success of the print of the *High Street*, it seems strange that six years elapsed before the engraving of this picture was published. In the event the print of this picture was not a success, due, in Rawlinson's opinion, to the weakness of the preliminary etching, in which Pye showed himself markedly inferior to Middiman who was responsible for the strong foundation of the *High Street, Oxford*.

Apparently based on a drawing in the Turner Bequest (CXCV(a)-A; $21\frac{1}{4} \times 29\frac{1}{2}$ in.) catalogued by Finberg as 'Oxford from Foxholme Hill'. The drawing

is now laid down so the watermark is no longer clearly visible but Finberg gives it as 'Whatman 1814'. Mr Eric Harding of the Print Room of the British Museum has kindly examined the watermark under strong light and considers that 1814 is probably correct although he does not rule out 1811 as the correct reading. The drawing has on it a number of pencil notes by Turner such as 'road', 'rushes', 'meadows', etc., which would normally be construed as the artist's memoranda for the finished oil, and the compiler is inclined to think that the watermark can only be 1811. It really seems most unlikely that the drawing could have been done after the picture, so exactly does it bear the characteristics of a working drawing, although it is perhaps just conceivable that it was done for the engraving.

Turner's letter of 6 March 1812 states 'As to the Oxford, I understood you that Mr. Pye would have it immediately after the High St should be finish'd. Therefore I began it at Xmas.' Wyatt seems to have wished to introduce a large tree into the composition, for the letter continues: 'But respecting the venerable Oak or Elm you rather puzzle me. If you wish either say *so* and it shall be done, but fancy to yourself how a large Tree would destroy the character! That *burst* of flat country with uninterrupted horizontal lines throughout the Picture as seen from the spot we took it from! The Hedgerow Oaks are all pollards, but can be enlarged if you wish.' Turner seems to have won his point for no venerable tree appears in the foreground and Wyatt was probably satisfied with the enlargement of the pollard oaks.

126. Snow Storm: Hannibal and his Army crossing the Alps Exh. 1812 (Plate 117)

THE TATE GALLERY, LONDON (490)

Canvas, $57\frac{1}{2} \times 93\frac{1}{2}$ (146×237.5)

Coll. Turner Bequest 1856 (6, 'Hannibal crossing the Alps' 7'9" × 4'9½"); transferred to the Tate Gallery 1910.

Exh. R.A. 1812 (258); Tate Gallery 1931 (49); Tate Gallery 1959 (347); Paris 1972 (262, repr.); Lisbon 1973 (6, repr. in colour); R.A. 1974–5 (88, repr.); Leningrad and Moscow 1975–6 (7).

Lit. Farington *Diary* 10, 11, 13, 14 and 15 April 1812; Ruskin 1843 (1903–12, iii, p. 239); Leslie 1860, ii, p. 12; Thornbury 1862, i, pp. 170, 294; ii, pp. 87–8; 1877, pp. 122, 168, 239, 342, 430–31; Hamerton 1879, pp. 138, 197; Monkhouse 1879, pp. 66, 76; Eastlake 1895, i, p. 188; Bell 1901, pp. 92–3 no. 127; Armstrong 1902, pp. 85, 104, 109–11, 222; MacColl 1920, pp. 9–10; Whitley 1928, pp. 199–200; Falk 1938, pp. 72, 96; Davies 1946, p. 185; Finberg 1961, pp. 187–90, 195, 276, 414, 474–5 no. 180; Herrmann 1963, pp. 19, 35, pl. 6; Kitson 1964, pp. 18, 73, repr. p. 32; Rothenstein and Butlin 1964, pp. 30–31, 76,

pl. 49; Michael Kitson, 'Snowstorm: Hannibal Crossing the Alps', *Painting of the Month* August 1965, pp. 73–6, repr. in colour; Gowing 1966, p. 9, repr.; Lindsay 1966, pp. 41, 107, 117–22, 132–3, 136, 138–9, 236 n. 29; Lindsay 1966², pp. 47–9; Brill 1969, pp. 14–15, repr.; Gage 1969, pp. 145, 161, 228 n. 41, 262 n. 114; Reynolds 1969, pp. 86–8, 94, pl. 65; Holcomb 1970, pp. 25–7, pl. 13; Gaunt 1971, p. 5, colour pl. 11; Herrmann 1975, pp. 20–21, 23, 39, 54, 229, colour pl. 57.

Turner's verses in the 1812 catalogue are described for the first time as coming from his 'MS.P[oem?]. Fallacies of Hope', the source of most of his later quotations though almost certainly never a complete entity:

'Craft, treachery, and fraud—Salassian force,
Hung on the fainting rear! then Plunder seiz'd
The victor and the captive,—Saguntum's spoil,
Alike, became their prey; still the chief advanc'd,
Look'd on the sun with hope;—low, broad, and wan;
While the fierce archer of the downward year
Stains Italy's blanch'd barrier with storms.
In vain each pass, ensanguin'd deep with dead,
Or rocky fragments, wide destruction roll'd.
Still on Campania's fertile plains—he thought,
But the loud breeze sob'd, "Capua's joys beware!"''

Hannibal's crossing of the Alps in 218 B.C. was a common source of Romantic and proto-Romantic inspiration. Mrs Radcliffe's *The Mysteries of Udolpho* 1794 describes the scene shown by Turner, who had also been inspired by the lost oil painting by J. R. Cozens, which passed through the salerooms in 1802. Cozens' painting, however, showed the later, more hopeful moment when Hannibal showed his troops the fertile plains of Italy. Here Turner not only showed the hazards of the crossing but hinted at the enervating effect of Italian luxury: '"Capua's joys beware!"' John Gage has suggested that Turner saw a parallel between the struggle of Rome and Carthage and that between England and Napoleonic France (see exhibition catalogue, Paris 1972, no. 262). On his visit to Paris in 1802 Turner had visited David's studio and seen his picture of *Napoleon on the St Bernard Pass* in which Napoleon was shown as the modern Hannibal.

However, another source of inspiration for this picture was a storm seen at his patron Walter Fawkes' house, Farnley Hall in Yorkshire, in 1810. According to Fawkes' son, Hawkesworth, Turner even foresaw the use he would make of his sketch: '"There", said he, "Hawkey; in two years you will see this again, and call it Hannibal crossing the Alps."' There is a sketch for the foreground figures in the 'Calais Pier' sketchbook (LXXXI-38, 39) which suggests that Turner was thinking of the subject at least eight or so years earlier.

Farington, who was on the Hanging Committee of the R.A. in 1812, records Turner's concern over the hanging of this picture at Somerset House. On 10 April 'Turner's large picture of "Hannibal crossing the Alps"

was placed over the door of the new room (but in the great room) & it was thought to be seen to great advantage. Mr. West came and concurred in this opinion with Smirke, Dance & myself. Calcott [sic] came and remarked that Turner had sd. That if this picture were not placed under the line He wd. rather have it back. Calcott also thought it wd. be better seen if under the line. He went away & we took the picture down & placed it opposite to the door of the entrance, the situation which Calcott mentioned. Here it appeared to the greatest disadvantage, a scene of confusion and injuring the effect of the whole of that part of the arrangement. We therefore determined to replace it which was done.'

On the 11th, 'In the course of the morning Calcott came & Dance with Smirke informed him that Turner's large picture had been tried under the line and the effect was very disadvantageous both to the picture & to the Exhibition. I did not meet Calcott . . . Whilst we were at dinner Turner came and took a little only having dined early. He asked me "What we had done with His pictures?". I told him we had had much difficulty abt. His large picture "Hannibal crossing the Alps". He went upstairs & staid a while and afterwards returned to us with an apparently assumed cheerfulness but soon went away and took Howard out of the room, who soon came back & informed us that Turner objected to His picture being placed above the line, & Howard assured Him it was seen there to better advantage, but He persisted in saying that if it were not to be placed below the line He would take it away; that as He saw us chearfully seated He would not now mention His intention to us, but would come on Monday morning [this was Saturday] to have the matter finally determined. Smirke & Dance were decided to abide by the arrangement the Committee had made, and to leave Him to act as He may please.'

On Monday 13 April 'Turner came at noon and after some conversation with Smirke in which He expressed his determination to have His picture of "Hannibal crossing the Alps" placed below the line, or He would withdraw it, adding that [he] wished to have the joint determination of the Committee respecting it. Smirke told him in the presence of Dance & myself, that having heard what He had said on the subject it was a matter for our consideration. He then went away. I then proposed to place His picture at the head of the *new room* which was agreed to . . . Callcott came before dinner. He talked with Smirke abt. the new situation of Turner's picture, sd. it was better placed than before, but did not say He approved of it.'

The next day, Tuesday 14 April, after a Council meeting in the evening, 'Turner went upstairs & saw his large picture as it was placed in the new room. He appeared to be in good humour, but said He would not decide till tomorrow when he shd. see it by daylight.'

On 15th April Farington 'went to breakfast at the Academy. Turner came and approved of the situation of His large picture provided other members shd. have pictures near it.'

Turner's concern that the painting should hang relatively low so as to ensure the correct viewpoint had a paradoxical result for at least one viewer. C. R. Leslie, writing to his sister Miss Leslie on 12 May 1812, reported that he had been to the first day of the R.A. exhibition but that 'the rooms were so crowded I could not enjoy it all . . . There is a grand Landscape by Turner, representing a scene in the Alps in a snow storm, with Hannibal's army crossing; but as this picture is placed very low, I could not see it at the proper distance, owing to the crowd of people. Allston [the American painter Washington Allston, 1779–1843] says it is a wonderfully fine thing: he thinks Turner the greatest painter since the days of Claude.'

The picture was well received by the critics. For the *Examiner* on 7 June 1812, 'This is a performance that classes Mr. Turner in the highest rank of landscape painters, for it possesses a considerable portion of that main excellence of the sister Arts, Invention . . . This picture delights the imagination by the impressive agency of a few uncommon and sublime subjects in material nature, and of terror in its display of the effects of moral evil.' The main body of the army is 'represented agreeably to that principle of the sublime which arises from obscurity' but 'An aspect of terrible splendour is displayed in the shining of the sun . . . A terrible magnificence is also seen in the widely circular sweep of snow whirling high in the air . . . In fine, the moral and physical elements are here in powerful unison blended by a most masterly hand, awakening emotions of awe and grandeur.' The critic of the *Repository of Arts, Literature, Commerce* for 12 June was 'almost led to describe it as the effect of magic, which this Prospero of the graphic arts can call into action, and give to airy nothing a substantial form . . . All that is terrible and grand is personified in the mysterious effect of the picture; and we cannot but admire the genius displayed in this extraordinary work.' According to the *St. James's Chronicle* for 23–6 May the 'sun is painted with peculiar felicity, and the warm tinting from the great source of light struggling through the blackness of the storm, gives a fine relief to the subject, which is still further improved by the introduction of a corner of cloudless sky on the left.'

127. Frosty Morning Exh. 1813 (Plate 115)

THE TATE GALLERY, LONDON (492)

Canvas, $44\frac{3}{4} \times 68\frac{3}{4}$ (113.5 × 174.5)

Coll. Turner Bequest 1856 (8, 'Frost Scene' 5′9″ × 3′9″); transferred to the Tate Gallery 1953.

Exh. R.A. 1813 (15); Turner's gallery 1835; Tate Gallery 1931 (57); Paris 1938 (141, repr.); New York, Chicago and Toronto 1946–7 (49, repr. pl. 40); Whitechapel 1953 (77); R.A. 1974 (18, repr.); R.A. 1974–5 (161, repr.); Leningrad and Moscow 1975–6 (16); Hamburg 1976 (22, repr.).

Lit. Thornbury 1862, i, pp. 170–71, 295; 1877, pp. 121–2, 431; Hamerton 1879, p. 149; Monkhouse 1879, p. 89; Bell 1901, pp. 63, 93 no. 128; Armstrong 1902, pp. 111–12, 222, repr. facing p. 112; Finberg 1910, pp. 61, 63–8; Whitley 1928, p. 211; Falk 1938, p. 43; Davies 1946, pp. 148–9, 185; Clare 1951, pp. 52–3, repr.; Finberg 1961, pp. 196, 229, 238, 252, 475 no. 183, pl. 15; Rothenstein and Butlin 1964, p. 27, pl. 51; Gage 1965, p. 79; Lindsay 1966, pp. 108, 114, 148; Lindsay 1966², p. 58; Brill 1969, pp. 14–15, repr.; R. B. Beckett (ed.), *John Constable's Correspondence* vi 1968, p. 21; Reynolds 1969, pp. 89–90, 106, colour pl. 67; Gaunt 1971, p. 6, colour pl. 13; Herrmann 1975, pp. 23, 229, colour pl. 58.

Exhibited with the following line:

'The rigid hoar frost melts before his beam.'
Thomson's Seasons

According to the younger Trimmer the picture immortalised Turner's 'old crop-eared bay horse, or rather a cross between a horse and a pony'. 'The "Frost Piece" was one of his favourites ... He said he was travelling by coach in Yorkshire, and sketched it *en route*. There is a stage-coach in the distance that he was on at the time. My father told me that when at Somerset House [in the 1813 R.A. Exhibition] it was much brighter and made a great sensation ... The girl with the hare over her shoulders, I have heard my father say reminded him of a young girl whom he occasionally saw at Queen Anne-street [Turner's gallery], and whom, from her resemblance to Turner, he thought a relation. The same female figure appears in his "Crossing the Brook" [No. 130]' (Thornbury 1862, i, pp. 170–71). The reference to the girl is, as Lindsay has pointed out, to Evelina, one of Turner's two illegitimate daughters by the widow Sarah Danby.

The picture was praised in the *Morning Chronicle* for 3 May 1813 and, more significantly, by Constable's great patron Archdeacon Fisher who singled it out as the only picture to be preferred to Constable's in the exhibition: 'But then you need not repine at this decision of mine; you are a great man like Buonaparte, and are only beaten by a frost' (Beckett, *loc. cit.*).

In 1815 Ambrose Johns, arranging an exhibition in Plymouth, asked Turner to send this work and 'Dido' (probably No. 131). However, Turner had already sent off *Jason* and *Bligh Sands* (Nos. 19 and 87), writing of this picture, 'The *Frostpiece*—I never thought of [? ','] as being generally wrong' (letter of 4 November 1815, reprinted in Finberg 1961, p. 229). In May 1818 Turner offered it to Dawson Turner for 350 guineas, but it was never sold.

That the picture was on view in Turner's gallery in 1835 is attested by the account in the *Spectator* for 26 April: 'We have seen Turner in cool and warm effects, and here we admire him also in a wintry scene. The hard frosty ground, the naked trees, the cold, dead, white sky, and the pale, weak, yellow gleam of sunlight,

that scarcely relieves the cheerless desolation, or lessens the cold of the air, are imitated with the most delicate truth. Here are no raw white masses of snow and black branches, but the true tone of nature is imitated to perfection, for the picture conveys the feeling of the season.'

128. Apullia in Search of Appullus vide Ovid
Exh. 1814 (Plate 130)

THE TATE GALLERY, LONDON (495)

Canvas, $57\frac{1}{2} \times 93\frac{7}{8}$ (146×238.5)

Inscr. 'Appulia in Search of Appulus learns from the Swain the cause of his Metamorphosis' b.l. and 'Appulus' on tree b.l.

Coll. Turner Bequest 1856 (4, 'Apuleia in search of Apuleius' $7'9\frac{1}{2}'' \times 4'9\frac{1}{2}''$); transferred to the Tate Gallery 1910.

Exh. B.I. 1814 (168); ?Turner's gallery 1835; Tate Gallery 1931 (58); R.A. 1974–5 (162).

Engr. By William Say for the *Liber Studiorum*, R.72, but never published (repr. Finberg 1924, p. 289; the preliminary etching repr. p. 288).

Lit. Thornbury 1862, i, pp. 296–7; 1877, p. 432; Hamerton 1879, pp. 150–51; Monkhouse 1879, pp. 69, 76, 93; Bell 1901, pp. 94–5 no. 131; Armstrong 1902, pp. 59, 218; MacColl 1920, p. 11; Finberg 1924, p. 289, repr. p. 288; Davies 1946, p. 185; Clare 1951, p. 55; Finberg 1961, pp. 206–9, 217, 475 no. 185; Rothenstein and Butlin 1964, p. 32, pl. 54; Lindsay 1966, pp. 150–51, 156; Gage 1969, p. 103, pl. 54; Reynolds 1969, pp. 94–5, pl. 71; Woodbridge 1970, p. 246; Herrmann 1975, pp. 23, 230, pl. 72.

The reference in the title 'vide Ovid' refers to Ovid's *Metamorphoses*, Book xiv which contains the story of the transformation of the Apulian shepherd. In Garth's translation, this became the transformation of 'Appulus', and Turner seems to have invented a mythical wife 'Apullia', to whom the swain points out the name 'Appulus' carved on the tree.

The painting was submitted for one of the British Institution's annual premiums. Two or three premiums were usually awarded for pictures 'in Historical or Poetical Composition' and one for 'the best Landscape'. However, Katharine Nicholson (in a paper delivered at the Turner Symposium held at Johns Hopkins University, Baltimore, on 18 April 1975) has shown that the picture was delivered too late to qualify for the premium and that the whole affair was probably designed as a challenge to the British Institution and its main supporters, Sir George Beaumont and Payne Knight. The closing date was 4 January and Turner did not deliver his picture until 15 January, when he failed even to make any apology for his lateness. His

submission was also unusual in that the competition was designed for young, unestablished artists; no full Royal Academician competed after 1810.

An anonymous letter in the *Examiner* for 13 February 1814 attacked Turner's submission as unfair to young artists and because it was late, and protested that the picture 'is not an original composition, being really a direct copy of Lord Egremont's Claude', and indeed it is very close to Claude's *Jacob with Laban and his Daughters* (repr. exh. cat. *Pictures and Works of Art from Petworth House*, Wildenstein's 1954, no. 6). Thornbury even suggests that it was painted as a pendant for Lord Egremont (1862, i, p. 296). Turner varied the architectural forms and some of the figures, but all the main elements of the compositions are the same. Finberg (1961, pp. 208–9) justifies the similarity by the British Institution's requirement that the winning landscape should be 'proper in Point of Subject and Manner to be a Companion' to a work by Claude or Poussin, but this seems in fact only to have been true for the first year of the premiums, 1807. However, the requirement may well have prompted Turner's treatment.

Significantly, perhaps, Lord Egremont, who was to have been on the British Institution's jury, failed to appear on the day. It is even possible, as Katharine Nicholson suggests, that the central nymph who looks out directly at the spectator in what seems to be a mocking way is a deliberate gesture of defiance to the British Institution, another of whose patrons, the Marquess of Stafford, owned Claude's treatment of the same subject. The same year, at the R.A., Turner exhibited his own personal reinterpretation of Claude, *Dido and Æneas* (No. 129).

William Hazlitt, writing in the *Morning Chronicle* for 5 February 1814, found Turner's dependence on Claude an advantage. 'All the taste and all the imagination being borrowed, his powers of eye, hand and memory, are equal to anything.' He attacked the figures as even worse than Claude's and found 'the utter want of a capacity to draw a distinct outline with the force, the depth, the fulness, and precision of this artist's eye for colour . . . truly astonishing.'

That this picture was on view in Turner's gallery in 1835 is suggested by the account in the *Spectator* for 26 April 1835: 'At the other end of the gallery, is another green landscape: a classical composition, with a long stately bridge crossing a river, Claude-like in arrangement and tone, having equal space and repose, with greater solidity of substance . . . We wish Turner would return to the sober beauty and elaborate truth of his earlier works, and cease "to gild refined gold and paint the lily".'

There are composition sketches in the 'Woodstock Shooting' and 'Chemistry and Apuleia' sketchbooks and a drawing for the group of figures in the latter (CXXIX-41 and CXXXV-66 verso to 68 verso; and CXXXV-65 verso and 66 respectively).

129. Dido and Æneas Exh. 1814 (Plate 131)

THE TATE GALLERY, LONDON (494)

Canvas, $57\frac{1}{2} \times 93\frac{3}{8}$ (146 × 237)

Coll. Turner Bequest 1856 (57, 'The Morning of the Chase' $7'11'' \times 4'10''$); transferred to the Tate Gallery 1910.

Exh. R.A. 1814 (177); Tate Gallery 1931 (59).

Engr. By W. R. Smith 1842 as 'Dido and Æneas: the Morning of the Chase'.

Lit. Thornbury 1862, i, pp. 173, 296; 1877, pp. 123, 342, 432; Hamerton 1879, pp. 150–51, 197; Monkhouse 1879, p. 93; Bell 1901, p. 94 no. 130; Armstrong 1902, p. 221; Whitley 1928, p. 224; Davies 1946, p. 186; Clare 1951, p. 55; Finberg 1961, pp. 192, 210–12, 238, 276, 340, 386, 475 no. 186, pl. 16; Rothenstein and Butlin 1964, p. 32; Lindsay 1966, p. 160; Reynolds 1969, p. 186.

Exhibited in 1814 with the following lines:

'When next the sun his rising light displays,
And gilds the world below with purple rays,
The Queen, Æneas, and the Tyrian Court,
Shall to the shady woods for sylvan games resort.'
 4th Book of Dryden's Æneis.

The first idea for the composition, subsequently considerably altered, seems to have been the water-colour in the 'Studies for Pictures: Isleworth' sketch-book of *c.* 1804–6 (XC-21; repr. in colour Wilkinson 1974, p. 106, as of 1811). There is a further composition study, together with a number of figure studies, in the 'Hesperides (1)' sketchbook of about the same date (XCIII-5; and 4 verso and 5 verso–7 respectively). Finberg suggests that it is this picture, rather than *Crossing the Brook* (No. 130, *q.v.*), that Cyrus Redding identified as being based on scenery in Devonshire, but this seems unlikely save possibly in the most general sense.

The younger Trimmer, in an account reported by Thornbury, says of the '*equi effrenati* . . . without bridles' that his father had told Turner that 'the Libyan horses had no bridles, and Turner said he knew it, though I doubt if their views are borne out by modern critics.'

An uncredited press-cutting in the Victoria and Albert Museum, dated May 1814, explains the subject: 'There is a fine historical landscape by Mr. Turner, representing the State of Carthage, its rising towers, and public games on the arrival of Æneas, who conducted by Dido issues from her palace to survey the busy scene. There is great facility and great knowledge of grouping evinced in the order and harmony with which a multitude of objects are here accumulated and distributed.' Another uncredited press-cutting in the same collection describes the picture as 'a charming landscape, [with] figures classically grouped'. Hazlitt in the *Morning Chronicle* for 3 May was rather more

critical: 'This picture, powerful and wonderful as it is, has all the characteristic splendour and confusion of an Eastern composition. It is not natural nor classical'. A review in the *Champion* for 7 May, attributed by Finberg to the same critic, elaborates the same theme, adding that the picture is 'faulty in the too violent opposition of positive blues to vivid yellows, which destroys chasteness of colour, and is at variance with the truth of a representation of early day. We observe, also, an unsatisfactory execution of the parts near the foreground; in distinctness and correctness, a picture of such high pretensions ought not to be deficient. But it is a performance of which our nation has reason to be proud, for we believe no other could at present furnish its equal.'

Unfortunately the present state of the picture, covered with irremovable discoloured varnish, makes assessment of Turner's original colouring impossible.

130. Crossing the Brook Exh. 1815 (Plate 124)

THE TATE GALLERY, LONDON (497)

Canvas, 76 × 65 (193 × 165)

Coll. Turner Bequest 1856 (7, 'Crossing the Brook' 6′3″ × 5′4½″); transferred to the Tate Gallery 1956.

Exh. R.A. 1815 (94); Turner's gallery 1835; Tate Gallery 1931 (60, repr.); R.A. 1974–5 (164, repr.).

Engr. By R. Brandard 1838/1842.

Lit. Farington *Diary* 5 June 1815; Ruskin 1843, 1851, 1857[2] and letters (1903–12, iii, pp. 241, 267, 297, 587; xii, p. 367; xiii, pp. 276–7; xxxvii, p. 13); Cunningham 1852, pp. 29, 32, 44; Cyrus Redding, *Fifty Years' Recollections* 1858, i, pp. 199–205; Thornbury 1862, i, pp. 171, 210–11, 219, 297–8; 1877, pp. 96, 122, 146–7, 152–3, 345, 378, 432–3; Hamerton 1879, pp. 151–5: Monkhouse 1879, p. 93; Bell 1901, pp. 62–3, 96 no. 133; Armstrong 1902, pp. 59, 106–7, 113, 220, repr. facing p. 110; Finberg 1910, p. 87; MacColl 1920, p. 12; Whitley 1928, pp. 241–4; Falk 1938, pp. 42–3; Davies 1946, pp. 149, 185; Clare 1951, pp. 55–7, repr. p. 50; Finberg 1961, pp. 212, 218–20, 238, 241, 252, 340, 386, 476 no. 188, pl. 17; Kitson 1964, p. 74, repr. pp. 28–9; Rothenstein and Butlin 1964, pp. 32–4, colour pl. vii; Lindsay 1966, pp. 114, 152, 157, 242 n. 33; Gage 1969, pp. 39, 90, 171; Reynolds 1969, pp. 80, 96, 106, 186, colour pl. 72; Gaunt 1971, p. 6, colour pl. 14; Herrmann 1975, pp. 23–4, 57, 230, colour pl. 78.

This highly Italianate, Claudian landscape, developed from *Mercury and Herse* (No. 114), is in fact a product of Turner's visit to Devon in 1813 (see Nos. 213–25), as was recognised in a review known from a press-cutting in the Victoria and Albert Museum, annotated 5 May 1815 but without the name of the publication: 'Notwithstanding the buildings are Italian, the scene is found in Devonshire.' Further evidence comes from two people who were with Turner for part of this tour. Cyrus Redding 'traced three distinct snatches of scenery on the river Tamar' when he saw what seems to have been this picture later in Turner's gallery and mentions how 'Turner was struck with admiration at the bridge above the Wear, which he declared altogether Italian'.

According to Charles Eastlake 'The bridge . . . is Calstock Bridge; some mining works are indicated in the middle distance. The extreme distance extends to the mouth of the Tamar, the harbour of Hamoaze, the hills of Mount Edgcumbe, and those on the opposite side of Plymouth Sound. The whole scene is extremely faithful' (Thornbury 1862, i, pp. 210–11, 219). There are drawings of the countryside represented but not actually copied in the picture in the 'Plymouth, Hamoaze' sketchbook (CXXXI, e.g., p. 118, repr. Reynolds 1969, pl. 60) and a small composition sketch in the 'Woodcock Shooting' sketchbook (CXXIX-52).

Despite the strong Claudian elements the *Repository of Arts* for June 1815 could write, 'We perceive no affinity to any style or any school in these works of Mr. Turner [*Crossing the Brook* and *Dido building Carthage*, No. 131]; we think his manner and execution are as purely original as the poetic forms which create his compositions . . . Never have we seen a more elegant landscape than this'. The *Champion* for 7 May described the same two paintings as of the class of 'achievements that raise the achievers to that small but noble groupe, formed of the masters whose day is not so much of to-day, as of "all-time".'

However, Sir George Beaumont was of the contrary opinion as reported by Farington on 5 June 1815: 'Of his picture "Crossing the Brook" He sd. it appeared to Him *weak* and like the work of an Old man, one who had [*sic*] no longer saw or felt colour properly; it was all of *peagreen* insipidity. —These are my sentiments said He, & I have as good a right & it is as proper that I shd. express them as I have to give my opinion of a *poetical* or any other production. As to the Portrait Painters [e.g., Thomas Phillips] who are particularly loud in their praise, unlimited, of these pictures I can only repeat what I have often said that I never knew a Portrait Painter excepting Sir Joshua Reynolds who had a right feeling and judgment of Landscape Painting.' Perhaps because of the criticism of this influential connoisseur Turner failed to sell the picture, though Dawson Turner asked about it in 1818 when the price was 550 guineas. The picture was on view again in Turner's gallery in 1835 when it was noted by the *Spectator* for 26 April as 'a lovely scene of the verdrous valley of the Tamar'.

In a letter to Charles Eliot Norton of 7 August 1870 Ruskin retails an anecdote of Turner's indifference to seeing 'a piece of paint out of the sky, as large as a fourpenny piece, . . . lying on the floor [of Turner's gallery]. . . . "How can you look at the picture and see it so injured?" said Kingsley. "What does it matter?" answered Turner; "the only use of the thing is to recall the impression."'

131. Dido building Carthage; or the Rise of the Carthaginian Empire Exh. 1815 (Plate 118)

THE NATIONAL GALLERY, LONDON (498)

Canvas, 61¼ × 91¼ (155·5 × 232)

Inscr. 'DIDO BUILDING CARTHAGE OR THE RISE of the CARTHAGINIAN EMPIRE JMW Turner 1815' on a wall at left and 'SICHAEO' on tomb at right

Coll. Turner Bequest 1856.

Exh. R.A. 1815 (158); Turner's gallery 1835.

Lit. Farington *Diary* 4–5 June 1815, 5 June 1816; Ruskin 1843, 1857 (1903–12, iii, pp. 113, 241, 267, 297; xiii, p. 124); Cunningham 1852, pp. 29, 32, 44; Alaric A. Watts, *Liber Fluviorum* 1853, p. xxix; Leslie 1860, i, pp. 207–8; Thornbury 1862, i, pp. 175, 180, 270, 298–300, 394–5; ii, pp. 178, 244; 1877, pp. 119, 125, 128, 182–3, 321, 338, 342–3, 345, 361, 369–70, 375, 433–4, 491; Hamerton 1879, pp. 162–4, 197, 306–10; Monkhouse 1879, p. 93; F. M. Redgrave, *Richard Redgrave, C.B., R.A., A Memoir compiled from his Diary* 1891, pp. 84–5; Eastlake 1895, i, p. 188; Bell 1901, pp. 62, 96–7 no. 134; Armstrong 1902, p. 219; Whitley 1928, pp. 241–4; 1930, pp. 282–3; Falk 1938, pp. 111–12; Davies 1946, pp. 149–50; F. Saxl and R. Wittkower, *British Art and the Mediterranean* 1948, p. 69, repr. pl. 4; Clare 1951, p. 63, repr. p. 58; Davies 1959, p. 96; Finberg 1961, pp. 218–20, 229, 290–91, 330, 340, 414, 441, 476 no. 189; Herrmann 1963, p. 19, pl. 7; Rothenstein and Butlin 1964, p. 34, pl. 56; Lindsay 1966, pp. 147, 178, 196; Brill 1969, p. 15, repr.; Reynolds 1969, pp. 94–6, pl. 69; Gaunt 1971, pp. 5–8, colour pl. 12; Gage 1974, pp. 75–8; Herrmann 1975, pp. 23–4, 54, 57, 227, 230, colour pl. 77.

Exhibited in 1815 with the reference, '—1st book of Virgil's Æneid'. The inscription 'Sichaeo' identifies the tomb of Sychaeus, Dido's husband, whose murder at the hands of her brother Pygmalion had led to her fleeing from Tyre to North Africa, where she founded Carthage (see also No. 431).

The 'Studies for Pictures; Isleworth' sketchbook of *c.* 1804–6 contains what may be early ideas for the composition (XC-11 verso, 31 verso; the first repr. Wilkinson 1974, p. 109). For what Turner seems to have intended as a companion picture of *The Decline of the Carthaginian Empire*, exhibited two years later, see No. 135, under which entry there is also a discussion of the significance of the subject in relation to contemporary ideas on the rise and fall of empires.

This significance does not seem to have been noted by contemporary critics though they were united in their praise of the picture. The *Sun* for 16 May 1815 was indeed slightly mystified by the subject: 'Without inquiring too hypercritically into the catalogue description . . . or investigating in what way "the Rise of the Carthaginian Empire" is superadded in its details of the building of Carthage, we may pronounce that,

however described, it is an admirable production. It is in the grand style, and the effects produced correspond with the classical dignity of the subject, without departing from some of the most beautiful appearances of nature in the department of landscape'. The critic alludes to what seems to be an early example of Turner's work on the three Varnishing Days preceding the opening of the R.A. Exhibition, which had been established in 1809: 'When we first saw this Picture, the yellow predominated to an excessive degree, and though the Artist has since glazed it down in the water, it still prevails far too much in the sky, where such a mass of ochre, in combination with the vivid blue, is not only injudicious but unnatural'; that Turner did at some point repaint the sky as well is suggested by the passage from Thornbury's *Life* quoted below. The critic concludes by stating that the picture was, 'upon the whole, one of the chief ornaments of this year's exhibition'.

The *Morning Chronicle* for 1 May was more lavish in praise of the picture: 'one of those sublime achievements which will stand unrivalled by its daring character. It is too much the practice of some critics to judge of an author by his defects only; and in this querulous way we heard this picture decried, on account of its blaze of yellow: but let any accurate observer of Nature say, whether he has not often been struck by the gleams of sunshine and colours of sky, which, he has said to himself, if those tints and effects were to be imitated on canvas, would be pronounced to be out of nature. The warm glow of the sun on the water, with its reflection on the groupes in this wonderful effort of the art, produces a most striking effect, and it is a work which years and ages will improve.' For *The Times*, 6 May, 'Mr. Turner maintains his rank as the first landscape painter of the period which his works adorn. The principal picture of this artist is a rich production of his pencil, and his mind must have been saturated with Claude Lorrain, when he composed it; though in the sky he appears to have forgotten his great exemplar, the sole defect in this superb landscape.' The *Champion* for 7 May described this picture and *Crossing the Brook* (No. 130) as 'achievements that raise the achievers to that small but noble groupe, formed of the masters whose day is not so much of to-day as of "all time".' The *Repository of Arts* for June 1815, after asserting that 'it is generally acknowledged . . . that all the sublime qualities which the poetic style of painting embraces, are manifested in a superior degree in his [Turner's] landscape compositions', goes on, 'All that the most fertile mind can conceive is brought to light in this ideal scene, wherein every thing holds the appearance of reality. Much as we esteem the works of Claude, of Salvator Rosa, of the Poussins, Dominechino, the Caracci, or other justly celebrated Italian masters, we can boast a painter whose pictures comprise qualities of superior excellence to theirs; and we refer to this performance as the warranty for our assertion.'

However, there were hostile reactions from Sir

George Beaumont and his coterie, as Farington reports. On 4 June 1815 he notes that Thomas Phillips '. . . further spoke to me of the great injury done to *Turner* by the reports of Sir George Beaumont and others of His Circle. He said Holwell Carr, speaking to a person of Turner's picture "*Dido building Carthage*" observed that "Turner did not comprehend his Art".—By such speeches Philips thought Turner was greatly injured & the sale of His works checked. I did not agree with Him in this opinion to the extent of his belief and told Him that the high prices demanded by Turner put His pictures above the purchase of many who wd. be disposed to buy pictures at a lower price.' The next day, 5 June, Farington noted that Beaumont 'had just come from the Exhibition of the Royal Academy. He had again attentively considered Turner's picture "*Dido building Carthage*"—so much cried up by Artists and newspapers. He wished to satisfy himself that He was not mistaken in the judgment He had formed upon it. He felt convinced that He was right in that opinion, and that the picture is painted in a false taste, not true to nature; the colouring discordant, out of harmony, resembling those French Painters who attempted imitations of *Claude*, but substituted for His purity & just harmony, violent mannered oppositions of Brown and hot colours to Cold tints, blues & greys: that several parts of Turner's picture were pleasingly treated but as a *whole* it was of the above character.

Later in 1815, when Ambrose Johns was trying to borrow two pictures from Turner for an exhibition at Plymouth, Turner explained his refusal to lend 'Dido', probably this picture (though just possibly No. 129), as its 'unwieldy framework might e'en of itself produce a miscarriage in so long a journey' (letter of 4 November 1815, reprinted in Finberg 1961, p. 229; the pictures he did send were Nos. 19 and 87).

The following year, on 5 June 1816, Farington notes that 'Owen spoke of Sir John Leicester having bought Turner's picture of "*The Building of Carthage*" which was exhibited last year, and had given 800 guineas for it.' There is no evidence that such a sale ever took place though the price accords more or less with that mentioned in one of the many anecdotes told about the various efforts made by collectors to buy the picture. This is contained in an annotation to Thornbury 1862, i, p. 298, made by Munro of Novar in a copy belonging to Francis Haskell: 'Turner told me when first exhibited he was offered £500 for the Rise of Carthage, but, says he, that would not have paid for my trouble. I wanted £800.' According to Thornbury, in what is perhaps yet another version of the same story, 'Chantrey once tried to buy it, but was startled by finding each time its price rose higher: 500*l*.,—1000*l*.,—2000*l*.

' "Why what in the world, Turner, are you going to do with the picture?"

' "Be buried in it, to be sure", growled Turner' (Thornbury 1862, i, pp. 299–300).

Another version of this last remark, addressed to Chantrey in his capacity as one of Turner's executors, is reported by C. R. Leslie: ' "I have appointed you one of my executors. Will you promise to see me rolled up in it [*Dido building Carthage*]?" "Yes", said Chantrey; "and I promise you also that as soon as you are buried I will see you taken up and unrolled" . . . The story was so generally believed, that when Turner died, and Dean Milman heard he was to be buried in St Paul's, he said, "I will not read the service over him if he is wrapped up in that picture" ' (Leslie 1860, *loc. cit.*, repeated in Thornbury 1862, ii, p. 244; see also Trimmer's version of this anecdote, *op. cit.*, i, p. 180).

Another effort to purchase the picture during Turner's lifetime was also rebuffed. In 1825 Alaric A. Watts and J. O. Robinson tried to buy it in order to make an engraving, but found the price upped from 750 guineas to 1000 (Watts 1853, *loc cit.*).

Despite his mutterings about using the picture as a shroud Turner had, well before his death, determined on an alternative fate for it. In 1829, in the first draft of his will, he chose to bequeath it, with *The Decline of the Carthaginian Empire* (No. 135, *q.v.*; later changed for *Sun Rising through Vapour*, No. 69), direct to the National Gallery to be 'placed by the side of Claude's "Sea Port" and "Mill" that is to hang on the same line same height from the ground' (the two Claudes referred to would seem to have been the two largest purchased by the National Gallery from the Angerstein Collections in 1824, those now known as *Seaport: The Embarkation of the Queen of Sheba* (N.G. no. 14) and *Landscape: the Marriage of Isaac and Rebekah* (no. 12)). Later a body of subscribers including Sir Robert Peel and Lord Hardinge proposed purchasing both of the large Carthage pictures for presentation to the National Gallery for £5,000; Turner told their emissary the dealer Griffith that 'Carthage may some day become the property of the nation' (Thornbury *op. cit.*, i, pp. 394–5).

At some unspecified date, but perhaps during the R.A. Varnishing Days (see the review in the *Sun* quoted above), the picture ' "had an entire new sky painted at the desire of Lawrence and other brother artists, who, when he [Turner] had altered it, said the picture was ruined. The sun was yellow in Turner's gallery, it is now white" ' (Trimmer as reported by Thornbury, *op. cit.*, i, p. 175). Later the picture was one that was specifically mentioned as having suffered in Turner's gallery; Elizabeth Rigby, later Lady Eastlake, saw it there on 20 May 1846 and described it as 'all mildewed and flaking off'. The painting was repaired for the National Gallery by William Seguier *c.* 1852.

132. The Eruption of the Souffrier Mountains, in the Island of St Vincent, at Midnight, on the 30th of April, 1812, from a Sketch taken at the time by Hugh P. Keane, Esqre Exh. 1815

(Plate 120)

UNIVERSITY OF LIVERPOOL

Canvas, $31\frac{1}{4} \times 41\frac{1}{4}$ (79·4 × 104·8)

Coll. No history is known until it was bought from S. T. Gooden by Agnew in 1902 and sold to Pandeli Ralli in 1904; A. J. Sulley; sale Christie's 1 June 1934 (26) bought in; R. L. Lowy sale Christie's 8 May 1942 (118) bought Richards; entered the collection of the University of Liverpool in November 1948.

Exh. R.A. 1815 (258); R.A. 1908 (116 lent by Pandeli Ralli); R.A. 1974–5 (163).

Engr. By Charles Turner in mezzotint, published 6 November 1815. This was a large plate, $23\frac{1}{4} \times 32$ in., and was given the title 'The Burning Mountain'. An impression in the Print Room of the British Museum, from the collection of John Dillon (a collector of Turner watercolours) has a note in the margin by Dillon (dated Sept. 1852) which says that Charles Turner engraved it 'for a gentleman who took it—copper plate, impressions and all, abroad with him, they have not since been heard of. Only three impressions were left in England of which this is one—and one of the other two is much damaged.' It is listed in Alfred Whitman's catalogue of *Charles Turner's Engraved Work* 1907, p. 269 no. 863 as 'Vesuvius in Eruption (Burning Mountain)'.

Lit. Burnet and Cunningham 1852, p. 113 no. 118; Thornbury 1877, p. 573; Bell 1901, pp. 49–50 no. 74, listed as a watercolour; Finberg 1961, pp. 219, 476 no. 191.

Exhibited with the following lines by Turner, although with no reference to *Fallacies of Hope*:

> 'Then in stupendous horror grew
> The red volcano to the view
> And shook in thunders of its own,
> While the blaz'd hill in lightnings shone,
> Scattering their arrows round.
> As down its sides of liquid flame
> The devastating cataract came,
> With melting rocks, and crackling woods,
> And mingled roar of boiling floods,
> And roll'd along the ground.'

Turner is here following the eighteenth-century tradition in painting volcanoes and earthquakes; earlier artists like Joseph Wright of Derby and Volaire had frequently painted Vesuvius in eruption, but Turner characteristically chose a volcano of exceptional power: it was said that this eruption could be heard over a hundred miles away and that the Barbados Islands were covered with volcanic dust. Turner may have read the long account of the eruption in the *Gentleman's Magazine* for October 1812 to add to his knowledge of the scene derived from Keane's sketch. Turner also owned vols. i and ii of the *Transactions of the Geological Society* 1811–14. In vol. i (pp. 185–90) there is an article by N. Nugent entitled 'An Account of "The Sulpher" or "Souffriere" of the Island of Monserrat'.

When shown at the R.A. this picture was praised in the *Repository of Arts* for June 1815:

'It appears that there is no record existing of a volcanic irruption on so mighty a scale as this of St. Vincent. Those who were on the ocean supposed the whole island was destroyed and this opinion lasted for several days. To represent the grand phenomena of nature in painting requires the powers of a mind like that of Mr. Turner, whose daring flights have often surprised the connoisseur. This wonderful effort of his pencil [this is presumably what led Bell to list it as a watercolour but there are many other instances of oils being so described] is said, by those who witnessed the effects of the eruption of the Souffrier Mountains, to convey a faithful resemblance of the awful scene.'

In Finberg's papers in the British Museum, he noted 'I do not accept this as genuine. Probably a fake, from Chas Turner's Engraving'. However, Mrs Finberg added a note to the effect that she was not sure her husband was right about this, and the chance to study it at the Turner Bicentenary exhibition confirmed its authenticity beyond any doubt.

133. The Temple of Jupiter Panellenius restored
Exh. 1816 (Plate 132)

PRESENT WHEREABOUTS UNKNOWN

Canvas, 46×70 (116.8×177.8) (Wynn Ellis sale catalogue)

Coll. The picture has disappeared since the Wynn Ellis sale in 1876. At the sale (Christie's 6 May 1876 (121)) doubt was cast on the authenticity of this picture, and this was announced by Mr Woods, the auctioneer, from the rostrum. The rumour was that Wynn Ellis had sold the original for 1,400 guineas and that this was a copy.

H. Graves, publisher to the Queen, then wrote to say that the original had been bought from Turner by his predecessors, Messrs. Hurst and Robinson (probably early in 1823—see below) and that he had acquired it with the business in 1827. Pye's engraving of it, issued in 1828, was thus one of Graves' earliest publications. Wynn Ellis then bought the picture for 300 guineas from Graves in about 1836, after which he had it relined.

Before the sale, Graves cast doubts on whether it was the same picture he had sold to Wynn Ellis, but this may have been pre-sale tactics on Graves' part as he was the under-bidder at the sale where it was bought by Goupil for 2,000 guineas.

Redford (*Art Sales* ii 1888, p. 122) has a record of a *Temple of Jupiter*, sold at Phillips on 30 April 1884 by an anonymous vendor and bought by Gambart for 1,200 guineas. Redford says that this is the picture which was later acquired by the Duke of Northumberland, but this must be a mistake as the Northumberland picture (see No. 134) had been in his collection since 1856. In fact, however, no Turner of this title appears in the sale at Phillips on 30 April

1884 so that it seems that Redford must again have been mistaken.

Exh. R.A. 1816 (55); B.I. 1853 (169 lent by Wynn Ellis.)

Engr. By John Pye, 1828. The print is dedicated to the Lord Chancellor, Lord Lyndhurst, and was published on 1 March by 'Moon, Boys and Graves (successors to Hurst, Robinson & Co.) Printsellers to the King'. By J. B. Allen in the *Turner Gallery* 1859–61.

The *European Magazine* for February 1823 carried the following report: 'Turner's large and beautiful picture of *The Temple of Jupiter Panellenius* (in the island of Aegina) *restored*, has been purchased for a very considerable sum, and is now engraving by one of our finest artists. It will probably be two years before the plate is finished.' (In fact it was five.) Alaric Watts in his biographical sketch of Turner which he contributed as a foreword to the *Liber Fluviorum* (1853, p. xxix) gives the price paid by Hurst and Robinson as 500 guineas.

Lit. Ruskin 1843 (1903–12, iii, p. 241); Burnet and Cunningham 1852, pp. 29, 42, 44, 114, no. 122; Waagen 1854, ii, p. 298; Thornbury 1862, ii, p. 400; 1877, pp. 574, 598; Hamerton 1879, p. 164; Bell 1901, p. 98 no. 136; Armstrong 1902, p. 217; Rawlinson i 1908, pp. xlv, lx, 116; ii 1913, pp. 194, 208, 358; Finberg 1961, pp. 241, 277, 290, 306, 477 no. 195; Rothenstein and Butlin 1964, p. 32; Lindsay 1966, pp. 184, 200, 206, 209; Lindsay 1966², pp. 60–61, 82.

Exhibited with the following quotation:

' ''Twas now the earliest morning; soon the sun,
 Rising above Abardos, poured his light
 Amid the forest, and, with ray aslant,
 Entering its depth, illumed the branking pines,
 Brightened their bark, tinged with a redder hue
 Its rusty stains, and cast along the ground
 Long lines of shadow, where they rose erect
 Like pillars of the temple.'

Lindsay discusses the significance of the verses and suggests that besides carrying the image of a restored nation further than the inclusion of the national dance had done in the companion picture, 'they also suggest the restoration of man and nature . . . the direct political theme thus deepens into the theme of man's freedom altogether from alienation.' Lindsay's views were no doubt partly due to his mistaken supposition that the lines quoted in the R.A. catalogue were by Turner himself. This in turn hinges on Lindsay's misreading of Ægina for Abardos (*sic*) in line 2. Although unacknowledged by Turner in the R.A. catalogue, the verses were in fact taken from Southey's *Roderick, the Last of the Goths*, published in 1814 (Part iii ll. 1–8 with some divergences e.g., 'Abardos' for 'Albardos', 'branking' for 'branchless pines' etc.). Turner pre-

sumably considered the plight of Spain under Moorish domination to be a sufficiently close parallel with that of Greece under the Turks to make the quotation an apposite one.

For the reception of the two pictures at the R.A. see the entry for No. 134. This picture was generally adjudged to be the finer of the two (or the less bad in Hazlitt's eyes). The *Sun*, 7 May, considered 'Both seem more to aim at effect, than to exhibit the exquisite genius of their author. Southey's natural description left little for the painter who chose his theme for a text; but Mr. Turner has by no means made a literal copy from the Poet. In truth, the quotation might as well have been dispensed with, from any applicability it has to the landscape, where we look in vain for the 'earliest morning' and the 'depth' of shade. The grace and grandeur of these pieces however must strike every eye, and while we wish they were mellowed down by some process, were it even by an accession of smoke or dust, we cannot help admiring their classic elegance and redundant richness.'

134. View of the Temple of Jupiter Panellenius, in the Island of Ægina, with the Greek National Dance of the Romaika: the Acropolis of Athens in the Distance. Painted from a sketch taken by H. Gally Knight, Esq. in 1810 Exh. 1816
 (Plate 133)

THE DUKE OF NORTHUMBERLAND, K.G.

Canvas, 46¼ × 70 (118·2 × 178·1)

Signed and dated 'JMW Turner RA 1814' (the last figure is uncertain) on rock in left foreground

Coll. Bought from George Pennell by Joseph Gillott in June 1843 for £850 (this is the first recorded purchase of a Turner by Gillott); John (not Adam as stated in the catalogue of the Neo-Classical Exhibition 1972, p. 160) Fairrie of Clapham Common; sale Phillips 22 April 1856 (145) bought Gambart; bought from Colnaghi by Algernon, fourth Duke of Northumberland (1792–1856) by June 1856 when he lent it to the exhibition at the British Institution; by descent to the present owner.

According to the Northumberland catalogue, the Duke (who succeeded to the title in 1847) had tried to buy *The Fighting Temeraire* (No. 377) from Turner, who had refused to sell it. The Duke then asked Colnaghi to let him know of the first Turner to come onto the market and thus acquired this picture, Colnaghi having bought it from Gambart. This story seems suspect in that a number of other Turners became available for sale between Turner's death and 1856, and we know from Mr Woods, the auctioneer (see the entry for No. 144), that Colnaghi had both *Boats carrying out Anchors* (No. 52) and the *Iveagh Seapiece* (No. 144) on sale 1855–56.

Exh. R.A. 1816 (71); B.I. 1817 (62); Royal Manchester

Institution 1845 (228 lent by Gillott); R.S.A. 1847 (175 lent by Gillott); B.I. 1856 (53 lent by the Duke of Northumberland); R.A. 1906 (83); R.A. 1951–2 (170); Leggatt 1960 (2); R.A. 1968–9 (211); R.A. *The Age of Neo-Classicism* 1972 (254).

Engr. By H. Dawe for the *Liber Studiorum* but never published (Rawlinson 77). Two sepia drawings exist connected with the print, one in the British Museum (Vaughan Bequest CXVIII-S); the other was sold at Sotheby's on 15 July 1964 (43) bought Leggatt. According to Finberg the latter was used for the engraving.

Lit. Ruskin 1843 (1903–12, iii, p. 241); Burnet and Cunningham 1852, pp. 29, 42, 114 no. 123, 121 no. 7; Thornbury 1862, i, p. 300; 1877, pp. 434, 574; Hamerton 1879, p. 164; Monkhouse 1879, p. 93(?); Bell 1901, pp. 99–100 no. 138; Armstrong 1902, p. 217; Rawlinson ii 1913, p. 208; Finberg 1924, p. 309; C. H. Collins Baker, *Catalogue of the Pictures in the Collection of the late Duke and Duchess of Northumberland* 1930, p. 155 no. 723, pl. 104 (where it is dated 1818, amended in the copy at Alnwick to 1816); Finberg 1961, pp. 241, 477 no. 196, 515 no. 571a, 516 no. 580b; Lindsay 1966, pp. 184, 200, 206, 309.

Bell confuses the R.A. Exhibition in 1816 and the B.I. Exhibition in 1817 and lists two versions of this picture: this one at the B.I. but a small version, canvas $27\frac{1}{2} \times 35$ in., at the R.A. in 1816 which he states belonged originally to Joseph Gillott and, in 1901, to a Miss Heaven. The latter, which was given to the Whitworth Institute by Miss Heaven in 1897, was later sold by them but in their inventory of 1913 it is described as 'A Copy—more or less contemporary'.

When exhibited at the R.A. with the companion picture (No. 133) both pictures were praised by the critic of the *Sun*, 7 May, who described them as being 'like two new guineas fresh from the mint; yellow, shining, gorgeous and sterling.' Both this writer and the critic in the *Repository of Arts* for June were inclined to consider the companion picture to be the finer of the two, but the *Annals of the Fine Arts*, also for June, judged them to be of equal merit and beauty and considered that the figures in this picture 'form valuable accessories and are beautifully and gracefully designed'.

However, the *Champion*, 12 May, has a long and strongly critical review of both pictures written, according to Whitley, by Hazlitt. Hazlitt attacked the pictures particularly on account of their colours which he claimed 'are not to be found in Spring, Summer, Autumn or Winter; neither in the East nor in the West, neither in Greece nor in England. They are . . . a combination of gaudy hues intended to become a striking point of attraction on the Walls of the Exhibition. This is a motive most unworthy of an artist of eminence like Mr. Turner . . .' Further on Hazlitt accuses Turner of failing to practise what he preached

'. . . Mr. Turner has very clearly laid down in his lectures the principle which he has in his practice violated by making the shadows, occasioned by sunlight, rich and hot, although, as he has himself taught, they are always cool. Our criticism applies to the best picture, No. 55, the second, No. 71, is but a miserable copy of the first:—it is weak as well as gaudy . . .' Hazlitt concludes with a final insult: 'Mr. Turner may now take useful lessons from Mr. Callcott, instead of Mr. Callcott from Mr. Turner.'

An interesting feature of Hazlitt's criticism is that he clearly followed Turner's lectures on perspective with close attention and was thus able to pick Turner up on the point about the shadows. Hazlitt's view of the pictures was reinforced by Ruskin who listed them both under the general heading of 'nonsense pictures'.

However, when exhibited at Manchester in 1845 and at Edinburgh in 1847, the picture was greatly praised by the *Manchester Guardian* of 23 July, the *Manchester Times* of 16 August and the *Edinburgh Evening Courant* of 27 February 1847. All three papers agree in stating that the picture was painted in 1818 (the *Manchester Guardian* stated that it was dated 1818). This might lead one to conclude that a second version existed but for the fact that the last figure in the date is (and probably always was) so difficult to decipher.

Lindsay suggests that the titles reflect Turner's sympathy for the cause of Greek nationalism and a wishful antedating of Greek liberation—in this picture by the introduction of the national dance and in its companion by the image of the restored temple of Zeus, signifying a unified people.

Turner's sympathy for the Greek cause was certainly in evidence later in his life in connection with his illustrations to Byron's poems, but these pictures may be its earliest manifestation, inspired perhaps by the publication of the Second Canto of *Childe Harold* in 1812, although a pen and ink drawing in the Turner Bequest (CXX-Z), a design for a classical composition, is inscribed by Turner with the alternative titles; 'Homer reciting to the Greeks his Hymn to Apollo' and 'Attalus declaring the Greek States to be Free'. If Finberg is correct in dating this drawing not later than 1810, it would seem to provide still earlier evidence of Turner's sympathy with the Greeks.

The portrayal of the Greek architecture shows Turner's interest in this subject and his knowledge of contemporary archaeological publications. He was certainly familiar with Stuart and Revett's *Antiquities of Athens*, which he used in the preparation of his Perspective lectures. Later, c. 1832, Turner painted a watercolour of the *Temple of Jupiter Panhellenius* (Collection: Lord Joicey) for his friend, the architect C. R. Cockerell (1788–1863), who published a book on the temple in 1860 (see Thornbury 1877, p. 179, who relates that Cockerell considered that Turner's price of 35 guineas for the watercolour was exorbitant).

Henry Galley Knight (1786–1846), the amateur artist who supplied Turner with the sketch for this picture, lived at Langold Hall, Yorkshire. A letter from

Turner to his friend Holworthy of 31 July 1816 (to be published by Gage) concerns a plan for them to meet 'at Mr. Knights'.

135. The Decline of the Carthaginian Empire — Rome being determined on the Overthrow of her Hated Rival, demanded from her such Terms as might either force her into War, or ruin her by Compliance: the Enervated Carthaginians, in their Anxiety for Peace, consented to give up even their Arms and their Children Exh. 1817 (Plate 119)

THE TATE GALLERY, LONDON (499)

Canvas, 67 × 94 (170 × 238·5)

Coll. Turner Bequest 1856 (2, 'The decline of Carthage' $7'11'' × 5'7\frac{1}{2}''$); transferred to the Tate Gallery 1929.

Exh. R.A. 1817 (195); Turner's gallery 1835; exchange loan to the Louvre, Paris, 1950–59; *Berlioz*, Victoria and Albert Museum 1969 (379, repr.); R.A. 1974–5 (165, repr. in colour p.35).

Lit. Ruskin 1843, 1860, and 1857 (1903–12, iii, pp. 241, 267, 298; vii, p. 437–8 n.; xiii, pp. 124–5, 157); Thornbury 1862, i, pp. 180, 300; 1877, pp. 128, 343, 435; Hamerton 1879, pp. 164–5, 197; Monkhouse 1879, p. 93; Bell 1901, p. 99 no. 137; Armstrong 1902, p. 219; Whitley 1928, p. 272; Davies 1946, p. 185; Finberg 1961, pp. 247–8, 330–31, 477 no. 197; Rothenstein and Butlin 1964, p. 34; Lindsay 1966, pp. 153–4; Lindsay 1966², p. 49; Gage 1969, p. 90; Reynolds 1969, p. 94, colour pl. 70; Gage 1974, pp. 75–8.

Despite the slight difference in size this picture is the counterpart to *Dido building Carthage; or the Rise of the Carthaginian Empire* of two years earlier (No. 131). Turner's verses for the catalogue stress the significance of the setting sun:

> '* * * * * At Hope's delusive smile,
> The chieftain's safety and the mother's pride,
> Were to th'insidious conqu'ror's grasp resign'd;
> While o'er the western wave th'esanguin'd sun,
> In gathering haze a stormy signal spread,
> And set portentous.'

Ruskin, who recognised the two Carthage pictures as companions, quoted the text from the R.A. catalogue and added, 'This piece of verse, Turner's own, though, it must be confessed, not particularly brilliant, is at least interesting in its proof that he meant the sky—which, as we have seen, is the most interesting part of the picture—for a stormy one'. He comments further on the verses in *Modern Painters* v: 'And remember also, that the very sign in heaven itself which, truly understood is the type of love, was to Turner the type of death. The scarlet of the clouds was his symbol of

destruction. In his mind it was the colour of blood. So he used it in the Fall of Carthage. Note his own written words . . .'

John Gage (1974) has pointed out that such comparisons of the rise and fall of empires, and their application to the contemporary situation, were a commonplace in the late eighteenth and early nineteenth centuries, as in Oliver Goldsmith's *Roman History* and Edward Gibbon's *Decline and Fall of the Roman Empire* (both writers had been Professors of Ancient History at the Royal Academy). The then well-known guide to Italy, J. C. Eustace's *Classical Tour through Italy* of 1813, even draws the parallel between Carthage and England. Claude's paintings had been interpreted in a similar way, the two pictures at Longford Castle having been engraved in 1772 as 'the Landing of Æneas in Italy: The Allegorical Morning of the Roman Empire' and 'Roman edifices in Ruins: the Allegorical Evening of the Empire'. Turner's two large Claudian harbour scenes seem therefore to have been deliberate essays in this tradition. Ruskin saw the pictures as companions but Thornbury appears to have been the first to draw attention to their message.

Contemporary reviews did not note any connection between the two pictures though, with rare exceptions, they were high in praise of both. The *Repository of Arts* for June 1817 even praised Turner's verses: 'The awful description of the setting sun, so exquisitely described by the poet in the three last lines of the extract above, has been chiefly attended to by Mr. Turner; and never has so bold an attempt been crowned with greater success . . . The colouring of every part of the picture is full of extreme richness . . . It is impossible to pass over the execution of the architectural parts of this picture: they are drawn with purity and correctness; the Grecian orders are carefully preserved, and the arrangement of the buildings in perspective is formed with so much adherence to geometrical rule, that the eye is carried through the immense range of magnificent edifices with such rapidity, that we entirely forget the artist, and merely dwell on the historic vision. Mr. Turner has here embodied the whole spirit of Virgil's poetical description of the event, its awful grandeur, and solemnity of effect.' The *Annals of the Fine Arts* wrote, 'Mr. Turner has only one, but that one is a lion . . . excelling in the higher qualities of art, mind and poetical conception, even Claude himself.'

In an issue of the *Annals* earlier the same year the critic John Bailey had already said that 'I wish the Directors of the British Institution would purchase it. When shall we see a National Gallery, where the works of the old masters and the select pictures of the British School, may be placed by the side of each other in fair competition, then would the higher branches of painting be properly encouraged?' Could this have been the inspiration to Turner to bequeath two of his paintings to hang next to two Claudes in the National Gallery? In his first will, drawn up in 1829 five years after the National Gallery first opened at 100 Pall Mall, Turner left the two Carthage pictures to be 'placed by

the side of Claude's "Sea Port" and "Mill" '; later, in 1831, *The Decline of Carthage* was replaced by the earlier painting *Sun rising through Vapour* (R.A. 1807; see No. 69).

There are composition sketches in the 'Yorkshire 1' sketchbook (CXLIV-101 verso (repr. Reynolds 1969, pl. 68) and 102 verso) and perhaps also in the 'Hastings to Margate' sketchbook (CXL-73 verso), and studies for the architectural setting in the 'Hints River' sketchbook (CXLI-32 verso and 33).

136. Raby Castle, the Seat of the Earl of Darlington Exh. 1818 (Plate 121)

THE WALTERS ART GALLERY, BALTIMORE, MARYLAND (Inventory no. 37.41)

Canvas, $46\frac{7}{8} \times 71\frac{1}{8}$ (119 × 180·6)

Coll. Painted 1817–18 for the third Earl of Darlington (1766–1842) who was created first Duke of Cleveland in 1833; by descent to the fourth Duke on whose death in 1891 the title became extinct; his widow survived him until 1901 and it was presumably she who sold the picture; with Messrs. Wallis of the French Gallery, London in 1899 and later that year with the dealer W. Scott and Son of Montreal; it was bought by Henry Walters of Baltimore before 1902; the Walters Collection was willed to the City of Baltimore in 1931 and in 1934 the Walters Art Gallery reopened as a public museum.

Exh. R.A. 1818 (129); French Gallery, London, 1899.

Lit. Burnet and Cunningham 1852, p. 114 no. 125; Thornbury 1862, ii, pp. 400–01; 1877, pp. 574, 598; 'The Private Collections of England No. xxiii Raby Castle', *Athenaeum* 1876, pp. 274–6; Bell 1901, p. 101 no. 139; Armstrong 1902, pp. 60, 227; *Walters Collection Catalogues* 1909, 1922, 1929, no. 41; Whitley 1928, p. 285; Finberg 1961, pp. 251, 477 no. 198; Rothenstein and Butlin 1964, p. 27, pl. 58; Gage 1969, pp. 111, 250 n.189; Reynolds 1969, p. 106, fig. 87; Wilkinson 1974, pp. 168–9 repr.

A number of pencil drawings of the castle—and others of a huntsman and hounds—occur in the 'Raby' sketchbook (CLVI, watermarked 1816) which Turner used on his visit to Raby in the autumn of 1817. There is a watercolour which comes close to the composition on pp. 23 verso–24 but the most detailed and exact study is one in pencil on pp. 21 verso–22, taken from a little nearer the castle. Turner went to Raby after returning from his trip to the Rhine in mid September and before arriving at Farnley in November (Finberg 1961, p. 249). Further references to Raby in Turner's hand appear in the 'Hints River' sketchbook (CXLI) in a list of pictures in hand, and in the 'Liber Notes (2)' sketchbook (CLIV(a)) in which it would appear that the price was 200 guineas, which seems low in

comparison with the *Dort* (No. 137) which has 550 against it in the same list.

A draft of a letter from Turner to the Earl of Darlington is on p. 15 of the 'Guards' sketchbook (CLXIV); Turner asks his patron if he is likely to be in London during April 1818 and thus could see the picture before 1 May when it had to be sent to the R.A.

As Rothenstein and Butlin point out, this is a later variation on the type of 'house portrait' which Turner had painted of Petworth and Somer Hill several years before, with the incident of the hunting scene added for extra interest. The wide panoramic sweep of landscape perhaps owes something to the experience of painting the watercolours of the Sussex landscape round Rosehill for Mr Fuller (1815–16) and of the Yorkshire series (1817–18) which were engraved in Whitaker's *Richmondshire*.

The picture was on the whole accorded a cool reception at the R.A. and more attention was given to Turner's other two exhibits there: the *Dort* (No. 137) and *The Field of Waterloo* (No. 138).

The critic of the *Repository of Art* for June wrote 'It seems a morning view, and not in any clear weather. The colouring is plain, and the perspective excellent: perhaps this is the greatest merit in the picture.'

Another critic (*Annals of the Fine Arts* iii, part ix, section xi, pp. 296, 297, 299) considered that the picture exhibited 'rather the versatility than the best powers of Mr. Turner's pencil.' This view was echoed in the *Sun*, 12 May, which considered that Turner's abilities in the province of landscape 'are more successfully employed in the poetical department of that province, than in the representation of local and individual scenery.'

Last, the *Literary Chronicle* for 22 June, in a long plea for a more regulated plan for hanging the pictures at Somerset House, to include the grouping in one room of all pictures aimed to appeal to the imagination under the heading 'poetical', then listed a number of pictures which would not be admitted to this room: ' . . . and, above all, the abortive attempt by Turner, called in the catalogue *The Field of Waterloo* and his still more detestable fox hunting picture, which we consider a disgrace to his great talents. If there is one man in existence whose works possess the quality of which we are speaking in a higher degree than another, it is Turner; but we should be sorry to carry our admiration of his genius so far as to tolerate his failures, or applaud his errors.'

Miss Elisabeth Packard, Director of the Conservation Department of the Walters Art gallery, has been enormously kind in supplying me with information about the technical state of the picture which was revealed when it was cleaned in 1958. Miss Packard has allowed me to study both the X-ray photographs taken at the time and to read the manuscript of a paper entitled 'A Penetrating Look into Turner's *Raby Castle*' which she gave at Ottawa in 1967 to the American group of the International Institute for Conservation.

From these it is clear that the composition was altered quite significantly at some stage and that

originally the incidents of the hunt formed a much more obtrusive feature: mounted horsemen on a much larger scale than those now visible occupied the foreground on the right while, in the left centre, the fox was held aloft above the hounds by the huntsman in the traditional representation of 'the kill'. Various possibilities are raised by these alterations but I am sure Miss Packard is right to dismiss as extremely unlikely the theory that Turner painted over an old canvas when executing this important commission. The questions then arise as to whether the alterations are by Turner himself and, if so, when they were done. Looking at the picture as it now is, there seems no doubt that it is entirely by Turner's hand and that doubts on this score expressed in the past were due to further repainting, done perhaps shortly before its sale to Henry Walters, which has now been removed.

Assuming that the alterations are Turner's work, when were they done? The review quoted above from the *Literary Chronicle* referring to the 'still more detestable fox hunting picture' implies that, when shown at the R.A., it featured the hunt more prominently than at present, when such a description would hardly be accurate. Miss Packard refers to Finberg who notes that 'the critics were not enthusiastic over the groups of huntsmen and the pack of hounds in the foreground' and points out that the horsemen are certainly not now in the foreground. Although I have been unable to trace Finberg's source for this remark among the reviews, it does tend to confirm that the picture's appearance was different when exhibited at the R.A. As Turner's letter, cited above, to the Earl of Darlington makes it seem very possible that the latter did not in fact see the picture before it was sent to the R.A., the most logical explanation is surely that Lord Darlington did not like the picture when he saw it, and objected to it on the grounds that the hunting incidents in the foreground (doubtless included by Turner as an allusion to his patron's prowess in the hunting field) diverted interest from the castle and its immediate surroundings. In this case, Turner probably altered the picture soon after the R.A. exhibition closed and, although his repainting of the foreground may have resulted in some loss of anecdotal interest, it had the great advantage of focusing attention on the middle distance where light and shadow sweep over the landscape in a passage of breathtaking beauty.

137. Dort, or Dordrecht, the Dort Packet-Boat from Rotterdam becalmed Exh. 1818 (Plate 122)

YALE CENTER FOR BRITISH ART, PAUL MELLON COLLECTION

Canvas, 62 × 92 (157·5 × 233)

Signed and dated 'J M W Turner RA 1818 Dort' on a log bottom right (Plate 539)

Coll. Walter Fawkes of Farnley who bought it at the R.A. in 1818 for 500 guineas (recorded by Farington who was told by William Owen). According to

Finberg (1912, p. 17) it was Hawksworth Fawkes who urged his father to buy the picture; Fawkes sale Christie's 2 July 1937 (61) bought in; sold by Agnew to Mr Paul Mellon in 1966 on behalf of Major le G. G. W. Horton-Fawkes, who inherited Farnley in 1937.

Exh. R.A. 1818 (166); Lawrie and Co. 1902 (7); Wembley *British Empire Exhibition* 1924 (v.34); Leeds City Art Gallery *Treasures from Yorkshire Houses* February 1947; Whitechapel 1953 (79); Washington 1968–9 (10); Tate gallery 1971 (44).

Engr. In P. G. Hamerton's *Les Artistes Célèbres—Turner* (the French edition of his *Life* of Turner) and in the *Magazine of Art* 1887.

Lit. Farington *Diary* 4 May 1818; Burnet and Cunningham 1852, p. 114 no. 126; Ruskin 1856 (1903–12, xiii, pp. 47–48 and note); Thornbury 1862, ii, pp. 85, 89, 393; 1877, pp. 237, 240, 574, 589; Bell 1901, p. 101 no. 140; Armstrong 1902, pp. 85, 109, 221 (who notes 'sky changed in colour'); Finberg 1912, pp. 10, 11, 17, 20, 21; Whitley 1928, p. 285; Falk 1938, pp. 92, 97; Clare 1951, p. 64; Finberg 1961, pp. 251 ff., 275, 279, 478 no. 199; Rothenstein and Butlin 1964, pp. 34–5, pl. 59; Lindsay 1966, pp. 154, 157; Gage 1969, pp. 90, 117, pl. 20; Reynolds 1969, pp. 99, 121, fig. 73; Gaunt 1971, p. 6, colour pl. 16; Bachrach 1974, pp. 17–18, repr. in colour p. 19; Herrmann 1975, pp. 25, 230, 231, pl. 86.

This picture resulted from Turner's visit to the Netherlands and the Rhine, whence he returned by way of Rotterdam in mid September 1817. He visited other towns in Holland including Dordrecht just before this. A tiny drawing of the composition is on part of p. 59 of the 'Liber Notes (2)' sketchbook (CLIV(a)). The drawing does not show the reed bed on the right of the composition. Two further studies occur on p. 50 of the 'Itinerary Rhine Tour' sketchbook (CLIX) and on p. 8 of the 'Guards' sketchbook (CLXIV). Both are reproduced by Bachrach (p. 18) and the former by Wilkinson 1974, p. 158. The picture is also referred to, among others in hand, in a list in Turner's writing on p. 35 verso of the 'Hints River' sketchbook (CXLI) and again by Turner in the 'Liber Notes (2)' (CLIV(a)) when the artist seems to have considered using it to be engraved among the marine subjects.

Although these drawings are the immediate source for the *Dort* there seems little doubt that Turner also painted it by way of a challenge to one of Callcott's masterpieces, the *Entrance to the Pool of London*, which had been exhibited at the R.A. in 1816 (175), as David Cordingly has pointed out in his article on Callcott's marine paintings in the *Connoisseur* (October 1973, pp. 99–101). The *Pool of London* (Collection: the Earl of Shelburne, Bowood) is reproduced in colour on p. 98 and measures 60¼ × 87, and is thus the same size within a few inches as the *Dort*. Turner is said to have admired

Callcott's picture greatly and, according to Thornbury, when told Callcott had received two hundred guineas for it, observed 'Had I been deputed to set a value upon *that* picture, I should have awarded a thousand guineas.'

The *Morning Chronicle* for May 1818 thought the *Dort* was 'one of the most magnificent pictures ever exhibited, and does honour to the age. It was eagerly purchased on Saturday' (probably at the Private View of the R.A.).

Although the *Dort* moved to Farnley Hall in Yorkshire in 1818 and hung there almost uninterruptedly until it went to America in 1966, it has always been one of Turner's most famous pictures (e.g., Lord Houghton (Monckton Milnes) in a letter from Holland written in September 1869: 'When the steamer came in sight of Dort, I knew exactly what to expect from Turner's picture at the Fawkeses at Farnley ...' (See James Pope-Hennessy *Monckton Milnes:* ii *The Flight of Youth 1851–1855*, 1951, p. 214) and one which has certainly survived in impeccable condition, despite Armstrong's comment which seems unjustified. (Although it is only fair to add that the watercolour by Turner of the drawing room at Farnley, painted 1818–19, which shows the *Dort* hanging above the fireplace, does show the sky as being considerably more blue than is now the case, but it is hard to be sure how accurate a transcription this was intended to be. For example, the tower of the Groote Kerk is certainly made to look taller in the watercolour than in the oil and this was probably done deliberately by Turner in order to make it 'tell' in a replica on such a tiny scale).

Rothenstein and Butlin consider that 'in its perfect equipoise of personal vision and the inspiration of an Old Master, of naturalism and traditional methods of composition and technique, it marks the culmination of the first half of Turner's career'. Ruskin, on the other hand, when he visited Farnley in 1851, wrote of the picture in strongly disparaging terms:—

'Dort. Large oil. Dated 1818. Very fine in distant effect—but a mere amplification of Cuyp: the boat with figures almost copied from him. But the water, much more detailed, is not at all as like water as Cuyp's: there are far more streaks and spots on it than can properly be accounted for, the eye is drawn entirely to the surface, and it looks like wet sand—no depth in it nor repose. I never saw any of his work with so little variety of tone in it as this; or so thoroughly ill painted. The distant city and boats are all drawn in a heavy brown and grey— quite cold and uninteresting. The sky is the best part of the picture, but there is a straggly and artificial look in its upper clouds, quite unusual with Turner. His name and the date are written on a log at the right-hand corner, and reflected in the water.'

Ruskin partially contradicted himself later when he wrote that the *Dort* possessed Turner's 'peculiar calmness, in which respect it is unrivalled; and if joined with Lord Yarborough's *Shipwreck* [No. 210], the two may be considered as the principal symbols, in Turner's early oil paintings, of his two strengths in Terror and Repose.'

According to Farington, Callcott, who was on the Hanging Committee that year, removed a picture of his own at Turner's request in order that the *Dort* should hang in the centre of the wall at the end of the Great Room. On 29 April Henry Thomson called on Farington and told him that the colours of the *Dort* were so brilliant that 'it almost puts your eyes out'.

Although praised by Turner's fellow artists and by some critics, the picture was not universally admired. The critic of the *Champion*, 24 May, who signed himself 'T', compared it unfavourably with Callcott's *Mouth of the Tyne* (no. 95 at the R.A.) on the grounds that it failed to follow the colours of nature. Although Turner's 'ideality' might be permissible in sublime or poetic subjects, such as *The Decline of Carthage* (No. 135) exhibited in 1817, the critic considered it 'certainly quite out of character when the scene intended to be represented is selected from ordinary nature'.

Finberg is convinced that Constable was referring to the *Dort* when he wrote to Leslie in 1832 'I remember most of Turner's early works; amongst them one of singular intricacy and beauty; it was a canal with numerous boats making thousands of beautiful shapes, and I think the most complete work of genius I ever saw.' It requires a good deal of licence to call the *Dort* an early work but Finberg argues that in 1832 it may have seemed so (Ruskin referred to it as such, see above), although we also have to allow for Constable forgetting the title of the picture. See, however, the entry for No. 69 for an alternative candidate for the picture which Constable was describing. Indeed, as Fawkes bought the *Dort* as soon as it was placed on show at the R.A., it seems almost certain that it would not have required any restoration by Bigg. On the other hand, if Constable could describe *Sun rising through Vapour* as 'a canal', it is difficult to give much credence to so inaccurate a memory.

The picture is clearly influenced by Cuyp, and was no doubt also intended as a homage to the painter in portraying his birthplace (even the form of a signature on the log is, as Lindsay suggests, probably a reference to the practice among the seventeenth-century Dutch sea painters). In particular, the Cuyp then belonging to the Duke of Bridgewater, *The Maas at Dordrecht* (now in the National Gallery of Art, Washington), served as Turner's model, although Turner may also have had in mind Cuyp's *Passage Boat* which the Prince Regent had acquired in 1814 as part of the Baring Collection. Turner, however, did not follow Cuyp's sense of scale, for he has greatly exaggerated the size of the hull of his packet boat in relation to the figures on board.

A contemporary influence is provided by the passage on the right with the boat near the reeds which recalls certain of John Sell Cotman's watercolours as well as pictures by the Dutch 'riverscapists'. The picture does indeed embody Turner's own response to the peculiar characteristics of the Dutch landscape: in particular, as Bachrach suggests, to the flat panoramas 'devoid of the theatrical "wings" provided by the hills and mountains framing traditional vistas elsewhere', but also, surely, to

the seemingly limitless expanse of the sky in Holland. Therefore, despite its dependence on the work of an earlier painter, the *Dort* looks forward as much as it looks back: the bright chromatic scale and the contrasting of warm and cool colours which raises the whole key of the picture points the way, as Gage has noticed, to pictures such as the two versions of the *Burning of the Houses of Parliament* (Nos. 359 and 364) painted in 1835 and even to *The Fighting Temeraire* of 1839 (No. 377). The *Dort*, therefore, as well as being a most celebrated picture (and reputedly one of the artist's own particular favourites) is also a crucial one in Turner's development. It is not, perhaps, after all the culmination of the first half of Turner's career so much as the bridgehead towards the second.

138. The Field of Waterloo Exh. 1818 (Plate 134)

THE TATE GALLERY, LONDON (500)

Canvas, 58 × 94 (147·5 × 239)

Coll. Turner Bequest 1856 (60 'The Field of Waterloo' 7′10″ × 4′10½″); transferred to the Tate Gallery 1910.

Exh. R.A. 1818 (263).

Engr. By F. C. Lewis in mezzotint 1830.

Lit. Thornbury 1862, i, pp. 300–01; 1877, p. 435; Hamerton 1879, pp. 168–9; Monkhouse 1879, p. 130; Bell 1901, p. 102 no. 141; Armstrong 1902, p. 236; MacColl 1920, p. 13; Whitley 1928, p. 285; Davies 1946, p. 187; Clare 1951, p. 64; Finberg 1961, pp. 249, 251, 478 no. 200; Lindsay 1966, pp. 154, 156; Gerald E. Finley, 'Turner's Illustrations to *Napoleon*', *Journal of the Warburg and Courtauld Institutes* xxxvi 1973, pp. 391, 393.

Exhibited in 1818 with the following quotation from Byron's *Childe Harold* iii, 28:

'Last noon behold them full of lusty life;
Last eve in Beauty's circle proudly gay;
The midnight brought the signal—sound of strife;
The morn the marshalling of arms—the day,
Battle's magnificently stern array!
The thunder clouds close o'er it, which when rent,
The earth is covered thick with other clay
Which her own clay shall cover, heaped and pent,
Rider and horse—friend, foe, in one red burial blent!'

This painting was the largest result, and probably the main cause, of Turner's first journey to the continent after the conclusion of the Napoleonic war. He left London on 1 August 1817 and was at the field of Waterloo by the 16th. Subsequently he went up the Rhine as far as Mainz and returned to Yorkshire via Holland.

There are a number of sketches of the battlefield, including the Château of Hougoumont which is shown burning on the right, in the 'Waterloo and Rhine' sketchbook (CLX–17 verso to 26). These were also used

for the finished watercolour of the same subject bought by Walter Fawkes and now at the Fitzwilliam Museum (see Cormack 1975, p. 41 no. 14 repr.).

Newspaper criticism rather surprisingly ranged from scorn to outright praise. The *Annals of the Fine Arts* wrote, 'Before we referred to the catalogue we really thought this was the representation of a drunken hubbub on an illumination night, and the host as far gone as his scuffling and scrambling guests, was, with his dame and kitchen wenches looking with torches for a lodger, and wondering what was the matter.' The *Literary Chronicle* for 22 June referred to the picture as an 'abortive attempt.' On the other hand, the *Sun* for 15 May 1818 described the picture as 'a terrific representation of the effects of war'. The *Repository of Art* for 1 June described it as 'more an allegorical representation of "battle's magnificently stern array" than any actual delineation of a particular battle ... It possesses a strong claim to attention from the arrangement of powerful masses of colouring, descriptive of the smoky elements of a wide-spreading conflagration ... There is a good deal of grandeur in the effect of this picture as a whole, and the executive parts are handled with care and attention.'

139. Entrance of the Meuse: Orange-Merchant on the Bar, going to Pieces; Brill Church bearing S.E. by S., Masensluys E. by S. Exh 1819
(Plate 123)

THE TATE GALLERY, LONDON (501).

Canvas, 69 × 97 (175·5 × 246·5)

Coll. Turner Bequest 1856 (55, 'Orange Merchant going to pieces' 8′0″ × 5′8½″); transferred to the Tate Gallery 1912.

Exh. R.A. 1819 (136); New Zealand (8), Australia and South Africa (56, repr.) 1936–9; Paris 1972 (263, repr.); R.A. 1974–5 (166).

Lit. Ruskin 1860 (1903–12, vii, p. 376); Thornbury 1862, i, p. 301; 1877, pp. 435–6; Hamerton 1879, p. 169; A. H. Palmer, *The Life and Letters of Samuel Palmer* 1892, p. 7; Bell 1901, p. 102 no. 142; Armstrong 1902, pp. 59, 230, repr. facing p. 84; Davies 1946, p. 186; Finberg 1961, pp. 259, 397, 481 no. 250; Gage 1967, p. 171; Louis Hawes, 'Constable's Sky Sketches, iv. Turner's Skies 1817–19', *Journal of the Warburg and Courtauld Institutes* xxxii 1969, p. 357, pl. 55c; Raymond Lister (ed.), *The Letters of Samuel Palmer* 1974, ii, p. 872; Herrmann 1975, pp. 26, 230, pl. 81.

One of the series of large coast or harbour scenes in northern Europe painted in a style and tonality that owe much to Cuyp (see also Nos. 137, 231 and 232). The title embodies a typical pun, the 'Orange Merchant' not only hailing from the country ruled by the House of Orange but having spilled its cargo of oranges. 'Masensluys' is Maassluis, the other side of the Maas from Brill.

There are three composition sketches in the 'Farnley' sketchbook, one sketch in which is dated 1818 (CLIII-89 verso, 90 verso and, less closely related, 41). There is also a related sketch in the 'Hints River' sketchbook of about the same date (CXLI-3 verso). The distant shoreline seems to be based on summary drawings in the 'Dort' sketchbook of 1817 (CLXII-81, 82 and 82 verso). The particularly highly developed study of cloud effects may owe something to the watercolour studies in the 'Skies' sketchbook, perhaps painted in 1818 (CLVIII).

The picture was singled out for praise in the *Repository of Arts* for June 1819 in a review beginning 'To speak of the extraordinary powers of this artist would indeed be a work of superogation'. It was also praised in the *British Press* for 10 May as 'an admirable specimen of this Artist's unrivalled powers of imitation from nature'. The *Literary Gazette* (untraced; see Finberg *op. cit.*, p. 259) said of it that it exhibited 'some of the noblest powers of landscape painting'. However, the *Annals of the Fine Arts* for the year found it 'Too scattered and frittered in its parts to be reckoned among Turner's happiest productions. Compared with himself, this picture suffers,—compared with others, it maintains Turner's rank uninjured.' It was the first Turner to be seen by the fourteen-year-old Samuel Palmer who, writing on 9 December 1872 to George Richmond's daughter Julia, said, 'The first exhibition I saw, in 1819 is fixed in my memory by the first Turner "The Orange merchant on the bar"—and being by nature a lover of smudginess, I have revelled in him from that day to this.'

In a letter to his dealer Griffith in 1844 Turner mentioned this picture among others 'subject to neglect and dirt', speaking of its 'accidental stains'.

140. England: Richmond Hill, on the Prince Regent's Birthday Exh. 1819 (Plate 125)

THE TATE GALLERY, LONDON (502)

Canvas, $70\frac{7}{8} \times 131\frac{3}{4}$ (180 × 334.5)

Coll. Turner Bequest 1856 (1, 'Richmond Hill' 11'0" × 5'11"); transferred to the Tate Gallery 1910.

Exh. R.A. 1819 (206); Turner's gallery 1835; R.A. 1974–5 (167).

Lit. Farington *Diary* 2 May 1819; Ruskin 1857 (1903–12, xiii, pp. 127, 135); Thornbury 1862, i, p. 301; 1877, p. 436; Hamerton 1879, pp. 169–70; Bell 1901, pp. 102–3 no. 143; Armstrong 1902, pp. 227; Whitley 1928, p. 300; Davies 1946, p. 185; Finberg 1961, pp. 259, 481 no. 251; Rothenstein and Butlin 1964, pp. 32–4, pl. 55; Lindsay 1966, p. 157; Gage 1969, p. 167; Reynolds 1969, pp. 106–8, pl. 86; Ziff 1971, p. 126; Herrmann 1975, pp. 26, 230–31, pl. 83.

Exhibited with the following lines:

'Which way, Amanda, shall we bend our course?
The choice perplexes. Wherefore should we chuse?
All is the same with thee. Say, shall we wind
Along the streams? or walk the smiling mead?
Or court the forest-glades? or wander wild
Among the waving harvests? or ascend,
While radiant Summer opens all its pride,
Thy Hill, delightful Shene?'

 Thomson

The verses, from Thomson's *Seasons*, 'Summer', ll. 1401–8, continue, after the reference to Sheen, by describing the various places that can be seen from Richmond Hill, including a reference to

'. . . the matchless vale of Thames;
Fair-winding up to where the muses haunt
In Twit'nam's bowers, and for their Pope implore
The healing god; . . .' (ll. 1425–8).

This reference to the stretch of river seen in the picture also links it with Turner's earlier pictures *Pope's Villa* (which is situated in Twickenham) and *Thomson's Æolian Harp* (Nos. 72 and 86).

The large size of this picture is all the more surprising in view of its domestic, pastoral subject. Like the later *What you Will* (No. 229), the subject may reflect in part the effect of French eighteenth-century painting: Jerrold Ziff has pointed out that several of the figures are based on a sketch in the 'Hints River' sketchbook of *c.* 1815 after Watteau's *L'Ile Enchantée* (CXLI-26 verso and 27; see Ziff's review of Gage 1969, 1971). The same sketchbook also contains drawings of the general view from Richmond Hill (10 verso–13), as does the 'Hastings to Margate' sketchbook of about the same date (CXL-77 to 82). There are also a number of unfinished watercolours and colour beginnings in the British Museum of various dates, as well as the finished watercolours in the Lady Lever Art Gallery, Port Sunlight, and in the Walker Art Gallery, Liverpool, the first engraved in 1826 for *The Literary Souvenir*, the second in 1838 for *Picturesque Views in England and Wales*.

More closely related is the unfinished oil of the same view in Turner's normal large format, $58 \times 93\frac{3}{4}$ in. (No. 227). There are only a few figures in the foreground and the painting was presumably abandoned when Turner turned to the unprecedented scale of the finished picture, perhaps inspired by the idea of doing homage to the Prince Regent, a possible and highly desirable patron.

Charles Stuckey, in an as yet unpublished lecture, has pointed out that in 1818 the Prince Regent had in fact ridden up to Richmond Hill from Kew Palace on 10 August, two days before his actual birthday, but that, perhaps more significantly, his official birthday was celebrated on his name day, St George's Day, 23 April, Turner's (and Shakespeare's) own birthday, when he was in London. Turner has shown a bright August afternoon but may well have also intended to celebrate

his own birthday; his own country cottage, Sandy-combe Lodge, falls within the picture, which shows the familiar and much painted view to the west over Twickenham rather than that to the north and Kew Palace.

This is one of the first of Turner's R.A. exhibits in connection with which there is some hint of his activities on the three Varnishing Days, granted to Academicians to give final touches to their pictures before the exhibition opened to the public. On 2 May 1819 Farington recorded criticism of the effect of 'the flaming colour of Turner's pictures' on their neighbours, immediately following this with a reference to 'the pernicious effects arising from Painters working upon their pictures in the Exhibition by which they often render them unfit for a private room' (reprinted in Gage 1969, p. 167). The *Repository of the Arts* for June 1819, though liking the picture less than *Entrance of the Meuse* (No. 139), praised 'the foreground beautifully worked up, and the azure blue of the distances modified in all the gradations of aerial perspective'. The *Annals of the Fine Arts*, on the other hand, recommended Turner 'to pumice it down, give it a coat of priming, and paint such another picture as his building of Carthage' (No. 131).

Nos. 141–227: Unexhibited Works

Nos 141–53: Miscellaneous, *c*. 1803–5

141. Conway Castle *c*. 1803 (Plate 126)

TRUSTEES OF THE GROSVENOR ESTATE

Canvas, $40\frac{3}{4} \times 55$ (103.5×139.7)

Coll. William Leader, who appears either to have ordered or bought it directly from Turner; J. T. Leader (William's son) sale Christie's 27 June 1840 (62) bought Brown; Wynn Ellis by 1855; sale 6 May 1876 (119) bought the Duke of Westminster; by descent to present owners.

Exh. B.I. 1855 (161); Wrexham 1876 (249); R.A. 1877 (108); Grosvenor Gallery 1888 (107); Melbourne *Centennial International Exhibition* 1888; R.A. 1896 (33); Guildhall 1899 (6); R.A. 1901 (38); Shepherd's Bush 1910 (51); Wembley *British Empire Exhibition* 1924 (v.37 repr. in Souvenir pl. 30); Tate Gallery 1931 (14); R.A. 1934 (167); Manchester 1934 (51); Leicester Museum and Art Gallery *Landscape Painting 1750–1850* 1956 (30).

Lit. *Catalogue of the Collection of Pictures at Grosvenor House* 1882, no. 87; Armstrong 1902, pp. 53, 220, repr. facing p. 52; Finberg 1961, pl. 8 facing p. 136; Rothenstein and Butlin 1964, pp. 18, 19, pl. 20.

There is a drawing for this picture on p. 50 verso of the 'Hereford Court' sketchbook (XXXVIII) in use on Turner's trip to Wales in 1798. On the back is written

'Mr. Leader
4F8 Long
3F6 wide 70.'

These dimensions, 42×56 in., agree pretty exactly with those of the finished canvas and suggest that *Conway* was a direct commission from Leader after seeing the drawing ('70' may perhaps indicate that the price was 70 guineas). This would also account for it not being sent to the R.A., as one would have expected Turner to exhibit a picture of this size and quality.

Leader also owned two watercolours by Turner of Conway so it seems as if the subject was of especial significance for him. These watercolours were also sold at Christie's 18 March 1843 (50) and (57) and Gage is to publish an abstract of a letter from Turner to Richard Westmacott in which Turner agrees that 'Mr. Westmacott had advised Mr. Trelawney rightly in sending Mr. Leader's pictures to Christie's, though Turner was sorry Mr. Leader feels disposed to part with them.'

Dated by Armstrong *c*. 1802, the left-hand side of the picture is still very Wilsonian, which makes it appear perhaps even earlier. The composition, with the line of the coast running perpendicular to the picture's plane, owes something to earlier artists such as Morland and de Loutherbourg and this also makes it seem more archaic than seapieces in which the coastline is placed at a more oblique angle. However, strong affinities, especially in colour, with the *Iveagh Seapiece* (No. 144) would seem to contradict this. Rothenstein and Butlin suggest 1802–3. In the absence of any documentary evidence, *c*. 1803 seems the most convincing answer.

The features noted above which appear to contradict this dating may perhaps be due to Turner having painted it in a spirit of competition with de Loutherbourg, who had exhibited his *View of Conway Castle from the Ferry* at the R.A. in 1801 (212). This interesting suggestion was made by Mr Louis Hawes in a paper on 'Turner's Early Coastal Scenes', delivered at the Turner Symposium at Johns Hopkins University, Baltimore in April 1975, and his theory surely strengthens that already put forward that Turner's lost

Army of the Medes may also have been an attempt to outshine de Loutherbourg (see the entry for No. 15). Mr Hawes suggests two other Turners which may also owe their origins—in part at any rate—in a desire to eclipse de Loutherbourg: the *Fall of the Rhine at Schaffhausen* (No. 16) and *Cottage destroyed by an Avalanche* (no. 109). If this was so, then Thornbury's story (1862, i, p. 162) that de Loutherbourg's wife shut the door in Turner's face when they were neighbours at Twickenham, because she feared that Turner had come to steal her husband's technical secrets, may, in reality, have had this rivalry between the two artists as its basis.

142. Fishing Boats entering Calais Harbour
c. 1803 (Plate 135)

THE FRICK COLLECTION, NEW YORK

Canvas, 29 × 38¾ (73·7 × 98·4)

Coll. No early history of the picture has come to light, although it may well have been among the pictures shown in Turner's gallery in 1804. From the *Liber Studiorum* engraving it would appear that the picture was still in Turner's possession in 1816 but there is no clue as to when it was sold or who owned it before its appearance at the Winter Exhibition at the R.A. in 1884. The provenance from 1884–1902 can be deduced from loan exhibitions and from Armstrong's catalogue: Henry Drake by 1884 and until 1892; Archibald Coats by 1893 and until at least 1902; bought by Henry Clay Frick from Knoedler in 1904. (Accession no. 04.1.120)

Exh. ?Turner's gallery 1804; R.A. 1884 (53); Whitechapel *Fine Art Loan Exhibition* 1886 (310); Guildhall 1892 (94); Lawrie and Co., *Loan Collection of Pictures Principally of the French School of 1830*, 1893 (28); Glasgow 1901 (80); Boston Museum of Fine Arts *Frick Collection* 1910 (37); Knoedler, New York, 1914 (30).

Engr. By Turner himself in the *Liber Studiorum* (Rawlinson 55), published January 1816; no drawing is known for this plate.

Lit. Armstrong 1902, p. 229; C. J. Holmes, 'Recent Additions to the Collection of Mr. Henry C. Frick', *Burlington Magazine* xi 1907, pp. 397–403; Finberg 1924, p. 219; Davidson 1968, i, pp. 119–20, repr.

The town of Calais can be seen on the horizon, the tower of Notre Dame and the belfry of the Hotel de Ville both being prominent. This picture must date from about the same time as No. 48, exhibited in 1803, and obviously recalls Turner's experience on his visit to Calais the previous summer. Finberg suggests that a slight sketch on p. 105 of the 'Studies for Pictures' sketchbook (LXIX) may be a study for the picture. The drawing on p. 96 seems to have an equally good claim but neither is certainly connected.

143. Seascape with a Squall coming up *c.* 1803–4
(Plate 136)

MALDEN PUBLIC LIBRARY, MALDEN, MASS.

Canvas, 18 × 24 (45·7 × 61)

Coll. Jack Bannister (*d.* 1836), a famous comedian who had been a student at the R.A. Schools when young, who seems to have bought it from Turner 1803–4; Bannister's executors' sale Foster's 28 March 1849 (89) bought Farrer; John Gibbons (*d.* 1851); the Rev. B. Gibbons; sale Christie's 26 May 1894 (62) bought Agnew; Sir Julian Goldsmid, Bt; sale Christie's 13 June 1896 (53) bought Agnew; Pandeli Ralli until 1929; Howard Young Galleries, New York; acquired by the Malden Public Library in 1930 from the Vose Galleries of Boston with funds provided by Elisha S. Converse and Mary D. Converse.

Exh. R.A. 1890 (48) and 1896 (15); Boston 1946 (1); Toronto and Ottawa 1951 (2); Fogg Art Museum *Landscape: Massys to Corot* 1955 (18); Indianapolis 1955 (10).

Lit. Armstrong 1902, pp. 228–9; *Fogg Museum Bulletin* 1932, I, 4, p. 77; Malden Public Library, *Twenty Paintings* 1949, pl. 12; Finberg 1961, pp. 424–5,

On p. 67 verso of the 'Academies' sketchbook (LXXXIV) in a list in Turner's own writing of pictures which he had on hand, or had completed, occurs: 'Sea-Piece Mr. Bannister' which presumably refers to this picture. Whether this means it was commissioned by Bannister, as Finberg implies, is not clear, although the Christie's sale catalogue in 1894 states 'Painted for Mr. Bannister'. On the other hand, there is a tendency in old sale catalogues to claim, with pictures purchased directly from the artist, that they were painted expressly for the first owner. (An extreme example of this is the claim in the Bicknell sale catalogue of 1863 that *Palestrina* (No. 295) had been painted for Bicknell whereas in fact Turner seems to have started it in Rome in 1828 for Lord Egremont and Bicknell did not buy it from Turner until 1844.)

The presence of other pictures on the list, such as two of Bonneville, which were exhibited in 1803 (Nos. 46 and 50) and one of which was sold in 1804, makes a similar date for this picture seem likely.

Finberg records that it 'had been painted for Bannister a year or two after the *Bridgewater Sea Piece* (No. 14) which it much resembled in everything but size—indeed, one writer described it as, "almost a miniature in feeling and effect" of that famous picture.' The Indianapolis catalogue suggests a dating of *c.* 1805, but probably the closest comparison stylistically is the *Old Margate Pier* (see No. 51) which Turner gave to Samuel Dobree in 1804. The figures and the water are painted in an almost exactly similar manner which suggests 1803–4 as the most convincing date for this picture.

144. A Coast Scene with Fishermen hauling a Boat ashore *c.* 1803–4 (Plate 127)
also known as *The Iveagh Seapiece*

THE IVEAGH BEQUEST, KENWOOD

Canvas, 36 × 48 (91·4 × 122)

Coll. Bought from Turner by Samuel Dobree (1759–1827); after Dobree's death this picture and the *Boats carrying out Anchors* (see No. 52) were acquired by Thomas, first Lord Delamere (*d.* 1855); anon. (executors of Lord Delamere) sale Christie's 24 May 1856 (129) bought in; acquired after the sale by W. Benoni White, a dealer in the Strand; sale Christie's 24 May 1879 (279) bought Agnew; sold to Sir E. C. Guinness in 1888 (he was created first Earl of Iveagh in 1919) and left by him to Kenwood as part of the Iveagh Bequest in 1928.

Exh. R.A. 1883 (214 lent by William Agnew); Guildhall 1899 (7); Shepherd's Bush 1908 (42); R.A. and Manchester *Iveagh Bequest of old Masters* 1928 (228) and (54); Agnew 1967 (3).

Engr. By A. L. Brunet-Debaines.

Lit. Thornbury 1862, ii, p. 400; 1877, p. 598; Redford, *Art Sales* ii 1888, p. 122; Armstrong 1902, p. 230, repr. facing p. 50; H. F. Finberg 1953, pp. 98–9; *Kenwood Catalogue* 1960, no. 41; Reynolds 1969, p. 46, fig. 30; Wilkinson 1972, pp. 14, 117, repr. in colour pp. 14–15.

The references in Turner literature are almost inextricably entwined with the Southampton picture (No. 16) as in many cases the *Fishermen on a Lee-Shore* and the *Iveagh Seapiece* are treated as being synonymous.

The circumstances attending the sale of this picture at Christie's in 1856 are given by Redford and were told to him by Mr Woods the auctioneer. In 1855 Lord Delamere (or perhaps his executors) placed this picture together with *Boats carrying out Anchors* (see No. 52) with Colnaghi's for sale. After a year, as they were still unsold, they were sent to Christie's to be auctioned, where Mr White saw them and offered £2,500 for them. The dealer, George Pennell, then objected and insisted upon their coming under the hammer, whereupon they were 'bought in' at 3,000 guineas, 'Mr White then acquiring them on his own terms'.

Under the entry for No. 16, I have given my reasons for believing that the picture which Turner exhibited at the R.A. in 1802 (110) entitled 'Fishermen upon a Lee-Shore, in Squally Weather' is to be identified with the picture now in the Southampton Art Gallery rather than with the picture at Kenwood. Although the Kenwood picture was listed by Thornbury in 1862, when in Mr. White's collection, as 'Fishermen upon a lee-shore', no connection between the Kenwood picture and the R.A. 1802 picture was suggested either (presumably) while the picture was at Colnaghi's in 1855–6 or when it was sold at Christie's in 1856 when it

was described thus: 'A Dutch Coast Scene with Fishermen hauling up a boat in shallow water towards the shore, a galleot lying at the water's edge, a fishing boat under sail in the centre, grand effect of approaching storm'. It is perhaps worth nothing that *Boats carrying out Anchors*, exhibited at the R.A. in 1804, although it accompanied the Kenwood picture from Dobree's collection to Lord Delamere's and also to Colnaghi's and Christie's, did *not* lose its exhibited title.

If the Kenwood picture is not the picture exhibited in 1802, when was it painted? In fact, the date cannot be far from 1802 although the very bright local colours, which have always seemed a little surprising for 1802, suggest that it was perhaps painted a year or two later, possibly at about the same time as *Boats carrying out Anchors*. Turner's letter to Samuel Dobree of 30 June 1804, regarding arrangements for delivery of a number of pictures to Dobree, specifically mentions *Boats carrying out Anchors* but the Kenwood picture may have been bought and delivered at the same time. Turner wrote 'you will find that I have sent you *all* . . .', thereby implying a consignment of several pictures, and it seems quite possible that the Kenwood picture may have been among the pictures exhibited at Turner's gallery that year.

145. Fishmarket on the Beach *c.* 1802–4
(Plate 137)

R. F. ROBERTSON–GLASGOW ESQ., HINTON HOUSE, HINTON CHARTERHOUSE

Canvas, 17½ × 23¼ (44·5 × 59)

Coll. ?Samuel J. Day, Hinton Charterhouse (probably before 1813—see below); bequeathed by his widow in the 1840s to Thomas Jones whose descendants changed their name to Foxcroft in the 1860s on inheriting property in Yorkshire; then by inheritance to Mrs R. W. Robertson-Glasgow; sale Sotheby's 30 November 1960 (127) bought in; by descent to the present owner.

Lit. *The Beauties of England and Wales* (ed. J. Britton and E. W. Brayley) xiii, Part i, Rev. J. Nightingale *Shropshire and Somersetshire* 1813, p. 456.

Dated *c.* 1810 in Sotheby's catalogue of 1960, this is clearly too late; affinities with the *Iveagh Seapiece* (No. 144) and with *Boats carrying out Anchors* (No. 52) make 1802–4 much more convincing. Indeed the contemporary newspaper criticism which complained of the figures in the *Boats carrying out Anchors* that they were 'all bald, and like Chinese' might apply equally to the two left-hand figures here. On a smaller scale this picture also has points in common with the Malden Library *Seapiece* of about 1803–4 (No. 143)

Despite the unenthusiastic reception the picture got when offered at Sotheby's, the compiler believes it to be genuine and considers that hesitation about its authenticity was caused by its condition. The canvas, like that

of other seapieces of the same date, is of a fairly broad weave and has been subjected to harsh cleaning and pressure with too hot an iron during the process of relining. This has caused fairly general rubbing and some losses on the 'tops' of the canvas which accounts for the flat aspect of the sky and some lack of recession in general. However, the painting of the beached boat, of the figures and of the fish all unmistakably proclaim Turner's hand.

Although the Rev. Nightingale's description of the pictures at Hinton Charterhouse (now Hinton House) merely records an oil by Turner without further details, the fact that a picture by Turner was in the house by 1813—and as far as one can ascertain has been there ever since—provides quite strong reinforcement that the picture can be considered genuine, as it is unlikely that a mistake about authenticity should have been made at so early a date.

146. The Pass of St Gothard c. 1803-4 (Plate 129)

CITY MUSEUMS AND ART GALLERY, BIRMINGHAM

Canvas, $31\frac{3}{4} \times 25\frac{1}{4}$ (80·6 × 64·2)

Coll. John Allnutt (1773–1863) for whom this and No. 147 were said to have been painted; G. R. Burnett; sale Christie's 13 February 1875 (137, size given incorrectly as 37 × 24 in.), bought Coleman (Redford has 'Calderon'; the Birmingham catalogue suggests it was probably bought in); F. Beresford Wright from whom bought by Agnew in 1909; Hon. A. J. Balfour 1910; bought back from him by Agnew in 1916; C. Morland Agnew from whose executors bought by Birmingham Art Gallery in 1935 (purchased by the Trustees of the Public Picture Gallery Fund 198/35).

It should perhaps be recorded that John Allnutt's sale at Christie's on 20 June 1863 included as Lot 492 a Turner oil catalogued at 'The Pass of Simplon—a beautiful easel picture' bought Webb. As no Turner of this title is known, it seems just possible that it was this picture that was sold on this occasion, although the fact that both this and No. 147 appeared together in the Burnett sale in 1875 would seem to refute this.

Exh. Agnew 1910 (18); Agnew *Pictures from Birmingham City Art Gallery* 1957 (18).

Lit. Thornbury 1862, ii, p. 408; 1877, p. 620 (both these references could equally well apply to No. 147 as the picture is simply listed as 'The St. Gothard' early oil); Armstrong 1902, p. 222 (size incorrectly given as 37 × 24); *Catalogue of Paintings in the City Museum and Art Gallery Birmingham* 1960, p. 146.

A strip of canvas about 1 in. wide was at one time folded over the stretcher at the top of the picture. This was, however, part of the original picture and not a later addition as the Birmingham Catalogue suggests. I am indebted for this information to Mr Alec Cobbe,

formerly Assistant Keeper of Conservation at the City Art Gallery, Birmingham.

Based on a watercolour ($18\frac{5}{8} \times 12\frac{3}{8}$ in.) on p. 33 of the 'St Gothard and Mt. Blanc' sketchbook (LXXV) in use in 1802, which is almost identical in composition; the only difference is that the oil has the additional feature of the wayside cross at the end of the mountain track.

The Turner Bequest watercolour was also used for the basis of a much larger ($40\frac{1}{2} \times 27$) watercolour, signed and dated 1804, which Turner may well have exhibited in his gallery in 1804, and which was bought by Walter Fawkes, and later sent to the R.A. in 1815 (281) entitled *The Passage of Mount St Gottard: taken from the centre of the Teufels Broch (Devil's Bridge) Switzerland.* It is now in the Abbot Hall Art Gallery, Kendal. It includes two mules on the track on the extreme left of the picture. (See John Russell and Andrew Wilton *Turner in Switzerland* repr. in colour p. 61. The sketches for this and No. 147 are repr. in colour pp. 62 and 63.

The problem of dating has been somewhat obfuscated by inconsistencies in the past. Armstrong suggests c. 1805–10 for this picture and 'c. 1815 or earlier?' for No. 147. The date of 1815 may have got attached to No. 147 through confusion with the Fawkes watercolour shown at the R.A. in that year. When No. 147 was exhibited at the R.A. Winter Exhibition in 1885 (18) it was stated in the catalogue that it was 'Painted 1815' and this is transcribed in the Birmingham catalogue as 'stated in the catalogue to be dated 1815'. On stylistic grounds a date of around 1804 is far more convincing.

The oils are in fact closer to the watercolour sketches than to the finished watercolours, which suggests that Allnutt commissioned the oils after looking through the 'St. Gotthard and Mt. Blanc' sketchbook. In this case, the oils may date from 1803–4 and thus precede the large watercolours.

On the other hand, if Finberg is correct in his suggestion that the large watercolours were exhibited in Turner's gallery in 1804, Allnutt would most probably have seen them there and the possibility that he commissioned the oils after seeing the large watercolours cannot be ruled out entirely. The Abbot Hall watercolour, although very magnificent, could be considered by some to be too large for the medium. Turner's handling, which is almost savage in places, seems to be striving for effects which Allnutt may have felt could be rendered more successfully in oil. Allnutt and Turner are known to have been in touch at this time as Allnutt's name appears in Turner's writing on p. 66 verso of the 'Academies' sketchbook (LXXXIV), dating from c. 1804.

The Birmingham catalogue states that 'Some critics have expressed doubt as to whether this picture was executed by Turner' but such doubts are quite unfounded in the opinion of the compiler.

147. The Devil's Bridge, St Gothard c. 1803–4
(Plate 128)

PRIVATE COLLECTION

Canvas, $31\frac{1}{4} \times 24\frac{3}{4}$ (76.8×62.8)

Coll. John Allnutt for whom this is said to have been painted together with No. 146; G. R. Burnett; sale Christie's 13 February 1875 (136, size given incorrectly as 37×24) bought Agnew; sold in May 1875 to Holbrook Gaskell; sale Christie's 24 June 1909 (98) bought Sulley; J. R. Thomas; sale Christie's 19 November 1920 (151) bought Sampson; E. R, Bacon, New York; by descent to his grand-daughter in New York until 1976, when acquired by Agnew; sold 1977 to the present owners.

Exh. Liverpool Art Club 1881 (49); R.A. 1885 (18); Glasgow 1888 (77); R.A. 1907 (137).

Lit. ?Thornbury 1862, ii, p. 408; 1877, p. 620 (see No. 146); Armstrong 1902, p. 222.

At one time a strip about $\frac{3}{4}$ in. wide extending along the whole right hand side of the canvas must have been folded over the stretcher.

For the problems of dating and possible circumstances leading up to this commission, see the entry for No. 146.

A label on the back reads: 'This painting of the Pass of St Gothard by J. M. W. Turner R.A. presented to my daughter Jane this tenth day of March 18?4 [The third figure is illegible; Jane was born 1818 and died 1845] J. Allnutt'.

Based on a watercolour sketch ($18\frac{5}{8} \times 12\frac{3}{8}$ in.) on p. 34 of the 'St Gothard and Mt Blanc' sketchbook of 1802 (LXXV). Very slightly indicated figures appear to the left of the bridge and there is a single figure in red on the track on the right. The watercolour sketch was exhibited at the British Museum 1975–6 (32, repr. in colour p. 43). In the oil version, Turner has added the soldiers, peasants and mules on the right of the composition.

A watercolour entitled *The Devil's Bridge* ($41\frac{1}{2} \times 29\frac{1}{2}$ in.) was exhibited at the Guildhall in 1899 (20, lent by Thomas Mackenzie) and Armstrong suggests a date for it of c. 1804. It is reproduced by Wedmore (ii, facing p. 256), and its present whereabouts is unknown. Whether or not this was conceived as a pendant to the watercolour at Abbot Hall, Kendal and therefore also exhibited at Turner's gallery in 1804, the composition is quite different from this oil. This surely increases the likelihood that Allnutt's commission preceded the exhibition of the large watercolours, unless one accepts the possibility that Allnutt did not like the composition of the large watercolour of *The Devil's Bridge* when he saw it, and so ordered this oil to be made from the sketch in the 'St Gothard and Mt Blanc' sketchbook. On the whole, however, this interpretation seems both improbable and unnecessarily complicated.

148. Bonneville, Savoy c. 1803–5
(Plate 138)

PRESENT WHEREABOUTS UNKNOWN

Panel, $13\frac{1}{4} \times 19\frac{1}{4}$ (33.5×48.9)

Coll. Walter Fawkes of Farnley who bought it from Turner; Fawkes sale Christie's 27 June 1890 (60, as 'Peasants driving Sheep in Apennines') bought Vokins; E. Louis Raphael by 1893; Leggatt who sold it in 1927 to the Hon. Mrs Whitelaw Reid; Reid sale, American Art Association, New York, 14–18 May 1935 (1178, repr. as 'A Scene in the Apennines') bought E. and A. Silberman.

Exh. R.A. 1893 (26); Birmingham 1899 (1); Guildhall 1899 (11).

Lit. Thornbury 1862, ii, p. 393; 1877, p. 589 as 'Landscape' painted between 1808 and 1816; Armstrong 1902, p. 218 as 'Scene in the Apennines'; Finberg 1912, p. 20.

Armstrong's title (presumably taken from the Fawkes 1890 sale catalogue) is clearly impossible as the picture must derive from Turner's visit to the Continent in 1802 rather than from his first visit to Italy in 1819. Indeed, Armstrong dates this picture 1803–5 and suggests a comparison between it and a watercolour of Bonneville, belonging in 1902 to the Rev. Stopford Brooke and now in the British Museum (R. W. Lloyd Bequest 1958-7-12-407, $12\frac{1}{8} \times 15\frac{5}{8}$ (30.8×47.3)). This suggestion was presumably occasioned by both oil and watercolour being exhibited at the Guildhall in 1899. Although the watercolour shows Bonneville from a different angle to that shown in any of the other versions of the subject, there seems no reason to doubt the identification of the view. The oil is almost identical in composition and certainly depicts the same scene.

To judge from a rather old and brown photograph in the Witt Library, Armstrong's dating may well be correct, although Finberg's notes in the British Museum suggest about 1809 but without giving any reasons for doing so. It seems likely that this picture is now in a private collection in the U.S.A. but so far efforts to trace it have not been successful.

149. Windsor Castle from the Thames c. 1804–6
(Plate 162)

H.M. TREASURY AND THE NATIONAL TRUST (Lord Egremont Collection) PETWORTH HOUSE

Canvas, 35×47 (88.9×119.4)

Signed 'I M W TURNER RA ISLEWORTH' lower right (Plate 538)

Coll. Bought from Turner by the third Earl of Egremont; by descent to the third Lord Leconfield, who in 1947 conveyed Petworth to the National Trust; in 1957 the contents of the State Rooms were

accepted by the Treasury in part payment of death duties.

Exh. S.B.A. 1834 (15 lent by Lord Egremont); Tate Gallery 1951 (1); Brussels 1973 (6); R.A. 1974–5 (80).

Lit. Petworth Inventories 1837, 1856 (North gallery); Waagen 1854, iii, p. 39; Thornbury 1877, p. 199 (?); Armstrong 1902, p. 237, where it is dated *c.* 1808; Collins Baker 1920, p. 123 no. 4; Finberg 1961, pp. 192, 196, 350, 475 no. 181, 199 no. 454; Rothenstein and Butlin 1964, p. 19, pl. 26; Lindsay 1966, p. 107; Herrmann 1975, pp. 15, 228, pl. 45.

There is a watercolour study for this picture on p. 29 verso of the 'Studies for Pictures; Isleworth' sketchbook (XC; repr. by Herrmann pl. 46 and in colour by Wilkinson, 1974, p. 108). A slight pencil sketch on p. 2 of the 'Windsor and Eton' sketchbook (XCVII) is also possibly connected.

There is also a drawing CXVIII-e, catalogued by Finberg simply as 'Sketch for *Liber Studiorum* subject', which, despite one or two minor architectural peculiarities, seems certainly to depict Windsor, and the group of figures and sheep in the foreground on the right are closely connected with the oil. In the drawing a flagstaff is visible on the turret in the centre and the Round Tower can be clearly seen whereas in the picture it is obscured by trees.

The questions of when the picture was painted and when it was acquired by Lord Egremont are still unresolved but Finberg's suggestion that this picture was exhibited at Turner's gallery in 1813 is unsupported by any evidence. Finberg's theory rested on his belief that the 'Studies for Pictures; Isleworth' sketchbook, containing the watercolour study for the oil, dates from 1811–12. On the inside cover of the book is written:

> J.M.W. Turner
> Sion Ferry House
> Isleworth.

and Finberg suggests that Turner moved there when he left Hammersmith in 1811 while he was waiting for Solus Lodge, Twickenham, to be got ready. While it is true that this sketchbook contains drawings connected with pictures such as *Mercury and Herse* (No. 114, R.A. 1811) and *Dido and Æneas* (No. 129, R.A. 1814), it also has details of bank notes in use in 1804, which implies that the sketchbook, like many others, was in use over a number of years.

Rothenstein and Butlin date this picture *c.* 1805 and see in it a sign of Turner's early interest in a more classical form of composition, based 'mainly on forms lying parallel to the picture surface', and they cite a number of points of similarity with *The Garden of the Hesperides* (No. 57, exh. 1806). There is also an echo of Gaspard Poussin and another close parallel in Turner's own work is to be found in the *Narcissus and Echo* of 1804 (No. 53), also at Petworth. On stylistic grounds,

therefore, there seems to be a strong case for accepting a date of *c.* 1805.

The dating proposed by Rothenstein and Butlin received strong support when Kenneth Woodbridge (1970, p. 182) published a previously unknown letter from Turner to Sir Richard Colt Hoare, written on 23 November 1805 and headed 'Sion Ferry House, Isleworth'. This proves that Turner had a house at Isleworth much earlier than has been known hitherto and there seems no reason why the most obvious explanation should not be correct: that Turner painted, signed and sold the picture all in about 1805 or 1806. The unusual form of signature implies that Turner was living at Isleworth when he signed it and that, according to his usual custom, he signed it at the time that Lord Egremont bought the picture. There is also a possibility that Turner exhibited it at his own gallery in 1805 or 1806. Certainly the evidence for a dating at about this time now seems overwhelming.

150. Venus and Adonis or **Adonis departing for the Chase** *c.* 1803–5 (Plate 161)

CHRISTOPHER GIBBS LTD, LONDON

Canvas, 59 × 47 (149 × 119·4)

Signed 'I M W Turner' lower right (Plate 538)

Coll. John Green of Blackheath; sale Christie's 26 April 1830 (82) bought Munro of Novar; Munro sale Christie's 6 April 1878 (103) bought E. Benjamin; C. Becket-Denison; sale Christie's 13 June 1885 (892) bought Agnew; Sir W. Cuthbert Quilter Bt; sale Christie's 9 July 1909 (82) bought in; by descent to Sir Raymond Quilter Bt; with Leggatt 1960 who sold it to Huntington Hartford, New York; sale Sotheby's 17 March 1971 (56) bought in; acquired the following year by the present owners.

Exh. R.A. 1849 (206); R.A. 1887 (149); Guildhall 1897 (65); R.A. 1906 (28); Tate Gallery (on loan) 1955–60; Leggatt 1960 (29); on view at the Huntington Hartford Museum, New York 1960–71; Christopher Gibbs Ltd *Painting in England 1799–1900*, 1973–4 (3); R.A. 1974–5 (78).

Lit. Burnet and Cunningham 1852, pp. 30, 44, 121 no. 247; Alaric A. Watts, *Liber Fluviorum or River Scenery of France* 1853, p. xxx; Waagen 1854, ii, p. 140; Thornbury 1862, i, p. 58; ii, pp. 190, 327, 345, 400; 1877, pp. 33, 300, 395, 526, 547, 597; Frost 1865, p. 94 no. 120 where it is dated *c.* 1806; Monkhouse 1879, p. 52; Wedmore 1900, i, repr. facing p. 62; Armstrong 1902, pp. 104, 105, 107, 108, 161, 217, repr. as frontispiece; Finberg 1961, pp. 98, 118, 425, 510 no. 583; Rothenstein and Butlin 1964, pp. 18, 73, pl. 24; *Catalogue of Paintings from the Huntington Hartford Collection in the Gallery of Modern Art* 1964, pl. 4 (Accession no. 60.5); Lindsay 1966, p. 245 n. 3; Gage 1969, p. 141, pl. 62;

Reynolds 1969, pp. 56, 62, 204, fig. 38; Herrmann 1975, p. 235.

Adonis was the favourite of Venus. He was fond of hunting, and was often cautioned by his mistress not to hunt wild beasts, for fear of being killed in the attempt. This advice Adonis slighted, and at last received a mortal bite from a wild boar he had wounded, and Venus, after shedding many tears at his death, changed him into a flower called anemone (Lemprière).

Alaric Watts records that, at the sale of John Green's pictures in 1830, this picture would have been knocked down for considerably less, but for the 'impetus given to the bidding by one of Mr. Turner's agents ... a clean, ruddy-cheeked butcher's boy, in the usual costume of his vocation.' Munro, however, gives a much fuller and widely differing account of the sale (in a MS note in Thornbury 1862, ii, p. 149 in the collection of Professor Francis Haskell, to be published by Gage). According to Munro, Turner got in touch with him before the sale to find out if he meant to bid for this picture and the *Bonneville* (see No. 46). On hearing that Munro was prepared to go up to £200 for each and perhaps more for *Venus and Adonis*, Turner himself seemed pleased and said 'then I shall leave it entirely to you'. Munro attended the sale but bid through an agent, buying both pictures for 83 guineas each, his only opponent being an unknown boy. Much later a dealer in Marylebone Street called Peacock told Munro 'had I been able to go to Blackheath you would have had to pay more for those Turners but I could not go myself and *sent my boy.*'

Munro presumably agreed to allow Turner to exhibit this at the R.A. in 1849 as well as *The Wreck Buoy* (No. 428) as Turner must have wished to send two pictures to the R.A. but was not up to producing new work.

On the whole the picture was admired at the R.A., although some critics seemed puzzled by this early figure picture. The *Athenaeum* for 12 May wrote that the theme 'having been painted by Titian and sung by Shakespeare, has lost none of its beauty on Mr. Turner's canvas ... The little cupids loosening the sandal of Adonis is a suggestion as significant as pages of words could express'. Cosmo Monkhouse also described the picture in portmanteau terms as reminding one 'of Titian, Sir Joshua Reynolds and Etty in about equal proportions'.

The *Art Union* for June 1849 wrote 'here is proof that he lived in the light of Giorgione, and was the friend of Titian and Paul Veronese', but goes on to ask 'Who would say that this picture was executed by the same hand as, for instance, the other in this exhibition [*The Wreck Buoy*], or even those all-beautiful Venetian subjects?'

The Times, 5 May, made the point that 'There is but little to connect this picture with the artist's present style, except a characteristic disregard of minute details and an evident intent of avoiding close investigation'. The *Spectator*, 12 May, called it 'a strange work by Mr. Turner, who does not wish us to forget that he can't paint the human form ... the general effect is obtained by a process which makes the picture, on examination, look dead and dingy not brilliant', while the *Illustrated London News*, 26 May, considered that 'it wears the look, certainly, as if it belonged to the National Gallery'.

A study for the picture is in the 'Calais Pier' sketchbook (LXXXI, p. 50) inscribed in Turner's hand 'Parting of Venus and Adonis'. This differs from the final composition (Venus is upright and not reclining in a bower) which is based directly on Titian's *Death of St Peter Martyr*, which Turner saw and admired in the Louvre in 1802, after its removal from Venice by Napoleon (Martino Rota's engraving repr. Plate 549). Turner's notes on the Titian run to three pages in the 'Studies in the Louvre' sketchbook (LXXII).

Two pages later, in the same sketchbook, another study is inscribed by Turner 'Death of Adonis' suggesting that Turner planned a companion picture, but no trace of this picture has ever been found, and it was probably never painted (but see No. 151). Gage suggests that the proposed sequel means we must 'look for a darker and more complex theme beneath the apparently Rococo subject of *Venus and Adonis*.' Gage notes that 'According to Pernety (A-J Pernety, *Les Fables egyptiennes et grecques*, 1758) Adonis represented the same natural principle as Apollo and Osiris, the emblems of the sun, and his escapade with Venus (saffron colour) led to his alchemical death in transmutation. The red roses which Turner, following Ovid, has painted round the goddess's couch, foreshadow those she tinged with her blood as she ran through the briar thickets in search of her dying love.'

Dated by Armstrong 1806–10, by Rothenstein and Butlin 1803–5, and by Finberg (notes in the British Museum) soon after 1802, the close links between it and *The Holy Family* (No. 49), exhibited in 1803, make this the most convincing date. Furthermore, it may be relevant that it was in 1803 that Turner exhibited the version of *Bonneville* (No. 46) which was also bought by Mr Green. Gage (1974, p. 84 n. 7) assigns it firmly to 1802 and suggests that the Titian of the same subject, acquired by William Angerstein in 1801 (now in the National Gallery, No. 34) may have been a factor in Turner choosing this subject.

151. Venus and the Dead Adonis *c.* 1805?

(Plate 139)

THE TATE GALLERY, LONDON (5493)

Canvas, $12\frac{1}{2} \times 17\frac{3}{4}$ ($31 \cdot 5 \times 45$)

Coll. Turner Bequest 1856 (? 183, 1 unidentified $1'5\frac{1}{2}'' \times 1'0\frac{1}{2}''$); transferred to the Tate Gallery 1947.

Lit. Davies 1946, p. 160.

The back of the canvas, where not masked by the stretcher, was covered by a fairly thin layer of brown paint, partly covered by dryish white paint, bumpy in

places; this had to be removed prior to the laying down of the canvas on a synthetic board, but a photograph exists.

It is very difficult to date this little picture. The figures' somewhat Titianesque poses suggest a date not too far from Turner's study of Titian's works in the Louvre in 1802, which led to the large painting of an earlier episode in the story of Venus and Adonis, No. 150. Indeed, the 'Calais Pier' sketchbook includes, as well as sketches for that picture, others for a 'Death of Adonis', never executed, though these are not directly related to this little oil sketch (LXXXI-48 and 52). On the other hand, the head of the dead Adonis is not very different from *Head of a Person asleep*, here dated *c.* 1835 (No. 452). The picture could perhaps therefore reflect Turner's return to Titianesque subjects and techniques on his second visit to Rome of 1828–9.

152. The Procuress? *c.* 1805? (Plate 140)

THE TATE GALLERY, LONDON (5500)

Canvas, $47\frac{7}{8} \times 36$ (121·5 × 91·5)

Coll. Turner Bequest 1856; transferred to the Tate Gallery 1947.

Lit. Davies 1946, p. 161.

Possibly developed from the sketch in black and white chalks in the 'Calais Pier' sketchbook, LXXXI-41, where, however, the figure to the left and behind the young woman appears to be male and bearded, though this is not altogether certain (Finberg 1909, p. 215, entitled the drawing 'Study for Joseph and Mary(?)'; repr. in colour Wilkinson 1974, p. 59). Martin Davies identified the painting as representing 'Death before Dishonour'. The present title, derived from

seventeenth-century Dutch prototypes, is due to Lawrence Gowing.

At all events this unfinished oil, painted in a generally Titianesque manner, is probably fairly early, deriving from Turner's experience of Titian at the Louvre in 1802, rather than from the period of such figure paintings of comparable scale as No. 448. On the other hand, it could have resulted from Turner's renewed interest in Titian during his Italian journey of 1828–9; *c.f.* Nos. 293 and 296.

The back of the canvas is covered with a normal ground and it seems that the composition was painted on what would normally be the unprimed reverse, the oil medium having impregnated the canvas in many areas.

153. The Finding of Moses *c.* 1805? (Plate 141)

THE TATE GALLERY, LONDON (5497)

Canvas, $59\frac{1}{4} \times 44$ (150·5 × 111·5)

Coll. Turner Bequest 1856 (?259, '1 (Figure subject)' $4'11\frac{1}{2}'' \times 3'8\frac{1}{2}''$); transferred to the Tate Gallery 1947.

Lit. Davies 1946, p. 160.

The identification of the subject is due to Mary Chamot; Martin Davies' title was 'Three Women and a Baby (unfinished)'. The picture, as yet unrestored, is difficult to date. Although more roughly painted than *The Procuress* (No. 152) it seems, like that picture, to represent Turner's reaction to the Venetian pictures he saw in the Louvre in 1802, in particular the works of Titian and Veronese. Turner's renewed interest in figure subjects on this scale as a result of his second visit to Italy in 1828–9 seems to have resulted in works of a rather richer texture, whether thinly painted like the *Reclining Venus* (No. 296) or more heavily worked up like *Two Women and a Letter* (No. 448).

Nos. 154–9: Knockholt Sketches *c.* 1805–6

OF THE seven oil studies associated by Finberg with Turner's visits to his friend W. F. Wells at Knockholt, Kent, one has been catalogued already (No. 35). According to Finberg, confirmed by Andrew Wilton in the case of Nos. 154 and 156, five of the others bear inscriptions linking them with Knockholt or other Kent subjects, and the remaining example, No. 159, is similar in general treatment.

Turner seems to have known the landscape artist and drawing master William Frederick Wells (1762–1836) by 1800 if not earlier, and it is no longer necessary to associate this group of sketches with the visit on which, according to Wells' daughter Clara, Mrs Wheeler, Wells persuaded Turner to start work on the *Liber Studiorum* and which she states took place in October 1806 (letter of 27 July 1853, reprinted in W. G. Rawlinson, *Turner's Liber Studiorum* 1906, pp. xii–xiii).

However, Andrew Wilton's dating of *c.* 1800 seems too early. The park scenes, Nos. 156, 157 and 158, are close to such watercolours as the Thames views in the 'Thames from Reading to Walton' sketchbook of *c.* 1806 (XCV-34, repr. in colour Wilkinson 1974, p. 77, and in exh. cat., B.M. 1975, p. 40 no. 34), while the interiors seem to reflect the same interests as the *County Blacksmith disputing upon the Price of Iron*, exhibited in 1807 (No. 68; see also the wash drawing repr. exh. cat., B.M. 1975, p. 41 no. 36, and *Pembury Mill, Kent*, published in the *Liber Studiorum*, R. 12, on 10 June 1808 and repr. Finberg 1924, p. 47). A dating of *c.* 1805–6 still, therefore, appears reasonable.

The presence of oil paint on these mixed-media sketches is not absolutely certain, but from purely visual evidence seems likely. In at least some cases, to judge from No. 159, the paper seems to have been sized before the colour was applied, after which certain areas, if not the whole, may have been gone over in size again. In the cases of Nos. 154 and 155 one can see an underdrawing in ink or pencil. Most of the studies with inscriptions on the back are now stuck down. The transcriptions given here depend on Finberg's, amended to follow Wilton's versions, without punctuation, for Nos. 154 and 156. The date at which these inscriptions were made is not certain.

Lit. Finberg 1909, i, p. 247; Lindsay 1966, p. 101; Gage 1969, p. 36; Andrew Wilton in exh. cat., B.M. 1975, pp. 36–7.

154. The Kitchen of Wells' Cottage, Knockholt
c. 1805–6 (Plate 142)

THE BRITISH MUSEUM, LONDON (XCV(a)-A)

Oil and watercolour (?) and ink on paper, irregular, $10\frac{3}{4} \times 14\frac{3}{4}$ (27·4 × 37·5)

Inscr. on back '101 Wells' Kitchen Knockholt'

Coll. Turner Bequest 1856.

Exh. B.M. 1975 (24, repr.).

155. Interior of a Cottage *c.* 1805–6 (Plate 143)

THE BRITISH MUSEUM, LONDON (XCV(a)-C)

Oil, and watercolour (?) and ink, approx. $10\frac{3}{4} \times 14\frac{1}{2}$ (27·5 × 37) on paper, irregular, $10\frac{7}{8} \times 15\frac{1}{8}$ (27·7 × 38·4)

Inscr. on back '103 Interior of a cottage Kent'

Coll. Turner Bequest 1856.

Exh. *Turner Watercolours from the British Museum* Smithsonian Institution tour, U.S.A., September 1963–May 1964 (12, repr.).

The paint was applied when the left-hand edge of the paper was already crumpled. This interior is if anything rather more clearly a kitchen than is No. 154.

156. Chevening Park *c.* 1805–6 (Plate 163)

THE BRITISH MUSEUM, LONDON (XCV(a)-D)

Oil and watercolour (?) and size on paper, irregular, $10\frac{3}{4} \times 14\frac{11}{16}$ (27·3 × 37·6)

Inscr. on back '104 Chevening Park'

Coll. Turner bequest 1856.

Exh. B.M. 1975 (25).

157. Chevening Park, Kent *c.* 1805–6 (Plate 144)

THE BRITISH MUSEUM, LONDON (XCV(a)-B)

Oil and watercolour (?) and size on paper, irregular, $10\frac{15}{16} \times 14\frac{7}{8}$ (27·8 × 37·8)

Inscr. on back '102 Chevening Park Kent'

Coll. Turner Bequest 1856.

Exh. Berlin 1972 (47); Lisbon 1973 (13, repr.).

158. 'An Evening Effect'; Trees at Knockholt
c. 1805–6 (Plate 146)

THE BRITISH MUSEUM, LONDON (XCV(a)-E)

Oil (?), size and watercolour, approx. $9\frac{1}{2} \times 6\frac{1}{2}$ (24 × 16·5) on paper, irregular, $10\frac{3}{8} \times 7\frac{3}{8}$ (26·3 × 18·7)

Inscr. on back '106 Knockholt Kent'

Coll. Turner Bequest 1856.

Exh. Paris 1972 (285); *Turner and Watercolour* Arts Council tour, April–September 1974 (11, repr.).

The title 'An Evening Effect' is Finberg's. The study shows a broken-off tree stump with further trees beyond.

159. An Armchair *c.* 1805–6 (Plate 147)

THE BRITISH MUSEUM, LONDON (XCV(a)-F)

Oil, approx. $8\frac{1}{2} \times 7\frac{1}{4}$ (21·5 × 18·5) on sized paper, torn irregularly at top of left-hand edge, $11 \times 8\frac{15}{16}$ (27·9 × 22·7)

Coll. Turner Bequest 1856.

The paper has three horizontal folds.

Nos. 160–76: Large Thames Sketches c. 1806–7

THIS group of seventeen sketches on canvas from the Turner bequest, though carried to different degree of finish, are all similar in technique, being lightly painted over a dry chalky ground, and are all roughly similar in size save for *Sketch for 'Harvest Dinner, Kingston Bank'*, which measures only 24 × 36 in. (No. 160). This last was used for the painting exhibited at Turner's gallery in 1809 and again in 1810 (No. 90). Others are more loosely related to finished oil paintings exhibited in 1808, 1809 and 1810. A number of them are also related to drawings in the 'Thames from Reading to Walton' sketchbook, datable c. 1806 (XCV; pp. 22–3 are sketches for the pictures of Walton Bridges, paid for early in 1807, see Nos. 60 and 63); c.f. for example pp. 31 and 37 with No. 173, and p. 35 with No. 172; there is a different view of Goring Church, the subject of No. 161, on p. 19. The composition of one example, *Trees beside a River, with Bridge in the Middle Distance* (No. 169), is very close to a drawing in the rather earlier 'Studies for Pictures; Isleworth' sketchbook, sandwiched between lists of classical and Biblical subjects (XC-55 verso and 56): for the evidence for dating this sketchbook c. 1804–5 see Nos. 149 and 169.

There is reason to suppose that, contrary to Turner's usual practice, some if not all of these sketches were at least begun out-of-doors. Thornbury prints some reminiscences of the son of Turner's 'oldest friend the Rev. Mr. Trimmer', who had been out fishing with Turner when a child. 'He had a boat at Richmond . . . From his boat he painted on a large canvas direct from Nature. Till you have seen these sketches, you know nothing of Turner's powers. There are about two score of these large subjects, rolled up, and now national property . . . There is a red sunset (simply the sky) among the rolls'. The last, probably the sadly darkened *Sunset* (No. 525), is different in character from the works under discussion and is probably later, but the folded and battered condition of many of the Thames sketches such as Nos. 171 and 173 supports the identification with the works mentioned by Trimmer, as does the fact that the sketches seem to have been unstretched when they came to be relined early this century; indeed, some if not all may never have been stretched, No. 167 for instance showing none of the usual pulling at the edges from the nails attaching a canvas to a stretcher. As in the case of two later groups of sketches on canvas, those painted in the Isle of Wight in 1827 (Nos. 260–268) and those done in Rome 1828–9 (Nos. 302–317), Turner may have painted on rolls of canvas, working them over a frame to use different areas as required. If these sketches were always on loose canvases they may have been the 'Roll of 17 separate Canvasses', nos. 219 to 235 in the inventory of the Turner Bequest. All but one were first numbered, restored and put on public exhibition in 1910; No. 165, which is in considerably worse condition, was not even numbered until 1944.

Though Turner did not complete his own cottage at Twickenham, across the river from Richmond, until 1813, he already had a second home at Isleworth, not that much further from Richmond, in 1804 or 5 (see Nos. 149 and 169), and at Upper Mall, Hammersmith probably from late 1806 until 1811, and he could well have had a boat at Richmond during all this period. John Gage has suggested that this group of sketches was executed over a number of years from about 1807 to as late as *Crossing the Brook*, exhibited in 1815 (No. 130), but it seems equally possible that despite the differences between them they were all done at more or less the same time, Turner only using this rather unusual size and technique for this sort of sketch as a limited experiment. Despite their differences they all seem to show the fresh approach to simple, everyday subjects that is reflected in the great change in his exhibited pictures in 1807 and 1808, after which such an elaborate recourse to nature would no longer have been necessary.

Lit. Thornbury 1862, i, p. 169; 1877, pp. 120–21; MacColl 1920, pp. 38–40; Herrmann 1963, p. 12; Kitson 1964, pp. 77–8; Rothenstein and Butlin 1964, pp. 24–6; Gage 1969, pp. 37–8; Reynolds 1969, p. 71; Ziff 1971, p. 125; Herrmann 1975, pp. 19, 229.

160. Sketch for 'Harvest Dinner, Kingston Bank'
c. 1806–7 (Plate 145)

THE TATE GALLERY, LONDON (2696)

Canvas, 24 × 36 (61 × 91·5)

Coll. Turner Bequest 1856 (? one of 219–35); transferred to the Tate Gallery 1910.

Lit. Rothenstein and Butlin 1964, p. 24.

Used with variations for the finished picture exhibited at Turner's gallery in 1809 (No. 90). In the latter the placing of the figures is altered, the hay-cart is moved to behind the standing figure silhouetted against the sky, and a group of boats and further distant hills are introduced on the right.

This is the only picture in this group to have been used so directly as a sketch for another work, and it also differs from the others in being only half the size. In technique, however, it is identical.

161. Goring Mill and Church *c.* 1806–7
(Plate 164)

THE TATE GALLERY, LONDON (2704)

Canvas, 33¾ × 45¾ (85·5 × 116)

Coll. Turner Bequest 1856 (? one of 219–35); transferred to the Tate Gallery 1910.

Exh. Cardiff 1951; R.A. 1974–5 (145).

Lit. Davies 1946, pp. 156, 189; Gage 1969, p. 37.

Formerly tentatively identified as Cleeve Mill, also on the Thames above Reading. That the picture in fact shows Goring was demonstrated by Mr J. R. Millar in 1976; the church tower and much of the mill are exactly the same to-day. The manner in which parts of the picture are carried more or less to detailed completion whereas elsewhere the white ground is left bare recalls the technique of the traditional topographical water-colour, and does not altogether support Gage's suggestion that it was painted entirely out-of-doors.

162. Caversham Bridge with Cattle in the Water
c. 1806–7 (Plate 148)

THE TATE GALLERY, LONDON (2697)

Canvas, 33⅝ × 45⅝ (85·5 × 116)

Coll. Turner Bequest 1856 (? one of 219–35); transferred to the Tate Gallery 1910.

There are two drawings of Caversham Bridge in the 'Thames, from Reading to Walton' sketchbook (XCV-38 and 41).

163. A Thames Backwater with Windsor Castle in the Distance *c.* 1806–7 (Plate 149)

THE TATE GALLERY, LONDON (2691)

Canvas, 34⅛ × 47⅝ (86·5 × 121)

Coll. Turner Bequest 1856 (? one of 219–35); transferred to the Tate Gallery 1949.

Exh. Toronto and Ottawa 1951 (3); on loan to the National Museum of Wales since 1964.

Lit. Davies 1946, pp. 156, 189.

164. Hampton Court from the Thames *c.* 1806–7
(Plate 150)

THE TATE GALLERY, LONDON (2693)

Canvas, 33¾ × 47¼ (86 × 120)

Coll. Turner Bequest 1856 (? one of 219–35); transferred to the Tate Gallery 1910.

Exh. Rotterdam 1955 (51); R.A. 1974–5 (143).

Lit. Rothenstein and Butlin 1964, p. 24, pl. 36; Brill 1969, p. 13, repr.

165. The Thames glimpsed between Trees, possibly at Kew Bridge *c.* 1806–7 (Plate 151)

THE TATE GALLERY, LONDON (5519)

Canvas, 35⅞ × 47⅞ (91 × 121·5)
Coll. Turner Bequest 1856; transferred to the Tate Gallery 1947.

Lit. Davies 1946, p. 164.

Though in particularly bad condition this seems to be one of the large Thames sketches painted *c.* 1806–7. The composition is close to the watercolour in the 'Thames, from Reading to Walton' sketchbook (XCV-46) and may show Kew Bridge (see exh. cat., B.M. 1975, p. 40 no. 34, repr.; also repr. in colour Wilkinson 1974, p. 77); this sketchbook has been variously dated between 1806 and 1808 (see Finberg 1909, p. 245; Gage 1969, p. 36; Butlin in exh. cat. R.A. 1974–5, p. 68 under nos. 143–6; Wilton in exh. cat., B.M. 1975, p. 40 no. 33); see p. 104 for reasons for dating it *c.* 1806.

166. House beside the River, with Trees and Sheep *c.* 1806–7 (Plate 152)

THE TATE GALLERY, LONDON (2694)

Canvas, 35⅝ × 45⅞ (90·5 × 116·5)

Coll. Turner Bequest 1856 (? one of 219–35); transferred to the Tate Gallery 1910.

Exh. Amsterdam 1936 (158); Amsterdam, Berne, Paris, Brussels, Liege (12, repr.), Venice and Rome (13, repr.) 1947–8.

Lit. Rothenstein 1949, p. 8, colour pl. 4; Herrmann 1963, p. 12, colour pl. 5; Kitson 1964, p. 77, repr. p. 42; Gage 1969, p. 38.

Christopher Pinsent has suggested that this may be a view of St. Catherine's Ferry on the River Wey (letter of 2 March 1970). Gage dates this to after 1811 or 1812 on the basis of its 'very developed approach to working from nature in oils' and a not very convincing comparison to the trees in Turner's Italianate landscapes after 1811 such as *Crossing the Brook*, exhibited in 1815 (No. 130). In mood and to a certain extent in composition one might better compare it with the *View of Pope's Villa* exhibited in 1808 (No. 72).

167. Weir and Cattle *c*. 1806–7 (Plate 153)

THE TATE GALLERY, LONDON (2705)

Canvas, $34\frac{3}{4} \times 47\frac{1}{4}$ (88 × 120)

Coll. Turner Bequest 1856 (? one of 219–35); transferred to the Tate Gallery 1910.

Exh. Cape Town 1952 (26).

Lit. Davies 1946, pp. 156, 189.

Christopher Pinsent has suggested that this may show the Wey near Guildford (letter of 2 March 1970).

168. Barge on the River, Sunset *c*. 1806–7
(Plate 165)

THE TATE GALLERY, LONDON (2707)

Canvas, $33\frac{1}{2} \times 45\frac{3}{4}$ (85 × 116)

Coll. Turner Bequest 1856 (? one of 219–35); transferred to the Tate Gallery 1910.

Lit. Davies 1946, p. 189.

Related in general terms to *Newark Abbey on the Wey* possibly exhibited in 1807 (No. 65) in which Turner again used the motif of the fire lighting up the inside of a covered barge.

169. Trees beside the River, with Bridge in the Middle Distance *c*. 1806–7 (Plate 154)

THE TATE GALLERY, LONDON (2692)

Canvas, $34\frac{5}{8} \times 47\frac{1}{2}$ (88 × 120·5)

Coll. Turner Bequest 1856 (? one of 219–35); transferred to the Tate Gallery 1910.

Lit. Rothenstein and Butlin 1964, p. 26; Gage 1969, pp. 37, 240 n. 51, pl. 40.

The composition is derived from two drawings in the 'Studies for Pictures; Isleworth' sketchbook (XC-55 and 56), which, *pace* Finberg 1961, Gage 1969 and Wilkinson 1974, p. 106, must be dated *c*. 1804–5. The inside of the front cover bears a memorandum dated 1804 and the address 'Sion Ferry House, Isleworth', from which Turner addressed a letter to Colt Hoare on 23 November 1805. In addition the many composition sketches reflect Turner's neo-classical style in the few years after Turner returned from his studies in the Louvre in 1802, one of them (XC-29 verso, repr. in colour Wilkinson 1974, p. 108) being for the oil of *Windsor Castle from the Thames* which was signed at Isleworth (No. 149). The relationship seen by Gage to a watercolour in the 'Thames, from Reading to Walton' sketchbook (XCV-46, repr. in colour Wilkinson 1974, p. 77) is less close, but the composition is however very close, apart from the presence of the bridge, to a drawing apparently from nature in the 'Wey, Guildford' sketchbook of *c*. 1807 (XCVIII-10; repr. Wilkinson 1974, p. 85).

This painting has been carried further than the other large Thames sketches and is more thickly painted. Its Italianate ruined bridge, which links the preliminary drawings with the classical subjects in the same 'Studies for Pictures' sketchbook, suggests that Turner may have been working towards a subject-picture for exhibition.

170. Men with Horses crossing a River *c*. 1806–7
(Plate 155)

THE TATE GALLERY, LONDON (2695)

Oil over pencil on canvas, $34\frac{5}{8} \times 46\frac{5}{8}$ (88 × 118·5)

Coll. Turner Bequest 1856 (? one of the 219–35); transferred to the Tate Gallery 1954.

Lit. Davies 1946, pp. 156, 189.

171. River Scene with Weir in the Middle Distance *c*. 1806–7 (Plate 166)

THE TATE GALLERY, LONDON (2703)

Canvas, $33\frac{5}{8} \times 45\frac{1}{2}$ (85·5 × 115·5)

Coll. Turner Bequest 1856 (? one of 219–35); transferred to the Tate Gallery 1910.

Unrestored, this picture still shows signs of the neglect it suffered while in Turner's possession, though the losses may have been accentuated when the facing paper was removed following relining in about 1910.

172. Willows beside a Stream *c*. 1806–7 (Plate 167)

THE TATE GALLERY, LONDON (2706)

Canvas, $33\frac{7}{8} \times 45\frac{3}{4}$ (86 × 116·5)

Coll. Turner Bequest 1856 (? one of 219–35); transferred to the Tate Gallery 1910.

Exh. Tate Gallery 1931 (33); Amsterdam 1936 (157); Venice 1938 (12, repr. pl. 6); Prague, Bratislava (146) and Vienna (53) 1969; Norwich and V. and A. 1969–70 (42, repr. p. 23); Tokyo and Kyoto 1970–71 (32, repr.); Lisbon 1973 (3, repr. in colour); R.A. 1974–5 (146).

Lit. Rothenstein and Butlin 1964, p. 24, colour pl. iii; Gage 1969, p. 37; Ziff 1971, p. 125; Herrmann 1975, pp. 19, 229, p. 53.

Comparable with the pencil drawing of trees on page 35 of the 'Thames, from Reading to Walton' sketchbook of *c.* 1806 (XCV-35). The flurry of activity in the left foreground may represent dogs attacking a stag, a reminiscence of one of Rubens' paintings of boar hunts. This canvas may have been in Turner's mind when he did the drawing for the unpublished *Liber Studiorum* plate 'Pan and Syrinx', R. 80 (British Museum; repr. Finberg 1924, p. 320).

173. Washing Sheep *c.* 1806–7 (Plate 168)

THE TATE GALLERY, LONDON (2699)

Canvas, $33\frac{1}{4} \times 45\frac{7}{8}$ (84·5 × 116·5)

Coll. Turner Bequest 1856 (? one of 219–35); transferred to the Tate Gallery 1910.

Exh. R.A. 1974–5 (144).

Lit. Gage 1969, p. 37.

Possibly the same stretch of river as that shown in two drawings in the 'Thames, from Reading to Walton' sketchbook of *c.* 1806 (XCV-31 and 37). Christopher Pinsent, in a letter of 2 March 1970, has suggested that the scene may be on the Wey.

Despite discreet restoration the main damages caused by folding and neglect have been left; these may have been accentuated when the facing paper was removed after relining *c.* 1910.

174. Harbour Scene, probably Margate *c.* 1806–7
 (Plate 169)

THE TATE GALLERY, LONDON (2700)

Canvas, $33\frac{3}{4} \times 45\frac{3}{4}$ (85·5 × 116)

Coll. Turner Bequest 1856 (? one of 219–35); transferred to the Tate Gallery 1910.

The composition seems to lie behind that of *St. Mawes at the Pilchard Season*, exhibited in Turner's gallery in 1812 (No. 123) but the town shown appears to be different, one would guess on or near the Thames Estuary. Andrew Wilton has suggested Margate; *c.f.* particularly the drawing in the 'River and Margate'

sketchbook of *c.* 1806–9 identified by Finberg as probably Margate (XCIX-9 verso) and also other drawings in the same book and in the 'Gravesend and Margate' sketchbook of *c.* 1832 (CCLXXIX). The 'River and Margate' sketchbook also contains a drawing of a rather similar harbour scene, annotated 'Hastings Fish Market' (XCIX-81, repr. Wilkinson 1974, p. 87; the oil painting of the subject of 1810, No. 105, is not related).

175. Shipping at the Mouth of the Thames
c. 1806–7 (Plate 170)

THE TATE GALLERY, LONDON (2702)

Canvas, $33\frac{3}{4} \times 46$ (86 × 117)

Coll. Turner Bequest 1856 (? one of 219–35); transferred to the Tate Gallery 1910.

Exh. Tate Gallery 1931 (35); Venice 1938 (11); Amsterdam (repr.), Berne (repr.), Paris, Brussels (repr.), Liege (repr.) (13), Venice and Rome (14) 1947–8; Arts Council tour 1952 (3); R.A. 1974–5 (154); Leningrad and Moscow 1975–6 (14, repr.).

Lit. Davies 1946, p. 189; Rothenstein and Butlin 1964, p. 24, pl. 38; Brill 1969, p. 13, as 'North [*sic*] of the Thames'; Gage 1969, p. 37.

An unfinished variant of Turner's various pictures of 1807–9 of shipping in the Thames Estuary, particularly off Sheerness (see Nos. 62, 67, 74–6, 85 and 91); this example too seems to show Sheerness in the background. Various elements such as the laden small boats tossing on the waves are also found in the finished oils but no detail is identical.

In technique, this painting is similar to the sketches of this size of scenes further up the Thames, some at least of which may have been done on the spot. However, it is difficult to imagine Turner managing a canvas of this size in the middle of the Thames Estuary.

176. Coast Scene with Fishermen and Boats
c. 1806–7 (Plate 156)

THE TATE GALLERY, LONDON (2698)

Canvas, $33\frac{3}{4} \times 45\frac{3}{4}$ (85·5 × 116)

Coll. Turner Bequest 1856 (? one of 219–35); transferred to the Tate Gallery 1910.

Exh. Tate Gallery 1931 (34); Australian tour 1960 (4).

A variant of the subject of *Fishing upon the Blythe-Sand*, exhibited at Turner's gallery in 1809 (No. 87). The scene is probably somewhere in the Thames Estuary.

Nos. 177–94: Small Thames Sketches *c.* 1807

THESE eighteen sketches of various sizes, painted on mahogany veneer, are all from the Turner Bequest. They were included in the 1854 Schedule as Nos. 184 to 200*, '18 fragments various sizes on Veneers—or thin panels'; in the 1856 Schedule no. 200* was inadvertently omitted. They were first numbered, laid down on panels, cleaned and exhibited in 1908 and 1910.

The identifiable subjects of these sketches are all on the Thames or its tributary the Wey; several of the Guildford and Godalming views were identified in 1970 by Christopher Pinsent, including No. 186, formerly thought to show Windsor Castle. The same area, with the exception of Walton Bridges, is covered by drawings in the 'Windsor, Eton' sketchbook and the 'Wey, Guildford' sketchbook (XCVII and XCVIII).

The small Thames sketches on panel, like these two sketchbooks, were dated *c.* 1807 by Finberg (1909, i, pp. 251, 253, and 1961, p. 137), a date that still seems most probable. John Gage has however divided the sketches into three groups and dates them all later. His first group, Nos. 179–80, 183, 187–92 and 194, he associates with the 'Wey, Guildford' sketchbook but dates *c.* 1809–10. His second group, Nos. 184 and 185, he dates *c.* 1811–12. His third group comprises Nos. 177, 178, 181, 182 and 186 and is dated by him to *c.* 1813 or even later, on account of a supposed similarity to the foliage of *Crossing the Brook*, exhibited in 1815 (No. 130), and a greater accomplishment than the small oil sketches on paper of Devonshire subjects done in 1813 (Nos, 213–25). The Devonshire sketches, however, are not strictly comparable in either technique or general approach, and again it seems more likely that, as is argued in the case of the large Thames sketches on canvas (Nos. 160–176), the whole group represents a single campaign playing a crucial part in the rapid development of Turner's approach to nature in the exhibited pictures of 1807 and 1808.

These sketches were probably done out-of-doors, perhaps from a small boat as the younger Trimmer described, even though he talks of Turner using 'a large canvas' (see p. 104). In them Turner approaches nearest to what Constable termed 'a natural painter', but, unlike Constable, Turner always seems to have been interested in making a complete pictorial composition even when he came closest to recording a direct experience of nature.

Lit. MacColl 1920, pp. 36–8; Clark 1949, pp. 98–9; Finberg 1961, pp. 136–7; Herrmann 1963, p. 12; Kitson 1964, p. 77; Rothenstein and Butlin 1964, pp. 23–4; Gage 1965, p. 75 n. 2; Gage 1969, p. 38; Reynolds 1969, p. 71; Ziff 1971, p. 125; Herrmann 1975, pp. 16–19, 228.

177. Windsor Castle from Salt Hill *c.* 1807

(Plate 171)

THE TATE GALLERY, LONDON (2312)

Mahogany veneer, $10\frac{7}{8} \times 29$ (27×73.5)

Coll. Turner Bequest 1856 (one of 184–200*); transferred to the Tate Gallery 1919.

Exh. Tate Gallery 1931 (65); Amsterdam, Berne, Paris, Brussels, Liege (5), Venice and Rome (6), 1947–8; Paris 1953 (69, repr. pl. 32); R.A. 1974–5 (139).

Lit. Davies 1946, p. 189 n. 19; Gage 1969, p. 38.

178. Windsor from Lower Hope *c.* 1807

(Plate 157)

THE TATE GALLERY, LONDON (2678)

Mahogany veneer, $12\frac{5}{8} \times 29$ (32×73.5)

Coll. Turner Bequest 1856 (one of 184–200*); transferred to the Tate Gallery 1919.

Exh. Tate Gallery 1931 (69); New York, Chicago and Toronto 1946–7 (48, pl. 37); British Council tour, Cologne (54, repr.), Rome (55, repr.) and Warsaw (54, repr.) 1966–7; *The Thames in Art* Henley and Cheltenham June–July 1967 (20); Tokyo and Kyoto 1970–71 (33, repr.); Dresden (repr.) and Berlin (colour pl. 8) 1972 (2); Milan 1975 (150, repr.); Hamburg 1976 (18, repr.).

Lit. Davies 1946, p. 189 n. 19; Gage 1969, p. 38.

179. Windsor Castle from the Meadows *c*. 1807

(Plate 158)

THE TATE GALLERY, LONDON (2308)

Mahogany veneer, $8\frac{3}{4} \times 21\frac{7}{8}$ (22 × 55·5)

Coll. Turner Bequest 1856 (one of 184–200*); transferred to the Tate Gallery 1910.

Exh. Tate Gallery 1931 (63); Amsterdam, Berne, Paris, Brussels (repr.), Liege (repr.) (4), Venice and Rome (5), 1947–8; Antwerp 1953–4.

Lit. Davies 1946, p. 189 n. 19; Rothenstein and Butlin 1964, p. 23, colour pl. ii; Gage 1969, p. 32.

There is a pencil drawing of approximately the same view in the 'Windsor, Eton' sketchbook (XCVII-12).

180. Windsor Castle from the River *c*. 1807

(Plate 159)

THE TATE GALLERY, LONDON (2306)

Mahogany veneer, $7\frac{7}{8} \times 14\frac{7}{16}$ (20 × 36·5); an irregular strip along the top, ranging from $\frac{3}{4}$ (2) on left to $\frac{3}{8}$ (1) on right, is a restoration

Coll. Turner Bequest 1856 (one of 184–200*); transferred to the Tate Gallery 1910.

Lit. Davies 1946, p. 189 n. 19; Gage 1969, pp. 37–8.

There is a similar but not identical view in the 'Wey, Guildford' sketchbook (XCVIII-128 verso).

181. Eton from the River *c*. 1807 (Plate 160)

THE TATE GALLERY, LONDON (2313)

Mahogany veneer, $14\frac{1}{4} \times 26\frac{1}{8}$ (37 × 66·5)

Coll. Turner Bequest 1856 (one of 184–200*); transferred to the Tate Gallery 1919.

Exh. Tate Gallery 1931 (70); Amsterdam, Berne, Paris, Brussels, Liege (6), Venice and Rome (7), 1947–8; Paris 1953 (68, pl. 34); Cologne (55, repr.), Rome (56, repr.) and Warsaw (56, repr.) 1966–7; *The Thames in Art* Henley and Cheltenham June–July 1967 (19); *Paintings of the Thames Valley* Reading Museum and Art Gallery February–March 1968 (24); R.A. 1974–5 (140).

Lit. Davies 1946, p. 189 n. 19; Herrmann 1963, p. 12, pl. 4; Gage 1969, p. 38.

182. The Ford *c*. 1807 (Plate 177)

THE TATE GALLERY, LONDON (2679)

Mahogany veneer, $14\frac{5}{8} \times 28\frac{15}{16}$ (37 × 73·5)

Coll. Turner bequest 1856 (one of 184–200*); transferred to the Tate Gallery 1910.

Exh. Tate Gallery 1931 (66); Amsterdam, Berne, Paris, Brussels, Liege (9), Venice and Rome (10) 1947–8; Norwich and V. and A. 1969–70 (40, repr. p. 22).

Lit. Davies 1946, p. 189 n. 19; Gage 1969, p. 38.

Tentatively included by Gage in his third small group of small Thames sketches of *c*. 1813–15, and also related by him to the large Thames sketch, *House beside the River* (No. 166) which he similarly dates later than is usual; but see p. 108.

183. The Thames near Windsor *c*. 1807 (Plate 178)

THE TATE GALLERY, LONDON (2305)

Mahogany veneer, $7\frac{3}{8} \times 10\frac{5}{16}$ (18·5 × 26)

Coll. Turner Bequest 1856 (one of 184–200*); transferred to the Tate Gallery 1910.

Exh. Lisbon and Madrid 1949 (48); Hamburg, Oslo, Stockholm and Copenhagen 1949–50 (95); Arts Council tour 1952 (5, repr.); Australian tour 1960 (3); Tokyo and Kyoto 1970–71 (36, repr. in colour).

Lit. Davies 1946, p. 189, n. 19; Gage 1969, p. 38.

184. The Thames near Walton Bridges *c*. 1807

(Plate 172)

THE TATE GALLERY, LONDON (2680)

Mahogany veneer, $14\frac{5}{8} \times 29$ (37 × 73·5)

Coll. Turner Bequest 1856 (one of 184–200*); transferred to the Tate Gallery 1956, returned to the National Gallery 1961, and to the Tate Gallery 1962.

Exh. Amsterdam (repr.), Berne (repr.), Paris, Brussels (repr.), Liege (repr.) (10), Venice and Rome (11) 1947–8; Lisbon 1973 (2, repr. in colour); R.A. 1974–5 (138, repr.).

Lit. Davies 1946, pp. 155, 189 n. 19; Clark 1949, pp. 98–9, pl. 84b; Clare 1951, p. 42, repr. p. 44; Rothenstein and Butlin 1964, p. 23, pl. 35; Gage 1969, p. 38; Reynolds 1969, p. 74, colour pl. 57; Gaunt 1971, p. 5, colour pl. 6; Herrmann 1975, pp. 16, 19, 228, colour pl. 33.

John Gage isolates this sketch and the next (No. 185) from the other small Thames sketches on account of technique (thin paint directly over the mahogany veneer, without a ground) and subject, and dates them *c*. 1811–12; but see p. 108. The two finished paintings of Walton Bridges (Nos. 60 and 63), which were probably exhibited in Turner's gallery in 1806 and 1807 respectively, are not related in composition to the sketches and therefore do not help in dating the latter.

185. Walton Reach *c.* 1807 (Plate 179)

THE TATE GALLERY, LONDON (2681)

Mahogany veneer, $14\frac{1}{2} \times 29$ (37×73.5); a wedge-shaped area approx. $5 \times \frac{3}{4}$ (12.5×2) top left is a restoration

Coll. Turner Bequest 1856 (one of 184–200*); transferred to the Tate Gallery 1956.

Exh. Tate Gallery 1931 (62); Amsterdam, Berne, Paris Brussels, Liege (11), Venice and Rome (12) 1947–8; Prague, Bratislava (no number) and Vienna (52) 1969.

Lit. Davies 1946, pp. 156, 189 n. 19; Gage 1969, p. 38.

Particularly close in technique to No. 184, dated by Gage to *c.* 1811–12, but see p. 108.

186. Tree Tops and Sky, Guildford Castle (?), Evening *c.* 1807 (Plate 173)

THE TATE GALLERY, LONDON (2309)

Mahogany veneer, $10\frac{7}{8} \times 29$ (27.5×73.5); a strip along the bottom, $\frac{5}{8}$ (1.5) at the left, rising to 2 (5) on the right, has been added and repainted

Coll. Turner Bequest 1856 (one of 184–200*); transferred to the Tate Gallery 1910.

Exh. Tate Gallery 1931 (62); New York, Chicago and Toronto (47, pl. 37); Moscow and Leningrad 1960 (53); Norwich and V. and A. 1969–70 (41, repr. p. 23); R.A. 1974–5 (141); Leningrad and Moscow 1975–6 (12); Hamburg 1976 (17, repr.).

Lit. MacColl 1920, p. 37; Davies 1946, p. 189 n. 19; Rothenstein and Butlin 1964, p. 23, pl. 34; Gage 1969, p. 38; Herrmann 1975, pp. 19, 228, colour pl. 34.

The building, formerly thought to be Windsor Castle, has been identified by Christopher Pinsent, in a letter of 2 March 1970, as Guildford Castle seen by evening light from the River Wey, the course of which is indicated by the gap between the trees. Before this identification Gage had included this sketch in his third group, entirely of Windsor and Eton subjects, seeing an affinity with the handling of foliage in *Crossing the Brook*, exhibited in 1815 (No. 130); but see p. 108.

187. St Catherine's Hill, Guildford *c.* 1807
 (Plate 182)
THE TATE GALLERY, LONDON (2676)

Mahogany veneer, $14\frac{3}{8} \times 29$ (36.5×73.5)

Coll. Turner Bequest 1856 (one of 184–200*); transferred to the Tate Gallery 1910.

Exh. Tate Gallery 1931 (61); Amsterdam (repr.), Berne

(repr.), Paris, Brussels (repr.), Liege (repr.) (7), Venice and Rome (8) 1947–8.

Lit. Davies 1946, p. 189 n. 19; Kitson 1964, p. 77, repr. in colour p. 27; Gage 1969, p. 38; Ziff 1971, p. 125.

There are pencil drawings of similar views in the 'Wey, Guildford' sketchbook (XCVIII-110 verso and 118 verso).

John Gage includes this sketch in his first group of *c.* 1809–10, but Jerrold Ziff would group it with No. 186, in Gage's third group of *c.* 1813–15; see p. 108.

A small piece of the original veneer and paint surface is missing from the bottom edge at the right and there are smaller losses along the rest of the bottom edge.

188. Guildford from the Banks of the Wey *c.* 1807
 (Plate 180)
THE TATE GALLERY, LONDON (2310)

Mahogany veneer, $10 \times 7\frac{3}{4}$ (25×20); the painting has been restored on a tapering strip stretching about 6 (15) down the right-hand side, about $\frac{3}{4}$ (2) wide at the top.

Coll. Turner Bequest 1856 (one of 184–200*); transferred to the Tate Gallery 1910.

Exh. Whitechapel 1953 (74); R.A. 1974–5 (135).

Lit. Davies 1946, p. 189 n. 19; Gage 1969, p. 38.

The view has been identified by Christopher Pinsent, in letters of 1 January and 2 March 1970, as showing Guildford Castle and the eighteenth-century brick tower of Trinity church from the banks of the Wey near St Catherine's Chapel; there are chalk quarries on the right. There are related pencil drawings in the 'Wey, Guildford' sketchbook (XCVIII-111 verso, 112 verso and 113 verso).

189. A Narrow Valley *c.* 1807 (Plate 181)

THE TATE GALLERY, LONDON (2303)

Mahogany veneer, $8\frac{1}{8} \times 6\frac{1}{2}$ (20.5×16.5)

Coll. Turner Bequest 1856 (one of 184–200*); transferred to the Tate Gallery 1910.

Exh. Tokyo and Kyoto 1970–71 (35, repr.); Lisbon 1973 (1, repr.)

Lit. Davies 1946, p. 189 n. 19; Gage 1969, p. 38.

Christopher Pinsent identifies this as 'almost certainly another view of Guildford from the South' (letter of 2 March 1970). It is certainly similar in style to other sketches of Guildford, Nos. 187–8; like them it is dated *c.* 1809–10 by John Gage, but see p. 108.

190. Godalming from the South *c.* 1807 (Plate 175)

THE TATE GALLERY, LONDON (2304)

Mahogany veneer, $8 \times 13\frac{3}{4}$ (20 × 35)

Coll. Turner Bequest 1856 (one of 184–200*); transferred to the Tate Gallery 1910, returned to the National Gallery 1952, and to the Tate Gallery 1961.

Exh. R.A. 1974–5 (136).

Lit. MacColl 1920, p. 36; Davies 1946, p. 189 n. 19; 1959, p. 101; Gage 1969, p. 38.

Godalming is one of the places listed inside the front cover of the 'Wey, Guildford' sketchbook (XCVIII).

191. Newark Abbey *c.* 1807 (Plate 184)

THE TATE GALLERY, LONDON (2302)

Mahogany veneer, $11\frac{5}{8} \times 13\frac{7}{8}$ (29.5 × 35)

Coll. Turner Bequest 1856 (one of 184–200*); transferred to the Tate Gallery 1910.

Exh. Tate Gallery 1931 (71); Australian tour 1960 (2); Tokyo and Kyoto 1970–71 (34, repr.); Dresden (not in catalogue, repr.) and Berlin (3) 1972.

Lit. Davies 1946, p. 189 n. 19; Gage 1969, p. 38.

See also Nos. 65, 192 and 201. There are a number of pencil sketches of Newark Abbey on the Wey in the 'Wey, Guildford' sketchbook (XCVIII-105 verso, 107 verso and 108 verso).

192. Newark Abbey on the Wey *c.* 1807 (Plate 185)

THE TATE GALLERY, LONDON (2677)

Mahogany veneer, $14\frac{1}{2} \times 28\frac{15}{16}$ (37 × 73.5); an irre-

gular strip lower right, $\frac{7}{16} \times 4\frac{5}{8}$ (1 × 10.5), is a restoration

Coll. Turner Bequest 1856 (one of 184–200*); transferred to the Tate Gallery 1919.

Exh. Tate Gallery 1931 (64); Amsterdam, Berne, Paris, Brussels, Liege (8), Venice and Rome (9) 1947–8.

Lit. Davies 1946, p. 189 n. 19; Gage 1969, pp. 37–8.

See No. 191. Of the pencil drawings of Newark Abbey in the 'Wey, Guildford' sketchbook, XCVIII-108 verso is closest to this picture. There is a small damage lower left.

193. On the Thames? *c.* 1807 (Plate 183)

THE TATE GALLERY, LONDON (2307)

Mahogany veneer, $11\frac{5}{8} \times 13\frac{3}{4}$ (29.5 × 35); a wedge-shaped area lower left, $9 \times \frac{3}{4}$ (23 × 2), has been restored.

Coll. Turner Bequest 1856 (one of 184–200*); transferred to the Tate Gallery 1968.

Exh. Tate Gallery 1931 (67).

Lit. Davies 1946, pp. 155, 189 n. 19; 1959, pp. 101–2.

194. Sunset on the River *c.* 1807 (Plate 174)

THE TATE GALLERY, LONDON (2311)

Mahogany, $6\frac{1}{16} \times 7\frac{5}{16}$ (15.5 × 18.5)

Coll. Turner Bequest 1856 (one of 184–200*); transferred to the Tate Gallery 1910.

Exh. Norwich and V. and A. 1969–70 (39, repr. p. 21); R.A. 1974–5 (137).

Lit. Davies 1946, p. 189 n. 19; Gage 1969, p. 38.

Nos. 195–212: Miscellaneous, *c.* 1805–15

195. Windsor Park: Cows in a Woody Landscape *c.* 1805–7 (Plate 186)

THE TATE GALLERY, LONDON (5541)

Canvas mounted on pine, $18\frac{3}{4} \times 28\frac{1}{4}$ (47.5 × 71.5)

Coll. Turner Bequest 1856 (49, 'Windsor Park' $2'3\frac{3}{4}'' \times 1'6\frac{1}{2}''$; identified 1946 by chalk number on back); transferred to the Tate Gallery 1947.

Lit. Davies 1946, pp. 167, 186.

Fairly close in size and subject to No. 196, but the more

frontal composition and apparently (allowing for the differences in condition between the two pictures) tamer handling suggest a slightly earlier date, closer to *Cliveden on Thames*, possibly exhibited in Turner's gallery in 1807 (No. 66). There seems to be no reason to disregard the title 'Windsor Park' given in the inventory of the Turner Bequest, which was presumably based on some evidence now lost.

The picture is very dirty and has suffered losses along the joins of the supporting panel.

196. Cows in a Landscape with a Footbridge
c. 1805–7 (Plate 187)

THE TATE GALLERY, LONDON (4657)

Canvas, $18\frac{7}{8} \times 28$ (48×71)

Coll. Turner Bequest 1856; transferred to the Tate
Gallery 1938.

Exh. Arts Council tour 1952 (4).

Close in style and technique to the larger Thames
sketches of *c.* 1806–7. The subject and, in general terms
and in reverse, the composition were followed in a plate
in the first part of the *Liber Studiorum*, 'Bridge and
Cows', R. 2, published on 11 June 1807 and classified as
'P' for Pastoral (repr. Finberg 1924, p. 7; the pre-
liminary drawing, CXVI-A, and etching repr. p. 6). In
addition the rectangular form seen through the break in
the trees in the centre foreshadows another *Liber* plate,
'Solitude', R. 53, published 12 May 1814 and itself
developed in a much later oil painting, No. 515 (the
Liber plate, classified as 'E.P.' for 'Elegant [?] Pastoral',
in repr. Finberg 1924, p. 211).

197. Hurley House on the Thames *c.* 1807–9
 (Plate 188)

MRS M. V. GAIRDNER AND OTHERS

Canvas, $15\frac{1}{2} \times 27$ (39.4×68.5)

Coll. Painted for Thomas Wright of Upton; John
Miller of Liverpool; sale Christie's 22 May 1858
(241) bought Robertson; Sir Donald Currie by 1888;
by descent to the present owners; sale Sotheby's 17
July 1974 (37, repr. in colour) property of Major
F. D. Mirrielees's Will, bought in.

Exh. R.S.A. 1847 (158 lent by John Miller); Manches-
ter 1857 (272); Glasgow 1888 (97); Agnew 1967 (6).

Engr. By R. Wallis in the *Art Journal* 1854 and in the
Turner Gallery (1875 edn) as 'On the Thames'.

Lit. Armstrong 1902, p. 222 as 'Henley House on
Thames'; Rawlinson ii 1913, pp. 207, 214, 357, 410;
Finberg 1961, p. 515 no. 580a. Finberg is incorrect
in saying that this picture was in Viscount
Leverhulme's sale in New York in 1926. From the
photograph, the Leverhulme picture looks like a
copy based on the engraving of this picture.

In the text which accompanies the engraving in the
Turner Gallery Cosmo Monkhouse describes this scene
as 'the very place for a fine chub'. This may have
recommended it to Turner, who was a keen fisherman.
Hurley House, also known as Ladye Place, was
demolished in 1837 and, although there are at present
houses bearing both these names in Hurley, a village
between Marlow and Henley, neither is on the site of
the house which Turner painted.

Comparison with the small oil *Cliveden* in the Tate

Gallery (No. 66) reveals close similarities of handling,
especially in the sky and the foliage. This points to a
date of *c.* 1807 and therefore later than Armstrong and
Finberg (notes in the British Museum) suggest. This
picture may even be a year or two later than 1807, for
now that the *Cockermouth Castle* at Petworth (see No.
108), which is documented to 1809–10, has been
cleaned, the stylistic affinities between the two pictures
can be seen to be very close.

198. On the River Brent *c.* 1807–9 (Plate 189)

PRIVATE COLLECTION

Canvas, $14\frac{3}{4} \times 27$ (37.5×68.6)

Coll. Thomas Griffith, Turner's dealer; 'Mr. Brooks' of
the St. James's Gallery, Regent Street; sale Christie's
29 April 1871 (121 repr.; this catalogue gives the
Griffith provenance) bought Cox; Adamson, accord-
ing to Armstrong who states that it was bought in at
his sale at Christie's in 1874 (I have been unable to
trace an Adamson sale in 1874 although J. W.
Adamson had sales on 10 May 1875 and 7 May 1887
which included a number of English landscapes but
no Turner among them); A. M. Wilson; sale
Christie's 3 April 1914 (26) bought Agnew and sold
to Major (later Sir) Stephen Courtauld; bequeathed
by Lady Courtauld to the present owners.

Lit. Armstrong 1902, p. 219.

Armstrong does not give any size for the picture, nor
does he suggest a date. Comparison with No. 197,
Hurley House on Thames, of similar dimensions, reveals
close stylistic affinities and therefore points to a date of
c. 1807–9. In particular, the painting of the sky is very
similar and the touches of bright local colour which are
provided in *Hurley House* (and in the *Cockermouth
Castle* No. 108) by the washing drying on the bank, are
matched in this picture by the colour of the water-lilies
and of the flowers growing along the river banks. These
in turn have much in common with the plants in the
foreground of *Pope's Villa at Twickenham* (see No. 72),
exhibited in 1808. This picture also shows some
affinities with the work of Peter de Wint (1784–1849)
whose first exhibits in oil at the R.A. had been shown in
1807.

A watercolour of this subject and of virtually
identical size was sold at Foster's 1 June 1864 (121),
property of Henry James Wheeler. Although it fetched
a very high price of 1,350 guineas it appears to have
been bought in (or perhaps bought by a member of the
family) as it was lent to the R.A. Winter Exhibition in
1887 (63) by Alfred L. Wheeler. Armstrong dates the
watercolour *c.* 1820 while the R.A. catalogue suggests
c. 1825; from the description that they give, it would
seem that the oil and the watercolour must have been
very similar in composition: for instance both feature
the moorhen scudding along the water, although the
watercolour included, on the left, a woman with a

basket on her head who does not appear in the oil. It seems possible that the watercolour (now untraced) was a good deal closer in date to the oil than is suggested above. The painting of a subject in both oil and watercolour is of course common in Turner's oeuvre, but to do so on an identical scale is certainly not and this may be one of the only two known examples, the other being the two versions of *Bonneville* (see No. 148) which are also virtually the same size.

199. A Valley between Hills *c*. 1807 (Plate 190)

IAN GREENLEES ESQ

Paper, $5\frac{1}{2} \times 9$ (14 × 22·8)

Coll. John Edward Taylor (1830–1905); sale Christie's 5 July 1912 (99) as 'A Valley Scene' bought Wallis; bought from Knoedler by Agnew in 1939 and sold to the present owner in 1941.

When sold in 1941 the picture was entitled 'Wharfedale' and dated *c*. 1816. It is clearly earlier than this, and must certainly precede the Devonshire oil sketches of 1813 (Nos. 213–25) by several years. It may date from *c*. 1807 and certainly has the look of having been done on the spot. There are similarities in the tonality and in the rather dry handling between it and a sketch in the Tate Gallery, *Godalming from the South* (No. 190). There seems no evidence for calling it 'Wharfedale' and this title and the later dating may both derive from an attempt to connect it with a visit to Farnley, although it remains perfectly possible that it does show a view in Yorkshire, painted on an earlier trip to the north.

200. Cattle in a Stream under a Bridge *c*. 1805–7
(Plate 191)

THE TATE GALLERY, LONDON (5534)

Mahogany, $12\frac{3}{8} \times 15\frac{1}{2}$ (31·5 × 40)

Coll. Turner Bequest 1856 (278, one of '37 Pictures various'; identified by chalk number on back, see No. 23); transferred to the Tate Gallery 1947.

Lit. Davies 1946, pp. 166, 191.

Very dirty and with considerable losses of paint, this unambitious picture probably dates from about the same time as No. 195; it lacks the freedom of the Thames sketches of *c*. 1807 and other landscapes of later in the decade.

201. Newark Abbey *c*. 1807–8 (Plate 192)

THE LOYD COLLECTION

Panel, 11 × 18 (27·9 × 45·7)

Coll. The Rev. Dr Thomas Lancaster, Perpetual Curate (1801–27) of Merton, Surrey; John Pye (1782–1874),

who engraved a number of plates after Turner between 1810 and 1845; sale Christie's 20 May 1874 (39) bought Agnew from whom bought by Lord Overstone; by descent to the present owner.

Lit. G. Redford, *Descriptive Catalogue of the Pictures at Lockinge House* (Lord Overstone's Collection) 1875, p. 30 no. 45; Armstrong 1902, p. 226 (who dates it 1815); Temple 1902, p. 161 no. 242; Parris 1967, p. 41 no. 59 repr.

It seems likely that the statement in the catalogue of John Pye's sale in 1874 that the picture was painted for the Rev. Lancaster is true. There are two references to the Rev. Mr Lancaster in Turner's sketchbooks: p. 52 of the 'Hereford Court' sketchbook (XXXVIII) shows a view of Conway Castle and on the reverse Turner has written 'Revd Mr. Lancaster, 45 Gower Street', and on p. 66 verso of the 'Academies' sketchbook (LXXXIV) another note by Turner shows that he has painted (or is painting) a small view of Conway for 'Rd. Mr. Lancaster' probably in oil as it is bracketed with 'Tummel B' which possibly refers to the panel now belonging to Mr and Mrs Paul Mellon (No. 41).

As well as the large picture in the collection of Mr and Mrs Paul Mellon (No. 65), two oil sketches of Newark Abbey are in the Tate Gallery (Nos. 191 and 192). The problems of dating these small oil sketches, as well as the larger canvases of similar subjects in the Turner Bequest, are still far from being solved and are discussed in more detail on p. 108.

Gage (1969, pp. 36–9) suggests a division of the sketches into three groups and includes the studies of Newark Abbey in the earliest group which he dates tentatively to 1809–10. Although in my opinion the dating *en bloc* in the past of all these sketches to 1807 may need some revision, Gage's division of the sketches into three groups, quite widely separated in date, seems so far unconvincing. The rather dark tonality of this picture and the comparatively tight handling suggest a dating of 1807–8 as perhaps the most likely and there seems to be no reason to assume a date very different from the Mellon picture which was possibly exhibited in 1807.

202. Windsor Forest: Reaping *c*. 1807 (Plate 176)

THE TATE GALLERY, LONDON (4663)

Oak, $35\frac{7}{16} \times 48$ (90 × 122)

Coll. Turner Bequest 1856; transferred to the Tate Gallery 1938.

Exh. R.A. 1974–5 (147).

Very similar to the large Thames sketches (Nos. 160–76) but painted on wood instead of canvas; this presumably must have been painted indoors. In the related pen and wash drawing in the British Museum (CXX-D) the building in the background could well be

Windsor Castle, but that in the oil has been identified as
the Cranbourne Tower in Windsor Great Park.

203. Gipsy Camp *c.* 1807 (Plate 193)

THE TATE GALLERY, LONDON (3048)

Oak, 48 × 36 (122 × 91·5)

Coll. Turner Bequest 1856 (? 265, '1 (panel upright)'
 4′0″ × 3′0″); transferred to the Tate Gallery 1922.

Lit. Rothenstein 1949, p. 6, colour pl. 3.

Close in style, technique and its wooden support to
Windsor Forest: Reaping (No. 202) and like it probably
close in date and intention to the large Thames sketches
on canvas (Nos. 160–76), though presumably definitely
painted indoors. It is also close to *The Quiet Ruin* (No.
83) and *Sketch of a Bank, with Gipsies* (No. 82), which
were probably exhibited in Turner's gallery in 1809. As
in these, the cows are probably based on studies in the
'Cows' sketchbook (LXII).

204. The Thames at Weybridge *c.* 1807–10
 (Plate 212)

H.M. TREASURY AND THE NATIONAL TRUST (Lord Eg-
remont Collection) PETWORTH HOUSE

Canvas, 35 × 47 (88·9 × 119·4)

Coll. Bought by the third Earl of Egremont, possibly
 from Turner's gallery *c.* 1807 but in any case he
 owned it by 1819 (see below); by descent to the third
 Lord Leconfield who in 1947 conveyed Petworth to
 the National Trust; in 1957 the contents of the State
 Rooms were accepted by the Treasury in part
 payment of death duties.

Exh. Tate Gallery 1951 (2).

Engr. By W. Say in the *Liber Studiorum* under the title
 'Isis' published 1 January 1819, 'Picture in the
 Possession of the Earl of Egremont' (Rawlinson 68).

Lit. Petworth Inventories 1837, 1856 (North gallery);
 Waagen 1854, iii, p. 39; Thornbury 1862, ii, pp. 5,
 397; 1877, pp. 199, 200, 202, 594; Armstrong 1902,
 p. 236 (dated *c.* 1810); Collins Baker 1920, p. 125
 no. 5; Finberg 1924, p. 271; 1961, pp. 196, 475 no.
 182.

The *Liber Studiorum* drawing is in the British Museum,
Vaughan Bequest (CXVIII-N) where it is dated *c.* 1810
by Finberg. A number of drawings connected with this
picture are in the 'Studies for Pictures; Isleworth'
sketchbook (XC pp. 6, 9, 29 and 31; that on p. 29
includes a reclining figure, an idea Turner evidently
later abandoned in favour of the peacock; the drawing
on p. 8 verso may also be connected). In his 1909
Inventory Finberg originally dated this sketchbook
1805–6 but later corrected this to 1811–12 in his *Life of*

J. M. W. Turner. While the presence of sketches for
Mercury and Herse (No. 114) exhibited in 1811, suggests
support for Finberg's second thoughts, the truth is
probably that the book, as was often the case, may have
been in use over a period of time, for there is also a
watercolour study for *Windsor Castle from the Thames*
(see No. 149) which can be fairly certainly dated on
stylistic grounds to *c.* 1804–6. No details of which
pictures were shown at Turner's gallery in 1813 have
survived so that Finberg's suggestion that this picture
was included remains pure guesswork, based largely on
his dating of the sketchbook already mentioned and the
fact that Turner was living at Isleworth from 1811–13.
Now, however, that we know (see entry for No. 149)
that he used this address as early as 1805, the brackets
for dating this picture become much wider. On stylistic
grounds affinities with other river scenes such as *On the
Brent* (No. 198) and *Pope's Villa at Twickenham* (No. 72)
support a dating of 1807–10. (For instance, the painting
of the flowers and foliage in the foreground in all three
pictures is particularly close.) As we know to a great
extent the pictures shown in Turner's gallery in 1808
and all those shown in 1809 and 1810, this may even
have been shown as early as 1807 and be amongst the
views on the Thames which disgusted Benjamin West
so much on his visit to the exhibition in that year.

It appears to be uncertain when this picture first
received its present title but it is listed as such both by
Waagen and in the 1856 Petworth Inventory. Mr
Edward Croft-Murray has suggested that it may be a
view along the river from Isleworth, with the battle-
mented corner of Syon House visible between the
trees at the left. This seems a more likely possibility
than the traditional identification but the view may be
to some extent a 'capriccio'.

205. 'The Leader Seapiece' *c.* 1807–9 (Plate 195)

PRESENT WHEREABOUTS UNKNOWN

Size unknown

Coll. William Leader by 1809, when the *Liber
 Studiorum* engraving was published (see below);
 otherwise there is no record of this picture. The
 lettering on the print implies that the oil was painted
 for W. Leader.

Engr. By Charles Turner in the *Liber Studiorum*
 (Rawlinson 20) published 29 March 1809. The
 lettering of the first state reads: 'Original sketch of a
 Picture for W. Leader Esq.' The etching is lettered
 'Possession of Wm. Leader Esqr'. The drawing is in
 the Turner Bequest (CXVI-X); it shows only the
 two main ships, the two distant ones shown in the
 print being later additions.

Lit. Finberg 1924, pp. 79–80.

Evidence for the existence of this picture rests solely on
the inscription on the *Liber* print. On the other hand,

the name 'Leader' appears several times in Turner's notebooks in his hand: twice in connection with the oil of *Conway Castle* (No. 141, sold in 1840 at auction by William Leader's son, J. T. Leader, but there is no trace of another Turner oil in the sale, nor in the later J. T. Leader sale at Christie's in March 1843), once as a subscriber to the print of *The Shipwreck* (No. 54) and once in the 'Finance' sketchbook (CXXII) in some calculations of Turner's accounts dated '9 Sep. 1812'. Also in the 'Liber Notes (2)' sketchbook (CLIV(a)) Turner twice includes this amongst a list of engraved subjects, referring to it simply as 'Leader' or 'Leaders'.

206. Gravesend *c*. 1807–10? (Plate 194)

PRESENT WHEREABOUTS UNKNOWN

Canvas, 45 × 60 (114·3 × 152·4)

Coll. In Turner's studio, December 1810; ? in the collection of Charles Borrett in 1862 (see below).

Lit. ?Thornbury 1862, ii, p. 398; ? 1877, p. 595; C. Hussey, 'Tabley House II' *Country Life* liv 1923, pp. 117–18; Finberg 1961, p. 173.

This picture is referred to in a letter from Turner, written on 12 December 1810, to Sir John Leicester who had evidently asked Turner what seascapes he had available. Turner's letter contains at the top four small pen sketches to remind Sir John of the only paintings that would seem to answer his requirements. No. 3 is entitled: 'Gravesend—5 ft. long 3¾ high. This wants lining and a week's work.' It is based on a drawing on p. 63 verso of the 'River and Margate' sketchbook (XCIX), dated by Finberg 1806–8.

Apart from this letter the only possible reference to this picture occurs in Thornbury's Appendix listing Turners in various private collections. Among those belonging to 'Charles Borrett, Esq., in Queen Anne Street' appears 'The Thames at Gravesend' which seems to refer to an oil rather than to a watercolour but no subsequent trace of the picture has come to light.

So far as dating goes, if it was already in need of lining in 1810, it must presumably date from rather earlier, although it is difficult to be dogmatic about this as Turner seems to have considered lining almost a prerequisite of pictures leaving his studio (see his letter to Griffith of February 1844 quoted in the entry for No. 372).

207. An Artists' Colourman's Workshop *c*. 1807
(Plate 196)

THE TATE GALLERY, LONDON (5503)

Oil, 24½ × 36 (62 × 91·5) on pine, 24½ × 37⅞ (62 × 95)

Inscr. 'OLD MASTERS' on book above door centre right and illegibly on vat lower left.

Coll. Turner Bequest (? 271, '1 (Panel' 3′1¾″ × 2′1″); transferred to the Tate Gallery 1947.

Lit. Davies 1946, pp. 161–2.

This unfinished painting was tentatively identified by Martin Davies as showing 'The Faker's Studio (?)'. However, Stefan Slabczynski, former Keeper of Conservation at the Tate Gallery, has pointed out that the man in the centre is grinding red pigments on a marble slab while a horse-driven wheel is grinding colours more coarsely behind; the various jars and vats are filled with paints or media.

The picture was painted on three rough planks of pine, the back having been gouged out to take a cross-bar, rather than on a specially prepared artists' panel. On each side, though not at top or bottom, there is a ¾ in. strip of bare wood, without ground or paint, suggesting that there were framing members there when the picture was painted. It is probable, therefore, that Turner used part of a door or panelling for this work.

Though unfinished and a bit larger, the painting is close in style and technique to *A Country Blacksmith* exhibited in 1807 (No. 68). *The Garreteer's Petition*, exhibited two years later, already seems to be somewhat later in style (No. 100).

208. Tabley House 1808 (Plate 198)

THE BRITISH MUSEUM, LONDON (CIII-18)

Oil and gum arabic on paper, 9 × 11¾ (22·7 × 29·6)

Coll. Turner Bequest 1856.

Exh. R.A. 1974–5 (118).

Lit. Finberg 1961, p. 151; Gage 1969, p. 36.

From the 'Tabley' sketchbook (CIII), used when Turner stayed at Tabley House, the home of Sir John Leicester, in the summer of 1808. This oil sketch was worked up from the pencil drawing on pages 15 verso and 16 of the same sketchbook.

The sketch has been cut out of the sketchbook and folded as if for despatch through the post, though presumably it remained in Turner's possession. Alternatively, as Finberg suggests, the sketch may have been sent to Sir John Leicester for approval and subsequently returned. In the event, when Turner came to paint the two large pictures of Tabley exhibited in 1809 (Nos. 98 and 99) he introduced the large water-tower that he had apparently deliberately omitted in the sketch.

209. Harvest Home *c*. 1809 (Plate 197)

THE TATE GALLERY, LONDON (562)

Pine, 35⅝ × 47⅞ (90·5 × 120·5); there is an additional strip of unpainted panel, ½ (1·5) along the top edge

Coll. Turner Bequest 1856 (260, '1 (Harvest Home) panel' 4′0″ × 3′0″); transferred to the Tate Gallery 1905.

Exh. Tate Gallery 1931 (31).

Lit. Thornbury 1862, i, pp. 289, 349; 1877, pp. 425, 467; Eastlake 1895, i, pp. 188–9; Armstrong 1902, p. 222; MacColl 1920, p. 27; Davies 1946, p. 190.

Probably the picture seen by Elizabeth Rigby, later Lady Eastlake, in Turner's studio on 20 May 1846; 'a picture in Wilkie's line—a harvest feast—painted the same year as Wilkie's 'Rent Day', and showing most astonishing powers and truth; but he [Turner] was disgusted at some remarks, and never finished it.' Wilkie's *The Rent Day* is dated 1807 and was exhibited at the R.A. in 1809 (see exh. cat. *Sir David Wilkie R.A.* 1958, p. 15 no. 9).

There are a number of related drawings both for the composition and for individual figures or groups of figures in the 'Harvest Home' sketchbook (LXXXVI-2, 3, 4 verso, 5 and 6).

210. The Wreck of a Transport Ship *c.* 1810

(Plate 215)

THE FUNDAÇAO CALOUSTE GULBENKIAN, LISBON

Canvas, 68 × 95 (172·7 × 241·2)

Coll. Bought in 1810 by the Hon. Charles Pelham (1781–1846) who succeeded his father as Lord Yarborough in 1823, and was created first Earl Yarborough in 1837; bought by C. S. Gulbenkian (*d.* 1955) from the Yarborough Collection in 1920 through A. Ruck.

Exh. B.I. *Old Masters* 1849 (38); R.S.A. 1851 (306); Manchester 1857 (208); R.A. 1875 (158); Grosvenor Gallery 1888 (159); Glasgow 1888 (333); Guildhall 1892 (73); R.A. 1894 (135) and 1901 (66); R.A. 1968–9 (160); Lisbon 1973 (5); R.A. 1974–5 (83).

Engr. By T. O. Barlow, R.A.

Lit. Burnet and Cunningham 1852, pp. 27, 28, 44, 75, 77–8; Waagen 1854, ii, p. 87; 1857, iv, p. 70 as 'Wreck of ... the Minotaur', dated 1810; the picture was not hanging at the time of Waagen's visit in 1854 as it was in the hands of the engraver; Ruskin 1856 (1903–12, xiii, p. 47); Thornbury 1862, i, pp. 266, 267, 290; ii, p. 397; 1877, pp. 421–3, 424, 426–7, 594; Monkhouse 1879, p. 50; Armstrong 1902, pp. 59, 137, 230; W. L. Wyllie, *Life of J. M. W. Turner* 1905, p. 48; Boase 1959, pp. 338–9, pl. 33a; Finberg 1961, pp. 167–8, 171, 425–6, 472 no. 152, 511 no. 584, 516 no. 594; Rothenstein and Butlin 1964, p. 30, pl. 45; Lindsay 1966, pp. 106–7, 156; Gaunt 1971, colour pl. 5; Herrmann 1975, pp. 13, 227, pl. 32.

There has been much confusion over the title of this picture, which was often called 'The Wreck of the Minotaur'. In 1851 it was exhibited at the R.S.A. as 'The Wreck of Minotaur, Seventy-four, on the Haak Sands, 22nd December 1810', and the catalogue stated that it was painted 1811–12. However, when exhibited at the British Institution two years earlier, it was titled as above. There seems no reasonable explanation why the title should have been changed although both exhibitions took place in Turner's lifetime. Both exhibition catalogues agree, however, in saying that the picture was 'painted for the father of the Earl of Yarborough,' and Burnet, writing in 1852, states that Lord Yarborough bought it in 1810.

Armstrong follows the 1851 title and identifies it with the wreck of the *Minotaur* which resulted in the loss of 570 out of 680 on board. In the 1939 edition of his life of Turner, Finberg thought it probable that the picture had been exhibited in Turner's gallery in 1810 and therefore could not represent the wreck of the *Minotaur* which did not occur until December. Finberg also stated, erroneously, that the picture had been destroyed. The subsequent discovery of a catalogue of the pictures shown in Turner's gallery in 1810 shows that this was not among them. In Finberg's papers in the British Museum, there is a note that, when in the engraver's hands, the picture was said to depict the wreck of a British seventy-four which took place off the Dutch coast about 1800.

However, in notes of Turner's accounts in both the 'Finance' (CXXII) and 'Hastings' (CXI) sketchbooks, there is a record of a purchase of consols on 25 May 1810 with the name Pelham against it, indicating that Turner had received 300 guineas from a purchaser of this name. Although this is less than the 400 guineas paid in 1804 for *Macon* (No. 47), a picture of comparable size (but see note in the entry for *Macon* about the price), there is no other candidate for the Pelham picture and it therefore seems almost certain that it had been sold by May 1810 and that therefore the 1849 title was correct. Furthermore two small pen and ink studies, which were used for the composition, occur in the 'Shipwreck No. 1' sketchbook (LXXXVII pp. 8 and 23) which also includes a list of subscribers to the engraving of *The Shipwreck* (No. 54), issued in 1806 (among them The Hon. Mr Pelham). This suggests that these drawings also date from *c.* 1806 which effectively rules out their having any connection with the wreck of the *Minotaur* in December 1810. Dated *c.* 1805–10 in the catalogue of the Turner Bicentenary Exhibition, the handling, which is noticeably looser than in *The Shipwreck*, suggests that a date close to 1810 is more convincing.

A number of replicas exist as well as some sketches deriving from the composition. These are listed and discussed in an article by J. M. Jacob in the *York Art Gallery Preview* x, no. 39, July 1957. In the compiler's opinion, the sketch at York is certainly not by Turner, and that in the City Art Gallery, Auckland—to judge from a photograph—is very doubtful.

This picture marks the culmination of a decade of painting grand seapieces, beginning with the *Bridge-water Seapiece* (No. 14). In this case the whirlpool-like composition anticipates much later canvases. In fact, with the exception of the *Entrance of the Meuse* (No. 139) shown at the R.A. in 1819, Turner did not return to the theme of the sea, at any rate in the case of his pictures painted for exhibition purposes, until the late 1820s.

The picture was highly praised when shown at the British Institution in 1849, although the critic of the *Spectator* for 16 June compared it unfavourably with the *Macon* and saw in it 'a partial foretaste of that dissolution which now decomposes all Turner's works even before they reach the canvas.'

The *Athenaeum* for the same date wrote that 'For the credit of England and of Mr. Turner let it be said that the picture in this assemblage of most excellence and interest is from his hand' (the exhibition included among others pictures by Cuyp, Claude, and both Poussins). '. . . The picture is a great conception of an appalling event . . . The deep tragedy of the scene is rendered in the sublimest poetry of the art.'

After the exhibition closed, the *Spectator*, 24 November, noted that 'the collection of Old Masters have been detained and copied by students of both sexes . . . and now the copies are exhibited with the originals . . . of his [Turner's] turbulent *Shipwreck* there are thirteen copies.'

Lady Trevelyan (wife of Sir Charles Trevelyan, and Lord Macaulay's sister), who saw the picture when exhibited in Edinburgh in 1851, wrote '. . . one of the most sublime and awful pictures that ever came from mortal hand . . . the dread reality seems before us.' And Burnet and Cunningham record that it was on looking at this picture at the British Institution that Admiral Bowles said 'No ship or boat could live in such a sea.'

211. Rosehill Park, Sussex *c.* 1810 (Plate 213)

LT. COL. SIR GEORGE MEYRICK, BT, BODORGAN, ANGLESEY

Canvas, 35 × 47 (88·9 × 119·5)

Signed 'J M W Turner R A [?] P P' lower left

Coll. Almost certainly painted for the owner of Rosehill, John Fuller, M.P. for Sussex (*d.* 1834); his son, Augustus Elliott Fuller, married Clara Meyrick, heiress of Bodorgan; their son Owen assumed the surname of Meyrick in addition to that of Fuller by Royal Licence on 6 May 1825 and died in 1876; by descent to the present owner.

However, the catalogue of the Turner Bicentenary Exhibition quotes the tradition in the Meyrick family that the picture was not acquired from Turner until much later when he brought it to Bodorgan and sold it to Owen Fuller Meyrick for as much as 1,000 guineas. Turner is said to have asked for half a guinea for his cab fare as well, which would date the visit to

about 1849 when the railway to Anglesey was opened.

This story seems implausible on several counts. The price seems entirely out of scale with those asked by Turner even at that date; by 1849 his failing health must have made him very reluctant to undertake such a journey, and Burnet and Cunningham specifically state that it was after delivering a picture to *John* Fuller that Turner asked for his cab fare as well (see No. 105).

Exh. National Museum of Wales and Glyn Vivian Art Gallery, Swansea *Pictures from Welsh Private Collections* 1951 (55); R.A. 1974–5 (142).

A small but accurate pencil study for the picture occurs on pp. 20 verso–21 (composition continued on p. 22) of the 'Hastings' sketchbook (CXI), dated 1809–11 by Finberg who catalogued the drawing merely as 'View on the Sussex Downs'.

Although no commission for this picture is recorded, a visit by Turner to Rosehill is documented in Farington's *Diary* for 21 April 1810. Farington records that Fuller had engaged Turner 'to make drawings of three or four views. He is to have 100 guineas for the *use* of his drawings, which are to be returned to him.' The terms of this commission must have been altered or extended later for Fuller finally owned thirteen Turner watercolours. A pencil drawing of Rosehill occurs in the 'Hastings 2' sketchbook (CXXXIX pp. 33 verso–34) watermarked 1815, which certainly suggests a further visit or visits, and other Turner watercolours which belonged to Fuller (including one of Rosehill itself now in the British Museum: R. W. Lloyd bequest 1958-7-12-411) are datable to 1816. This picture must therefore have been painted between 1810 and 1816; the Turner Bicentenary Exhibition catalogue suggested *c.* 1810-15. On stylistic grounds it would seem closer to the two views of *Lowther Castle* (Nos. 111 and 112, R.A. 1810) and to the *Somer Hill* (No. 116, R.A. 1811—especially in the painting of the sky) than to the *Raby Castle* (No. 136) of 1818. Indeed, the absence of human figures, a rarity in Turner's work which does, however, occur around 1810, points to a dating around then, although similarities with the Sussex watercolours certainly does not rule out the possibility of it being rather later. It was in 1810 that Fuller bought his other oil by Turner, the *Fishmarket on the Sands, Hastings* (No. 105) and there are several references to payments from Fuller in Turner's sketchbooks in use at this time. It seems possible that an outstanding amount of £200, which it appears Fuller owed Turner at the end of 1810, refers to the oil of *Rosehill*.

Rosehill Park (now renamed Brightling Park) is in East Sussex, about four miles from Battle. It was bought in 1697 by John Fuller's ancestor and later passed by inheritance to Sir Alexander Acland Hood, Bt, on whose death in 1908 the Turner watercolours and the oil of *Hastings* were dispersed at Christie's.

212 Mountain Stream *c.* 1810–15 (Plate 199)

THE TATE GALLERY, LONDON (561a)

Oil over pencil on paper, $17\frac{5}{8} \times 23\frac{1}{4}$ (44·5 × 59)

Watermarked 'WHATMAN 1801'

Coll. Turner Bequest 1856; transferred to Tate Gallery 1910.

Exh. On loan to the National Museum of Wales 1964–75.

Lit. Armstrong 1902, p. 225; MacColl 1920, p. 27.

Dated *c.* 1810 by MacColl and close in its subject and technique, allowing for the change in medium, to the watercolours of Yorkshire scenes painted for Walter Fawkes *c.* 1809–18. The drawing with the brush-handle in the wet paint to indicate the branches of the trees on the far side of the stream parallels that on one of the earliest of the group of watercolours, *Bolton Abbey, Wharfedale*, signed and dated 1809 (British Museum 1910-2-12-282; repr. Butlin 1962, colour pl. 4, and exh. cat., B.M. 1975, p. 42 no. 39). The composition resembles such watercolours as *A Rocky Pool with Heron and Kingfisher* in Leeds City Art Gallery (repr. exh. cat., R.A. 1974–5, p. 82 no. 193, where dated ? *c.* 1818, but perhaps a bit earlier). In addition there are a number of sketches of similarly rugged river scenery, some even with tiny figures of fishermen as in this work, in the 'Yorkshire 4' and 'Yorkshire 5' sketchbooks of *c.* 1816 (CXLVII and CXLVIII).

Nos. 213–25: Devonshire Oil Sketches, *c.* 1813

THIS group of oil sketches on paper of Devonshire subjects has always been associated with Turner's second visit to Devon. His first had been in the summer of 1811 and the second is dated by Finberg to the summer of 1813; the chief evidence lies in the later account of Cyrus Redding, whose reference to the visit of the singer Madame Catalani to Saltram can presumably be linked with her known appearances at Exeter and Truro in August 1813. The same journey lay behind Turner's *Crossing the Brook*, exhibited in 1815 (see No. 130).

Redding describes a picnic on the heights of Mount Edgecumbe at which 'Turner showed the ladies some of his sketches in oil, which he had brought with him, perhaps to verify them'. This could suggest that they had been executed indoors, but on the other hand, as Evelyn Joll has pointed out, Turner may have painted them on a previous excursion and now wished to check the exact locations. Indeed, another companion, Charles (later Sir Charles) Eastlake, told Thornbury how, when Turner 'returned to Plymouth, in the neighbourhood of which he remained some weeks, Mr. Johns [Ambrose Johns, 1776–1858, a local landscape painter] fitted up a small portable painting-box, containing some prepared paper for oil sketches, as well as the other necessary materials. When Turner halted at a scene and seemed inclined to sketch it, Johns produced the inviting box, and the great artist, finding everything ready to his hand, immediately began to work. As he sometimes wanted assistance in the use of the box, the presence of Johns was indispensible, and after a few days he made his oil sketches freely in our presence. Johns accompanied him always; I was only with them occasionally. Turner seemed pleased when the rapidity with which those sketches were done was talked of; for, departing from his habitual reserve in the instance of his pencil sketches, he made no difficulty of showing them. On one occasion, when, on his return after a sketching ramble, to a country residence belonging to my father near Plympton, the day's work was shown, he himself remarked that one of the sketches (and perhaps the best) was done in less than half an hour.

'When he left Plymouth, he carried off all the results. We had reckoned that Johns who had provided all the materials, and had waited upon him devotedly, would at least have had a present of one or two of the sketches. This was not the case; but long afterwards, the great painter sent Johns in a letter a small oil sketch, not painted from nature, as a return for his kindness and assistance [see No. 225]. On my inquiring afterwards what had become of those sketches, Turner replied that they were worthless, in consequence, as he supposed of some defects in the preparation of the

paper; all the grey tints, he observed, had nearly disappeared. Although I did not implicitly rely on that statement, I do not remember to have seen any of them afterwards.' These sketches are presumably Nos. 213–25.

Although the support is described by Finberg as prepared board it seems rather to be a heavy paper, prepared on one side with an oil medium. In one case there is an unfinished composition on the unprepared verso (No. 214); in another, Turner's only sketch is on the unprepared side of the paper (No. 220). According to Finberg the reverse of No. 213, which is now stuck down, bears the printed title of what seems to be the 1808 Prospectus for *The British Gallery of Pictures*, not finally published until ten years later but for which J. Fittler engraved the *Bridgewater Seapiece* (No. 14) with the date 1 July 1812. This suggests that Turner, or rather Johns, may have torn suitably blank areas of paper from this publication and then prepared them for the sketches. All the sheets except No. 217 measure approximately the same size, the exception being double that size, and most seem to have been torn down the left-hand edge as if from a book. However, No. 213 is on a paler toned paper than the rest, which may therefore come from another source.

Lit. Cyrus Redding, *Fifty Years' Recollections* 1858, i, pp. 199–205; Thornbury 1862, i, pp. 219–20; 1877, p. 153; Finberg 1909, i, pp. 364–5; 1961, pp. 197–203; Gage 1969, pp. 38–9.

213. A Village in a Hollow 1813 (Plate 200)

THE BRITISH MUSEUM, LONDON (CXXX-A)

Oil on black chalk, approx. $6 \times 9\frac{1}{4}$ (15 × 23.5), on prepared paper, sight $6\frac{1}{2} \times 9\frac{1}{2}$ (16.5 × 24)

Coll. Turner Bequest 1856.

According to Finberg 1909, p. 364, the following inscription is printed on the back of the paper (see above):

> The British Gallery of Pictures.
> The historical part by
> William Young Ottley, Esq., F.S.A.
> The descriptive part by
> Henry Tresham, Esq., R.A., and W. Y. Ottley, Esq.
> And the executive part under the
> management of
> P. W. Tomkins—

214. Recto: Landscape with a Bridge and a Church Tower Beyond 1813 (Plate 201)
 Verso: **Landscape Study** 1813

THE BRITISH MUSEUM, LONDON (CXXX-B)

Recto: Oil over black chalk, framing line approx. $5\frac{1}{2} \times 9\frac{1}{4}$ (14 × 23.5), on prepared paper, $5\frac{13}{16} \times 10\frac{1}{16}$ (14.7 × 25.5). Verso: Oil, approx. $6\frac{1}{2} \times 5\frac{1}{2}$ (16.5 × 14) on unprepared side of paper.

Inscr. '8' and '1' on verso
 a

Coll. Turner Bequest 1856.

Repr. Rothenstein and Butlin 1964, colour pl. vi (recto).

The sketch on the back is a very rough, upright landscape composition.

215. Falmouth Harbour 1813 (Plate 203)

THE BRITISH MUSEUM, LONDON (CXXX-C)

Oil, framing line approx $6\frac{1}{4} \times 9\frac{1}{4}$ (16 × 23.5), on prepared paper, $6\frac{7}{16} \times 10\frac{1}{8}$ (16.3 × 25.7)

Coll. Turner Bequest 1856.

Exh. Berlin (48); Lisbon 1973 (16, repr.); R.A. 1974–5 (124).

216. A Quarry 1813 (Plate 204)

THE BRITISH MUSEUM, LONDON (CXXX-D)

Oil, framing line approx. $5\frac{1}{4} \times 9\frac{1}{4}$ (13.5 × 23.5), on prepared paper, $5\frac{13}{16} \times 10\frac{1}{8}$ (14.7 × 25.7)

Coll. Turner Bequest 1856.

Exh. Berlin 1972 (49); Lisbon 1973 (15, repr.); R.A. 1974–5 (125).

Listed by Finberg as 'A Mountain Side'.

217. A River Valley 1813 (Plate 209)

THE BRITISH MUSEUM, LONDON (CXXX-E)

Oil, framing line approx. $9\frac{1}{4} \times 11\frac{3}{4}$ (23.5 × 29.8), on prepared paper, $9\frac{5}{8} \times 12$ (24.5 × 30.5)

Coll. Turner Bequest 1856.

Exh. Berlin 1972 (50); Lisbon 1973 (17, repr.); R.A. 1974–5 (126, repr.); Leningrad and Moscow 1975–6 (11).

Twice the size of the other Devonshire sketches, which were perhaps painted on similar sheets of paper torn in half. The composition and treatment are more elaborate.

218. A Bridge with a Cottage and Trees beyond
1813 (Plate 210)

THE BRITISH MUSEUM, LONDON (CXXX-F)

Oil over black chalk, framing line approx. $5\frac{7}{8} \times 9\frac{1}{4}$ (15×23.5), on prepared paper, $6\frac{5}{16} \times 10\frac{1}{4}$ (16×26)

Coll. Turner Bequest 1856.

Exh. Paris 1972 (289a); *Turner and Watercolour* Arts Council tour, April–September 1974 (13, repr.).

For another view of the same bridge see No. 223, and perhaps No. 221.

219. A River with Distant Town 1813 (Plate 205)

THE BRITISH MUSEUM, LONDON (CXXX-G)

Oil, framing line approx. $5\frac{3}{4} \times 9\frac{1}{4}$ (14.5×23.5), on prepared paper, $6\frac{1}{8} \times 10\frac{1}{8}$ (15.5×25.7)

The composition is more deliberately picturesque than the other Devonshire sketches.

220. A Distant Town, perhaps Exeter 1813
 (Plate 206)

THE BRITISH MUSEUM, LONDON (CXXX-H)

Oil approx. $4 \times 9\frac{1}{4}$ (10×23.5), on paper, irregular, $6\frac{5}{16} \times 10\frac{1}{2}$ (16×26.7)

This sketch, less finished than the rest of the group, is painted on the unprepared side of the usual prepared paper.

221. Bed of a Torrent with Bridge in the Distance 1813 (Plate 207)

THE BRITISH MUSEUM, LONDON (CXXX-I)

Oil on prepared paper, $6\frac{1}{4} \times 10\frac{1}{2}$ (15.9×26.7)

Coll. Turner Bequest 1856.

Painted up to the edge of the paper. The bridge is possibly the same as that shown in Nos. 218 and 223.

222. Barges 1813 (Plate 208)

THE BRITISH MUSEUM, LONDON (CXXX-J)

Oil over black chalk, approx. $6 \times 9\frac{1}{4}$ (15×23.5), on prepared paper, irregular, $6\frac{5}{16} \times 10\frac{1}{8}$ (16×25.7)

Coll. Turner Bequest 1856.

Exh. Paris 1972 (289b); *Turner and Watercolour* Arts Council tour, April–September 1974 (14).

223. Devonshire Bridge with Cottage 1813
 (Plate 226)

THE BRITISH MUSEUM, LONDON (CXXX-K)

Oil over black chalk, framing line approx. $5\frac{15}{16} \times 9\frac{1}{4}$ (15×23.5), on prepared paper, $6\frac{1}{8} \times 9\frac{1}{2}$ (15.5×24.1)

Coll. Turner Bequest 1856.

There is no framing line along the bottom of the composition. The same bridge appears in No. 218 and perhaps also in No. 221.

224. A Road leading down into a Valley 1813
 (Plate 227)

THE BRITISH MUSEUM, LONDON (CXXX-Add L)

Oil, framing line approx. $5\frac{3}{4} \times 9\frac{1}{4}$ (14.5×23.5), on prepared paper, $6\frac{1}{8} \times 10\frac{1}{8}$ (15.5×25.7)

Coll. Turner Bequest 1856

Omitted from Finberg's 1909 *Inventory* of the Turner Bequest drawings.

225. A Valley in Devonshire 1813 (Plate 211)

LEEDS CITY ART GALLERIES (Accession no. 13. 278/53)

Oil on prepared paper, $7\frac{5}{8} \times 10\frac{3}{8}$ (19.4×26.3)

Coll. John Edward Taylor (1830–1905); sale Christie's 5 July 1912 (103) bought Wallis; bought from Messrs. Meatyard by Agnes and Norman Lupton who bequeathed it to Leeds in 1952. At Leeds it is entitled 'Landscape, possibly near Plymouth' but the view remains so far unidentified.

Lit. Armstrong 1902, p. 224 (?) who lists two oil sketches on paper measuring $7 \times 10\frac{1}{2}$ in. belonging to J. E. Taylor merely as 'Landscapes' but further describes them as 'Views from hillside' which would seem to fit the Leeds sketch; *Leeds Art Calendar* vii 1953, p. 3 no. 23; Leeds City Art Galleries *Concise Catalogue* 1976, as 'Landscape'.

For the genesis of the Devonshire oil sketches, which date from the 1813 visit, see pp. 118–19. So far as is known at present, the sketch at Leeds is the only one of the series outside the British Museum for, although other oil sketches on a small scale were in the J. E. Taylor sale in 1912, the only one identifiable today is No. 199 which seems certainly to be earlier in date. It appears quite possible, therefore, that the Leeds sketch can be identified with the oil sketch which Turner sent 'long afterwards' as a present to Ambrose Johns (see p. 118). However, according to Eastlake's account, the sketch sent to Johns was not done from nature whereas the Leeds sketch has all the appearance of having been painted on the spot. In the group in the Turner Bequest (Nos. 213–24), the two sketches which seem closest stylistically to this one are *A Village in a Hollow* (No. 213) and *A Road leading down into a Valley* (No. 224).

Nos. 226–7: Miscellaneous, *c.* 1815–19

226. Lake Avernus: Æneas and the Cumaean Sibyl 1814–15 (Plate 214)

YALE CENTER FOR BRITISH ART, PAUL MELLON COLLECTION

Canvas, $28\frac{1}{4} \times 38\frac{1}{4}$ (72×97)

Coll. Painted for Sir Richard Colt Hoare (1758–1838) who paid for it in February 1815; by descent to Sir Henry Colt Hoare; sale Christie's 2 June 1883 (17) bought McLean; Captain C. G. Reid-Walker; bought in 1963 by Mr Paul Mellon from Gooden and Fox Ltd.

Exh. R.A. 1964–5 (181); Yale 1965 (198); Washington 1968–9 (7).

Lit. *Annals of the Fine Arts* 1817, ii, Part v, section xxx p. 270, Collection of Sir Richard Colt Hoare, Bt, at Stourhead, Wilts. No. 22 is described as follows: 'The Lake of Avernus near Naples comprehending the Temple on its banks, the Monte Nuovo, the Lucrine lake, the castle of Baiae, the promontory of Misenum and the distant island of Capri, from a sketch taken on the spot by Sir R. C. Hoare by J. M. Turner R.A.'
The story of Æneas and the Sybil is here introduced:

> Fly ye prophane! far, far away remove,
> Exclaims the Sybil from the sacred grove,
> And thou, Æneas, draw thy shining steel,
> And boldly take the dreadful road to hell.
> To the great task, thy strength, and courage call,
> With all thy powers: this instant claims them all.

Sir Richard Colt Hoare, *Stourhead: Description of the House and Gardens*, rev. edn, Bath 1818, p. 14; Sir Richard Colt Hoare, *History of Modern Wiltshire* (Hundred of Mere) 1822, p. 76; Armstrong 1902, p. 218; Woodbridge 1970, pp. 89, 183, 243, 270, pl. 29a; Gage 1974, pp. 71–5, fig. 16.

See No. 34 for the sketches which served as a source both for that picture and for this.

The receipt for this picture is among the Stourhead papers in the County Record Office at Trowbridge, Wiltshire. It reads:

Received the 25 of February 1815 of Sir Richard Hoare Bart. One Hundred and fifty guineas for a Landscape representing the Lake of Avernus.

157-10 J M W Turner

The relationship between the two versions is obscure and nothing is known of the circumstances which led to the painting of the later version, a sufficiently rare occurrence in Turner's oeuvre to warrant comment. It seems possible that Colt Hoare may have rejected the Tate version on the grounds that it was too Wilsonian.

On the other hand, Woodbridge thinks it more likely that Colt Hoare never owned the Tate version as it was not the kind of picture to have interested him at the time it was painted. He suggests Turner painted it for his own purposes as an exercise in the manner of Wilson. Colt Hoare's father had bought a Wilson of *Lake Nemi with Diana and Callisto* (see W. G. Constable, *Richard Wilson* 1953, p. 165), which was about the same size as the Tate and Yale Turners, and according to the Stourhead catalogue of 1822, the Wilson and the Mellon *Avernus* hung in the same room as pendants. The Wilson is no longer at Stourhead (although it still belongs to a member of the Hoare family) but it seems possible that the Tate Turner, if it ever hung at Stourhead, failed to stand up to the comparison and was returned to Turner either at the time the Yale version was painted or perhaps earlier.

It is difficult to explain the time lag of sixteen or seventeen years between the two versions but it seems possible that Colt Hoare wanted his sketch to be translated into Claudian rather than Wilsonian terms and that it was not until Turner painted *Mercury and Herse* (1811 No. 114) and *Apullia in Search of Apullus* (1814 No. 128) that Colt Hoare recognised that Turner's powers and interests were now equal to the task. Certainly this picture is at the beginning of a period of renewed preoccupation with Claude in Turner's work, and even if we did not have the receipt to guide us about the date, this picture fits in clearly on stylistic grounds with *View of the Temple of Jupiter Panellenius* (No. 134 dated 181(4)?) and *Crossing the Brook* (No. 130 exh. 1815). This picture also displays the same lightness of key and the same quality of light as some of the small watercolours of 1812–13 such as *Weymouth* (Mr and Mrs Paul Mellon Collection) or *Poole Harbour* (Gaskell Collection), engraved in the *South Coast* series in 1814.

Woodbridge puts forward a number of reasons why Colt Hoare should have commissioned the picture. He suggests that in 1815, 'a wave of nostalgia for the past was prompting him to publish the journals of his tour in Italy', and that his twin interests in the classical past and in his own early travels here coincided with Turner's exhibiting, in 1814, a subject from the *Æneid*: *Dido and Æneas* (R.A. 177, see No. 129). Woodbridge also suggests that Colt Hoare may have been encouraged to employ Turner again (and for the last time) by the example of the patronage of his friend Sir John Leicester whose collection at Tabley House Colt Hoare certainly knew. Woodbridge's final suggested reason for the commission, that Colt Hoare felt it was an adventurous step in view of Beaumont's hostility towards *Crossing the Brook*, seems difficult to justify in view of the dating, as the *Lake Avernus* must have been finished before *Crossing the Brook* appeared on the walls

of the Academy, but Beaumont's criticism of Turner was well established before this and the point may be valid in principle.

The sources for Turner's picture are discussed under the entry for the Tate version (see No. 34). In the 1814–15 version, Turner added a third figure which Gage plausibly identifies as Chryses (the subject of a large water-colour now belonging to Lord Ashton of Hyde, exhibited R.A. 1811); Chryses, like Deiphobe, was in the service of Apollo, for whom the burnt offering is intended. Another change in Mr and Mrs Mellon's version, noticed by Gage, is that 'the vague carving on the sarcophagus (in the right foreground) has now become the figure of a man attacking a many-headed monster, possibly Cerberus, the guardian of Hades, although in the *Æneid* he is subdued not by Æneas but by the Sybil, with a drug. By underlining, in this later version of the subject, the roles of Apollo, the god of light, and Hades, the realm of darkness, in the story of Æneas, Turner shows his increasing involvement in the conflict of light and darkness embodied in Classical myth; it is an extension of the theme of Apollo and Python which he had painted in 1811 [Exh: R.A. (81) but perhaps painted earlier; see No. 115] and it looks forward to the far more intensive myth interpretation of Turner's final version of the subject in *The Golden Bough* of 1834' (No. 355).

227. Richmond Hill with Girls carrying Corn
c. 1819 (Plate 228)

THE TATE GALLERY, LONDON (5546)

Canvas, 58 × 93¾ (147 × 238)

Coll. Turner Bequest 1856 (? 270 in 1856 Schedule, 1 unidentified 8′0″ × 5′8½″; see below); transferred to the Tate Gallery 1947.

Lit. Davies 1946, pp. 168, 190 nn. 23 and 26; exh. cat., R.A. 1974–5, p. 78.

According to Davies there were two numbers chalked on the back of this picture in 1946, '270', crossed out, and '250'. For the confusion in the 1854 Schedule over these numbers see No. 529 which also bore the chalk number '250'.

Formerly catalogued as 'Extensive Landscape with girls carrying Corn' but recognised in 1974 as a first version, on Turner's standard large-size canvas, of *England: Richmond Hill* exhibited in 1819 (No. 140). The composition extends less far to the right and rather further on the left, where there is a building; the Thames is shown slightly to the right of centre. Instead of the throng of figures in the exhibited picture only four girls are shown in the left foreground. The trunk of one of the large framing trees on the right has not been painted in.

There are two small tears in the canvas, top left and top right. The surface is dirty and badly water-stained.

3. From Turner's First Visit to Italy to his Second, 1819–29

Nos. 228–44: Exhibited Pictures

228. Rome, from the Vatican. Raffaelle, accompanied by La Fornarina, preparing his Pictures for the Decoration of the Loggia.
Exh. 1820 (Plate 217)

THE TATE GALLERY, LONDON (503)

Canvas, $69\frac{3}{4} \times 132$ ($177 \times 335 \cdot 5$)

Inscr. 'Pianta del Vaticano' on plan lower centre.

Coll. Turner Bequest 1856 (50, 'Rome' $11'0'' \times 5'11''$); transferred to the Tate Gallery 1920.

Exh. R.A. 1820 (206); R.A. 1974–5 (236, repr.).

Lit. Ruskin 1857 (1903–12, xiii, pp. 127–8); Thornbury 1862, i, p. 303; 1877, p. 437; Hamerton 1879, pp. 170–72; Bell 1901, p. 103 no. 144; Armstrong 1902, p. 228; Whitley 1928, p. 317; Davies 1946, p. 186; Clare 1951, pp. 66–7; Finberg 1961, pp. 264–5, 482 no. 252; Herrmann 1963, p. 23; Rothenstein and Butlin 1964, p. 36, pl. 62; Lindsay 1966, p. 158; Gage 1969, pp. 92–5, 265 n. 158; Reynolds 1969, p. 114, pl. 94; Gaunt 1971, p. 7; Ziff 1971, p. 126; Raymond Lister (ed.), *The Letters of Samuel Palmer* 1974, ii, p. 897; Herrmann 1975, pp. 29, 231, pl. 84; Mordechai Omer, 'Turner and "The Building of the Ark" from Raphael's Third Vault of the Loggia', *Burlington Magazine* cxvii 1975, pp. 694–8, figs. 2 and, detail, 3.

This picture, exhibited on the three-hundredth anniversary of Raphael's death, sums up Turner's reactions to his first visit to Rome and to the Renaissance artist particularly associated with that city, shown with his mistress, La Fornarina. In addition, as John Gage has shown, the painting is more specifically autobiographical, with Turner identifying himself with the universal artist of the Italian Renaissance. When visiting the Louvre in 1802 Turner had ignored Raphael but by 1820 there was a growing appreciation of Raphael as a colourist as well as a draughtsman; Turner himself

noted in the 'Route to Rome' sketchbook that the frescoes in the Villa Farnesina were 'Exquisite colored' (CLXXI-14 verso). Raphael was also increasingly appreciated as a painter of landscape, hence the inclusion of the surprisingly Claudian landscape in the foreground. Gage suggests that Turner deliberately included inaccurate and anachronistic details to stress the autobiographical character of the picture. Raphael's great decorative schemes, painted in fresco direct on the wall, are represented by an easel painting on canvas of one of the Loggie subjects. Bernini's colonnades in front of St Peter's, not built until the seventeenth century, are included to represent Turner's ambitions as an architect, fulfilled to some extent by his designs for his own gallery in Queen Anne Street, which he was rebuilding at this time, and his cottage near Twickenham. Sculpture is also included.

In the 'Tivoli and Rome' sketchbook of 1819 there are a number of sketches of the Loggie, including one general view as they appear in the finished picture as well as several detailed studies, two general composition sketches that were considerably modified, and a drawing of the distant snow-capped Apennines (CLXXIX-13 verso, 14–21 verso, 25 verso and 26 (repr. Wilkinson 1974, p. 188) and 25 respectively.). There is a finished drawing in pen and ink, finished in Chinese white, in the 'Rome: C[olour] Studies' sketchbook (CLXXXIX-41).

Although Finberg quotes two unfavourable reviews the reception of the picture was not entirely negative. Two unidentified cuttings at the Victoria and Albert Museum speak of 'a grand view of Rome' and of it 'possessing all the magical effects, the clear and natural atmosphere, and the glorious lights which give such a beauty and a charm to all his compositions' (vol. v, p. 1217, and vol. iv, p. 1178). The *British Press* for 2 May 1820 described the painting as 'an exquisite composition. The perspective and colouring are beautiful, and the architectural ruins [*sic*] which burst upon the eye, give a sentiment and grandeur to the

subject which cannot fail to excite great interest'. The *Repository of Art* for June describing it as 'a strange but wonderful picture', criticising 'the crossing and re-crossing of reflected lights about the gallery', the figures and 'the perspective of the fore-ground', but praising the distance and the 'richness and splendour of the colouring'. The *Annals of the Fine Arts* (v, p. 395) said that 'Turner has not gone back, he only stands where he did', praised the 'grandeur of conception', but attacked the 'excessive yellowness, which puts everything out of tune that hangs by it'.

Samuel Palmer, in a letter to George Richmond of 1 June 1874, commented on the condition of the picture at that time: 'Where is the *essence* of Rome in Turner's Loggie with La Fornarina—utterly ruined through sparing a few pounds-worth of glass?'

229. What You Will! Exh. 1822 (Plate 216)

SIR MICHAEL SOBELL

Canvas, 19 × 20½ (48·2 × 52)

Coll. Sir Francis Chantrey, R.A. (1781–1842), a close friend of Turner's who bought the picture at the R.A. in 1822; Lady Chantrey sale Christie's 15 June 1861 (91) bought Agnew; R. Newsham; J. H. Nettlefold; sale Christie's 12 February 1910 (68) bought Vicars from whom bought by Agnew and sold to H. Darell-Brown; sale Christie's 22 May 1924 (42) bought in; sold on behalf of Darell-Brown's executors by Agnew in 1927 to Albert Rofé; bought back from the Rofé collection by Agnew in 1959 and sold to the present owner.

Exh. R.A. 1822 (114); Agnew 1910 (2); Agnew 1967 (13); R.A. 1974–5 (307).

Lit. Burnet and Cunningham 1852, p. 115 no. 132; Ruskin 1856 (1903–12, xiii, p. 128 and n.); Thornbury 1877, p. 575; Monkhouse 1879, p. 97; Bell 1901, p. 103 no. 145; Armstrong 1902, p. 237 (who adds that it was once in the Swinburne Collection; this is incorrect and is due to Armstrong believing the vendor in 1861 to have been Swinburne, a mistake he also made in the case of No. 38); Whitley 1930, pp. 28–9; Finberg 1961, pp. 274–5, 484 no. 277; Rothenstein and Butlin 1964, pp. 42, 68, pl. 78; Lindsay 1966, p. 245 n. 49; Gage 1969, p. 92; Reynolds 1969, p. 139.

When shown at the R.A. (the smallest picture Turner exhibited there between 1797 and 1850, excepting possibly No. 352, and the first he had sold since the *Dort*, No. 137), it was regarded by the critics as something of an aberration on Turner's part. The *Examiner* for 13 May considered that 'Mr. Turner has nothing of Art this season in the Exhibition. He has only a piece of coloured canvas, called (No. 114) What You Will! and to which challenge for a determinate denomination, we reply—"Almost anything but what a picture ought to be!"'

The *New Monthly Magazine* was still more critical: 'By Turner we have nothing at all, or rather we have worse than nothing, for he cannot mean to call No. 114 a picture. It is a scrap of spoilt canvas, at once a libel on his great name and an affront to the public taste.'

The *Literary Gazette*, 25 May, thought it 'a sketch, and no more. It is a pretty piece of colouring, something in the style of Watteau, with a name that makes it looked after. But for its general application it might suit many a subject, portrait or view; as, the Portrait of Lady—, or who you will; His Grace, or &; a view of—, or what you will, and so on to the end of the catalogue.'

The *Repository of Arts* for 1 June was also reminded of Watteau and considered the picture 'a whimsical attempt' at his manner, continuing 'Mr. Turner is a man of too much original power, and capable of producing a corresponding effect, to be indulged in this species of painting.'

None of these somewhat facetious notices seem to have grasped the picture's true meaning and realised that '*What You Will!*' is Shakespeare's alternative title to *Twelfth Night*. In fact, the picture shows Olivia and her two attendants in the foreground with Sir Toby Belch, Sir Andrew Aguecheek and Maria concealed behind the garden statues. The title probably had an added attraction for Turner, whose addiction to punning was well known, and we learn from Ruskin (xxxv, p. 601) that Turner told his friend the Rev. William Kingsley that 'he had learned more from Watteau than from any other painter'. This debt was later to be more explicitly acknowledged by Turner in his exhibited picture of 1831, *Watteau Study by Fresnoy's Rules* (No. 340). In this picture, however, Turner was also clearly influenced by his friend and contemporary Thomas Stothard, R.A. (1755–1834), whose work was to influence Turner still more directly in the *Boccaccio* (No. 244 of 1828). Among Turner's fellow artists, Stothard was the one whose work he is known to have praised most warmly; according to Lovell Reeve (*Literary Gazette* 1851, p. 924) Turner considered him 'The Giotto of the English School'(!) but, as Gage has suggested, this must surely have been a mishearing for 'Watteau'. (See also under No. 244.)

According to Armstrong, Thornbury described this as 'The first picture in the artist's last manner', a wild assertion, but perhaps he meant it to refer to a new direction Turner had taken, exemplified in his growing interest in figure subjects which was to occupy him further in the late 1820s and early 1830s. Professor Ziff (*Gazette des Beaux-Arts* January 1965, p. 64 n. 30) has pointed out that some of the statuary in the background derives from Turner's journey to Italy in 1819 when he copied various classical reliefs in Rome. A sketchbook labelled by Turner 'Vatican fragments' (CLXXX) has a number of such studies which Turner seems to have used in this picture although he has slightly altered them in each case, (e.g., pp. 6 verso, 22, 31 and 53). Very likely it was the introduction of this statuary into the picture that attracted Chantrey to it.

230. The Bay of Baiæ, with Apollo and the Sybil
Exh. 1823 (Plate 218)

THE TATE GALLERY, LONDON (505)

Canvas, $57\frac{1}{4} \times 94$ (145.5×239)

Inscr. 'Liquidae Placuere Baiae' on stone lower left.

Coll. Turner Bequest 1856 (5, 'Bay of Baiae' $7'9\frac{1}{2}'' \times 4'9\frac{1}{2}''$); transferred to the Tate Gallery 1910.

Exh. R.A. 1823 (77); Turner's gallery 1835; New York, Chicago and Toronto 1946–7 (50, pl. 41); Edinburgh 1968 (4, repr.); R.A. 1974–5 (237).

Lit. Ruskin 1843, 1860 and 1857 (1903–12, iii, pp. 243, 492; vii, pp. 421, 431; xiii, pp. 127–8, 131–5); Thornbury 1862, i, pp. 228–9, 259, 303; 1877, pp. 103, 416, 437; Hamerton 1879, pp. 198–9; Monkhouse 1879, p. 97; F. M. Redgrave, *Richard Redgrave, C.B., R.A., A Memoir compiled from his Diary* 1891, pp. 81–2; Bell 1901, pp. 103–4 no. 146; Armstrong 1902, pp. 113–14, 191–2, 218; MacColl 1920, p. 14; Whitley 1930, pp. 42–3; Falk 1938, pp. 131, 224; Davies 1946, p. 185; Clare 1951, pp. 71–2, repr. p. 68; Finberg 1961, pp. 279–80, 340, 347, 354, 485 no. 289; Herrmann 1963, p. 24, colour pl. 10; Kitson 1964, pp. 74–5, repr. in colour p. 31; Rothenstein and Butlin 1964, pp. 36–8, pl. 64; Lindsay 1966, pp. 72–3, 160, 168, 180, 258; Brill 1969, p. 16, repr.; Gage 1969, p. 103; Reynolds 1969, pp. 119–20, colour pl. 101; Gaunt 1971, p. 7, pls. 15 (detail) and 17 (in colour); Gage 1974, pp. 78–82, pl. 18; Herrmann 1975, pp. 30, 231, colour pl. 89.

The second of the large finished pictures resulting from Turner's first visit to Italy, exhibited with the line:

'Waft me to sunny Baiæ's shore.'

The Latin inscription on the picture comes from Horace's *Ode to Calliope* and alludes to the poet's delight in the waters of Baiæ. Though the district had been painted by Wilson, this was the first time it had been used for a subject picture.

Ruskin, in 1857, explains the subject, which comes from Ovid's *Metamorphoses* Book xiv, as follows: 'the Cumæan Sibyl, Deiphobe, being in her youth beloved by Apollo, and the god having promised to grant her whatever she would ask, she, taking up a handful of earth, asked that she might live for as many years as there were grains of dust in her hand. She obtained her petition, and Apollo would have given her also perpetual youth, in return for her love; but she denied him, and wasted into the long ages; known at last only by her voice. We are rightly led to think of her here, as the type of the ruined beauty of Italy; foreshadowing, so long ago, her low murmurings of melancholy prophecy, with all the unchanged voices of her sweet waves and mountain echoes.' In *Modern Painters* v he described the picture together with Nos. 337 and 342, as illustrations 'of the vanity of human life'.

Baiae had been renowned for its luxury under the Romans and, as John Gage has pointed out (1974, pp. 44–7), Turner probably followed his early patron Colt Hoare in drawing the lesson of its decline through profligacy and degeneracy. In addition Part I of Thomson's *Liberty* 1735, on 'Ancient and Modern Italy Compared', a theme taken up by Turner in a number of works (e.g. Nos. 374 and 375, and 378 and 379), compares

'. . . Baia's viny coast, where peaceful seas,
Fanned by kind zephyrs, ever kiss the shore'

with its later decay (ll. 58–60, 291–2). While the white rabbit alludes to Venus, to whom one of the local temples is dedicated, the snake is symbolic of latent evil.

Turner visited Baiae from Naples in 1819 and there are many drawings in the 'Gandolfo to Naples' and 'Pompeii, Amalfi, Sorrento and Herculaneum' sketchbooks, including one in the former of the same view as the picture (CLXXXIV-82 verso and 83; see also CLXXXV). In this picture the Claudian panorama that had characterised so many of Turner's previous landscapes is composed in flowing curves rather than the more distinct zones and linear stresses of the earlier examples.

The adjective almost universally applied to this picture by the critics was 'gorgeous', as in the *Literary Gazette* for 3 May 1823, which added that it was 'like the vision of a poet, rapidly and slightly embodied by a painter.' The writer in the *European Magazine* for May 1823 was 'much annoyed by a cold-blooded critic . . . who observed that it was not natural. Natural! No, not in his limited and purblind view of nature. But perfectly natural to the man who is capable of appreciating the value of practical concentration of all that nature occasionally and partially discloses of the rich, the glowing and the splendid.' According to the *Repository of Arts* for June 1823 'Mr. Turner's answer, and perhaps a sufficient one' to the 'somewhat monotonous effect produced by the unclouded richness of the landscape . . . may be, that he has painted the landscape as nature and the poets have given it.' The *Literary Gazette*, in its second notice of the picture of 17 May 1823, had a slightly different answer: 'The seductive influence of colours, and the necessity of painting up to the standard of an exhibition, where the spread of gold is more than that of canvas, will prevent, if it does not annihilate, the study of nature . . . Though we have no eye for criticism on this splendid piece, it is only when considered as a vision, or a sketch, or as a variety in a large collection,—in one word, it is not painting.' The only hostile review came from the *British Press* for 5 May: 'of late there is a glare, and a meretricious attempt at effect about his [Turner's] pictures, that make them offensive to every man of judgment and good taste. The *extravaganza* before us is of this cast. It is really little better than a burlesque upon painting. Where, we would ask, did Mr. Turner get this deep blue tint for the water? not from the sky . . .'

By 1835, when the picture was on view in Turner's

gallery, at least one critic had got over his initial shock. The *Spectator* for 26 April 1835 wrote, 'His picture of Baiae, exhibited two or three seasons ago [*sic*], and which was considered at the time one of his most garish paintings, now exhibits only an allowable heightening of the hues of nature, to suit the colouring of poetic fancy.'

A more direct attack on the picture's lack of verisimilitude was George Jones', as retailed by Thornbury: 'One day Mr. G. Jones, having discussed Turner's picture of the "Bay of Baiae" with a traveller who had recently been there, was surprised to find that half the scene was Turner's sheer invention; upon which, in fun, Mr. Jones wrote on the frame, 'SPLENDIDE MENDAX'. Turner saw it, and laughed. His friend told him that where he had planted some hills with vineyards, there was nothing in reality but a few dry sticks. Turner smiled, and said it was all there, and that all poets were liars. The inscription remained on the frame of the picture for years; Turner never removed it.'

In *Modern Painters* i Ruskin at first dismissed this work as one of the category of what he called 'nonsense pictures': 'the Bay of Baiae is encumbered with material, it contains ten times as much as is necessary to a good picture, and yet is so crude in colour as to look unfinished'. Later in the same volume however he quotes it as an example of the 'noble works' in which Turner's management of the foreground unifies an abundance 'so deep and various, that the mind, according to its own temper at the time of seeing, perceives some new series of truths . . .'

In 1856 Ruskin commented on the condition of the painting: 'Partly, the deadness of effect is owing to change in the colour; many of the upper glazings, as in the dress of Apollo, and in the tops of the pine-trees, have cracked and chilled; what was once golden has become brown; many violet and rose tints have vanished from the distant hills, and the blue of the sea has become pale.' He added in a footnote, 'I do not at present express any opinion as to the degree in which these changes have been advanced or arrested by the processes to which the pictures have recently been subjected, since the light in which they are placed does not permit a sufficient examination of them to warrant any such expression.'

Richard Redgrave picked out *The Bay of Baiae* as an example of the change caused by the constantly patched plaster in Turner's gallery when he saw it following Turner's death: 'Ah! what a wreck it was, compared with the sunny paradise I remembered! The canvas was hanging over the frame at the bottom like a bag, and when Maclise and I pressed against it, we found that this was occasioned by the mortar from the ceiling which had fallen behind it, and was piled up between the stretcher and the canvas.'

231. Harbour of Dieppe (Changement de Domicile) Exh. 1825 (Plate 220)

THE FRICK COLLECTION, NEW YORK (Accession no. 14.1.122)

Canvas, 68⅜ × 88¾ (173·7 × 225·4)

Dated '182[6?]' on the logs chained together in the right foreground

Coll. James Wadmore; sale Christie's 5–6 May 1854 (185) bought Grundy, the Liverpool dealer, on behalf of John Naylor (1813–1889) of Leighton Hall, Welshpool; bought from J. M. Naylor in 1910 together with *Cologne* (No. 232) by Agnew and Sulley, through Dyer and Sons; Knoedler by 1911 who sold it to H. C. Frick in 1914.

Exh. R.A. 1825 (152); Liverpool Town Hall 1854 (6 lent by Naylor); Agnew 1903 (13); R.A. 1910 (112 lent by Naylor; Knoedler 1911 (6); Knoedler, New York, 1914 (31).

Lit. Burnet and Cunningham 1852, pp. 44, 115 no. 134; Thornbury 1862, ii, p. 400; 1877, pp. 575, 597, 598; Monkhouse 1879, p. 99; Bell 1901, p. 104 no. 147; Armstrong 1902, p. 221; Whitley 1930, pp. 86–7; C. H. Collins Baker, 'The Greatness of Turner', *Gazette des Beaux-Arts* xxxiv 1948, p. 102; Clare 1951, p. 72; Finberg 1961, pp. 289, 486 no. 305; Rothenstein and Butlin 1964, p. 35; Davidson 1968, i, pp. 122–5, repr.; Reynolds 1969, pp. 120–21, 124; Morris 1974–5, p. 97 no. 193, fig. 62; Herrmann 1975, pp. 32, 231, pls. 93, 94.

The view shows the Quai Henri IV on the right, with most prominent the pedimented Hotel D'Anvers and, on its left, the columns of the Collège Communal. In the distance on the left the spire and cupola of St Jacques are visible.

Based on sketches made during the late summer or autumn of 1821 when Turner paid a hurried visit to Paris. The 'Paris, Seine and Dieppe' sketchbook (CCXI) contains studies of fishing boats at Dieppe and on p. 21 there is a drawing of shipping in the harbour with the tower and cupola of St Jacques visible in the distance. Page 217 of the 'Rivers Meuse and Moselle' sketchbook (CCXVI) shows a very slight sketch of the harbour and the principal buildings which appear in the oil while p. 223 verso shows a small but careful sketch of the Hotel D'Anvers with colour notes. The sketchbook contains further drawings of buildings shown in the picture (e.g. St Jacques on p. 227). The 'Dieppe, Rouen and Paris' sketchbook (CCLVIII, dated 1830 by Finberg but now considered to have been in use in 1821) also contains drawings of Dieppe including one on part of p. 16 inscribed 'Fish Market Dieppe' which shows a group of seated women similar to those on the extreme right of the picture.

The reading of the last figure of the date is extremely difficult. It might be either a '5' or '6'. If the latter, which seems less likely but looks more likely, Turner

may have worked on the picture again at the time he exhibited *Cologne*, and dated it then.

On the floating spar on the left, Turner has written 'Changement de domicile' with the wooden end of the brush and then partially painted it over. The beginning of 'Changement' and the end of 'domicile' are clearly legible and, in view of the exhibited title, this must certainly be what is inscribed, presumably an allusion to some incident which occurred during the artist's visit to Dieppe in 1821.

At its showing at the R.A., the picture received qualified praise. While its magnificence and grandeur of composition were generally acknowledged, some critics were offended by the brightness of the colours, especially when applied to a harbour in northern France.

Henry Crabb Robinson, who visited the exhibition on 7 May, wrote (*Diary, Reminiscences and Correspondence* 1869, ii, p. 294): '. . . Turner RA has a magnificent view of Dieppe. If he will invest an atmosphere, and a play of colours all his own, why will he not assume a romantic name? No one could find fault with a Garden of Armida, or even of Eden, so painted. But we know Dieppe, in the north of France, and can't easily clothe it in such fairy hues. I can understand why such artists as Constable and Collins are preferred . . .'

The *Literary Magnet* (iii, p. 140) called it 'Mr. Turner's brilliant experiment upon colours, which displays all the magic of skill at the expence of all the magic of nature.'

The *European Magazine* for May 1825, however, was enthusiastic in its praise and considered that the picture 'has been justly said to be one of those magnificent works of art, which may make us proud of the age we live in, and the associations of our birth. Not even Claude in his happiest efforts, has exceeded the brilliant composition before us: in transparent effect it is equal to that great master; while in the drawing and grouping of the numerous figures, it is superior.' Later, however, the reviewer suggested that the 'poetic colouring' was more suited to a 'sea port of a southern clime than to one on the northern coast of France.'

However, the *New Monthly Magazine* (15, 1825, p. 300) called it 'perhaps the most splendid piece of falsehood that ever proceeded from the pencil of its author' and continued 'it should seem from the *colouring* of the picture, as if, after the artist had finished it according to the best lights that Nature had chosen to furnish him with, he had felt totally dissatisfied with his work, and had determined to *heighten* it up to his own ideas of what Nature *might* have done for it if she had chosen! Accordingly, the work now presents as striking, and we must be allowed to add, as vicious a specimen as can well be imagined, of mingled truth and falsehood.'

The Frick Catalogue suggests that this picture and the *Cologne* form a trio with the *Dort* (No. 137), representing northern Continental ports, but there seems to be no evidence that Turner regarded the Frick pair as successors to the *Dort*. In any case, for all their merits, they have a somewhat grandiose quality about them which is entirely absent in the earlier picture.

232. Cologne, the Arrival of a Packet Boat. Evening Exh. 1826 (Plate 221)

THE FRICK COLLECTION, NEW YORK

Oil and possibly watercolour on canvas, $66\frac{3}{8} \times 88\frac{1}{4}$ (168·6 × 224·1)

Coll. Broadhurst; James Wadmore; sale Christie's 5–6 May 1854 (184) bought Grundy (see No. 231) acting on behalf of John Naylor of Leighton Hall, Welshpool, Montgomeryshire; bought from J. M. Naylor in 1910, together with *Dieppe* by Agnew and Sulley through Dyer and Sons; Knoedler by 1911 from whom bought by H. C. Frick in 1914. (Accession no. 14.1.119)

Exh. R.A. 1826 (72); Liverpool Town Hall 1854 (15 lent by Naylor); Manchester 1857 (224); Knoedler, New York, 1914 (32).

Lit. Burnet and Cunningham 1852, pp. 25, 44, 115 no. 135; Ruskin 1854, 1856, 1873 (1903–12, xii, pp. 130–31; xiii, pp. 47, 140n.; xxvii, p. 477); Thornbury 1862, i, p. 306; ii, pp. 113–14, 257, 400; 1877, pp. 274, 347–8, 439, 575, 597, 598; Hamerton 1879, pp. 206, 207; Monkhouse 1879, pp. 99, 107; Bell 1901, pp. 104–5 no. 148; Armstrong 1902, p. 220; Falk 1938, p. 125; Clare 1951, pp. 77–8; Finberg 1961, pp. 295, 303–4, 486 no. 307; Rothenstein and Butlin 1964, p. 35; Lindsay 1966, pp. 243, 257; Davidson 1968, i, pp. 126–30, repr.; Gage 1969, pp. 20, 167; Reynolds 1969, pp. 120–21, 124; Morris 1974–5, pp. 97–8 no. 194, fig. 63; Herrmann 1975, pp. 32, 231.

The view shows on the right the Kostgasseforte gate with the Frankenturm beyond it. In the middle distance are the sixteenth-century Bollwerk and archway over the entrance to the Zollstrasse. Behind are the Stapelhaus and, to its right, the church of Gross St Martin. In the far distance can be seen the Bayenturm between the boats and the Bollwerk.

The packet boat has 'AMITIE' on its stern and 'KOLEN DUSSELDORF UND RETOUR' (a characteristic Turnerian amalgam of language).

Drawings of Cologne occur in the 'Rhine' sketchbook (CLXI pp. 54, 55, etc.), used on Turner's trip there in the autumn of 1817. Page 54 (which is considerably stained) shows a general view of the right-hand side of the composition including the principal buildings and the waterfront with a hay-barge, etc.; p. 55 shows the Cathedral and Bayenturm but it is not as closely connected with the oil as the Frick Catalogue suggests. Further drawings of some of the buildings which appear in this picture occur in the 'Holland' and 'Holland, Meuse and Cologne' sketchbooks (CCXIV, pp. 143, 145, 148 and CCXV, especially p. 33) which date from Turner's visit in September 1825.

Mr. Broadhurst, apparently the first owner of the picture, is mentioned in a letter written by Turner to his father from Cowes when staying with John Nash in 1827:

'Mr. Broadhurst is to have the Picture of Cologne, but you must not by any means wet it, for all the colour will come off. It must go as it is—and tell Mr. Pearse, who is to call for it, and I suppose the Frame, that it must not be touched with water or varnish (only wiped with a silk handkerchief) until I return, and so he must tell Mr. Broadhurst . . .'

Whether Broadhurst had bought the picture and later sold it to Wadmore or whether he was only having it 'on approval' seems uncertain. He appears to have been a restless collector, as Turner painted *Dido directing the Equipment of the Fleet* (No. 241) for him in 1828 but Broadhurst apparently did not keep it as it was in Turner's possession at his death.

Turner's fears about wetting the surface may also have been due to his use of a tempera ground in this instance, a practice, as we learn from Eastlake, that he later employed in some of the Roman pictures and elsewhere.

Turner's instructions to his father about the delicate surface of the picture raise the issue of two stories which are told of this picture by Thornbury. The first concerns Sir Francis Chantrey who, on hearing a rumour that Turner was toning the picture with watercolour on one of the Varnishing Days, in disbelief rubbed a wet finger across one of the sails, and, to his dismay, found he had removed some glazing. Second, the bright colours of *Cologne*, hanging at the R.A. between two portraits by Lawrence of *Lady Wallscourt* and *Lady Robert Manners*, made the portraits seem very dull by comparison which greatly distressed Lawrence. On noticing this, Turner, in a fit of generosity on Varnishing Day, covered the surface of *Cologne* with a wash of lampblack, thereby changing the golden hues to a much more sober colour. This story was widely publicised by Ruskin and was said to have been told him by Turner's friend George Jones, R.A. Finberg accepted it, although aware that there was a discrepancy between the critics' reports of the brilliance of the colours in the *Cologne* and the layer of lampblack, but he got over it by suggesting that Turner only used the lampblack after the critics had seen it on the opening day. A letter written to the architect C. R. Cockerell, R.A., by J. D. Coleridge (later Lord Chief Justice) in February 1857 (published in *The Times*, 27 December 1951) states that this story of Ruskin's was a complete fable. Although there are a number of instances of Turner's generosity to his fellow artists, and he was certainly fond of Lawrence, it hardly seems likely that Turner would have allowed such an important picture of his to appear throughout the exhibition at such a disadvantage and, as the Frick catalogue points out, Turner's concern about the surface of the picture, expressed in the letter quoted above, seems difficult to reconcile with the lampblack story.

Certainly most critics complained of the picture's gaudiness at the R.A. and it was not on the whole well received. Above all, the writers stressed how yellow the picture looked. The *Morning Post*, 9 May, wrote: 'Mr.

Turner has made very free use of the chrome yellow—will it stand the test of time?' The *New Monthly Magazine* (part iii, p. 243) considered that this and the *Forum Romanum* (No. 233) 'look as if they were copied from a model of the actual scene, cut out of amber. In other respects they include the principal merits and defects of the artist's style—particularly his general truth of effect, and his slovenliness of detail'. The *Literary Gazette* for 13 May thought that in both his exhibition pictures Turner 'seems to have sworn fidelity to the *Yellow Dwarf*, if he has not identified himself with that important necromancer. *He* must be the author of gamboge light.' Yellow was certainly Turner's favourite colour but this was the first time that this had been so generally commented upon. This was acknowledged by Turner himself in a letter written to his friend Holworthy on 6 May 1826, when, referring to Phillips' (Thomas Phillips, R.A., 1770–1845) suntan after a visit to Italy, he suggested that being on the Hanging Committee at the R.A. would soon bring Phillips back to his original tone of colour—'but I must not say yellow, for I have taken it *all* to my keeping this year, so they say.'

233. Forum Romanum, for Mr Soane's Museum
Exh. 1826 (Plate 219)

THE TATE GALLERY, LONDON (504)

Canvas, $57\frac{3}{8} \times 93$ (145·5 × 237·5)

Coll. Turner Bequest 1856 (63, 'Rome' 7′10″ × 4′10″); transferred to the Tate Gallery 1929.

Exh. R.A. 1826 (132); R.A., *Italian Art and Britain* January–March 1960 (215); R.A. 1974–5 (238).

Lit. Ruskin 1843 (1903–12, iii, p. 248); Thornbury 1862, i, p. 303; 1877, p. 437; Bell 1901, pp. 105–6 no. 149; Armstrong 1902, p. 228; MacColl 1920, pp. 13–14; Davies 1946, p. 187; Finberg 1961, pp. 196, 486 no. 308; Rothenstein and Butlin 1964, p. 36, pl. 63; Gowing 1966, p. 21; Brill 1969, p. 16, repr.; Adele M. Holcomb, 'A Neglected Classical Phase of Turner's Art: his Vignettes to Roger's *Italy*', *Journal of the Warburg and Courtauld Institutes* xxxii 1969, p. 408, pl. 71c; Reynolds 1969, p. 120.

Painted, to judge by the title in the R.A. catalogue, for Turner's fellow-Academician the architect Sir John Soane (1753–1837). Soane designed three adjacent houses in Lincoln's Inn Fields and moved from no. 12 to the central one, no. 13 in 1813, turning it also into a setting for his considerable collection of works of art, particularly after the death of his wife in 1815. In 1833 he obtained a private Act of Parliament setting up the Museum under a body of trustees. The space is very constricted and it was probably because of this that he did not in fact take the picture. There is a letter from Soane to Turner of 9 July 1828 with a draft for 500 guineas and a request that 'you will have the goodness

to take charge of the picture until I can find a suitable place for it or a purchaser'. The picture is not specified but the sum of money suggests a work of this size. The letter and draft however are still at the Soane Museum; presumably Turner did not hold his old friend to their bargain and just took the picture back. Soane later acquired one of Turner's standard 3 × 4 ft canvases, *Admiral Van Tromp's Barge at the Entrance of the Texel, 1645*, exhibited at the R.A. in 1831 (No. 339).

This, the third of the large pictures resulting from Turner's first visit to Italy in 1819, concentrates on the monuments of Ancient Rome and so would have had a particular interest for Soane. There is a composition sketch from a slightly different view in the 'Small Roman C[olour] Studies' sketchbook (CXC-1) and another fairly similar view in the 'Rome: C[olour] Studies' sketchbook (CLXXXIX-43; repr. Wilkinson 1975, p. 18). In this painting Turner stresses the monumental quality of the Arch of Titus and the Basilica of Constantine on the right by the close view point and consequent foreshortening, and even more by the massive arch which frames the picture at the top. The contrast between the *gravitas* of this picture and the lush curvilinear composition of *Bay of Baiae* (No. 230) was perhaps deliberate. However, though there are contrasts of light and shade, the whole painting glows with colour, as the critic of the *Literary Gazette* for 13 May 1826 noted, not altogether approvingly: 'The artist, we can readily perceive, has combated a very difficult quality of art, in giving solidity without strong and violent opposition of light and shade ... Mr. Turner ... seems to have sworn fidelity to the *Yellow Dwarf*, if he has not identified himself with that important necromancer.'

Some letters have been inscribed down the left-hand edge near the bottom, scratched into the wet paint, some of it apparently added specially in small squares. They seem to read 'A [?] GM [?] SRMPA', but have not yet been satisfactorily explained (see Plate 550).

Adele Holcomb has pointed out how Turner later used elements from this composition for the illustration of *The Roman Forum* in Rogers' *Italy*, 1830 (repr. with related watercolour and sketches, *op. cit.*, pls. 70a, b, c and e).

234. View from the Terrace of a Villa at Niton, Isle of Wight, from Sketches by a Lady

Exh. 1826 (Plate 225)

MR WILLIAM A. COOLIDGE, BOSTON, MASS.

Canvas, $17\frac{3}{4} \times 23\frac{1}{2}$ (45·5 × 61)

Coll. Painted for Lady Willoughby Gordon (the fact that it belonged to Lady Gordon rather than to her husband is proved by a letter written by Turner to Sir John Soane during the course of the R.A. Exhibition; this letter is to be published by Gage). Soane, who was not satisfied with the *Forum*

Romanum (No. 233) and was considering an exchange, had evidently enquired which of Turner's pictures were for sale and Turner replied that no. 297 belonged already to Lady Gordon); by descent to her grand-daughter Mrs Disney Leith and then to her son, the seventh Lord Burgh; sale Christie's 26 July 1926 (27) bought Sampson; with Tooth 1929 from whom bought by the present owner in 1933.

Exh. R.A. 1826 (297); R.A. 1912 (117); Tooth 1931 (5); R.A. 1974–5 (309).

Lit. H. F. Finberg 1957, pp. 48–51; Finberg 1961, pp. 296, 486 no. 309.

This picture was omitted from the index of the R.A. catalogue which doubtless explains why it was later also omitted by Burnet, Thornbury and Bell from their lists of Turner's exhibited works, and by Armstrong from his catalogue of Turner's oils. Its history was first published by Mrs Finberg. One of Turner's earliest pupils was Julia Bennet and Mrs Finberg reproduces a watercolour of *Llangollen Bridge* (1957, fig. 21) inscribed on the back: 'Julia Bennet—with Mr. Turner May 1797'. Her friendship with Turner evidently continued throughout her life. In 1805 Julia Bennet married James Willoughby Gordon, who was created a baronet in 1818. He owned a villa at Niton and it was from its terrace that this view was taken and evidently, as indicated by the title, from sketches by Turner's former pupil, Lady Gordon. Turner has clearly followed her work very closely as details such as the flower border and the garlanded urns are characteristic of Lady Gordon's watercolours and, indeed, the lightness of key throughout and the pastel-like colours make this picture resemble a watercolour perhaps more closely than any other among Turner's exhibited oils.

The catalogue of the Turner Bicentenary Exhibition suggested that painting this picture may have reawakened Turner's interest in the Isle of Wight, which he had not been to since 1795, and led to his visit in the following year—1827—in the same way that showing his first Venetian oils in 1833 led to a second visit to Venice later that year.

When exhibited at Burlington House in 1912 together with two other Turner oils from the same source (Nos. 269 and 270), the authenticity of all three, which were catalogued simply as 'Landscape' in each case, was challenged by the art critic of the *Daily Telegraph*, 2 February 1912. This was answered by a letter from Mrs Disney Leith, giving the history of the pictures although she made no reference to Turner having painted this view from her grandmother's sketches.

At the R.A. Exhibition the critics concentrated on *Cologne* (No. 232) and the *Forum Romanum*, ignoring completely this small picture which is not mentioned in any of the notices of the exhibition.

235. The Seat of William Moffatt Esq., at Mortlake. Early (Summer's) Morning
Exh. 1826 (Plate 222)

THE FRICK COLLECTION, NEW YORK

Canvas, $36\frac{5}{8} \times 48\frac{1}{2}$ (93 × 123·2)

Coll. Painted for William Moffatt; Harriott sale Christie's 23 June 1838 (111) bought Allnutt; E. I. Fripp; sale Christie's 9 July 1864 (126 as 'Barnes Terrace on the Thames') bought G. E. Fripp, therefore probably bought in; Sam Mendel from whom bought by Agnew in 1873 and sold to James Price, 1874; sale Christie's 18 June 1895 (64) bought Agnew for Stephen Holland; sale Christie's 25 June 1908 (111) bought Knoedler; Andrew Mellon (?); H. C. Frick, 1909. (Accession no. 09.1.121)

Exh. R.A. 1826 (324); R.A. 1872 (22 lent by Sam Mendel); R.A. 1895 (25); Agnew 1896 (6); Guildhall 1899 (22); Knoedler 1908 (5); Boston Museum of Fine Arts *Frick Collection* 1910 (39).

Lit. Burnet and Cunningham 1852, p. 115 no. 137; Thornbury 1862, i, p. 305 (as exhibited in 1828); 1877, pp. 438, 575; Hamerton 1879, p. 216; Bell 1901, p. 106 no. 150; Armstrong 1902, pp. 118–19, 225, repr. facing p. 118; Holmes 1908, pp. 17–25, repr.; Falk 1938, pp. 159, 250; Finberg 1961, pp. 296, 486 no. 310; Rothenstein and Butlin 1964, p. 40, pl. 66; Davidson 1968, i, pp. 131–2, repr.; Reynolds 1969, p. 121, fig. 102; Herrmann 1975, pp. 32–3, 232, pl. 117.

William Moffatt of 'The Limes', Mortlake, died at Weymouth on 25 August 1831 aged 77. He lived at 'The Limes' from 1812 until his death. Turner's letter of 8 July 1826 to Soane, mentioned in the entry for No. 234, confirms Moffatt's ownership of the picture at that date.

Turner exhibited a companion at the R.A. in the following year, looking from Moffatt's house along the river in the opposition direction (No. 239, now in Washington). There are a number of studies for both pictures in the 'Mortlake and Pulborough' sketchbook (CCXIII). A careful pencil sketch of the whole composition of this picture appears on pp. 10 verso–11 (and is continued on p. 12; pp. 10 verso–11 are repr. Wilkinson 1975, p. 31), inscribed by Turner 'Tuscan 4 Trigliphs' (?); other studies of the house occur on pp. 15 verso–16, 43 verso and 44. CCLXIII (a) no. 3 in 'Miscellaneous Black and White 1820–30' is also a faint and very summary study for this composition, showing the four main trees and the house.

Although the Washington picture is sometimes known as 'Barnes Terrace' (perhaps to differentiate it from this picture), the histories of the pictures have been confused in the past: the 1864 Christie's catalogue and both the Price sale catalogue in 1895 and the R.A. Winter Exhibition catalogue, 1895, describe this picture as if it were No. 239. The evidence for Andrew Mellon having owned this picture for a short time between the Holland sale in June 1908 and its acquisition by Frick in 1909 seems to rest on a payment to Mellon being made by Frick at the time he bought it as noted in the Frick Catalogue.

This picture was scarcely noticed in the reviews of the R.A. Exhibition, the critics concentrating on *Cologne* (No. 232) and *Forum Romanum* (No. 233). However, the *Literary Gazette* for 13 May did give it a word of praise in passing and by contrast to the other two, remarking 'There is yet, however, another of Mr. Turner's pictures that is truly attractive, from the lightness and simplicity, No. 324'.

It is interesting to note that the eighteenth-century topographical tradition, which Turner had already revolutionised in his *Somer Hill* (No. 116) of 1811, has undergone further changes in this pair of pictures, so that 'The Seat of William Moffatt Esq.' which features so prominently in the titles of both pictures plays a less than prominent role in this picture and does not appear at all in its pendant.

236. 'Now for the Painter', (Rope.) Passengers going on Board Exh. 1827 (Plate 224)
also known as the *Pas de Calais*

CITY OF MANCHESTER ART GALLERIES

Canvas, 67 × 88 (170·2 × 223·5)

Coll. Bought by John Naylor of Leighton Hall, Welshpool, Montgomeryshire from Turner himself in 1851 (this is recorded by Naylor in the inventory of his pictures begun in October 1856; he paid £1,276 for it); bought from J. M. Naylor by Agnew through Dyer and Sons in 1910; sold in 1928 to F. J. Nettlefold who presented it to the City Art Gallery, Manchester, in 1947.

Exh. R.A. 1827 (74); Liverpool Town Hall 1854 (36); Manchester 1857 (295); Agnew 1902 (1) and 1910 (10); Leggatt 1947 (36); Agnew 1967 (14).

Engr. By W. Davison 1830 and by J. Cousen in the *Turner Gallery* 1859

Lit. Ruskin 1843, 1851, 1856 (1903–12, iii, pp. 510, 568; xii, p. 380; xiii, p. 47); Burnet and Cunningham 1852, p. 115 no. 138; Thornbury 1862, i, p. 305; ii, pp. 50, 140, 266, 267, 335–6, 400; 1877, pp. 232, 293, 353–4, 438, 533, 575, 597; Hamerton 1879, p. 214; Bell 1901, p. 107 no. 151; Armstrong 1902, p. 229; Rawlinson ii 1913, pp. 208, 210, 358, 383; Whitley 1930, p. 131; Falk 1938, p. 156; Finberg 1961, pp. 301, 397, 487 no. 311; Gage 1969, p. 171; Morris 1974–5, p. 98 no. 195, fig. 64.

Also known as the *Pas de Calais* as this is inscribed on the pennant flying on the nearest boat.

Turner's title for this picture was arrived at thus, according to Thornbury: in 1826 Clarkson Stanfield

painted a picture of a calm which he named *Throwing the Painter*, but was not able to finish it in time for the R.A. Exhibition. On hearing of this, Callcott produced a picture which he jocularly entitled *Dutch Fishing Boats running foul in the endeavour to board, and missing the Painter Rope* (exh. R.A. 1826 (165)). The following year Turner painted this picture in order to have the last laugh—the sort of elaborate play on words that appealed to his sense of humour. Thornbury concludes 'It is easy to see that this was but conducting a joke started by Calcott to a further stage; yet detractors perverted it to Turner's defamation.'

This picture is referred to in a letter from Turner to his dealer, Thomas Griffith, written on 1 February 1844, concerning the pictures in his studio and their need of care and restoration: 'The Pas de Calais is now in the Gallery (suffering).' The publication of the first volume of *Modern Painters* in the previous year had evidently led to a fresh interest in Turner's work and Griffith was anxious that pictures should be put into good order so that there should be something to show potential buyers. Gage suggests that it was probably for this purpose that Turner employed the young painter, Francis Sherrell, as a studio assistant from 1848 and he may have carried out the necessary repairs on this picture before Naylor bought it.

The picture was well received on the whole at the Academy, one critic remarking that Turner 'has retrieved his character on the present occasion'. This seapiece and *Port Ruysdael* (No. 237) were singled out for praise and *The Times* for 11 May considered that the painting of the water 'has perhaps never been surpassed' although 'the boats want that appearance of buoyancy and motion which Mr. Copley Fielding knows how well to give.'

In the *Examiner* Robert Hunt wrote 'We have Mr. Turner this season completely as sea, where he is as much at home as on land, perhaps more so; and as much so too, in our humble judgment, as the best of the Dutch marine painters.'

The critic of the *Literary Gazette* for 2 June, however, thought *Port Ruysdael* the finer picture, as *Now for the Painter* 'has much of the ultra both in effect and colour'.

Ruskin pointed out that the reflection of the buoy on the left descends vertically instead of following the contour of the waves but wrote he could not tell 'whether this is licence or mistake'. He suspected the latter, but thought that Turner may possibly have painted it thus on purpose 'for the vertical line is necessary to the picture and the eye is so little accustomed to catch the real bearing of the reflections on the slopes of the waves that it does not feel the fault.'

237. Port Ruysdael Exh. 1827 (Plate 264)

YALE CENTER FOR BRITISH ART, PAUL MELLON COLLECTION

Canvas, $36\frac{1}{4} \times 48\frac{1}{4}$ (92 × 122·5)

Coll. Bought from Turner in March 1844 by Elhanan Bicknell (together with five other Turner oils);

Bicknell sale Christie's 25 April 1863 (120) bought Agnew for John Heugh; bought back by Agnew in 1864 and sold to John Kelk (afterwards Sir John Kelk, Bt); sale Christie's 11 March 1899 (40) bought Tooth; Hon. (later Sir) George Drummond, Montreal by 1901; sale Christie's 27 June 1919 (158) bought Knoedler; sold in 1946 (!) to John J. Astor, New York; sale Parke Bernet 19 October 1961 (44) bought Newhouse and Agnew; bought by Mr Paul Mellon from Agnew in 1962.

Exh. R.A. 1827 (147); Earl's Court *Victorian Era* 1897 (17); Montreal Art Association 1901; San Francisco, Palace of the Legion of Honour, *English Painting* 1933 (66); Carnegie Institute, Pittsburgh, *A Survey of British Painting* 1938 (58); New York, World's Fair, *Masterpieces of Art* 1940 (159); Detroit Institute of Art, *Five Centuries of Marine Painting* 1942 (64, repr. pl. 9); Indianapolis 1955 (22); Montreal Museum of Fine Arts, *Canada Collects 1860–1960* 1960 (37); Richmond 1963 (134); R.A. 1964–5 (168); Washington 1968–9 (11).

Lit. Ruskin 1843 (1903–12, iii, p. 568 repr.); Burnet and Cunningham 1852, pp. 29–30, 115 no. 139; Waagen 1854, ii, p. 350; Thornbury 1862, ii, p. 401; 1877, pp. 575, 599, 610; Hamerton 1879, p. 217; Wedmore 1900, i, repr. facing p. 134; *Art Journal* 1901, p. 288; Bell 1901, p. 107 no. 152 (who states wrongly that the picture belonged to R. Hall McCormick, Chicago in 1901); Armstrong 1902, p. 230; A. M. Hind, *Turner's Golden Visions* 1925, p. 217; Whitley 1930, p. 131; Clare 1951, pp. 73–4; Boase 1959, p. 338; Finberg 1961, pp. 301, 399, 487 no. 312; Rothenstein and Butlin 1964, pp. 40, 68, pl. 67; Reynolds 1969, p. 122; Bachrach 1974, p. 9, repr. p. 10.

Port Ruysdael is a fictitious title, chosen by Turner, according to Finberg, as a mark of respect for the great Dutch painter Jacob Ruisdael (1628/9–82), whose *Coast Scene* Turner had so much admired when he visited the Louvre in 1802, but, according to Burnet and Cunningham, the title was 'said to have been suggested to him by a dark sea view by Ruisdael belonging to Munro of Novar'. However, the Ruisdael in Munro's collection which came closest to Turner's picture in composition was not bought until 1856. Rather than a specific picture, therefore, it is more likely that Turner had a number of seapieces by Ruisdael in mind when he painted this. Possible sources include, beside those already mentioned, *A Rough Sea* (Hofstede de Groot no. 945) now in an American private collection, which was brought to England by Smith and sold to the Earl of Liverpool in 1824, and contains a number of features which recur in Turner's painting, and *Storm off the Dutch Coast* (L. Gow sale Christie's 28 May 1937 (113)) which seems equally relevant as a source, although it is not known if Turner knew this picture. Turner used the title again in a picture he exhibited in 1844 (see No. 408).

It was generally admired at the R.A. by critics but little space was devoted to it. The *Literary Magnet* (3, p. 334) considered that 'the water is exquisitely managed', an opinion shared by Ruskin in *Modern Painters* who wrote: 'I know of no work at all comparable for the expression of the white, wild, cold, comfortless waves of the north sea, even though the sea is almost subordinate to the awful rolling clouds.' It was eight years since Turner had last exhibited a seapiece (*The Entrance of the Meuse*, No. 139) at the R.A. *Port Ruysdael* was the magnificent forerunner of a series of pictures featuring tempestuous seas, which occupied Turner's attention intermittently for the next two decades. Some of these were exhibited, but many others remained in the artist's possession and are now in the Tate Gallery as part of the Turner Bequest (Nos. 455–71).

238. Rembrandt's Daughter Exh. 1827 (Plate 244)

THE FOGG ART MUSEUM, HARVARD UNIVERSITY, CAMBRIDGE, MASS.

Canvas, 48 × 34 (122 × 86·3)

Coll. Bought at the R.A. in 1827 by Francis Hawksworth Fawkes, the only work by Turner to be added to the collection at Farnley after the death of Walter Fawkes in 1825; bought from F. H. Fawkes in 1912 by Agnew and Knoedler who sold it in 1913 to Edward Forbes who gave it to the Fogg Art Museum in 1917 (Accession no. 1917:214).

Exh. R.A. 1827 (166); R.A. 1877 (261); Lawrie and Co. 1902 (6); Grafton Gallery *3rd Exhibition of Fair Women* 1910 (35); Carnegie Institute, Pittsburgh *A Survey of British Painting* 1938 (60).

Lit. Burnet and Cunningham 1852, pp. 25–6, 29, 115 no. 140; Thornbury 1862, ii, pp. 85, 89–90, 165, 393; 1877, pp. 237, 240, 312, 575, 589; Bell 1901, p. 108 no. 153; Armstrong 1902, pp. 57, 85, 119–20, 227; Finberg 1912, pp. 20, 21; *Studio* lxvi, 1915–16, repr. in colour facing p. 278; Whitley 1930, p. 131; Falk 1938, p. 159; Finberg 1961, pp. 301, 487 no. 313; Rothenstein and Butlin 1964, pp. 40, 44; Lindsay 1966, pp. 165, 170; Gage 1969, pp. 91, 167, 262 n. 116; Reynolds 1969, pp. 127–8; Gage 1972, pp. 50–51, fig. 30.

This was the subject of one of those incidents on the Varnishing Days which occurred from time to time in Turner's career. Hanging close to Archer Shee's portrait of *John Wilde Esq. LL.D.* (R.A. 165) in academic robes, the reds in Turner's picture appeared dull beside the brilliancy of the red of Wilde's University gown. Therefore, Turner added red lead and vermilion to his picture in order to outshine Shee's portrait. It seems likely that this manoeuvre was resented by Shee who, on becoming President of the Royal Academy in 1830, attempted to reduce the number of days allowed for varnishing.

However successful was the short-term result of Turner's tinkering, the picture suffered grievously from it in the long run, for large areas are now badly eaten away by bituminous cracking and only a small part round the principal figure remains in reasonable condition. This technical recklessness on Turner's part may have been due also in part to an attempt to equal the luminosity in the shadows in Rembrandt's work, for this picture was planned deliberately as an exercise in the Rembrandtesque based on a specific picture, *Joseph and Potiphar's Wife*, now in the Staatliche Museum, Berlin-Dahlem, but which at that time belonged to Sir Thomas Lawrence (the dimensions of the two pictures are reasonably similar: the Rembrandt measures 43¼ × 34¼ in.). Gage (1972) suggests that the engraving of *Rembrandt's Mistress* by J. G. Haid, made in 1767, may very probably have been a further source for Turner's picture, which combines elements from both his friend Lawrence's Rembrandt and from this engraving. *Rembrandt's Daughter* marks a revival of interest by Turner in Rembrandt's work, a preoccupation which had lain dormant since *The Unpaid Bill* (No. 81) and *Windmill and Lock* (No. 101) but which was now to claim his attention anew and which led on to *Pilate washing his Hands* (No. 332) and *Jessica* (No. 333), both exhibited three years later. In a paper on 'Turner, Rembrandt and the Discourses of Sir Joshua Reynolds', read in April 1975 at the Turner Symposium held at Johns Hopkins University, Baltimore, Mr Evan Maurer suggested two additional nuances which he discerns in the picture. He believes that the figures in the background —Rembrandt and his mistress Hendrickje Stoffels (whom he could not marry because of the terms of the will of his wife, Saskia, who died in 1642) were seen by Turner as being analagous to his own position *vis à vis* Sarah Danby, although there is no evidence that she was similarly constrained from remarrying.

Mr Maurer further suggested that the fact that Rembrandt's daughter is seen reading a letter is not without significance, being an allusion to the episode in Turner's youth, recounted by Thornbury (1877, pp. 41–3), when his betrothed, a girl at Margate, finally married another suitor because Turner's letters to her had been suppressed by her step-mother. However, Thornbury's account of this *affaire du coeur* seems to lack any solid evidence to support it.

As may be imagined, the picture was much ridiculed by the critics, save by *The Times*, 11 May, which considered it 'a curious and beautiful example of the effect of light and colour. It is evidently a rough sketch'. The *Literary Magnet* (3, p. 334) called it Turner's 'first attempt at historical painting' and 'a parody on Rembrandt's *Joseph and Potiphar's Wife*' and it was also considered as 'a joke upon Rembrandt' by the *New Monthly Magazine* (part iii, pp. 379, 380).

The *Morning Post* for 15 June wished that Turner, who had evidently 'had Rembrandt in his fancy when he painted this extraordinary picture, had also had him in his eye!' and complained of 'a confusion of colour,

like nothing we can imagine in nature, unless one could imagine a great dish of gooseberries and cream spilled over the quilt and the petticoat.' This criticism suggests an iridescent colouring, apparent when first exhibited, but sadly now no longer visible, although an idea of its original appearance may perhaps be gleaned from the jewel-like colours of *Pilate washing his Hands*.

239. Mortlake Terrace, the Seat of William Moffatt, Esq. Summer's Evening Exh. 1827

(Plate 223)

NATIONAL GALLERY OF ART, WASHINGTON D.C.

Canvas, $36\frac{1}{4} \times 48\frac{1}{8}$ (92 × 122)

Coll. Painted for William Moffatt who died in 1831 (see No. 235); Harriott sale Christie's 23 June 1838 (112) bought Allnutt; the Rev. E. T. Daniell (1804–1842); sale Christie's 17 March 1843 (160) bought M. E. Creswick; bought by Agnew in 1851 from Creswick and sold to Samuel Ashton; by descent to Captain Ashton from whom bought by Agnew 1920; Knoedler, who sold it to Andrew Mellon in December 1920; given by him to National Gallery, Washington D.C., 1937 (Accession no. 109).

Exh. R.A. 1827 (300); Manchester 1857 (256); Guildhall 1899 (23); R.A. 1974–5 (310 repr.).

Engr. By G. Cooke in the *Book of Gems* 1836.

Lit. Burnet and Cunningham 1852, p. 115 no. 141; Thornbury 1862, i, pp. 305, 413; 1877, pp. 196, 438, 575; Bürger, *Trésors d'Art en Angleterre* 1865, p. 425; Hamerton 1879, p. 216; *Magazine of Art* 1899, p. 403; Bell 1901, p. 108 no. 154; Armstrong 1902, pp. 118–19, 225, repr. facing p. 130; Whitley 1930, pp. 131–2, 282; Finberg 1961, pp. 301, 487 no. 314; Rothenstein and Butlin 1964, p. 40; Lindsay 1966, p. 165; Reynolds 1969, p. 121.

As noted in the entry for No. 235, the histories of the two Mortlake pictures have been confused in the past. Armstrong was wrong in stating that this picture ever belonged to Fripp.

There is a pencil study for this picture on pp. 15 verso–16 of the 'Mortlake and Pulborough' sketchbook (CCXIII, repr. Wilkinson 1975, p. 31), while further studies are found under nos. 1 and 2 of CCLXIII(a) ('Miscellaneous Black and White'), no. 1 being much more clearly defined than no. 2. Finberg is wrong in saying that no. 1 is connected with the Frick picture.

Thornbury relates that he was told by Sir George Harvey, the Scottish artist (1806–1876), that Turner and a gentleman, who had just bought this picture from a third party, discussed it and Turner gleefully told him that the dog on the parapet was cut out of black paper and stuck on the canvas. Turner had done this because he suddenly realised that a dark object there would increase the sense of recession. But Frederick Goodall, R.A., whose father had engraved some of Turner's

pictures, claimed that it was the work of Edwin Landseer. 'He cut out a little dog in paper, painted it black, and on Varnishing Day, stuck it upon the terrace . . . all wondered what Turner would say and do when he came up from luncheon table at noon. He went up to the picture quite unconcernedly, never said a word, adjusted the little dog perfectly, and then varnished the paper and began painting it. And there it is to the present day.'

It is difficult to say now which version is true. The dog *is* stuck on (except apparently for its tail which is painted directly onto the canvas, but the 'original' paper tail may have become detached) which argues in favour of Landseer's authorship, but, on the other hand, the dog seems entirely characteristic of the dogs which appear frequently elsewhere in Turner's work, especially in his watercolours. Perhaps the truth is that, in painting over Landseer's under-dog, Turner refashioned it into one which is now indistinguishable from one painted wholly by himself. Somewhat similar incidents, also involving a stuck-on detail, occurred with *Childe Harold* (No. 342) and *The Golden Bough* (No. 355).

The picture was violently abused at the R.A. on account of its yellowness. The *Morning Post* for 15 June remarked that Turner was getting worse and worse of 'what we may call a yellow fever' and that this picture was 'desperately afflicted with the disease'. The critic of *John Bull* for 27 May refers to 'Mr. Turner's pertinaceous adherence to yellow' and singles out this picture as the most glaring example, because when every part of the picture 'should be afflicted with the jaundice, it is too much to be endured'. The critic compared Turner to a cook with a mania for curry and the notice concludes 'When we look back at the works of Turner, of some twenty or five and twenty years standing, and see nature in all her healthfulness glowing under his powerful hand, it really makes us as sick as she looks in his pictures now to see so sad, so needless a falling off.' This is therefore one of the earliest—if not the earliest—notices to allege a decline in Turner's powers, a theme which was to recur increasingly as time went on.

240. Scene in Derbyshire Exh. 1827

PRESENT WHEREABOUTS UNKNOWN

Size unknown

Exh. R.A. 1827 (319).

Lit. Burnet and Cunningham 1852, p. 115 no. 142; Thornbury 1877, p. 575; Bell 1901, p. 109 no. 155; Finberg 1961, pp. 301, 487 no. 315.

Exhibited with the quotation:

'When first the sun with beacon red.'

This picture has disappeared entirely since originally exhibited. As noted in the entry for No. 270, it cannot

possibly be identified with the picture now in Worcester, Mass., as suggested by Finberg. Indeed, Mrs Finberg expresses doubts about this in a footnote to the second edition of her husband's *Life*, p. 487: 'Except for its reference to the sunset (recalling Campbell's "When first the fiery-mantled Sun") this title does not suggest the Italianate composition of the picture sold at Christie's in 1926.'

This picture was warmly praised at the R.A., although not very much space was devoted to it compared with the criticism heaped on Turner's other exhibits. In general, it was recognised as showing a more naturalistic approach to landscape than had been evident in Turner's recent work. The *Literary Magnet* (3, 1827, p. 334) called it 'a bit of unrivalled richness and beauty. We are glad to perceive that Mr. Turner has, in a great measure, abandoned the unnatural style of colouring, of which we have too frequently had to complain.'

It was also praised by both the *Morning Post* for 15 June and the *New Monthly Magazine* (Part iii, 1827, pp. 379, 380), the former considering it Turner's best picture at the R.A. 'which, though certainly not equal to his former productions, is nearer to nature than anything of his in the present exhibition'.

The Times of 11 May alone was critical, lamenting that 'Mr Turner has not yet got rid of his ambition of painting the sun. There is an attempt of this kind in the exhibition which is, as usual, ludicrously unsuccessful.' (This may possibly refer to the *Mortlake Terrace*, No. 239, but, in view of the quotation appended to the title, it seems more likely that this picture is meant.)

This picture is mysterious in both the form of the title and in the subject itself. 'Scene in Derbyshire' is an unusually imprecise title for an exhibited picture and there is no record of Turner making a trip to the north of England about this time. Indeed, his only known journey north in the 1820s was to Edinburgh in 1822 when he travelled both ways by sea. This picture must then either have been based on sketches made much earlier or be the result of a hitherto unrecorded journey.

241. Dido directing the Equipment of the Fleet, or The Morning of the Carthaginian Empire
Exh. 1828 (Plate 229)

THE TATE GALLERY, LONDON (506)

Plywood, transferred from canvas, 59 × 89 (150 × 226)

Coll. Turner Bequest 1856 (65, 'Carthage (Mr. Broadhursts Commission)' 7′6″ × 5′0″); transferred to the Tate Gallery 1910; returned to National Gallery 1917 and to Tate Gallery 1968.

Exh. R.A. 1828 (70).

Lit. Thornbury 1862, i, pp. 306–7; 1877, p. 439; Hamerton 1879, p. 218 (repr. 1895 edn, facing p. 216); Bell 1901, p. 109 no. 156; Armstrong 1902, p. 219; MacColl 1920, p. 14; Whitley 1930, p. 146;

Davies 1946, p. 187; Finberg 1961, pp. 303–4, 306, 487 no. 316; Lindsay 1966, p. 166; Reynolds 1969, p. 124.

This picture was written off as a complete wreck after being transferred from its original canvas to plywood in 1917, following a long history of blistering; it had already been relined in 1871. It was then mislaid at the National Gallery and not rediscovered until 1968, when it was returned to the Tate Gallery. Sufficient original paint remains for there to be some possibility that the picture can be at least partially restored sometime in the future. At present, however, its surface is protected by mulberry paper.

There is a possible sketch for the picture in the 'River' sketchbook of *c.* 1823–4 (CCIV-7 verso) and a study among the drawings in pen and white chalk on blue paper done by Turner while staying with John Nash at East Cowes Castle in July–September 1827 (CCXXVII(a)-15). For this reason Finberg suggests that Turner may even have begun the painting there, on the full-length canvas that, in a letter written to his father during his stay, Turner suggested might be sent in addition to the 6 ft by 4 ft canvas used for the Cowes sketches, Nos. 260–68.

The Schedule of the Turner Bequest, supported by Thornbury, suggests that the picture was painted for Mr Broadhurst, though he never seems to have owned it (see also No. 232). In June 1828 John Pye advertised for subscribers to an engraving of the picture, but this was never produced.

The picture was hung immediately below Thomas Phillips' full-length portrait of the Duke of Sussex at the head of the Great Room at the R.A., then at Somerset House, and was described there by the *Literary Gazette* for 3 May 1828 as 'a very brilliant and powerful landscape.' A week later, however, on 10 May, the *Literary Gazette* was more critical: 'Visitor, before you venture to look at this picture pray take a hint from the pretty *Peasant of Andernach* (No. 78, by H. Howard, R.A.), and veil your sight as she does; or it will be over-powered by the glare of the violent colours here assembled. It is really too much for an artist to exercise so despotic a sway over the sun, as to make that glorious, and, as it has been hitherto supposed, independent luminary, act precisely in conformity to his caprice; pouring its rays on objects upon which they could not possibly fall, and hiding them from others in the direct line of their influence. There is scarcely a word of truth in the whole picture.'

The general consensus seems to have been that it was 'extremely beautiful and powerful' but 'is like nothing in nature' (*The Times*, 6 May, which also said, *apropos* the title, that it 'might as well be called any thing else'). Or, as the *Athenaeum* for 7 May put it, it 'is a remarkable and spirited composition; replete with ideas of beauty, and extremely brilliant, hardy, and powerful; but over-wrought in effect — *hors de nature, tout à fait*. The right-hand corner of the picture is wonderfully rich; and the introduction of the dark-green pine-tree is

astonishingly bold.' The *Repository of Arts* for June 1828, beginning with the general point that 'where an artist has gained so much deserved celebrity in his profession as the academic professor of perspective, the repetition of his merits becomes a trite topic', and likening Turner to those meteor-like spirits of the sun which 'nourish and illumine our denser and more opaque orbs', went on to praise the 'richness of colouring' of this picture: 'the brilliant and glowing verdure on the left is in the highest degree fine: but whence comes the ruffling of the water? With such a serene and calm atmosphere, there ought not to be a ripple, even if a tide flowed into the ports of Carthage. The reflected light on the edifices upon the right bank is of an unpleasant buff-colour; perhaps Dido liked it; now we don't, and are glad it is only used as what the painters call *priming* in this country. The conception of this picture is, however, grand; its execution full of powers of the highest order; and the subject is one we must admit which gave the artist a great latitude in the management of details.'

242. East Cowes Castle, the Seat of J. Nash, Esq.; the Regatta beating to Windward
Exh. 1828 (Plate 262)

THE INDIANAPOLIS MUSEUM OF ART, INDIANA

Canvas, $35\frac{1}{2} \times 47\frac{1}{2}$ (90·2 × 120·7)

Coll. Painted for John Nash together with No. 243; Nash sale Christie's 11 July 1835 (88) bought Tiffin; E. W. Parker; sale Christie's 2 July 1909 (100) bought Agnew jointly with Knoedler; W. G. Warden, Philadelphia; M. C. D. Borden; sale New York 13–14 February 1913 (29) bought W. W. Seaman for Colonel Ambrose Monell; Mrs Harrison Williams; Newhouse Galleries, New York, from whom bought by N. H. Noyes; presented to the Indianapolis Museum by Mrs Noyes in 1971 (Accession no. 71.32).

Exh. R.A. 1828 (113); Fort Worth Art Center *Old Masters* 1953 (17); Indianapolis 1955 (23); R.A. 1974–5 (321 repr.).

Lit. Burnet and Cunningham 1852, p. 155 no. 145; Thornbury 1877, p. 575; Hamerton 1879, p. 218; Bell 1901, p. 109 no. 157; Armstrong 1902, p. 220; Clare 1951, p. 75; Finberg 1961, pp. 307, 487 no. 317; Rothenstein and Butlin 1964, p. 39, pl. 71; Reynolds 1969, p. 123; 1969², pp. 67–73, pl. i; Herrmann 1975, pp. 33, 232, pl. 119.

For the circumstances leading to the painting of this picture see No. 243. Although the Royal Yacht Club was founded in 1812, it was not until 1826 that they began to hold races at Cowes. Of the three pictures by Turner knocked down to the dealer Tiffin at the Nash sale, the other two (Nos. 243 and 336) were both bought on behalf of Sheepshanks. If Sheepshanks ever owned

this picture as well, he must have resold it after a short time as, in a report of the Parker sale in 1909, *The Times* of 3 July stated that this picture 'had not been seen or known to writers on Turner for over 70 years'. This is borne out by the references to it both by Bell and by Armstrong. It seems more likely that in this case Tiffin was acting for a buyer other than Sheepshanks at the Nash sale.

At the R.A. this picture was strongly criticised in the *Morning Herald*, 26 May, which considered the sea 'more like marble-dust than any living waters', while, on technical grounds, Turner's yachts were found to be 'over-masted, and represented as carrying sail such as no vessel of their dimensions could carry in such a wind for a single moment.' This criticism was echoed in the *Athenaeum* for 7 May but the picture was praised in the *Literary Gazette* for 31 May, in the *Repository of Arts* (xi, pp. 355–6), and by *The Times* for 6 May, which thought that it did Turner justice and was 'less pretentious' than his other pictures in the exhibition.

As with No. 243, three oil sketches in the Tate Gallery (see Nos. 260–62) are studies for the exhibited picture. For their origins see pp. 142–3.

243. East Cowes Castle, the Seat of J. Nash, Esq.; the Regatta starting for their Moorings
Exh. 1828 (Plate 263)

THE VICTORIA AND ALBERT MUSEUM, LONDON

Canvas, $36 \times 48\frac{1}{2}$ (91·4 × 123·2)

Coll. Painted for John Nash (1752–1835), the architect, who owned East Cowes Castle; Nash sale Christie's 11 July 1835 (87) bought Tiffin, an agent acting for John Sheepshanks who gave it to the Victoria and Albert Museum in 1857 (Accession no. 210).

Exh. R.A. 1828 (152).

Lit. Burnet and Cunningham 1852, p. 115 no. 144; Waagen 1854, ii, p. 301; Thornbury 1877, p. 575; Hamerton 1879, p. 218; Bell 1901, pp. 109–10 no. 158; Armstrong 1902, p. 220; Clare 1951, p. 75; Finberg 1961, pp. 307, 487 no. 318; Rothenstein and Butlin 1964, p. 39; Reynolds 1969, pp. 123–4, 140, fig. 107; 1969², pp. 67–79, colour pl. iiia; V.A.M. catalogue 1973, p. 138.

This and the companion picture (No. 242) were the direct result of a visit of some weeks which Turner paid to Nash at East Cowes Castle from the end of July to September 1827. Nash set aside a special painting room for Turner's use during the visit and Finberg prints a letter from Turner, written to his father in London asking for more paint and canvases to be forwarded to the Isle of Wight. It was doubtless on these canvases that he painted the oil sketches of yachts in the Medina river and racing in the Solent, now in the Tate Gallery (Nos. 260–68). Three of these (see Nos. 263–65) are taken from very much the same viewpoint

as this picture, and each has a number of elements in common with the finished composition. Reynolds plausibly suggests that Nos. 263 and 264 were done on the spot from a point on the shore. The third sketch (No. 265) was probably worked up afterwards in Turner's painting room. We know that Turner divided one of his 4 ft by 6 ft canvases into two each measuring 3 ft by 4 ft, presumably to make them more easily manageable.

Reynolds points out that this is one of the pictures which has suffered from an insufficiently prepared ground (probably prepared with a kind of tempera, a practice Turner was still experimenting with in Rome the following year as we learn from Eastlake), and in which the accretions of pigment, designed to give extra brightness to the sun and its reflection, have resulted in a permanent tendency to flake. Evidence that flaking may have begun not many years after the picture was painted is provided by a letter from Constable to Leslie, written about November 1836, after visiting Sheepshanks' collection at Blackheath: 'Turner is very grand . . . but some of [his] best work is swept up off the carpet every morning by the maid and put onto the dust hole' (R. B. Beckett (ed.), *John Constable's Correspondence* iii, 1965, p. 143). Hitherto this has been taken to refer to the condition of the pictures in Turner's gallery in Queen Anne Street, but the context shows that it is about Sheepshanks' pictures (he owned five Turners), among which *East Cowes Castle* must surely have been present at the time of Constable's visit.

On the whole the two Regatta pictures were quite well received at the R.A., especially this one, and both were welcomed as subjects which the critics considered more suited to Turner's talents than either the *Boccaccio* (No. 244) or *Dido directing the Equipment of the Fleet* (No. 241), both of which were considered to be far too garish in colour. In fact Turner treated the Regatta in much the same way as he treated Tabley (Nos. 98 and 99) nearly twenty years earlier, and produced a pair of rather similar views, painted under widely contrasting weather conditions. He has also taken a stage further the treatment noticed in the two views of William Moffatt's house at Mortlake (Nos. 235 and 239) in that, although the exhibited titles give prominence to 'East Cowes Castle', the castle itself plays an extremely minor role in the finished compositions.

The barely discernible figures in the background on the right between the trees and the building are sketched in the manner of Watteau, indicating perhaps that Turner's mind was again (after *What You Will!* of 1822, No. 229) turning towards the French painter, especially when he found himself confronted with a subject which contained all the ingredients of a *fête galante*. This preoccupation was to lead to the picture of *Watteau Study by Fresnoy's Rules* (No. 340) exhibited three years later.

A small picture (13 × 19¾ in.), *Yachting at Cowes*, in the Auckland City Art Gallery, which is similar in composition to this picture and is reported to be signed

and dated 1835, appears, from a photograph, to stand little or no chance of being genuine.

244. Boccaccio relating the Tale of the Birdcage
Exh. 1828 (Plate 245)

THE TATE GALLERY, LONDON (507)

Canvas, 48 × 35⅝ (122 × 90·5)

Coll. Turner Bequest 1856 (73, 'The Bird Cage' 4′0″ × 3′0″); transferred to the Tate Gallery 1905.

Exh. R.A. 1828 (262); Venice and Rome 1948 (31, repr.); Hamburg, Oslo, Stockholm and Copenhagen 1949–50 (97); Whitechapel 1953 (81); R.A. 1974–5 (322).

Engr. By J. P. Quilley in mezzotint 1830.

Lit. Ruskin 1857 (1903–12, xiii, pp. 135–6); Leslie 1860, i, p. 130; Thornbury 1862, i, p. 306; ii, p. 35; 1877, pp. 222, 439; Hamerton 1879, pp. 134, 218; Bell 1901, p. 110 no. 159; Armstrong 1902, p. 219; MacColl 1920, p. 14; Whitley 1930, pp. 146–7; Davies 1946, p. 187; Finberg 1961, pp. 306–7, 487 no. 319; Herrmann 1963, p. 24; Rothenstein and Butlin 1964, p. 42; Lindsay 1966, p. 96; Gage 1969, p. 92; Reynolds 1969, p. 124, pl. 108; Reynolds 1969², p. 74, pl. 10; Herrmann 1975, p. 33, pl. 120.

Turner chose his title for general effect rather than to give a specific reference, there being no story about a birdcage in the *Decameron*. Turner was inspired by Thomas Stothard's illustrations to an edition of the book published in 1825; the plate of 'Giornata Seconda' is particularly close with its Watteauesque figures sitting on the grass amidst trees (repr. A. C. Coxhead, *Thomas Stothard R.A.* 1906, facing p. 140). According to C. R. Leslie, Turner painted the picture 'in avowed imitation' of Stothard and told him, while actually working on it during one of the Varnishing Days prior to the opening of the 1828 R.A. Exhibition, that 'If I thought he liked my pictures half as well as I like his, I should be satisfied. He is the Giotto [*sic*: probably a mishearing of 'Watteau'] of England'. There is a further link with Watteau in that Turner here illustrates the text from Du Fresnoy that he was later to give to his *Watteau Painting* (No. 340), using white to bring a distant object near. In this case the distant object is based on East Cowes Castle, the subject of a number of sketches on blue paper done during Turner's stay there in 1827 (CCXXVII(a), e.g., 34, repr. Wilkinson 1975, p. 38).

The critic of the *Literary Gazette* for 17 May 1828 recognised Turner's reference to his fellow artists, ancient and modern; after mentioning Turner's other exhibits that year he goes on '—On land, as well as on water, Mr. Turner is determined not merely to shine, but to blaze and dazzle. Watteau and Stothard, be quiet! Here is much more than you could match.' But he goes on to attack the picture as a 'sketch . . . With

respect of the details in this gaudy experiment the less they are inspected the better for the reputation of the artist.' The *Athenaeum* for 21 May attacked it as 'the *ne plus ultra* of yellow, and gaudiness, and of corrupt art.' *The Times* for 6 May, however, after describing another of Turner's exhibits as 'extremely beautiful and

powerful', said of *Boccaccio* 'that it displays equal genius and the same fault ... it is like nothing in nature.'

The paint was transferred to a new canvas after the Thames flood of 1928.

Nos. 245–91: Unexhibited Works

Nos. 245–59: Miscellaneous, *c.* 1820–25

245. The Rialto, Venice *c.* 1820　　　(Plate 243)

THE TATE GALLERY, LONDON (5543)

Canvas, $69\frac{7}{8} \times 132$ ($177 \cdot 5 \times 335 \cdot 5$)

Coll. Turner Bequest 1856 (? 245, 1 unidentified $11'0'' \times 5'10\frac{1}{2}''$); transferred to the Tate Gallery 1951.

Lit. Davies 1946, p. 162; exh. cat., R.A. 1974–5, p. 92.

Until recently known as 'A Canal seen under a Bridge' but recognised in 1974 as showing the Grand Canal seen through the arch of the Rialto looking roughly south. The exceptional size and format of the picture match *England: Richmond Hill* (No. 140) and *Rome from the Vatican* (No. 228) and suggest that this unfinished picture was projected as a Venetian counterpart to the latter following Turner's first visit to Italy in 1819. The 'Milan to Venice' sketchbook of 1819 contains a sequence of drawings moving up the Grand Canal from the Lagoon, approaching, at, and looking back towards the Rialto (CLXXV-73 to 84; see especially the close-up of the bridge on 78 verso and 79, repr. Wilkinson 1974, pp. 182–3, and the view under the bridge on 81 verso and 82).

The picture is very dirty with tears on the left, just within the arch, and bottom right. There are also numerous paint losses, particularly in the left quarter of the picture. Some pencil drawing is visible, including ruled lines to define architectural forms.

246. An Avenue of Trees *c.* 1822?　　　(Plate 246)

THE TATE GALLERY, LONDON (5483)

Canvas, $19\frac{1}{2} \times 21\frac{1}{8}$ ($49 \cdot 5 \times 53 \cdot 5$)

Coll. Turner Bequest 1856 (177, 1 unidentified $1'9\frac{1}{4}'' \times 1'7\frac{1}{2}''$; identified 1946 by chalk number on back); transferred to the Tate Gallery 1947.

Lit. Davies 1946, pp. 158, 189.

The composition is perhaps related to the background of *What You Will!*, exhibited in 1822 (No. 229), though in reverse. Turner overpainted the tops of the trees as sky, but the tops of the two trees in the centre are not completely covered.

There are considerable losses of original paint down the left-hand edge.

247. George IV at St Giles's, Edinburgh *c.* 1822
　　　　　　　　　　　　　　　　　　(Plate 232)

THE TATE GALLERY, LONDON (2857)

Mahogany, $29\frac{11}{16} \times 36\frac{1}{8}$ ($76 \times 91 \cdot 5$)

Coll. Turner Bequest 1856 (? 149, one of '3 each (panel)' $3'0'' \times 2'6''$); transferred to the Tate Gallery 1929.

Exh. *George IV in Edinburgh 1822* Scottish National Portrait Gallery, Edinburgh, July–September 1961 (49), and on loan there since.

Lit. Falk 1938, pp. 129–30; Rothenstein and Butlin 1964, p. 30; Finley 1975, p. 35, repr. p. 30 fig. 19.

Finley (*op. cit.*, pp. 27–31) suggests that this picture and No. 248 were painted in connection with Turner's scheme to do a series of pictures of George IV's state visit to Edinburgh in 1822, nineteen rough composition sketches for which occupy a double-spread in the 'King at Edinburgh' sketchbook (CCI-44 verso and back cover; repr. *op. cit.*, p. 29 figs. 17 and 18); that for this composition was probably that numbered '15' by Turner, but this is a very rough sketch and the connection is not certain.

There are more closely related sketches of the interior of St Giles in the 'King's Visit to Scotland' sketchbook (CC-32 verso, 33, 33 verso (repr. Finley *op. cit.*, p. 31 fig. 24) and 34).

Finley describes the two oil paintings as '*modelli*' but

this example in particular is carried fairly far towards completion. There is no evidence of how large Turner planned this series to be and, although the two pictures in the Tate Gallery differ in size, they are both probably rather to be regarded as 'works in progress' than sketches. The scheme may well, as Finley suggests, have been aimed at securing the patronage of the King, and could have been abandoned because of the lack of success of the picture *Trafalgar*, No. 252. This latter was completed early in 1824 and Nos. 247 and 248 probably date from between 1822 and that year.

George IV arrived in the Royal Squadron off Leith on 14 August 1822 and landed the next day. He visited St Giles on 25 August.

248. George IV at the Provost's Banquet in the Parliament House, Edinburgh *c.* 1822 (Plate 233)

THE TATE GALLERY, LONDON (2858)

Mahogany, 27 × 36⅛ (68·5 × 91·8)

Coll. Turner Bequest, 1956 (? 154, one of '3 each (ditto [panel])' 3'0" × 2'3"); transferred to the Tate Gallery 1929.

Exh. R.A. 1974–5 (308).

Lit. Falk 1938, pp. 129–30; Rothenstein and Butlin 1964, p. 30, pl. 65; Reynolds 1969, p. 117, colour pl. 97; Finley 1975, p. 35, repr. p. 30 fig. 20; Wilkinson 1975, p. 9, repr. in colour p. 10.

See No. 247. The last, unnumbered drawing in the series of designs connected with the royal visit to Edinburgh in 1822 seems to relate to this subject and there is also what seems to be a very rapid sketch of the scene, closer to this oil painting, in the 'King's Visit to Scotland' sketchbook (CC-22 verso). The Provost's Banquet was held in the Parliament House on 24 August 1822.

249. Scene in a Church or Vaulted Hall
c. 1820–30 (Plate 247)

THE TATE GALLERY, LONDON (5492)

Canvas, 29½ × 39 (75 × 99)

Coll. Turner Bequest 1856 (137, 1 unidentified 3'3¾" × 2'5½"; identified by chalk number on back); transferred to the Tate Gallery 1947.

Lit. Davies 1946, pp. 160, 188.

In style and general composition this picture has something in common with the two paintings of George IV on his state visit to Edinburgh in 1822 (Nos. 247 and 248). The composition is not particularly close to the scene in St Giles (No. 247) but bears some resemblance to one of the tiny composition sketches in the 'King at Edinburgh' sketchbook, that numbered '12' and

identified by Gerald Finley as possibly depicting the removal of the Regalia from the Throne Room in Holyrood Palace on 24 August (CCI-44 verso and back cover; Finley 1975, p. 32, repr. p. 29 fig. 18). Here, however, the effect is less of an arcaded background than of a Gothic vault.

Gerald Finley cannot, however, confirm a connection with the George IV project, and it is probably best at the moment to accept the more general identification of Martin Davies: 'A scene in a Church (unfinished): A procession, apparently'; alternatively, as two static groups of figures appear to be shown, perhaps a baptism or wedding is depicted. In this case the picture could be rather later than 1822, though it lacks the richness and Rembrandtesque chiaroscuro of the interiors associated with Petworth of the 1830s (Nos. 445–7 and 449).

There are some paint losses down the right-hand edge, particularly near the top; these have now been restored.

250. First Sketch for 'The Battle of Trafalgar'
c. 1823 (Plate 230)

THE TATE GALLERY, LONDON (5480)

Canvas, 35¾ × 47½ (91 × 120·5)

Coll. Turner Bequest 1856 (16, 'Companion to ditto [Battle of Trafalgar, see No, 251]' 4'0" × 3'0"); transferred to the Tate Gallery 1947.

Lit. Davies 1946, p. 158.

In the 1856 copy of the Schedule, Wornum annotated no. 16 as 'unfinished'. This is the first oil sketch for the large picture begun in 1823 for George IV, No. 252; for a second, more detailed sketch see No. 251. In this picture, there are no figures in the sea in the foreground and the *Victory* is seen slightly from the rear rather than approaching. The sails are also different, as is the placing of the other ships. However, as in the second sketch, the composition is closed on the right by a ship seen stern on.

There are paint losses in the top right-hand corner and to a lesser extent in small areas elsewhere.

251. Second Sketch for 'The Battle of Trafalgar'
c. 1823 (Plate 231)

THE TATE GALLERY, LONDON (556)

Canvas, 35½ × 47¾ (90 × 121)

Coll. Turner Bequest 1856 (15, 'Battle of Trafalgar' 4'0" × 3'0"); transferred to the Tate Gallery 1931.

Exh. Australian tour 1960 (6); on loan to the National Maritime Museum from 1975.

Lit. Thornbury 1862, i, p. 349; 1877, p. 467; Armstrong 1902, p. 233; Davies 1946, p. 185.

The second oil sketch for the large picture begun in 1823 for George IV, No. 252. For differences between this and the first sketch see No. 250. In the final picture the group of figures in the foreground is changed, though the general massing is the same. The *Victory* is twisted very slightly to emphasise the fact that it is approaching the spectator and the sails, particularly in the centre, are again altered. The other ships are also different, and in particular that on the right, seen stern on in both sketches, is now shown at an angle.

252. The Battle of Trafalgar 1823–4 (Plate 234)

NATIONAL MARITIME MUSEUM, GREENWICH

Canvas, 102 × 144 (259 × 365·8)

Coll. Commissioned by George IV in the latter part of 1823 as a pendant to de Loutherbourg's *Glorious First of June*; both pictures were intended as part of a series to commemorate British victories to hang in St James's Palace—a project to which George Jones had already contributed two large paintings of *Vittoria* and *Waterloo*. Turner's picture was apparently finished by the Spring of 1824, for it was then that Mr Lambton told Haydon that the Government was not satisfied with it. Both pictures hung in the Ante-Room in St James's Palace, flanking Lawrence's portrait of George III, until 1 August 1829 when both were taken to Carlton House on their way to Greenwich Hospital, the King having given them to the Picture Gallery there.

Engr. By W. Miller in the *Turner Gallery* 1859.

Lit. B. R. Haydon *Diary* 27 May 1824 (ed. W. B. Pope 1960, ii, p. 487); Ruskin 1851, 1856, 1860 (1903–12, xii, pp. 369–70; xiii, pp. 33, 47, 170; vii, p. 379); Burnet and Cunningham 1852, pp. 44, 79; Thornbury 1862, i, pp. 133, 291–2; ii, pp. 133, 236–7, 400; 1877, pp. 81, 288, 334, 428–9, 598; Hamerton 1879, pp. 120, 168; Bell 1901, p. 86 under no. 112; Armstrong 1902, p. 233 (who misdates it *c.* 1808); Rawlinson ii 1913, pp. 207, 357; Whitley 1930, pp. 62–4, 231–2; Falk 1938, p. 130; *Guide to the National Maritime Museum* 1947, pp. 215–16 no. 16; Clare 1951, p. 72; Oliver Warner, 'Turner and Trafalgar', *Apollo* lxii Oct. 1955, p. 104; Hall 1960–62, pp. 109–10; Finberg 1961, pp. 282–3, 290, 333–4; Oliver Millar, *Later Georgian Pictures in the Royal Collection* 1968, pp. xxxii, xxxix, fig. xxiii; Reynolds 1969, p. 122, fig. 104; Gaunt 1971, p. 9; Finley 1975, p. 31.

Two sketches are in the Tate Gallery (see Nos. 250 and 251). No. 250 is a preliminary design in which Turner is concerned only with the relative positions of the main ships and not at all with incidents in the foreground; No. 251 is much nearer to the finished picture, although the ships are not shown at quite such close quarters as in the final version.

It seems that as usual with a commission, and perhaps especially with one from so august a patron, Turner took immense pains to try to get the details right. In early December 1823 he wrote to the marine painter, J. C. Schetky (1778–1874), who was then living in Portsmouth, about obtaining sketches of some of the ships which had been engaged in the battle. The relevant part of the letter (see Miss Schetky, *John C. Schetky by his daughter* 1877, p. 129) is as follows:

Dear Sir,

I thank you for your kind offer of the *Temeraire*; but I can bring in very little, if any, of her hull, because of the *Redoubtable*. If you will make me a sketch of the *Victory* (she is in Hayle Lake or Portsmouth Harbour) three-quarter bow on starboard side, or opposite the bow port, you will much oblige; and if you have a sketch of the *Neptune*, Captain Freemantle's ship, or know any particulars of *Santissima Trinidada* or *Redoubtable*, any communication I will thank you much for . . .

Yours most truly obliged
J. M. W. Turner

P.S. The *Victory* I understand, has undergone considerable alterations since the action, so that a slight sketch will do, having my own when she entered the Medway (with the body of Lord Nelson) and the Admiralty or Navy Office drawing.'

Although the picture was certainly hanging in St James's in May 1824, payment had still not been made by July 1825 as the following letter from Turner to Lawrence shows:

July 1, 1825. Queen Ann St. West.

Dear Sir Thomas—I have just now received a letter from the Lord Chamberlain's Office stating that the amount for my Picture will be paid upon demand. I therefore feel the necessity of again asking you if you do authorize me in demanding the 600 gs. you mentioned, or, if in your warmth for the service of the Arts you did exceed (in your wishes) the terms proposed. Do pray have the goodness to tell me?

In regard to the fees I beg to renew my Objections, — but do believe me to be, with true regard, Yours most faithfully

J. M. W. Turner.

To Sir Thos. Lawrence.

This letter is printed by Finberg from a transcript published in William Miller's *Memoir*, where it is stated that George IV commissioned the picture on Lawrence's advice. This seems very likely, as not only was Turner the obvious choice to paint such a scene, but Lawrence was a warm admirer of Turner's and had tried to do him a good turn on previous occasions (see No. 88). In the end, Turner received 500 guineas, the last instalment of £25 being paid in June 1826 (I owe this information to the kindness of John Gage).

From the first, Turner's picture seems to have been much criticised, and Thornbury records that Turner was 'instructed daily by the naval men about the Court.

During eleven days he altered the rigging to suit the fancy of every fresh critic; and he did it with the greatest good humour. In fact, he always joked about having worked eleven days without any pay or other profit.' George Jones in his *Memoir* records Turner as quoting in jest the well-known remark about the Calendar: 'Give us back our eleven days.'

In this connection, a letter from Henry Tijou to Sir John Leicester of 22 December 1824 (published by Douglas Hall) recounts the following story about a visit from the Duke of Clarence, afterwards William IV, to see the picture while Turner was working on it: 'he immediately began as a sailor to make his observations which not being agreeable, he says that Turner was rather rough in his reply. They went on for some time and the Duke finished the conversation by saying "I have been at sea the greater part of my life, Sir, you don't know who you are talking to, and I'll be damned if you know what you are talking about." '

However, according to Munro 'Turner always said the admiralty made him spoil this picture and the only sensible observations were from the Duke of Clarence. Turner once invited Holworthy and myself to dine with him at Greenwich. We after dinner visited the Hall and were looking at this painting; a pensioner came up and told us it was like a carpet. "That is the one to look at" pointing to the de Loutherbourg. I turned to look on Turner who has gone.' (MS note by Munro in Professor Francis Haskell's copy of Thornbury 1862, i, p. 292.)

On 22 May 1824 the *Literary Gazette* published an account of the State Apartments at St James's and praised the de Loutherbourg as being one of his best works although 'it is rather too cool a tone of colouring for such a subject. Turner on the contrary is in his new performance nearly all fire.'

In 1826, in a long review of *James's Naval History from 1793–1820* (*Literary Gazette*, pp. 389–90), the author attacked Turner's picture in detail as giving a wholly inaccurate view of the battle, summing it up as being 'full of glaring falsehoods and palpable inconsistencies.'

These persistent criticisms seem to have had a number of results. First, they may have influenced the King to give the picture to Greenwich instead of keeping it at St James's Palace. Although a number of naval portraits from the Royal Collection—such as the series by Lely and Kneller—had already been handed over to Greenwich, the removal there of Turner's picture during the artist's lifetime seems to have been generally, although quite possibly mistakenly, interpreted as implying Royal indifference if not disapproval, although Professor Finley surely exaggerates in describing the picture's move to Greenwich as 'a final humiliation' for Turner. Whatever reasons lay behind the King's decision, it meant that England's greatest painter is not now represented in the Royal Collection. Second, the aura of failure which seems to have surrounded Turner's *Trafalgar*, may, in retrospect, have cost him the chance of being knighted, a rebuff he felt keenly, especially when lesser artists, such as

Callcott and Wilkie, were subsequently honoured. Finally, Turner may have been influenced, as Finley suggests, to abandon an ambitious project, which was to consist of a series of 19 paintings, to commemorate the main events of George IV's visit to Edinburgh in August 1822 (see Nos. 247–8).

However, it is also true that this kind of realistic battle picture was not to George IV's taste. The King's preferences in art are admirably summed up by Sir Oliver Millar who makes it clear that, despite his passion for military matters, what really appealed to the King were dazzling uniforms and the panache of the review rather than the portrayal of shot and shell. It was in the series of portraits by Lawrence, now in the Waterloo Chamber at Windsor, rather than in such pictures as Turner's *Trafalgar* that George IV wished the allied victories to be commemorated.

Even after its removal to Greenwich, the *Trafalgar* was not forgotten or exempt from further abuse. In 1832, when a controversy arose over William IV's choice of Clarkson Stanfield (not at that time an Academician) to paint a picture of the opening of the new London Bridge, a correspondent to *The Times* defended the King's decision by reminding readers of the disaster that had occurred when the previous King *had* commissioned an Academician. The pictures which resulted (the writer included the de Loutherbourg although it was not a Royal commission) were, the letter concluded, 'a stigma on British art, a stain on the Academy, and an everlasting evidence of the misdirected generosity and justifiable disgust of George IV'.

Sir Thomas Hardy (1769–1839), Nelson's flag-captain at Trafalgar, who became a governor of Greenwich in 1834, used to say that the picture was like 'a street scene, as the ships had more the effect of houses than men of war.'

It was presumably criticism of this kind which led Ruskin to go to equally prejudiced lengths in defence of the picture which, he claimed, 'at a moderate estimate, is simply worth all the rest of the hospital—grounds—walls—pictures and models put together.'

253. Tynemouth Priory *c.* 1820–5? (Plate 248)

THE TATE GALLERY, LONDON (3133)

Canvas, $12\frac{1}{2} \times 24$ (32×61)

Coll. Turner Bequest 1856; transferred to the Tate Gallery 1935.

The subject was formerly tentatively identified as Woodspring Priory, close to the Somerset coast a few miles north of Weston-super-Mare, but has been demonstrated by Nicholas Cooper of the National Monuments Record (letter of 10 March 1976) to show Tynemouth Priory. The late twelfth-century east wall of the chancel is framed by an arch just as in the engraving by J. Sands after T. Allom and can still be

recognised today, though the extension to the left and the classical urn, added by Turner after he had already completed the landscape background, may be his own invention.

Turner visited Tynemouth in 1797 (see the 'North of England' sketchbook, XXXIV-35, repr. in colour Wilkinson 1972, p. 45, and the more finished water-colour XXXIII-T) and later included Tynemouth in the *Picturesque Views in England and Wales* 1827–38, but no sketch related to this painting is known. Nor can the date of this very liquidly painted, almost (and unusually for Turner) Rubensian sketch be more than guessed at: the urn, delicate trees and general lack of weight recall such exhibited oils of the 1820s as *What You Will!* (R.A. 1822, No. 229) and *View from the Terrace of a Villa at Niton* (R.A. 1826; No. 234), but the picture might also be as early as the small Thames sketches on mahogany veneer of *c.* 1807, Nos. 177–94.

254. View on the Avon *c.* 1825 (Plate 249)

PRIVATE COLLECTION, ENGLAND

Canvas, 15 × 20⅞ (38 × 53)

Coll. . . . ; purchased by the present owner 1955.

This hitherto unpublished picture has only been seen in the flesh by Martin Butlin but is also accepted as probably genuine by Evelyn Joll on the basis of a colour transparency. The general style, and particularly the subtlety of the effects of light, is fairly close to such small oils as *Shipping off East Cowes Headland* of 1827 (No. 267) but the paint is rather more heavily applied. The working of the architectural forms on the right while the paint was still wet is also paralleled in the Cowes sketches, as also in works of earlier in the 1820s such as *George IV at the Provost's Banquet* of 1822 (No. 248). The use of crimson scumbled over in the sky to suggest early morning light also supports a relatively late date.

The scene has been identified as the Avon near Bristol, looking upstream towards the site of the present Clifton Suspension Bridge, begun in 1836. The long apparently colonnaded building on the right still exists, though the facade is in fact articulated by applied columns or pilasters.

255. River Scene, North Italy *c.* 1820–30?
 (Plate 250)

THE TATE GALLERY, LONDON (2988)

Canvas, 14¼ × 25¼ (36 × 64)

Coll. Turner Bequest 1856; transferred to the Tate Gallery 1919.

Exh. Dresden (repr.) and Berlin 1972 (1).

The scene has always been identified as showing north Italy, but the picture has proved very difficult to date. It

could be the result of Turner's trip to the Alps in 1802, but this seems rather early. More likely is a date between 1819 and 1828–9, when Turner paid his first two visits to Italy proper, though it is not particularly close to any of the oil sketches associated with the second of these visits (Nos. 302–28); in particular the forms are more solidly modelled and this and the interest in geometrical masses do in fact recall Turner's Poussinesque landscapes of Bonneville, exhibited in 1803 (Nos. 46 and 50) and the related watercolours (e.g., those repr. exh. cat., B.M. 1975, p. 38 no. 29 and p. 41 no. 37). A date in between these two periods, and a scene in the British Isles, might be the solution.

The top paint layer has suffered from overcleaning in the middle distance on the right and in an area below and slightly to the left of the towers in the centre of the picture.

256. Valley with a Distant Bridge and Tower
c. 1825 (Plate 251)

THE TATE GALLERY, LONDON (5505)

Canvas, 35⅞ × 48⅛ (91 × 122)

Coll. Turner Bequest 1856; transferred to the Tate Gallery 1947.

Exh. Arts Council tour 1952 (7).

Lit. Davies 1946, p. 162.

An unfinished oil with few parallels in Turner's work; perhaps the nearest is *Evening Landscape, Chichester Canal* (No. 282), also tentatively dated to *c.* 1825. There are other parallels, rather more developed in style it would seem, among the Italian sketches of 1828, e.g. Nos. 318–24; the scene here is possibly but not necessarily Italian.

257. Landscape Composition *c.* 1820–30
 (Plate 252)

THE TATE GALLERY, LONDON (5523)

Canvas, 21⅝ × 29½ (55 × 75)

Coll. Turner Bequest 1856 (161, 1 unidentified 2′6″ × 1′9½″; identified 1946 by chalk number on back); transferred to the Tate Gallery 1947.

Lit. Davies 1946, pp. 165, 188.

Formerly called 'A Common (?)', this is a simple lay-in for a landscape, or possibly for a seapiece though the colours suggest the former. The foreground is a band of brown with, above, a rather narrower band of brownish green; the rest of the picture consists of various shades of off-white in preparation for a cloudy sky. The picture, which has not yet been cleaned, can only be very tentatively dated to the 1820s; the basing of the composition on parallel bands of colour seems to derive

from Turner's practice in watercolour in, for instance, the 'Como and Venice' sketchbook of 1819 (CLXXXI-10, 11 and 12; a somewhat similar study from the 'Rome: C. [Colour] Studies' sketchbook of the same year, CLXXXIX-55, is repr. in colour Wilkinson 1974, p. 189).

258. The Cobbler's Home c. 1825 (Plate 253)

THE TATE GALLERY, LONDON (2055)

Mahogany, $23\frac{1}{2} \times 31\frac{1}{2}$ (59.5×80)

Coll. Turner Bequest 1856 (? 155, '1 panel' $2'7\frac{1}{2}'' \times 2'0''$); transferred to the Tate Gallery 1910.

Exh. Tate Gallery 1931 (29); Arts Council tour 1952 (6).

Lit. MacColl 1920, p. 33.

A Wilkie-like interior of the kind first treated in *A Country Blacksmith* exhibited in 1807 (No. 68), and dated c. 1808–10 by MacColl. However in style it probably dates from the time of Turner's return to figure subjects in the earlier 1820s or even later; there are similarities in handling to the paintings of George IV's visit to Edinburgh in 1822 (Nos. 247 and 248) and even to *Pilate washing his Hands*, exhibited in 1830 (No. 332).

259. Death on a Pale Horse (?) c. 1825–30
 (Plate 254)

THE TATE GALLERY, LONDON (5504)

Canvas, $23\frac{1}{2} \times 29\frac{3}{4}$ (60×75.5)

Coll. Turner Bequest 1856 (? 160, 1 unidentified $2'6'' \times 2'0''$); transferred to the Tate Gallery 1947.

Exh. Whitechapel 1953 (100); Tate Gallery 1959 (358); New York 1966 (5, repr. p. 24); *Il Sacro e il Profano nell'Arte dei Simbolisti* Galleria Civica d'Arte Moderna, Turin, June–August 1969 (13, repr.); Dresden (9, repr.) and Berlin (12, colour pl. 29); R.A. 1974–5 (335); Leningrad and Moscow 1975–6 (30).

Lit. Davies 1946, p. 162; Gowing 1966, pp. 24–7, repr. p. 24; Reynolds 1969, p. 203, pl. 174; Gaunt 1971, p. 12, colour pl. 48.

Formerly called 'A Skeleton falling off a Horse in Mid-Air', this picture has been identified as an illustration to the Book of Revelation, in particular the appearance of the pale horse bearing Death after the opening of the fourth seal (vi, 8); the skeleton's crown could have been suggested by that worn by the first horseman, who rides a white horse but also carries a bow (vi, 2). However, the slumped position of the rider does not suggest a conqueror with power over a fourth part of the earth. Nevertheless, Turner's somewhat confused choice of this subject could reflect his interest in a theme that was common with the more imaginative neo-classical artists of the late eighteenth and early nineteenth centuries such as Benjamin West, John Hamilton Mortimer, P. J. de Loutherbourg and William Blake. In addition Lawrence Gowing has suggested that the subject may have been inspired by the death of Turner's father in 1829.

The degree of rubbing and scratching away of the wet paint to produce special effects is unparalleled among Turner's oils but is found to a lesser extent in such works as *George IV at the Provost's Banquet in Edinburgh* of c. 1822 (No. 248), some of the Cowes sketches of 1827 (Nos. 264 and 267), and *Rocky Bay with Figures* of c. 1830 (No. 434). The picture can therefore be tentatively dated to c. 1825–30.

Nos. 260–8: Cowes Sketches, 1827

TURNER revisited the Isle of Wight in late July and August 1827, staying with the architect John Nash at East Cowes Castle. In an undated letter he asked his father to send one or if possible two pieces of unstretched canvas, either a piece measuring 6 ft by 4 ft or a 'whole length', and it was on a 6 ft by 4 ft canvas, cut into two, that he painted these nine sketches. The 1854 Schedule of the Turner Bequest listed, under nos. 203 to 206, 207 to 210, 211 to 214, and 215 to 218, four 'Roll[s] containing 4 subjects'. Despite the fact that one of the Cowes canvases contained five sketches the two rolls were probably among these four. They were rediscovered at the National Gallery in 1905 and divided into separate pieces. One roll contained Nos. 260, 262, 264, 266 and 268 and the other Nos. 261, 263, 265 and 267.

No record was made of the placing of the sketches on the two rolls on canvas, but to a certain extent this can be reconstructed. On the first roll the two largest sketches, Nos. 264 and 262, were one above the other, flanked on the left by Nos. 266, 260 (both upside down) and 268. On the other Nos. 267 and 263 were at the top, Nos. 265 and 261 below; No. 261 was definitely to the right of No. 265, and No. 267 seems to have been above No. 265.

It has been suggested by Graham Reynolds that at least some of these sketches were painted on the spot, though the practical difficulties, especially when the artist was out at sea, would have been considerable. As Evelyn Joll has suggested, a clue as to where Turner may have done the sketches is given by the sketch *Between Decks* (No. 266). This appears to have been painted aboard a man-of-war and there seems no reason why Turner could not have painted the sketches of yachts racing from a ship anchored off Cowes Roads. If so, Turner's vantage point would seem to have been on a ship rather further offshore than the guardship that can be seen in Nos. 242, 261 and 262. It is interesting that the three sketches for *The Regatta beating to Windward* would seem to have been painted alternately on each roll, No. 260 on the first, No. 261 on the second, and No. 262 again on the first; this could have been to allow an assistant time to adjust the roll for a new sketch.

The 'Windsor and Cowes' sketchbook (CCXXVI) contains drawings of boats racing, boats at anchor, views of the coast and figure studies, though none directly related to the oil sketches, which to a certain extent supports the suggestion that they were done on the spot. It also contains a list of the boats with their names, the names of their owners, and their colours, showing just how detailed was Turner's interest in the Regatta (CCXXVI-80 verso).

The two groups of sketches of the Regatta were used for the pictures commissioned by John Nash and exhibited the following year (see Nos. 242 and 243). The other three, including *Between Decks*, were not used for more finished pictures.

Lit. MacColl 1920, pp. 31–3; Reynolds 1969², pp. 67–72.

260. Sketch for 'East Cowes Castle, the Regatta beating to Windward' no. 1 1827 (Plate 239)

THE TATE GALLERY, LONDON (1995)

Canvas, 11¾ × 19¼ (30 × 49)

Coll. Turner Bequest 1856 (? one of 203–18; see p. 142); transferred to the Tate Gallery 1919.

Exh. Amsterdam, Berne, Paris, Brussels, Liege (25), Venice and Rome (27) 1947–8; Paris 1965 (38, repr.); *The Artist at Work* Hampstead Arts Centre, February–March 1966 (48); R.A. 1974–5 (311).

Lit. Clare 1951, p. 75; Rothenstein and Butlin 1974, p. 39; Reynolds 1969², pp. 67–72.

From the first roll containing five sketches, together with one of the two other studies for the finished painting of *The Regatta beating to Windward* (No. 242). The scene shown is very close to that in No. 261 save that the boats on the left are on a different tack. It seems to show a slightly earlier moment, the two boats in the right foreground not yet being quite so close to each other. The distant hills and buildings, particularly on the right, are less distinct.

One of the three sketches for No. 242 was exhibited at Venice in 1938 (9).

261. Sketch for 'East Cowes Castle, the Regatta beating to Windward' no. 2 1827 (Plate 235)

THE TATE GALLERY, LONDON (1994)

Canvas, 17¾ × 23⅞ (45 × 60·5)

Coll. Turner Bequest 1856 (? one of 203–18; see p. 142); transferred to the Tate Gallery 1906.

Exh. Amsterdam, Berne, Paris, Brussels, Liege (24), Venice and Rome (26) 1947–8; R.A. 1974–5 (312); Leningrad and Moscow 1975–6 (27).

Lit. Clare 1951, p. 75; Rothenstein and Butlin 1964, p. 39, pl. 70; Reynolds 1969², pp. 67–72.

One of the four sketches painted on the second roll of canvas, and, with two from the first roll, related to the finished painting of *The Regatta beating to Windward* (No. 242). Probably a slightly earlier moment than that shown in No. 262 though after No. 260. What appears to be the same guardship as that in the centre of No. 262 is here largely obscured by the boats in the right foreground, though another three-master without sails appears behind the regatta on the left. As well as East Cowes Castle there are further buildings, including a fort, on the west side of the Medina estuary on the right.

262. Sketch for 'East Cowes Castle, the Regatta beating to Windward' no. 3 1827 (Plate 240)

THE TATE GALLERY, LONDON (1993)

Canvas, 18¼ × 28½ (46·5 × 72)

Coll. Turner Bequest 1856 (? one of 203–18; see p. 142); transferred to the Tate Gallery 1954.

Exh. New Zealand (4, repr.), Australia and South Africa (53) 1936–9; Paris 1938 (142, repr.); on loan to the National Gallery of Scotland 1964–72; Edinburgh 1968 (2); R.A. 1974–5 (313).

Lit. Davies 1946, pp. 154–5; Clare 1951, p. 75; repr. p. 70; Rothenstein and Butlin 1964, p. 39; Reynolds 1969², pp. 67–72; Herrmann 1975, p. 33, pl. 118.

One of the five sketches painted on the first roll of canvas, and one of the three related to the finished *The Regatta beating to Windward* (No. 242). It is a slightly more distant view than the other two, and in its placing of the boats on the left and the distant guardship in the centre it is closer to the exhibited picture, though the boat in the right foreground is shown at a greater angle. East Cowes Castle can be seen against the sky to the left of the guardship. Rather more finished and balanced in composition than the other two related sketches, this painting was perhaps at least finished back at East Cowes Castle.

263. Sketch for 'East Cowes Castle, the Regatta starting for their Moorings' no. 1 1827
(Plate 236)

THE TATE GALLERY, LONDON (1998)

Canvas, 18⅛ × 23⅞ (46 × 60·5)

Coll. Turner Bequest 1856 (? one of 203–18; see p. 142); transferred to the Tate Gallery 1919.

Exh. Amsterdam, Berne, Paris, Brussels, Liege (27), Venice and Rome (29) 1947–8; Paris 1953 (74); R.A. 1974–5 (314); Leningrad and Moscow 1975–6 (28).

Lit. Reynolds 1969², p. 67, pl. 3.

One of the four sketches from the second roll of canvas and, like No. 264 from the other roll, probably done on the spot; *East Cowes Castle, the Seat of J. Nash, Esq.: the Regatta starting for their Moorings* (No. 243), exhibited at the R.A. in 1828, was based on these studies plus the more detailed No. 265. Here the activity of No. 265 and the finished picture is missing and the sketch may indeed have been done another day, without the Regatta specifically in mind.

264. Sketch for 'East Cowes Castle, the Regatta starting for their Moorings' no. 2 1827
(Plate 237)

THE TATE GALLERY, LONDON (2000)

Canvas, 17½ × 29 (44·5 × 73·5)

Coll. Turner Bequest 1856 (? one of 203–18; see p. 142); transferred to the Tate Gallery 1919.

Exh. Lisbon and Madrid 1949 (46); Hamburg, Oslo, Stockholm and Copenhagen 1949–50 (96); *La Peinture sous le Signe de la Mer* Galeries Royales, Ostend, August–September 1951 (97, repr); Cape Town 1952 (27); Arts Council tour 1952 (10, repr.); Antwerp 1953–4; Australian tour 1960 (7); R.A. 1974–5 (315).

Lit. Reynolds 1969², p. 67, pl. 4.

One of the five sketches from the first roll of canvas, like No. 263 from the other roll probably done on the spot, lacking the crowded activity of No. 265 and the finished picture of *The Regatta starting for their Moorings* (No. 243).

265. Sketch for 'East Cowes Castle, the Regatta starting for their Moorings' no. 3 1827
(Plate 238)

THE TATE GALLERY, LONDON (1997)

Canvas, irregular, 17¾ × 24 (45 × 61); the canvas, cut unevenly, is only 23¾ (60) across the top.

Coll. Turner Bequest 1856 (? one of 203–18; see p. 142); transferred to the Tate Gallery 1906.

Exh. Amsterdam (repr.), Berne (repr.), Paris, Brussels (repr.), Liege (repr.) (26), Venice and Rome (28) 1947–8; R.A. 1974–5 (316).

Lit. Rothenstein and Butlin 1964, p. 39; Reynolds 1969², p. 67, pl. 2.

One of the four sketches on the second roll of canvas, presumably painted after Nos. 263 and 264. In some ways, however, it may represent an alternative scheme for *The Regatta starting for their Moorings* (No. 243), the lighting being different from all three other versions. There is a greater emphasis on the figures and buildings than even in the final picture. Much of the detail, at least, was probably worked up indoors.

266. Between Decks 1827 (Plate 241)

THE TATE GALLERY, LONDON (1996)

Canvas, 12 × 19⅛ (30·5 × 48·5)

Coll. Turner Bequest 1856 (? one of 203–18; see p. 142); transferred to the Tate Gallery 1906.

Exh. *British Narrative Paintings* C.E.M.A. tour 1944 (35); R.A. 1974–5 (318).

Lit. Rothenstein and Butlin 1964, p. 39; Reynolds 1969², p. 72, pl. 5; Herrmann 1975, p. 33, pl. 121.

One of the five sketches from the first roll of canvas used at Cowes in 1827. This may be a scene of visitors on board the naval guardship seen in the background of Nos. 261–62; it could alternatively reflect the practice, up to about 1805 and perhaps later, of accommodating sailors' wives between the upper and lower decks when a ship was in port. For a suggestion that the ship was rather further offshore than the guardship, and was the base from which Turner painted his sketches of yachts racing, see p. 143.

267. Shipping off East Cowes Headland 1827

(Plate 261)

THE TATE GALLERY, LONDON (1999)

Canvas, irregular, approx. $18\frac{1}{8} \times 23\frac{3}{4}$ (46×60)

Coll. Turner Bequest 1856 (? one of 203–18; see p. 142); transferred to the Tate Gallery 1919.

Exh. Venice 1938 (8); Amsterdam, Berne, Paris, Brussels, Liege (28), Venice and Rome (30) 1947–8; R.A. 1974–5 (317, repr. in colour p. 54).

Lit. Rothenstein and Butlin 1964, p. 39, colour pl. ix; Reynolds 1969², p. 72.

One of the four sketches on the second roll of canvas used at Cowes. East Cowes headland is seen in the background.

268. Study of Sea and Sky, Isle of Wight 1827

(Plate 242)

THE TATE GALLERY, LONDON (2001)

Canvas, $12 \times 19\frac{1}{8}$ ($30\cdot5 \times 48\cdot5$)

Coll. Turner Bequest 1856 (? one of 203–18; see p. 142); transferred to the Tate Gallery 1919.

Exh. New Zealand (5), Australia and South Africa (55) 1936–9; Rotterdam 1955 (54); R.A. 1974–5 (319).

Lit. Rothenstein and Butlin 1964, p. 39; Reynolds 1969², p. 72.

One of the five sketches on the first roll of canvas used at Cowes in 1827, this may well be Turner's first oil painting concentrating on the two elements, sea and sky. The coast can just be seen on the horizon.

Nos. 269–81: Miscellaneous, *c.* 1825–30

269. Near Northcourt in the Isle of Wight *c.* 1827

MUSÉE DE QUÉBEC (Plate 265)

Canvas, $17\frac{1}{4} \times 24\frac{1}{8}$ ($43\cdot7 \times 61\cdot3$)

Signed 'J M W Turner RA' lower left

Coll. Sir Willoughby Gordon, whose wife had been a pupil of Turner's; in 1818 Lady Gordon (together with her elder sister, Lady Swinburne) inherited Northcourt, a Jacobean mansion in the parish of Shorwell, Isle of Wight; by descent to Mrs Disney Leith (Sir Willoughby and Lady Gordon's granddaughter) and then to her son, the seventh Lord Burgh; sale Christie's 9 July 1926 (28) bought Sampson; John Levy Galleries, New York; Marsden J. Perry; sale Parke Bernet, New York, 7 May 1948 (79) bought The Renaissance Galleries; Maurice du Plessis (Prime Minister of the Province of Quebec) who gave it to the Quebec Museum in November 1959 (Accession no. G-59, 579P).

Exh. R.A. 1912 (127).

Lit. H. F. Finberg 1957, p. 51.

For further information about this picture's history, see No. 234. Turner must have been in touch with his old pupil and friend, Julia Gordon, in 1826 when he exhibited No. 234 based on her sketches at the R.A. This picture, however, may date from the following year, 1827, when Turner spent several weeks staying with John Nash, the architect, at East Cowes Castle, about ten miles north of Shorwell. We learn from Finberg (1961, p. 302) that Nash provided Turner with

a special painting room and we also know from a letter Turner wrote to his father from the Isle of Wight that he asked for further supplies of both canvas and paint to be sent to him by coach (see note on the Cowes Sketches p. 142). It seems most probable, therefore, that this was painted during the 1827 visit as a pendant to No. 234, thus providing the Gordons with views by Turner painted from or near both the houses which they owned in the Isle of Wight.

No drawing connected with this picture has so far come to light, although three sketchbooks in the Turner Bequest (CCXXVI, CCXXVII and CCXXVII(a)) were in use during Turner's visit to the Isle of Wight in 1827.

270. A View overlooking a Lake *c.* 1827

(Plate 256)

WORCESTER ART MUSEUM, WORCESTER, MASS. (Accession no. 1940.59)

Canvas, $27\frac{15}{16} \times 20\frac{7}{8}$ ($71 \times 53\cdot2$)

Coll. Sir James and Lady Willoughby Gordon who probably acquired it from the artist *c.* 1827; by descent to their grand-daughter, Mrs Disney Leith, and then to her son, the seventh Lord Burgh; sale Christie's 9 July 1926 (26) bought Langton Douglas; Theodore T. Ellis by November 1927; bequeathed to the Worcester Art Museum by his widow, Mary G. Ellis, in 1940 (Theodore T. Ellis and Mary G. Ellis Collection).

Exh. R.A. 1912 (89).

Lit. *Worcester Art Museum Annual* iv 1941, pp. 35–41, repr. fig. 6; H. F. Finberg 1957, p. 51; Finberg 1961, p. 487 no. 315; *European Paintings in the Collection of the Worcester Art Museum* (British School catalogued by St John Gore) 1974, pp. 67–9, repr. p. 550.

For a complete history of the picture, see entry for No. 234.

This picture poses certain problems but one thing is certain: it cannot possibly be the *Scene in Derbyshire* (No. 240, exh. R.A. 1827) as suggested by Finberg who presumably had never seen even a photograph. The scene appears likely to be Swiss or Italian.

In the past, areas of repaint, especially in the sky, have led to doubts being expressed about the picture's authenticity, although these have not appeared in print (with the exception of the original attack in the *Daily Telegraph* at the time the picture was exhibited in 1912, which was answered by Mrs Disney Leith's letter to that paper of 16 February in which she gave an apparently cast-iron provenance). However, since the picture's recent cleaning, there is no longer any doubt in the compiler's view that the picture is genuine, despite what Mr Gore describes with some justification as 'its marked infelicities'. These occur mainly in the foreground in the area round the bridge. Mr Gore suggests that these may be due 'to alterations or additions by another hand; or it is not impossible to conceive a situation in which the picture was finished by Lady Gordon.' In the compiler's opinion the likelihood of Lady Gordon or of anyone else having worked on the picture is extremely remote and the 'infelicities' in the foreground are more likely to be the result of injudicious cleaning in the past and to the fact that the paint has darkened and cracked in this area.

So far as the dating goes, it seems likely that the Gordons acquired this at the same time as their other two Turners, 1826–7, and on stylistic grounds this would seem perfectly acceptable. The painting of the trees on the right of the picture is very close to those in the Frick Collection's *Mortlake Terrace* (see No. 235 exh. R.A. 1826) and both the handling and the colouring come close to the watercolour of *The Val d'Aosta* in the British Museum (15$\frac{7}{8}$ × 12$\frac{1}{8}$ in., R. W. Lloyd Bequest 1958-7-12-425) which is dated *c.* 1820–1825 in the catalogue of the 1975 Exhibition (no. 96). The rather more adventurous colour in the sky of the Worcester painting points to its being rather later than the Lloyd watercolour.

271. Three Seascapes *c.* 1827 (Plate 257)

THE TATE GALLERY, LONDON (5491)

Canvas, 35$\frac{3}{4}$ × 23$\frac{3}{4}$ (91 × 60·5)

Coll. Turner Bequest 1856 (146, one of '2 (one of these contains 2 subjects)' 3'0″ × 2'0″; identified 1946, ? by chalk number on back); transferred to the Tate Gallery 1947.

Exh. R.A. 1974–5 (320).

Lit. Davies 1946, pp. 159–60, 188.

Repr. *Art International* XIX/2, February 1975, p. 13 in colour.

This canvas is not precisely datable but is fairly close to the *Study of Sea and Sky* of 1827 (No. 268). It serves to give some idea of how the two rolls of canvas used at Cowes must have looked before they were cut up. Here, however, Turner painted three seascapes, one of them to be seen with the canvas upside down so that two of the compositions share a single sky, and the smaller size of the canvas would have made it much more manageable.

There are considerable losses, now restored, at the bottom of the picture (as seen with two seascapes the right way up).

272. A Sandy Beach *c.* 1825–30 (Plate 255)

THE TATE GALLERY, LONDON (5521)

Canvas, 23$\frac{5}{8}$ × 36 (60 × 91·5)

Coll. Turner Bequest 1856 (142, 1 unidentified 3'1$\frac{1}{2}$″ × 2'0″; identified 1946 by chalk number on back); transferred to the Tate Gallery 1947.

Lit. Davies 1946, pp. 165, 188.

Immature and tentative when compared with the seapieces here dated to the 1830s and 1840s (Nos. 454–472) and closer in style to the *Three Seascapes* on one canvas of *c.* 1827 which is, incidentally, of the same size overall (No. 271).

273. Rocky Coast *c.* 1825–30 (Plate 258)

THE TATE GALLERY, LONDON (5499)

Canvas, 19$\frac{3}{4}$ × 25$\frac{7}{8}$ (50 × 65·5)

Coll. Turner Bequest 1856 (? 165, one of 2 each 2' 2″ × 1'8″ with No. 274); transferred to the Tate Gallery 1947.

Exh. Arts Council tour 1952 (17).

Lit. Davies 1946, p. 161.

This relatively tame seapiece can probably be dated to the later 1820s. The scene has not been identified.

The original paint and ground is missing down the right-hand edge and along the right-hand quarter of the bottom edge.

274. Seascape with a Yacht? *c.* 1825–30
(Plate 259)

THE TATE GALLERY, LONDON (5485)

Canvas, $19\frac{3}{4} \times 26$ (50 × 66)

Coll. Turner Bequest 1856 (164, one of 2 each
2′2″ × 1′8″ with No. 273; identified 1946 by chalk
number on the back); transferred to the Tate Gallery
1947.

Lit. Davies 1946, pp. 159, 188.

The picture is more thinly and freely painted than those
here dated to the later 1820s (e.g., Nos. 268, 271–3 and
327), but with its lack of drama and small size probably
dates from much the same period.

There are some losses down the left-hand edge and
particularly at the top corner. The picture has not yet
been restored.

275. Seascape with a Sailing Boat and a Ship
c. 1825–30
(Plate 260)

THE TATE GALLERY, LONDON (5520)

Canvas, $18\frac{3}{8} \times 24$ (47 × 61)

Coll. Turner Bequest 1856 (? 168, one of 2 each
2′0″ × 1′6¼″ with ? No. 459; tentatively identified
1946 by chalk number on back); transferred to the
Tate Gallery 1947.

Lit. Davies 1946, pp. 165, 188.

The placing of the two ships is reminiscent of such
works as the Thames Estuary pictures of 1808–10 but in
a much simplified, abstracted manner and this
unfinished picture probably dates from the later 1820s
when Turner's interest in marine scenes was re-
awakened by his studies of the regatta at Cowes (see
Nos. 260–68).

276. Lake or River with Trees on the Right
c. 1825–30
(Plate 273)

THE TATE GALLERY, LONDON (5525)

Millboard, $16\frac{1}{4} \times 23\frac{1}{2}$ (41 × 59·5)

Coll. Turner Bequest 1856 (171, 1 unidentified
2′0″ × 1′4¼″; identified 1946 by chalk number on
back); transferred to the Tate Gallery 1947.

Exh. Dresden (4, repr.) and Berlin (8) 1972; Lisbon
1973 (8, repr.).

Lit. Davies 1946, pp. 165, 188; Rothenstein and Butlin
1964, p. 38, pl. 73; Gage 1969, pp. 39, 232 n. 106.

This could come from the same group of oil studies on
millboard as such Italian subjects as Nos. 318–27,
which are here tentatively dated to Turner's second

Italian visit of 1828–9, but there is nothing specifically
Italian about this scene and it is probably an inde-
pendent work executed in England. In handling it is
close to certain sketches on canvas such as No. 275 and
like that work probably dates from the later 1820s.

277. Shipping *c.* 1825–30?
(Plate 274)

THE TATE GALLERY, LONDON (2879)

Mahogany, $26\frac{3}{4} \times 36\frac{1}{8}$ (68 × 91·5)

Coll. Turner Bequest 1856 (152, one of '3 each (ditto
[panel])' 3′0″ × 2′3″; identified by chalk number on
back); transferred to the Tate Gallery 1919.

Severely overcleaned in the past in all areas except the
top corners. In particular the sails of the ship in the
middle distance on the right have practically disap-
peared. The picture is similar in style and treatment to
No. 278; a tentative dating would be *c.* 1825–30.

278. Shipping with a Flag *c.* 1825–30? (Plate 266)

THE TATE GALLERY, LONDON (2880)

Mahogany, $29\frac{5}{8} \times 36\frac{3}{16}$ (75 × 92)

Coll. Turner Bequest 1856 (151, one of '3 each (panel)'
3′0″ × 2′6″; identified by chalk number on back);
transferred to the Tate Gallery 1919.

Exh. On loan to the Ulster Museum 1964–9.

Lit. MacColl 1920, p. 42.

Probably painted at the same time as No. 277, say *c.*
1825–30. MacColl relates this to a watercolour sketch in
the Turner Bequest (CCLXIII-384, repr. exh. cat.,
R.A. 1974–5, p. 97 no. 255) but it is not particularly
close.

There are small losses to the panel lower left $\frac{1}{4} \times 5$
(0·75 × 12·5), and lower right $\frac{1}{8} \times \frac{3}{4}$ (0·25 × 2).

279. Steamer and Lightship *c.* 1825–30 (Plate 275)

THE TATE GALLERY, LONDON (5478)

Canvas, $36 \times 47\frac{7}{8}$ (91·5 × 121·5)

Coll. Turner Bequest 1856 (115, one of 36 each
4′0″ × 3′0″; identified 1946 by chalk number on
back); transferred to the Tate Gallery 1947.

Lit. Davies 1946, pp. 158, 188 n. 14.

Written on the back of the canvas in chalk, in Turner's
roughest hand, are six or seven lines of verse plus, the
other way up, three more, the first written on the
wooden stretcher (see Plate 551). It must be presumed
that Turner turned to this picture, face against the wall,
as the first surface ready to hand to draft verses just as
he normally did in his notebooks. The verses pre-

sumably do not relate to this picture, which Turner may well have regarded as abandoned before using it in this fashion; for a near parallel one may cite the use of the back of *Jacob's Ladder* as a palette (see No. 435). Even using infra-red photography it has only been possible to pick out isolated phrases and words. From the larger inscription one can possibly make out:

That Light which [5 words] to Glory
Now blushes Red at his disgrace
Now witness his disgrace and [3 or more words]
 been
She might have spared with the corded oak [2 words]
Thou art [1 word] tho thy [2 words] yet [1 word] the Earth
[1 word] when you [1 word, then space, then 4 words]
 brightens the Eve

The shorter inscription is virtually illegible. (The compiler is indebted to Dr John Gage for assistance in identifying the hand and many of the words of these verses.)

The inventory number '115' can also be seen in the reproduction of the back of the canvas.

280. Two Compositions: A Claudian Seaport and an Open Landscape *c.* 1825–30 (Plate 276)

THE TATE GALLERY, LONDON (5533)

Canvas, $13\frac{1}{4} \times 23\frac{3}{4}$ (33·5 × 60·5)

Coll. Turner Bequest 1856 (169, one of 2 each $2'0'' \times 1'1''$; identified 1946 by chalk number on back); transferred to the Tate Gallery 1947.

Lit. Davies 1946, pp. 166, 188.

Apparently two separate compositions on one canvas, a Claudian port scene with architecture in perspective on the left, and an open hilly landscape occupying about a third of the canvas on the right. The dating *c.* 1825–30 is very tentative.

281. Landscape with a Castle on a Promontory *c.* 1820–30? (Plate 279)

THE TATE GALLERY, LONDON (5484)

Canvas, $19\frac{1}{4} \times 15\frac{7}{8}$ (49 × 40·5)

Coll. Turner Bequest 1856 (? 270*, 1 unidentified $1'7'' \times 1'4''$; see below); transferred to the Tate Gallery 1947.

Lit. Davies 1946, pp. 158–9, 190 n. 26.

Probably, in view of its unusual dimensions, the work originally listed as 270 in the 1854 Schedule, but renumbered 270* in the margin and in the second, 1856, Schedule. For the reason the number was changed see No. 529.

This is a particularly fragmentary and unresolved composition, with a foreground tree, either unfinished or in the course of alteration, and a castle on a promontory projecting into a wide expanse of water beyond. Though the style and handling are completely typical of Turner, it is difficult to relate this to any other work, or to date it save very generally in the middle of Turner's career.

Nos. 282–91: Petworth Landscapes, *c.* 1828–30

THESE fall into two groups, plus the separate painting relating to the two versions of *Chichester Canal* (No. 282). The first group consists of the five works from the Turner Bequest now in the Tate Gallery (Nos. 283–7); the second of the four rather more finished pictures still at Petworth (Nos. 288–91). These latter works originally hung below full-length seventeenth-century portraits in the Grinling Gibbons panelled dining-room, and are more or less closely based on four of the Tate Gallery pictures, at least one of which seems originally to have hung in the place later occupied by one of the more finished pictures.

Although Turner had painted a view of Petworth House in 1810 (No. 113) and had sold a considerable number of pictures to Lord Egremont, he became a more frequent visitor to Petworth after the death of his father in 1829. In particular it is known that he stayed there from December 1830 to January 1831. Nearly all recent writers on Turner have followed Finberg in assuming that it was then that the landscapes were painted, or at least begun. On the other hand, Collins Baker dates them *c.* 1829–30, with the exception of the *Brighton*, which he assigns definitely to 1830. MacColl, following earlier National Gallery catalogues, dates the sketches for *Petworth Park* and *Chichester Canal* (Nos. 283 and 285) to 1829. Thornbury dates the *Petworth Park* even earlier, 1828.

In fact, the first known reference to the landscapes occurs in a letter from Thomas Creevey to Miss Ord of 18 August 1828, giving an account of his visit to Petworth on 16–17 August. After describing 'the sixty foot dining room' with its full-length portraits, he goes on, 'Immense as these pictures are with all their garniture there are still panels to spare, and as he [Lord Egremont] always has artists ready in the house, in one of these compartments, you have Petworth Park by Turner, in another Lord Egremont taking a walk with nine dogs, that are his constant companions, by the same artist . . .' The second of the pictures mentioned must be the Tate Gallery's *Petworth Park: Tillington Church in the Distance* (No. 283), the dogs in which are omitted from the more finished version at Petworth (No. 288). The other picture is presumably the Tate's *Lake, Petworth, Sunset* (No. 284), unless the more finished version (No. 289) was already *in situ*.

John Gage has recently discovered that Turner was at Petworth in August 1827, and the landscapes may have been begun then. On the other hand, Gage has also suggested that the Tate Gallery pictures were begun in London and rejected because they turned out to be too large (1969, p. 260 n. 91), but Creevey's report makes this highly unlikely unless the pictures he saw were somehow only temporarily superimposed on the panels. In any case, the Tate pictures are not consistently larger than the final versions. It may therefore be that Lord Egremont, whose collection had hitherto been confined to Turner's earlier style, found the first set of pictures too sketchy in style; the history of *Palestrina* (No. 295) suggests another instance of Lord Egremont failing to appreciate Turner's mature work.

That Turner painted some if not all of the Petworth landscapes in the studio specially provided for him in the house is suggested by an anecdote in George Jones' manuscript *Recollections of Sir Francis Chantrey*, written in 1849: 'When Turner painted a series of landscapes at Petworth, for the dining-room, he worked with his door locked against everybody but the master of the house. Chantrey was there at the time, and determined to see what Turner was doing; he imitated Lord Egremont's peculiar step, and the two distinct raps on the door by which his lordship was accustomed to announce himself: and the key being immediately turned, he slipped into the room before the artist could shut him out, which joke was mutually enjoyed by the two attached friends' (reprinted in Finberg 1961, p. 325).

Lit. Thornbury 1862, i, p. 306; 1877, p. 439; Collins Baker 1920, pp. 124–5; MacColl 1920, p. 27; John Gore (ed.), *Creevey's life and Times: A Further Selection from the Correspondence of Thomas Creevey* 1934, p. 277; John Gore (ed.), *Creevey* 1948, p. 293; Finberg 1961, p. 325; Herrmann 1975, pp. 34, 231–2.

282. Evening Landscape, probably Chichester Canal *c.* 1825 (Plate 267)

THE TATE GALLERY, LONDON (5563)

Canvas, $25\frac{1}{2} \times 49\frac{1}{2}$ (65 × 126)

Coll. Presumably by descent to Miss M. H. Turner, by whom presented to the Tate Gallery 1944; transferred to the National Gallery 1963, returned to the Tate Gallery 1964.

Exh. *The Tate Gallery's Wartime Acquisitions, Second Exhibition*, Council for the Encouragement of Music and the Arts tour (89) and National Gallery (82) 1945; Hamburg, Oslo, Stockholm and Copenhagen 1949–50 (99); Paris 1953 (76); R.A. 1974–5 (330).

This picture cannot be identified in the schedule of the Turner Bequest but was presumably one of the works that were in Turner's possession at his death but were handed over to his next-of-kin as not being by the artist, following the settlement that set aside the terms of his will in 1856. The attribution to Turner has indeed been doubted but the painting seems quite definitely to be by his hand.

The composition is closely related to the two versions of *Chichester Canal* (Nos. 285 and 290), though the scene is viewed from a slightly different angle, with the same setting sun but without the ship and the distant glimpse of Chichester Cathedral. In addition the distant hills have distinct peaks rather than being rounded, and it is therefore just possible that Turner adapted a view of a different place when he came to depict Chichester Canal.

This picture is distinct from the main group of Petworth sketches in its colouring and technique, being more thickly painted, some of the paint having been worked on the canvas while still wet. This suggests a slightly earlier date, say *c.* 1825.

283. Petworth Park: Tillington Church in the Distance *c.* 1828 (Plate 268)

THE TATE GALLERY, LONDON (559)

Canvas, $25\frac{3}{8} \times 57\frac{3}{8}$ (64·5 × 145·5)

Coll. Turner Bequest 1856 (? 99, 'Scene at Petworth', no dimensions given); transferred to the Tate Gallery 1910.

Exh. Amsterdam 1936 (160); New York, Chicago and Toronto 1946–7 (52, pl. 42); Venice and Rome 1948 (33); New York 1966 (6, repr. p. 26); R.A. 1974–5 (325).

Lit. Thornbury 1862, i, pp. 306, 349; 1877, pp. 439, 467; Armstrong 1902, p. 226; John Gore (ed.), *Creevey's Life and Times* 1934, p. 277; Davies 1946, p. 187; John Gore (ed.), *Creevey* 1948, p. 293; Rothenstein 1949, p. 14, colour pl. 7; Kitson 1964, p. 78, repr. in colour p. 35; Rothenstein and Butlin 1964, pp. 46–8, colour pl. xii; Gowing 1966, p. 27, repr. p. 26; Lindsay 1966, p. 177; Gage 1969, p. 260 n. 91; Reynolds 1969, pp. 135–7, colour pl. 120; Gaunt 1971, p. 7, colour pl. 22; Herrmann 1975, pp. 34, 231–2, colour pl. 108.

That this picture was no. 99 in the schedule is suggested by the fact that the next item, no. 100, was the companion *View near Chichester*; see No. 285.

A double-page sketch in the 'Petworth' sketchbook is related in general terms (CCXLIII-77 verso and 78). In the finished version of the composition (No. 288) extra animals have been added in the foreground, including a pair of fighting bucks. A cricket match replaces the scene of dogs rushing out to meet their master on the left. As in *Chichester Canal* (see Nos. 285 and 290) the sky has been softened and given less weight in the composition.

The painting of the sky seems to have been completed when the picture was already framed in some way, a strip along the top (but excluding the vertical of the window frame on the left) and upper right-hand edge being much less finished than the rest. This ties in with the evidence that the picture was actually installed in the dining room at Petworth when Thomas Creevey was there in August 1828 (see p. 149).

284. The Lake, Petworth, Sunset *c.* 1828
 (Plate 269)

THE TATE GALLERY, LONDON (2701)

Canvas, $25\frac{1}{2} \times 55\frac{1}{2}$ (65 × 141)

Coll. Turner Bequest 1856 (? one of 236 to 238, 'Roll of 3 separate Canvasses Petworth Chain Pier and another', no dimensions given); transferred to the Tate Gallery 1910, returned to the National Gallery 1961, and to the Tate Gallery 1968.

Exh. R.A. 1974–5 (326).

Lit. John Gore (ed.), *Creevey's Life and Times* 1934, p. 277; *Creevey* 1948, p. 293; Rothenstein and Butlin 1964, p. 46; Gage 1969, pp. 176, 290 n. 91; Reynolds 1969, pp. 135–7.

That this work may have been partly painted *in situ* in the dining room at Petworth and be the picture of 'Petworth Park' seen there by Thomas Creevey in August 1828 (see p. 149) is supported by the fact that the ground extends beyond the paint surface up to the cut edge of the canvas along part of the top of the picture.

In the finished picture (No. 289) Turner added swans and deer drinking on the left and right sides of the lake respectively.

285. Chichester Canal *c.* 1828 (Plate 270)

THE TATE GALLERY, LONDON (560)

Canvas, $25\frac{3}{4} \times 53$ (65·5 × 134·5)

Coll. Turner Bequest 1856 (? 100, 'View near Chichester', no dimensions given); transferred to the Tate Gallery 1914, returned to the National Gallery 1952, and to the Tate Gallery 1957.

Exh. Amsterdam 1936 (159); Paris 1938 (143, repr.); Amsterdam (repr.), Berne (repr.), Paris, Brussels (repr.), Liege (repr.) (30), Venice and Rome (34) 1947–8; R.A. 1974–5 (327, repr.); Leningrad and Moscow 1975–6 (29).

Lit. Thornbury 1862, i, p. 349; 1877, p. 467; Armstrong 1902, p. 219; Davies 1946, p. 188; Rothenstein 1949, p. 14, colour pl. 8; Herrmann 1963, p. 24, pl. 9; Rothenstein and Butlin 1964, pp. 46–8, pl. 86; Gage 1969, p. 260 n. 91; Reynolds 1969, pp. 135–7, colour pl. 119; Gaunt 1971, p. 7, colour pl. 25; Herrmann 1975, pp. 34, 231–2, colour pl. 109.

In the 1854 Schedule 'Tillington' has been added in pencil, perhaps in mistake for no. 99, *Scene at Petworth*, which was probably No. 283.

As in the case of the Chain Pier at Brighton (see No. 286) Lord Egremont was financially involved in the construction of Chichester Canal (see No. 290). For an earlier version of this composition see No. 282. Perhaps because of this earlier version this was the least altered of the Petworth sketches when Turner came to paint his final version for Petworth (No. 290), though in the latter the great arch of the sky has been softened.

286. The Chain Pier, Brighton *c.* 1828 (Plate 271)

THE TATE GALLERY, LONDON (2064)

Canvas, $28 \times 53\frac{3}{4}$ (71 × 136·5)

Coll. Turner Bequest 1856 (one of 236 to 238, 'Roll of 3 separate Canvasses Petworth Chain Pier and another', no dimensions given); transferred to the Tate Gallery 1906.

Exh. Liverpool 1933 (47); Amsterdam 1936 (161, repr.); Rotterdam 1955 (55, repr.); R.A. 1974–5 (328).

Lit. Thornbury 1862, i, p. 306; 1877, p. 439; Davies 1946, p. 189 n. 21; Kitson 1964, p. 78, repr. p. 34; Rothenstein and Butlin 1964, pp. 46–8, pl. 84; Gage 1969, p. 290 n. 91; Gaunt 1971, p. 7, pl. 32.

The Chain Pier at Brighton, partly financed by Lord Egremont, was begun in 1822 and opened the following year. In the finished picture (No. 291) Turner added debris in the foreground.

287. A Ship Aground c. 1828 (Plate 272)

THE TATE GALLERY, LONDON (2065)

Canvas, $27\frac{1}{2} \times 53\frac{1}{2}$ (70 × 136)

Coll. Turner Bequest 1856 (? one of 236 to 238, 'Roll of 3 separate Canvasses Petworth Chain Pier and another', no dimensions given); transferred to the Tate Gallery 1906.

Exh. Amsterdam, Berne, Paris, Brussels, Liege (31), Venice and Rome (35) 1947–8; R.A. 1974–5 (329, repr.).

Lit. MacColl 1920, p. 34; Rothenstein and Butlin 1964, p. 46, pl. 88; Gage 1969, p. 260 n. 91.

The composition was not used for the more finished pictures at Petworth but was developed in two paintings exhibited at the Royal Academy in 1831, *Fort Vimieux* (No. 341) and to a lesser extent *Life-Boat and Manby Apparatus* (No. 336). See under No. 290 for a suggestion that this subject may have been painted as a possible substitute for *Chichester Canal*.

288. The Lake, Petworth: Sunset, Fighting Bucks c. 1829 (Plate 290)

H.M. TREASURY AND THE NATIONAL TRUST (Lord Egremont Collection) PETWORTH

Canvas, $24\frac{1}{2} \times 57\frac{1}{2}$ (62·2 × 146)

Coll. Painted for the third Earl of Egremont for the dining-room at Petworth; by descent to the third Lord Leconfield who in 1947 conveyed Petworth to the National Trust; in 1957 the contents of the State Rooms were accepted by the Treasury in part payment of death duties.

Exh. R.A. 1894 (133); Tate Gallery 1951 (10); Paris 1953 (75); Wildenstein 1954 (18).

Engr. By J. Cousen for the *Turner Gallery* as 'Petworth Park' 1859.

Lit. Petworth Inventories 1837, 1856 (Carved Room); Burnet and Cunningham 1852, p. 44 (?); Thornbury 1862, i, p. 306 (?); ii, pp. 11, 397; 1877, pp. 201, 594;

Armstrong 1902, p. 226; Rawlinson ii 1913, pp. 208, 358; Collins Baker 1920, p. 125 no. 132; Hussey 1925, p. 975 repr.; Clare 1951, p. 79; Finberg 1961, p. 325; Rothenstein and Butlin 1964, pp. 46–8, pl. 87; Lindsay 1966, p. 177; Gage 1969, pp. 148, 260 n. 91; Reynolds 1969, p. 133; Herrmann 1975, pp. 34, 231, pl. 123.

A number of watercolours of the lake at sunset occur in the 'Petworth Watercolours' (CCXLIV) pp. 3, 4, 6, 7, 14, 18.

For the full-size sketch, now in the Tate Gallery, see No. 283. The sketch is similar in general composition but differs considerably in details. If these changes were made to accord with Lord Egremont's wishes, as was suggested in the catalogue of the Turner Bicentenary Exhibition, it is difficult to understand why he should have wanted Turner to omit the charming vignette in the sketch which showed him and his nine dogs walking away from the house towards the lake and the setting sun, although one can see why Lord Egremont may have asked for the black sheep, which are still a feature of the park at Petworth today, to be added to the finished version.

As Turner was already on his way to Rome at the time Creevey wrote to Miss Ord (see p. 149), and did not return to England until February 1829, the four finished canvases cannot have been installed until after this.

Thornbury (1862, ii, p. 2) relates how difficult it was to see these four pictures properly in the dining-room at Petworth with the sun shining on them. It is not known when all four were moved to their present positions in the Turner room.

289. The Lake, Petworth: Sunset, a Stag drinking c. 1829 (Plate 291)

H.M. TREASURY AND THE NATIONAL TRUST (Lord Egremont Collection) PETWORTH HOUSE

Canvas, 25 × 52 (63·5 × 132·1)

Coll. Painted for the third Earl of Egremont for the dining-room at Petworth; by descent to the third Lord Leconfield who in 1947 conveyed Petworth to the National Trust; in 1957 the contents of the State Rooms were accepted by the Treasury in part payment of death duties.

Exh. R.A. 1894 (130); Tate Gallery 1951 (12); Wildenstein 1954 (20).

Lit. Petworth Inventories 1837, 1856 (Carved Room); Burnet and Cunningham 1852, p. 44; Thornbury 1862, i, p. 306 (?); ii, pp. 11–12, 397; 1877, pp. 201, 594; Armstrong 1902, p. 226; Collins Baker 1920, p. 125 no. 142; J. Gore (ed.), *Thomas Creevey's Life and Times* 1934, p. 277; Clare 1951, p. 79; Finberg 1961, p. 325; Rothenstein and Butlin 1964, p. 46; Lindsay 1966, p. 177; Gage 1969, pp. 148, 260 n. 91; Reynolds 1969, p. 133.

A full size sketch is in the Tate Gallery (see No. 284). For related drawings and for the dating of the four pictures see No. 288. Gage has pointed out that in the finished canvases, Turner has painted the sun at the moment it dips behind the horizon, but that it does not bite into the horizon so sharply as it does in the sketches.

As suggested on p. 149 it seems likely that the sketches were too freely painted for Lord Egremont's taste and that the addition of deer, swans and waterfowl in this picture and the rather tighter handling were all carried out at his suggestion, and to accord with his wishes.

290. Chichester Canal c. 1829 (Plate 289)

H.M. TREASURY AND THE NATIONAL TRUST (Lord Egremont Collection) PETWORTH HOUSE

Canvas, 25 × 52 (63·5 × 132·1)

Coll. Painted for the third Earl of Egremont for the dining-room at Petworth; by descent to the third Lord Leconfield who in 1947 conveyed Petworth to the National Trust; in 1957 the contents of the State Rooms were accepted by the Treasury in part payment of death duties.

Exh. R.A. 1894 (138); Tate Gallery 1951 (9); Wildenstein 1954 (17).

Lit. Petworth Inventories 1837, 1856 (Carved Room); Burnet and Cunningham 1852, p. 44; Thornbury 1862, ii, pp. 2, 12–13, 397; 1877, pp. 199, 201–2, 594; Armstrong 1902, p. 219; Collins Baker 1920, p. 125 no. 130; Clare 1951, p. 79; Finberg 1961, p. 325; Rothenstein and Butlin 1964, p. 46; P. A. L. Vine, *London's Lost Route to the Sea* 1965, pp. 81–2, pl. 13; Gage 1969, p. 148; Reynolds 1969, p. 133.

A full-size sketch is in the Tate Gallery (No. 285), as is what was perhaps intended as a first attempt at the subject (No. 282). Of the four finished pictures at Petworth, this one follows the sketch considerably more closely than the other three.

Thornbury relates that the sun shining into the Carved Room made these pictures very difficult to see and that this caused damage to this picture in particular: 'Indeed, the beautiful painting of "Chichester Canal" is cracked all to pieces.'

This subject was presumably chosen because, as in the case of Brighton Pier, Lord Egremont had a financial interest in Chichester Canal. Indeed it was only after he had given his personal financial guarantee that the Government agreed to authorize the issue of Exchange Bills and work on the canal was able to proceed. The canal was opened officially on 9 April 1822 but Lord Egremont withdrew his money from the company in 1826. This suggests that the four pictures may have been planned some time before they were begun. It is, however, possible that *A Ship Aground* (No. 287), which is of similar dimensions to the

Petworth quartet, may have originally been painted as a replacement for *Chichester Canal* but that in the end Lord Egremont preferred the latter.

291. Brighton from the Sea c. 1829 (Plate 292)

H.M. TREASURY AND THE NATIONAL TRUST (Lord Egremont Collection) PETWORTH HOUSE

Canvas, 25 × 52 (63·5 × 132·1)

Coll. Painted for the third Earl of Egremont for the dining-room at Petworth; by descent to the third Lord Leconfield who in 1947 conveyed Petworth to the National Trust; in 1957 the contents of the State Rooms were accepted in part payment of death duties.

Exh. R.A. 1894 (141); Tate Gallery 1951 (11); Whitechapel 1953 (85); Wildenstein 1954 (19).

Engr. By R. Wallis in the *Turner Gallery* 1859.

Lit. Petworth Inventories 1837, 1856 (Carved Room); Burnet and Cunningham 1852, p. 44; Thornbury 1862, i, p. 306; ii, pp. 13, 160, 397; 1877, pp. 308, 439, 594; Armstrong 1902, p. 219; Rawlinson ii 1913, pp. 208, 358; Hussey 1925, p. 975, repr.; Collins Baker 1920, p. 125 no. 140; G. P. Boyce 'Diaries: 1851–75', *Old Water Colour Society's Nineteenth Annual Volume* 1941, pp. 24–5; Clare 1951, p. 79; T. S. R. Boase, *English Art 1800–1870* 1959, pp. 115–16, pl. 45a; Finberg 1961, p. 325; Rothenstein and Butlin 1964, pp. 46, 48, pl. 85; Gage 1969, pp. 148, 260 n. 91; Reynolds 1969, p. 133.

A full-size sketch is in the Tate Gallery (No. 286) and various drawings of the Chain Pier at Brighton and distant views of the town are included in the 'Arundel and Shoreham' sketchbook (CCXLV); pp. 18, 23 and 68 are sketches of the pier or of sections of it, p. 30 is a study of the boats, with differences, which appear on the left of the picture and p. 20 shows the buildings along the front with the windmill on the horizon which appears in the oil.

The Chain Pier, which figures so prominently, was built to the designs of Captain (later Sir) Samuel Brown, R.N., and opened in 1823. It was blown down in a gale in 1896 and vanished in a few months. Lord Egremont had a financial interest in the pier, being one of the original stockholders, which explains why it was chosen as a suitable subject to hang with the two views of Petworth Park.

For dating of the four landscapes see No. 288.

This picture features in an anecdote, the outcome of which is the subject of conflicting stories. In his diary, the artist G. P. Boyce (1826–97) mentions a visit to Petworth in 1857. The relevant passage is as follows: 'June 30 at Petworth. The pictures by Turner are of the crude yellow sort. The Chain Pier at Brighton being the best. He introduced in the foreground of it a broken basket with some floating turnips, carrots etc. and as the

old butler told me (who was in the house at the time and didn't relish the painter's uncouth manners) was savage when at Lord E's suggestion as to their specific gravity, he asked for a tub of water and some of the identical vegetables and found the latter all sank. They were evidently too useful in his picture to be removed.'

However, Thornbury in his account of the incident (1877, p. 308) confines the dispute to carrots alone (it is difficult to identify any of the vegetables in the picture as indisputable carrots) and records that when the bucket and carrots were brought Turner's affirmation that they would float was proved to be correct.

It would seem from a simple experiment conducted by the compiler that Turner was in fact right and indubitably so if the carrots are released in the sea.

4. Works Painted in Rome, 1828–9

TURNER went to Rome for the second time in 1828, leaving England in August and arriving in October; he stayed until early January 1829, and was back in England in February. Sir Charles Eastlake told Thornbury that they both stayed at 12 Piazza Mignanelli and that Turner 'painted there the "View of Orvieto", the "Regulus" and the "Medea" [Nos. 292, 294 and 293]. Those pictures were exhibited in Rome in some rooms which Turner subsequently occupied at the Quattro Fontane. The foreign artists who went to see them could make nothing of them'. However, Eastlake reported a more mixed reception in a letter to England in February 1829: 'More than a thousand persons went to see his works when exhibited, so you can imagine how astonished, enraged or delighted the different schools of artists were, at seeing things with methods so new, so daring and excellences so unequivocal. The angry critics have, I believe, talked most, and it is possible you may hear of *general* severity of judgment, but many did justice, and many more were fain to admire what they confessed they dared not imitate.'

Turner advertised in the *Diario di Roma* for 17 December 1828 that he was to exhibit '*due Paesaggi*' for a week at the Palazzo Trulli. These John Gage identifies as *Orvieto* and *Regulus*, though it is known that *Medea* was on view on 17 December. In a letter written in February 1829, Eastlake confirmed that Turner had exhibited these three works, as well as having begun 'eight or ten pictures'.

A number of paintings from the Turner Bequest are identical in their coarse canvas, the form of the original stretcher, and the way in which the canvas was fastened to the stretcher (with upholsterer's sprigs) to *Orvieto* and *Medea* (*Regulus* is on a similar canvas, but has lost its original stretcher and form of attachment). These are the three figure subjects, Nos. 296, 297 and 298, and *Southern Landscape*, No. 299. Other works probably from the group are Nos. 300 and 301. Other candidates for works begun in Rome are the composition sketches on a similar though even rather coarser canvas, Nos. 302–17; see p. 160. These sketches, and one of the larger unfinished pictures (No. 300), shows signs of having been rolled, presumably for ease of despatch to London. Both types of coarse canvas would seem to be Italian in origin, presumably purchased in Rome. Probably also from this trip are the smaller sketches on millboard, Nos. 318–27.

Turner had in fact written from Paris on 11 August 1828 to Charles Eastlake, who was already in Rome, asking him to secure one or two canvases, $59\frac{1}{4} \times 98\frac{1}{2}$ in., so that he could begin straight away on a landscape for Lord Egremont. This is generally held to be *Palestrina* (No. 295), which measures $55\frac{1}{4} \times 98$ in. but is in fact on a fine canvas.

Turner himself reported his progress in a letter to Sir Francis Chantrey of 6 November 1828: 'I have confined myself to the painting department . . . and having finished *one*, am about the second, and getting on with Lord E's [presumably *Palestrina*], which I began the very first touch at Rome; but as folk here talked that I would show them *not*, I finished a small three feet four to stop their gabbling'; this last was presumably *Orvieto*.

Eastlake's account in Thornbury goes on, 'When those same works were packed to be sent to England, I advised him to have the cover covered with waxed cloth, as the pictures without it might be exposed to wet. Turner thanked me, and said the advice was important; "for", he added, "if any wet gets to them, they will be destroyed." This indicates his practice of preparing his pictures with a kind of tempera, a method which, before the surface was varnished, was not waterproof [in fact analysis has not revealed any tempera, though Turner did quite often use watercolour on his oils and in at least one case, No. 300, a picture apparently from this group seems to have suffered losses to its water-soluble glazes]. The pictures referred to were in fact not finished; nor could any of his exhibited pictures be said to be finished till he had worked on them when they were on the walls of the Royal Academy'. This is supported by the review of *Orvieto* in the *Morning Chronicle* for 3 May 1830 quoted under *Pilate washing his Hands* (No. 332). Although Turner had hoped that his Rome paintings would reach London in time for the 1829 Exhibition, there were shipping delays and *Orvieto* and *Palestrina* were not exhibited until 1830, nor *Medea* until 1831; *Regulus* was not exhibited until 1837.

Lit. Thornbury 1862, i, p. 221; 1877, p. 100; Finberg 1961, pp. 307–11; Gage 1968, pp. 679–80.

Nos. 292–5 : Exhibited Pictures

292. View of Orvieto, painted in Rome 1828; reworked 1830 (Plate 293)

THE TATE GALLERY, LONDON (511)

Canvas, 36 × 48½ (91·5 × 123)

Coll. Turner Bequest 1856 (81, 'Orvieto' 4'0″ × 3'0″); transferred to the Tate Gallery 1919.

Exh. Rome 1828–9; R.A. 1830 (30); Amsterdam, Berne, Paris, Brussels, Liege (29), Venice and Rome (32) 1947–8; Arts Council tour 1952 (12, repr.); *Italian Art and Britain* R.A., January–March 1960 (217); Cologne (57, repr.), Rome (58, repr.) and Warsaw (57, repr.) 1966–7; *The Art of Claude Lorrain* Hayward Gallery, November–December 1969 (140); R.A. 1974–5 (472).

Lit. Ruskin 1857 (1903–12, xiii, p. 139); Thornbury 1862, i, pp. 221, 224, 307; 1877, pp. 100, 440; D. Laing, *Etchings by Sir David Wilkie* 1875, pp. 21–2; Hamerton 1879, pp. 220–22; Bell 1901, p. 112 no. 165; Armstrong 1902, pp. 120, 146, 165–6, 226; Whitley 1930, pp. 159, 192; R. B. Gotch, *Maria, Lady Callcott* 1937, pp. 279–80; Falk 1938, p. 131; Davies 1946, p. 187; Finberg 1961, pp. 310–11, 321, 490 no. 348; Rothenstein and Butlin 1964, p. 38; Gage 1968, pp. 679–80; Gage 1969, pp. 104, 165, 247 nn. 143–4; Herrmann 1975, pp. 35–6, 232, pl. 124.

One of the pictures painted and exhibited by Turner in Rome, and presumably the 'small three foot four' painted to stop folk 'gabbling' (see p. 154). There is a small composition sketch with five other subjects on a page in the 'Viterbo and Ronciglione' sketchbook, used by Turner on the 1828–9 visit to Italy (CCXXXVI-25, bottom left).

That this picture was partly overpainted at the R.A. in 1830 is suggested by the review in the *Morning Chronicle* for 3 May 1830 quoted under *Pilate washing his Hands*, No. 332, though in fact *Orvieto* is much more thinly painted, and apparently much less gone over, than *Pilate*. Neither the *Morning Chronicle* nor the *Morning Herald* for 18 May had any praise for *Orvieto*, the latter apparently dismissing it as one of 'two other productions by the same artist, in which gaudiness is the only cause of their being looked at'.

293. Vision of Medea 1828 (Plate 294)

THE TATE GALLERY, LONDON (513)

Canvas, 68⅜ × 98 (173·5 × 241)

Coll. Turner Bequest 1856 (52, 'Vision of Medea' 8'2½″ × 5'8½″); transferred to the Tate Gallery 1910.

Exh. Rome 1828–9; R.A. 1831 (178); R.A. 1974–5 (473).

Lit. Thornbury 1862, i, pp. 221, 319–20; 1877, p. 447; Bell 1901, p. 115 no. 172; Armstrong 1902, p. 225; Lord Broughton, *Recollections of a Long Life* 1910, iii, pp. 294–5; MacColl 1920, p. 16; R. B. Gotch, *Maria, Lady Callcott* 1937, pp. 279–80; Falk 1938, p. 130; Davies 1946, p. 186; Finberg 1961, pp. 310–11, 326–7, no. 358; Lindsay 1966², p. 49; Gage 1968, pp. 679–80; Gage 1969, pp. 91, 104–5, 163, 187, 263 n. 128; Herrmann 1975, p. 232.

This was one of the three pictures that Eastlake said Turner exhibited at Rome, telling Thornbury that 'Turner's economy and ingenuity were apparent in his mode of framing those pictures. He nailed a rope around the edges of each, and painted it with yellow

ochre in tempera.' The present reconstruction of the rope frame is by Lawrence Gowing.

Lord Broughton, who was taken by the sculptor Thomas Campbell to see Turner's exhibits on 17 December, noted in his diary that 'The chief of these strange compositions, called the Vision of Medea, was a glaring, extravagant daub, which might be mistaken for a joke—and a bad joke too. Mr. Campbell told us that the Romans who had seen these pictures were filled with wonder and pity.' The *Moderne Kunstchronik*, published in 1834 by J. A. Koch in collaboration with other German artists who were in Rome at the time, was equally scathing, perhaps in jealousy of the 'large and vulgar crowd which had gathered to see the exhibition of the world-famous painter, Turner . . . The pictures were surrounded with ship's cable instead of gilt frames . . . The composition purporting to show the Vision of Medea was remarkable enough. Suffice it to say whether you turned the picture on its side, or upside down, you could still recognise as much in it' (Gage 1969, pp. 104–5).

At the R.A. in 1831 the picture was exhibited with the following lines:

'Or Medea, who in the full tide of witchery
Had lured the dragon, gained her Jason's love,
Had filled the spell-bound bowl with Æson's life,
Yet dashed it to the ground, and raised the
 poisonous snake
High in the jaundiced sky to writhe its murderous
 coil,
Infuriate in the wreck of hope, withdrew
And in the fired palace her twin offspring threw.'
 MS Fallacies of Hope

This was number 1 on Turner's list of titles and verses for his R.A. exhibits of that year, now in the Tate Gallery archives: the spelling (e.g., 'Eason' for 'Æson') and punctuation differ slightly.

The critic of the *Athenaeum* for 14 May 1831 started off from these lines for his attack on the picture: 'The painting is of a piece with the poetry. Here we have, indeed, the Sister Arts—and precious sisters they are! Mr. Turner, doubtless, smeared the lines off with his brush, after a strong fit of yellow insanity . . . The snakes, and the flowers, and the spirits, and the sun, and the sky, and the trees, are all in an agony of ochre!' The artist had achieved 'a gambouge phrenzy worthy of the Bedlam lines . . . "Jaundiced sky!"—"a good phrase—a good phrase".' But the other critics, though deploring the main figures, found something to praise, albeit sometimes rather grudgingly. 'Colour! colour! colour!' exclaimed the *Literary Gazette* for 7 May; 'Still there is something so enchanting in the prismatic effect which Mr. Turner has produced, that we soon lose sight of the extravagance, in contemplating the magical results of his combinations'. For *La Belle Assemblée* for June 1831, 'as a combination of colour, the work is truly wonderful'.

294. Regulus 1828; reworked 1837 (Plate 295)

THE TATE GALLERY, LONDON (519)

Canvas, $35\frac{1}{4} \times 48\frac{3}{4}$ (91 × 124)

Coll. Turner Bequest 1856 (79, 'Regulus' 4'0" × 3'0"); transferred to the Tate Gallery 1929.

Exh. Rome 1828–9; B.I. 1837 (120); Arts Council tour 1952 (11); Edinburgh 1968 (5); R.A. 1974–5 (474, repr.).

Engr. By D. Wilson 1840 as 'Ancient Carthage—The Embarcation of Regulus.'

Lit. Ruskin 1843, 1857 (1903–12, iii, p. 241; xiii, pp. 151, 157); Thornbury 1862, i, pp. 221, 330; 1877, pp. 454–5; Lionel Cust, 'The Portraits of J. M. W. Turner', *Magazine of Art* 1895, pp. 248–9; Bell 1901, p. 133 no. 207; Armstrong 1902, p. 227; Whitley 1930, p. 159; Davies 1946, p. 187; Finberg 1961, pp. 310–11, 365, 367, 500 no. 471; Rothenstein and Butlin 1964, p. 12; Lindsay 1966, pp. 236 n. 29, 246 n. 4; Gage 1968, pp. 679–80; Gage 1969, pp. 143, 169, 264–5 n. 152, pl. 28; Herrmann 1975, pp. 35, 232, pl. 126.

One of the paintings, like Nos. 292 and 293, known to have been painted and exhibited in Rome in 1828, but considerably reworked before being exhibited again in 1837. The young Sir John Gilbert (1817–97), having a picture opposite Turner's in the British Institution, observed Turner at work on it. 'He was absorbed in his work, did not look about him, but kept on scumbling a lot of white into his picture—nearly all over it . . . The picture was a mass of red and yellow of all varieties. Every object was in this fiery state. He had a large palette, nothing in it but a huge lump of flake-white; he had two or three biggish hog tools to work with, and with these he was driving the white into all the hollows, and every part of the surface. This was the only work he did, and it was the finishing stroke. The sun, as I have said, was in the centre; from it were drawn—ruled—lines to mark the rays; these lines were rather strongly marked, I suppose to guide his eye. The picture gradually became wonderfully effective, just the effect of brilliant sunlight absorbing everything and throwing a misty haze over every object. Standing sideway of the canvas, I saw that the sun was a lump of white standing out like the boss on a shield' (Cust, *loc. cit.*). A small oil by Thomas Fearnley shows the scene, though the picture is enlarged in scale (repr. Gage 1969, pl. 30).

The composition is a Claudian seaport of the kind sketched by Turner at probably much the same time as he first worked on this picture (see No. 313), and the colour also resembles the rather unusual colour of these sketches. The absence, among the scene of activity, of any figure actually identifiable as Regulus has been explained by John Gage: Regulus, having deliberately failed to negotiate an exchange of prisoners with the Carthaginians, returned from Rome to Carthage and

was punished by having his eyelids cut off and being exposed to the sun, which blinded him. The spectator stands in the position of Regulus, with the sun shining out of the picture full in his face. That Turner knew the story is shown by the poem from his versebook quoted by Thornbury (1862, ii, p. 25), though this does not describe the form of Regulus' punishment.

All the same, the *Literary Gazette* for 4 February 1837 wasted some space in speculating on the whereabouts of the protagonist, despite recognising that the 'sun absolutely dazzles the eyes'. 'Nevertheless', wrote the critic, 'who could have painted such a picture but Mr. Turner? What hand but his could have created such perfect harmony? Who is there so profoundly versed in the arrangement and management of colours?' The *Spectator* for 11 February made an interesting comparison with Claude: 'Turner is just the reverse of Claude; instead of the repose of beauty—the soft serenity and mellow light of an Italian scene—here all is glare, turbulence, and uneasiness. The only way to be reconciled to the picture is to look at it from as great a distance as the width of the gallery will allow of, and then you see nothing but a burst of sunlight. This is scene-painting—and very fine it is in its way.'

295. Palestrina—Composition 1828? (Plate 296)

THE TATE GALLERY, LONDON (6283)

Canvas, $55\frac{1}{4} \times 98$ (140.5×249)

Coll. Sold March 1844 to Elhanan Bicknell; sale Christie's 25 April 1863 (122) bought (in) Henry Bicknell; sale Christie's 25 March 1865 (206) bought in Miller; sale Christie's 9 April 1881 (463) bought Agnew's for James Dyson Perrins; Charles William Dyson Perrins by 1939, bequeathed 1958 to the National Gallery; transferred to the Tate Gallery 1961.

Exh. R.A. 1830 (181); R.S.A. 1845 (60); R.A. Winter 1972 (11); R.A. 1951–2 (176); Tokyo and Kyoto 1970–71 (42, repr.).

Lit. Ruskin 1843 and letters (1903–12, iii, p. 243; xxxvi, pp. 441–2); Waagen 1854, ii, p. 350; Thornbury 1862, i, p. 224; 1877, p. 100; Hamerton 1879, pp. 220–22; Bell 1901, pp. 112–13 no. 166; Armstrong 1902, pp. 226; Whitley 1930, p. 192; Davies 1959, p. 102; Finberg 1961, pp. 307, 321–2, 340, 397, 406, 409, 490 no. 349, 509 no. 570; Rothenstein and Butlin 1964, p. 38; Lindsay 1966, p. 119; 1966², p. 49; Gage 1968, p. 679; Reynolds 1969, pp. 129, 137; Herrmann 1975, pp. 35–6, 49, 232, pl. 122.

Exhibited in 1830 with the following verses:

'Or from yon mural rock, high-crowned Præneste,
Where, misdeeming of his strength, the
 Carthaginian stood,
And marked, with eagle-eye, Rome as his victim.'
 MS Fallacies of Hope.

This is generally accepted as being the picture that Turner painted for Lord Egremont at Rome in 1828–9, though it never entered Egremont's collection and is on a relatively fine canvas very different from those known definitely to have been used in Rome (see p. 154). On 11 August 1828 Turner wrote from Paris to Charles Eastlake asking 'that the best of all possible grounds and canvass size 8 feet $2\frac{1}{2}$ by 4 feet $11\frac{1}{4}$ Inches to be if possible ready for me, 2 canvasses if possible', as 'It would give me the greatest pleasure, independent of other feelings which modern art and of course artists, and I among the number, owe to Lord Egremont, that my first brush in Rome . . . should be to begin for him *con amore* a companion picture to his beautiful CLAUDE'—presumably the *Jacob and Laban*, $56\frac{1}{2} \times 99$ in., still at Petworth (Plate 548). On 6 November 1828 Turner wrote to Chantrey that he was 'getting on with lord E's, which I began the very first touch at Rome'. In the event Lord Egremont bought *Jessica* (No. 333), also shown at the R.A. in 1830, though not until the following year. The picture was still in Turner's possession on 1 February 1844, when he wrote to the dealer Griffith that 'The Palestrina I shall open my mouth widely ere I part with it'. However, when Ruskin saw it a few weeks later, on 27 March, it was already sold to Elhanan Bicknell for a thousand guineas.

Later Ruskin himself became interested in the acquisition of this picture, writing to his father on 2 May 1863, shortly after the picture had been bought in at the Bicknell sale, to encourage him to buy it: 'I am also much inclined to say—buy the Palestrina. You may have it for nothing, literally—as long as you choose. It will be worth £4000 in five years more—which will pay both interest and insurance'. Alluding to Turner's original title he goes on, 'It is *not* a composition—it is Virgil's Præneste—insisting on the stream descending from the hills (the bridge evidently being a careful study on the spot), because of the following lines': he quotes Virgil *Æneid* vii, ll, 683–5. 'The way Turner used to find out the character and meaning of a whole family of scenes in this way is quite miraculous.'

The lines from Virgil referred to by Ruskin come in the description of the rallying of the bands of Latium against Æneas: 'men whose homes were on Præneste's height, on Juno's farmlands at Gabii, by the cool Anio and amid porous Hernican rocks which rivulets bedew' (transl. W. F. Jackson Knight 1956, p. 196). Turner's own verses, quoted above, seem however to refer to Hannibal. He may also have recalled the reference 'To where Presneste lifts her airy brow' in Thomson's *Liberty*, 1735, l. 64, part of a description of the 'once glorious Rome' which occurs in the section on 'Ancient and Modern Italy compared' and its message for contemporary Britain (for what seems to be an earlier reference to this theme see No. 135).

For the *Sun*, 3 May 1830, this was 'A glorious composition'. Other reviews were more guarded, though it was preferred to *Pilate washing his Hands* and *Jessica* (Nos. 332 and 333). The *Literary Gazette* for 15 May wrote, 'In such performances as this, he may

exhibit the richness and even the riot of his imagination with impunity, or rather with applause. There is enough of nature to shew that attention to her has formed the basis of a structure full of poetical feeling, but exceedingly artificial withal.'

When exhibited at Edinburgh in 1845 the picture aroused further critical comment. The *Caledonian Mercury* for 17 February, after noting that the picture had been purchased for a thousand guineas, found that, though it did not immediately have the effect of *Neapolitan Fisher-Girls* (No. 388), 'its beauties emerge as it is calmly surveyed . . . We heard one remark, that it seems as if his [Turner's] pencil was each time dipped in a sunbeam, so splendid was the effect'. The *Scotsman*

for 1 March was more severe, echoing the usual criticisms of 'the peculiarities of Mr. Turner's later style': 'There is certainly in it much glare and glitter . . . On the other hand, there is something very grand and splendid in the effect of the whole, as viewed from a little distance . . . Parts of the foliage and front regions, will bear to be inspected minutely . . . The avenue, the bridge, and the stream, are all finely given. Turner is a singular man, and he has shown his possession of that highest of all gifts, originality—which is genius.'

Armstrong's reference to this picture as belonging to 'Mrs Williams' seems to have been a mistake; by family tradition the picture remained in the possession of the Dyson Perrins from 1881 until 1958.

Nos. 296–328: Unexhibited Works

Nos. 296–301: Miscellaneous

296. Reclining Venus 1828 (Plate 298)

THE TATE GALLERY, LONDON (5498)

Canvas, 69 × 98 (175 × 249)

Coll. Turner Bequest 1856 (268, '1 (Academy figure)', no dimensions given; identified 1946, ? by chalk number on back); transferred to the Tate Gallery 1947.

Exh. Whitechapel 1953 (84).

Lit. Davies 1946, pp. 161, 190; Rothenstein and Butlin 1964, pp. 45–6, 76, pl. 89; Lindsay 1966, p. 176; Gage 1968, pp. 679; Gage 1969, p. 91; Reynolds 1969, pp. 137–8, pl. 123.

The canvas is very coarse and is attached to the back of the stretcher by long bent-over sprigs, a characteristic of pictures known to have been executed in Rome during Turner's visit of 1828–9 (see p. 154). The position of the figure's right arm has twice been altered and the picture is unfinished. The receding arcade in the distance is thinly painted over a roughly sketched outline of unrelated forms.

The picture would seem to have been intended as a tribute or challenge to Titian's famous *Venus of Urbino*, which Turner could have seen in the Uffizi when he passed through Florence on the way to Rome in September 1828.

297. Two Recumbent Nude Figures 1828
(Plate 277)

THE TATE GALLERY, LONDON (5517)

Canvas, 68¾ × 98⅛ (174·5 × 249)

Coll. Turner Bequest 1856 (? 269, '1 (ditto [Academy figure] very large size)'; see below); transferred to the Tate Gallery 1947.

Lit. Davies 1949, p. 164.

In canvas, stretcher and mode of attachment this picture shares the characteristics of the group of works known to have been painted by Turner in Rome in 1828 (see p. 154).

Although the second nude, on the left, is only faintly outlined and the painting could therefore be described as a single 'Academy figure', the identification with no. 269 on the 1854 Schedule is only tentative, particularly as it is in fact no larger than no. 268 'Academy figure' which can be identified with *Venus Reclining* (No. 296). The more finished figure is in much the same pose, though in reverse, as Venus in *Venus and Adonis* of *c.* 1803 (No. 150); the outlined figure, though in general a mirror image of the other, differs in that the head is apparently turned away in profile. The nose, chin and neck of the right-hand figure, the most solidly painted parts of the picture, are badly damaged.

298. Outline of the Venus Pudica 1828 (Plate 278)

THE TATE GALLERY, LONDON (5509)

Canvas, $53\frac{3}{8} \times 38\frac{5}{8}$ (135·5 × 98)

Coll. Turner Bequest 1856 (353, '1 Academy figure', no dimensions given; identified 1946 by chalk number on back); transferred to the Tate Gallery 1947.

Lit. Davies 1946, pp. 163, 191.

The canvas, stretcher and mode of attachment are identical to those of pictures known to have been painted in Rome in 1828. The figure, painted in red in very dilute oil paint or just possibly watercolour on a canvas prepared for oil paint, is of the well-known Antique type of the Venus Pudica; it may derive specifically from the Venus de' Medici, already to be seen in the Tribuna of the Uffizi in Florence, through which Turner had passed on his way to Rome in the late summer of 1828. However, Turner has shown Venus with her left leg bent, whereas in the Antique prototypes this is the weight-bearing leg; he was therefore presumably working from memory.

299. Southern Landscape 1828 (Plate 280)

THE TATE GALLERY, LONDON (5510)

Canvas, $69\frac{1}{2} \times 99\frac{1}{8}$ (176·5 × 252)

Coll. Turner Bequest 1856 (246, 1 unidentified $8'2\frac{1}{2}'' \times 5'10''$; identified 1946 by chalk number on back); transferred to the Tate Gallery 1947.

Lit. Davies 1946, pp. 163, 190.

Canvas, stretcher and mode of attachment are the same as in *Medea*, No. 293, and the picture must therefore have been painted in Rome during Turner's second Italian visit of 1828–9.

The picture is badly spotted with mould.

300. Southern Landscape with an Aqueduct and Waterfall 1828? (Plate 281)

THE TATE GALLERY, LONDON (5506)

Canvas, $59\frac{1}{8} \times 98\frac{1}{8}$ (150 × 249)

Coll. Turner Bequest 1856 (248, one of 2 each $8'2\frac{1}{2}'' \times 4'11\frac{1}{2}''$ with ? No. 301; identified 1946 by chalk number on back); transferred to the Tate Gallery 1947.

Exh. Dresden (10, repr. in colour) and Berlin (14) 1972; Lisbon 1973 (11, repr. in colour); Milan 1975 (151, repr.); Leningrad and Moscow 1975–6 (53).

Lit. Davies 1946, pp. 162, 190; Rothenstein and Butlin 1964, p. 50.

The canvas is similar to that of the works known definitely to have been painted in Rome in 1828 (see p. 154), but as the original edges and stretcher have disappeared one cannot be certain whether this was one of the group. It is however similar in style and technique, and can therefore be dated to the same period. Like the Roman sketches, Nos. 302–17, the canvas has been rolled (as is shown by the vertical craquelure), and was perhaps taken back by Turner to England overland rather than sent home by sea (see p. 160).

An old National Gallery photograph suggests that a considerable amount of detail, particularly in the trees, has been lost, possibly through the removal of water-soluble glazes during relining. The impasto has been flattened during the same operation.

301. Italian Landscape, probably Civita di Bagnoregio 1828? (Plate 297)

THE TATE GALLERY, LONDON (5473)

Canvas, $59 \times 98\frac{1}{4}$ (150 × 249·5)

Coll. Turner Bequest 1856 (? 247, one of 2 each $8'2\frac{1}{2}'' \times 4'11\frac{1}{2}''$ with No. 300; identified 1946 by probable number in chalk on back); transferred to the Tate Gallery 1947.

Lit. Davies 1946, pp. 157, 190.

The canvas and type of stretcher are the same as in *Medea* (No. 293) and other pictures definitely painted in Rome on Turner's second visit, but the picture has been striplined and it is impossible to tell how the canvas was originally attached. The landscape was later used, with some changes, for a regular 3 ft by 4 ft canvas of *Pluto carrying off Prosperine*, exhibited at the R.A. in 1839 (No. 380).

It has been suggested by Sig. Virginio Oddone (letter of 2 May 1976) that the picture shows Civita di Bagnoregio, a small hill town with a tower about five miles south of Orvieto, the subject of another picture painted on this visit (No. 292). Alternatively he suggests Pitigliano, another small town in the same mountainous district around Orvieto. Sketches of similar landscapes are to be found in the 'Viterbo and Ronciglione' sketchbook, used on this visit (CCXXXVI, especially pp. 3 and 4 verso).

Nos. 302–17 Roman Sketches, 1828?

THE first seven of these oil sketches (Nos. 302–8) were originally on one large canvas; the compositions were separated in 1913–14. The nine others are similar in style, technique and type of canvas but are not recorded as having been originally joined. However, this second group of sketches shares with the first the peculiarity of having been tacked to some sort of stretcher or support from the front, Turner having gone over the tacks with paint in the process of painting each composition. This suggests that in both cases a large piece of canvas was remounted on a relatively small support each time Turner wanted to paint a new sketch. Both groups are marked by a vertical craquelure, the result of rolling. The 1856 Schedule of the Turner Bequest lists under nos. 203–18 four 'Roll[s] containing 4 subjects', only two of which are accounted for by the Cowes sketches, one of which in fact contained five compositions (see p. 142); the other two rolls could have been that bearing Nos. 302–8 together with one containing the other Roman sketches.

Those subjects that can be identified are Italian and the first sketch was used for the large picture of *Ulysses and Polyphemus* exhibited at the R.A. in 1829 (No. 330). It therefore seems likely that they were done in Italy during Turner's second visit in 1828–9, the use of large rolls of canvas being presumably for ease of transport as seems to have been the case with the Cowes sketches. However, the canvas is not identical with that of the pictures that were exhibited by Turner in Rome (see Nos. 292–4), nor did those pictures reach London, having been sent by sea, until after the opening of the 1829 R.A. Exhibition, but Turner would not have needed the *Polyphemus* sketch directly in front of him to paint the large picture. Alternatively, whereas Nos. 292–4, and also Nos. 296–9 and 301, seem to have been stretched in Rome and were probably all sent back by sea, Turner could have taken the rolled canvases back with him by land.

Unlike the Cowes sketches, which seem to have been the direct result of specific experiences even if not actually painted on the spot, these works are essays in composition; even those based on actual landscapes are of places already known to Turner from his travels in Italy in 1819 if not from pictures by other artists: both Lake Nemi and Tivoli (for which see Nos. 44 and 545) had been painted by Wilson. They are studies in broad areas of strongly contrasted tones of flatly applied colour, occasionally enlivened, as in the case of *Lake Nemi*, by a flurry of heavy impasto. The subjects range from recognisable Italian landscapes, through the *Polyphemus* sketch which uses landscape motives based on what Turner could have seen in Italy, to Claudian seaports which depend entirely on the work of another artist. Differing in size one from the other, and not adhering to any of the standard sizes normally used by Turner, these works are definitely sketches rather than 'unfinished' paintings which could have been carried further.

Lit. MacColl 1920, p. 42; Davies 1946, p. 189.

302. Sketch for 'Ulysses deriding Polyphemus'
1828? (Plate 299)

THE TATE GALLERY, LONDON (2958)

Canvas, $23\frac{5}{8} \times 35\frac{1}{8}$ (60 × 89)

Coll. Turner Bequest 1856 (? one of 203–18; see above); transferred to the Tate Gallery 1919.

Exh. Arts Council tour 1952 (13); R.A. 1974–5 (475).

Lit. Rothenstein and Butlin 1964, pp. 38–9; Gage 1968, p. 679; Gage 1969, p. 129.

A sketch for the picture exhibited at the R.A. in 1829 (No. 330). This is the only one of this group of sketches with so specific a relationship to a finished work.

There are seven tack holes along the bottom, and two, close to each other, near the right-hand edge.

303. Italian Bay 1828? (Plate 282)

THE TATE GALLERY, LONDON (2959)

Canvas, $23\frac{3}{4} \times 40\frac{1}{4}$ (60·5 × 102)

Coll. Turner Bequest 1956 (? one of 203–18; see above); transferred to the Tate Gallery 1919.

Exh. Liverpool 1933 (16); Prague, Bratislava (145) and Vienna (54) 1969; Dresden (7, repr.) and Berlin (6) 1972.

There are tack holes along the top, right and lower edges.

304. Lake Nemi 1828? (Plate 300)

THE TATE GALLERY, LONDON (3027)

Canvas, $23\frac{3}{4} \times 39\frac{1}{4}$ ($60 \cdot 5 \times 99 \cdot 5$)

Coll. Turner Bequest 1856 (? one of 203–18; see p. 160); transferred to the Tate Gallery 1919.

Exh. Liverpool 1933 (12); Rotterdam 1955 (53, repr.); Leicester 1968 (59); Tokyo and Kyoto 1970–1 (38, repr.; colour detail on cover); Lisbon 1973 (9, repr. in colour); R.A. 1974–5 (476); Hamburg 1976 (98, repr.).

Lit. Rothenstein and Butlin 1964, pp. 38–9, colour pl. x; Lindsay 1966, p. 146.

There are drawings of Lake Nemi in the 'Vatican Fragments' and possibly the 'Gandolfo to Naples' sketchbooks of 1819 (CLXXX and CLXXXIV) but Turner could easily have visited the site again in 1828–9.
There are tack holes along the top and bottom edges.

305. Arricia (?): Sunset 1828? (Plate 283)

THE TATE GALLERY, LONDON (2990)

Canvas, $23\frac{7}{8} \times 31\frac{1}{4}$ ($60 \cdot 5 \times 79 \cdot 5$)

Coll. Turner Bequest 1856 (? one of 203–18; see p. 160); transferred to the Tate Gallery 1919.

Exh. Australian tour 1960 (8).

Lit. MacColl 1920, p. 43; Herrmann 1975, p. 35, colour pl. 90.

Repr. Gaunt 1971, colour pl. 7.

The tentative identification of the hill town as Arricia, near Rome, is MacColl's. There are tack holes along the top and bottom edges.

306. Overlooking the Coast, with Classical Building 1828? (Plate 284)

THE TATE GALLERY, LONDON (2991)

Canvas, irregular, approx. $23\frac{3}{4} \times 33\frac{1}{4}$ ($60 \cdot 5 \times 84 \cdot 5$)

Coll. Turner Bequest 1856 (? one of 203–18; see p. 160); transferred to the Tate Gallery 1919.

Less resolved than the other sketches in the group, in this case justifying the term 'unfinished'. The composition, with its relatively large, classical portico on the right helping to frame a panoramic view over a distant landscape, is unusual for Turner.
There are tack holes along the top and bottom edges.

307. Italian Landscape with Tower, Trees and Figures 1828? (Plate 285)

THE TATE GALLERY, LONDON (2992).

Canvas, irregular, approx. $23\frac{5}{8} \times 34\frac{7}{8}$ ($60 \times 88 \cdot 5$)

Coll. Turner Bequest 1856 (? one of 203–18; see p. 160); transferred to the Tate Gallery 1919.

Exh. Liverpool 1933 (70).

A typical Italian panoramic landscape with framing trees on the right.
There are tack holes along the top and bottom edges.

308. Classical Harbour Scene 1828? (Plate 286)

THE TATE GALLERY, LONDON (3026)

Canvas, $23\frac{3}{4} \times 40\frac{1}{8}$ ($60 \cdot 5 \times 102$)

Coll. Turner Bequest 1856 (? one of 203–18; see p. 160); transferred to the Tate Gallery 1919.

Exh. Amsterdam, Berne, Paris, Brussels, Liege (17), Venice and Rome (19) 1947–8.

The picture was formerly known as 'The Departure of St Ursula', a fanciful title presumably derived from Claude.
There are tack holes along the top and bottom edges.

309. Rocky Bay 1828? (Plate 287)

THE TATE GALLERY, LONDON (3380)

Canvas, irregular, approx. $23\frac{3}{4} \times 36\frac{1}{4}$ ($60 \cdot 5 \times 92$)

Coll. Turner Bequest 1856; transferred to the Tate Gallery 1920.

Exh. Tokyo and Kyoto 1970–71 (39, repr.).

There are apparently irregularly placed tack holes along the top edge, supporting the probability that this sketch and Nos. 310–17 were originally on a single roll of canvas like Nos. 302–8; see p. 160.

310. Archway with Trees by the Sea 1828? (Plate 301)

THE TATE GALLERY, LONDON (3381)

Canvas, $23\frac{5}{8} \times 34\frac{1}{4}$ ($60 \times 87 \cdot 5$)

Coll. Turner Bequest 1856 (? one of 203–18; see p. 160); transferred to the Tate Gallery 1920.

Exh. Amsterdam, Berne, Paris, Brussels, Liege (18), Venice and Rome (20) 1947–8; R.A. 1974–5 (478).

There are tack holes along the top and bottom; also two more close together half way up the right-hand edge; all are about 2 in. from the edge of the canvas.

311. Tivoli, the Cascatelle 1828? (Plate 302)

THE TATE GALLERY, LONDON (3388)

Canvas, $23\frac{7}{8} \times 30\frac{5}{8}$ ($60 \cdot 5 \times 78$)

Coll. Turner Bequest 1856 (? one of 203–18; see p. 160); transferred to the Tate Gallery 1920.

Exh. R.A. 1974–5 (477)

Lit. MacColl 1920, p. 44; Rothenstein and Butlin 1964, pp. 38–9, pl. 75.

Catalogued by MacColl as 'View of a Town: possibly Freiburg' but quite definitely of Tivoli. Turner visited Tivoli in 1819 (see the 'Tivoli and Rome', 'Tivoli' and 'Naples: Rome C. Studies' sketchbooks, CLXXIX, CLXXXIII and CLXXXVII) and 1828–9 (see the 'Roman and French' sketchbook, CCXXXVII). A watercolour of *c.* 1828 in the Whitworth Art Gallery, Manchester (D 31. 1922; repr. exh. cat., *British Artists in Europe* Whitworth Art Gallery, January–February 1973, p. 10 no. 23) is particularly close to this oil.

312. Italian Landscape with Bridge and Tower 1828? (Plate 288)

THE TATE GALLERY, LONDON (3387)

Canvas, $23\frac{3}{4} \times 38\frac{5}{8}$ ($60 \cdot 5 \times 98$)

Coll. Turner Bequest 1856 (? one of 203–18; see p. 160); transferred to the Tate Gallery 1920.

A typical panoramic Italian view but with rather more prominent foreground figures than usual: perhaps Turner already had in mind some Biblical or mythological subject paralleling those of *Christ and the Woman of Samaria* (No. 433) or *Tobias and the Angel* (No. 437).

There are tack holes along the top. Two areas of damage near the edges, one at the top to the right of centre, the other near the top of the right-hand edge, occured when the paint was still wet.

313. Claudian Harbour Scene 1828? (Plate 305)

THE TATE GALLERY, LONDON (3382)

Canvas, $23\frac{5}{8} \times 36\frac{7}{8}$ ($60 \times 92 \cdot 5$)

Coll. Turner Bequest 1856 (? one of 203–18; see p. 160); transferred to the Tate Gallery 1920.

Exh. Amsterdam, Berne, Paris, Brussels, Liege (19), Venice and Rome (21) 1947–8; *The Art of Claude Lorrain* Hayward Gallery, November–December 1969 (141); Tokyo and Kyoto 1970–71 (41); R.A. 1974–5 (479, repr.).

Lit. Rothenstein and Butlin 1964, pp. 38–9, pl. 74.

Formerly called 'Carthaginian Subject'.
There are the usual tack holes, top and bottom.

314. Stack and Fire? 1828? (Plate 306)

THE TATE GALLERY, LONDON (3383)

Canvas, $23\frac{5}{8} \times 33\frac{3}{8}$ ($60 \times 84 \cdot 5$)

Coll. Turner Bequest 1856 (? one of 203–18; see p. 160); transferred to the Tate Gallery 1920.

Exh. Amsterdam, Berne, Paris, Brussels, Liege (20), Venice and Rome (22) 1947–8.

Lit. MacColl 1920, p. 44

The subject is difficult to identify; MacColl's title was 'Tower, with Trees'. The composition is unusually frontal for Turner: a river with shipping runs right across the middle distance with wooded hills behind; a large rectangular undifferentiated structure in front of the river on the right is the 'stack' of the present title; and smoke rises in the centre, possibly from the ship on the left.

There are tack holes along the top and bottom edges and also well into the picture half way up on the right.

315. A Park 1828? (Plate 307)

THE TATE GALLERY, LONDON (3384)

Canvas, irregular, approx. $23\frac{3}{4} \times 38\frac{7}{8}$ ($60 \cdot 5 \times 98 \cdot 5$)

Coll. Turner Bequest 1856 (? one of 203–18; see p. 160); transferred to the Tate Gallery 1920.

Exh. Amsterdam, Berne, Paris, Brussels, Liege (21), Venice and Rome (23) 1947–8.

Lit. MacColl 1920, p. 44; Rothenstein 1949, p. 16, colour pl. 9.

Identified in MacColl as 'Possibly a Study for Windsor Castle', but in style, technique and type of canvas the picture is typical of the Italian sketches. There are the usual tack holes top and bottom; also traces of two long creases running horizontally across the middle of the picture as if it had been roughly folded at some time.

316. Scene on the Banks of a River 1828? (Plate 308)

THE TATE GALLERY, LONDON (3385)

Canvas, $23\frac{3}{4} \times 35\frac{1}{8}$ ($60 \cdot 5 \times 89$)

Coll. Turner Bequest 1856 (? one of 203–18; see p. 160); transferred to the Tate Gallery 1920.

Exh. Amsterdam, Berne, Paris, Brussels, Liege (22, repr.), Venice and Rome (24, repr.) 1947–8; Lisbon and Madrid 1949 (44, repr.); Hamburg, Oslo, Stockholm and Copenhagen 1949–50 (100); Cape Town 1952 (28, repr.); Arts Council tour 1952 (9); *A Hundred Years of British Landscape Painting 1750–1850* Leicester Museums and Art Gallery, October–November 1956 (31); *Panorama of Euro-*

pean Painting Inaugural Exhibition, Rhodes National Gallery, Salisbury, Southern Rhodesia, July–September 1957 (37, repr.); remained there on loan until 1962; Tokyo and Kyoto 1970–71 (40, repr.); Dresden (8, repr.) and Berlin (9, colour pl. 31) 1972; Lisbon 1973 (10, repr. in colour); R.A. 1974–5 (480); Hamburg 1976 (99, repr.).

Previously catalogued as 'Market Place' and 'Fish Market'. There are tack holes along the top and bottom; also two on a horizontal line running in from the right-hand edge.

317. Fishing Boat in a Mist 1828? (Plate 303)

THE TATE GALLERY, LONDON (3386)

Canvas, $23\frac{3}{4} \times 35\frac{3}{4}$ (60 × 91)

Coll. Turner Bequest 1856; (? one of 203–18; see p. 160); transferred to the Tate Gallery 1920.

Exh. Amsterdam 1936 (164); Venice 1938 (7); Amsterdam, Berne, Paris, Brussels, Liege (23), Venice and Rome (25) 1947–8; on loan to the National Museum of Wales since 1964.

There are four tack holes along the top.

Nos. 318–27 Small Italian Sketches, 1828?

THESE small sketches on millboard are distinct in style from those, also from the Turner Bequest, found at the British Museum (Nos. 485–500). Several are painted on muslin stretched over the millboard, but there is evidence that one of the sketches on muslin was originally on the same piece of millboard as one of those painted directly onto the board (see Nos. 324 and 325). A number of these sketches seem to show landscapes in the vicinity of Rome and Naples. Though very different from earlier sketches from nature like those done of the Thames *c.* 1807 (Nos. 160–94) they have a directness and freshness which suggests that they may also have been done out-of-doors, though with formal compositions in mind from the outset. There is no secure evidence that Turner went to Naples on his second visit to Rome but it would have been easy for him to do so, and this group of sketches has usually been dated to this visit. Nevertheless, they could have been done on the 1819 visit, when, however, Turner did a far greater amount of work on paper.

318. Hilltown on the Edge of the Campagna 1828? (Plate 309)

THE TATE GALLERY, LONDON (5526)

Millboard, $16\frac{1}{8} \times 23\frac{3}{8}$ (41 × 59·5)

Coll. Turner Bequest 1856 (176, one of 5 each $1'11\frac{1}{4}'' \times 1'4''$ with Nos. 319–22; identified 1946 by chalk number on back); transferred to the Tate Gallery 1947.

Exh. New York 1966 (3, repr. p. 59); Dresden (6) and Berlin (not in catalogue) 1972; R.A. 1974–5 (471).

Lit. Davies 1946, pp. 165, 189; Rothenstein and Butlin 1964, p. 38, pl. 72; Gowing 1966, p. 13, repr. p. 59; Gage 1969, pp. 39, 96, 232 n. 106.

One of the group of sketches discussed above. In this case there are fairly close parallels with watercolours and drawings definitely done when Turner went to Italy in 1819, for instance *Roman Campagna: Morning* and *The Tiber* (CLXXXVII-34 and CLXXXIX-24; repr. Thomas Ashby, *Turner's Vision of Rome* 1925, pls. 6 and 1; the former also repr. Reynolds 1969, pl. 93), but he could of course have painted similar views on both visits.

319. Seacoast with Ruin, probably the Bay of Baiae 1828? (Plate 310)

THE TATE GALLERY, LONDON (5530)

Muslin mounted on millboard, $16\frac{1}{4} \times 23\frac{11}{16}$ (41 × 60)

Coll. Turner Bequest 1856 (172, one of 5 each $1'11\frac{1}{4}'' \times 1'4''$, see No. 318; identified 1946 by chalk number on back); transferred to the Tate Gallery 1947.

Lit. Davies 1946, pp. 166, 189.

The octagonal ruin and distant promontory seem to be the same as those that appear on the right-hand side of *The Bay of Baiae* (No. 230), where they can be identified as the Antique Temple of Diana and the sixteenth-century Castello di Baia. The larger painting was exhibited in 1823, which could perhaps suggest that this sketch dates from Turner's first visit to Italy in 1819, but see above for the reasons for dating this groups of sketches to Turner's second visit of 1828–9.

320. Coast Scene near Naples 1828? (Plate 304)

THE TATE GALLERY, LONDON (5527)

Millboard, $16\frac{1}{8} \times 23\frac{1}{2}$ (41 × 59·5)

Coll. Turner Bequest 1856 (175, one of 5 each $1'11\frac{1}{4}'' \times 1'4''$; see No. 318; identified 1946 by chalk number on back); transferred to the Tate Gallery 1947.

Exh. New York 1966 (4, repr. p. 11); R.A. 1974–5 (470); Leningrad and Moscow 1975–6 (51).

Lit. Davies 1946, pp. 165, 189; Gage 1969, pp. 39, 96, 232 n. 106; Herrmann 1975, p.35, pl. 125.

One of the group of sketches discussed on p. 163.

321. Landscape with Trees and a Castle 1828?
(Plate 311)

THE TATE GALLERY, LONDON (5528)

Millboard, $16\frac{5}{16} \times 23\frac{5}{8}$ (41·5 × 60)

Coll. Turner Bequest 1856 (173, one of 5 each $1'11\frac{1}{4}'' \times 1'4''$, see No. 318; identified 1946 by chalk number on back); transferred to the Tate Gallery 1947.

Exh. Dresden (5, repr.) and Berlin (7) 1972; Lisbon 1973 (7, repr.).

Lit. Davies 1946, pp. 166, 189; Gage 1969, pp. 39, 96, 232 n. 106.

One of the group of sketches of Italian scenes on millboard, probably done in Italy during Turner's second visit of 1828–9; see p. 163.

322. Mountainous Landscape 1828? (Plate 312)

THE TATE GALLERY, LONDON (5531)

Muslin mounted on millboard, $16\frac{1}{4} \times 23\frac{1}{2}$ (41 × 59·5)

Coll. Turner Bequest 1856 (174, one of 5 each $1'11\frac{1}{4}'' \times 1'4''$, see No. 318; identified by chalk number on back); transferred to the Tate Gallery 1947.

Lit. Davies 1946, pp. 166, 189.

One of the group of probably Italian scenes painted on muslin mounted on millboard, here tentatively dated to Turner's second Italian visit of 1828–9; see p. 163. This example has not yet been cleaned.

323. Hilly Landscape with Tower (?) 1828?
(Plate 313)

THE TATE GALLERY, LONDON (5532)

Muslin mounted on millboard, $16\frac{9}{16} \times 20\frac{5}{8}$ (42 × 52·5)

Coll. Turner Bequest 1856 (182, one of 5 each $1'9\frac{1}{4}'' \times 1'7\frac{1}{2}''$, with Nos. 324–6 and ?327; identified by chalk number on back); transferred to the Tate Gallery 1947.

Lit. Davies 1946, pp. 166, 189.

Another of the group of sketches tentatively associated with Turner's second Italian visit of 1828–9; see p. 163. This example has not yet been cleaned and is particularly difficult to make out.

324. Landscape with a Tree on the Right 1828?
(Plate 314)

THE TATE GALLERY, LONDON (5545)

Millboard, $11 \times 16\frac{3}{8}$ (28 × 41·5)

Coll. Turner Bequest 1856 (part of 180 with No. 325, one of 5 each $1'8\frac{1}{2}'' \times 1'4\frac{1}{2}''$, see No. 323; identified 1946 by chalk number on back); transferred to the Tate Gallery 1947.

Lit. Davies 1946, pp. 168, 189 n. 18.

Originally on the same sheet of millboard as No. 325, though that picture was painted on muslin attached to the board, whereas this example was painted directly onto the board. An inscription on the back reads, '180a one board with 180b, cut by C.H. [(Sir) Charles Holroyd] June 1908'. The join was apparently along the top of each composition. This picture is clearly from the group of Italian landscapes such as Nos. 319–21, and like them can be tentatively associated with Turner's second visit to Italy of 1828–9.

325. Seascape with Burning Hulk 1828?
(Plate 315)

THE TATE GALLERY, LONDON (5535)

Muslin mounted on millboard, $9\frac{1}{2} \times 16\frac{3}{8}$ (24 × 41·5)

Coll. Turner Bequest 1856 (part of 180 with No. 324, one of 5 each $1'8\frac{1}{2}'' \times 1'4\frac{1}{2}''$, see No. 323; identified 1946 by chalk number on back); transferred to the Tate Gallery 1947.

Lit. Davies 1946, pp. 167, 180 n. 18.

Martin Davies records that Nos. 324 and 325 were originally on the same piece of millboard; they were cut apart in 1908. This is confirmed by an inscription on the back in pencil: '180b one board with 180a—cut by C.H. 12 June 1908'. 'C.H.' was (Sir) Charles Holroyd. No. 324 is one of the Italian scenes tentatively dated to Turner's second visit to Italy in 1828–9, and this seapiece presumably shares the same date.

326. A Seashore 1828? (Plate 316)

THE TATE GALLERY, LONDON (5524)

Muslin mounted on millboard, $16\frac{3}{8} \times 20\frac{1}{2}$ ($41\cdot5 \times 52$)

Coll. Turner Bequest 1856 (181, one of 5 each $1'8\frac{1}{2}'' \times 1'4\frac{1}{2}''$, see No. 323; identified by chalk number on back); transferred to the Tate Gallery 1947.

Lit. Davies 1946, pp. 165, 189; Gage 1969, pp. 39, 232 n. 106.

See No. 327 for the possible dating of this group of sketches of the sea. This example is one of the sub-group painted on muslin stretched over millboard; see also Nos. 319, 322, 323 and 325.

327. Seascape 1828? (Plate 317)

THE TATE GALLERY, LONDON (5481)

Millboard, $16\frac{1}{2} \times 20\frac{1}{2}$ (42×52)

Coll. Turner Bequest 1856 (? one of 178 to 182, 5 each $1'8\frac{1}{2}'' \times 1'4\frac{1}{2}''$, see No. 323); transferred to the Tate Gallery 1947.

Lit. Davies 1946, p. 158.

Fairly close in style to the *Study of Sea and Sky* painted at Cowes in 1827 (No. 268) and therefore probably to be dated in the later 1820s; *c.f.* also No. 271. If all the sketches in this group on millboard were the result of a single period of activity by Turner, then the scene is presumably Italian, but see No. 276 for a particularly un-Italian picture with which this sketch could be associated.

No. 328: Miscellaneous

328. Italian Landscape with a Tower *c.* 1825–30
 (Plate 318)

THE TATE GALLERY, LONDON (5540)

Canvas, 23×30 ($58\cdot5 \times 76$)

Coll. Turner Bequest 1856 (? 162 or 163, 2 each $2'6'' \times 1'11''$); transferred to the Tate Gallery 1951.

Lit. Davies 1946, p. 167.

Before restoration there were paint losses along the edges at the top right-hand corner and at intervals down the right-hand side; also a tear in the tree on the left and two holes in the canvas (each about 1 in. in diameter) in the landscape between the tree and the distant hills on the horizon.

Formerly catalogued as 'Seascape' or 'Coast Scene with a Round Tower', this seems rather to be an inland scene probably based on the Roman Campagna. In style it is close to sketches associated with Turner's visit to Rome in 1828, though it does not belong to either of the main groups of sketches probably done during this visit (see Nos. 302–17 and 318–27).

5. Later Works, 1829–51

Nos. 329–432: Exhibited Pictures

329. The Banks of the Loire Exh. 1829

PRESENT WHEREABOUTS UNKNOWN

Size unknown

Exh. R.A. 1829 (19).

Lit. Burnet and Cunningham 1852, p. 115 no. 147; Thornbury 1877, p. 575; Monkhouse 1879, p. 111; Bell 1901, p. 110 no. 160; Armstrong 1902, pp. 167, 224; Finberg 1961, pp. 313–14, 488 no. 322.

No trace of this picture exists since 1829 but it is certainly not that in the Kunsthalle, Hamburg (given in 1886 as part of the Schwabe Collection, 28·3 × 48 cm.) as stated by Bell and Armstrong and, more doubtfully, by Finberg. The picture in Hamburg has nothing to do with Turner but is a copy by an unknown hand of a watercolour by John Sell Cotman of Mount St Catherine, Rouen (several versions exist; e.g., one in brown wash in the Castle Museum, Norwich (Russell Colman Collection) repr. *Burlington Magazine* cxvii 1975, p. 655 fig. 77). The 1969 edition of the Hamburg catalogue recognises the Cotman connection and that the picture cannot be by Turner, although it still lists the picture (no. 1845) under his name. Nor can the exhibited picture be identified with one in the collection of Mr M. A. Moss, Memphis, Tennessee, as tentatively suggested by Mrs Finberg in a note added in the 1961 edition of her husband's *Life*.

At the R.A. the critics concentrated almost entirely on *Ulysses deriding Polyphemus* (No. 330) and *The Loretto Necklace* (No. 331); only the *Athenaeum*, 27 May, mentioned no. 19 as 'a gem of the first water, brilliant and beautiful'.

It seems just possible that a clue to the appearance of this picture may be provided by the *River Landscape with a Castle* formerly in the collection of Mr and Mrs Paul Mellon (exh. Richmond 1963 (133) and sold at Sotheby's 26 November 1975 (31) bought Stockton Matthews). The ex-Mellon picture was published in the *Burlington Magazine* xcvi 1954, pp. 18–19, repr. fig. 20 as by Turner, which it is not. It does, however, looks as if it represents a scene on a French river and may be a later copy or variation of Turner's exhibited picture.

A number of pencil sketches of the Loire occur in the 'Loire, Tours, Orleans and Paris' sketchbook (CCXLIX), which may have been used as a basis for the original oil. The sketchbook has an inscription in Turner's hand inside the front cover, with the date '1826 23 August'.

330. Ulysses deriding Polyphemus —Homer's Odyssey Exh. 1829 (Plate 323)

THE NATIONAL GALLERY, LONDON (508)

Canvas, 52¼ × 80 (132·5 × 203)

Inscr. 'ΟΔΥΣΣΕ' on flag of ship upper centre.

Coll. Turner Bequest 1856 (25, 'Ulysses deriding Polyphemus' 6′7″ × 4′3″).

Exh. R.A. 1829 (42); R.A. 1974–5 (482, repr. in colour p. 108).

Lit. Ruskin 1856, 1860 and 1857 (1903–12, vi, p. 381; vii, p. 411; xiii, pp. 136–9); Thornbury 1862, i, pp. 309–18; 1877, pp. 410, 441–7; Hamerton 1879, pp. 222–4; Monkhouse 1879, p. 107; Bell 1901, pp. 110–11 no. 161; Armstrong 1902, pp. 58, 111–16, 146, 233, repr. facing p. 114; Finberg 1910, pp. 118–19; MacColl 1920, p. 15; Whitley 1930, pp. 164–5, repr.; Falk 1938, pp. 126–7, colour frontispiece; Davies 1946, pp. 150, 186; Clare 1951, p. 76, repr. p. 73; Davies 1959, p. 96; Finberg 1961, pp. 313, 340, 488 no. 323; Rothenstein and Butlin 1964, pp. 38–9, pl. 77; Lindsay 1966, pp. 167, 170, 234 n. 51, 240; Gage 1968, pp. 679, 682; Brill 1969, p. 17, repr.; Gage 1969, pp. 96, 123, 128–32, 143, 145, colour pl. 21; Reynolds 1969, p. 132, colour

pl. 111; Gaunt 1971, p. 7, colour pl. 20 and pl. 40 (detail); Hawes 1972, p. 32, repr. p. 45 fig. 8; Herrmann 1975, pp. 35–6, 231, pls. 106 and, a detail in colour, 107.

The subject is from Book ix of the *Odyssey* and had been first sketched by Turner about 1807 in the 'Wey, Guildford' sketchbook, though there is no connection in composition (XCVIII-5). This picture is based on one of the sketches on coarse canvas almost certainly painted in Italy in 1828–9 (No. 302), though the hollowed-out arches of rock, probably based on those around the Bay of Naples, derive from another of the sketches (No. 303).

Ruskin, who called this 'the *central picture* in Turner's career', noted Turner's fidelity to Pope's translation of the text in the portrayal of the morning light, though his suggestion that the sun-god Apollo is formless because 'he *is* the sun' is countered by Thornbury's statement that 'thanks to sugar of lead, Phoebus has vanished' (1862, i, p. 315). John Gage has also pointed out Turner's fidelity over such things as Ulysses' ship being in 'the shallows clear' and the way in which Polyphemus almost forms part of the 'lone mountain's monstrous growth', but he suggests that Turner went further by using the mythological subject to illustrate a picture about the forces of nature (1969, pp. 128–32). The smoke rising from the mountain gives it a distinctly volcanic appearance and Polyphemus' fellow Cyclops were associated with thunder and lighting, which had themselves been associated with volcanic activity in the later eighteenth century. The Nereids playing around Ulysses' ship are not mentioned by Homer and seem to have been introduced as embodying the idea of phosphorescence, as in Erasmus Darwin's *The Botanic Garden* of 1791. Similarly the introduction of the horses of the sun-god, based on an engraving after the relief on the Parthenon, identifies an allegorical symbol with a natural phenomenon. By now, Gage summarises, Turner had moved beyond the mere personifying of natural causes he had found in Thomson and Akenside to something 'far closer to the more purely scientific mythography of Shelley' (p. 145).

Gage (1969, pp. 95–6) also suggests that the heightened colouring, particularly in the sky, was partly influenced by Italian fourteenth- and fifteenth-century frescoes and temperas, to which Turner seems to have paid particular attention on his second visit to Italy, perhaps reflecting the growing interest in this period of his friends Samuel Rogers, Thomas Phillips and William Young Ottley (see the 'Roman and French' notebook of 1828 CCXXXVII-38 verso and 39, for Turner's notes on the frescoes in the Campo Santo at Pisa).

Indeed the *Morning Herald* for 5 May 1829 held that Turner's bright colouring, which had 'for some time been getting worse and worse', had in this picture 'reached the perfection of unnatural tawdriness. In fact, it may be taken as a specimen of *colouring run mad*—

positive vermilion—positive indigo, and all the most glaring tints of green, yellow, and purple contend for mastery of the canvas, with all the vehement contrasts of a kaleidescope or Persian carpet; ... truth, nature, and feeling are sacrificed to melo-dramatic effect.' The *Literary Gazette* for 9 May protested that 'Although the Grecian hero has just put out the eye of the furious Cyclops, that is really no reason why Mr. Turner should put out both the eyes of us, harmless critics ... Justice, however, compels us to acknowledge, that although Mr. Turner thus continues to delight in violating nature and defying common sense, yet that, considering this performance as a gorgeous vision of the imagination, as a splendid dream of practical fancy, it is highly captivating.'

Other critics too felt that the painter's excesses were justified by his poetical feeling. For the *Athenaeum* of 13 May, 'The colouring may be violent, and "overstep the modesty of nature" ... but the poetical feeling which pervades the whole composition, the ease and boldness with which the effects are produced, the hardihood which dared to make the attempt,—extort our wonder and applause. It should be born in mind, moreover, that the subject is not drawn from the common reality of life. Nor do we see that the blood-red effects which accompany the mounting car of the God of day and light, tinging the scattered vapours with brightest amber, and burnishing the galley of the hero ... are at all more out of nature than the Cyclops himself.' For *The Times* of 11 May there was 'no other artist living who can exercise any thing like the magical power which Mr. Turner wields with so much ease', adding that 'the atmospheric effects are wonderful and delightful,—and that it is a much easier thing to criticise and decry such pictures than to produce their fellows.'

Ruskin's perhaps over-subjective view was that 'The somewhat gloomy and deeply coloured tones of the lower crimson clouds, and of the stormy blue bars underneath them, are always given by Turner to skies which rise over any scene of death, or one connected with any dreadful memories', and in *Modern Painters* iv he lists the picture among works in which the sky is 'the colour of blood'.

331. The Loretto Necklace Exh. 1829 (Plate 319)

THE TATE GALLERY, LONDON (509)

Canvas, $51\frac{1}{2} \times 68\frac{7}{8}$ (131 × 175)

Coll. Turner Bequest 1856 (68, 'The Loretto Necklace' 5′9″ × 4′4″); transferred to the Tate Gallery 1929.

Exh. R.A. 1829 (337).

Lit. Ruskin 1857 (1903–12, xiii, p. 139); Thornbury 1862, i, p. 307; 1877, pp. 439–40; Hamerton 1879, pp. 222–3; Bell 1901, p. 111 no. 162; Armstrong 1902, p. 224; Davies 1946, p. 187; Finberg 1961, pp. 313, 488 no. 324; Rothenstein and Butlin 1964, pp. 38, 42, pl. 80; Reynolds 1969, p. 132.

Turner had sketched at Loreto in the 'Ancona to Rome' sketchbook on his way from Venice to Rome in 1819 (CLXXVII-1 to 14 *passim*) and again on his way back to England from Rome early in 1829 in the so-called 'Rimini to Rome' sketchbook (CLXXVIII-32 verso and 33, 41 verso, the former showing much the same view of the town as in the picture; Finberg 1909 associated the sketchbook with Turner's 1819 visit but it has since been recognised as the product of the return journey in 1829). The finished picture was presumably one of those referred to by Wilkie in a letter of 16 March 1829, when he said that Turner was hard at work painting for that year's R.A. Exhibition, 'being uncertain of the arrival of his three Roman pictures in time'; these, probably *Orvieto, Medea* and *Regulus* or perhaps *Palestrina* (Nos. 292, 293, 294 and 295) did not in fact arrive until July, after the opening.

The *Athenaeum* for 27 May 1829 made heavy weather of the necklace's possible connection with the rosary and the cult of the Madonna at Loreto, concluding however that Turner 'has put us off with a landscape, delightful and brilliant it must be owned, and considerably, although by no means entirely, taken from the luxuriant scenery for which the vicinity of Loretto is well nigh as much distinguished as for the possession of the Santa Casa. The composition of this picture is in truth delightful: that the colour is extravagant, cannot be denied . . . yet it is impossible to regard the painting even in respect to its colour without gratification and admiration. The effect of the gleam which crosses and illumines the scene, is most happy; and indeed, were the tree in the foreground less gorgeous, the rest of the picture might be allowed to pass without any qualification to the highest eulogium.' *The Times*, 11 May, picked out for special mention 'an effect of sunset, the gleams falling on the rocks and the buildings that surmount them, which is at once the most natural and the most beautiful that can be imagined.' These references to the fall of light in the picture are particularly valuable in view of its ir-redeemably darkened state.

Ruskin described the picture as 'A very noble work, spoiled curiously by an alteration of the principal tree. It has evidently been once a graceful stone pine, of which the spreading head is still traceable at the top of the heavy mass: the lower foliage has been added subsequently, to the entire destruction of the composition.

'As far as I know, whenever Turner altered a picture, he spoiled it; but seldom so distinctly as in this instance.'

332. Pilate washing his Hands Exh. 1830
(Plate 322)

THE TATE GALLERY, LONDON (510)

Canvas, 36 × 48 (91·5 × 122)

Coll. Turner Bequest 1856 (75, 'Pilate washing his hands' 4′0″ × 3′0″); transferred to the Tate Gallery 1910.

Exh. R.A. 1830 (7); Whitechapel 1953 (83); Edinburgh 1968 (6, repr.); R.A. 1974–5 (332).

Lit. Thornbury 1862, i, p. 307; Hamerton 1879, p. 232; Bell 1901, p. 112 no. 164; Armstrong 1902, p. 227; Whitley 1930, p. 191; Davies 1946, p. 187; Finberg 1961, pp. 321, 490 no. 347; Rothenstein and Butlin 1964, p. 44, colour pl. xi; Gage 1965, p. 79; Gowing 1966, p. 31; Lindsay 1966, p. 178; Gage 1969, p. 91; Reynolds 1969, pp. 127–8, colour pl. 109; Gage 1972, pp. 53–6, pl. 33; Herrmann 1975, pp. 36, 232, pl. 127.

Exhibited in 1830 with the text from the Bible:

'"And when Pilate saw he could prevail nothing, but that rather a tumult was made, he took water and washed his hands before the multitude, saying, I am innocent of the blood of this just person, see ye to it."—*St. Matthew*, chap. xxvii. ver. 24.'

This is the first of three paintings of Biblical subjects that owe a lot to Rembrandt, already represented with works of this general character at the National Gallery from its opening in 1824; the others are *Shadrach, Meshech and Abednego*, exhibited in 1832 (No. 346), and the unfinished *Christ driving the Traders from the Temple*, also of about this date (No. 436). The renewed interest in figures, which, though relatively small in scale, dominate the composition, their rich costumes and the types of the Jewish priests, as well as the dramatic use of light and the thick heavily worked paint all point to Rembrandt, to whom Turner had already paid tribute in *Rembrandt's Daughter*, exhibited in 1827 (No. 238).

This picture and the similarly Rembrandtesque *Jessica* (No. 333), so different from the landscapes of that year (Nos. 292, 295, 334 and 335), provoked the virulence of the critics. The *Literary Gazette* for 8 May 1830 called the *Pilate* 'wretched and abortive' and followed this up the next week by quoting a wag 'saying, he fancied "a pilot washing his hands" was a fine marine subject'.

The *Morning Chronicle* for 3 May more interestingly linked its attack with an early account of Turner's practice of completing his pictures during the Academy's Varnishing Days. Speaking of this picture and *Orvieto* (No. 292) the critic writes, 'We understand that when these pictures were sent to the Academy, it was difficult to define their subject; and that in the four or five days allowed (exclusively, and, therefore, with shameless partiality to A's [Associates) and R.A.'s to touch on their works, and injure as much as possible the underprivileged) they have been got up as we see them. They still partake of the character of conundrums.'

333. Jessica Exh. 1830 (Plate 321)

H.M. TREASURY AND THE NATIONAL TRUST (Lord Egremont Collection) PETWORTH HOUSE

Canvas, 48 × 36¼ (122 × 91·7)

Coll. Bought from Turner by the third Earl of Egremont (the April number of the *Library of the Fine Arts* 1831 reported 'it is also said that his Lordship has purchased Mr. Turner's picture of *Jessica*'); by descent to the third Lord Leconfield who in 1947 conveyed Petworth to the National Trust; in 1957 the contents of the State Rooms were accepted by the Treasury in part payment of death duties.

Exh. R.A. 1830 (226); Tate Gallery 1951 (7); R.A. 1951–2 (175); Whitechapel 1953 (82); R.A. 1974–5 (331).

Lit. Petworth Inventories 1837, 1856 (North gallery); Burnet and Cunningham 1852, pp. 29, 44, 116 no. 154; Waagen 1854, iii, p. 38; Thornbury 1862, ii, pp. 14–15, 397; 1877, pp. 199, 202, 576, 594; Bell 1901, p. 113 no. 167; Armstrong 1902, p. 223; Collins Baker 1920, p. 124 no. 91; Hussey 1925, p. 974 repr.; Whitley 1930, pp. 191–2; Falk 1938, p. 90; Finberg 1961, pp. 321–2, 326, 490 no. 350; Rothenstein and Butlin 1964, p. 44, pl. 79; Lindsay 1966, p. 171; Gage 1969, pp. 91, 167; Reynolds 1969, p. 137, fig. 118; Gage 1972, p. 56; Herrmann 1975, pp. 36, 232–3, pl. 128.

Bell states 'That this picture was painted in Rome in 1828, is apparent from a letter from the artist to Chantrey, printed by Thornbury p. 100' (1877 edition). However, in fact the letter in question does not mention the subject of any of the pictures that Turner was engaged in painting at that time (November) and the reference that he was 'getting on with Lord E's' almost certainly alludes to *Palestrina* (No. 295) while the smaller 3 ft by 4 ft canvas that Turner finished to stop the visitors to his studio 'gabbling' was probably *Orvieto* (No. 292). Although, therefore, it remains possible that *Jessica* was painted in Rome, there is no firm evidence to support this and it seems more likely that Turner painted it in the normal way immediately before its exhibition in 1830.

An entirely different account of the origin of *Jessica* was printed in *The Times* for 9 December 1959 in an article by an anonymous writer whose mother was Lord Egremont's grand-daughter. The latter who, as a small child, remembered Turner well, in old age dictated some reminiscences of the artist's visits to Petworth. According to her, during a discussion among several celebrated painters who were then staying at Petworth, one of them, after chaffing Turner on his predilection for yellow, said 'A yellow background is all very well in landscapes, but would not be possible in our kind of pictures'. Turner replied, addressing his patron, 'subject pictures are not my style but I will undertake to paint a picture of a woman's head with a yellow background if Lord Egremont will give it a place in his gallery'. Although the interval which elapsed between the exhibition of *Jessica* and its reported purchase by Lord Egremont would seem to throw serious doubts on the authenticity of this story, it may yet contain a grain of truth concerning the genesis of the picture.

Exhibited with the following quotation:

'Shylock—"Jessica, shut the window, I say"—*The Merchant of Venice*.'

This quotation does not in fact occur in *The Merchant of Venice* but Turner must have had in mind the scene outside Shylock's house (Act II, scene v) when Shylock counsels Jessica:

'Lock up my doors . . .
But stop my house's ears, I mean my casements'.

However, Launcelot gives her different advice:

'Mistress, look out at window, for all this;
There will come a Christian by,
Will be worth a Jewess' eye.'

Perhaps the most violently abused of all Turner's exhibited works to date. Wordsworth, who saw the picture at the R.A. in 1830 said 'It looks to me as if the painter had indulged in raw liver until he was very unwell.' The *Sun* for 3 May asked how an artist 'who could paint *Palestrina* could deface the canvas by such a picture' while the *Morning Herald* of 18 May urged that in future the Academic Council should have the veto, in which case 'they doubtless would have rejected *Pilate washing his Hands* and that thing called *Jessica*'. The *Morning Chronicle*, 3 May, wrote 'It looks like a lady getting out of a large mustard-pot', a description which the *Literary Gazette*, 29 May, thought so apt that 'we feel the temptation to piracy to be irresistable'. This sobriquet seems to have become attached to the picture, for G. Storey, whose notes on the Petworth pictures are given by Thornbury, refers to it thus: 'The picture called the "Mustard Pot", Turner's "Jessica", is a roundabout proof that Turner was a great man; for it seems to me that none but a great man dare have painted anything so bad.' This view was echoed by Waagen who considered that *Jessica* 'shows that limits are assigned even to the most gifted. It is a truly frightful piece of scene painting.'

The *Athenaeum* for 5 June called *Jessica* 'this daub of a drab, libelling Shakespeare out of a foggy window of King's yellow' while *Fraser's Magazine* (2, 1830–31 p. 97) also referred to Turner's obsession with yellow, concluding that he must be incurably afflicted with 'jaundice on the retina.'

In fact, as Gage (1972) has pointed out, this is one of Turner's attempts to reinterpret the work of Rembrandt, not in terms of chiaroscuro, but rather by a blaze of jewel-like colours, and it is certainly more successful than *Rembrandt's Daughter* (No. 238). Indeed, it is perhaps Turner's most appealing figure picture, containing as it does a hint of Watteauesque pathos.

Gage also suggests that an immediate source for *Jessica* may have been Rembrandt's *Young Woman at a Door* (Gerson, *Rembrandt. The Complete Edition of the Paintings* 1969, pl. 288, Art Institute of Chicago) which was exhibited in London at the British Institution in 1818 (100) and appeared at Christie's on 13

June 1829 (68). The catalogue of the Turner Bicentenary exhibition suggests rather that the composition recalls that of Rembrandt's *Lady with a Fan* in the Royal Collection (Gerson, pl. 281), which was brought to England in 1814 by Niewenhuys and exhibited at the British Institution three times in the 1820s. Yet a third Rembrandt has been proposed as a source for *Jessica* by Mr Evan Maurer: the *Lucretia* in Minneapolis (Gerson, pl. 395), who also holds a tassel in her left hand, wears her hair in the same style and with a pearl similarly placed in her hair. The *Lucretia* was in the Wombwell collection in England by 1854 when seen by Waagen but it may well have come to England considerably earlier. *Jessica* certainly has points in common with all three Rembrandts and, as none is really close enough to be considered the definitive model, perhaps Turner had them all at the back rather than in the front of his mind when he painted *Jessica*.

Still another possible source has been suggested by Gage, the *Woman with a Rosebud* at Petworth which was called Rembrandt in Turner's day but is now attributed to P. de Koninck (Petworth catalogue no. 451). The connection here seems to me to be much less close.

Constable refers to the picture in a letter to C. R. Leslie written on 27 April 1832, in which he expresses alarm at the proposed reduction in the number of Varnishing Days allowed to R.A.s: 'As to Turner (to whom no doubt the blow was levelled) [see the entry for No. 238] nothing can reach him, he is in the clouds

> The lovely Jessica by his side
> Sat like a blooming Eastern bride.'

334. Calais Sands, Low Water, Poissards collecting Bait Exh. 1830 (Plate 324)

BURY ART GALLERY AND MUSEUM

Canvas, $28\frac{1}{2} \times 42$ (73×107)

Coll. Joseph Gillott who is reputed to have acquired it from the artist among a group of eight Turner paintings for which he paid £500 each *c.* 1844; Gillott's account books do not record the transaction with Turner but they do not commence until 1845 except for some records which are confined to Gillott's dealings with George Pennell; Gillott then sold six of the pictures for the same price that he had given for the eight, but kept *Schloss Rosenau* (No. 392) and this picture in his own collection (in the Gillott sale catalogue, both pictures were stated to have been bought directly from the artist); Gillott's account books show, however, that he sold this picture ('Callais Sands') to Thomas Rought in December 1846 for £550; in February 1849 Gillott sold George Pennell three pictures by T. S. Cooper and Etty in exchange for a picture by Turner 'Shrimping' and £130 in cash. There seems no other Turner oil which would fit this title and, as Gillott had recently bought three Coopers from the artist for £525, the bargain seems plausible from a commercial

viewpoint. As Gillott, Pennell and Rought (among others) were constantly selling and buying pictures to and from each other, the fact that the picture went from Gillott to Rought to Pennell and back to Gillott again in just over two years is by no means as unusual as it appears; in any case, the picture certainly re-entered the Gillott collection because it was in his sale at Christie's 20 April 1872 (161) bought Agnew for Thomas Wrigley who gave it to the Bury Art Gallery in 1897.

Exh. R.A. 1830 (304); Royal Manchester Institution 1878 (200); Agnew 1967 (15); R.A. 1968–9 (158); Paris 1972 (264); Berlin 1972 (10); R.A. 1974–5 (508 repr.); Leningrad and Moscow 1975–6 (56).

Lit. Ruskin 1851 (1903–12, xii, p. 381); Burnet and Cunningham, p. 116 no. 155; Thornbury 1862, i, p. 383; ii, p. 332; 1877, pp. 530(?), 576; Corporation of Bury Art Gallery, *Catalogue of the Wrigley Collection* 1901, no. 114; Bell 1901, p. 113 no. 168; Armstrong 1902, p. 219 (wrongly said to have belonged to Lord Bective); Finberg 1961, pp. 321–2, 490 no. 351; Rothenstein and Butlin 1964, pp. 46, 48, pl. 83; Lindsay 1966, pp. 171–2, 177; Herrmann 1975, pp. 36, 232, pl. 110.

Turner passed through Calais on his way to Paris in August 1829 but, although a number of sketches of Calais exist in the Turner Bequest which may date from this visit, none is close enough to be regarded as specifically connected with this composition, including the drawing (CCLIX-214) which Finberg claimed was a study for it. Turner sketched the subject on an earlier visit in 1826: CCXXIV p. 14 (now incorporated as no. 44 of CCLX), shows fisherwomen getting bait on Calais Sands with Fort Rouge in the distance and seems likely to be the germ of the exhibited picture. There is a minute drawing (approximately $\frac{1}{2} \times 1\frac{5}{8}$ in.) on p. 227 of CCXVI showing four women bending down in poses similar to those in which the foremost fisherwomen appear in the oil. Finberg reads Turner's inscription below this drawing as 'Fisherwomen looking for bait' but the first four words are clearly: 'fisher women digging for' and the last word is illegible. Turner had, of course, visited Calais many times and Ruskin is surely fanciful in suggesting that all Turner's versions of the subject stem from material gathered on his first visit in 1802.

Finberg and Lindsay detect in this picture a note of sorrow and a sense of desolation which, they infer, reflect Turner's feeling of loss at the death of his father which had occurred in September 1829, but it is difficult to accept this. However, the catalogue of the 1972 exhibition in Paris is surely right in suggesting that the real source for this picture lies in the French coast scenes of Bonington, who had died so young in 1828 and the contents of whose studio had been auctioned in London in June 1829. Turner is known to have admired Bonington's work and to have thought him the most brilliant young landscape painter of his

generation. This, then, can be considered as both a work of homage and an essay in Bonington's manner. Turner has deliberately chosen a subject which Bonington had made peculiarly his own: a vast expanse of beach from which the tide has receded. It was Bonington's especial *forte* that he could suggest, by infinitely subtle gradations of tone and colour, just how long each strip of sand had been uncovered and how quickly it was drying. Turner here succeeds triumphantly in matching Bonington's skill and adds to the Boningtonian motif a typical Turnerian touch, 'the grand sunset behind Fort Rouge' which sets both sky and sand aflame with colour.

The picture was not much noticed at the R.A. but what little comment it received was favourable and in sharp contrast to the virulent criticism reserved for *Jessica* (No. 333) and *Pilate washing his Hands* (No. 332). The *Morning Chronicle* for 3 May said 'it is literally nothing in labour, but extraordinary in art'.

335. Fish-Market on the Sands—the Sun rising through a Vapour Exh. 1830 (Plate 320)

DESTROYED IN A FIRE IN NEW YORK, 1956

Canvas, 34 × 44 (86·3 × 111·8)

Coll. William Wells of Redleaf; it seems almost certain that this is the picture sold by Wells at Christie's 28 May 1852 (50) bought Graves, described as 'Harbour Scene—Sunset, Ships of War at Anchor in Distance, figures assembled at a Fish market on the sands near a Jetty, Pier in Background'. The last feature of the pier is not visible in the illustration in Armstrong but otherwise the description seems to fit closely and the details in the background in the plate in Armstrong are very indistinct; John Chapman, M.P. (1810–77), by 1857; his younger son George John Chapman (b. 1848) inherited this picture while his elder son Edward (1839–1906) inherited the other Turner in the collection, *Pluto carrying off Proserine* (No. 380); sold *c.* 1936 to an American dealer; Jones sale Parke-Bernet New York, 4–5 December 1941 (74) bought Billy Rose, New York, who owned it at the time it was burned in 1956.

Exh. R.A. 1830 (432); Manchester 1857 (294); Manchester 1887 (610); Guildhall 1892 (118); R.A. 1896 (37); Guildhall 1899 (31); Manchester *Paintings lent by George John Chapman Esq and the Executors of the late Edward Chapman Esq* 1908 (018); Rome 1911 (76).

Lit. Burnet and Cunningham 1852, p. 116 no. 156; Waagen 1857, iv, p. 419 (wrongly described in Graves' Index as a drawing); Thornbury 1877, p. 576; Bell 1901, p. 114 no. 169; Armstrong 1902, p. 221, repr. facing p. 71; Whitley 1930, p. 192; Finberg 1961, pp. 321, 490 no. 352; Lindsay 1966, p. 171; Herrmann 1975, p. 36.

Both Bell and Armstrong suggest that the scene is Margate.

Turner's exhibits at the R.A. came in for some violent abuse and ridicule but an exception was made in the case of his two shore scenes. The *Morning Herald*, 18 May, praised this picture in particular, saying that it was 'worth all the rest of his pictures now here' and comparing its 'chaste, silvery style' with a picture in 'the possession of Lord de Tabley some years since, and which was greatly admired' (*Sun rising through Vapour*, No. 69).

The *Literary Gazette* for 5 June also praised the picture highly, but found it provoking that a painter 'capable of producing pictures like this' should 'condescend to send forth such abortions as those we had noticed in some of our former numbers.'

336. Life-Boat and Manby Apparatus going off to a Stranded Vessel making Signal (Blue Lights) of Distress Exh. 1831 (Plate 325)

THE VICTORIA AND ALBERT MUSEUM, LONDON

Canvas, 36 × 48 (91·4 × 122)

Coll. Painted for the architect, John Nash (1752–1835) or perhaps bought by him at the R.A. in 1831 (see below); sale Christie's 11 July 1835 (89) as 'Blue Lights off Yarmouth' bought Tiffin, probably acting on behalf of John Sheepshanks; given to the Victoria and Albert Museum by Sheepshanks in 1857 (Accession no. 211).

Exh. R.A. 1831 (73); R.A. 1934 (161); R.A. 1968–9 (163); Berlin 1972 (16); R.A. 1974 (21); R.A. 1974–5 (509); Leningrad and Moscow 1975–6 (58).

Engr. By R. Brandard in the *Turner Gallery* 1859 and in the *Art Journal* 1863.

Lit. Burnet and Cunningham 1852, p. 116 no. 158; Waagen 1854, ii, p. 300; Thornbury 1862, i, p. 320; 1877, pp. 448, 576; Wedmore 1900, ii, repr. facing p. 224; Bell 1901, pp. 114–15 no. 170; Armstrong 1902, pp. 120, 237, repr. facing p. 98; Rawlinson ii 1913, pp. 173, 208; Whitley 1930, pp. 212–13; Boase 1959, p. 341; Finberg 1961, pp. 326, 490 no. 356; Lindsay 1966, p. 173; Gage 1969, p. 191 (?); Reynolds 1969, pp. 140–41, fig. 125; Reynolds 1969², pp. 75–9, colour pl. iiib; V.A.M. catalogue 1973, p. 138; Herrmann 1975, pp. 38–9, 233, pl. 138.

Both Burnet and Thornbury state that the picture was painted for Nash but there is no earlier evidence about this. Reynolds suggests that Nash may have bought it at the R.A. and this theory is perhaps marginally reinforced by a letter from Sir Richard Westmacott, R.A. (1775–1856), to a friend in Liverpool about the exhibition which mentions this picture as 'very clever', and which adds mistakenly 'I think Soane bought it'. This error does, however, suggest that the picture was for sale when the exhibition opened.

The Manby apparatus was called after its inventor George William Manby (1765–1854). It was a means of saving people from a wreck by firing a stone at the end of a rope from a mortar on shore to provide a lifeline to the ship in trouble and had been developed by Manby after he had witnessed a disastrous shipwreck in 1807, when he was a barrack master at Great Yarmouth in Norfolk. He was elected a Fellow of the Royal Society in the same year that this picture was exhibited.

Turner passed the Norfolk coast on his way to Scotland in 1822 and visited Yarmouth itself in 1824. In the 'Norfolk, Suffolk and Essex' sketchbook (CCIX) there are a number of sketches of buildings and shipping at Yarmouth. Other watercolours in the Turner Bequest which may be connected are CCLXII-10, which shows the old pier, and CCCLXIV-134, which depicts firing rockets on the coast and which appears definitely to represent Yarmouth as both the pier and the Nelson Monument are shown. Reynolds suggests that it is a study for the oil rather than a sketch done from memory after it, but it is difficult to feel certain about this as the handling is so loose that it may date from after 1831.

Constable also exhibited a picture of *Yarmouth Pier* at the R.A. this year (123). This may have been simply a coincidence but it seems possible that Turner, having got wind of Constable's plans, decided to exhibit this picture by way of competition.

The picture was praised at the R.A. although not Much space was devoted to it. The *Library of the Fine Arts*, 1 June, considered it 'a magnificent picture, warm and all life', while *La Belle Assemblée* (xiii, p. 289) thought it 'a fine picture, full of nature and truth, and more in his manner of the older time, than anything we have seen of late', and this view of it seems to be borne out, as Reynolds suggests, by the fact that it was bought by Sheepshanks, not a very *avant-garde* collector, at John Nash's sale.

337. Caligula's Palace and Bridge Exh. 1831
(Plate 327)

THE TATE GALLERY, LONDON (512)

Canvas, 54 × 97 (137 × 246·5)

Coll. Turner Bequest 1856 (53, 'Caligula's Bridge' 8′2″ × 4′7½″); transferred to the Tate Gallery 1910.

Exh. R.A. 1831 (162); R.A. 1974–5 (485, repr.).

Engr. By E. Goodall 1842.

Lit. Ruskin 1843 and 1860 (1903–12, iii, p. 241; vii, p. 431); Thornbury 1862, i, p. 319; 1877, pp. 316, 447; Hamerton 1879, p. 257; Monkhouse 1879, pp. 97–8; Bell 1901, p. 115 no. 171; Armstrong 1902, p. 219; Rawlinson ii 1913, pp. 336–7; MacColl 1920, p. 16; Whitley 1930, p. 212; Davies 1946, p. 186; Finberg 1961, pp. 326–7, 340, 386–7, 491 no. 357; Lindsay 1966², p. 49; Gage 1969, p. 103; Reynolds 1969, p. 186; Gage 1974, p. 82, pl. 19.

Exhibited in 1831 with the following lines attributed to Turner's *Fallacies of Hope* (here quoted from Turner's own list of his 1831 exhibits, now in the Tate Gallery archive):

'What now remains of all the mighty Bridge
Which made the Lucrine Lake an inner pool,
Caligula, but massy fragments left,
As monuments of doubt and ruind hopes
Yet gleaming in the Morning's ray, doth tell
How Baia's shore was loved in times gone by?'
MS. Fallacies of Hope.

In the printed catalogue 'doth', in the fifth line, was replaced by 'that', and there were changes in capitalisation, etc. Turner's original title, number 2 on the list of his 1831 R.A. exhibits in the Tate Gallery archives, was also slightly altered: originally it read 'Caligula: Palace and Bridge'.

In this picture Turner returns to the theme of *Bay of Baiae* (No. 230), the decay of past glories. Caligula's bridge crossed the three and a half Roman miles from Baiae to Puteoli and was described by Oliver Goldsmith as 'the most notorious instance of his fruitless profusions'. It was built to confute a prophecy that Caligula would no more become Emperor than he could drive his chariot across the Bay of Baiae. Although the bridge was in fact a bridge of boats Turner followed popular accounts in showing it as a solid structure (see Gage 1974, p. 47).

Unlike *Vision of Medea*, exhibited the same year (No. 293), this picture seems to have aroused universal praise. 'In this picture "the fit hath gone off"' said the *Athenaeum* for 14 May 1831; 'Here we have the poetry of nature lavished upon us with a courteous hand'. *La Belle Assemblée* described it, in its June number, as 'one of the most magnificent and extraordinary productions of the day ... it is poetry itself. The air-tint—the distances—are magical: for brilliancy and depth, and richness, and power, it can hardly be surpassed.' For *The Times* of 6 May it was 'one of the most beautiful and magnificent landscapes that ever mind conceived or pencil drew.' The *Library of the Fine Arts* for June 1831, anticipating Ruskin's criticisms of these packed Italian landscapes as 'nonsense pictures', described it more positively as 'a composition, any one portion of which is in itself a picture, and would make the fortune of another artist.'

Turner's picture hung next to Constable's *Salisbury Cathedral from the Meadows* (Coll: Lord Ashton of Hyde). 'Fire and Water', the *Literary Gazette* for 14 May exclaimed. 'Exaggerated, however, as both these works are,—the one all heat, the other all humidity,—who will deny that they both exhibit, each in its way, some of the highest qualities of art? None but the envious or ignorant.' Apparently Constable, who was on the Hanging Committee that year, had moved Turner's picture and replaced it with his own, for which Turner teased him unmercifully at dinner with General Phipps in Mount Street, to the great amusement of the party, mainly artists (the story is David

Roberts', given in Thornbury 1862, ii, p. 56, and dated to this year by Finberg 1961, p. 327).

The picture was engraved in 1842 by E. Goodall, whose son told W. G. Rawlinson (ii 1913, pp. 336–7) that Turner, deciding that the composition required more figures, added them on the picture himself, first with white chalk, and then, when Goodall was unable to follow these slight sketches, in watercolour. According to Thornbury, who, however, asserts that the figures were introduced, with Turner's assent, by Goodall, they were the children playing with goats in the foreground (1862, i, p. 319). Recent restoration, however, has failed to determine that any of the figures as they now are were painted in watercolour; perhaps Turner went over them later in oils.

The picture was transferred from its original canvas onto a new one, probably in 1907, at which time there were extensive losses, particularly top left and top right and along a crack stretching most of the way across the picture from the left just above half-way up.

338. Lucy, Countess of Carlisle, and Dorothy Percy's Visit to their Father Lord Percy, when under Attainder upon the Supposition of his being concerned in the Gunpowder Plot
Exh 1831 (Plate 370)

THE TATE GALLERY, LONDON (515)

Oil, approx. 15¾ × 27¼ (40 × 61·5), on oak panel, 16 × 27½ (40·5 × 70); original framing members, 20 × 32⅛ (51 × 81·5)

Coll. Turner Bequest 1856 (22, 'Lord Percy' 2′3½″ × 1′3½″): transferred to the Tate Gallery 1905.

Exh. R.A. 1831 (263); C.E.M.A. tour 1944 (34); R.A. 1974–5 (333).

Lit. Thornbury 1862, i, p. 320; 1877, p. 447; Bell 1901, p. 116 no. 173; Armstrong 1902, p. 226; Whitley 1930, p. 213; Davies 1946, p. 186; Finberg 1961, pp. 326–27, 491 no. 359; Rothenstein and Butlin 1964, p. 45; Herrmann 1975, p. 38.

Number 4 on Turner's own list of titles for his 1831 R.A. exhibits (Tate Gallery archives): his punctuation differs slightly from that in the catalogue.

Painted, like its companion *Watteau Study by Fresnoy's Rules* (No. 340), on the panel of an upright door (the framing members of which remain as an inner frame round the picture) which one would like to believe came from a cupboard at Petworth. The link with Petworth is direct in this case, the house having belonged to the Percy family from 1150 until the end of the seventeenth century. Henry Percy, ninth Earl of Northumberland (1564–1632), known as the 'Wizard Earl' on account of his scientific and alchemical experiments, was suspected of complicity in the Gunpowder Plot and imprisoned for sixteen years in the Tower of London. On his release in 1621 he retired

to Petworth. Dorothy, his eldest daughter (1598–1677), married Robert Sidney, second Earl of Leicester, while Lucy (1599–1660), after spending some time with her father in the Tower, married in 1617 James Hay, later Earl of Carlisle, who, as one of the King's favourites, helped to secure Northumberland's release; she was famous as a beauty and a wit and played a considerable part in political affairs under Charles I and during the Civil War and Commonwealth, as a result of which she too was imprisoned in the Tower for eighteen months in 1649–50.

Turner based his figures on pictures by, or attributed to, Van Dyck at Petworth (for a copy of one of these portraits among the Petworth body-colours on blue paper see CCXLIV-100). The ninth Earl and Lucy Percy (on the left) are based on three-quarter-length portraits of the same sitters, while the woman standing behind the other two is based on another three-quarter-length portrait of Ann Carr, Countess of Bedford (1620–84) (see Plates 552, 553 and 554 respectively). The third woman, that on the right, is presumably Dorothy but is not specifically related to the Van Dyck portrait, three-quarter-length but seated, of that sitter. For another pastiche of the Petworth Van Dycks see *A Lady in Van Dyck Costume* of about the same date (No. 444).

Among the paintings shown on the right-hand wall are a view labelled 'TOWER OF LONDON' and a large picture of the Angel releasing St Peter from prison which also relates to Turner's subject.

Both Nos. 338 and 340 have unfortunately darkened irretrievably so it is particularly interesting that the *Library of Fine Arts* for June 1831 singled out 'the flood of light pouring like water over the ledges of a cataract into Lord Percy's chamber, dispelling its sombre hue', an effect to be carried much further in *Interior at Petworth* (No. 449). *La Belle Assemblée* for the same month recognised that 'the artist has ingeniously adopted some of Van Dyck's costumes. This production also, as well as the Watteau study by Fresnoy's rules ... will attract notice as an extraordinary combination of colour'. The *Morning Chronicle*, 16 May, was less complimentary to Turner, whom they called 'The Yellow Admiral': 'It seems that the design has no reference to history, but is amongst Mr. T's *jeux d'esprit* and represents the present Percy, Duke of Northumberland, huddled up in an arm chair with the stomach-ache, on *Dolly* and the other daughters of corruption announcing to him the success of *Reform*' (the Reform Bill was finally passed the following year).

339. Admiral Van Tromp's Barge at the Entrance of the Texel, 1645 Exh. 1831 (Plate 372)

SIR JOHN SOANE'S MUSEUM, LONDON

Canvas, 35½ × 48 (90·2 × 121·9)

Coll. Bought by Sir John Soane (1753–1837) from the R.A. Exhibition in 1831 for 250 guineas (Turner

acknowledged the receipt of this sum in a letter to Soane of 5 May); it became part of the collection which Soane formed in his house in Lincoln's Inn Fields and which he presented to the nation in 1833. Soane must have had the idea of his Museum in mind since 1826 at least when Turner painted the *Forum Romanum* (No. 233) for 'Mr. Soane's Museum', although Soane returned this to the artist. As has been noted in the entry for No. 234, Soane was evidently keen at the time to acquire another Turner in its stead, but this seems to have been the first picture, which Turner exhibited subsequently, to appeal to him.

Exh. R.A. 1831 (288).

Lit. Burnet and Cunningham 1852, pp. 29, 44, 116 no. 162; Thornbury 1862, ii, p. 400; 1877, pp. 576, 598; Carey 1899, pp. 173–5; Bell 1901, pp. 116–17 no. 174; Armstrong 1902, pp. 120, 231; Cunningham 1952, pp. 322–9; Finberg 1961, pp. 326, 491 no. 360; Rothenstein and Butlin 1964, pp. 51, 68.

Characteristically, Turner has made a mistake in the name of the subject of his picture: it was not Van Tromp but simply Tromp. Harpertzoon Tromp (1597–1653) was a Dutch Admiral whose successes against both the Spanish and British fleets did much to enhance the prestige of the Dutch nation as a seafaring power. For further details of his career, see the entry for No. 410. However, Turner is correct in so far as the rest of his title goes, for Tromp was on convoy duty in the Texel in 1645. Turner has shown him about to bring his barge up into the wind so that he can board his flagship, the *Aemilia*, shown on the right of the picture. The appearance of the *Aemilia* may well have been familiar to Turner through an engraving of her by Danckerts, taken from a drawing by Willem Van der Velde.

In the past, the histories and titles of the 'Van Tromp' pictures were much confused, until clarified by Cunningham's article. The specifically Dutch theme perhaps indicates that Turner had decided to explore a new vein in Dutch art after the derision with which his reinterpretations of Rembrandt, painted 1827–30, had been greeted by the critics, although he had already painted an imaginary Dutch marine subject, *Port Ruysdael* (No. 237), in 1827. The Soane picture was the first of the series to be exhibited; for the others, see Nos. 344, 351 and 410. Professor Bachrach has suggested that a further reason which may have prompted the Van Tromp pictures was Turner's chagrin at Palmerston's handling of the Belgian Question in 1830–31 and the terms of the 1831 settlement. By painting the Van Tromp series, Turner showed clearly that his sympathies in this matter lay with the Dutch.

It was accorded little attention at the R.A. except by one critic (*Library of the Fine Arts* i, No. 5, p. 419) who wondered that it could be by the same artist as the painting of *Watteau Study* (no. 298 at the R.A.), while this view was echoed more succinctly in the *Literary Gazette* for 21 May, which said 'No. 288 Mr. Turner at home, No. 298 Mr. Turner not at home.'

340. Watteau Study by Fresnoy's Rules Exh. 1831
(Plate 371)

THE TATE GALLERY, LONDON (514)

Oil, approx. $15\frac{3}{4} \times 27\frac{1}{4}$ ($40 \times 61\cdot5$), on oak panel, $16 \times 27\frac{9}{16}$ ($40\cdot5 \times 70$); original framing members, $20 \times 31\frac{3}{4}$ ($51 \times 80\cdot5$)

Coll. Turner Bequest 1856 (23, 'Watteau Painting' $2'3\frac{1}{2}'' \times 1'3\frac{1}{2}''$); transferred to the Tate Gallery 1905.

Exh. R.A. 1831 (298); R.A. 1974–5 (334).

Lit. Thornbury 1862, i, p. 320; 1877, p. 447; Bell 1901, p. 117 no. 175; Armstrong 1902, p. 236; MacColl 1920, pp. 16–17; Davies 1946, p. 186; Finberg 1961, pp. 326–7, 491 no. 361; Herrmann 1963, p. 24; Rothenstein and Butlin 1964, pp. 42, 45, pl. 81; Gage 1965, pp. 75–6; Lindsay 1966, pp. 108–9; Gage 1969, pp. 91–2, 170; Reynolds 1969, pp. 138–41, pl. 124; Herrmann 1975, p. 38, pl. 136.

Number 5 on Turner's list of his R.A. exhibits for 1831 and exhibited with the following lines:

'White, when it shines with unstained lustre clear, May bear an object back, or bring it near.'
Fresnoy's Art of Painting, 496.

The quotation comes from William Mason's translation of Charles Alphonse du Fresnoy's *De Arte Graphica*, first published with annotations by Sir Joshua Reynolds in 1783 and re-issued in *The Works of Sir Joshua Reynolds* edited by Edmond Malone, 1797. The complete section xxxiv, 'of White and Black', reads:

White, when it shines with unstain'd lustre clear
May bear an object back or bring it near.
Aided by black, it to the front aspires;
That aid withdrawn, it distantly retires;
But black unmix'd of darkest midnight hue,
Still calls each object nearer to the view.

Turner illustrates this theory with a tribute to Watteau, just as the companion *Lord Percy under Attainder* (No. 338) was a tribute to Van Dyck. Among the pictures shown in the background are Watteau's *Les Plaisirs du Bal* (which was already in the Dulwich College Picture Gallery), but in reverse as in Gerard Scotin's engraving and greatly enlarged, and *La Lorgneuse* which then belonged to Turner's friend Samuel Rogers.

See No. 338 for Turner's use of a cupboard door as the support for this picture. Like that picture *Watteau painting* has an iconographic link with Petworth in that the scene of an artist at work in a room with a number of bystanders is most clearly paralleled among the Petworth body-colours on blue paper, though these are, of course, contemporary scenes (e.g., CCXLIV-102; repr. exh. cat., R.A. 1974–5, p. 114 no. 358).

As in the case of the companion picture con-
temporary critics were on the whole surprisingly
complimentary, showing an appreciation of Turner's
special effects of colour. Who but Turner, asked the
Library of the Fine Arts for June 1831, could have
painted this picture 'with its almost impossible effects
produced on principles directly opposed to those
generally adopted, his lights merging in depths, his
depths thrown deeper by his lights, and this all in a
mere sketch and apparently produced without effort?'
The *Athenaeum* for 21 May called it 'of the wildest of
this artist's colouring fancies' but went on, 'What a
trifle in the tone would destroy the beauty. We have not
seen this picture commended, but to our taste it is full of
delicacy and beauty and is a rich gem.' Alas, the picture
can no longer be restored to its original condition.

341. Fort Vimieux Exh. 1831 (Plate 373)

PRIVATE COLLECTION, ENGLAND

Canvas, 28 × 42 (71·1 × 106·7)

Coll. Bought from Turner *c.* 1845 by Charles Meigh of
Shelton, Staffordshire; sale Christie's 21 June 1850
(154) bought Colonel James Lenox who gave it to the
Lenox Library, New York, which later became the
New York Public Library; sale Parke Bernet 17
October 1956 (43) bought Agnew on behalf of Arthur
Tooth and Sons who sold it to the present owner.

Lenox visited London in 1848 and was taken to see
Turner and his gallery by Thomas Griffith. It seems
unlikely that he would have seen *Fort Vimieux*
during his stay in England as it was by then already in
Staffordshire, but it is possible that Leslie may have
discussed the picture with him, as Leslie was a
frequent visitor to Turner's gallery and must have
known the picture well during the time it remained
unsold in Turner's possession from 1831 to 1845.
Indeed Leslie may even have considered buying it
for Lenox in 1845 on the occasion when he eventually
chose *Staffa* (No. 347).

Exh. R.A. 1831 (406); Boston 1946 (9); Toronto and
Ottawa 1951 (19); Indianapolis 1955 (31); R.A.
1974–5 (510, repr.).

Lit. Burnet and Cunningham 1852, p. 116 no. 164;
Thornbury 1862, ii, p. 243; 1877, pp. 338, 576; Bell
1901, pp. 117–18 no. 176; Armstrong 1902, p. 222;
Mauclair 1939, p. 95 repr.; *Catalogue of the Paintings
in the Picture Galleries of the New York Public Library*
1941, p. 6 no. 8; Finberg 1961, pp. 326, 409, 421, 491
no. 362; Rothenstein and Butlin 1964, p. 46, colour
pl. xiii.

Exhibited with no actual title but with the following
descriptive note:

'In this arduous service (of Reconnoissance) on the
French Coast, 1805, one of our cruisers took the
ground, and had to sustain the attack of the Flying
Artillery along shore, the Batteries, and the Fort of
Vimieux which fired heated shot, until she could
warp off at the rising tide which set in with all the
appearance of a stormy night.'

—Naval Anecdotes.

Turner's reference in the 1831 exhibition catalogue to
Naval Anecdotes is so far untraced despite some very
kind research by Mr Michael Robinson, late of the
National Maritime Museum at Greenwich. Mr Robin-
son reports that the extract from the catalogue does not
appear in *Naval Anecdotes 1805* published by J. Cundee
nor in the second edition of *Naval and Military
Anecdotes* published in 1824. The *Naval Chronicle*
contained a section entitled *Naval Anecdotes* but the
volumes from 1805 to 1812 do not contain this reference
either. After 1812 this section was renamed *Nautical
Anecdotes* but again I have been unable to trace this
reference between then and 1818 when the *Naval
Chronicle* ceased publication.

A pen and ink sketch inscribed in Turner's hand
'Vimereux' ('Vimieux' is presumably a later misspell-
ing) occurs as one of three rapid drawings on p. 17 of
CCXXIV (listed by Finberg among 'Black and White
Sketches on Blue connected with the Meuse-Moselle
Tour, but now classified as connected with the *French
Rivers* series and to be found in the Turner Bequest
inventory as no. 56 of CCLX).

A Ship Aground (No. 287), an oil sketch in the Tate
Gallery of the same size as the Petworth quartet and
perhaps originally painted as an alternative choice for
Chichester Canal (No. 290), seems to have formed the
basis for this picture. However, the dimensions were
altered by Turner to the same size as the *Calais Sands*
(No. 334) of the previous year, and the cool yellows and
greys of the Tate sketch have been transformed in the
exhibited picture by the fiery sunset which again
matches the mood of the *Calais Sands* at Bury and
follows it in deriving from Turner's interest in
Bonington's coast scenes.

The picture was warmly received at the R.A. *La Belle
Assemblée* for June thought it 'vividly natural and
effective. It can hardly be too much admired.' The
Spectator, 7 May, considered that Turner's two coast
scenes (see also No. 336) were 'replete with beauty',
while the *Library of the Fine Arts* (i, no. 5, p. 419) wrote
'the firing of red-hot shot, the sun of a bloody hue "low,
deep and wan", the forlorn and frightened gull, the ball
hissing in the water, and the stranded ship, present a
vivid picture of the event, while the imagination of the
ensemble is grand and stupendous. When will Mr.
Turner show symptoms of decay? . . . his genius is still
green as when we first saw it in the boyhood of our life.'

342. Childe Harold's Pilgrimage—Italy
Exh. 1832 (Plate 326)

THE TATE GALLERY, LONDON (516)

Canvas, 56 × 97¾ (142 × 248)

Coll. Turner Bequest 1856 (51, 'Childe Harolds Pilgrimage' 8′3½″ × 4′9″); transferred to the Tate Gallery 1914.

Exh. R.A. 1832 (70); Tate Gallery 1959 (350); Edinburgh 1968 (10); Bibliotheque Nationale *Berlioz*, Paris 1969 (97); Victoria and Albert Museum *Berlioz*, 1969 (170, repr.); Victoria and Albert Museum *Byron*, 1974 (537).

Lit. Ruskin 1860 and 1857 (1903–12, vii, p. 431; xiii, pp. 140–45); Thornbury 1862, i, pp. 320–21: 1877, p. 448; Hamerton 1879, pp. 257–61; Monkhouse 1879, pp. 97–8; Bell 1901, p. 58–9, 118 no. 177; Armstrong 1902, pp. 114, 220; MacColl 1920, p. 17; Whitley 1930, p. 235; Falk 1938, pp. 143–4; Davies 1946, p. 186; Finberg 1961, pp. 334–5, 337, 340, 493 no. 377; Rothenstein and Butlin 1964, pp. 12, 38, colour pl. xvi; Lindsay 1966, p. 180; Gage 1968, p. 682, repr. p. 683 fig. 50; Reynolds 1969, p. 160.

Exhibited in 1832 with the lines:

'—and now, fair Italy!
Thou art the garden of the world.
Even in thy desert what is like to thee?
Thy very weeds are beautiful, thy waste
More rich than other climes' fertility:
Thy wreck a glory, and thy ruin graced
With an immaculate charm which cannot be defaced.'
 Lord Byron, Canto 4.

The subject may have been partly influenced by the exhibition at the R.A. in 1829 of Eastlake's *Lord Byron's Dream*, painted in 1827 and now in the Tate Gallery.

The vase among the still-life detail in the left foreground was originally stuck on as a piece of paper and subsequently painted over. The picture was quoted by Ruskin, in his *Notes on the Turner Gallery at Marlborough House*, as an example of the decay he saw as having occurred in many of Turner's works. 'It *was*, once quite the loveliest work of the second period, but is now a mere wreck. The fates by which Turner's later pictures perish are as various as they are cruel; and the greater number, whatever care be taken of them, fade into strange consumption and pallid shadowing of their former selves. Their effects were either attained by so light glazing of one colour over another, that the upper colour, in a year or two, sank entirely into its ground, and was seen no more; or else, by the stirring and kneading together of colours chemically discordant, which gathered into angry spots; or else, by laying on liquid tints with too much vehicle in them, which cracked as they dried; or solid tints, with too little vehicle in them, which dried into powder and fell off; or painting the whole on an ill-prepared canvas, from which the picture peeled like the bark from a birch-tree; or using a wrong white, which turned black; or a wrong red, which turned grey; or a wrong yellow, which turned brown. But, one way or another, all but eight or ten of his later pictures have gone to pieces, or worse than pieces—ghosts, which are supposed to be representations of their living presence. This "Childe

Harold" is a ghost only. What amount of change has passed upon it may be seen by examining the bridge over the river on the right. There either was, or was intended to be, a drawbridge or wooden bridge over the gaps between the two ruined piers. But either the intention of bridge was painted over, and has penetrated again through the disappearing upper colour; or (which I rather think) the realization of bridge was once there, and is disappearing itself. Either way, the change is fatal; and there is hardly a single passage of colour throughout the cool tones of the picture which has not lost nearly as much. It would be less baneful if all the colours faded together amicably, but they are in a state of perpetual revolution; one staying as it was, and the others blackening or fading about it, and falling out with it, in irregular degrees, never more by any reparation to be reconciled. Nevertheless, even in its present state, all the landscape on this right hand portion of the picture is exquisitely beautiful—founded on faithful reminiscences of the defiles of Narni, and the roots of the Apennines, seen under purple evening light.'

The picture attracted considerable public attention, so much so that the *Spectator* for 12 May 1832 advised people to get to the Academy when it opened at eight and emulate the reviewer who had 'sated our senses with its luxuriant richness ... Let the reader first go close up ... and look at the way in which it is painted; and then, turning his back (as one does sometimes to the sun) till he reaches the middle of the room, look round at the streaky, scrambled, unintelligible chaos of colour, and see what a scene has been conjured up before him as if by magic ... Then he will see that this is no meretricious trick of art—no mad freak of genius—no mere exaggeration of splendour—no outrage of propriety—but an imaginative vision of nature seen by the waking mind of genius, and transferred to canvas by the consummate skill of a master-hand. He will feel that it is the poetry of art and of nature combined—that it bears the same relation to the real scene as does Byron's description.' Other critics were equally full of praise. For the *Athenaeum*, 12 May, 'This is one of the noblest landscapes of our gifted artist; it has all the poetry of his best pictures, with all the true colouring of his less imaginative compositions.'

However, elsewhere there was some criticism of Turner's colours, of 'a constant recurrence of a laky red glow ... fatiguing to the eye' (*Morning Herald*, 7 May), or 'a blaze of king's-yellow and chrome' with which 'the sky is cold in comparison' and which 'does not harmonize with the scene below' (*Library of the Fine Arts*, June 1832). For the *Examiner*, 1 July, the picture 'has little to recommend it as a composition. Its colouring is gorgeous, but monotonous'. The *Morning Post* for 29 May said of the picture that 'it is more gorgeous than true ... In all the requisites of form in the perspective, grouping, and disposition of the various portions of this varied scene, all the mastery of art is displayed; but in the essential of colour ... dame Nature never wore so meretricious a robe ... For-

tunately we have a few Claudes in the Galleries of this country to instruct our untravelled eyes in the true features and hues of the classic land, or we might be borne down by the authoritative assertion of certain pilgrims of art, who would persuade us that there are no colours beyond the Alps but the colours of the rainbow.' Similarly, the *Literary Gazette* for 12 May wrote: 'We look upon this beautiful, but exceedingly artificial picture, as a vision, and cannot for a single instant believe in its reality.'

Finally, for the *Morning Chronicle*, 7 May, Turner 'is a sort of Paganini, and performs wonders on a single string—is as astonishing with his chrome, as Paganini is with his chromatics ... But even now, with all his antics, he stands alone in all the higher qualities of landscape painting.'

343. The Prince of Orange, William III, embarked from Holland, and landed at Torbay, November 4th, 1688, after a Stormy Passage
Exh. 1832 (Plate 374)

THE TATE GALLERY, LONDON (369)

Canvas, $35\frac{1}{2} \times 47\frac{1}{4}$ (90·5 × 120)

Coll. Robert Vernon, presumably purchased at the R.A. 1832; given to the National Gallery 1847; transferred to the Tate Gallery 1912.

Exh. R.A. 1832 (153); Australian tour 1960 (10); *Marine Painting* City Art Gallery, Plymouth, August 1969 (27); on loan to National Maritime Museum from 1975.

Lit. Hall 1851², p. 10 no. 78; 'The Vernon Gallery: The Prince of Orange landing at Torbay', *Art Journal* 1852, p. 226, engr. W. Miller; Hall iii 1853, no. 8, engr.; Waagen 1854, i, p. 385; Thornbury 1862, i, p. 321; Wornum 1875, pp. 77–8, engr.; Thornbury 1877, p. 448; Bell 1901, pp. 118–19 no. 178; Armstrong 1902, p. 226; MacColl 1920, p. 1; Finberg 1961, pp. 335, 493 no. 378; Lindsay 1966, pp. 141–2; Lindsay 1966², pp. 61–2.

Exhibited in 1832 with a reference to '–"*History of England*"' and the text

'The yacht in which his Majesty sailed was, after many changes and services, finally wrecked on Hamburgh sands, while employed in the Hull trade.'

According to Wornum she was in fact wrecked on the Black Middens, near Tynemouth Castle. The landing in fact took place on the morning of 5 November. William sailed from Helvoetsluys, the subject of another picture exhibited by Turner in the same year (No. 345).

As compared to *Childe Harold's Pilgrimage* (No. 342) this picture struck critics as of 'a soberer tone' (*Morning Chronicle*, 7 May 1832) and as showing a 'strict adherence to nature' (*Literary Gazette*, 12 May).

According to the *Athenaeum* for 26 May, however, 'The painter has made this picture somewhat poetical: he has squandered the finest hues and the finest perspective upon a subject which has lost somewhat of its feverish interest in the hearts of Englishmen.'

344. Van Tromp's Shallop, at the Entrance of the Scheldt Exh. 1832 (Plate 375)

WADSWORTH ATHENEUM, HARTFORD, CONNECTICUT

Canvas, 35 × 47 (89 × 119·5)

Coll. John Miller of Liverpool who bought it from the artist; by descent to T. Horrocks Miller and then to Thomas Pitt Miller of Singleton Park, Blackpool; sale Christie's 26 April 1946 (108) bought Fine Art Society; consigned by them in 1951 to the Vose Galleries of Boston, from whom bought by the Wadsworth Atheneum (Sumner Collection: Accession number 1951-233).

Exh. R.A. 1832 (206); R.A. 1889 (18); Fine Art Society 1948 (128); Indianapolis 1955 (35).

Lit. Burnet and Cunningham 1852, p. 116 no. 167; Thornbury 1862, i, p. 321; 1877, pp. 92(?), 577; Bell 1901, pp. 117, 119 no. 179; Armstrong 1902, p. 232; *The Year's Art* 1945–7, p. 120, repr. facing p. 66; *Wadsworth Atheneum Bulletin* February 1952, second series, no. 30, p. 1, repr.; Cunningham 1952, pp. 322–9, repr.; Finberg 1961, pp. 335, 493 no. 379; Rothenstein and Butlin 1964, pp. 51, 68 pl. 94.

As noted under the entry for No. 339 the titles and histories of Turner's Van Tromp paintings have been much confused in the past. In his pamphlet, written in 1899, C. W. Carey, Curator of the Royal Holloway College Gallery, attempted to disentangle them but he was not aware of the existence of this picture. It was not until Cunningham's article in the *Art Quarterly* in 1952 that the five pictures were sorted out and even then Cunningham concludes his article 'perhaps after all the last word has not been said on the Van Tromp subjects.' In particular, confusion has been caused by the fact that both this and the *Van Tromp going about to please his Masters* (No. 410) belonged to John Miller but more especially because both this picture and that now in the National Gallery of Art, Washington (No. 348) went under the same title and are listed in this way by Armstrong. The Washington picture, which formerly belonged to Mrs Mellon Bruce, has been convincingly identified by Cunningham as *Rotterdam Ferry Boat*, exhibited in 1833 at the R.A., but, even after his article was published, elements of the histories of the Hartford and Washington pictures were entwined in the Indianapolis Exhibition Catalogue. Furthermore there is no conclusive evidence to show whether the Hartford picture and the Tate picture, *Van Tromp returning after the Battle off the Dogger Bank* (No. 351), are correctly

identified as their titles might be considered interchangeable. However, as the Hartford title has been attached to it since at least 1889, there seems no reason not to assign *Van Tromp returning after the Battle off the Dogger Bank* to the Tate Gallery (it was listed in the inventories of 1854 and 1856 merely as 'Van Tromp') in the absence of any conflicting evidence. Classification is not made easier by the absence in either picture of any vessel which can be positively identified as a shallop, which is defined as 'a small light vessel, with only a small main-mast, a foremast, and lug sails. Shallops are commonly good sailers, and are therefore often used as tenders upon men-of-war.'

At the R.A., Turner's three marines (this and Nos. 343 and 345) were considered together by the *Morning Post* for 29 May and judged to have been 'treated with the known power of the artist in depicting aerial effects, and in giving animation to his canvass. They are, however, careless in point of execution, and mostly o'erstep the modesty of nature in colouring.' The critic of the *Library of the Fine Arts* (iii, no. 17, pp. 508–9) added *Staffa* (No. 347) and thought them four works 'beyond which art could never go, and which we may therefore perhaps truly say cannot go.' It was also praised by the *Literary Gazette* (no. 799, p. 298) but Turner's seas were criticised in the *Spectator*, 12 May, as being 'not lucid enough; they are rather *blanketty*. But then how airy and tender his distances! how perfect the keeping! how pure the colouring!'

345. Helvoetsluys;—the City of Utrecht, 64, going to Sea Exh. 1832 (Plate 328)

INDIANA UNIVERSITY ART MUSEUM, BLOOMINGTON, INDIANA

Canvas, 36 × 48 (91·4 × 122)

Coll. Bought from Turner early in 1844 by Elhanan Bicknell of Herne Hill; Bicknell sale Christie's 25 April 1863 (102) bought Agnew for John Heugh; bought back from Heugh by Agnew in 1864 and sold to Miss Woods; repurchased from her in 1883 by Agnew and sold to James Price; sale Christie's 15 June 1895 (65) bought Agnew; A. J. Forbes-Leith; repurchased from him in 1895 by Agnew and sold to James Ross of Montreal; sale Christie's 8 July 1927 (29) bought Paterson; Miss L. Coats; sale Christie's 23 July 1954 (56) bought Colonel S. J. L. Hardie; his executors' sale Sotheby's 19 November 1969 (125) bought Agnew; bought by the University of Indiana in 1971 (gift of Mrs Nicholas H. Noyes).

Exh. R.A. 1832 (284); R.A. 1895 (32); Agnew 1895 (18); Agnew 1967 (16).

Lit. Burnet and Cunningham 1852, p. 116 no. 168; C. R. Leslie, *Autobiographical Recollections* 1860, i, p. 202; Thornbury 1862, ii, pp. 187–8; 1877, pp. 326–7, 577; Monkhouse 1879, p. 100; Bell 1901, pp. 119–20 no. 180; Armstrong 1902, p. 222; *The*

Reminiscences of Frederick Goodall R.A. 1902, p. 54; Whitley 1930, p. 236; Falk 1938, pp. 136, 251; Finberg 1961, pp. 335–7, 399, 493 no. 380; Gage 1969, p. 168; Reynolds 1969, pp. 142–2, 175; Bachrach 1974, p. 20.

Professor Bachrach points out that the portrayal of the seventeenth-century ship-of-the-line *De Stad Utrecht* is historically accurate. Although no drawings of Helvoetsluys have been identified in the Turner Bequest, the name occurs in Turner's 'Itinerary Rhine Tour' sketchbook (CLIX), dating from 1817, where Turner notes on p. 13 verso: 'Helvoetsluys Place Inn 80 feet water'. Professor Bachrach has also kindly drawn my attention to a chart of this area, published in 1823, which shows quite clearly that the breakwater and tower which appear on the left of the picture are those at Goeree while, on the right, ships can be seen at anchor at the naval station of Helvoetsluys. *De Stad Utrecht* is therefore correctly shown by Turner as heading for the open sea, as described in his title.

As has been noted in the entry for No. 344, at the R.A. the critics tended to deal with Turner's seapieces in general rather than describing them individually but on the whole they were praised. The *Athenaeum*, 2 June, was the only paper to devote more than a line or two to *Helvoetsluys*:

'Turner, in this picture, must unite the praises of all who love truth and fancy. The scene is real. Helvoetsluys is a good point to start from, and the circumstance of a sixty-four sailing out, is like an oath before a magistrate to establish identity; all else is imagination, and that of a fine kind.'

However, while working on *Helvoetsluys* during the Varnishing Days, Turner was involved in one of those incidents which he so much enjoyed. The incident is described thus by C. R. Leslie:

'In 1832, when Constable exhibited his "*Opening of Waterloo Bridge*" it was placed in the school of painting—one of the small rooms at Somerset House. A sea-piece, by Turner, was next to it—a grey picture, beautiful and true, but with no positive colour in any part of it. Constable's "Waterloo" seemed as if painted with liquid gold and silver, and Turner came several times into the room while he was heightening with vermilion and lake the decorations and flags of the city barges. Turner stood behind him looking from the "Waterloo" to his own picture, and at last brought his palette from the great room where he was touching another picture, and putting a round daub of red lead, somewhat bigger than a shilling, on his grey sea, went away without saying a word. The intensity of the red lead, made more vivid by the coolness of his picture, caused even the vermilion and lake of Constable to look weak. I came into the room just as Turner left it. "He has been here," said Constable, "and fired a gun". On the opposite wall was a picture, by Jones, of Shadrach, Meshach and Abednego in the furnace. "A coal" said Cooper, "has bounced across the room from Jones's picture, and set fire to Turner's sea." The great man did

not come again into the room for a day and a half; and then, in the last moments that were allowed for painting, he glazed the scarlet seal he had put on his picture, and shaped it into a buoy.'

Armstrong describes this as a companion to the Frick Collection's *Van Goyen looking out for a Subject* (No. 350) but there is no evidence for this, although it was not unknown for Turner to exhibit companion pictures in successive years (e.g. Nos 235 and 239). In fact, the picture which most resembles the *Van Goyen* both in tonality and in handling is the *Rotterdam Ferry Boat* (No. 348) which was also exhibited in 1833, but again there is no evidence that they were ever intended as pendants by Turner. However, this picture does have a connection with another of the 1832 exhibits: *The Prince of Orange, William III ... landed at Torbay* (No. 343) for it was from Helvoetsluys that William III's fleet set sail on its voyage to England, although his flagship on that occasion was *Den Briel*.

346. Shadrach, Meshech and Abednego in the Burning Fiery Furnace Exh. 1832 (Plate 378)

THE TATE GALLERY, LONDON (517)

Mahogany, $36\frac{1}{16} \times 27\frac{7}{8}$ (91·5 × 71)

Coll. Turner Bequest 1856 (41, 'Shadrach, Meshech and Abednego' $3'0'' \times 2'\frac{3}{4}''$); transferred to the Tate Gallery 1905.

Exh. R.A. 1832 (355); R.A. 1974–5 (B39).

Lit. Ruskin 1857 (1903–12, xiii, pp. 135–6, 156–7); Thornbury 1862, i, p. 321; ii, pp. 112, 183–4; 1877, pp. 273, 324–5, 448; Bell 1901, p. 120 no. 181; Armstrong 1902, p. 232; Whitley 1930, p. 235; Falk 1938, p. 136; Davies 1946, p. 186; Finberg 1961, pp. 335, 493 no. 381; Rothenstein and Butlin 1964, p. 44; Lindsay 1966, p. 174; Gage 1969, p. 243 n. 95; Reynolds 1969, p. 160; Reynolds 1969[2], pp. 74–5, pl. 11.

Exhibited at the R.A. in 1832 with no actual title but the text:

'Then Nebuchadnezzar came near to the mouth of the burning fiery furnace, and said, Shadrach, Meshach, and Abednego, come forth and come hither. Then Shadrach, Meshach, and Abednego came forth of the midst of the fire.'—*Daniel*, chap. iii, ver. 26.

The picture was painted in friendly competition with George Jones who related the circumstances in his manuscript reminiscences now in the Ashmolean Museum, Oxford: 'Another instance of Turner's friendly contests in Art, arose, from his asking me what I intended to paint for the ensuing Exhibition. I told him that I had chosen the delivery of Shadrach Mesheck, and Abednego from the Fiery Furnace—"a good subject, I will paint it also, what size do you propose?" Kitcat. "Well, upright or length way,"? upright. "well I'll paint it so—have you ordered your panel"? no—I shall order it tomorrow—"Order two and desire one to be sent to me, and mind I never will come into your room without inquiring what is on the easel; that I may not see it—Both pictures were painted and exhibited, our brother Academicians thought that Turner had secretly taken an advantage of me and were surprised at our mutual contentment little suspecting our previous friendly arrangement; they very justly gave his picture a much superior position to mine, but he used his utmost endeavours to get my work changed to the place his occupied & his placed where mine hung, they were exactly the same size.'

Jones' picture was bought by Robert Vernon and is now also in the Tate Gallery (see Plate 555), and his account is supported by the fact that both pictures are on identical mahogany panels, similar in size, supplied by R. Davy.

Only one reviewer, writing in the *Examiner* for 10 June 1832, seems to have compared the two works and that not very charitably: 'All that can be said for his [Jones'] *Nebuchadnezzar*, No. 256, is, that it is not so absurdly treated by him as by his brother academician Mr. Turner, who, in No. 355, has painted the same subject without the slightest display of character or expression, but with his accustomed ignorance of the human form.' This condemnation of Turner's figures was echoed by the *Athenaeum* for 16 June. *Fraser's Magazine* for July dismissed it as one of Turner's 'unintelligible pieces of insanity', and the *Morning Post* of 29 May as 'a kind of phantasmagoric extravaganza ... in which the reds have prevailed', which 'ought itself to be put into the mouth of a fiery furnace'. The *Spectator*, 12 May, exclaimed that 'its glare is scorching; we hope the Academy is insured—or perhaps the picture is painted on canvas of asbestos', while the *Literary Gazette* for 19 May said that it had been hung opposite a sea-piece 'in order to prevent the room from becoming damp. Certainly, since the introduction of chrome, more fires have broken out in art than formerly; and this is one of them.'

An exception to this negative criticism was the *Library of Fine Arts* for June 1832, which described the picture as 'one of those extraordinary flights in which Mr. Turner is so often so fond of indulging, to the astonishment and unfeigned delight of one half of the world of art, and the astonishment and self-conceited supercilious remarks of the other ... The figures are almost unintelligible—they flit before us, as they ought to do, in a superhuman manner, but to our mind it is impossible to conceive a finer effect of lurid light than is here portrayed. The picture is a small one ... we should delight to see it attempted on a larger scale, believing it would be a great trial even to Mr. Turner's powers to give a large finished picture of what would, if successful, be a truly wonderful performance.'

347. Staffa, Fingal's Cave Exh. 1832 (Plate 329)

LORD ASTOR OF HEVER

Canvas, 36 × 48 (91·5 × 122)

Signed 'J M W Turner RA' lower right (Plate 539)

Coll. Bought from Turner in 1845 by Colonel James Lenox of New York who employed the artist C. R. Leslie, R.A. (1794–1859), as an intermediary in the transaction; given by Colonel Lenox to the Lenox Library which later became the New York Public Library; sale Parke Bernet, New York, 17 October 1956 (39) bought Agnew from whom bought by the present owner.

Exh. R.A. 1832 (453); Boston 1946 (10); Toronto and Ottawa 1951 (18); Indianapolis 1955 (33); Tate Gallery 1959 (351); Cologne (58, repr.), Rome (60, repr.) and Warsaw (58, repr.) 1966–7; Agnew 1967 (17); R.A. 1968–9 (159); Paris 1972 (265); Berlin 1972 (17); R.A. 1974–5 (490); Leningrad and Moscow 1975–6 (59).

Lit. Burnet and Cunningham 1852, p. 117 no. 170; C. R. Leslie, *Autobiographical Recollections* i 1860, pp. 205–7; Thornbury 1862, ii, pp. 242–3; 1877, pp. 336–7, 577; Hamerton 1879, p. 235; Ruskin 1886 (1903–12, xxxv, p. 577); Bell 1901, pp. 120–21 no. 182; Armstrong 1902, p. 232; Carter, 'First Turner in America', *Creative Art* 1929, p. 912; *Catalogue of the Paintings in the Picture Galleries of the New York Public Library* 1941, p. 9, no. 21; Geoffrey Grigson, *Architectural Review* civ 1948, pp. 51–4; Clare 1951, p. 109; Boase 1959, p. 343; Finberg 1961, pp. 332–3, 335–6, 409, 420, 493 no. 382: Rothenstein and Butlin 1964, pp. 50, 58, 60, 62, colour pl. xv; Kitson 1964, pp. 79, 80, repr. p. 53; Lindsay 1966, pp. 228, 232, 248, 338, 350; Gage 1969, p. 126; Reynolds 1969, pp. 153–6, fig. 135; Adele M. Holcomb, 'Turner and Scott', *Journal of the Warburg and Courauld Institutes* xxxiv 1971, pp. 389, 396 pl. 67a; Gaunt 1971, p. 10; Gerald Finley, 'J. M. W. Turner and Sir Walter Scott: Iconography of a Tour', *Journal of the Warburg and Courtauld Institutes* xxxv 1972, pp. 364–5; Adele M. Holcomb, ' "Indistinctness is my fault": A letter about Turner from C. R. Leslie to James Lenox', *Burlington Magazine* cxiv 1972, pp. 555, 557–8; Gage, 'The Distinctness of Turner', *Journal of the R.S.A.* July 1975, pp. 448–57; Herrmann 1975, pp. 39–40, pl. 139.

Exhibited with the following quotation from Canto iv of Scott's *Lord of the Isles*:

'——— nor of a theme less solemn tells
That mighty surge that ebbs and swells,
And still, between each awful pause,
From the high vault an answer draws.'

In early August 1831 Turner paid a visit to Sir Walter Scott at Abbotsford with the purpose of selecting and sketching subjects to be engraved for an illustrated edition of Scott's *Poetical Works*. Scott's publisher Robert Cadell was also of the party. After making the necessary drawings in the neighbourhood of Abbotsford, Turner returned to Edinburgh and thence set out on 16 August for the more spectacular scenery of the north on a tour that was to last a month. After visiting Loch Katrine and the Trossachs, Turner went down to Glasgow by way of Loch Lomond and then took a steamer through the Crinan Canal to Oban and Skye. Returning to Tobermory, he set off one day in the steamer *Maid of Morven* to visit Staffa and Iona.

The journey to Staffa was described many years later in a letter from Turner to James Lenox:

' . . . but a strong wind and head sea prevented us making Staffa until too late to go on to Iona. After scrambling over the rocks on the lee side of the island, some got into Fingal's Cave, others would not. It is not very pleasant or safe when the wave rolls right in. One hour was given to meet on the rock we landed on. When on board, the Captain declared it doubtful about Iona. Such a rainy and bad-looking night coming on, a vote was proposed to the passengers: "Iona at all hazards, or back to Tobermoray." Majority against proceeding. To allay the displeased, the Captain promised to steam thrice round the island in the last trip. The sun getting towards the horizon, burst through the rain-cloud, angry, and for wind; and so it proved, for we were driven for shelter into Loch Ulver, and did not get back to Tobermoray before midnight.'

It is characteristic of Turner's spirit of adventurousness that he was among those who got into Fingal's Cave which, since its accidental discovery by Joseph Banks in 1772, had become a place of pilgrimage for those concerned in the romantic movement—indeed, it was soon to become overrun by tourists. Its association with the father of Ossian, Fiuhn Mac Coul (Fingal), ensured its poetic significance and the formation of the cave itself, consisting of basalt columns, was a source of wonder and admiration to students of architecture and archaeology alike. Turner shows the extraordinary structure of the cave in his vignette, painted from inside the cave looking out towards the sea, which he drew to illustrate *The Lord of the Isles*. Other sketches connected with the visit occur in the 'Staffa' sketchbook (CCLXXIII). These show that, in fact, Turner's main interest was in the sea voyage rather than in Fingal's Cave itself. He did, however, make a few rapid pencil sketches, drawn from inside the cave looking outwards, which occur from p. 27 verso to p. 30 verso, but devoted more attention to studies of the curiously striated cliff formation of Staffa from p. 18 verso to p. 21, and on pp. 40–40 verso.

At the Academy exhibition, the critics recognised that the grandeur of the scene had been matched by Turner's romantic treatment of it so that, as *Fraser's Magazine* for July put it, 'All is unison in this fine picture, and impresses us with the sublimity of vastness and solitude.' In general, Turner was praised for the poetic effect with which he had invested the subject and

for keeping his 'love of yellow, red and blue in this instance subordinate', as the *Morning Herald* put it on 7 May. Only the *Athenaeum*, 16 June, was less than generous in its praise, finding that 'Nature, in the original scene, has done her best, and Turner cannot surpass her.'

However, despite the fact that *Staffa* was widely praised, it remained unsold, like so much of Turner's exhibited work at this time, until 1845 when Leslie was commissioned by James Lenox to spend up to £500 on a picture of Turner's. When Leslie called on Turner, and asked if he would let a picture go to America, Turner replied 'No, they won't come up to the scratch.' Leslie told him that he had a friend who would give £500 for anything he would part with, and finally chose *Staffa* which thus became the first painting by Turner to go to America.

When the picture reached New York, Colonel Lenox was out of town, but a few days later Turner asked Leslie 'Well, and how does he like the picture?' Leslie answered 'He thinks it indistinct' to which Turner is said to have given the famous reply 'You should tell him that indistinctness is my *forte*.' Unfortunately, this reply, which has become so much a part of Turnerian mythology, has been shown to be inaccurate by Dr Holcomb, who has studied the original letter (written by Leslie to James Lenox on 4 November 1845) in the Manuscript Division of the New York Public Library, and there is no doubt that it reads 'Indistinctness is my fault.' In fact, there is good reason to believe that at any rate part of the indistinctness of which Lenox complained was due to the varnish having bloomed on the journey. Turner advised wiping the surface with a silk handkerchief and this appears to have done the trick. Eventually, however, Lenox came to admire the picture greatly, and five years later added a second Turner oil, *Fort Vimieux* (No. 341), to his collection.

As Gage has suggested in the catalogue of the 1972 exhibition in Paris, the way that Turner has painted the setting sun surrounded by a nimbus, which does not appear in any of the sketches, may derive from his meeting with the Edinburgh physician, Sir David Brewster, in 1831. It is probable that this meeting took place at dinner with the Rev. John Thomson of Duddingston who was a friend of both Turner and Brewster. At this time, Brewster and his circle were investigating such natural phenomena. The sun haloed in this way, does, however, foretell rain, as Gage pointed out in his lecture on 'The Distinctness of Turner' and this bears out Turner's description of the scene given in his letter to Lenox.

348. Rotterdam Ferry Boat Exh. 1833 (Plate 330)

NATIONAL GALLERY OF ART, WASHINGTON D.C.

Canvas, 36½ × 48½ (92·7 × 123·2)

Coll. H. A. J. Munro of Novar who bought it at the time of the R.A. Exhibition; sale Christie's 6 April 1878

(101) bought Agnew; Kirkman D. Hodgson, M.P.; bought back from him by Agnew in 1893 and sold to Sir Charles Tennant, Bt (1823–1906); by descent to his grandson, the second Lord Glenconner, from whom bought by Knoedler in 1923 and sold in the same year to Andrew Mellon; given to his daughter, Mrs Ailsa Mellon Bruce, who bequeathed the picture to the National Gallery of Art on her death in 1970 (Accession no. 2507).

Exh. R.A. 1833 (8); R.A. 1894 (103) and 1901 (82); Knoedler, New York 1924 (9).

Lit. Burnet and Cunningham 1852, p. 117 no. 171; Waagen 1854, ii, p. 141? (this seems a more likely candidate than *The Wreck Buoy* (No. 428) among Munro's pictures, although Waagen's description of 'a large sea-piece with still water and light atmosphere, most poetically composed and executed in every part with powerful and transparent colouring' does not fit this picture very exactly. Waagen, however, also describes as 'large' Munro's *Venice* (see No. 362) which is the same size as this picture); Thornbury 1862, ii, p. 400; 1877, pp. 577, 597; Frost 1865, p. 94 no. 40; Redford, *Art Sales* i 1888, pp. 270, 272; *Catalogue of Pictures in Sir Charles Tennant's Collection* 1896, repr.; Carey 1899, pp. 173–5; Bell 1901, p. 121 no. 183; Armstrong 1902, p. 232; Cunningham 1952, pp. 323–9, repr.; Finberg 1961, pp. 340, 493 no. 383; Bachrach 1974, p. 20, repr. p. 21 (mistakenly acknowledged as in the collection of Mr and Mrs Paul Mellon).

The history and title of this picture have been much confused especially in relation to the picture now in the Wadsworth Atheneum, Hartford (see the entry for No. 344).

In Carey's article he states that this picture was bought by Munro of Novar in 1832 for £500. Cunningham rightly dismissed this as fictitious on the evidence that Soane is known to have paid only 250 guineas for his Van Tromp picture (No. 339) in 1831.

After Munro's death in 1865, a catalogue of the Munro pictures was prepared by W. Frost, R.A., and revised by H. Reeve. A note in the catalogue says that no manuscript material existed at the time of Munro's death so that 'it is less complete and accurate than if by Munro himself'. On p. 94 no. 40 is described as ' "Admiral Van Tromp's barge at the entrance of the Texel 1645" 35½ × 47½, Exhibited R.A. in 1831'. This seems to be a straight confusion with the Soane picture. In the 1878 Munro sale catalogue this title was retained but 'shallop' substituted for 'barge' which further confused the issue. The critic of *The Times* drew attention to the incorrect title in the sale catalogue and suggested that it was the picture exhibited in 1832 rather than 1831. It is not known what evidence he produced beyond the obvious fact that the 1831 picture was accessible to the public in the Soane Museum, but the picture was rechristened and went under the title of 'Van Tromp's Shallop at the Entrance to the Scheldt' (a

tablet with this title was still on the frame in 1970) until the publication of Cunningham's article. This pointed out that in the first edition of Thornbury's *Life*, published in 1862 when Munro was still alive, a picture of *Rotterdam* was listed in Munro's possession, and that, whereas all the other Turner oils listed by Thornbury appeared in the 1867 or 1878 sales, the picture of *Rotterdam* does not occur in either sale, but the *Van Tromp* does, although not listed by Thornbury. Cunningham also points out that the Church tower visible in the centre of the picture is very similar to the Groote Kerk (Church of St Lawrence), Rotterdam with its three broad but tapering stories, and this identification is positively confirmed by Bachrach.

Touches of a very idiosyncratic orange–ochre in the water, which denote the reflections of the sails of the central boat, are identical in hue with a colour used extensively in the sky and water of the *Quille-Boeuf* (No. 353, R.A. no. 462) which suggest that these last touches in the water were probably added on the Varnishing Days when Turner was working on both pictures at the R.A.

The picture was briefly noticed at the R.A. exhibition by most of the critics and received considerable praise. *The Times* for 1 July commended Turner's use in this picture of 'a more sober, and, though less imaginative, a much more natural and satisfactory tone of colour' and considered that 'in this picture and in several others he displays that perfect mastery over his art which he is known to possess'. This view was echoed by the *Literary Gazette*, 11 May, which wrote that in this picture 'this admirable artist has exhibited those great powers which, in such subjects, place him above all competition.' The picture was also favourably mentioned in both the *Athenaeum*, 11 May, and *Arnold's Magazine* for June.

349. Bridge of Sighs, Ducal Palace and Custom-House, Venice: Canaletti painting Exh. 1833
(Plate 331)

THE TATE GALLERY, LONDON (370)

Mahogany, $20\frac{3}{16} \times 32\frac{7}{16}$ (51 × 82·5)

Coll. Robert Vernon, purchased at the R.A. 1833 for 200 guineas and given to the National Gallery 1847; transferred to the Tate Gallery 1912.

Exh. R.A. 1833 (109); Venice and Rome 1948 (37, repr.); *Byron* Victoria and Albert Museum 1974 (S40); R.A. 1974–5 (529, repr.).

Lit. 'The Vernon Gallery: Venice, the Grand Canal', *Art Journal* 1850, p. 92, engr. T. A. Prior; Hall i 1850, no. 33, engr. T. A. Prior, as 'Venice. — The Grand Canal'; Hall 1851², p. 9 no. 59, as 'Grand Canal, Venice'; Burnet 1852, pp. 106–7, engr., as 'Scene on the Grand Canal at Venice'; Cunningham 1852, p. 32; Waagen 1854, i, p. 385, as one of 'the two views of Venice'; Thornbury 1862, i, p. 322: ii, pp. 241–2; 1877, pp. 336, 449; Bell 1901, pp. 58, 70,

121 no. 184; Armstrong 1902, p. 234; MacColl 1920, p. 1; Finberg 1930, pp. 78–84, 155, pl. 14; Whitley 1930, p. 253; Finberg 1961, pp. 340–41, 493 no. 384; Herrmann 1963, p. 32, pl. 14; Rothenstein and Butlin 1964, pp. 51–2, pl. 95; Brill 1969, pp. 18–19; Gage 1969, pp. 164, 168, 170, 243 n. 95, colour pl. 27; Reynolds 1969, pp. 158–61, pl. 141; George 1971, p. 87, pl. 4; Ziff 1971, p. 126.

In Turner's list of the titles of his 1833 R.A. exhibits, now in the Tate Gallery archives, the punctuation is slightly different: '5. Bridge of Sighs, Ducal Palace & Custom House Venice. Canaletti painting.' The title shows that this was in part a tribute to the most renowned of painters of Venetian *vedute*. Canaletto himself is shown painting away at a picture in a heavy gilt frame on the left, although Turner, of all artists, would have been aware of the unlikeliness of such a practice. The picture may also, as Graham Reynolds has suggested, have been in part inspired by the Venetian scenes of Bonington, whose death in 1828 had been followed by a large sale of his works in London in 1829 (see also Nos. 334 and 341).

But the immediate cause seems to have been friendly rivalry with one of his followers, William Clarkson Stanfield (1793–1867), who exhibited *Venice from the Dogana* the same year. According to the *Morning Chronicle* for 6 June 1833 Turner did this picture 'it is said, in two or three days, on hearing that Mr. Stanfield was employed on a similar subject — not in the way of rivalry of course, for he is the last to admit to anything of the kind, but generously, we will suppose, to give him a lesson in atmosphere and poetry.' The same story was repeated by Allan Cunningham and by *Arnold's Magazine* for November 1833–April 1834, though Cunningham manages to refer to it both as 'Venice and the Bridge of Sighs' and as 'Ducal Palace', the title of the lost painting of the same year (see No. 352). Cunningham explains that it was because of this competition that Turner's picture was hung below the line, implying that this was because it was a later addition to the exhibition, to 'teach Stanfield to paint a picture in two days'.

However, that Turner only decided on his subject two or three days before the opening of the exhibition, on seeing Stanfield's picture at the R.A. on the Varnishing Days, seems unlikely, as his detailed title, with its reference to Canaletto, would presumably have had to have been sent in beforehand. Stanfield's picture was in fact bought by his patron Lord Lansdowne, who had an important collection of Bonington's works, so the two possible causes for Turner's taking up Venetian subjects could have been interrelated.

The critics readily accepted Turner as the winner in this contest. The *Spectator* for 11 May 1833 said of the Stanfield, 'it is cleverly painted, but the unavoidable comparison with the same subject by Turner is fatal to it. It is to Turner's picture what a mere talent is to genius.' The Turner was described as 'a most brilliant gem. The emerald waters, the bright blue sky, and the

ruddy hue of the Ducal Palace, relieved by the chaste whiteness of the stone buildings around, combine to present a picture as bright, rich and harmonious in tone, as the actual scene painting can surpass the purity of the colour. It is a perfectly beautiful picture.' For *Arnold's Magazine* (iii, 1833–4, pp. 408–9) 'the juxtaposition brought out more glaringly the defects of Stanfield, and illustrated more strongly the fine powers of Turner. For, viewed from whatever distance, Turner's work displayed a brilliancy, breadth, and power, killing every other work in the exhibition'. The *Morning Chronicle* went on with its account of the Turner (see above) to say that 'it is beautiful and replete in the greys on the left, &c, with his magical powers, so often disgraced in other pieces, and frittered away for pence in his little drawings.' Here was a continuing theme of later criticism, which praised Turner's Venetian works while attacking his 'extravagancies.' The *Athenaeum*, 11 May, thought that Turner had worsted Canaletto as well, describing Turner's picture as 'more his own that he seems aware of: he imagines he has painted it in the Canaletti style: the style is his, and worth Canaletti's ten times over.'

An anecdote by George Jones, in his manuscript reminiscences in the Ashmolean Museum, Oxford, suggests that it was Jones who won a second contest in the 1833 exhibition. Turner's *Canaletti painting* was hung next to Jones' *Ghent* which had a very blue sky. Turner jokingly put down Jones' bright colour by working on 'the magical contrasts' in his own picture, but Jones then added a great deal more white into his own sky, which made Turner's look much too blue. 'The ensuing day, he saw what I had done, laughed heartily, slapped my back and said I might enjoy the Victory.'

This was the first year in which Turner exhibited oil paintings of Venetian subjects; another picture, *Ducal Palace, Venice* is now lost (No. 352). To explain this sudden interest, so long after his visit to Venice of 1819, some scholars have suggested another visit in 1832, but the evidence points to Turner not having returned until the summer of 1833, after the R.A. exhibition (George 1971, pp. 84–7). It would seem that Turner only felt the urge to return to Venice in person after his artistic development had led him to embark on Venetian subjects for his oil paintings.

350. Van Goyen, looking out for a Subject
Exh. 1833 (Plate 377)

THE FRICK COLLECTION, NEW YORK (Accession no. 01.1.118)

Canvas, $36\frac{1}{8} \times 48\frac{3}{8}$ (91·8 × 122·9)

Coll. Bought from Turner in 1844 by Elhanan Bicknell; sale Christie's 25 April 1863 (97) bought Agnew for John Heugh; bought back by Agnew in 1864 and sold to John Graham, Skelmorlie Castle, Ayrshire; sale Christie's 30 April 1887 (92) bought Agnew;

F. B. Henson; bought in 1900 from Mrs. Guthrie by Agnew; Knoedler, who sold it to H. C. Frick in 1901.

Exh. R.A. 1833 (125); Glasgow 1878 (101); Boston Museum of Fine Arts *Frick Collection* 1910 (38); Knoedler, New York, *Old Masters* 1912 (36).

Lit. Burnet and Cunningham 1852, p. 117 no. 173; Thornbury 1862, ii, p. 401; 1877, pp. 577, 599; Bell 1901, p. 122 no. 185; Armstrong 1902, pp. 120, 217, repr. facing p. 108; Finberg 1961, pp. 340, 399, 494 no. 385; Rothenstein and Butlin 1964, pp. 51, 52; Davidson 1968, i, pp. 134–6, repr.; Bachrach 1974, p. 20.

The picture is often referred to as 'Antwerp: Van Goyen . . .' (and is listed as such by Armstrong) but in fact the prefix 'Antwerp' is a later addition and was not part of the title when originally exhibited.

The view is taken from a point on the River Gauche near the Old Fort d'Austruweel looking across the waters of the Scheldt towards the city of Antwerp. Among the buildings that can be identified are, on the left, the Pilotage with a flag flying; in the right centre are the spires of the cathedral, and on the extreme right, in the distance, the tower of St André. The boat in the foreground has 'VAN G' painted on its stern to indicate that the figure standing in the stern of that vessel is meant to represent Van Goyen, who is recorded as having sought out suitable subjects for pictures from an open boat off Antwerp in this way.

Drawings of Antwerp Cathedral occur on pp. 2 verso and 3, 3 verso and 4 of the 'Dort' sketchbook (CLXII) in use in 1817 but these are taken from inside the town and not from the Scheldt as in this picture.

This picture and *Rotterdam Ferry Boat* (No. 348) are pitched in a noticeably higher key than the other seascapes which Turner exhibited in the early 1830s. On the whole this picture was welcomed at the Academy, and was praised by the critics of both the *Athenaeum*, 11 May, and the *Morning Chronicle*, 6 June, but the latter deplored the painting of the figures in both this and the *Van Tromp returning . . .* (No. 351), commenting that 'even Constable could not have been delivered of greater abortions.' The *New Monthly Magazine and Literary Journal*, May–August 1833, noted that the most remarkable thing about Turner's exhibits this year was that they were 'gray not yellow . . . His cold style is, if possible, more powerful than his warm', and cited this picture as 'the most powerful instance of what we advance'.

351. Van Tromp returning after the Battle off the Dogger Bank Exh. 1833 (Plate 376)

THE TATE GALLERY, LONDON (537)

Canvas, $35\frac{5}{8} \times 47\frac{1}{2}$ (90·5 × 121)

Coll. Turner Bequest 1856 (35, 'Van Tromp' 4′0″ × 3′0″); transferred to the Tate Gallery 1929.

Exh. R.A. 1833 (146); Edinburgh 1968 (11); Lisbon 1973 (13, repr.); Leningrad and Moscow 1975–6 (60).

Lit. Carey 1899, pp. 173–5, repr.; Bell 1901, p. 122 no. 186; Armstrong 1902, p. 231; Davies 1946, p. 186; Cunningham 1952, pp. 323–30, pl. 4; Finberg 1961, pp. 340, 494 no. 386.

Number 1 in Turner's list of titles for his 1833 R.A. exhibits (Tate Gallery archives).

For 'Van' Tromp and the former confusion between Turner's pictures see Nos. 339 and 344. The Battle of the Dogger Bank did not in fact take place until 1781.

As noted in the entries for Nos. 348 and 350, this was one of the paintings in which a number of reviewers of the R.A. in 1833 noted a return to a cooler palette. The *Morning Herald* for 6 May wrote of this work, 'Clear, broad and chaste in colour and effect—the bright straw colour has disappeared from this master's new works, which is a great advantage; they have more of a silvery tone, which harmonizes better with his subjects.' To the critic of the *Morning Chronicle* '*Liston* standing up in a boat is very funny'—presumably a reference to the comic actor John Liston (?1776–1846).

352. Ducal Palace, Venice Exh. 1833 (Plate 380)

PRESENT WHEREABOUTS UNKNOWN

Size and support unknown.

Coll. No history of this picture can be traced with certainty since its appearance at the R.A., although a number of possibilities are discussed below.

Exh. R.A. 1833 (169).

Engr. By W. Miller, 1854 as 'The Piazzetta, Venice'.

Lit. Burnet and Cunningham 1852, p. 117 no. 175; Thornbury 1877, p. 577; Bell 1901, p. 122 no. 187; Armstrong 1902, p. 234, who confuses it with the picture now at Oberlin (No. 390); Rawlinson ii 1913, pp. 207, 349; Finberg 1930, pp. 78, 84, 155; Clare 1951, p. 101; Finberg 1961, pp. 340–41, 494 no. 387; Rothenstein and Butlin 1964, p. 52.

This picture was mentioned in a letter which Turner wrote on 20 May 1833 to F. G. Moon, the publisher and printseller:

'My dear Sir,
 In reply to your favour of this morning I beg to say No. 169 Ducal Palace, Venice, will be 60 guineas and not to be engraved.'

This last stipulation put an end to Moon's interest but the price quoted implies that the picture must have been on a very modest scale, almost certainly smaller than Turner's other Venetian subject exhibited that year, *Bridge of Sighs . . . Canaletti painting* (No. 349).

(Clare who gives the size as 20 × 32 may have been confusing it with *Canaletti painting*.) The relative unimportance of the picture is unfortunately confirmed by the fact that it was the only one among Turner's six oil paintings sent to the R.A. which failed to get a mention of any kind by any critic.

Finberg gives the provenance as follows:
B. G. Windus; Mrs de Putron [Windus' daughter]; Christie's 16 March 1912 (32); Sotheby's 15 October 1952 as 'San Giorgio Maggiore, seen from the Piazzetta'.

In Christie's catalogue of the sale of 16 March 1912 lot 32 is described as follows: 'The Piazzetta Venice with the Corner of the Doge's Palace and numerous figures Panel, 11½ × 9½. Property of a Gentleman and formerly in the collection of the late B. G. Windus Esq. and from the collection of Henry Rice, 1845'. (In Christie's own copy of the sale catalogue, the vendor is identified as Mrs J. de Putron.) The picture fetched 80 guineas, and was bought by R. Smith.

Graves (*Art Sales* iii 1921, p. 219) lists a Turner of 'St. Mark's Place, Venice' sold at Christie's on 24 April 1845 (889) property of Henry Rice which was bought by Cells for 32 guineas and may have been the picture originally exhibited at the R.A. If this was the same picture that later belonged to Windus and appeared at Christie's in 1912, then one has to accept that suddenly, in late middle-age, Turner exhibited the smallest picture he ever sent to the R.A., considerably smaller even than the *Moonlight, a Study at Millbank* (No. 2), shown in 1797. All the evidence provided by Turner's later Venetian pictures argues against him showing such a small picture and only the single factor of the price asked supports its possible candidature as an exhibited picture. On the other hand, the size of the picture at Christie's is so close to that of the engraving (12 × 9⅜ in.) that it seems possible that it may have been an impression of it. The engraving of the subject in the British Museum states that it was taken 'from the picture in the possession of Mrs. de Putron'. Rawlinson says that the engraving was made for B. G. Windus but he seems to confuse a watercolour of *Venice: the Campanile*, engraved by W. Miller in 1836 for Scott's *Life of Napoleon*, with the source of the 1854 print.

In Sotheby's catalogue of 15 October 1952, the provenance was given as above with the addition of 'From the collection of Reginald Smith K.C..' who was presumably the buyer in 1912. The picture was not catalogued with confidence and was bought in for only £18.

353. Mouth of the Seine, Quille-Boeuf Exh. 1833
 (Plate 332)

FUNDAÇAO CALOUSTE GULBENKIAN, LISBON

Canvas, 36 × 48½ (91·5 × 123·2)

Coll. Charles Birch of Harborne near Birmingham by 1849; T. Horrocks Miller by 1889; by descent to his nephew T. Pitt Miller; sale Christie's 26 April 1946

(110) bought Knoedler for C. S. Gulbenkian (*d.* 1955).

Exh. R.A. 1833 (462); Royal Birmingham Society of Artists 1849 (113 lent by Charles Birch); R.A. 1889 (49 lent by T. Horrocks Miller); Shepherd's Bush 1908 (71); R.A. 1951–2 (181); R.A. 1974–5 (491).

Lit. Ruskin 1843 (1903–12, iii, p. 296); Burnet and Cunningham 1852, p. 117 no. 176; Thornbury 1877, p. 577; Bell 1901, pp. 122–3 no. 188; Armstrong 1902, pp. 120, 227; Finberg 1961, pp. 340, 494 no. 388; Rothenstein and Butlin 1964, p. 51, pl. 97; Lindsay 1966, p. 177.

Exhibited with this note appended:

> This estuary is so dangerous from its quicksands, that any vessel taking the ground is liable to be stranded and overwhelmed by the rising tide, which rushes in in one wave. This wave is known locally as the '*Mascaret*' or '*Barre*'.

This picture is based on a watercolour in the 'Rivers of France' series (CCLIX no. 103) for which pencil sketches are on pp. 77 and 79 of the 'Seine and Paris' sketchbook (CCLIV). The watercolour of *c.* 1829 was engraved by R. Brandard in 1834. In both the watercolour and engraving there is a single plume of spray to the left of the lighthouse. Turner has altered this in the oil in order to heighten the dramatic effect. In the picture two great spray-crested waves surge down the river from right to left. Turner has balanced them marvellously by introducing on the left a spiral of gulls wheeling upwards and curving back to meet the oncoming waves. This feature of the gulls was singled out for praise by the critic of the *Athenaeum*, 25 May, who considered that 'the descent of a cloud of water fowl' was 'finely managed'.

Bell mistakenly lists this picture as in the Boston Museum of Fine Arts. This would seem to refer to a smaller copy, canvas 27 × 34 in., which belonged to J. Bibby of Liverpool and was sold at Christie's 3 June 1899 (102) bought Ichenhauser for the Boston Museum, with a note in the catalogue that it had been exhibited in Liverpool in 1886. Another version, also probably a copy, seems to have been on the London art market in the 1930s according to Finberg's notes in the British Museum.

Although the picture was criticised in some newspapers, by far the greater number of reviews were favourable. The main objections made were to the gaudiness of the colour, especially by the *Morning Chronicle*, 6 June, which wrote it was a picture that 'would make you long for a parasol, and put you in fear of the yellow fever, and into a suspicion of the jaundice'. This criticism was to some extent echoed by *The Times*, 1 July, which, however, wrote that Turner was an artist 'for whom we might advantageously exchange a score of those landscape painters who never commit any exaggeration, nor any fault but that of being intolerably tame and accurate.' Otherwise the picture was generally

warmly praised, particularly by the *Spectator*, 11 May, which considered it 'one of those daring triumphs of genius which Turner alone achieves', and also by a critic in *Arnold's Magazine*, August 1833, who, in a long notice on the British School of Living Painters, thought it Turner's most poetical and imaginative picture since *Ulysses deriding Polyphemus* (No. 330). Ruskin considered it magnificent and 'one of the most perfect pieces of simple colour existing', being based on the colours black and yellow alone.

Rothenstein and Butlin point out that, after the comparative serenity of Turner's work at Petworth in 1828–30, his old preoccupation with the destructive forces of nature reasserted itself in pictures such as this and *Staffa* (No. 347). Turner now brings to them all the experience in painting the sea which he had gained throughout his life and, in particular, from the studies of waves breaking which occupied him in the early 1830s (see Nos. 455 ff.).

The catalogue of the Turner Bicentenary Exhibition suggested that this picture helped to date a number of studies of stormy seas in the Tate Gallery, especially the *Rough Sea with Wreckage* (No. 455) but, when hung close together at the exhibition, the Tate picture looked to me to be later than the early 1830s and this was borne out by the painting of the sky having some affinities with that in *Ostend* (No. 407, exh. R.A. 1844, and also hanging close by). However, Martin Butlin's views differ from mine here, as can be seen in the entry for No. 455.

354. The Fountain of Indolence Exh. 1834

(Plate 333)

BEAVERBROOK FOUNDATIONS, ON LOAN TO THE BEAVER-BROOK ART GALLERY, FREDERICTON, NEW BRUNSWICK

Canvas, 42 × 65½ (106·5 × 166·4)

There appear to be traces of a signature lower left directly below the reclining male figure. Only two or three letters are still visible now but the 'ur' of Turner is reasonably clear.

Coll. H. Lumley from whom bought in 1882 by Agnew and sold to W. H. Vanderbilt; by descent in the Vanderbilt family until 1958 when acquired by Lord Beaverbrook; placed on loan to the Beaverbrook Art Gallery by the Beaverbrook Foundations in 1959 (Inventory no. 59.259).

Exh. R.A. 1834 (52).

Lit. Burnet and Cunningham 1852, p. 117 no. 177; Thornbury 1877, p. 577; Ruskin 1886 (1903–12, xxxv, p. 217); Bell 1901, p. 123 no. 188, p. 138 no. 217; Armstrong 1902, pp. 120, 222; Finberg 1961, pp. 348, 372, 498 no. 446; Lindsay 1966, pp. 176, 207.

The vexed question of whether or not this picture is identical with 'The Fountain of Fallacy', exhibited at

the British Institution in 1839, is dealt with under the entry for the latter picture (No. 376). The source of the subject may be traced once more to James Thomson whose poem *The Castle of Indolence* was published in 1748, a few months before his death, although it had been begun as early as 1736. The critic of the *Athenaeum*, 10 May, was quick to seize on a line from the poem, 'fond to begin, but for to finish loth', as being applicable to the painting, although he had earlier praised the picture as a 'wondrous landscape over which a sort of charmed light is shed'.

On the whole the picture was sympathetically received at the R.A. The critics recognised that it was a work of imagination and were thus willing to allow Turner more licence than normal in the use of his colours, although the *Morning Chronicle*, 26 May, was referring to this and to *The Golden Bough* (No. 355) when its critic wrote 'This season he has no sober moments—all art, in its "tipsy dance and revelry".' These two pictures were also noticed together by the *Spectator*, 10 May, which considered that 'the purity, harmony and transparency of Turner's colouring, redeem his pictures from the reproach of being wholly unnatural: but not all the magic of his pencil, nor the poetry of the scene justifies him in o'erstepping the modesty of nature.' However, both pictures were warmly praised in the *Literary Gazette*, 31 May, and this picture in particular in *Arnold's Magazine* for June, which wrote that 'The painter who transfers nature to canvass in her literal form is as different from TURNER as the historian from the novelist or the poet . . . a more gorgeous specimen of his genius never came before the public.'

355. The Golden Bough Exh. 1834 (Plate 334)

THE TATE GALLERY, LONDON (371)

Canvas, $41 \times 64\frac{1}{2}$ ($104 \times 163 \cdot 5$)

Coll. Robert Vernon, purchased before its exhibition at the R.A. 1834 and given to the National Gallery 1847; transferred to the Tate Gallery 1929.

Exh. R.A. 1834 (75); Toronto and Ottawa 1951 (8, repr.); Paris 1953 (81, pl. 33); Australian tour 1960 (11); Edinburgh 1968 (12).

Lit. 'The Vernon Gallery: The Golden Bough' in *Art Journal* 1851, p. 132, engr. T. A. Prior; Hall ii 1851, no. 22, engr. T. A. Prior; Hall 1851², p. 4 no. 7; Burnet 1852, p. 107, engr.; Cunningham 1852, pp. 29, 39, 44; Waagen 1854, i, p. 385; Ruskin 1857 and 1860 (1903–12, xiii, pp. 133, 159; vii, p. 421); Wornum 1857, ii, engr.; Thornbury 1862, i, p. 322; Wornum 1875, pp. 65–6, engr.; Thornbury 1877, p. 449; Vernon Heath, letter to *The Times* 23 April 1878; Hamerton 1879, pp. 261–3; Vernon Heath, *Recollections* 1892, pp. 5–7; Bell 1901, p. 124 no. 190; Armstrong 1902, pp. 192, 218; MacColl 1920, pp. 1–2; Whitley 1930, pp. 281–2; Falk 1938,

pp. 159–60; Finberg 1961, pp. 347, 498 no. 447; Kitson 1964, p. 75, repr. p. 56; Lindsay 1966, pp. 72, 180; Reynolds 1969, p. 161, pl. 144; Gage 1974, pp. 74–5, pl. 13 (caption wrongly exchanged with pl. 16).

Exhibited in 1834 with the reference '(*M.S.*, "*Fallacies of Hope*")'; Turner's original verses were, according to a report heard by Cunningham, suppressed by the Council of the R.A. Turner's original title (though not in his hand), number 1 on the list of his 1834 R.A. exhibits in the Tate Gallery archives, was also fuller: 'The Sibyl [the 'i' and 'y' originally written the other way round] gathering the golden bough', but the MS bears no verses. The painting has sometimes been described under the fuller title of 'Lake Avernus, the Fates and the Golden Bough'.

Ruskin, talking of *The Bay of Baiae* (No. 230), mentions the story of Deiphobe, the Cumaean Sibyl, and continues, 'The fable seems to have made a strong impression on Turner's mind, the picture of the "Golden Bough" being a sequence to this; showing the Lake of Avernus, and Deiphobe, now bearing the golden bough—the guide of Æneas to the shades. In both these pictures there is a snake in the foreground among the fairest leafage, a type of terror or temptation, which is associated with the lovely landscapes; and it is curious that Turner seems to have exerted all his strength to give the most alluring loveliness to the soft descents of the Avernus lake'.

As Gage has pointed out, Turner seems to have followed Virgil's *Æneid* vi, 136 ff., in the translation of Christopher Pitt. Only this version, unlike Dryden's, refers to the Golden Bough and, in its reference to the 'nether world' of 'the Queen of Stygian Jove', supplies a pretext for Turner's possible references to Hades and the Fates. The snake, and what seems to be a fox playing with it below the tree on the right, are seen by Gage as a reference to the underworld because, according to Aristotle, they both live underground; Gage also sees the fragment of a frieze of sarcophagus as having a similar reference.

Two or three years after Vernon bought the picture his nephew Vernon Heath noticed that a figure in the foreground was splitting away. Turner went to see the picture 'and in an instant exclaimed, "Why, this is only paper! I now remember all about it. I determined, the picture being all but finished, to paint a nude figure in the foreground, and with this intention went one night to the Life School at the Royal Academy, and made a sketch in my note-book. Finding, next day, that it was the exact size I required my figure to be, I carefully, by its outline, cut it out of the book and fixed it on to the picture, intending, when I had time, to paint the figure in properly. But I forgot this entirely, and do not think I should have remembered but for you." . . . The Sybil picture was then sent to Queen Anne Street and the present figure painted in.' Gage identifies the original figure with the fragment in the British Museum, in oil on paper (CCCLXIV-395, repr. *op. cit.* pl. 17), which

in fact shows three figures, identified by him as the Fates, which would have been replaced by the two figures now seen at the foot of the tree on the right.

There is a large colour sketch for the composition in the British Museum (CCLXIII-323).

Several critics saw Turner's conception as being let down by his execution. According to the *Athenaeum* for 10 May 1834 'the scene is wild and splendid—almost dim through excess of brightness, and the conception is wonderful, yet the slight and slovenly handling presses sorely upon us, and we mingle regret with admiration.' A similar notice appeared in the *Morning Chronicle* for 26 May, which particularly attacked the picture's yellowness. On the other hand the *Literary Gazette*, 31 May, wrote that 'Much criticism has been bestowed on these extraordinary performances'—this picture and *The Fountain of Indolence* (No. 354)—'and to some they are no doubt justly liable. Yet by what living artist but Mr. Turner could they have been produced? Whose mind is so replete with rare and gorgeous landscape imagery? What other hand could have produced such streams of rich and lucid colour over the canvass or have filled it with such masses—indistinct and unintelligible when closely inspected, but, when viewed at proper distance, assuming shape and meaning, and delighting the eye with the finest poetical and pictorial beauty?'

356. Venice Exh. 1834 (Plate 340)

NATIONAL GALLERY OF ART, WASHINGTON D.C.

Canvas, $35\frac{1}{2} \times 48$ (90·2 × 121·9)

Coll. Painted for Henry McConnell; bought in 1849 from McConnell by John Naylor of Leighton Hall, Welshpool; bought by Agnew from Mrs Naylor in 1910 through Dyer and Sons; sold through Sulley to P. A. B. Widener of Philadelphia who bequeathed it to the National Gallery, Washington in 1942 (Accession no. 681).

Exh. R.A. 1834 (175); Royal Manchester Institution 1834 (53); Liverpool Town Hall 1854 (2); Knoedler, New York 1914 (35).

Lit. Burnet and Cunningham 1852, p. 117 no. 179; Ruskin ('Venetian Index') 1853 (1903–12, xi, p. 428); Waagen 1854, iii, p. 241; Thornbury 1862, i, p. 322 (where he states that it was bought by Vernon); ii, pp. 239–40 (where it is confused with the Metropolitan picture (see No. 362)), 400; 1877, pp. 449, 577, 597; Bell 1901, p. 124 no. 191; Armstrong 1902, p. 234; W. Roberts, *Pictures in the Collection of P. A. B. Widener: British and Modern French Schools* 1915, no. 26; Whitley 1930, p. 281; Finberg 1930, pp. 85, 155; 1961, pp. 347–8, 498 nos. 448 and 453; Rothenstein and Butlin 1964, pp. 52, 54, pl. 98; Reynolds 1969, p. 161; Gaunt 1971, p. 8, colour pl. 28; George 1971, pp. 84–7, fig. 5; Morris 1974–5, p. 98 no. 196, fig. 65; Herrmann 1975, p. 233.

The evidence that this picture and the *Keelmen* (No.

360) were painted for McConnell is provided not only by John Naylor's inventory of his pictures begun in 1856, where this is expressly stated to have been the case, but also in a letter written on 28 May 1861 by McConnell to Naylor:

'I cannot overcome my hankering after one of the Turners. I know, at least, I feel pretty certain, nothing would tempt you to part with the Venice; but are you irresistibly determined not to part with the Moonlight? [*Keelmen*]. I believe I can get other Turners, but yours, being painted at my especial suggestion, produce a yearning of the spirit which others do not.' Whether the phrase 'painted at my especial suggestion' is indicative of a direct commission is a matter of interpretation. McConnell wrote of this picture (*Athenaeum* 1861, p. 808) that 'before it had hung one week on the walls of the Academy, I paid without the slightest objection or hesitation £350, the price which he had fixed for the picture and 300£ a larger sum than Turner had asked, was a year or more afterwards paid for that beautiful creation of 'Lightermen heaving in Coals by Night at South Shields'.

This account suggests that the pictures were painted for McConnell but that the prices were not definitely agreed at the time, as occasionally occurs elsewhere in Turner's relationship with his patrons. Certainly this seems to have been the case with the *Keelmen*.

The *Venice* was dispatched by Turner to McConnell in Manchester on 9 August 1834 (Turner's letter to McConnell arranging this is to be published by Gage), thus just in time to be shown again at the Royal Manchester Institution's Exhibition which opened on 20 August.

The fact that the *Venice* was painted at McConnell's suggestion surely clears Turner of the charge of having painted it in order to outshine Clarkson Stanfield (whatever may have occurred in 1833; see entry for No. 349), whose view of Venice, commissioned by Lord Lansdowne, was also exhibited at the R.A. (249). It was the *Morning Chronicle* for 26 May that laid this accusation at Turner's door: 'We are loth to praise Mr. Turner on this occasion; he has done an ill-natured thing here, because the Marquess gave Mr. S. the commission and did not give it to him, and his poetry and superior skill do not look lovely in such a struggle.' Later on in the same notice, however, the reviewer admits that this is Turner's 'best piece' in the Exhibition. In fact there seems little evidence for the *Morning Chronicle*'s imputations and the fact that Turner and Stanfield were apparently on good terms at this time might seem to refute them.

Mr Hardy George's article proves that Turner paid a visit to Venice in September 1833, and it was perhaps from sketches made on this trip that McConnell suggested that Turner should paint this picture.

The *Spectator* for 10 May thought it 'dazzling, like a bright vision of its glory—and as unreal', but it was praised by the *Athenaeum*, 10 May, as 'a splendid view and the only one of Turner's five exhibits which could not be accused of being too slight, and in some parts

slovenly.' The *Literary Gazette* for 10 May also singled it out as displaying Turner's 'poetical imagination and splendid colouring.'

It was also warmly praised when exhibited again later in 1834 at the Royal Manchester Institution. The *Manchester Courier and Lancashire General Advertiser*, 18 October, considered that 'no artist, perhaps, ever showed such a mastery over his colours, availing himself of the most brilliant, we had almost said glaring, and yet harmonizing them so charmingly that the eye is never offended though frequently dazzled.' The *Manchester Guardian*, 30 August, wrote '. . . We stand transfixed, we ask no name—nor open we the catalogue, and as we look on the waters of peerless Venice, we confess by our enraptured, breathless attitude, the power of the unrivalled and gorgeous TURNER.' The same review also notes that this picture was 'the first from that masterly hand, which has honoured and graced our walls.' (This was not in fact true as *Linlithgow Palace* (No. 104) had been shown there in 1829.)

357. Wreckers,—Coast of Northumberland, with a Steam-Boat assisting a Ship off Shore
Exh. 1834 (Plate 336)

MRS LYON SLATER, NEW YORK

Canvas, 36 × 48 (91·4 × 121·9)

Coll. Bought from Turner by Elhanan Bicknell in 1844 together with five other Turner oils; Bicknell sale Christie's 25 April 1863 (108) bought Agnew; John (later Sir John) Pender; sale Christie's 29 May 1897 (83) bought Wallis; A. M. Byers of Pittsburgh by 1901; by descent to the present owner.

Exh. R.A. 1834 (199); B.I. 1836 (53); R.S.A. 1849 (339); Manchester 1887 (622); R.A. 1891 (21) and 1896 (128).

Lit. Burnet and Cunningham 1852, p. 117 no. 180; Thornbury 1862, ii, p. 401; 1877, pp. 577, 599; T. S. Cooper *My Life* 1890, ii, pp. 5–6; Bell 1901, p. 125 no. 192; Armstrong 1902, pp. 120, 237; Boase 1959, p. 341; Finberg 1961, pp. 348, 358, 399, 498 no. 449, 500 no. 466, 516 no. 585a; Rothenstein and Butlin 1964, p. 60; Lindsay 1966, pp. 176, 182.

This possibly records a scene witnessed by Turner on his way back from Scotland in September 1831; no drawing for it has so far been traced, but if the castle in the background is Dunstanborough (see Nos. 6 and 32), as it seems almost certainly to be, then Turner had ample material in his sketchbooks relating to the subject which he could have drawn on, e.g., XXXIII-S and XXXVI-S both dating from Turner's initial visit in 1797. Turner had also painted Dunstanborough more recently in a watercolour of *c.* 1828 (City Art Gallery, Manchester) which had been engraved for the *England and Wales* series. This drawing had been exhibited in London in 1833.

This picture, which has not been exhibited during this century and is therefore virtually unknown, is, in the opinion of the compiler, one of Turner's masterpieces, containing some breathtaking passages: for example, the way in which Turner has painted the spray drifting in front of the castle.

The composition, in which the diagonal line of the shore is balanced by the castle on its promontory, foreshadows, in its essentials, the same arrangement which Turner was to adopt in the first of his two versions of *The Burning of the Houses of Parliament* (No. 359) which he was to exhibit the following spring.

At the Academy the picture did not receive much notice compared to *The Fountain of Indolence* (No. 354) and *The Golden Bough* (No. 355) but it was praised in the *Spectator* for 10 May as combining 'the truth of nature with the splendour of Turner.' The only notice of any length appeared in *Arnold's Magazine* for May–June which suggested that Turner had here followed the practice of the Dutch seventeenth-century marine painter Ludolf Bakhuyzen who was 'in the habit of putting to sea in the most tempestuous of weather, that he might behold the waves mounting to the clouds, or dashing against the rocks' (*c.f.* Turner's experience in *Ariel* in 1841, see No. 398). The review continued by saying that 'there is perhaps no branch of art which presents a wider field for exaggeration than that of marine-painting' but that in this case Turner had produced 'one of the most natural representations that ever came from the hands of this, or any other master.'

When exhibited again in 1836 at the British Institution, the *Examiner* described it as 'a very great picture . . . a production of true genius.' Thomas Sidney Cooper, R.A., considered that 'in thought and fancy it stands unparalleled even by other works of his own.'

358. St Michael's Mount, Cornwall Exh. 1834
(Plate 337)

THE VICTORIA AND ALBERT MUSEUM, LONDON

Canvas, 24 × 30½ (61 × 77·4)

Coll. Bought by John Sheepshanks probably at the R.A. exhibition (or perhaps commissioned by him—see below) and given by him to the Victoria and Albert Museum in 1857 (Accession no. 209).

Exh. R.A. 1834 (317); Antwerp Festzaal *Harbours Exhibition* 1973 (25, repr. pl. 85).

Engr. By J. Cousen in the *Art Journal* and in the *Turner Gallery* 1859; by W. Miller 1866.

Lit. Burnet and Cunningham 1852, pp. 29, 44, 117 no. 181; Waagen 1854, ii, p. 305; Thornbury 1862, i, p. 322; 1877, pp. 449, 577; Bell 1901, p. 125 no. 193; Armstrong 1902, pp. 120, 228; Rawlinson ii 1913, pp. 207, 208, 354, 358; Finberg 1961, pp. 348, 498 no. 450; V.A.M. catalogue 1973, p. 138.

A subject which Turner drew on a number of occasions.

Sketches occur in the 'Ivy Bridge to Penzance' sketchbook (CXXV) in use in 1811. The subject was engraved in the *Southern Coast* series in 1814, as a vignette illustration to *Milton's Poetical Works* in 1835, and in the *England and Wales* series.

This version in oil is taken from the same viewpoint as the watercolour engraved in 1814, rather than the *England and Wales* drawing (probably executed *c.* 1830 but not engraved until 1838), although in the oil Turner has characteristically increased the height of the Mount considerably.

The fact that this picture and *Line-Fishing off Hastings* (No. 363), exhibited in the following year, were both acquired by Sheepshanks naturally raises the question of whether they were in fact commissioned by Sheepshanks, as for instance were Nos. 356 and 360, also exhibited respectively in 1834 and 1835, by Henry McConnell. As Sheepshanks does not appear to have been a very *avant-garde* collector, the fact that both this picture and the *Line-Fishing off Hastings* were based, albeit loosely, on earlier watercolours, would seem to increase the likelihood that they were ordered by Sheepshanks, although the only evidence to support this comes from Burnet who records that both pictures were 'painted for Mr. Sheepshanks', but he is not always reliable in this respect. Certainly, despite the opinion of the critic of the *Morning Post* quoted below, both these pictures seem relatively conventional when viewed in the context of Turner's other exhibited pictures of the mid-1830s.

No doubt because of its comparatively small size, it did not attract much attention at the Academy, although *Arnold's Magazine* for July rather surprisingly refers to it as 'one of the most conspicuous' among the exhibits, and says that 'although the scene cannot be said to convey a literal idea of the object chosen for representation, we have little doubt it corresponds precisely with that which the artist had conjured up in his imagination.'

The *Morning Post*, 17 July, described it as 'a favourable specimen of his new style of painting; but we ourselves are old-fashioned enough to prefer his discarded one as coming more within the limits of our comprehensions, and nearer, as we think, to nature.'

At the R.A. it hung close to Callcott's *Recollection of the Campagna of Rome* (R.A. 316) which led the critic of the *Spectator* for 10 May to point out that, on comparing the two pictures, 'the difference of these, the two first English landscape painters, is made strikingly evident. Callcott's colours look opaque and heavy, and Turner's painting unsubstantial and visionary.'

359. The Burning of the House of Lords and Commons, 16th October, 1834 Exh. 1835

(Plate 338)

THE PHILADELPHIA MUSEUM OF ART

Canvas, 36¼ × 48½ (92 × 123)

Coll. Bought at the British Institution Exhibition in 1835 by Chambers Hall (the purchase is recorded in the *Literary Gazette* for 25 April, the day the exhibition closed); sold by Hall to a Mr Colls according to Burnet; Charles Birch by 1852; Lloyd Bros; sale Foster's 13 June 1855 (59) bought Wallis; H. Wallis; sale Christie's 16 November 1860 (209) bought White; C. J. Palmer; his executors' sale Christie's 16 May 1868 (133) bought Agnew; John Graham; bought back from him by Agnew in 1873 and sold to Holbrook Gaskell; sale Christie's 24 June 1909 (97) bought Agnew; sold to J. H. McFadden of Philadelphia, by whom it was bequeathed to the Museum in 1921.

Graves is wrong in identifying the vendor in 1868 as 'Fisher' (*Art Sales* iii 1921, p. 225) although this name does appear in ink in Christie's annotated sale catalogue opposite lot 133. However, the front page of the sale catalogue specified that this picture was being sold by the executors of C. J. Palmer of Portland Place, so the obvious inference is that Fisher was one of them.

Exh. B.I. 1835 (58); Royal Birmingham Society of Artists 1852 (114 lent by Charles Birch); R.A. 1885 (197) and 1907 (113); New York, 1966 (9); on loan to the Tate Gallery autumn 1966; Detroit and Philadelphia 1968 (120); Berlin 1972 (18); R.A. 1974–5 (512).

Lit. Ruskin 1843, 1851 (1903–12, iii, p. 423; xii, p. 389); Thornbury 1862, i, p. 327; ii, pp. 166, 217–18; 1877, pp. 313, 452–3(?), 534–5, 582; Bell 1901, pp. 128–9 no. 199; Armstrong 1902, pp. 117 and n., 120, 146, 236; Whitley 1930, pp. 292–4; Falk 1938, pp. 137–8, 157, 250, 251; Clare 1951, pp. 101–2; Finberg 1961, pp. 351–2, 499 no. 458; Rothenstein and Butlin 1964, p. 54; Lindsay 1966, pp. 178–81, 187, 204; Gage 1969, pp. 35, 117, 169, colour pl. 11 (reversed); Reynolds 1969, pp. 164–5, 197; Clark 1973, p. 256, colour pl. 17; Herrmann 1975, p. 42, pl. 141.

The fire which destroyed the Houses of Parliament broke out in the early evening of 16 October 1834 and vast crowds, Turner among them, rushed to watch the spectacle. So great was the throng that the army was called in to assist the police in controlling it. Westminster Hall was in great danger of destruction, but a fortunate change in the direction of the wind saved it in the nick of time. (In fact in both this version and that in Cleveland (No. 364), Turner has changed the direction of the flames which really blew back towards the Abbey and not over the river.) At half-past nine the roof of the House of Lords fell in, and, according to a writer in the *Gentleman's Magazine*, 'so struck were the bystanders with the grandeur of the sight at this moment that they involuntarily (and from no bad feeling) clapped their hands as though they had been present at the closing scene of some dramatic spectacle.'

It is impossible to think of any European artist more fitted to record such a scene than Turner. If depicting disaster was his *forte*, to adapt a misquotation about his

own work, in the past he had often had to search the Old Testament or mythology for such subjects—but here was a natural disaster taking place before his eyes. Turner recorded his impressions in the two 'Burning of the Houses of Parliament' sketchbooks (CCLXXXIII and CCLXXXIV), the latter in pencil and the former in colour. It has been suggested that the blotting of the watercolours was caused by Turner's haste in turning the pages before they were dry in order to record a further aspect of the fire, but this view has been challenged by Mr Eric Harding of the British Museum (see Gage, p. 231, n. 91) who believes that this may have been due to the immersion of the sketchbook in the Tate Gallery flood in 1928. Whatever the reason for the blotting, the rapidity of the sketches cannot be denied and conveys something of Turner's excitement at such a wondrous spectacle. Looking at them carefully, it seems impossible to doubt that they were done on the spot.

Whatever preliminary sketches Turner may have had to hand, he does not seem to have made much use of them (except for a finished watercolour, CCCLXIV no. 373) to judge from the following account from the *Art Journal* (1860, p. 100) written by the Norfolk artist E. V. Rippingille (1798–1859). It provides such important evidence of Turner's methods of work that it deserves to be quoted almost in full. It describes the scene at the British Institution on one of the Varnishing Days.

Turner 'was there, and at work' wrote Rippingille, 'before I came, having set-to at the earliest hour allowed. Indeed it was quite necessary to make the best of his time, as the picture when sent in was a mere dab of several colours, and "without form and void," like chaos before the creation. The managers knew that a picture would be sent there, and would not have hesitated, knowing to whom it belonged, to have received and hung up a bare canvas, than which this was but little better. Such a magician, performing his incantations in public, was an object of interest and attraction. Etty was working by his side [on his picture "The Lute Player"] and every now and then a word and a quiet laugh emanated and passed between the two great painters. Little Etty stepped back every now and then to look at the effect of his picture, lolling his head on one side and half closing his eyes, and sometimes speaking to some one near him, after the approved manner of painters: but not so Turner; for the three hours I was there—and I understood it had been the same since he began in the morning—he never ceased to work, or even once looked or turned from the wall on which his picture hung. All lookers-on were amused by the figure Turner exhibited in himself, and the process he was pursuing with his picture. A small box of colours, a few very small brushes, and a vial or two, were at his feet, very inconveniently placed; but his short figure, stooping, enabled him to reach what he wanted very readily. Leaning forward and sideways over to the right, the left-hand metal button of his blue coat rose six inches higher than the right, and his head buried in his

shoulders and held down, presented an aspect curious to all beholders, who whispered their remarks to each other, and quietly laughed to themselves. In one part of the mysterious proceedings Turner, who worked almost entirely with his palette knife, was observed to be rolling and spreading a lump of half-transparent stuff over his picture, the size of a finger in length and thickness. As Callcott was looking on I ventured to say to him, "What is that he is plastering his picture with?" to which inquiry it was replied, "I should be sorry to be the man to ask him." ... Presently the work was finished: Turner gathered his tools together, put them into and shut up the box, and then, with his face still turned to the wall, and at the same distance from it, went sidling off, without speaking a word to anybody, and when he came to the staircase, in the centre of the room, hurried down as fast as he could. All looked with a half-wondering smile, and Maclise, who stood near, remarked, "There, that's masterly, he does not stop to look at his work; he *knows* it is done, and he is off."'

As can be imagined, Turner's rendering of such a scene, still fresh in the minds of many visitors to the exhibition, was eagerly sought out. Inevitably, faults were pointed out in it (a general complaint being that the sky was too light a blue for a scene at night) but on the whole the critics had to admit that Turner's painting had captured the confusion, wonder and horror of the occasion to a marvellous extent.

The Times for 10 February considered that 'in this very difficult undertaking Mr. Turner has only partially succeeded. The effect in general is good, but the details require to be better defined.' In a long review in the *Spectator*, 14 February, although the painting of the crowd is criticised as well as the effect of daylight which 'is not counter-balanced by the gas-lamp in the foreground', the writer admits that 'Turner's picture transcends its neighbours as the sun eclipses the moon and the stars', and later on, 'Turner seems to paint slovenlily—daubing, as one would say; yet what other painter preserves equal clearness of colour?' The *Athenaeum* for 14 February called it 'a splendid impossibility' and considered that in it 'truth is sacrificed for effect, which, however, is, in parts of the picture, magnificent.' The *Literary Gazette*, 14 February, pointed out that 'it is the contrast of warm and cold, of the blazing flame and of the early morning before "the stars are all burnt out" that gives magic to the scene; which manifests quite as much of vision and poetry as of nature.' (It was this same warm–cool contrast that Turner was to use again in *The Fighting Temeraire*, No. 377). The *Examiner* for 8 March called it 'one of the noblest pieces of execution we have ever seen' but stressed, as did other critics, the necessity of standing at a proper distance from it in order to appreciate it.

Lawrence Gowing, in the catalogue of the exhibition held at the Museum of Modern Art in 1966, points out that this version is more consciously dramatic than that in Cleveland and compares it to a Romantic Opera, with elaborate scenery and full chorus of horrified spectators.

Besides the version in Cleveland (No. 364), Armstrong states that Turner painted the subject at least once more in oil and lists a smaller canvas, 19¾ × 23½ in., which belonged to Arthur Sanderson in 1902, was sold at Christie's on 3 July 1908 and was later with Sedelmeyer in Paris. Its present whereabouts is unknown but from a poor photograph in the Witt Library it would appear to be a pastiche of the Philadelphia picture. Nor can a small oil sketch on panel (5½ × 7½ in.) in the collection of Mr and Mrs Paul Mellon (exh. Washington 1968–9 (12)) be considered authentic.

360. Keelmen heaving in Coals by Night
Exh. 1835 (Plate 341)

NATIONAL GALLERY OF ART, WASHINGTON D.C.

Canvas, 35½ × 48 (90·2 × 121·9)

Signed 'J M W T' on the buoy on left

Coll. Painted for Henry McConnell (see below); bought in 1849 from McConnell by John Naylor of Leighton Hall, Welshpool; bought by Agnew from Mrs Naylor in 1910 through Dyer and Sons; Sulley and Co.; P. A. B. Widener of Philadelphia who bequeathed it to the National Gallery, Washington with the rest of his collection in 1942 (Accession no. 682).

Exh. R.A. 1835 (24); Royal Manchester Institution 1835 (260) as 'Moonlight' (this followed the showing of *Venice* (No. 356) in the previous year and is how McConnell referred to the picture in his letter to Naylor in 1861 (see No. 356)); Liverpool Town Hall 1854 (21); R.A. 1887 (14); Knoedler, New York 1914 (36); R.A. 1974–5 (513).

Lit. Burnet and Cunningham 1852, p. 117 no. 182; Waagen 1854, iii, p. 242 (?), where it is listed as: 'A harbour in a cool morning mist; a somewhat decorative effect'. Although this is rather a bizarre way to describe the *Keelmen*, Waagen's visit took place in 1850 when Naylor seems to have owned only two Turner oils: this picture and the companion picture of *Venice* which is also mentioned by Waagen. There remains a possibility that Waagen was referring to *Mercury and Argus* (No. 367) but there is no evidence that Naylor owned it as early as 1850; Thornbury 1862, ii, pp. 239, 400; 1877, p. 577, 597; Ruskin 1886 (1903–12, xxxv, p. 217); Bell 1901, p. 126 no. 194; Armstrong 1902, p. 223; W. Roberts, *Pictures in the Collection of P. A. B. Widener: British and Modern French Schools* 1915, no. 27; Whitley 1930, p. 298; Finberg 1961, pp. 354, 499 no. 459; Rothenstein and Butlin 1964, p. 54, pl. 99; Kitson 1964, p. 83, repr. in colour p. 59; Reynolds 1969, pp. 81, 165, fig. 143; Gaunt 1971, p. 8, colour pl. 28; Clark 1973, p. 256, colour pl. 16; Morris 1974–5, p. 98 no. 197, fig. 66; Herrmann 1975, pp. 42–3, 233, pl. 143.

The composition follows fairly closely that of the *Shields on the River Tyne* (CCVIII-V, signed and dated 1823) which was engraved by C. Turner in *The Rivers of England* series in 1823. In the oil, however, Turner has put the ships further into the distance and has also widened the channel between the two lines of ships, thus greatly increasing the sense of space in the composition.

When this picture was exhibited at Burlington House in 1887, the reviewer in *The Times*, 11 January, described it as 'puzzling' but added that 'there can hardly be a question about the genuineness of this canvas.' This element of doubt was refuted in a letter from the painter J. C. Horsley, R.A. (1817–1903), published on 29 January. Horsley stated that it was painted on commission for Mr Henry McConnell of Manchester and recalled how he, when a student, admired it—at the time it was exhibited in 1835—'with all the enthusiasm I do now . . . To regard the work in any other light than as one stamped in every square inch of it with the painter's marvellous power and poetic genius is to me impossible.' Horsley then goes on to quote the letter from McConnell to Naylor (written in 1861 and printed in the entry for No. 356) in which he asked Naylor if he would consider selling this picture back to him, but Naylor refused to part with it.

Keelmen was painted as a companion to McConnell's *Venice*, exhibited in the previous year. McConnell, a Manchester textile manufacturer, may have suggested to Turner that he should paint a pair of pictures contrasting the sunlit indolence of Venice with the smoke and bustling activity, carried on even by night, of the industrial north of England. Although the compositions are in general similar, that of *Venice* is rather more crowded, perhaps because Turner wished to underline the point that this apparently more animated scene in reality masked a city declining in power and prestige. Furthermore, the significance of Venice as a port was also on the wane, in contrast to the growing wealth and importance of Britain as a mercantile nation, personified here by the keelmen of Tyneside.

A letter from Turner to McConnell written in January 1836 (to be published by Gage) almost certainly refers to *Keelmen*: 'I write merely to say I received your letter *asking me for my account* which I left to you to decide upon for me *as to the amount*.' This would seem to fit in with McConnell's account of the transaction, recounted in the entry for No. 356, in which he states that he paid £300 for the picture 'a year or more later' (after paying for the *Venice*) 'a larger sum than Turner had asked'. This makes it seem as if McConnell thought Turner had originally priced *Keelmen* at £250 while *Venice* was £350, showing that Turner was aware how much subject matter counts in pricing a picture. Indeed it is interesting to note that, to judge from McConnell's letter, Naylor certainly—and perhaps McConnell also—preferred *Venice* whereas today the preference would seem equally surely to lie with *Keelmen*.

On the whole the picture was admired at the R.A. The *Literary Gazette* for 9 May wrote: 'And such a night!—a flood of glorious moon-light wasted upon dingy coal-whippers, instead of conducting lovers to the appointed bower.' *The Times* for 23 May called it 'one of those masterly productions by which the artist contrives to convey very striking effects with just so much adherence to nature as prevents one from saying they are merely fanciful. It represents neither night nor day, and yet the general effect is very agreeable and surprising', while the *Spectator* for 9 May thought that 'the tone seems too like daylight; but a year or two hence it will be as bright and true a night scene as ever—or rather *never* was painted.'

Fraser's Magazine for July noted that it 'is thought highly of; it is nevertheless a failure. The night is not night; and the keelmen and the coals are any thing.' The *Morning Chronicle*, 6 May, agreed that the sky was 'in parts far too blue for a night scene' but thought the picture to be 'the most effective and correct of the five contributions of its singular author.'

Ruskin recalled the picture as 'being of little charm in colour' but admitted that the impressions that the Academy Turners produced on him before 1836 were confused.

361. The Bright Stone of Honour (Ehrenbreitstein), and Tomb of Marceau, from Byron's 'Childe Harold' Exh. 1835 (Plate 335)

PRIVATE COLLECTION, LONDON

Canvas, $36\frac{1}{4} \times 48\frac{1}{2}$ (93 × 123)

Coll. Painted for John Pye, the engraver; this commission has only recently come to light among the Pye MSS in the Victoria and Albert Museum and was discovered by Gage. It seems clear from Pye's letter to Turner of 19 August 1835 that originally a drawing had been contemplated but that this was later changed to a picture which was lent to Pye for the purpose of a plate being engraved from it. In his MS memoir Pye states that it was intended that Turner should paint a picture for Pye to engrave while he was abroad educating his daughter, but that *Ehrenbreitstein* proved too large to take, so it was not engraved until he returned. In fact the engraving was not published until 1845, after the picture had been sold to Elhanan Bicknell. The agreement between Pye and Turner seems to have been subject to much dispute but one of the terms agreed was that the picture was 'to be returned to Mr. Turner within the space of five years from its delivery to Mr. Pye and as much earlier as can be effected consistently with Mr. Pye's professional engagements'. This accounts for its presence in Turner's studio in 1844 when it was bought by Bicknell among a group of six paintings by Turner; Bicknell sale Christie's 25 April 1863 (118) bought Agnew for Ralph Brocklebank; sold in 1942 on behalf of the trustees of Captain H. C. R.

Brocklebank by Agnew to the second Viscount Allendale; sale Sotheby's 7 July 1965 (90) bought Agnew for the father of the present owners.

Although Bicknell bought the picture in 1844 it is clear from the following letter from him to John Pye of 23 June 1845 (referred to by Gage) that he had great difficulty in getting Turner to release it: 'My getting the painting *appears* as distant now as it was in March 1844. I thought I had only to send to Queen Anne Street to have it—but the grim master of the Castle Giant Grimbo shakes his head and says he and you must first agree that all is done to the plate that is necessary, and the picture will be wanted to refer to.'

Exh. R.A. 1835 (74); Liverpool Art Club 1881 (38); R.A. 1883 (211); Guildhall 1899 (33); Agnew 1967 (19); Paris 1972 (266); Berlin 1972 (19); Victoria and Albert Museum *Byron* 1974 (S38); R.A. 1974–5 (514); Hamburg 1976 (106).

Engr. By John Pye 1845 and by J. Cousen in the *Turner Gallery* 1859.

Lit. Waagen 1838, ii, p. 152; Burnet and Cunningham 1852, p. 117 no. 183; Thornbury 1862, i, pp. 326–7, 380; ii, p. 401; 1877, pp. 452, 578, 599; Wedmore 1900, ii, repr. facing p. 234; Bell 1901, p. 126 no. 195; Armstrong 1902, pp. 120, 221, repr, facing p. 146; Rawlinson ii 1913, pp. 206, 208, 342, 358; Whitley 1930, p. 298; Finberg 1961, pp. 355, 399, 499 no. 460; Rothenstein and Butlin 1964, p. 56; Lindsay 1966, p. 246; Reynolds 1969, p. 81.

Exhibited with the following quotation from Canto III of *Childe Harold* (the lines are mainly from verse lvi with additions from lvii and lviii):

'By Coblentz, on a rise of gentle ground,
There is a small and simple pyramid,
Crowning the summit of the verdant mound;
Beneath its base are heroes' ashes hid,
Our enemy's—but let that not forbid
Honour to Marceau ————————
———————— He was freedom's champion!
Here Ehrenbreitstein, with her shattered wall,
Yet shows of what she was . . .'

In fact when Turner submitted the picture to the Royal Academy, his quotation included a further three lines from verse lvii:

'But peace destroyed what war could never blight,
And laid those proud roofs bare to Summer's rain—
On which the iron shower for years had pour'd in
 vain'

So presumably the authorities at the Academy must have decided to shorten the quotation. The manuscript of Turner's entries for the exhibition, addressed to Henry Howard, R.A., at the Royal Academy, now belongs to Dr Max Thore of Chicago. I owe this information to the kindness of John Gage.

The poem alludes to an incident in the campaign of

1796 when the French Revolutionary General Marceau was killed by a bullet during the siege of the fortress of Ehrenbreitstein, near Coblentz.

Turner had visited Ehrenbreitstein on his tour of the Rhine in 1817 and again in 1834 in connection with a projected series of engravings of German rivers, which was to follow *The Rivers of France* but which never came to anything.

Turner made a number of sketches of the scene; in particular, there is in the Turner Bequest a large sheet, folded into 16 sections, which has a number of drawings connected with this picture (CCCXLIV nos. 1–16, especially nos. 1, 3 and 6).

Here Turner is in the happy position of painting a picture which combines an allusion to the poet whose work clearly inspired him increasingly during the 1830s with a subject in nature which evidently fascinated him to an unusual degree.

Turner was to capture the craggy splendour of Ehrenbreitstein in watercolour again and again in the early 1840s in a series of superb drawings (CCCLXIV-285, 319, 328, 346) showing the fortress under differing conditions of light and at different times of day, almost analogous to Monet's studies of Rouen Cathedral, or, in his own work, to his numerous sketches of the Rigi, Lake Lucerne, drawn *c.* 1841.

In 1835 Gustave Planche wrote of *Ehrenbreitstein* (*Revue des Deux Mondes* 4 serie ii, p. 680 ff.): 'il m'est impossible de croire qu'un pareil paysage ait jamais existé ailleurs que dans la royaume des fées; je ne dis rien des figures, qui sont informes et grossières ... Est-ce (la montagne) de l'or, de l'acajou, du velours ou du biscuit? La pensée se fatigue en conjectures et ne sait ou s'arrêter. Le ciel où nagent les lignes de l'horizon est lumineux et diaphane. Mais ni L'Espagne, ni L'Italie, ni les rives du Bosphore, n'ont pu servir de type à Turner pour la création de cette splendide atmosphère ...'

The picture was also praised by the English critics. *The Times* of 23 May considered that 'the force of colour and the admirable harmony of tone are not to be equalled by any living artist.' The writer in *Fraser's Magazine* (xii no. lxvii, p. 52) found it 'beautiful' and superior to Turner's other exhibits at the R.A. The *Spectator* for 9 May thought it 'a splendid tribute of genius to one of the champions of freedom', while the *Athenaeum*, 23 May, wrote 'Imagination and reality strive for mastery in this noble picture.' Dr Waagen, however, on his first visit to Britain was sharply critical. On going to the Academy, he made a point of seeking out the pictures by Turner whose work 'was known throughout Europe where they appear in beautiful steel engravings'. Faced by Turner in the original, Waagen wrote 'But I could scarcely trust my eyes when, in a view of Ehrenbreitstein ... I found such a looseness, such a total want of truth, as I had never before met with. He has here succeeded in combining a crude, painted medley with a general foggy appearance.'

362. Venice, from the Porch of Madonna della Salute Exh. 1835 (Plate 342)

THE METROPOLITAN MUSEUM, NEW YORK

Canvas, 36 × 48 (91·4 × 122)

Coll. H. A. J. Munro of Novar; according to Thornbury, Turner's trip to Venice, now known to have taken place in 1833, had been financed by Munro. Turner had been commissioned to make a watercolour but produced this oil instead, 'which Mr. Munro never much took to. The artist, who was greatly mortified at seeing his patron's disappointment, at first declined to sell him the picture; but at last he consented.' Munro sale Christie's 26 March 1860 (150) bought Gambart; John Heugh from whom bought by Agnew in 1862 and sold to Sam Mendel of Manley Hall, Manchester; sale Christie's 24 April 1875 (445) bought Agnew; in describing the sale, Redford reported (*Art Sales* ii 1888, p. 121) 'Lord Dudley bid against Agnew, but gave in, and afterwards bought the picture off him at his 10 per cent advance'; sold by Lord Dudley *c.* 1890; Cornelius Vanderbilt who presented it to the Metropolitan Museum, New York, in 1899 (Accession no. 99.31).

Exh. R.A. 1835 (155); Royal Manchester Institution 1866 (637); Boston 1946 (12); Agnew 1967 (18).

Engr. By W. Miller, published 1 June 1838, and by R. Brandard in the *Turner Gallery* 1875.

Lit. Burnet and Cunningham 1852, p. 117 no. 184; Waagen 1854, ii, p. 141; Ruskin 1853, 1857, 1860, 1872 (catalogue of the Ruskin Collection at Oxford), 1878, 1886 (1903–12, x, p. xxix; xiii, p. 213; vii, p. 149 n.; xxi, p. 41; xiii, p. 498; xxxv, p. 256); Thornbury 1862, i, pp. 232, 326; ii, p. 399; 1877, p. 105, 452, 578, 596; Manley Hall Catalogue 1867, no. 125; Monkhouse 1879, p. 124; Bell 1901, p. 127 no. 196; Armstrong 1902, p. 234; Rawlinson ii 1913, pp. 206, 208, 333, 358; Finberg 1930, pp. 85, 155; 1961, pp. 355, 499 no. 461; Rothenstein and Butlin 1964, p. 52; Reynolds 1969, p. 158.

Mr Jeremy Maas has recently acquired a letter from Ruskin senior to Gambart, written on 26 April 1860 a month after the latter had bought this picture at the Munro sale. Ruskin senior considered that this picture should be in the Louvre, which lacked a Turner, and proposed that, if twenty men could be found who would give £100 each, he would give £500. (The picture fetched £2,520 at the sale and Gambart was asked to forego his commission.) A few days later, Ruskin senior had Gambart and eight others to lunch which suggests that £800 had been raised but the balance was evidently not forthcoming and Gambart later sold the picture to John Heugh. The Louvre then had to wait for over a hundred years before acquiring its first oil by Turner in 1967 (see No. 509).

Finberg, following Ruskin (who says it is 'the first

idea') suggests that a watercolour in the 'Roll Sketch-book of Venice' (CCCXV p. 5) may be a sketch for this picture. However, the watermark, Whatman 1834, now that Turner's second visit is known to have taken place in 1833 and as he did not return until 1840, suggests that this sketchbook was used on the later visit and this is supported on stylistic grounds. In any case the view is taken looking towards the Rialto rather than, as in the oil, towards the Dogana. A pencil drawing (CLXXV p. 67 verso), dating from Turner's first visit to Venice in 1819, was certainly one of the sources he used for this picture. As Miss Barbara Reise has pointed out, the picture is based on an amalgam of two viewpoints: the buildings on the left are seen from the corner of the steps of the Salute while those on the right are seen from a point across the canal and about 100 yards further up it from the edge of the Campo del Traghetto de Sta Maria del Giglio. Although Turner has taken some liberties (e.g., the elongation of the Campanile and the addition of the tall building between the Salute and the Dogana) the view is on the whole fairly accurate topographically.

Turner later used substantially the same view, but drawn from the steps of the Salute, in a watercolour of 1840 which is now in the R. W. Lloyd Bequest in the British Museum (Inventory no. 1958-7-12-443, exh. B.M. 1975–6 (259, repr. in colour).)

Turner's pictures at the R.A. were criticised in general in the *Examiner* on 10 May but the writer still considered Turner 'the first landscape painter in the world'. *Fraser's Magazine* (xii no. lxvii pp. 52–5) thought this picture 'a piece of brilliant obscurity' and counselled Turner not to fancy 'that in order to be poetical it is necessary to be almost unintelligible' and recommended him to study attentively that 'exquisitely fine scene of the *Grand Canal* by Harding in the water-colour Exhibition'. (The Harding now belongs to Mr and Mrs Paul Mellon; it was shown in Agnew's 103rd Annual Watercolour Exhibition 1976 (93, repr. in colour on front cover).)

This insult apart, the picture was warmly praised in the *Literary Gazette* for 9 May which admired 'its general gaiety', in *The Times* for 23 May which considered it one 'of his most agreeable works', and above all, by the *Spectator* for 9 May which referred to it (mistakenly) as a companion to the 'Ducal Palace' of 1834 (No. 356) and ended its notice 'It is a superb picture.' The *Observer* for 10 May repeated the contention, already noticed under the entry for No. 356, that Turner's Venetian scenes were painted in de-liberate rivalry to Clarkson Stanfield's and in order to show Lord Lansdowne how mistaken he had been in commissioning views of Venice from Stanfield rather than employing him. The *Observer* claimed that Turner 'could get no repose while Mr. S. is proceeding with the Marquess of Lansdowne's commission . . .' but it seems as if the rivalry, already recorded in 1833 (see No. 349), was here unjustifiably assumed to have continued in 1834 and 1835.

363. Line-Fishing, off Hastings Exh. 1835
(Plate 381)

THE VICTORIA AND ALBERT MUSEUM, LONDON

Canvas, 23 × 30 (58·4 × 76·2)

Coll. Bought at the R.A. Exhibition in 1835 by John Sheepshanks (or possibly commissioned by him—see below); given by him to the Victoria and Albert Museum in 1857 (Accession no. 207).

Exh. R.A. 1835 (234).

Engr. By W. Miller in the *Turner Gallery* 1859.

Lit. Burnet and Cunningham 1852, pp. 29, 44, 117 no. 185; Waagen 1854, ii, p. 305; Thornbury 1862, i, p. 326; 1877, pp. 452, 578; Wedmore 1900, ii, repr. facing p. 272; Bell 1901, p. 127 no. 197; Armstrong 1902, pp. 120, 222; Rawlinson ii 1913, pp. 208, 358; Finberg 1930, pp. 103–4 (repr.), 107, 108; 1961, pp. 355, 499 no. 462; Gage 1969, p. 191 (?); V.A.M. catalogue 1973, p. 137.

This shows essentially the same view of the town and cliffs as the watercolour in the British Museum (39·8 × 59·1 cm., R. W. Lloyd Bequest 1958-7-12-419) which is signed and dated 1818 and which is in turn based on a drawing on pp. 22 verso–23 of the second 'Hastings' sketchbook (CXXXIX) in use in 1816. However, the positions of the boats and ships in the foreground show many differences between the oil and the watercolour, and the land appears further away in the oil.

For the question of whether this and *St Michael's Mount, Cornwall* (No. 358) may have been commis-sioned by Sheepshanks, as recorded by Burnet, see the entry for that picture. It is of course possible that Sheepshanks, having bought the *St Michael's Mount* at the R.A. in 1834, chose this subject to be painted as a pendant to it after being shown the 1818 watercolour. Turner's technique in both oils comes close in places to his practice in watercolours at the time.

As might be imagined, among the stunners exhibited this year, *The Burning of the Houses of Parliament* (No. 364) and the *Keelmen* (No. 360), this picture of modest dimensions and pretensions received little notice from the critics. The *Literary Gazette* for 9 May thought it 'Decidedly one of Mr. Turner's most charming productions', and the *Spectator* for 9 May considered that it was 'a beautiful marine piece', but these were the only journals that mentioned it.

364. The Burning of the Houses of Lords and Commons, October 16, 1834 Exh. 1835 (Plate 339)

THE CLEVELAND MUSEUM OF ART, OHIO (bequest of John L. Severance)

Canvas, 36½ × 48½ (92·5 × 123)

Coll. Bought from Turner by J. G. Marshall of

Headingly, Leeds; in 1888 it was offered for sale at Christie's on 28 April (32) but was bought in under the name of 'Ponsford' and descended in the Marshall family through Victor Marshall of Mark Coniston, Lancashire, to James Marshall; in 1920 it was with the Leicester Galleries for sale but was later returned to the owner; acquired by John L. Severance from Knoedler in 1922 and bequeathed by him to Cleveland in 1936.

Exh. R.A. 1835 (294); B.I. 1836 (69); Leeds 1868 (1172); R.A. 1883 (215); Cleveland *Twentieth Anniversay Exhibition* 1936 (249); Cleveland *Severance Collection* 1942 (16); Boston 1946 (11); Toronto and Ottawa 1951 (9); Indianapolis 1955 (38); Tate Gallery 1959 (353); New York, 1966 (10).

Lit. Ruskin 1843, 1851 (1903-12, iii, p. 423; xii, p. 389 where he states in error that the picture 'now belongs to Mr. Ponsford', misled, no doubt, by the 'bought in' name at the 1888 sale); Burnet and Cunningham 1852, p. 117 no. 186; Thornbury 1862, ii, p. 217; 1877, pp. 534-5, 578, 582; Monkhouse 1879, p. 118; Bell 1901, p. 128 no. 198; Armstrong 1902, pp. 117, 120, 146, 236; Whitley 1930, p. 298; *Catalogue of the John L. Severance Collection* Cleveland 1942, p. 25; *Cleveland Museum Bulletin* xxix 1942, p. 136; Clare 1951, pp. 101-2; Finberg 1961, pp. 354, 358, 499 no. 463, 500 no. 467; Rothenstein and Butlin 1964, pp. 48-50, 54, 64, colour pl. xvii; Lindsay 1966, pp. 178-82, 187, 204; Gage 1969, p. 117; Reynolds 1969, pp. 81, 165, fig. 142; Gaunt 1971, p. 8, colour pl. 31; Clark 1973, p. 256; Herrmann 1975, p. 42, pl. 133.

For the version exhibited earlier in 1835 at the British Institution, and for the circumstances of the fire itself, see No. 359. The Cleveland picture is painted from the Surrey end of Waterloo Bridge, looking towards Westminster and Westminster Bridge.

The picture had a mixed reception at the R.A. The *Morning Herald* of 2 May did not refer to it specifically but, after praising the improved quality of the exhibition in general, complained that 'This very agreeable state of affairs is, however, glaringly invaded by some flaming canvasses of Mr. J. M. W. Turner R.A. We seriously think the Academy ought, now and then, at least, to throw a wet blanket or some such damper over either this fire King or his works; perhaps a better mode would be to exclude the latter altogether, when they are carried to the absurd pitch which they have now arrived at . . .'

The *Spectator*, 9 May, considered that 'The sheet of flame that is carried across the sky and is reflected in the water is a stroke of art that none but a master could dare. It looks too flaring just now, especially as the scene is very slightly painted: we should like to see it a year hence. Turner paints for posterity, and allows for the effect of time as Robin Hood when he shot allowed for the wind . . .'

The Times for 23 May found that Turner's 'fondness

for exaggeration' had here 'led him into faults which nothing but his excellence in other respects could atone for.'

The *Athenaeum* for the same date said that 'of the thousands and tens of thousands who saw those ancient edifices

> "Redden the midnight sky with fire"

not one of them we would be sworn, thought the scene half so portentous—nay, supernatural, as the artist has delineated it on his canvas . . .'

Fraser's Magazine for July thought it 'a great curiosity' and criticised Turner for taking 'daring licenses and liberties with perspective, which do not exactly become one who is a professor of it.'

As Lawrence Gowing has pointed out, the Cleveland version, although painted after that in Philadelphia, is in fact closer to the watercolours in the sketchbook which were painted at the time the fire occurred. The vast pall of flame, and its reflection in the water, dominate the picture and dwarf the spectators who are far less in evidence than in the Philadelphia version.

Turner drew attention to another topical feature by including in this version one of the new water-borne City fire pumps. In fact, however, owing to the combination of a dry autumn and the tide being especially low that evening, the fire-pump went aground on its way to Westminster. Nevertheless, when it finally arrived, the correspondent of *The Times* (who had had to return to his office in order to write his account) reported that 'its effect on the burning embers *was said to be* prodigious.' I owe this entertaining item of news to the kindness of Professor John McCoubrey.

365. Juliet and her Nurse Exh. 1836 (Plate 343)

MRS FLORA WHITNEY MILLER, NEW YORK

Canvas, 35 × 47½ (89 × 120·6)

Coll. Bought by H. A. J Munro of Novar at the R.A. exhibition in 1836; Munro sale Christie's 6 April 1878 (100) bought Agnew; Kirkman Hodgson, M.P., from whom bought back by Agnew in 1893 and sold to James Price; the picture was not included in the Price sale at Christie's in 1895 but was sold during that year to Messrs. Wallis; Colonel O. H. Payne, New York by 1901; by descent to the present owner.

Exh. R.A. 1836 (73); New York 1966 (14).

Engr. By G. Hollis 1842.

Lit. Ruskin 1843, 1853, 1886, 1903 (introduction to Library edition), 1909 (letter of 1857) (1903-12, iii, pp. xviii, 247, 249 n., 423, 636-9; x, p. xli; xiii, p. 408; xxxv, pp. 217, 253 n.; i, p. xxxiii; xxxvi, p. 270); Burnet and Cunningham 1852, p. 117 no. 187; Thornbury 1862, ii, p. 400; 1877, pp. 578, 597; Frost 1865, p. 94 no. 145; Monkhouse 1879, pp. 118, 124; Bell 1901, pp. 129-30 no. 200; Armstrong 1902, p. 234, repr. facing p. 148; Rawlinson ii

1913, pp. 206, 337; Whitley 1930, pp. 318–19; Finberg 1930, pp. 88, 93–4, 97–101, 155, pl. xvii; Falk 1938, pp. 167, 168; Finberg 1961, pp. 359, 363 ff., 386, 500 no. 468; Rothenstein and Butlin 1964, pp. 56, 62, pl. 102; Lindsay 1966, pp. 182–3, 186; Reynolds 1969, pp. 150, 167, 168, 169, 178, 186, 190, 197, fig. 147.

This picture is virtually unknown to the public except for its appearance in the exhibition at the Museum of Modern Art in 1966. Yet it may claim to be, with the exception of *The Slave Ship* (No. 385), Turner's most celebrated work outside Great Britain. For it was the vituperative attack on Turner's three pictures in the 1836 exhibition, and on this picture in particular, which appeared in *Blackwood's Magazine*, that led Ruskin, shortly to go up to Christ Church, to write a reply in Turner's defence. Ruskin later expanded this defence into the five volumes of *Modern Painters* (1843–60).

The review in *Blackwood's Magazine* was written by the Reverend John Eagles (1783–1855) of Wadham College, Oxford. He called the picture 'A strange jumble—"confusion worse confounded". It is neither sunlight, moonlight, nor starlight, nor firelight . . . Amidst so many absurdities, we scarcely stop to ask why Juliet and her nurse should be at Venice. For the scene is a composition as from models of different parts of Venice, thrown higgledy-piggledy together, streaked blue and pink and thrown into a flour tub. Poor Juliet has been steeped in treacle to make her look sweet, and we feel apprehensive lest the mealy architecture should stick to her petticoat, and flour it.'

The Times of 11 May was also derisive, describing No. 365 as 'nothing more than a second and worse edition' of the *Burning of the Houses of Parliament* and concluding: 'Shakespeare's Juliet! Why it is the tawdry Miss Porringer, the brazier's daughter of Lambeth and the Nurse is that twaddling old body Mrs. MacSneeze who keeps the snuff-shop at the corner of Oakley Street.'

However, some critics praised the picture, including the *Morning Herald* of 2 May but more especially the *Morning Post* of 25 May which described it as 'one of those magical pictures by which Mr. Turner dazzles the sense and storms the imagination . . . this picture is a perfect scene of enchantment.' The notice ends by saying 'But the merit of the picture is in its appeal, through the medium of colour to the imagination, and a more astonishing appeal was never made nor a more splendid deception ever witnessed.'

As can be imagined, there are many other references to the picture in Ruskin's *Works* including a statement (iii, p. 249 n.) that it 'is now the ghost of what it was'. So obsessive was Ruskin's concern for the physical changes which he felt sure he detected as taking place in Turner's paintings, that in the same note, he actually states 'No *picture* of Turner's is seen in perfection a month after it is painted', a wild generalization that must be largely discounted.

Ruskin drafted his reply to *Blackwood's Magazine* on 1 October when he was 'in a state of great anger'. On his father's advice, Ruskin sent the proposed draft to Turner who, however, advised against publication, writing as follows:

> '47 Queen Anne St. West
> Oct. 6 1836
>
> My dear Sir,
> I beg to thank you for your zeal, kindness, and the trouble you have taken on my behalf, in regard of the criticism of Blackwood's Mag for Oct respecting my works; but I never move in these matters—they are of no import save mischief and the meal tub, which Maga fears for by my having invaded the flour tub.
> P.S. If you wish to have the Manst back have the goodness to let me know. If not with your sanction I will send it on to the Possessor of the picture of Juliet.'

It is interesting to note that when Ruskin sent his draft to Turner he did not give his full name, as Turner's reply is addressed merely to 'J.R. Esq.' If Munro, the purchaser of the picture, was sent Ruskin's manuscript he seems to have lost it, for Ruskin was unable to find it when he was writing *Praeterita*. Later, however, a copy was found in an old notebook at Brantwood and incorporated into the Library Edition of Ruskin's *Works* (iii, pp. 635–40).

366. Rome, from Mount Aventine Exh. 1836
(Plate 344)

THE EARL OF ROSEBERY

Canvas, 36 × 49 (91·6 × 124·6)

Coll. Bought by H. A. J. Munro of Novar from the R.A. exhibition in 1836; sale Christie's 6 April 1878 (98) bought Davis; as *Modern Rome—Campo Vaccino* (No. 379) was also knocked down to Davis at the Munro sale and as both pictures were lent to the R.A. Winter Exhibition in 1896 by the Earl of Rosebery, it seems very likely that they were bought by—or for—Lord Rosebery at the 1878 sale; by descent to the present owner.

Exh. R.A. 1836 (144); R.A. 1896 (12); Whitechapel 1953 (89); R.A. 1974–5 (515).

Lit. Ruskin 1843, 1886, 1903 (1903–12, iii, pp. xviii, 636 n.; xxxv, p. 217; i, p. xxxiii); Burnet and Cunningham 1852, pp. 29, 117 no. 188; Thornbury 1862, i, pp. 231–2; 1877, pp. 105, 578; Frost 1865, p. 95 no. 121; Bell 1901, p. 130 no. 201; Armstrong 1902, pp. 120, 228; Finberg 1961, pp. 359, 400 no. 469; Lindsay 1966, p. 182; Gage 1968, p. 682; Reynolds 1969, pp. 150, 168.

Gage suggests that topographical studies for this picture were collected by Turner in company with Eastlake in Rome 1828–9. This would seem to agree in part at any rate with Thornbury's account of Turner surprising Eastlake by the care he took in choosing his viewpoint 'for a picture of modern Rome which had

been commissioned by Mr. Munro'. Thornbury states that 'Turner had been particularly anxious to comply with the requirements of "a copy", not an ideal picture. A "copy" was asked for, and a copy he made. So faithful, indeed, has the painter been in this beautiful picture that he has, even at some peril to his success, introduced in the left-hand foreground a long monotonous row of modern houses . . .' However, if this picture was really commissioned as early as 1828–9, it seems difficult to explain why so long an interval elapsed before Turner exhibited the finished picture. Nonetheless, the statement in Munro's 1865 catalogue that this was 'Painted for Mr. Munro on the spot', while clearly untrue in the literal sense, does support the story that Munro had played a part in the picture's conception. Thornbury gives the price as £300, 'Turner refusing to raise the price beyond that of some other picture Mr. Munro had had.'

Until 1902 when Armstrong's catalogue was published, there was considerable confusion between this picture and *Modern Rome—Campo Vaccino*. Both belonged to Munro of Novar and later to Lord Rosebery but the titles became transposed, both in the catalogue of the R.A. Winter Exhibition in 1896, and by Bell in 1901.

This was one of the three picture exhibited in 1836, with *Juliet and her Nurse* (No. 365) and *Mercury and Argus* (No. 367), which were so viciously attacked by the Rev. John Eagles (1783–1855) in *Blackwood's Edinburgh Magazine* for October 1836. For further details see the entry for *Juliet and her Nurse*.

In fact, Eagles' strictures on this picture in *Blackwood's Magazine* were not so intemperately phrased as those on Turner's other two exhibits. Of *Rome from Mount Aventine*, he wrote: '. . . a most unpleasant mixture, whereupon white gamboge and raw sienna are, with childish execution, daubed together.'

However, the picture was on the whole well received by other reviewers. The *Athenaeum* on 14 May called it 'a gorgeous picture, full of air and sunshine, though sadly unfinished in its execution', while the *Morning Post* for 3 May wrote 'This is one of those amazing pictures by which Mr. Turner dazzles the imagination and confounds all criticism. It is beyond praise.'

367. Mercury and Argus Exh. 1836 (Plate 346)

THE NATIONAL GALLERY OF CANADA, OTTAWA

Canvas, 59 × 43 (150 × 109·2)

Coll. Joseph Gillott by 1845; sold to Charles Birch of Harborne near Birmingham in June 1845 (Gillott's account book records that '*Mercury and Argus* is in Mr. George Pennell's care on 26 May 1845 and is valued at 600 guineas.' On 3 June Gillott received from Pennell C. Birch's two bills of £525 each for the purchase of this picture); bought from Birch by John Naylor of Leighton House, Welshpool; the date of

the purchase is not known although Naylor owned it certainly in 1854, but the price paid, 1,300 guineas, which was more than Naylor paid Turner for *Now for the Painter* (No. 236) or the *Dutch Fishing Boats* (No. 372) in 1851, suggests that this was a later transaction; bought from Naylor by Agnew in 1863 and sold to John Graham; sale Christie's 30 April 1887 (93) bought Laurie; Sir Donald Alexander Smith by November 1888 (he was created Lord Strathcona and Mount Royal in 1897); sold by the third Baron Strathcona and Mount Royal to the National Gallery of Canada in 1951 through Agnew.

Exh. R.A. 1836 (182); B.I. 1840 (59); R.S.A. 1846 (231 lent by Charles Birch); Birmingham Royal Society of Artists 1846 (70); Liverpool Academy 1853 (24, no lender's name given); Liverpool Town Hall 1854 (34); Art Association of Montreal 1888 (87 lent by Sir Donald A. Smith) and 1893 (87); Guildhall 1899 (30); Paris 1900 (43); Glasgow 1901 (93); Shepherd's Bush 1910 (47); Rome 1911 (97); Vienna 1927 (4); London (Olympia) *Daily Telegraph Exhibition* 1928 (x58); R.A. 1934 (646); Manchester 1934 (49); Toronto, Montreal and Ottawa *European Masters* 1954 (42); Indianapolis 1955 (39).

Engr. By J. T. Willmore, 1841, and again in 1859 in the *Turner Gallery*. In a letter of 21 October 1836 to William Miller, Turner suggests that Miller might like to engrave *Mercury and Argus* as a companion plate to *Mercury and Herse* (No. 114, which the year before Miller had evidently suggested engraving 'upon his own speculation' as Turner puts it) but Turner adds that another engraver (presumably Willmore) 'has fallen in love with it'.

Lit. Ruskin 1843, 1860, 1865 ('The Cestus of Aglaia'), 1874 ('Ariadne Florentina'), 1878, 1886, 1903 (1903–12, iii, pp. xviii, 264, 292, 300 n., 335, 364, 422, 485, 492, 558, 587 n., 594, 596 n., 638, repr. pl. 14; vii, p. 84; xix, pp. 90–92; xxii, pp. 369–70; xiii, p. 408; xxxv, p. 217; i, p. xxxiii); Burnet and Cunningham 1852, pp. 29, 44 (a mistake for *Mercury and Herse*), 117 no. 189, 122 no. 10, repr. pl. x; Thornbury 1862, i, pp. 329, 392, 393; ii, pp. 334, 400; 1877, pp. 180–81, 454, 532, 578, 582, 597; Hamerton 1879, p. 273; Monkhouse 1879, p. 118; Wedmore 1900, i, repr. facing p. 104; Bell 1901, pp. 130–31 no. 202; Armstrong 1902, pp. 120, 225, repr. facing p. 144; A. M. Hind, *Turner's Golden Visions* 1910, p. 186; Rawlinson ii 1913, pp. 206, 208, 334, 358; Whitley 1930, p. 318; National Gallery of Canada, *Annual Report* 1951–2, pp. 9–10, repr. as frontispiece; *Art News* December 1952, p. 28, repr.; R. H. Hubbard, *European Painting in Canadian Collections* 1956, pp. 132, 154, repr.; Finberg 1961, pp. 358, 382, 500 no. 470, 505 no. 529, 515 no. 579a; Rothenstein and Butlin 1964, pp. 38, 56; Lindsay 1966, pp. 164, 168, 182, 237; Reynolds 1969, p. 150; Morris 1974–5, p. 98 no. 198, fig. 68.

The subject depicts the story in which Io, daughter of

the King of Argus, was loved by Zeus and changed by him into a cow because of the jealousy of his wife, Hera. Argus, who had a hundred eyes, was appointed by Hera to watch over Io. Zeus then ordered Mercury to carry off Io which he achieved by lulling Argus to sleep by playing his flute to him, and then cutting off his head.

Turner seems to have contemplated a picture of the subject many years earlier, as in the 'Studies for Pictures; Isleworth' sketchbook (XC), in use as early as 1804, there is a drawing on p. 54 inscribed 'Mercury and Argus' in Turner's hand.

Munro of Novar would have liked to have bought *Mercury and Argus* at the R.A. Exhibition but, as he had already bought Turner's other two exhibits (Nos. 365 and 366), he told a friend that he would be 'ashamed of taking so large a haul'. According to Munro, the design for this picture was suggested to Turner by the scenery on the coast of Ross-shire, in the neighbourhood of Munro's house at Novar near Evanton where Turner had stayed with him in 1831. 'Cromarty, I believe', wrote Munro 'is only famed as a good harbour. Turner thought by enlarging, something might be made of it; and this idea he realized in his *Mercury and Argus*, which he exhibited the same year as my *Rome* and *Venice by Moonlight*.'

Thornbury states that a Mr 'Dives', a merchant of Liverpool (which seems to refer to Joseph Gillott although he came from Birmingham not Liverpool) bought the picture and was then made by Turner to commission a companion to it, but that, as they later quarrelled, the second picture was never painted or, rather, perhaps never completed (see No. 439 for a possible candidate for this picture). However, in a copy of Thornbury (1877 edn) which once belonged to Redford, now in Agnew's library, Redford has noted: 'I saw *Mercury and Argus* in Birch's house about the year 1838'. This cannot be reconciled with the entries in Gillott's account book concerning the sale of the picture to Birch in 1845 and, as the picture still belonged to Turner at the time it was exhibited at the British Institution in 1840, it seems as if Redford must have mistaken the date he saw it in Birch's house,—perhaps 1838 was a slip for 1848.

Finberg does, however, suggest that the picture was reworked by Turner between the 1836 and 1840 exhibitions and that the resemblance to the harbour at Cromarty may then have been disguised and the landscape given a more classical, Claudian character. It is now so entirely Mediterranean and Southern in feeling that it is hard to detect the slightest trace of the Scottish topography which Munro claimed as the model for the picture.

At the Academy the picture was one of the trio so savagely attacked in *Blackwood's Magazine* (40, pp. 550–51; see the entry for No. 365 for the circumstances and results of this review), which wrote: 'It is perfectly childish. All blood and chalk. There was not the least occasion for a Mercury to put out Argus's eyes; the horrid glare would have made him shut the whole hundred, and have made Mercury blind.' *The Times* for

11 May was almost as harsh, describing it as 'composed of mercury, sulphur and crude antimony, and completely imbued with sulphureo-ochreous tints . . .' ending with the insult that to 'look at Callcott's *Trent in the Tyrol* [R.A. no. 130] after a dose of Turner's *Mercury and Argus* is as cool and refreshing as iced champagne after mulligatawny.'

The *Spectator* for 28 May called it 'an unreal landscape with *real* sunlight' and the *Morning Herald* of 2 May, although admitting that it was 'very showy indeed in its hues,' and that ' the effect is consequently brilliant', criticised the 'unbroken glitter which now overshadows the composition'.

Only two papers had anything much to say in its favour: the *Athenaeum* on 14 May described it as 'another of his rainbow-toned rhapsodies, a thing like much of Shelley's poetry, to be felt rather than understood: here, too, he has given full vent to his poetical imagination, and, we grieve to add, extravagant colouring', and the *Literary Gazette*, 7 May, said 'it is a work replete with imagination and beauty and would make a fine engraving.' In 1841 the *Art Union* wrote of the engraving that 'in it we cannot perceive the defects so generally attributed to the picture' and considered that 'the good qualities of the work have been preserved, while the wilful follies of the great painter have been entirely abrogated.'

When this picture was exhibited in Edinburgh in 1846, the Scottish critics seemed overawed by Turner's reputation and, although the reviewer in the *Edinburgh Evening Courant* for 23 February produced one sentence containing 119 words in his notice, no critic ventured beyond banal generalities.

As might be imagined, there are numerous references to both the picture and the engraving in *Modern Painters*. In particular the painting of the foreground is praised by Ruskin for its fidelity to nature and its 'infinite unity'. Ruskin considered that it was Turner's ability to unite his foregrounds in this way that set him above Claude.

368. The Grand Canal, Venice Exh. 1837
also known as *Scene—a Street in Venice* (Plate 347)
HENRY E. HUNTINGTON LIBRARY AND ART GALLERY, SAN MARINO, CALIFORNIA

Canvas, $58\frac{1}{4} \times 43\frac{1}{2}$ (148×110.5)

Coll. In March 1845 it is recorded in Joseph Gillott's account book as belonging to him but 'in the care of George Pennell, Berners Street, London'; bought by Charles Birch in December 1845 for £850; bought by John James Ruskin on 27 April 1847 for 800 guineas through the agency of Thomas Rought. The purchase price and date are recorded in J. J. Ruskin's account book (information kindly supplied by Dr Harold Shapiro). The date is confirmed in a letter written by Effie Gray to her parents on 28 April 1847 and quoted by Admiral Sir William James on p. 28 of *The Order of Release*:

'They have got home a very fine picture by the above artist [Turner] yesterday of Venice which is the largest they have and which must have cost *something*'.

John Ruskin sale Christie's 8 June 1872 (68) bought Agnew; Baron A. Grant, 1873 for whom Agnew resold the picture to Ralph Brocklebank in 1874; sold on behalf of R. Brocklebank's executors by Agnew to Duveen in October 1922; acquired by Henry Huntington on 23 November 1922 (information kindly supplied by Dr R. R. Wark).

Exh. R.A. 1837 (31); R.A. 1880 (35); Walker Art Gallery, Liverpool, 1886 (1221); Guildhall 1894 (97) and 1899 (34).

Lit. Ruskin 1843, 1849 ('Notes on the Louvre'), 1857, 1877 ('Fors Clavigera'), 1878, 1886, 1909 (letter of 1872) (1903-12, iii, pp. 336 n., 363-4, 422; xii, pp. 461-2, 467; xiii, p. 213; xxix p. 100 n.; xiii, pp. 409, 606; xxxv, p. 380; xxxvii, p. 52); Burnet and Cunningham 1852, p. 118 no. 190; Thornbury 1862, ii, p. 334, 395; 1877, pp. 532, 578, 592; Wedmore 1900, i, repr. facing p. 14; Bell 1901, p. 131 no. 203; Armstrong 1902, pp. 121, 234 (where it is wrongly stated to have been painted for Mr Ruskin senior), repr. facing p. 150; *Pictures and Engravings at Houghton Hall, Tarporley in the Possession of Ralph Brocklebank* 1904, no. 46, repr. as frontispiece; Finberg 1930, pp. 101-2, 156; C. H. Collins Baker, *Catalogue of British Painting in the Henry E. Huntington Library and Art Gallery* 1936, pp. 96-7; Falk 1938, p. 141; Finberg 1961, pp. 366-7, 500 no. 472; Herrmann 1968, p. 22; Reynolds 1969, p. 169; R. R. Wark, *Ten British Pictures 1740-1840* 1971, pp. 123-34, repr.; Herrmann 1975, pp. 43, 45.

Exhibited with a quotation from *The Merchant of Venice* (Act III, scene iii):

Antonio Hear me yet, good Shylock
Shylock I'll have my bond.

In some copies of the 1837 R.A. catalogue the title is given as 'Scene—a Street in Venice'.

As Dr Wark has shown, the picture is based on two pencil sketches in the 'Milan to Venice' sketchbook (CLXXV pp. 72 verso and 73, although only part of the drawing on the left-hand page is used in the oil) which dates from Turner's first visit to Venice in 1819. Turner has taken considerable liberties with some of the buildings shown but faithfully reproduces an oddity which actually occurs in the Grimani Palace (the building which dominates the right-hand side of the picture and which is now the Court of Appeal) where the corner nearest to the spectator is not in fact square, as the walls meet at a slightly acute, rather than at a right angle. Ruskin verified this for himself on a visit in 1851 and wrote back to his father on 19 September, enclosing a diagram to show that 'Turner's perspective is therefore perfectly right' (reprinted in John Lewis Bradley's *Ruskin's Letters from Venice 1851-2* 1955, p. 16).

Finberg detects a feverish quality in the picture

which he thinks may be the result of a bad bout of influenza which Turner had had recently. This seems a somewhat fanciful inference but it is true that the colour in certain passages has a somewhat garish quality about it—but this may be due to changes in the pigments that have occurred with the passage of time. On the other hand, the word 'garish' was actually applied to the picture by the critic of the *Spectator* for 6 May in his review of the R.A. exhibition, although admittedly the word is used in comparison with the colour of *Apollo and Daphne* (No. 369) and this picture is also described as 'brilliant in the extreme'. The *Athenaeum*, 6 May, thought Turner's exhibits 'more *Turneresque* than ever' and cited this picture as the prime example, saying that 'while it pleases the eyes of some till they can forgive the absurdity for the sake of the fine fancy also displayed in it; ours ached as we stood before it.'

As might be expected, *Blackwood's Magazine* for July–December 1837 was especially harsh both on Turner's exhibits in general and on this picture in particular, perhaps because it had a number of points in common with *Juliet and her Nurse* (No. 365) which it had so savagely attacked the previous year. The pictures Turner showed in 1837 were considered 'a bold attempt to insult the public taste . . . the execution is as if done with the finger and the nail, as if he had taken a pet against brushes . . . Here we have the *Grand Canal, Venice* but 'tis no more Venice than it is Jericho. In this picture there is really one exact portrait and doubtless it was studied. His Shylock, an undoubted portrait of Punch, the common street Punch; and there he is at the side of the picture as looking out of his box, with his very lean and his jointless arms holding the scales, while Antonio's fate "like a clipt guinea, *trembles* in the scales".'

The gibe about Shylock looking like Mr Punch has a good deal of truth in it as can be seen from a detail photograph illustrating Dr Wark's essay but, in general, the figures play an important part in the composition and materially assist the sense of recession.

In fact, as Dr Wark has suggested, the Huntington picture may have been conceived as a contrast to *Juliet and her Nurse*, for the difference between Venice at night and Venice at high noon provides just the sort of subject that would have appealed to Turner both visually and emotionally. And it is entirely characteristic of him to try to focus attention on this theme by adding the Shakespearean references as subtitles to both pictures when they were exhibited.

This picture has, in the past, sometimes been called 'The Marriage of the Adriatic', a title which must have become mistakenly attached to it when the quotation, with which it was originally exhibited, became forgotten. However, 'The Marriage of the Adriatic', an annual ceremony in which the Doge, representing the City of Venice, espoused the sea, has no connection with the subject matter of the Huntington picture. However, for an unfinished picture in the Turner Bequest which may, in fact, represent this ceremony, see No. 501.

369. Story of Apollo and Daphne Exh. 1837
(Plate 345)

THE TATE GALLERY, LONDON (520)

Mahogany, $43\frac{1}{4} \times 78\frac{1}{4}$ (110 × 199)

Coll. Turner Bequest 1856 (27, 'Apollo and Daphne' $6'5\frac{1}{2}'' \times 3'7''$); transferred to the Tate Gallery 1929.

Exh. R.A. 1837 (130).

Lit. Ruskin 1843, 1856, 1860 and 1857 (1903–12, iii, pp. 337–8, 453–4; v, p. 391; vi, p. 353; vii, p. 484; xiii, pp. 148–50); Thornbury 1862, i, pp. 329–30; 1877, p. 454; Bell 1901, p. 132 no. 204; Armstrong 1902, p. 218; Davies 1946, p. 186; Finberg 1961, pp. 367, 500 no. 473; Rothenstein and Butlin 1964, p. 56; Lindsay 1966, p. 183; Reynolds 1969, p. 169; Gage 1972, pp. 20–21, pls. 9a and b (detail); Raymond Lister (ed.), *The Letters of Samuel Palmer* 1974, i, p. 182; Herrmann 1975, p. 44.

Exhibited at the R.A. with the following caption, which uses Dryden's translation:

—*Ovid's Metamorphoses.*
'Sure is my bow, unerring is my dart;
But, ah! more deadly his who pierced my heart.
* * * * * * * *
As when th'impatient greyhound, slipt from far,
Bounds o'er the glebe to course the fearful hare,
She, in her speed, does all her safety lay;
And he, with double speed, pursues the prey.'

Ruskin, in his notes on the Turner gallery at Marlborough House, explains the subject: 'It is necessary, however, that the reader should in this case, as in that of the "Bay of Baiae" [No. 230], understand Turner's meaning in the figures, and their relation to the landscape. Daphne was the daughter of the river Peneus, the most fertilizing of the Greek rivers, by the goddess Terra (the earth). She represents, therefore, the spirit of all foliage, as springing from the earth, watered by rivers; rather than the laurel merely. Apollo became enamoured of her, on the shore of the Peneus itself—that is to say, either in the great vale of Larissa, or in that of Tempe. The scene is here meant for Tempe, because it opens to the sea: it is not in the least *like* Tempe, which is a narrow ravine: but it expressed the accepted idea of the valley as far as Turner could interpret it, it having long been a type to us moderns of all lovely glens or vales descending from the mountains to the sea. The immediate cause of Apollo's servitude to Daphne was his having insulted Cupid, and mocked at his arrows. Cupid answered, simply, "Thy bow strikes all things, Apollo, but mine shall strike *Thee*."

'The boy god is seen in the pictures behind Apollo and Daphne. Afterwards, when Daphne flies and Apollo pursues, Ovid compares them to a dog of Gaul, coursing a hare—the greyhound and hare Turner has, therefore, put into the foreground. When Daphne is nearly exhausted, she appeals to her father, the river Peneus—"gazing at his waves"—and he transforms her

into a laurel on his shore. That is to say, the life of the foliage—the child of the river and the earth—appeals again to the river, when the sun would burn it up; and the river protects it with its flow and spray, keeping it green for ever.

'So then the whole picture is to be illustrative of the union of the rivers and the earth; and of the perpetual help and delight granted by the streams, in their dew, to the earth's foliage.'

Unlike Ruskin, *Blackwood's Magazine* for July–December 1837 thought that Turner had 'odd notions of a simile. He makes it precede, and thrusts it into the very foreground before his figures, and there we have such a hare and hound! and to show the hound has the poet's "double-speed", the poor white-livered dog Apollo stands stock-still in friddled feebleness, and the red-nosed Daphne waiting lamentably to be caught. But the ground, or whatever we may please to call it, of the piece, is neither earth nor water, nor anything that grows, or ever grew on it, or in it.' The rest of the press was rather more complimentary. For the *Spectator*, 6 May, the landscape was 'a wonder of art; a splendid picture of nature, and with a less share than usual of his [Turner's] glaring defects'. The *Athenaeum* of the same date wrote that 'Mr. Turner's grand landscape of *Apollo and Daphne* . . ., though sufficiently exuberant in its invention, and rich in its colouring, and exceptionable in the careless deficiency of its figures, is more moderate than the last-mentioned extravaganza [*Hero and Leander*, No. 370], and we therefore prefer it, at the risk of being called lukewarm and one-sided.' For the *Literary Gazette*, again of the same date, the picture was 'One of those gorgeous effects of prismatic colours in all their original and distinct vividness, which under any other management than that of Mr. Turner, would be offensive; but which he renders absolutely magical.'

Samuel Palmer, writing to John Linnell from Italy on 22 August 1838, said that 'Turner's corruscation of tints and blooms in the middle distance of his Apollo and Daphne is nearly, tho' not quite so much a mystery as ever: and I am inclined to think that it is like what Paganini's violin playing is said to have been; something to which no one ever did or will do the like; though Claude and Titian have done just as well or better in another way.' For another example of a parallel being drawn between Turner and Paganini see No. 342.

Finberg suggests that this picture may have been in hand for some years but there are no particular stylistic or technical reasons to support this.

370. The Parting of Hero and Leander—from the Greek of Musæus Exh. 1837 (Plate 348)

THE NATIONAL GALLERY, LONDON (521)

Canvas, $57\frac{1}{2} \times 93$ (146 × 236)

Coll. Turner Bequest 1856 (59, 'Hero and Leander' $7'10'' \times 4'10\frac{1}{2}''$); transferred to the Tate Gallery 1929, returned to the National Gallery 1961.

Exh. R.A.1837 (274); Lisbon and Madrid 1949 (45); Tate Gallery 1959 (355).

Lit. Ruskin 1843 and 1860 (1903–12, iii, pp. 242, 306, 389–90, 561–2, 607; vii, p. 246 n.); Thornbury 1862, i, p. 330; ii, p. 178; 1877, pp. 321, 455; Bell 1901, p. 132 no. 205; Armstrong 1902, p. 223; Davies 1946, p. 186; Finberg 1961, pp. 367, 397–8, 501 no. 474, pl. 19; Lindsay 1966, p. 183; Gage 1969, p. 61, 171; Reynolds 1969, pp. 170–73, colour pl. 152; Gaunt 1971, p. 10, colour pl. 39; Herrmann 1975, pp. 44, 233, pl. 142.

Exhibited in 1837 with the following lines:

'The morning came too soon, with crimsoned blush
Chiding the tardy night and Cynthia's warning beam;
But Love yet lingers on the terraced steep,
Upheld young Hymen's torch and failing lamp,
The token of departure, never to return.
Wild dashed the Hellespont its straited surge,
And on the raised spray appeared Leander's fall.'

Musaeus, the Greek poet and grammarian, is best known for his poem on Hero and Leander.

The left-hand side of the composition is based on the much earlier drawing inscribed 'Hero and Leander' in the 'Calais Pier' sketchbook (LXXXI-57; repr. Reynolds 1969, pl. 151) and there is another sketch on part of a letter addressed to Walter Fawkes (CCCXLIV-427). Finberg suggests that, like *Regulus* (No. 294), the picture may have been in hand for some years, and indeed the rather unusual colouring is closest to some of the sketches on coarse canvas done in Rome in 1829–9 (see Nos. 302–17). But the canvas is a fine one, and the picture seems to have been painted rapidly, not heavily reworked (the compiler is indebted to Arthur Lucas, Chief Restorer at the National Gallery, for a report on this picture).

Turner's choice of subject was perhaps suggested by Etty's *The Parting of Hero and Leander*, exhibited at the R.A. in 1827 and again at York in 1836 (Tate Gallery).

Unlike some of the other exhibits of 1837, particularly the Venetian subject (No. 368), this picture was critically received by the press, though the *Spectator* for 6 May, while describing it as 'an architectural composition with sea and storm, and some incomprehensible fantasies', did find it 'extraordinary for colour and effect'. The *Athenaeum* of the same date found the picture 'full of imagination—but it is imprudent imagination . . . and its coarse glaring faults can be only let pass by the exercise of the strongest forbearance'; the figures were 'gross and deformed in their shapes'. The ever-hostile critic of *Blackwood's Magazine*, for July–December 1837, called it 'the dream of a sick genius . . . It is an indistinct dream, blending the ridiculous and the mysterious; yet are there in it the elements of a good picture. Go to a distance, and imagine it to be a sketch in chalk as a design, and you would expect something from it; but what all that white has to do in the picture, it would puzzle any one to find out.'

This is one of the pictures that Thornbury specifies as having suffered in Turner's gallery, and Turner's letter to Griffith of 1 February 1844 seems to imply that he had asked the framemakers Foord's to advise about cleaning and lining it. In *Modern Painters* v Ruskin criticised the cleaning of the picture, presumably after it had entered the National Gallery. Writing how 'Turner's storm-blues, for instance, were produced by a black ground with opaque blue, mixed with white, struck over it', he adds the footnote, 'In cleaning the "Hero and Leander" . . . these upper glazes were taken off, and only the black ground left. I remember the picture when its distance was of the most exquisite blue.'

371. Snow-storm, Avalanche and Inundation—a Scene in the Upper Part of Val d'Aouste, Piedmont Exh. 1837 (Plate 349)

THE ART INSTITUTE OF CHICAGO

Canvas, $36\frac{1}{4} \times 48$ (91·5 × 122·5)

Coll. According to Joseph Gillott's account book, he owned this picture in March 1845 (described as 'Avalanche') but it seems that he left it for sale with the dealer George Pennell; H. A. J. Munro of Novar; sale Christie's 6 April 1878 (102) bought Lord Wharncliffe, who still owned it in 1889; James Price; sale Christie's 15 June 1895 (66) bought Agnew for Sir Donald Currie; by descent to his grand-daughter, Mrs Craven, from whom bought by Agnew in 1947; sold to the Art Institute of Chicago (Frederick T. Haskell Collection) in December 1947 through Roland, Browse and Delbanco.

Exh. R.A. 1837 (480); B.I. 1841 (104); Grosvenor Gallery 1889 (27); R.A. 1895 (126); Agnew 1926 (16); Brussels 1929 (179); R.A. 1934 (661); Toronto and Ottawa 1951 (10); Indianapolis 1955 (40); New York 1966 (15); Agnew 1967 (21); Berlin 1972 (21); R.A. 1974–5 (567); Zurich 1976–7 (39).

Lit. Ruskin 1843, 1878 (1903–12, iii, pp. 239, 462; xii, p. 409); Burnet and Cunningham 1852, pp. 118 no. 193, 122 no. 11; Thornbury 1862, i, p. 231; ii, p. 400; 1877, pp. 104, 578, 583, 597; Frost 1865, p. 95 no. 45; Bell 1901, pp. 132–3 no. 106; Armstrong 1902, p. 218; A. M. Hind, *Turner's Golden Visions* 1925, p. 188; *Bulletin of the Art Institute of Chicago* February 1940, pp. 20–22, repr.; Finberg 1961, pp. 501 no. 475, 506 no. 537; Rothenstein and Butlin 1964, p. 62, pl. 103; Lindsay 1966, p. 245; Reynolds 1969, p. 169, fig. 148; Herrmann 1975, pp. 43–4; John Russell and Andrew Wilton *Turner in Switzerland* 1976, p. 19.

This is a product of Turner's trip to the Val d'Aosta in 1836 which he undertook in the company of his friend and patron H. A. J. Munro of Novar although, as Herrmann points out, as they were there in the summer

they could hardly have experienced such a storm at that time. In Christie's catalogue of the Munro sale in 1878 it states: 'When the sketch was made for this picture Mr. Munro was with Turner, who expressed a hope to him that he (Munro) did not know what he proposed to paint, for if so, he should feel himself obliged to abandon the subject.'

Turner also painted a number of watercolours of the subject, two of which are now in the National Gallery of Scotland, and a third in the Fitzwilliam Museum, Cambridge. Their relationship to the oil however is not close enough for them to be considered sketches for it.

The picture was not much noticed at the R.A. compared with Turner's other exhibits but the *Spectator*, 6 May, considered it 'extraordinary for colour and effect' while *Blackwood's Magazine* for July–December 1837, after criticising the excessive amount of white in *Hero and Leander* (No. 370), continues 'but that he [Turner] might have an excuse for as much white as he pleases, he has treated the public with No. 480, "A Snow-Storm, avalanche and inundation", but which is which, for our life, we cannot tell. Has any accident befallen Mr. Turner's eyes? Have they been put out by the glare of his own colours?'

In 1838, the *Quarterly Review* (lxii, p. 144), in a review of Waagen's *Works of Art and Artists in England*, referred to this picture as 'the ebullition of cotton, which Mr. Turner was pleased to call an avalanche last year . . .'

When shown again at the British Institution in 1841, together with *Rockets and Blue Lights* (No. 387), both pictures were strongly criticised in the *Athenaeum* of 6 February which wrote of this picture 'he [Turner] has loaded his weapon of offence with such pigments as the Quakers love, and shot a round of drab, dove-colour, and dirty white, with only a patch of hot, southern-red, in the foreground, to heighten, as it were, the horrors of a snow scene by a few *probable* touches of fire and sunshine. To speak of these works as pictures, would be an abuse of language.'

As the Turner Bicentenary Exhibition catalogue pointed out, the composition, as well as the scenery, recalls the vortex which Turner had used a quarter of a century earlier in *Hannibal crossing the Alps* (No. 126).

Ruskin called it 'one of his mightiest works' and devoted a fine passage to it in volume i of *Modern Painters*, mainly with the intention of denigrating Salvator Rosa's mountain landscapes in comparison with 'these supreme pieces of mountain drawing'.

372. Fishing Boats with Hucksters bargaining for Fish Exh. 1838 (Plate 350)
also known as *Dutch Fishing Boats*

THE ART INSTITUTE OF CHICAGO

Canvas, $68\frac{5}{8} \times 88\frac{1}{4}$ (174·3 × 224·1)

Signed 'J M W Turner' on the topmost flag of the large fishing boat

Coll. Bought from Turner in 1851 by John Naylor of Leighton Hall, Welshpool at the same time as he bought *Now for the Painter* (No. 236) and for the same price; bought from Mrs Naylor in 1910 by Agnew through Dyer and Sons and sold in the same year to Mrs W. W. Kimball; presented to the Art Institute of Chicago from the collection of Mr and Mrs W. W. Kimball in 1922 (Accession no. 4472).

Exh. B.I. 1838 (134) 79 × 100 in. (these measurements include the frame); Liverpool Town Hall 1854 (40) as 'Dutch Boats off Rotterdam'. (It is not known how 'Rotterdam' became incorporated in the title but, as Naylor bought the picture directly from the artist, Turner may have given Naylor some information about the scene represented.)

Lit. Waagen 1854, iii, p. 251 as 'A Harbour (Rotterdam)'; Thornbury 1862, ii, p. 400; 1877, pp. 582, 597; Bell 1901, p. 135 no. 211; Armstrong 1902, p. 229; Finberg 1961, pp. 360, 397–8, 501 no. 477; Jeremy Maas, *Victorian Painters* 1969, p. 61, repr. in colour p. 71; Morris 1974–5, p. 98 no. 199.

Armstrong dates this *c.* 1826 and calls it a companion to *Now for the Painter* (No. 236) and in John Naylor's inventory of his pictures it is listed as 'inscr 1826', but there seems to be no sign of a date now and, in any case, there is no reason to suspect on stylistic grounds that the picture was painted appreciably earlier than the date it was exhibited. To some extent, Turner seemed to confirm this (although his letter is inaccurate in some respects) when he wrote to his dealer Griffith in 1844, apparently in reponse to a request from the Duke of Sutherland, to see the picture (or possibly, as Finberg suggests, because Griffith himself had suggested that the Duke might like to see it).

Turner's letter is as follows:

47 Queen Ann St. Feb. 1, 1844
My dear Sir,—The picture was exhibited at the British Institution about 8 years ago—30 years between the two makes Lord Egerton's Picture the first, about 1806. Lord Gower bought it and thereby launched by Boat at once with the Vandevelde. I should much like the Duke of Sutherland to see it, but in regard to price, that is the greatest difficulty with me. The price was not sent with it to the Institution—so I escape condemnation on that head, and any who like may offer what they please.

This is not answering your views I know, and may be troublesome, but the Picture has to work up against the reputation of Lord E.'s Picture, and I wish they could be seen together, or belonged to the same family.

It is interesting to note that the picture was sent to the British Institution in 1838 without a price, and that in 1844 Turner invited 'any who like may offer what they please'. Whether this proved the stumbling block with the Duke of Sutherland—or, indeed, whether he ever went to see the picture—is not recorded, but the picture remained unsold until 1851.

As Finberg notes, Turner's memory was hazy over dates: this picture had been exhibited at the British Institution six years previously, not eight as Turner states, and an interval of thirty seven years, rather than thirty, separated the exhibiting of the two pictures.

At the British Institution it received guarded praise. The *Literary Gazette* for 10 February echoed a good many notices of Turner's work about this time by saying 'There are always passages in this great artist's work above all praise; there are others that cannot but provoke criticism.' Later on, the critic deplored the fact that 'the effect of so fine a work is so much deteriorated by the introduction of such crude and gaudy colours.'

The *Athenaeum*, 17 February, acknowledged that 'the restless illuminated water is dashed in with a power and mastery, in which Mr. Turner stands alone among his contemporaries . . . This picture though slight even to slovenliness in many parts, bears, nevertheless, a cabinet finish, compared with others recently exhibited by Mr. Turner,—his *Hero and Leander* [No. 370] for instance: and, with a striking fault or two, is still the finest work in not a very fine Exhibition.'

A point which seems to have been overlooked is that this picture was exhibited at the British Institution in the year following the showing there of *Dutch Boats in a Gale: Fishermen endeavouring to put their Fish on Board* (the *Bridgewater Seapiece*, No. 14), which had been loaned by Lord Francis Egerton together with the Van der Velde as a pendant to which the Turner had originally been painted in 1801.

It appears quite possible that it was on seeing his early seascape again that Turner had the idea of painting this picture, which is almost the same size as the *Bridgewater Seapiece*. Indeed Turner's letter of 1844 suggests strongly that he regarded them as being related and the title of this picture may be considered as a sequel to the earlier one, marking the next stage after getting the catch aboard. A point which may confirm this is that the boat in the middle distance in the Chicago picture is a close replica of the most conspicuous boat in the *Bridgewater Seapiece*, although it must be admitted that similar vessels appear elsewhere in Turner's oeuvre, but here the comparison is surely deliberate. Turner has even repeated the motif of the vessels being on a collision course although he has greatly increased the distance between them in the later picture. The horizon is also spotlit with a band of light which recalls Turner's practice in some early seascapes although the orange colour of the light in this picture belongs wholly to the 1830s.

It is of course also possible, as Professor Bachrach has suggested, that Turner felt that he had followed the model of the Van der Velde too closely in the *Bridgewater Seapiece* and intended the Chicago picture as a revised version of the theme, but Turner's reference in his letter to 'the reputation of Lord E's Picture' would seem to gainsay any dissatisfaction on his part with his earlier picture.

373. Phryne going to the Public Baths as Venus—Demosthenes taunted by Æschines
Exh. 1838 (Plate 379)

THE TATE GALLERY, LONDON (522)

Canvas, 76 × 65 (180·5 × 165)

Coll. Turner Bequest 1856 (67, 'Phryne going to the Bath' $6'4\frac{1}{2}'' \times 5'5\frac{1}{2}''$); transferred to the Tate Gallery 1929.

Exh. R.A. 1838 (31).

Lit. Ruskin 1857 (1903–12, xiii, pp. 107–9, 145, 151–8); Thornbury 1862, i, p. 331; 1877, p. 455; Hamerton 1879, pp. 275–6; Monkhouse 1882, p. 130; Bell 1901, pp. 133–4 no. 208; Armstrong 1902, pp. 206–7, 226; Davies 1946, p. 187; Finberg 1961, pp. 370, 501 no. 478; Herrmann 1963, p. 24; Rothenstein and Butlin 1964, pp. 38, 60, pl. 105; Lindsay 1966, pp. 184, 187–8.

Phryne, who is shown on the right, was a celebrated Greek courtesan of the fourth century B.C. who spent most of her life in Athens. The two rival fourth-century Athenian orators, Demosthenes and Æschines, are on the left. Although there is no known historical connection between them and Phryne, Turner, who probably used Lemprière's *Classical Dictionary*, could have read there how Demosthenes accused Æschines of being the son of a courtesan, though not of Phryne (this accusation, for which there is no proof, occurs in the speech *De Corona*, of 330 B.C., § 129). Ruskin suggests that the picture therefore shows 'the man who could have saved Greece [Demosthenes] taunted by the son of the harlot!'

The scene is probably also intended as a general picture of life in Athens at the time. However, the reference to Phryne going to the baths as Venus seems to allude to an event that took place at near-by Eleusis, when she celebrated the festival of Poseidon by going naked into the sea; this subject had been treated by Henry Tresham in a picture exhibited at the R.A. in 1789 (200).

The *Athenaeum*'s general comments on Turner's 1838 exhibits, in the issue of 12 May, apply well to this picture. 'Mr. Turner is in all his force this year, as usual—showering upon his canvas splendid masses of architecture, far distant backgrounds; and figures whereby the commandment is assuredly not broken— and presenting all these objects through such a medium of yellow, and scarlet, and orange, and azure-blue, as only lives in his own fancy and the toleration of his admirers, who have followed his genius till they have passed, unknowingly, the bounds between magnificence and tawdriness . . . It is grievous to us to think of talent, so mighty and so poetical, running riot into such frenzies; the more grievous, as we fear, it is now past recall.' In this picture 'the wanton lady is postively lost among a crowd of flame-coloured followers—and these, again, show tame beneath such a golden tree as never grew save in the gardens of the Hesperides.'

Ruskin singled this picture out for special attention as a typical late figure composition, it being 'of all the pictures dating after 1820 in the possession of the nation . . . the least injured . . . except in the sky'. After a long discussion of the reasons for the oddities of Turner's late figures he concludes, 'I cannot, however, leave this Phryne without once more commending it to the reader's most careful study. Its feeling is exquisite; the invention of incident quite endless—from the inlaid marbles of the pavement to the outmost fold of fading hills, there is not a square inch of the picture without its group of fancies: its colour, though broken in general effect, is incomparably beautiful and brilliant in detail; and there is as much architectural design and landscape gardening in the middle distance as would be worth, to any student of Renaissance composition, at least twenty separate journeys to Genoa and Vicenza. For those who like towers better than temples, and wild hills better than walled terraces, the second distance, reaching to the horizon, will be found equally rich in its gifts.'

374. Modern Italy—the Pifferari Exh. 1838

(Plate 352)

GLASGOW ART GALLERY

Canvas, $36\frac{1}{2} \times 48\frac{1}{2}$ (92·5 × 123)

Coll. H. A. J. Munro of Novar who bought it from the artist (a letter published in *The Times* on 27 December 1951 quotes from a letter written on 17 February 1857 to the architect C. R. Cockerell, R.A., by J. D. Coleridge (later Lord Chief Justice). This contains a number of anecdotes about Turner, including one, originating from William Boxall, which says that *Modern Italy* was painted at the request of the Rev. E. T. Daniell (1804–42). Daniell, although he greatly admired it, was unable to afford the full price, but Turner insisted that he should have it for the reduced figure of £200, but Daniell died before the transaction was completed. Turner then refused to sell the picture but finally relented and parted with it to Munro of Novar, who already owned *Ancient Italy* (No. 375), charging him only £200 saying 'I have told you, you shall stand in poor Daniell's shoes. I can't make money by that picture.' The objection to this story is that Daniell did not die until four years after the picture was shown at the R.A., but the picture was certainly away at the engraver's from 1839–42 and Turner may have agreed that Daniell should have it on its return. But by the time the picture at last returned from the engraver, Daniell was dead. This story is to some extent corroborated by Munro himself, in a note in his annotated copy of Thornbury (1862 edn) belonging to Professor Francis Haskell: 'I wished to have the *Modern Italy* when Daniell, for whom it was painted, died. "No", says Turner, "I won't part with it." I afterwards got the *Ancient Italy* from the R.A. [Munro seems to have his dates confused here]. Mr. Turner now says, "Turner [i.e. Munro] you shall

have Daniell's picture," and he would only take the price Daniell was to have paid'); Munro sale Christie's 11 May 1867 (176) bought Johnstone; James Fallows; sale Christie's 23 May 1868 (145) bought Johnstone; Butler Johnstone; Munro of Novar sale Christie's 6 April 1878 (97) bought Price; David Price sale Christie's 2 April 1892 (110) bought Laurie; Kirkman Hodgson; James Reid of Auchterarder; presented by his sons to the Glasgow City Art Gallery in 1896.

The provenance from 1867–78 is puzzling but as Johnstone was one of Munro's Christian names it seems probable that it was used as a 'bought in' name at the 1867 sale, and that the picture was sold privately later to James Fallows and then repurchased by H. Butler Johnstone, a relation of Munro's, only a year later after the picture had been bought in at the Fallows sale at Christie's. The 1892 Price sale catalogue confirms that Butler Johnstone bought the picture back in 1868. The fact that Fallows had to resell the picture within a year implies that he was in financial difficulties as he lost money on the transaction. In any case, it must remembered that at that date it was normal practice for collectors to change and exchange their pictures with far greater frequency than is done nowadays.

Exh. R.A. 1838 (57); R.A. 1903 (23); Bradford *Inaugural Exhibition* 1904 (42); R.A. 1934 (676); R.A. 1951–2 (166); Whitechapel 1953 (90); Tate Gallery 1959 (356); Leningrad and Moscow 1975–6 (63).

Engr. By W. Miller 1842 (large plate) and in the *Turner Gallery* 1859.

Lit. Ruskin 1843, 1856, 1878 (1903–12, iii, pp. 243, 300 n., 607 n.; v, p. 157 pl. 2, fig. 6; vi, p. 353; xiii, p. 409); Burnet and Cunningham 1852, p. 118 no. 195; Thornbury 1862, i, pp. 330–31; ii, pp. 347, 400; 1877, pp. 162, 170–73, 455, 549, 578, 597; Frost 1865, p. 95 no. 35; Hamerton 1879, p. 278; Bell 1901, p. 134 no. 209; Armstrong 1902, pp. 121, 223; James Paton *Catalogue of the Pictures in the Glasgow Art Gallery and Museum* 1908, p. 211 no. 1016; Rawlinson ii 1913, pp. 206, 208, 340–41, 358; Livermore 1957, pp. 81–2; Finberg 1961, pp. 370, 384, 387, 392, 501 no. 479; Rothenstein and Butlin 1964, pp. 12, 56; Lindsay 1966, p. 184; Gage 1968, p. 682 n. 38; Gage 1969, pp. 44–7, 265 n.162, pl. 15 (engraving); Reynolds 1969, fig. 149; Herrmann 1975, pp. 45, 233–4, pl. 154.

Herrmann has suggested that Turner, while painting this and *Ancient Italy*, had in mind the possibility of their being engraved and issued as large plates. The picture was with Miller for engraving from May 1839 until late 1842 and much of Turner's correspondence with the engraver has survived and is to be published by Gage. This shows Turner's extreme attention to detail and the enormous pains he was prepared to go to—and

to make others take—in order to get the effects that he desired. The touched proofs of the plate (which belong to Mr and Mrs Paul Mellon) bear additional witness to the mass of advice and instructions with which Turner bombarded the engraver.

Turner also appears to have been concerned for the picture's safety while it was away and urged Miller (in a letter of 9 May 1839 to be published by Gage) 'to keep the Picture of Modon Italy always in the *Packing Case* that the back of the Picture may be protected from injury'.

The view shows an arrangement of the scenery at Tivoli with the Roman Campagna in the distance. Ruskin thought that, although the Tivoli material 'was enriched and arranged most dexterously, it has the look of a rich arrangement and not the virtue of the real thing.' The Pifferari were shepherd bagpipers from the Abruzzi Hills, who converged upon Rome at Christmas time each year in order to pay homage to the Virgin Mary. Herrmann considers that Turner's choice of title may owe something to his strongly developed spirit of competition, for Wilkie had exhibited a picture entitled *The Pifferari* at the R.A. in 1829 (298), which had been bought by George IV.

In the same year Turner also exhibited *Ancient Italy: Ovid banished from Rome* (No. 375). The contrasting titles have been variously interpreted by different writers: Rothenstein and Butlin consider that Turner was here concerned with the passing of the glories of Rome in much the same way as he had treated the theme of the Carthaginian Empire twenty years before. Ann Livermore stresses that the genesis of the two pictures is to be found in Part I of Thomson's poem *Liberty* in which ancient and modern Italy are contrasted, with the moral that the arts of men fall to ruin when Liberty is banished from the scene, and that any country is similarly threatened if oppression is allowed.

Gage, on the other hand, has suggested that Turner's real concern here was not so much with the passing glory of an ancient Empire but with parallels in superstition in ancient and modern religion. Turner is known to have owned a copy of the Rev. J. J. Blunt's *Vestiges of Ancient Manners and Customs discoverable in Modern Italy and Sicily* 1823, where Ovid is cited (*Fasti* iv 616, vi 652, *Epistles* i, i, 11) as the principal source of the ancient practice of the worship of images of the Gods with music, and this is compared with modern peasant pipers playing before images of the Madonna. Thus in the two pictures, Turner would have equated the blasphemy implicit in the *Ars Amatoria* for which Ovid was banished with the superstitious piping of the modern Italian peasant.

At the R.A., the *Athenaeum*, 12 May, praised the painting of the background as offering 'a resting-place to the eye, fatigued by an accumulation of gorgeous and picturesque objects in the foreground' and considered that it and *Phryne* (No. 373) were both 'chaste and homely in their colouring and exquisite and precise in their finish compared with *Ancient Italy*'.

375. Ancient Italy—Ovid banished from Rome
Exh. 1838 (Plate 353)

PRIVATE COLLECTION

Canvas, $37\frac{1}{4} \times 49\frac{1}{4}$ (94·6 × 125)

Coll. Bought at the R.A. 1838 by H. A. J. Munro of Novar (this purchase is confirmed by Munro himself; see the entry for No. 374); Munro sale Christie's 6 April 1878 (96) bought Agnew; Kirkman Hodgson, M.P.; bought back from him by Agnew in 1893 and sold to Messrs. Sedelmeyer, Paris, who sold it to Camille Groult (*d.* 1907); by descent to his grandson M. Pierre Bordeaux-Groult, from whom bought by Wildenstein and Agnew 1971; bought from the latter by Dr Correa da Silva, Lisbon, 1973; resold through Agnew to the present owner in 1975.

Exh. R.A. 1838 (192); Paris 1894 (see below); Christie's *Fanfare for Europe* 1973 (31); Agnew 1973 (24).

Engr. By J. T. Willmore 1842 and in the *Turner Gallery* 1859.

Lit. Ruskin 1843 (1903–12, iii, p. 241); Burnet and Cunningham 1852, pp. 54, 118 no. 196, pl. iv; Thornbury 1862, i, pp. 330–31; ii, p. 400; 1877, pp. 455, 578, 597; Frost 1865, p. 95 no. 108; Hamerton 1879, p. 278; Redford, *Art Sales* i 1888, p. 270; Alfred Stevens, *Magazine of Art* xvii 1894, p. xxxvi; Sedelmeyer Gallery, *Illustrated Catalogue of 100 Paintings of Old Masters* 1894, p. 114 no. 98, repr.; Bell 1901, p. 135 no. 310; Armstrong 1902, pp. 121, 233 (where it is stated that the picture was painted for Munro); Rawlinson ii 1913, pp. 206, 208, 338, 358; Camille Pissarro *Letters to his Son Lucien* ed. John Rewald n.d., p. 242; Finberg 1961, pp. 370, 392, 501 no. 480; Rothenstein and Butlin 1964, pp. 12, 56; Lindsay 1966, p. 184; Gage 1968, p. 682 n. 38; Gage 1969, pp. 192, 269; Herrmann 1975, pp. 45, 233–4.

Ovid was exiled from Rome by the Emperor Augustus in 8 A.D. The official reason given for his banishment was that his love poetry, in particular the *Ars Amatoria*, offended public morals. However, since this volume of poems had been published ten years before, a more likely explanation is that Ovid was involved in a private scandal, possibly some domestic or political intrigue with the Emperor's daughter, Julia. The poet was exiled to Tomi, a remote outpost of the Empire on the shores of the Black Sea, and it was here that he wrote the famous elegiac poems the *Tristia*, and a series of letters, *Epistolae ex Ponto*, in an attempt to win back the Emperor's favour. In fact, Ovid was never recalled to Rome, and died in exile *c*. 17 A.D.

When *Ancient Italy* was with Sedelmeyer in 1894, an unsuccessful attempt was made to purchase it by subscription for presentation to the Louvre (which had to wait until 1967 before acquiring its first Turner, also from the Groult Collection (see No. 509)). According to

Gage, the critics were generally in favour of its acquisition but the plan was defeated by the more conservative artists of the time. Camille Pissarro certainly did not admire it, and Alfred Stevens considered it a work of Turner's decadence. In June 1894 Pissarro wrote to his son as follows:

'At the moment there is a great noise about a Turner which Sedelmeyer was to sell to the Louvre for two or three hundred thousand francs. The whole thing is a machination of dealers and collectors. So an exhibition of the English School is being held; some superb Reynolds, several very beautiful Gainsboroughs, two Turners belonging to Groult which are quite beautiful [probably Nos. 509 and 520], and the Turner they want to "give" to the Louvre, which is not beautiful, far from it!' I have been unable to discover any details about this exhibition; no catalogue appears to exist but it was certainly not held at the Sedelmeyer Gallery.

For various interpretations underlying Turner's purpose in painting this and the companion *Modern Italy*, see the entry for No. 384.

Both this and *Modern Italy* were engraved and the plates were sold by F. G. Moon to the National Art Union who offered subscribers cheap impressions produced by the new electro-galvanic process. The results were not satisfactory, but they injured the sale of the better impressions from the plates published by Turner.

When shown at the R.A. Exhibition, the critic of the *Athenaeum*, 12 May, wrote: 'It is grievous to think of talent, so mighty and so poetical, running riot into such frenzies; the more grievous, as we fear, it is now past recall.'

Ancient Italy was copied by Munro of Novar while in his possession. Munro's copy was sold at Christie's 19 March 1880 (223) but is now untraced.

376. The Fountain of Fallacy Exh. 1839

BEAVERBROOK FOUNDATIONS, ON LOAN TO THE
BEAVERBROOK ART GALLERY, FREDERICTON, NEW BRUNS-
WICK (?)

Canvas, 56 × 80 (101·5 × 162·5) (these measurements include the frame, but see below)

Coll. William Marshall of Eaton Square (?). A letter of 12 June 1839 from Turner to a Mr Marshall is to be published by Gage. Marshall had obviously written to ask the prices of Turner's pictures at the R.A. and also of this picture. Turner replied 'The Fountain of Fallacy 400 guineas—exclusive of frame and the Copyright of Engraving' and later in the letter mentioned that he had no other picture of the same size. The question of the picture's subsequent provenance is considered below.

Exh. B.I. 1839 (58).

Lit. Ruskin 1843 (1903–12, iii, p. 242); Ruskin *Diary* 26 February 1844; Burnet and Cunningham 1852,

pp. 39, 122 no. 9; Waagen 1857, iv, p. 184 records a large Turner oil in the collection of William Marshall of Eaton Square (listed in Graves' Index as 'A large Lake Picture'); Thornbury 1877, p. 582; Bell 1901, p. 138 no. 217; Armstrong 1902, p. 222; Falk 1938, p. 75; Finberg 1961, pp. 372, 501 no. 481; Lindsay 1966, pp. 206–7; Lindsay 1966², pp. 56–7; Gage 1969, p. 120; Shapiro 1972, p. 80 n. 3.

Exhibited with the following lines:

Its Rainbow-dew diffused fell on each anxious lip,
Working wild fantasy, imagining;
First, Science in the immeasurable Abyss of thought,
Measured her orbit slumbering.
 MS *Fallacies of Hope*

This picture provides one of the most teasing conundrums in Turner's oeuvre. Is it or is it not the same as *The Fountain of Indolence* (No. 354) exhibited at the R.A. in 1834?

Until the discovery by Gage of Turner's letter to William Marshall about the price of this picture, nothing was known of it beyond its appearance at the British Institution and two references to it by Ruskin, one in his *Diary* for 26 February 1844: 'Called on Blakes in Portland Place, and saw the *Fountain of Fallacy* which I was bitterly vexed about—the sky entirely gone—but a nobler picture than even I imagined', and the second in *Modern Painters* where he describes it as 'a piece of rich Northern Italy, with some fairy waterworks; this picture was unrivalled in colour once, but is now a mere wreck . . .'

This lack of information about the picture led C. F. Bell to suggest that it was one and the same as *The Fountain of Indolence*, although he describes this as 'specious conjecture'. As the size of works exhibited at the British Institution is given to include the frame, Bell argues that, if one allows for the frame to be 8 in. wide, as can be shown to have been so with other exhibited Turners, then the canvas dimensions of 40 × 64 in. are virtually identical with those of *The Fountain of Indolence* (42 × 65½ in. although in the case of the much larger *Dutch Fishing Boats* (No. 372), exhibited in 1838, the frame was only 6 in. wide.)

Ruskin, who also mentions *The Fountain of Indolence* in *Praeterita*, seems to have had no doubt that there were two pictures, although his knowledge of Turner's work exhibited before 1836 was, by his own admission, rather sketchy. Unfortunately Waagen's description of the picture at Mr Marshall's is little help beyond suggesting that Marshall's picture was 'an example of his [Turner's] later time', although Waagen classes it among those Turners 'which I have denominated as souls of pictures without bodies', which might be thought to be not wholly inapplicable to *The Fountain of Fallacy* as described by the critics when it was shown in 1839 (see below). This, strongly reinforced by the evidence of Turner's letter, makes it seem very possible that Marshall's picture can be identified with *The Fountain of Fallacy*. Finberg seems to think that there

may have been only one picture but that Turner altered it between 1834 and 1839. The different title would seem to be a stumbling block to this theory, although it is true that Turner did sometimes exhibit the same picture with varying titles (e.g. *Wreckers* (No. 357) had slightly different titles when shown at the R.A. in 1834, the B.I. in 1836 and the R.S.A. in 1849), but such an emphatic difference as is implied in this case would seem without precedent.

Perhaps, however, Turner, having worked on the picture again, decided to give it a fresh start at the British Institution. Then, having appended some lines from *Fallacies of Hope* to the picture in the exhibition catalogue, he had the idea—perhaps in a jocular mood—of reinforcing his claims as a poet by changing the title from one which referred to Thomson the poet to Turner the poet.

The picture received a good deal of attention from the critics at the British Institution. It was singled out by the *Literary Gazette* on 2 February (Private View Day) as 'a gorgeous specimen of Turner on an imaginative subject'. *The Times* of 4 February, however, called it 'an extraordinary mess of colours', and the *Art Union* for 15 February, after admitting that 'it is wonderfully painted', added 'it is also wonderfully incoherent . . . Mr. Turner, as he grows older, grows more fantastical and though he may astonish us more, he gratifies us less.' The *Spectator*, 16 February, thought it 'an insubstantial and dazzling vision' and considered the title 'an appropriate name for this fanciful problem of chromatography'.

In order to help solve the question of the picture's identity it is worth quoting the two newspaper notices which describe the picture's appearance. The *Literary Gazette* for 16 February wrote 'the rainbow tints that play in prismatic order about the fountain (which occupies the centre of the piece), are quite enchanting, as well as entirely novel in their character; and, with the Claude-like distance, and classical arrangement, render it one of Mr. Turner's most captivating pictures.' The *Athenaeum*, 9 February, gives more details about the composition: 'A wide, far-reaching horizon of uplands, towers, temples and streams losing their light among tufted groves, offers to the eye an ample and delicious repose from the dreamy splendours of the foreground, where the magic fountain, like an enormous bubble of painted air, is throwing gleams of rainbow light on every side in the midst of which a thousand winged spirits are floating, like a shower of flower leaves—gay, light and indistinct. In harmony with the brilliance of this enchantment, the sun of noon mingles its unbroken light with the glory of the fountain. Critics may shake their heads at this picture, but poets will go home from it—to dream.'

Reading these descriptions in front of *The Fountain of Indolence* they fit so closely that it seems quite unnecessary to seek further for an explanation: the 'two' Fountains must be considered to be identical, although Turner may well have repainted it in part between 1834–9, particularly perhaps in the sky, which

occasioned Ruskin's comment when he saw it in 1844. If Marshall had bought the picture in 1839 and still owned it at the time Waagen wrote in 1857, it is difficult to explain why it should have been 'at Blakes' in 1844. William Blake (1775–1853) was a Life Governor of the British Institution from 1818 and had become a Director in 1838, so perhaps Marshall had consulted him in his official capacity about the picture's condition. On the other hand, Blake may have been the owner of the picture in 1844, as stated by Harold Shapiro in his edition of *Ruskin's Letters to his Parents 1845*, and then, sold it to William Marshall between 1844 and Waagen's visit. The way that Ruskin phrases the entry in his *Diary*, 'called on Blakes in Portland Place', suggests that 'Blakes' refers to some sort of business and may perhaps have been connected with picture restoration, although I have not been able to trace anyone of this name in the London Trade Directory of this date. On balance I feel that Marshall's letter of 1839, coupled with the reference to 'Blakes', makes it seem unlikely that Blake ever owned the picture but the possibility that he did so can by no means be ruled out. Further points which are worth noting in considering the problem are:

1. *The Fountain of Indolence* was exhibited at the R.A. and *The Fountain of Fallacy* at the British Institution. It was not permitted to exhibit the same picture twice— even in an altered state—at the R.A. However, between 1835 and 1841 six of Turner's eight pictures exhibited at the British Institution had been previously exhibited at the R.A. (the exceptions being *Regulus* (1837) and *Fishing Boats with Hucksters bargaining for Fish* (1838) which was a special case if I am right in interpreting it as a sequel to *Dutch Boats in a Gale* (No. 14) which had been lent to the Old Masters Section of the B.I. Exhibition in 1837.) This surely strengthens the theory that they are the same picture.

2. Turner's letter to Marshall states that he has no other picture of the size of the *Fallacy*. Therefore *Indolence* (if it was a different picture) must have been sold before 1839. Unfortunately, no history for *Indolence* is known before its purchase by Agnew from H. Lumley in 1882, so this point is of negative rather than positive significance.

The sum of the evidence seems to me to outweigh fairly convincingly Ruskin's reference to two pictures and to show that in fact there was—and is—only one. It must be admitted, however, that it is by no means proven and is unlikely to be so unless some more evidence is forthcoming, such as a link between Marshall and Lumley in the provenance. If this should come to light, it is still necessary to account for the way in which the title reverted to its earlier form, and also to explain away the fact that none of the critics recognised that *Fallacy* was in fact *Indolence*, albeit in an altered state. However, for another instance of art critics failing to observe alterations in Turner's titles, see No. 80.

Lindsay interprets the quotation from *Fallacies of Hope* as evidence of Turner's anti-Newtonian attitude but this view is challenged by Gage who, correctly in

my opinion, considers that Turner is here invoking science rather as a stabilising influence on 'wild fantasy'.

377. The Fighting 'Temeraire', tugged to her Last Berth to be broken up, 1838 Exh. 1839

(Plate 351)

THE NATIONAL GALLERY, LONDON (524)

Canvas, $35\frac{1}{4} \times 48$ (91 × 122)

Coll. Turner Bequest 1856 (34, 'The Temeraire' 4′0″ × 3′0″); transferred to the Tate Gallery 1951, returned to the National Gallery 1956.

Exh. R.A. 1839 (43); J. Hogarth's, 1844; Amsterdam, Berne, Paris, Brussels, Liege (36, repr.), Venice and Rome (42, repr.) 1947–8; Cape Town 1952 (29).

Engr. By J. T. Willmore 1845 as 'The Old Téméraire'.

Lit. Ruskin 1843, 1856 and 1860, *Harbours of England* 1856, and 1857 (1903–12, iii, pp. 246–9, 275, 286, 364, 422; vi, p. 381; vii, p. 157; xiii, pp. 41, 47, 147, 167–72); *Art Union* September 1844, p. 294; Burnet 1852, pp. 105–6, engr. pl. 7; Thornbury 1862, i, pp. 333–45; ii, p. 332; 1877, pp. 337–8, 361, 446, 458–65, 530; Hamerton 1879, pp. 282–5; Monkhouse 1879, pp. 118–20; Eastlake 1895, i, p. 189; Bell 1901, pp. 135–6 no. 212; Armstrong 1902, pp. 112, 116–18, 146, 233, repr. facing p. 116; Amy Woolner, *The Life and Letters of Thomas Woolner R.A.* 1903, ii, pp. 260–61; Falk 1938, pp. 145–9, 208, repr. in colour facing p. 148; Davies 1946, pp. 150, 186; Clare 1951, pp. 105–6, 111, repr. p. 100; Davies 1959, p. 97; Finberg 1961, pp. 371–4, 376, 414, 417–18, 421, 502 no. 482, pl. 20; Rothenstein and Butlin 1964, pp. 30, 58, 60, pl. 108; Lindsay 1966, pp. 187–8, 202, 255; 1966², pp. 42, 50; Reynolds 1969, p. 178, colour pl. 153; Gaunt 1971, pp. 9–10, colour pl. 38; Hawes 1972, pp. 23–48, repr. p. 22 fig. 1; Shapiro 1972, pp. 230 n., 248.

Exhibited in 1839 with the following lines, paraphrasing two lines from Thomas Campbell's 'Ye Mariners of England' (Turner had illustrated Campbell's *Poetical Works* in 1837):

> 'The flag which braved the battle and the breeze,
> No longer owns her.'

In a note attached to a copy of the prospectus for the 1845 engraving (see below) in the Tate Gallery archives Turner used slightly different punctuation:

> The (fighting) Temeraire (tugged to her last berth
> to be broken up 1838)
> The flag which braved the Battle and the Breeze
> No longer own's her J M W Turner RA.

The *Téméraire*, having been remasted after use as a victualling depot at Sheerness, was towed up the Thames to the Beatson ship-breaking yard at Roth-

erhithe on 6 September 1838. According to Thomas Woolner, who heard it from his fellow sculptor W. F. Woodington, Turner and Woodington were on the same packet steamer returning from Margate that day and saw the ship appear in 'a great blazing sunset'; Woodington saw Turner 'also noticing and busy making little sketches on cards'; alas, none of these sketches has been traced. Owing to the direction of the deep-water channel near the Nore Light, where it runs eastwards, the position of the sunset is not so impossible as it might seem. The relative positions of the tug's mast and funnel are, however, impossible and were corrected in Willmore's engraving of 1845. Thornbury's statement (1862, i, p. 335) that the subject of Turner's picture was suggested by Stanfield was denied by Stanfield, as noted by H. A. J. Munro in the margin of his copy of Thornbury's *Life*, now in the possession of Francis Haskell.

The *Téméraire*, named after a French ship captured at Lagos Bay in 1759, was a warship of 98 guns, launched in 1798. She played a distinguished part at the Battle of Trafalgar, and Louis Hawes has shown that Turner's picture was in part a symptom of the interest that grew up in the later 1830s in the dwindling number of veteran ships from the Napoleonic wars. He also sees it as a portrayal of the more general theme of the decline of Britain's mercantile power, paralleled by Turner in many of his Carthaginian and Venetian subjects.

R. C. Leslie, in a letter to Ruskin of *c.* 1884 (reprinted in Ruskin 1903–12, xxxv, p. 574), talking about Turner at Academy Varnishing Days, adds that 'I am almost sure that I saw him at work on the *Téméraire*, and that he altered the effect after I first saw it. In fact, I believe he worked again on this picture in his house long after I first saw it in the R.A. I remember Stanfield at work too, and what a contrast his brushes and whole manner of work presented to that of Turner.' In a further letter of 15 June 1884 (*op. cit.*, p. 576), Leslie, talking of the corrections to the rigging and placing of the tug's funnel in J. T. Willmore's engraving of 1845, speaks of Turner's 'first, strong, almost prophetic idea of smoke, soot, iron, and steam, coming to the front in all naval matters, being thus changed and, I venture to think, weakened by this alteration.'

The picture was exhibited at J. Hogarth's, 60 Great Portland Street, in the late summer of 1844 in connection with Willmore's engraving, as noted by the *Art Union* for September that year: 'It is a glorious sunset, and we are to suppose that by the time that the glowing disk shall rest upon the horizon, the Temeraire shall have been towed into her last resting place.'

This symbolic interpretation of the setting sun had already appeared in a number of the reviews of the picture at its first showing at the R.A. in 1839. For the *Morning Chronicle* of 7 May, 'There is something in the contemplation of such a scene which affects us almost as deeply as the decay of a noble human being. It is impossible to gaze at the remains of this magnificent and venerable vessel without recollecting, to use the

words of Campbell, "how much she has done, and how much she has suffered for her country." In his striking performance Mr. Turner has indulged his love of strong and powerfully-contrasted colours with great taste and propriety. A gorgeous horizon poetically intimates that the sun of the Temeraire is setting in glory.' Similarly the *Athenaeum* for 11 May: 'A sort of sacrificial solemnity is given to the scene, by the blood-red light cast upon the waters by the round descending sun, and by the paler gleam from the faint rising crescent moon, which silvers the majestic hull, and the towering masts, and the taper spars of the doomed vessel, gliding in the wake of the steam-boat—which latter (still following this fanciful mode of interpretation) almost gives to the picture the expression of such malignant alacrity as might befit an executioner.'

The *Literary Gazette* for the same date wrote, 'We have seen nothing of late so much to our mind, from the pencil of this artist, as this performance, treated as it is historically and allegorically. The sun of the glorious vessel is setting in a flood of light, such as we do not remember ever to have seen represented before, and such as, we think, no one but Mr. Turner could paint.' For the *Spectator*, again of 11 May, the picture 'is real nature, and its poetry is intelligible'; it 'is a grand image of the last days of one of Britain's bulwarks: the huge hulk—looming vast in the distance in the midst of a faint gleam of moonlight, that invests with a halo the ghost of her former self—is towed by a steam-boat whose fiery glow and activity and small size make a fine contrast with the majestic stillness of the old line-of-battle ship, like a superannuated veteran led by a sprightly boy: the sun is setting on the opposite side of the picture, in a furnace-like blaze of light, making the river glow with its effulgence, and typifying the departing glories of the old Temeraire. The colouring is magical, and does not "o'erstep the modesty of nature:" this picture ought to be purchased for Greenwich.'

The *Art Union* for 15 May 1839 personalised the *Temeraire* shamelessly, after singling the picture out as, 'perhaps, the most wonderful of all the works of the greatest master of the age; a picture which justifies the warmest enthusiasm:—The most fervent praise of which cannot incur the charge of exaggeration . . . The venerable victor in a hundred fights is tugged to his rest by a paltry steam-boat, upon whom he looks down with powerless contempt:—the old bulwark of a nation governed and guided by the mean thing that is to take his place! On one side is the setting sun—emblem of the aged ship—its glory tinging the clouds with brilliancy, but with little warmth; while on the other is the young moon—type of the petty steamer—about to assume its station in the sky. The picture is, indeed, a nobly composed poem,—one to which the pen of genius can add nothing in the way of illustration.'

Thackeray, writing as Michael Angelo Titmarsh in *Fraser's Magazine* for June, likened the effect of a performance of 'God save the Queen' to 'some such thrill of excitement as makes us glow and rejoice over Mr. Turner and his "Fighting Temeraire"; which I am sure, when the art of translating colours into music or poetry shall be discovered, will be found to be a magnificent national ode or piece of music.' He also described the picture as 'as grand a painting as ever figured on the walls of any academy, or came from the easel of any painter.'

Even *Blackwood's Magazine* for July–December 1839 was relatively favourable. 'It is very beautiful—a very poetical conception; here is genius. But we think it would have lost none of its beauty, had it been more true. The unsubstantial and white look of the vessel adds nothing to the feeling—rather removes it; and the sky, glorious as it is, would not be less so, if the solemnity were kept up on both sides. It is, however, a work of great effect and feeling, and worthy of Turner when he was Turner.' Only *The Times* for 7 May (before the critic could have seen the reaction of his colleagues) was content to dismiss the picture, with *Ancient Rome* and *Pluto* (Nos. 378 and 380), as exhibiting 'the extraordinary and extravagant colouring of the artists. They are full of imagination, but bear little or no resemblance to nature, and if it were not for the intelligence conveyed in the catalogue it would be impossible to conjecture what they are designed to represent.'

Ruskin, in *The Harbours of England*, asserted that 'the last thoroughly perfect picture [Turner] ever painted, was the *Old Téméraire*.' In his notes on the Turners exhibited at Marlborough House in 1856 he qualified this: 'I have stated in the *Harbours of England* that it was the last picture he ever executed with his *perfect* power; but that statement needs some explanation. He produced, as late as the year 1843, works which, take them all in all, may rank among his greatest; but they were great by reason of their majestic or tender conception, more than by workmanship; and they show some failure in distinctness of sight, and firmness of hand . . . The "*Old Téméraire*" is the last picture in which Turner's execution is as firm and faultless as in middle life;—the last in which lines requiring exquisite precision, such as those of the masts and yards of shipping, are drawn rightly, and at once. When he painted the "*Temeraire*", Turner could, if he had liked, have painted the "Shipwreck" [No. 54] or the "Ulysses" [No. 330] over again; but, when he painted the "Sun of Venice" [No. 402: exhibited in 1843], though he was able to do different, and in some sort more beautiful things, he could not have done *those* again.'

Ruskin had already listed this picture in *Modern Painters* i as one of most perfect of Turner's late pictures in respect of colour. 'For the conventional colour he substituted a pure straight-forward rendering of fact . . . and that not of such fact as had been before even suggested, but of all that is *most* brilliant, beautiful and inimitable'. But 'Innovations so daring and so various could not be introduced without corresponding peril' and in addition 'colour has always been only his second object. The effects of space and form . . . often

required the employment of means and method totally at variance with those necessary for the obtaining of pure colour . . . I am perfectly willing to allow, that the lemon sky is not properly representative of the yellow of the sky, that the loading of the colour is in many places disagreeable, that many of the details are drawn with a kind of imperfection different from what they would have in nature, and that many of the parts fail of imitation, especially to an uneducated eye. But no living authority is of weight enough to prove that the virtues of the picture could have been obtained at a less sacrifice, or that they are not worth the sacrifice.' Ruskin adds in a footnote, apropos of the poor state of many Turners even only a few years after their execution, that 'the Old Temeraire is nearly safe in colour.'

In *Modern Painters* iv Ruskin remarks that Turner 'was very definitely in the habit of indicating the association of any subject with circumstances of death . . . by placing it under one of his most deeply *crimsoned* sunset skies. The colour of blood is thus plainly taken for the leading tone in the storm-clouds above the 'Slave-ship' [No. 385]. It occurs with similar distinctness . . . subdued by softer hues, in the *Old Téméraire*.'

378. Ancient Rome; Agrippina landing with the Ashes of Germanicus. The Triumphal Bridge and Palace of the Cæsars restored Exh. 1839
(Plate 354)

THE TATE GALLERY, LONDON (523)

Canvas, 36 × 48 (91·5 × 122)

Coll. Turner Bequest 1856 (84 'Rome' 4'0" × 3'0"); transferred to the Tate Gallery 1939.

Exh. R.A. 1839 (66); Arts Council tour 1952 (16); exchange loan to the Boston Museum of Fine Arts 1954–7; Edinburgh 1968 (22); R.A. 1974–5 (516, repr.).

Lit. Ruskin 1857 (1903–12, xiii, p. 158); Thornbury 1862, i, pp. 331–2; ii, p. 332; 1877, pp. 455–6, 530; Hamerton 1879, pp. 278–80; Bell 1901, p. 136 no. 213; Armstrong 1902, pp. 150, 217; Davies 1946, p. 187; Finberg 1961, pp. 373–4, 502 no. 483; Rothenstein and Butlin 1964, p. 56; Lindsay 1966², pp. 49–50; Gage 1974, pp. 77, 87 no. 55; Herrmann 1975, p. 47, pl. 153.

Exhibited in 1839 with the following lines:

———— 'The clear stream,
Aye,—the yellow Tiber glimmers to her beam,
Even while the sun is setting'.

Germanicus Julius Caesar (15 B.C.–A.D. 19) was the nephew and adopted son of the Emperor Tiberius and, by his wife Agrippina, the father of the future Emperor Caligula and Nero's mother, the younger Agrippina. He died in Antioch, the cause being rumoured to be poison or the magical arts. Germanicus' widow brought his ashes home in an urn, but in fact landed at Brundisium (Brindisi), not Rome. In his verses Turner is presumably alluding to this incident as a stage in the decline of Rome. The picture is a pair to *Modern Rome—Campo Vaccino* (No. 379); *c.f. Ancient Italy* and *Modern Italy* of the previous year (Nos. 375 and 374).

The *Athenaeum* for 11 May 1839 dismissed the two pictures as being in Turner's 'maddest manner'. *Blackwood's Magazine* for July–December described them as 'both alike in the same washy-flashy splashes of reds, blues, and whites, that, in their distraction and confusion, represent nothing in heaven or earth, and least of all that which they profess to represent, the co-existent influence of sun and moon.' But the *Spectator* for 11 May, introducing Turner as being 'as gorgeous and mysterious as ever', while regretting his extravagances found it 'impossible not to admire the wondrous power of his art in representing an atmosphere of light. "*Ancient Rome*" . . . is a blaze of orange-golden sunshine, reflected from piles of architecture that must be of marble to be so steeped in the hues of light.' And the *Art Union* for 15 May described it as 'Another of Turner's gorgeous works;—a reckless example of colour, but admirable in conception, and brilliant in execution', adding rather strangely in view of the present appearance of the picture, 'The critics who protest against his using too much yellow, will this year have to complain of his dealing too much in red.' It may be that some colour has been lost, but Ruskin's remark, reviewing the pictures hung at Marlborough House in 1856, that 'there was once some wonderful light in this painting but it has been chilled by time' seems over-pessimistic.

For a watercolour 'colour beginning' of a bridge with much the same general effect and mood as the painting, though with none of the classical detail, see CCLXIII-351 (repr. in colour Wilkinson 1975, p. 113).

379. Modern Rome—Campo Vaccino Exh. 1839
(Plate 355)

THE EARL OF ROSEBERY

Canvas, 35½ × 48 (90·2 × 122)

Coll. H. A. J. Munro of Novar who probably bought it at the R.A. Exhibition; Munro sale Christie's 6 April 1878 (99) bought Davis, probably a *nom de vente* for the fifth Earl of Rosebery (1847–1929) or an agent acting on his behalf (see also No. 366); by descent to the present owner.

Exh. R.A. 1839 (70); R.A. 1896 (8); Whitechapel 1953 (91); Victoria and Albert Museum *Byron* 1974 (S39); R.A. 1974–5 (517).

Lit. Burnet and Cunningham 1852, pp. 29, 118 no. 199; Thornbury 1862, i, p. 232; ii, p. 400; 1877, pp. 105, 579; Frost 1865, p. 95 no. 135; Hamerton 1879, p. 279; Bell 1901, pp. 136–7 no. 214; Armstrong 1902, pp. 121, 228; Finberg 1961, pp. 373, 502 no. 484; Rothenstein and Butlin 1964, pp. 12, 56; Gage 1968, p. 682; Herrmann 1975, p. 47.

A large stone in the centre foreground is inscribed 'PONT [IFEX?] MAX.' The goats which are gambolling behind it are surely included as a recollection of Claude.

Exhibited with the following quotation from Byron:

> 'The moon is up and yet it is not night,
> The sun as yet divides the day with her'.

The same quotation was to be used again by Turner as a caption to his *Approach to Venice* in 1844 (see No. 412). The first line is that of verse xxvii of Canto IV of *Childe Harold* but Turner has altered Byron's second line which should read:

> 'Sunset divides the sky with her—a sea'.

A companion to *Ancient Rome*; *Agrippina landing with the Ashes of Germanicus* (No. 378). This pair, following the *Ancient Italy* and *Modern Italy* (Nos. 375 and 374), exhibited in 1838, reflects the impact on Turner of Thomson's poem *Liberty* of which part iii (published in 1735) is devoted to tracing the establishment of Liberty in Rome and its subsequent loss after the death of Brutus.

At the R.A. the picture received mixed opinions, the most favourable appearing in the *Art Union* of 15 May which considered it 'A fine and forcible contrast to No. 66 [*Ancient Rome*]. The glory has departed. The eternal city, with its splendours—it stupendous temples, and its great men—all have become a mockery and a scorn. The plough has gone over its grandeurs, and weeds have grown in its high places.' Thackeray, writing under the name of Michael Angelo Titmarsh in *Fraser's Magazine* for June, after praising the *Temeraire* (No. 377) admitted that Turner's 'other performances are for the most part quite incomprehensible to me'. Most of the other critics considered this and *Ancient Rome* together and their comments are given in the entry for No. 378.

380. Pluto carrying off Proserpine Exh. 1839
(Plate 382)

NATIONAL GALLERY OF ART, WASHINGTON D.C.

Canvas, $36\frac{3}{8} \times 48\frac{5}{8}$ (92·4 × 123·6)

Coll. According to Redford (*Art Sales* 1888, ii, p. 119) this was sent to Christie's for sale in 1849 by a collector named Wetherall but was bought in, but I have been unable to trace such a sale in Christie's records, nor does Lugt list any vendor of this name (Finberg identifies Wetherall with the collector and dealer W. Wethered junior of King's Lynn who was to commission views of Venice from Turner in 1845–6. Wethered had two sales at Christie's on 7–8 March 1856 and 27 February 1858 but neither contained an oil by Turner. Wethered consulted Ruskin about buying Turner's work late in 1843 so that, if he ever owned this picture, it seems likely that he acquired it after this rather than at the R.A. Exhibition); John Chapman, M.P. (1810–1877), of Hill End, Cheshire, by 1852 according to a note in the 1839 R.A. catalogue in Agnew's library and

certainly by 1857; by descent to his son Edward Chapman, M.P. (1839–1906); bought in 1911 from Sulley by Knoedler and sold to Watson B. Dickerman in 1912; given to the National Gallery, Washington in 1951 by Mrs Dickerman in memory of her husband (Accession no. 1080).

Exh. R.A. 1839 (369 with '—*Ovid's Metam.*' appended to the title); Manchester 1857 (191 lent by John Chapman); Manchester 1887 (609); Guildhall 1892 (112); R.A. 1896 (28); Guildhall 1899 (35); Manchester *Paintings lent by George John Chapman Esq. and the Executors of the late Edward Chapman Esq.* 1908 (020); Knoedler, New York, 1914 (37 lent by W. B. Dickerman).

Lit. Ruskin 1843 (1903–12, iii, p. 242 where, in a footnote, it is hilariously mistitled '*Plato* carrying off Prosperine'); Burnet and Cunningham 1852, p. 118 no. 200; Waagen 1857 iv, p. 149 (wrongly listed in Graves' Index as a drawing); Thornbury 1877, p. 579; Hamerton 1879, p. 279; Bell 1901, p. 137 no. 215; Armstrong 1902, pp. 121, 227; Finberg 1961, pp. 373, 408, 502 no. 485.

Proserpine, a daughter of Ceres by Jupiter, was so beautiful that the father of the gods himself became enamoured of her and deceived her by changing himself into a serpent and folding her in his coils. Turner clearly makes an allusion to this by putting a snake on the stone in the foreground on the right.

The scenery appears to be based on that near Orvieto (compare No. 301), although Pluto carried Proserpine off to the infernal regions from the plains of Enna in Sicily where Proserpine lived. The connection with the landscape outside Rome has led to the suggestion that the picture may have been painted, or at any rate started, some time before being exhibited. Furthermore, the handling does seem a little dry for 1839 but the picture badly needs cleaning and its present condition makes it difficult to make a definite pronouncement about dating on stylistic grounds.

At the Academy, the critics differed violently in their estimates of the picture. The *Athenaeum*, 11 May, thought it 'one of the best of his grand landscapes' and the *Art Union*, 15 May, called it 'a gorgeous piece of wild imagining—abounding in proofs of genius', although it added 'This picture more than any by the great master gives us hints of the perishable nature of his materials.' This latter comment perhaps reinforces the suggestion, made above, that the picture may have been worked on over a considerable period.

On the other hand the *Spectator* for 11 May dismissed it as 'utterly unintelligible' and *Blackwood's Magazine* for July–December lamented how painful it was to turn to it from *The Fighting Temeraire* (No. 377): 'Here we have a red-hot Pluto frying the frigid Proserpine ... Turner's draperies are all asbestos: and here are figures that look like sulphureous tadpoles. It is really detestable and childish in colour, composition and everything belonging to it.' Thackeray writing in

Fraser's Magazine in June also found the picture incomprehensible and sarcastically advised that 'It is worth a shilling alone to go and see *Pluto and Proserpine*. Such a landscape! Such figures! Such a little red-hot coal scuttle of a chariot!'

Ruskin considered that 'in his picture of Proserpine the nature is not the grand nature of all time, it is indubitably modern, and we are perfectly electrified at anybody's being carried away in the corner except by people with spiky hats and carabines.'

381. Cicero at his Villa Exh. 1839 (Plate 356)

EVELYN DE ROTHSCHILD ESQ., ASCOTT, BUCKS

Canvas, 36½ × 48½ (92·7 × 123·2)

Coll. Joseph Gillott by March 1845; his account book shows that he either sold it to George Pennell or that Pennell sold it for him, probably to John Miller of Liverpool who certainly owned it by 1848 when he lent it to the R.S.A. Exhibition; the National Trust guide to Ascott is therefore mistaken in stating that it was bought from Turner by Munro of Novar who cannot have acquired it until after 1848; Munro sale Christie's 11 May 1867 (179) bought Lord Powerscourt; bought from him by Agnew in 1872 and sold to Edward Hermon; sale Christie's 13 May 1882 (81) bought in; Sir Charles Seely, Bt (1833–1915); Sir Hugh Seely, Bt, from whom bought by Knoedler in 1928 and sold in October 1928 to Anthony de Rothschild; by descent to the present owner.

Exh. R.A. 1839 (463); R.S.A. 1848 (144) Brussels 1929 (180); R.A. 1934 (647).

Lit. Ruskin 1843, 1856 (1903–12, iii, pp. 241, 248, 267; xiii, p. 130n.); Burnet and Cunningham 1852, p. 118 no. 201; Thornbury 1862, i, p. 232; ii, pp. 343, 400; 1877, pp. 105, 546, 579, 597; Frost 1865, p. 95 no. 38; Hamerton 1879, p. 279; Bell 1901, p. 137 no. 216; Armstrong 1902, p. 233; Finberg 1961, pp. 373, 502 no. 486, 516 no. 581a; *The National Trust Guide to the Ascott Collection* 1963, p. 32 no. 55; Rothenstein and Butlin 1964, pp. 38, 56, pl. 107; Lindsay 1966, p. 168.

This is a romantic reconstruction of Tusculum, the ancient city in the Alban Hills above Frascati which was the supposed site of Cicero's favourite villa. No drawing is known to exist and the view may be largely imaginary. The subject may have appealed to Turner as it was one that Wilson had painted, a version of which was engraved by Woollett.

At the R.A. the picture received two very brief but favourable reviews and two longer and very critical notices. The *Spectator*, 11 May, wrote that 'when viewed at a proper distance [it] opens the wall like a vision of enchantment' while the *Art Union*, 15 May, described it as 'Another of Turner's examples of revelling with

colour, and picturing the dreams of his fancy.' However, Thackeray, writing as Michael Angelo Titmarsh Esq. in *Fraser's Magazine* for 19 June dismissed it, *Agrippina* (No. 378) and *Pluto carrying off Proserpine* (No. 380) as 'quite incomprehensible' and 'not a whit more natural, or less mad, than they used to be in former years, since he has forsaken nature, or attempted (like your French barbers) to embellish it'. The most hostile notice appeared, as might be expected, in *Blackwood's Magazine* for July–December. It described the figure of Cicero as standing 'having dipped his head and arms into a vermilion pot, as red-hot as a salamander' and his domestics as looking like 'vitrified tadpoles'. The handling of paint was described as 'such fuzzy unmeaning execution! It looks scratched in with old broken combs, not with painter's brushes.'

Ruskin classified it among the 'nonsense pictures', adding 'There can never be any wholesome feeling developed in these preposterous accumulations, and where the artist's feeling fails, his art follows; so that the worst possible examples of Turner's colour are found in pictures of this class.' Later, he singled it out as the exception among 'recent Academy pictures ... which either present us with perfect tone, or with some higher beauty to which it is necessarily sacrificed.'

382. Bacchus and Ariadne Exh. 1840 (Plate 383)

THE TATE GALLERY, LONDON (525)

Canvas, 31 × 31 (79 × 79)

Coll. Turner Bequest 1856 (91, 'Bacchus and Ariadne' 2′7″ × 2′6½″); transferred to the Tate Gallery 1929.

Exh. R.A. 1840 (27).

Lit. Ruskin 1857 (1903–12, xiii, pp. 157–8); Thornbury 1862, i, p. 346; 1877, p. 465; Hamerton 1879, p. 285; Bell 1901, p. 138 no. 218; Armstrong 1902, p. 218; Davies 1946, p. 187; Finberg 1961, pp. 379, 505 no. 530; Rothenstein and Butlin 1964, p. 70; Lindsay 1966, pp. 185, 204; Reynolds 1969, p. 179.

Ariadne, daughter of Minos, King of Crete, was deserted by Theseus on the island of Naxos; the painting shows her discovery by Bacchus, who made her his bride. The figures are closely based on Titian's picture of the same subject, which had entered the National Gallery in 1826.

Turner's debt to Titian was recognised by the critic of *Blackwood's Magazine*, September 1840, in one of his usual abusive reviews: 'to this we turn with instant pain and from it with great disgust ... Here we have such an Ariadne and such a Bacchus as for ever, if the picture be remembered, must cast ridicule upon the subject, and is therefore injurious to the well-known Titian in the National Gallery, from which Turner (as one would think, malevolently) has burlesqued the figures. Ariadne is the oddest creature! Mr. Turner has contrived to scratch in, we cannot say paint, at once a

profile and a full face, but without shadow; so that Ariadne is something between an owl and the fish called old maid—old maid, however, with a numerous family, poor Bacchus and white doll Fauns. This has neither composition, nor execution, nor any beauty of any kind that we can see, and is altogether a melancholy absurdity. We find one rather startling novelty, that the sybil's temple was a ruin in the days of Bacchus.' Other reviews were little kinder. To *The Times*, 6 May, 'This picture represents nothing that ever existed in nature and scarcely anything that the most distorted imagination ever conceived without it. The colours are as vivid as the patchwork of a painter's palette, and apparently laid on the canvas by dabbing that implement at haphazard repeatedly against it.' For the *Athenaeum*, 16 May, the picture, 'though little better than a palette, set with the appetizing yellow and brown of an omelette, is tame in its lines, exquisite in its drawing, and prosaic as to composition, when compared with other works' by Turner in the exhibition. The *Spectator* of the same date spoke of 'The gorgeous explosion of light—literally a sun-burst—that Turner calls *Bacchus and Ariadne*' and counted it among his 'freaks of chromomania'.

Even Ruskin described this picture 'as the first exhibited in the Academy which was indicative of definite failure in power of hand and eye; the trees being altogether ill painted, and especially uncertain in form of stem.'

This picture is the first of a number in which Turner experimented with a square canvas, sometimes intended to be framed as a circle or with the corners cut across (see Nos. 394–5, 399–400, 404–5 and 424–5). In this case, although the paint continues into the corners, Turner seems to have finished the picture with the idea of framing the picture as an irregular octagon, with the corners cut diagonally approx. 5 ins. from the actual corner. For a possible pendant see No. 394.

383. Venice, the Bridge of Sighs Exh. 1840

THE TATE GALLERY, LONDON (527)

(Plate 357)

Canvas, 27 × 36 (61 × 91·5)

Coll. Turner Bequest 1856 (one of 18–21, 36–40; see below); transferred to the Tate Gallery 1961.

Exh. R.A. 1840 (55); R.A. 1974–5 (530, repr.).

Lit. Ruskin 1857 (1903–12, xiii, pp. 158–9); Thornbury 1862, i, p. 346; 1877, p. 465; Bell 1901, pp. 138–9 no. 219; Armstrong 1902, p. 234; Finberg 1930, pp. 103, 112, 132, 156, pl. 19; Davies 1946, pp. 151, 186; Davies 1959, pp. 97–8; Finberg 1961, pp. 379, 505 no. 531; Lindsay 1966, pp. 174, 246 no. 34.

Exhibited in 1840 with the following lines based on Byron's *Childe Harold's Pilgrimage*, Canto iv, verse 1:

'I stood upon a bridge, a palace and
A prison on each hand.' — *Byron*

In Byron's original text the lines read,

I stood in Venice, on the Bridge of Sighs;
A palace and a prison on each hand: . . .

The lines show that Turner saw even the beauties of Venice as a sham, concealing the grim realities on which her departed glories had depended.

Most of the critics of the 1840 R.A. exhibition were so shattered by Turner's other contributions that they failed to mention the two Venetian scenes, this picture and the *Venice from the Canale della Giudecca, Chiesa di S Maria della Salute, &c* (No. 384). Even the critic of the *Spectator*, who did notice them on 16 May, could not forbear to include them in his general condemnation of 'mere freaks of chromomania', the Venetian pictures being included with their 'sundry patches of white and nankeen, with a bundle of gayer colours . . . intended to represent buildings and vessels'.

Nos. 383, 402, 406, 411, 413, 416–19 appear in the 1854 Schedule as nos:

18 and 19, '2 Views of Venice in one frame' each 3′0″ × 2′0″;
20 and 21, '2 d⁰ d⁰ d⁰' each 3′0″ × 2′0″;
36 and 37, '2 Pictures of Venice in one frame' each 3′0″ × 2′0″;
38, 'View in Venice', 3′0″ × 2′0″;
39 and 40, each 'Ditto' and each 3′0″ × 2′0″.

384. Venice, from the Canale della Giudecca, Chiesa di S. Maria della Salute, &c. Exh. 1840

(Plate 358)

VICTORIA AND ALBERT MUSEUM, LONDON

Canvas, 24 × 36 (61 × 91·4)

Coll. Painted for John Sheepshanks who gave it to the Victoria and Albert Museum in 1857 (no. 208).

According to Burnet it was painted on commission but Finberg states that Sheepshanks bought it at the R.A. in 1840. That Burnet was correct has only recently been confirmed by the discovery of a letter from Turner to Sheepshanks, written on 29 January 1840, asking for his patron's wishes about size and format. In fact this and No. 383 are the first pictures of Venice of the 2 × 3 feet size which Turner came to consider as the most suitable for Venetian subjects. John Gage very kindly let me know about Turner's letter, which he is to publish shortly.

Exh. R.A. 1840 (71); Berlin 1972 (24).

Engr. By E. Brandard in the *Turner Gallery* 1859.

Lit. Ruskin 1843 (1903–12, iii, p. 546); Burnet and Cunningham 1852, pp. 44, 119 no. 204; Waagen 1854, ii, p. 305; Thornbury 1877, p. 579; Wedmore 1900, i, repr. facing p. 74; Bell 1901, p. 139 no. 220; Armstrong 1902, pp. 121, 234, repr. facing p. 157;

Rawlinson ii 1913, pp. 208, 359; Finberg 1930, pp. 102, 103–4, 108, 111–12, 156, colour pl. xviii; Finberg 1961, pp. 379, 505 no. 532; Rothenstein and Butlin 1964, p. 52; Gage 1969, p. 191 (?); Reynolds 1969, pp. 179–82, fig. 158; V.A.M. catalogue 1973, p. 138; Herrmann 1975, p. 49, pl. 157.

At the R.A. Turner's exhibits were much criticised, being described as 'flaring abortions' in the *Spectator*, 9 May, and as 'the rhapsodies of Turner's insane pencil' in the same journal a week later. Most critics concentrated their fire on *The Slave Ship* (No. 385) and this picture was only mentioned individually in *Blackwood's Magazine* for September which wrote: 'Turner again! Is there anything to enable us to put in a good word? There is. The sky is very natural, and has its due aerial perspective; all the rest is wretched: buildings as if built of snow by children in sport.'

So far as the last part of this criticism goes, it is true that even today the domes of Santa Maria della Salute appear glaringly white and chalky; yet there is reason to believe that the appearance of the picture has not altered significantly since Turner's day for it is in an exceptional state of preservation. This is due to its having been placed in 1893 in an air-tight container, called a Simpson Case after its inventor W. S. Simpson, in which it has remained ever since. I am most grateful to John Murdoch of the Victoria and Albert Museum for much helpful information on this subject. Further details of this method of preserving objects *in vacuo* in general and about its application to this picture in particular are given in two articles by the chief restorer at the Museum, Mr Norman Brommelle (*Museums Journal* 62, no. 1, June 1962, pp. 337–346 and *Studies in Conservation* 9, no. 4, November 1964, pp. 140–52).

385. Slavers throwing overboard the Dead and Dying—Typhon coming on Exh. 1840 (Plate 359) also known as *The Slave Ship*

MUSEUM OF FINE ARTS, BOSTON, MASS.

Canvas, $35\frac{3}{4} \times 48$ (91×138)

Coll. With Turner's dealer, Thomas Griffith, for sale in December 1843 for it was then that John Ruskin suggested to William Wethered of King's Lynn (see No. 416) that he might like to consider buying it; in fact it must have been bought very shortly after this by John James Ruskin (for 250 guineas, recorded in Ruskin senior's account book) and given to his son as a New Year's present, 1844; John Ruskin sale Christie's 15 April 1869 (50) bought in; sold by Ruskin to America 1872; J. T. Johnston, New York 1873; Miss A. Hooper, Boston; W. H. S. Lothrop, Boston; acquired by the Museum of Fine Arts, Boston, 1899 (Henry Lillie Pierce Fund: Accession no. 99:22).

Exh. R.A. 1840 (203); Phillips Memorial Gallery, Washington, *Functions of Color in painting* 1941 (38); Art Association, Montreal, *Masterpieces of Painting* 1942 (94); Boston 1946 (14); Toronto and Ottawa 1951 (12); Tate Gallery 1959 (357, pl. 50 and cover detail); New York 1966 (20); Agnew 1967 (28); Berlin 1972 (25); R.A. 1974–5 (518, repr. in colour); National Gallery of Art, Washington, Cleveland Museum of Art and Grand Palais, Paris, *The European Vision of America* 1975–77 (315, repr.).

Lit. Ruskin 1843, 1846, 1849 (Notes on the Louvre), 1856, 1859 (Academy Notes), 1860, 1874, 1878, 1884 ('The Storm-Cloud of the Nineteenth Century'), 1886, 1909 (letter of 1847), 1909, 1912 (1903–12, iii, pp. lv, 247, 249 n., 267, 273, 297, 414, 422, 571–3, pl. 12; iv, p. 311; xii, p. 458; vi, p. 381; xiv, p. 226; vii, pp. 187–8, 435 and n., 438; xxiii, p. xxv; xiii, pp. 409, 469, 605; xxxiv, p. 45; xxxv, pp. 318–19, 380; xxxvi, pp. 67, 81–2; xxxvii, p. 689; xxxviii, p. 351); Burnet and Cunningham 1852, pp. 39, 119 no. 205; Thornbury 1862, i, p. 235; ii, pp. 329, 333, 335, 395; 1877, pp. 304, 531, 532–3, 579, 592; Monkhouse 1879, p. 129; Wedmore 1900, i, pp. 98–9, repr. facing p. 98; Bell 1901, pp. 140–41 no. 221; Armstrong 1902, pp. 121, 147, 150–53, 231; Falk 1938, p. 208; Clark 1949, p. 108; Clare 1951, p. 106; Livermore 1957, p. 80; Boase 1959, pp. 341–2, pl. 34a; Finberg 1961, pp. 378–9, 408, 505 no. 533; Rothenstein and Butlin 1964, pp. 12, 50, 58–60, 68, pl. 109; Lindsay 1966, pp. 162, 169, 178, 185, 188, 200; Herrmann 1968, p. 22; Reynolds 1969, pp. 178–9, fig 154; Gaunt 1971, pp. 10, 11, colour pl. 44; Clark 1973, p. 185; Herrmann 1975, pp. 48, 233, pl. 148.

Exhibited with the following lines:

'Aloft all hands, strike the top-masts and belay;
Yon angry setting sun and fierce-edged clouds
Declare the Typhon's coming.
Before it sweeps your decks, throw overboard
The dead and dying—ne'er heed their chains
Hope, Hope, fallacious Hope!
Where is thy market now?'

 MS. Fallacies of Hope

This is undoubtedly Turner's most famous picture outside the Turner Bequest, partly because of its great beauties and partly because Ruskin, who owned it for twenty-eight years until the subject became too painful for him to live with, devoted some of his finest passages to extolling its merits. Ruskin considered that it contained 'the noblest sea that Turner has ever painted . . . and, if so, the noblest certainly ever painted by man . . . Purple and blue, the lurid shadows of the hollow breakers are cast upon the mist of night, which gathers cold and low, advancing like the shadow of death upon the guilty ship as it labours amidst the lightning of the sea, its thin masts written upon the sky in lines of blood, girded with condemnation in that fearful hue which signs the sky with horror, and mixes its flaming flood with the sunlight, and cast far along the desolate heave

of the sepulchral waves, incarnadines the multitudinous sea.' He asserted that 'if I were reduced to rest Turner's immortality upon any single work, I should choose this.' Ruskin also cites *The Slave Ship* when commenting on Turner's reluctance to discuss or even to look at his own pictures. 'I have watched him sitting at dinner nearly opposite one of his chief pictures; his eyes never turned to it.'

As so often in the past, Turner here turns to the poetry of James Thomson for his source; in this case to the account of the typhoon in *Summer*, to which is linked the story of the slave ship where the 'direful shark awaits' the mangled limbs of slaves as well as tyrants.

Professor Boase, however, discovered that Turner used another source besides Thomson's poem, the story of the slave ship *Zong* on which an epidemic broke out in 1783. The captain then ordered the slaves to be thrown overboard, as insurance could be claimed for those drowned at sea, but not for those who died of disease. At his court martial the captain claimed that his action was justified by a shortage of water on board, but it was shown that the supplies would have been replenished by the coming storm. The history of the *Zong* was given in T. Clarkson's *History of the Abolition of the Slave Trade* (first published in 1808 but with a second edition issued in 1839). Gage, in the catalogue of the Turner Bicentenary Exhibition, pp. 188–9, also points out that '*Slavers* offers us a remarkable example of the richness and complexity of Turner's mental world, and of the synthesising power of his imagination . . . It is the focus of an astonishingly wide range of reading.' This reading included, besides Thomson, Thomas Gisborne's *Walks in a Forest* (1799), which contains an attack on slavery in *Summer*, which was itself modelled on Thomson. Further contemporary sources that may have influenced Turner in choosing this subject were the publication of the *Life of William Wilberforce* in 1839 and of his *Correspondence* in 1840. Finally, the Anti-Slavery League Conference opened at Exeter Hall on 1 June 1840 within a month of the opening of the R.A. exhibition. This conference was opened by Prince Albert who made his first public speech in England, deeply regretting that 'the benevolent and persevering exertions of England to abolish that atrocious traffic in human beings have not as yet led to any satisfactory conclusion.' Turner may have seen a chance here of attracting royal favour, an aim in which he was to persevere later in the year with his visit to Schloss Rosenau at Coburg (No. 392).

Lindsay considers that in *The Slave Ship* Turner is recognising that 'the guilt of the slave trade is something too vast to be wiped out by any belated act of Parliament.' Turner is also drawing attention to the state of a society in which 'human relationships were being supplanted by the cash nexus. The slave trader and the shark are one . . .' 'Where is thy market now?' is the question Turner puts to a society wholly engrossed by material ends.

This picture met with much ridicule at the R.A. *The Times*, 6 May, thought it 'impossible to look at without mingled feelings of pity and contempt' and drew attention to 'the leg of a negro, which is about to afford a nibble to a John Dory, a pair of soles, and a shoal of whitebait.' The *Athenaeum* for 16 May described it as 'a passionate extravagance of marigold sky, and pomegranate-coloured sea, and fish dressed as gay as garden flowers in pink and green, with one shapeless dusky-brown leg thrown up from this parti-coloured chaos to keep the promise of the title.' The *Art Union*, 15 May, asked 'Who will not grieve at the talent wasted upon the gross outrage on nature, No. 203?', and went on to observe that Turner was living on his past reputation and that if 'high capability may be perceived in the midst of a mass of absurdities in these, his productions, it reminds us more of the occasional outbreaks of the madman, who says wonderful things between the fits that place him on a level with creatures upon whom reason never had been bestowed.' As usual, *Blackwood's Magazine*, for September, was very severe and also rather amusing: 'Between the vessel and the fish there is an odd object that long puzzled us. We may be wrong; but we have conjectured it to be a Catholic Bishop, in Canonicals gallantly gone overboard to give benediction to the crew, or the fish, or Typhon . . . The fish claiming their leg-acy is very funny.' Thackeray in *Fraser's Magazine* for June was uncertain whether it was 'sublime or ridiculous' but considered 'the slaver throwing its cargo overboard is the most tremendous piece of colour that ever was seen; it sets the corner of the room in which it hangs into a flame' and later exclaims 'Ye Gods, what a "Middle passage".' Thackeray also suggested that 'If Wilberforce's statue downstairs [by Samuel Joseph, No. 1100 in the R.A. exhibition] were to be confronted with this picture, the stony old gentleman would spring off his chair and fly away in terror!'

The picture created an impression which lasted, for in 1844, in a skit on the R.A. Exhibition, *Punch* (vi, January–June) produced the following:

'TRUNDLER R.A. treats us with some magnificent pieces.
34. A Typhoon bursting in a simoon over the Whirlpool of Maelstrom, Norway, with a Ship on fire, an eclipse, and the effect of a lunar rainbow.'

386. The New Moon; or, 'I've lost My Boat, You shan't have Your Hoop' Exh. 1840 (Plate 360)

THE TATE GALLERY, LONDON (526)

Mahogany, $25\frac{3}{4} \times 32$ ($65 \cdot 5 \times 81 \cdot 5$)

Coll. Turner Bequest 1856 (90, 'The New Moon' 4′3″ (sic) × 2′3½″); transferred to the Tate Gallery 1910.

Exh. R.A. 1840 (243); Paris 1953 (83, pl. 36).

Lit. Thornbury 1862, i, p. 346; 1877, p. 465; Bell 1901, p. 140 no. 222; Armstrong 1902, p. 225; Davies

1946, p. 187; Finberg 1961, pp. 379, 505 no. 534; Rothenstein and Butlin 1964, p. 48; Reynolds 1969, p. 179.

A rebate along the right-hand edge shows that the picture was partly painted in its frame.

The picture came in for its fair share of the abuse or occasional qualified praise earned by Turner's 1840 exhibits. For the ever-hostile *Blackwood's Magazine*, September 1840, 'The painting does not belie the silliness of the title ... What can the moon have to do with the loss of a hoop and a boat? Who would have imagined this to be moonlight? It is far below even "moonshine". There is a red child squalling lustily. The moral is, that spoiled children of all ages do very silly things.' *The Times* for 6 May dismissed the sub-title as 'unintelligible periphrasis', after beginning, 'This new moon has the merit of being perfectly novel. It resembles no moon that has ever yet illumined the heavens. The substance appears to be putty.' Only the *Spectator* for 16 May conceded that the picture had 'a semblance to nature when viewed from the middle of the room'.

387. Rockets and Blue Lights (close at Hand) to warn Steam-Boats of Shoal-Water Exh. 1840

(Plate 361)

STERLING AND FRANCINE CLARK ART INSTITUTE, WILLIAMSTOWN, MASS.

Canvas, $35\frac{1}{2} \times 47$ (90.2×119.4)

Coll. With Turner's dealer, Thomas Griffith, for sale in December 1843, for it was then that Ruskin advised William Wethered of King's Lynn to consider buying it; Charles Birch of Harborne, Birmingham by 1850; bought from him for £800 by John Naylor of Leighton Hall, Welshpool (the date of Naylor's purchase is not known but it certainly belonged to him by 1856 when Naylor made an inventory of his pictures. As it was the only one of the eight oils by Turner that Naylor owned which was not included in the exhibition at Liverpool Town Hall in September, 1854, it seems probable that Naylor acquired it between 1854 and 1856); bought from Naylor by Agnew, 1863; John Graham 1863–4 and then repurchased by Agnew; Henry McConnell 1864; sale Christie's 27 March 1866 (77) bought Agnew; Sir Julian Goldsmid, Bt; sale Christie's 13 June 1896 (54) bought Agnew; James Orrock 1901; Charles T. Yerkes, New York by 1902; sale American Art Galleries, New York, 5 April 1910 (75) bought Duveen; bought by Knoedler from Duveen in 1914 and sold to G. Eastman; returned by him in 1916 and resold to C. M. Schwab; sold by him after 1928 to Knoedler from whom bought by Robert Sterling Clark in 1932.

Exh. R.A. 1840 (419); B.I. 1841 (112); Royal Birming-

ham Society of Artists 1850 (123 lent by Charles Birch); R.A. 1896 (122); Agnew 1899 (20); National Museum of Wales, 1913 (27 lent by Duveen); Knoedler, New York *A Loan Exhibition of Twelve Masterpieces of Painting* 1928 (unnumbered, lent by C. M. Schwab).

Engr. By Robert Carrick 1852 (chromolithograph).

Lit. Burnet and Cunningham 1852, pp. 119 no. 207, 122 no. 12; Thornbury 1862, ii, p. 400; 1877 pp. 579, 597; Wedmore 1900, ii, repr. facing p. 258; Bell 1901, pp. 140–41 no. 223; Armstrong 1902, pp. 121, 147, 228, repr. facing p. 158; Falk 1938, p. 250; Finberg 1961, pp. 379, 505 no. 535, 506 no. 538; 'Extracts from Hugh Blaker's Diary', *Apollo* October 1963, p. 264; Rothenstein and Butlin 1964, p. 60, pl. 113; Lindsay 1966, pp. 185, 200; Reynolds 1969, p. 179, fig. 155; Reynolds 1969², p. 76, fig. 14; Morris 1974–5, p. 98 no. 200, fig. 67.

This picture, which is described by Finberg as having 'made a sensational appearance in the Yerkes sale (1910) when Lord Duveen paid £25,000 for it', has certainly suffered in condition. In 1963–4 it was at Mr William Suhr's studio in New York for restoration after the surface was seen to be suffering from widespread blistering. Mr Suhr told the compiler at the time that the picture had been relined several times in the past and had suffered from the use of too hot an iron being used in the process, causing the impasto in the waves, etc., to be almost totally flattened. The result of this harsh treatment in the past is that the sense of movement in the water has now almost disappeared which has led to a loss of coherence in the overall composition.

The picture was severely criticised both at the R.A. and at the British Institution when shown there the following year. The *Athenaeum*, 16 May 1840, wrote that it was necessary in the case of this picture and the *Neapolitan Fisher-Girls* (No. 388) 'to transcribe the titles, lest any, led by the numbers, should in their innocence imagine that we had been passing off upon them the spoiled canvasses upon which a painter had been trying the primative colours.'

The *Art Union* of 15 May asked if 'the Artist meant the title and the subject as a sarcasm upon the style?' *Blackwood's Magazine*, September 1840, was, as usual, very harsh in its criticism: 'Mr. Turner's representation of water is very odd. It is like hair-powder and pomatum, not over-well mixed' and concluded 'These absurd extravagances disgrace the exhibition not only by being there, but by occupying conspicuous places.'

A year later in 1841, a second chance to study the picture did not seem to make the critics warm to it at all. The *Art Union*, 15 February, said of it and the *Snowstorm, Avalanche* ... (No. 371) that they were 'wonderful, as examples of colour and prodigious as eccentric flights of genius. They would be equally effective, equally pleasing, and equally comprehensible if turned upside down.'

The *Spectator* for 6 February wrote 'but beyond the rolling clouds of dun smoke, the flashing explosion of white light, and a vegetable mass, intended for the sea, nothing is distinguishable', while the *Athenaeum* for the same date suggested that Turner had charged a blunderbuss with pigments and had fired a volley against the canvas to produce this picture. Only the *Literary Gazette*, 6 February, had a good word to say for it, conceding that 'the general effect is very powerful ... we forget the parts that are extravagant in admiration of the whole.'

388. Neapolitan Fisher-Girls surprised bathing by Moonlight Exh. 1840? (Plate 368)

PRIVATE COLLECTION, LONDON

Canvas, $25\frac{5}{8} \times 31\frac{5}{8}$ ($65 \cdot 1 \times 80 \cdot 3$)

Coll. ? Robert Vernon who bought it at the R.A. in 1840; sale Christie's 6 May 1842 (107) bought Fuller; John Miller of Liverpool by 1845; bought from Lloyd Bros. in 1856 by Agnew and sold to the dealer William Cox; sale Foster's, 29 January 1857 (193) property of 'A Gentleman resident in the North of England' bought in; C.E. Flavell sale Christie's 26 March 1860 (151a) bought Flatow (Graves, *Art Sales* iii, 1921 p. 222, is incorrect in giving the vendor in 1860 as Munro of Novar. Munro did sell a number of pictures on this occasion including Lot 150 but the seller of Lot 151a is clearly identified in Christie's catalogue as Flavell. Graves' error has been followed by others, e.g., in the catalogue of Agnew's 1967 Exhibition); Munro of Novar (*d.* 1865); Phyllis Woolner; sale Christie's 23 April 1954 (118) bought Appleby from whom bought by the present owner; sale Sotheby's 23 October 1974 (23) as 'Turner (after)' withdrawn.

Exh. ?R.A. 1840 (461); R.S.A. 1845 (300 lent by John Miller).

Lit. Burnet and Cunningham 1852, p. 119 no. 208; Frost 1865, p. 94 no. 110 (as 'River Scene with Female Figures Bathing' but with correct measurements. The catalogue, however, confuses its history with that of *Modern Italy* (see No. 374) in stating that 'it was executed for Mr. Daniel who died in Asia Minor before it was completed'); Thornbury 1877, p. 579; Bell 1901, p. 141 no. 224; Armstrong 1902, pp. 147, 225–6; Finberg 1961, pp. 379, 406, 506 no. 536, 509, no. 571; Lindsay 1966, p. 185; Herrmann 1975, p. 49.

If this picture is accepted as the original exhibited in 1840, the fact that both versions (see No. 389) have a connection in the past in the Woolner family makes it seem possible that a copy of this picture was made on panel when it belonged to Thomas Woolner, although the possibility that both versions were done by Turner himself cannot be ruled out. However, autograph replicas by Turner are so rare that this is an explanation

which must be regarded with a good deal of scepticism, although in this case, the compiler inclines to accept it as the correct one; Martin Butlin, however, considers only this version to be autograph.

The whole problem is complicated by the fact that this version has been flattened in relining and harshly cleaned. Despite this, it has qualities which are lacking in the panel version, especially in the lighting and in the painting of the trees and their relationship to the sky, where Turner's characteristic habit of painting the clouds right up to the edge of the foliage can plainly be seen. It is also painted in a higher key which may make it the more likely candidate to be the picture exhibited in 1840, as more than one critic remarked on Turner's light being far too bright for moonlight. The fact that Robert Vernon weeded out the exhibition picture (whichever it was) from his collection within two years of buying it at the R.A. suggests that it was never one of Turner's most successful works.

At the R.A. the picture did not receive much individual notice but was included in some abusive reviews aimed generally at Turner's six exhibits. The *Athenaeum*, 16 May, said that the flagrancy of *The Slave Ship* (No. 385) was 'out-Turnered' by *The New Moon* (No. 386), *Rockets and Blue Lights* (No. 387) and *Neapolitan Fisher-Girls*. Further remarks in the same review are noted under No. 387.

Blackwood's Magazine for September was its usual derogatory self, beginning 'If Mr. Turner means discovered by the word surprised, we cannot agree with him, for it puzzles one to find any fishergirls at all; but we will suppose the indistinct creatures we dimly see in no dim colour, are really "the maids who love the moon" ... This is another of the absurd school which Mr. Turner endeavours to establish ...'

This picture and *Palestrina* (No. 295) were admired by Elizabeth Rigby (later Lady Eastlake) when exhibited at the Royal Scottish Academy in 1845. In her *Journals* (i 1895, p. 159) she wrote that she considered it 'absolutely unfair to place Turner in competition with others; it is like exhibiting a little bit of reality among ranks full of imitation ...' Indeed the newspaper critics were on the whole more sympathetic in 1845 than they had been in 1840; the writer in the *Scotsman* for 1 March, for instance, considered that Turner 'succeeds in producing brilliant things, which, as in the present case, men may not fully comprehend, but cannot help admiring.'

389. Neapolitan Fisher-Girls surprised bathing by Moonlight Exh. 1840? (Plate 369)

PRIVATE COLLECTION, SCOTLAND

Panel, 25×31 ($63 \cdot 5 \times 78 \cdot 7$)

Coll. Thomas Woolner, R.A.; sale Christie's 12 June 1875 (133) bought Ellis; Henry McConnell; sale Christie's 27 March 1886 (75) bought W. B. Denison; George Coats, Glasgow by 1901; by descent to the present owner.

Exh. R.A. 1875 (261 lent by T. Woolner); Glasgow 1901 (66 lent by George Coats); Aberdeen Art Gallery 1951 (140); R.A. 1951–2 (160); Agnew 1967 (27).

Lit. Armstrong 1902, pp. 147, 225–6; E. K. Waterhouse 'Exhibition at the Aberdeen Art Gallery', *Burlington Magazine* xciii 1951, p. 324, fig. 31.

The reappearance in 1974 of a second version, painted on canvas (see No. 388), which has strong claims to be considered as the picture Turner exhibited at the R.A. in 1840, has meant that complete uncertainty now exists about which version is involved in early changes of ownership. For reasons of clarity, therefore, it has been assumed that the version on canvas was that exhibited in 1840 and the entries have been arranged accordingly. As will be seen from the entry for No. 388, a picture of this title changed hands in 1856, 1857 and 1860 and these transactions may well involve two pictures rather than one. Unfortunately, none of the earliest sale or exhibition catalogues specifies whether a picture is on canvas or on panel and it is not until 1875 that this version was definitely catalogued as being on panel when it was lent to the R.A. Winter Exhibition by Thomas Woolner, R.A. Christie's catalogue for 23 April 1954 is therefore incorrect in stating that the version on canvas, sold that day by Miss Phyllis Woolner of Tunbridge Wells, was the picture exhibited in 1875.

Besides the fact that the provenances of the two versions may well be entwined in the 1850s and '60s, a number of the references in Turner literature assume that it was this version that was exhibited by Turner in 1840, so the two entries are only comprehensible if considered together.

390. Ducal Palace, Dogano, with part of San Georgio, Venice Exh. 1841 (Plate 362)

THE DUDLEY PETER ALLEN MEMORIAL ART MUSEUM, OBERLIN COLLEGE, OHIO

Canvas, 25 × 36⅝ (63·5 × 93)

Coll. Bought on Varnishing Day at the 1841 R.A. exhibition by Turner's friend, the sculptor, Sir Francis Chantrey, R.A., who died on 25 November that year; W. J. Broderip; sale Christie's 18 June 1853 (89) bought Egg; T. Horrocks Miller by 1889; bought from Mrs Horrocks Miller in 1925 by Agnew jointly with Duveen and sold by the latter in November 1925 to Mrs F. F. Prentiss of Cleveland; bequeathed by her to Oberlin in 1944 (Accession no. 44:54).

Exh. R.A. 1841 (53); R.A. 1889 (141); Guildhall 1894 (78); Toronto and Ottawa 1951 (13); Knoedler, New York *Paintings and Drawings from Five Centuries* 1954 (58); Indianapolis 1955 (44); and subsequently in a number of mixed exhibitions in the U.S.A.

Lit. Burnet and Cunningham 1852, p. 119 no. 209; Thornbury 1862, i, pp. 390–91; 1877, pp. 170, 179, 579, 604; Bell 1901, p. 141 no. 225; Armstrong 1902, p. 234; Finberg 1930, pp. 139–40, 150; Falk 1938, p. 163; Finberg 1961, pp. 383, 506 no. 539; *Catalogue of European and American Paintings and Sculpture in the Allen Memorial Art Museum, Oberlin College* 1967, pp. 151–2, pl. 92.

Thornbury states that Chantrey bought this picture, unseen, on the recommendation of a fellow Academician. This seems unlikely in view of Turner's close friendship with Chantrey. Thornbury's further claim, that 'At the sculptor's death this picture, though much damaged by an ignorant dealer, was secured at Christie's by one who also had not seen it, for the enormous sum of £1,500', can be shown to be inaccurate on several counts. First, there was an interval of nearly 12 years between Chantrey's death and the picture being sold at Christie's (in the Broderip sale catalogue it stated that on Chantrey's death the picture 'passed direct into Mr. Broderip's possession'); second, the statement that by the time of Chantrey's death the picture had already been damaged is almost certainly untrue, as Chantrey had only owned it for a matter of months; and third, the picture fetched £1,155 (1,100 guineas) not £1,500 at Christie's in 1853. Armstrong repeats the claim that the picture was 'damaged by restoration', but this may be largely unjustified, despite a good deal of surface cracking. The impasto, especially in the clouds, is still sound and intact and although the picture is very dry and discoloured, the condition might well emerge as basically good if the picture were cleaned, and the colour would undoubtedly be brilliant.

At the R.A. the critics were, on the whole, favourably inclined towards Turner's three views of Venice (Nos 391 and 393 besides this picture), turning to them in relief after the rage and incomprehension with which they greeted *Rosenau* (No. 392), *Glaucus and Scylla* (No. 395) and *Dawn of Christianity* (No. 394). The *Athenaeum*, 5 June, praised this and no. 66 (No. 391) as being 'so much less extravagant than his late Turner-*isms*' and continued 'In these Venetian pictures it would be hard to exceed the clearness of air and water — the latter taking every passing reflection with a pellucid softness beyond the reach of meaner pencil. The architecture, too, is more carefully made out than has lately been the case with Mr. Turner, and both pictures are kept alive by groups of southern figures, which, seen from a certain remoteness, give a beauty and not a blemish to the scenes they animate.'

The *Art Union* for 15 May was still more laudatory: 'A glorious example of colour, leaving, as usual, much to the fancy of the spectator; and absolutely extorting applause.' *The Times*, 4 May, the *Spectator* and the *Literary Gazette*, both 8 May, also praised both pictures warmly, the last-named describing them as 'two beautiful masterpieces'.

The Broderip sale catalogue describes this as a pendant 'to the picture now in the Vernon Gallery',

which presumably means No. 396 which Vernon gave to the National Gallery in 1847. There seems no reason, however, why the pictures should be considered as a pair.

391. Giudecca, La Donna della Salute and San Georgio Exh. 1841 (Plate 363)
also known as *The Giudecca from the Canale di Fusina*

MR WILLIAM WOOD PRINCE, CHICAGO

Canvas, 24 × 36 (61 × 91·5)

Coll. Bought by Elhanan Bicknell at the R.A. in 1841; sale Christie's 25 April 1863 (116) bought Agnew for Sir John Pender; sale Christie's 29 May 1897 (85) bought Agnew for Sir Donald Currie; by descent to his grandson, Major G. L. K. Wiseley, for whom Agnew sold the picture to the present owner in 1959.

Exh. R.A. 1841 (66); Birmingham 1899 (10); Guildhall 1899 (32); R.A. 1906 (60); R.A. 1934 (682); Agnew 1967 (30); R.A. 1974–5 (531).

Lit. Burnet and Cunningham 1852, p. 119 no. 210; Waagen 1854, ii, p. 350; Thornbury 1862, ii, p. 401; 1877, pp. 170, 579, 599; Bell 1901, pp. 141–2 no. 226; Armstrong p. 234, repr. facing p. 152; Finberg 1930, pp. 139, 156; Falk 1938, p. 250; Finberg 1961, pp. 383, 506 no. 540.

As noticed under No. 390, Turner's three Venetian views were on the whole praised by the critics and were in any case given far more favourable treatment than Turner's other three pictures (Nos. 392, 394 and 395) which he showed at the R.A. A number of reviews such as those in the *Spectator* and the *Literary Gazette*, both for 8 May, noticed this picture and the *Ducal Palace* together and their remarks have been noted under the entry for No. 390. *The Times*, 4 May, called this 'another of Mr. J. M. W. Turner's splendid pictures'.

Armstrong describes this as a companion to the *Campo Santo, Venice* (No. 397), exhibited in the following year, and states that both pictures were painted for Bicknell, following the Bicknell sale catalogue of 1863. Finberg, however, states that Bicknell bought them at the R.A. exhibition and this is borne out, at any rate so far as this picture is concerned, by the letter, quoted in the entry for No. 393, in which Turner states clearly that this picture was for sale at the time that the R.A. exhibition opened.

392. Schloss Rosenau, Seat of H.R.H. Prince Albert of Coburg, near Coburg, Germany
Exh. 1841 (Plate 364)

WALKER ART GALLERY, LIVERPOOL

Canvas, 38¼ × 49⅛ (97 × 124·8)

Coll. Joseph Gillott by 1845 and almost certainly one of a group of eight pictures purchased by him from Turner *c.* 1844 (this transaction is just earlier than the date of Gillott's first account book which has recently come to light and which belongs, with a great deal of other Gillott material, to Mr Jeremy Maas); he subsequently sold six to recover the purchase price of the eight but kept two, including *Rosenau* which he considered the finest (see also No. 334); Gillott sale Christie's 20 April 1872 (162) bought Agnew and sold to C. Skipper; sale Christie's 24 May 1884 (100) bought Agnew and sold to George Holt 1886; by descent to his daughter Emma Holt, who bequeathed the picture to the City of Liverpool on her death in 1944.

Exh. R.A. 1841 (176); Royal Manchester Institution 1845 (285 lent by Joseph Gillott); Manchester 1887 (624); Guildhall 1892 (117) and 1899 (26); Birmingham 1899 (6); Agnew 1925 (16); Brussels 1929 (181); R.A. 1934 (644); Leggatt 1960 (33).

Lit. Ruskin 1843 (1903–12, iii, p. 539); Burnet and Cunningham 1852, p. 119 no. 211; Thornbury 1877, pp. 170, 579, 618; Wedmore 1900, ii, repr. facing p. 222; Bell 1901, p. 142 no. 227; Armstrong 1902, pp. 147, 228, repr. facing p. 164; Finberg 1961, pp. 381, 383, 506 no. 541, 515 no. 571b; Lindsay 1966, p. 244; Reynolds 1969, p. 183; Bennett and Morris 1971, pp. 73–4 no. 309, pl. 11; Herrmann 1975, p. 49, pl. 160.

Turner visited Coburg on his way back from Venice in 1840 and seems to have made a detour in order to do so. His wish to see Coburg was no doubt prompted by Queen Victoria's marriage to Prince Albert which had taken place in February. Turner's visit is recorded in his 'Coburg, Bamburg and Venice' sketchbook (CCCX) and he was at Coburg at least from 17–20 September. Page 22 of this sketchbook contains a study for this picture. The trees in the distance just to the right and beyond the bridge are inscribed 'alders' in Turner's hand. Page 21 verso also includes a summary sketch of the part of the composition in the distance on the left where the stream disappears, and p. 24 shows the castle drawn from the opposite side.

If Turner hoped, in exhibiting this picture, that it might be bought for the royal collection, he was to be disappointed. Indeed, the Queen, far from buying *Rosenau*, did not even mention it in her *Journal* among the pictures she had noticed at the R.A. However, due perhaps to its royal connection, the picture did receive a good many notices at the R.A., most of them abusive. Only the *Spectator*, 8 May, had a good word to say for it, describing it as 'luminously splendid in colour; and though overcharged, not unnatural in effect, if viewed at a proper distance.' The *Literary Gazette* for 8 May thought it 'a wild extravaganza, a vision of an unreality, and like nothing on the earth or in the waters under it.' The *Art Union* for 15 May waxed sarcastic: 'An interesting scene—if one could make out its character;

but German nature may be like German art, not designed to be intelligible to common-place mortals.' *Blackwood's Magazine* for September 1841 asked '. . . but what can be said of No. 176 *Schloss Rosenau*, but that it may have a "name", but can have no "local habitation".' The *Athenaeum*, 5 June, included it among those of Turner's exhibits, other than the Venetian views, that it described as 'the fruits of a diseased eye and a reckless hand' while *The Times*, 4 May, was the most hostile of all: 'Here is a picture that represents nothing in nature beyond eggs and spinach. The lake is a composition in which salad oil abounds, and the art of cookery is more predominant then the art of painting.'

These criticisms were answered by Ruskin in the first volume of *Modern Painters* with extravagant praise, particularly for the way in which the reflections in the water were painted, although this praise was qualified considerably in the third edition (1846).

For a second version see No. 442.

393. Depositing of John Bellini's Three Pictures in La Chiesa Redentore, Venice Exh. 1841
(Plate 384)

PRIVATE COLLECTION

Canvas, 29 × 45½ (73·6 × 115·5)

Coll. Bought from Charles Birch in December 1847 by Joseph Gillott and resold by him to Thomas Rought in January 1849 (referred to as 'Jean Bellini' in both transactions); Lloyd Brothers; sale Foster's 13 June 1855 (60) bought in; bought by Agnew from Lloyd in 1857 and sold to Richard Hemming of Bentley Manor, Bromsgrove; bought back from Mrs Hemming in 1892 by Agnew and sold to Sir John Pender; sale Christie's 29 May 1897 (84) bought Agnew for J. Pierpont Morgan; in the Morgan collection until *c.* 1947 when bought by Myron Taylor, the U.S. Ambassador to the Vatican; acquired from him in 1961 by Wildenstein and Agnew and sold in the same year by the latter to the Hon. Colin Tennant from whom bought by the present owner in 1969.

Exh. R.A. 1841 (277); Paris 1900 (39); Whitechapel *Spring Exhibition* 1901 (164); R.A. 1910 (167); Metropolitan Museum of Art, New York, *Exhibition of Paintings lent by Mr. J. Pierpont Morgan* 1913–14 (unnumbered); Boston 1946 (15); Leggatt *English Painting c. 1750–1850* 1963 (9); Agnew 1967 (29).

Engr. By J. T. Willmore for the *Art Union* 1858 and in the *Magazine of Art* 1897.

Lit. Burnet and Cunningham 1852, p. 119 no. 212; Thornbury 1862, ii, p. 229; 1877, pp. 170, 329, 579; Bell 1901, pp. 142–3 no. 228; Armstrong 1902, p. 234, repr. facing p. 166; T. Humphrey Ward and W. Roberts, *Pictures in the Collection of J. Pierpoint Morgan: English School* 1907, repr.; Rawlinson ii 1913, pp. 207, 351; Finberg 1930, pp. 139, 156; 1961, pp. 383, 506 no. 542; Gage 1969, pp. 96, 243 n. 91, 252 n. 215.

The paintings which can be seen in the leading gondolas are three Madonnas from the Sacristy of the Redentore which were believed to be by Giovanni Bellini at the time Turner exhibited this picture. Unfortunately the pictures in question appear on such a small scale in Turner's picture that it is impossible to identify them with any certainty. None of the pictures now in the Sacristy are still attributed to Giovanni Bellini but it contains at least four strongly Bellinesque Madonnas. It seems most likely that the pictures which Turner wished to depict were:

Andrea da Murano *Madonna adoring Child on Parapet*
Francesco Bissolo *Madonna with John and Catherine*
Alvise Vivarini *Madonna with Putti*

but it is also just possible that Turner had in mind a *Madonna between Francis and Benedict* by Rocco Marconi which was attributed to Bellini by Ridolfi (this does appear to be the same shape as the left-hand picture of the three shown in Turner's picture).

Turner was probably depicting an imaginary scene rather than recording an historical event, even allowing for the way Turner was wont to transform such events by imposing his own version on them. His intention was presumably, as on other occasions (Nos. 228 and 340, for instance), to pay tribute to a revered Old Master.

Gage suggests that the reference to Bellini in the title is a sign of Turner's renewed interest in early Venetian painting which had been stimulated by his visit to Vienna the previous year. Evidence of this interest can be found in Turner's sketchbooks in use during his stay in Vienna whereas, although he also went to Venice in 1840, his attention there seems to have concentrated on the High Renaissance.

While painting this picture Turner evidently forgot the name of the church, for Thornbury (1877, p. 329) prints a letter from Turner to Miss Harriet Moore, dated 'Wednesday, 20th, 1841', in which he concludes 'Very many thanks for the name of the Church, Redentori'.

At the R.A. Exhibition, a Mr Collard evidently considered buying the picture. Finberg gives Turner's letter to him:

Dear Sir,

I beg your pardon in not sending an earlier answer to your note respecting the Picture No. 277, John Bellini and now beg to say the price is 350 Guineas, No. 72 [a mistake for No. 66] 250 Guineas, 53 sold. These picts are exclusive of the Copyrights and that the power of Engraving resting with Mr. Turner. The Frames if liked at their cost price—or lent—until others are made, or to any fixed time, to be returned before the next Exhibition.

 Yours most truly,
—Collard Esqre (Bank) J. M. W. Turner

It is not known whether Mr Collard bought the picture but as there is no evidence of any link between him and Charles Birch who owned the picture by 1847, the odds seem to be slightly against it.

Less well received by the critics than Turner's other two Venetian exhibits (Nos. 390 and 391), it was nonetheless welcomed as showing less eccentricity than Turner's recently exhibited pictures: 'so much less extravagant than his late *Turnerisms*' as the *Athenaeum*, 5 June, put it. *The Times* for 4 May described no. 277 as 'a finely painted picture, full of crotchety colouring, but grand'. The *Spectator* for 8 May called it 'a pageant of painting', adding rather confusingly that it was 'worthy to be pendant to Danby's *Triumph of Sculpture*' (this was no. 466 at the R.A. with the full title *The Sculptor's Triumph when his statue of Venus is about to be placed in her temple—a morning at Rhodes*; it is untraced since 1942 but the description of it in the *Athenaeum* (p. 433) makes it sound rather an odd companion for Turner's *Bellini*). The *Art Union*, 15 May, wrote 'A gorgeous picture; full of the highest and richest poetry.' *Blackwood's Magazine* for September was as scathing as usual, claiming that No. 393 'could only please a child whose taste is for gilt gingerbread'.

394. Dawn of Christianity (Flight into Egypt)
Exh. 1841 (Plate 366)

THE ULSTER MUSEUM, BELFAST

Canvas, circular, diameter 31 (78·5)

Coll. B. G. Windus of Tottenham who bought it at the R.A. in 1841; sale Christie's 20 June 1853 (3) bought in; sale Christie's 26 March 1859 (49) bought in; sale Christie's 19 July 1862 (57) bought Rought; Louis Huth; sale Christie's 2 March 1872 (74) bought Agnew; R. K. Hodgson, M.P., from whom bought back by Agnew in 1891 and sold to Sir Donald Currie; presented to the Belfast Art Gallery in 1913 by Lady Currie (Accession no. 276: 1913).

Exh. R.A. 1841 (532); R.A. 1951–2 (165); Agnew 1967 (31) repr. in colour on cover; R.A. 1974–5 (519).

Lit. Ruskin 1843 (1903–12, iii, p. 390); Burnet and Cunningham 1852, p. 119 no. 213; Thornbury 1862, ii, p. 399; 1877, pp. 170, 579, 597; Bell 1901, p. 143 no. 229; Armstrong 1902, p. 221; Finberg 1961, pp. 383, 506 no. 543; Rothenstein and Butlin 1964, p. 70; Lindsay 1966, p. 204.

Exhibited with the quotation:

'That Star has risen'
Rev. T. Gisborne's Walks in a Forest.

Although this is on a square canvas, Lindsay notes pencil lines in the corners which suggest that Turner may at first have planned an octagonal composition. If so, the presence of a 'try-out' of the composition in the Turner Bequest (No. 441) indicates that he soon settled on a circular format, as perhaps he originally intended for No. 405, *q.v.* Indeed, the way the paint is handled in this picture is very close to the 'Deluge' pair, as will be seen if one compares the painting of the Virgin's face

here with that of the head of the dog in *Shade and Darkness*.

Critics differ on the question of the pendant to this picture: some propose *Glaucus and Scylla* (No. 395), others *Bacchus and Ariadne* (No. 382). In support of *Glaucus and Scylla*, there is the fact that they were exhibited in the same year, and in the same room, and remained together for a further thirty years. There is also the evidence of the critic in the *Spectator*, 8 May, who referred to them thus: 'his [Turner's] two circular studies of a warm and cool effect are brilliant rondos of harmony in prismatic hues.' This specific reference to 'a warm and cool effect' suggests that Turner may have conceived them as the first pair of a series which mark this contrast, to be followed by *Peace* and *War* (Nos. 399 and 400) in 1842 and by the 'Deluge' pair in 1843. They may have been further linked in Turner's mind as illustrating variations on the theme of 'flight'.

In favour of *Bacchus and Ariadne*, Lindsay's observation that both were at one time marked out as octagonals has already been noted. Furthermore, the compositions of the two pictures make a more convincing match and the handling in both is very similar. They both provide evidence of Turner's reawakened interest in the Venetian school in general and in Titian in particular, an interest that had doubtless been rekindled by Turner's visit to Venice in the autumn of 1840.

At the R.A., as may be seen from the entries for *Rosenau* (No. 392) and *Glaucus and Scylla* (No. 395), the three pictures were harshly criticised by many reviewers. Only the *Spectator* for 8 May had a good word for the *Dawn of Christianity*, as quoted above. Otherwise, *The Times*, 4 May, dismissed it with: 'As it is impossible to tell what this picture means, it is difficult to criticise it.'

The *Art Union*, 15 May, described it as 'another example of a great man's folly. It is far more like the dawn of creation—when "earth was without form and void"', while *Blackwood's Magazine* for September was particularly critical. 'No. 532 is really quite horrible, and happily unintelligible without the description. As to the passage into Egypt, it is long before you can distinguish a figure; Egypt is taken literally for the "fiery furnace" and it is out of the frying-pan into the fire.'

395. Glaucus and Scylla Exh. 1841 (Plate 367)

KIMBELL ART MUSEUM, FORT WORTH, TEXAS

Panel, 31 × 30½ (79 × 77·5)

For inscription see below

Coll. Bought by B. G. Windus at the R.A. Exhibition in 1841; sale Christie's 20 June 1853 (40) bought in; sale Christie's 26 March 1859 (50) bought in; sale Christie's 19 July 1862 (58) bought Rought; Louis Huth; sale Christie's 2 March 1872 (73) bought Tooth; José de Murrieta, Marquis de Santurce; sale

Christie's 7 April 1883 (171) bought in; Sir Horatio Davies, 1901; Sedelmeyer Gallery, Paris, 1902; John Jaffé, Nice, 1903–1943; bought by Agnew from Emile Leitz, Paris, 1956; Howard Young Galleries, New York, 1957; Mrs Chamberlain until 1966 when acquired by the Kimbell Art Foundation (Accession no. AP 66.11).

Exh. R.A. 1841 (542); R.A. 1968–9 (166).

Lit. Burnet and Cunningham 1852, p. 119 no. 214; Thornbury 1862, ii, p. 399; 1877, pp. 170, 579, 597; Bell 1901, p. 143 no. 230; Armstrong 1902, pp. 147, 222; Sedelmeyer Gallery, Paris *Catalogue of 100 Paintings by Old Masters*, 1902 (99 repr.); Finberg 1961, pp. 383, 506 no. 544; Rothenstein and Butlin 1964, p. 70; *Catalogue of the Kimbell Art Foundation* 1972, pp. 168–70 repr. in colour.

When exhibited at the R.A., Turner appended *Ovid's Metamorphoses* to the title (the reference is to Book xiii ll. 895–967). Scylla, a daughter of Typhon, was greatly loved by Glaucus, one of the deities of the sea, but she scorned his addresses. Glaucus applied for help to Circe who fell in love with him herself and so decided to punish her rival. This she did by pouring the juice of some poisonous herbs into the fountain where Scylla bathed and no sooner had the nymph touched the place than she found every part of her body below the waist changed into frightful monsters, such as dogs which never ceased barking. This sudden metamorphosis so terrified her that she threw herself into that part of the sea which separates Italy and Sicily (Mount Etna can be seen in the distance of this picture), where she was changed into the rocks which continued to bear her name and which were universally deemed very dangerous to sailors. Turner had in fact treated the subject earlier in an engraving for the *Liber Studiorum* (Rawlinson 73) which was never published. The drawing for it is in the Vaughan Bequest to the British Museum (CXVIII-P).

Although painted to the limits of the rectangular panel, there is the evidence of the *Spectator* review (see the entry for No. 394) that, at the R.A., the picture was framed as a circle. This evidence is reinforced by the presence of some writing in pencil in the bottom left-hand corner of the panel, which must have been hidden by the frame at the time of the R.A. Exhibition and perhaps for many years afterwards, as it was also framed in this way when with the Sedelmeyer Gallery in 1902. This writing, which is upside down compared with the subject matter, is underneath the paint surface and is unfortunately only legible in part. The Kimbell Collection catalogue gives the following transcription: 'delay that then is a . . . paint of the panel . . . ground . . . but the gesso for the . . . but like I can get . . . in the . . .' The catalogue states that this writing is Turner's but this is not certainly so.

At the R.A. the *Spectator* review, 8 May, has already been quoted under the entry for No. 394. Otherwise, it was considered by the *Athenaeum*, 5 June, to be, with

Rosenau (No. 392) and the *Dawn of Christianity* (No. 394), 'the fruits of a diseased eye and a reckless hand'. *Blackwood's Magazine* for September, after commenting generally that 'There is not a picture of his in this year's exhibition that is not more than ridiculous' went on 'Can anything be more laughable, in spite of regrets than No. 542?—where the miserable doll Cupids are stripping off poor Scylla's clothes; yet there is no chance of indecent exposure, for there is certainly no flesh under them.'

For a discussion of the question of whether this or *Bacchus and Ariadne* (No. 382) was painted as a pendant to *Dawn of Christianity* (No. 394), see the entry for the latter. On the whole, despite affinities between *Dawn of Christianity* and *Bacchus and Ariadne*, it seems that the evidence is in favour of this picture, bearing in mind the way in which they were originally framed and hung at the R.A.

396. The Dogano, San Giorgio, Citella, from the Steps of the Europa Exh. 1842 (Plate 365)

THE TATE GALLERY, LONDON (372)

Canvas, $24\frac{1}{4} \times 36\frac{1}{2}$ (62 × 92·5)

Coll. Robert Vernon, purchased at the R.A. 1842 and given to the National Gallery 1847; transferred to the Tate Gallery 1949.

Exh. R.A. 1842 (52); Chelsea Society, May 1948; Hamburg, Oslo, Stockholm and Copenhagen 1949–50 (98); Arts Council tour 1952 (19, repr.); Edinburgh 1968 (19); R.A. 1974–5 (532, repr. in colour p. 147); Leningrad and Moscow 1975–6 (66, repr.).

Lit. 'The Vernon Gallery: The Dogana', *Art Journal* 1849, p. 260, engr. J. T. Willmore; Hall, i, 1850, no. 7, engr. J. T. Willmore; Hall 1851², p. 8 no. 54; Cunningham 1852, p. 46; Waagen 1854, i, p. 385 as no. 57, second of 'the two views of Venice'; Wornum 1875, pp. 64–5, engr.; Thornbury 1862, i, p. 322; 1877, p. 449; Vernon Heath, *Recollections* 1892, p. 353; Bell 1901, pp. 143–4 no. 231; Armstrong 1902, p. 235; Finberg 1930, pp. 140, 156, pl. 27; Davies 1946, p. 147; Clare 1951, p. 111; Finberg 1961, pp. 390, 506 no. 545; Kitson 1964, pp. 81–2, repr. in colour p. 65; Rothenstein and Butlin 1964, p. 66, colour pl. xxii; Herrmann 1975, pp. 49, 234, pl. 158.

Turner seems to have stayed at the Hotel Europa on some if not all of his visits to Venice. There are many drawings and watercolours made from the hotel, including views of fireworks taken from the roof or an upper room. Exceptionally among Turner's late oil paintings, this picture seems to be in part taken from a drawing of the Dogana and the Zitella (the 'Citella' of Turner's title) in the 'Milan to Venice' sketchbook, made on Turner's first visit in 1819 (CLXXV-40, repr.

Finberg 1930, pl. 2). However, the view is such a well-known one that recourse to a drawing may not have been necessary. A similar view but omitting San Giorgio on the left appears in the watercolour entitled *The New Moon* in the collection of D. G. Ells. This probably dates from about 1840 but, *pace* Finberg (*ibid.*, pp. 140, 161, colour pl. 24), is unlikely to have been used as a basis for the oil as the viewpoint is slightly different.

Thornbury's reference to a painting of '"Canal of the Giudecca, San Giorgio Maggiore, the Dogana" and other objects' as having been exhibited in 1834 and bought by Vernon is a confusion with the *Venice* of that year (No. 356). This mistaken identification seems first to occur in the first edition of Ralph N. Wornum's *Descriptive and Historical Catalogue of the Pictures in the National Gallery . . . : British School* 1857, p. 80; it is not found in Hall 1851. The picture was listed in Vernon's deed of gift of 22 December 1847 merely as 'Venice'. Given to the National Gallery by Vernon with three other Turners in 1847 (Nos. 343, 349 and 355), it was placed on view as a token of the whole of Vernon's collection of contemporary British painting, the first Turner to be shown in the National Gallery.

This picture and the other Venetian oil exhibited in 1842, *Campo Santo, Venice* (No. 397), were, on the whole, highly praised by the critics. For the *Spectator*, 7 May, they were 'Two lovely views of Venice, gorgeous in hue and atmospheric in tone.' For the *Athenaeum* of the same date they were 'among the loveliest, because least exaggerated pictures, which this magician (for such he is, in right of his command over the spirits of Air, Fire, and Water) has recently given us. Fairer dreams never floated past poets' eye; and the aspect of the City of Waters is hardly one iota idealised. As pieces of effect, too, these works are curious; close at hand, a splashed palette—an arm's length distant, a clear and delicate shadowing forth of a scene made up of crowded and minute objects!' The *Art Union* for 1 June was rather more critical. 'Venice was surely built to be painted by Canaletto and Turner . . . The Venetian pictures are now among the best this artist paints, but the present specimens are of a decayed brilliancy; we mean, they are by no means comparable with others he has within a few years exhibited. A great error in Mr. Turner's smooth water pictures is, that the reflection of colours in the water are painted as strongly as the substances themselves, a treatment which diminishes the value of objects.' See also under No. 397.

397. Campo Santo, Venice Exh. 1842 (Plate 385)

THE TOLEDO MUSEUM OF ART, TOLEDO, OHIO

Canvas, $24\frac{1}{2} \times 36\frac{1}{2}$ (62·2 × 92·7)

Coll. Bought at the R.A. Exhibition in 1842 by Elhanan Bicknell or perhaps painted for him (see below); sale Christie's 25 April 1863 (112) bought Agnew for Henry McConnell; sale Christie's 27 March 1886

(76) bought S. White for Mrs J. M. Keiller of Dundee; acquired from her in 1916 through Henry Reinhardt and Son by Edward Drummond Libbey, and presented by him to the Toledo Museum in 1926 (Accession no. 26·63).

Exh. R.A. 1842 (73); Royal Manchester Institution 1878 (111); Guildhall 1899 (36); Boston 1946 (16); Toronto and Ottawa 1951 (20); Indianapolis 1955 (46); New York 1966 (25); R.A. 1968-9 (162); Paris 1972 (273).

Engr. In the *Art Journal* 1899. An etching of the cirrus of the sky by J. C. Armytage is published in *Modern Painters* (1860, v, pl. 67).

Lit. Ruskin 1843, 1853, 1860, 1878 (1903-12, iii, pp. xxiv, 250, 251n.; x, p. 38n.; vii, pp. 149n. 157 and n., pl. 67; xiii, pp. 409, 454, 499); Burnet and Cunningham 1852, p. 119 no. 216; Waagen 1854, ii, pp. 350-51; Thornbury 1862, i, p. 260; ii, p. 401; 1877, pp. 172, 579, 599, 610; Bell 1901, p. 144 no. 232; Armstrong 1902, p. 235, repr. facing p. 168; Finberg 1930, pp. 140, 157; Toledo Museum of Art, *Catalogue of European Paintings* 1939, p. 312 repr.; Finberg 1961, pp. 390, 506 no. 546; Rothenstein and Butlin 1964, pp. 52, 66, pl. 116; Lindsay 1966, pp. 40-41; Herrmann 1975, p. 49, pl. 149; The Toledo Museum of Art, *European Paintings* 1976, pp. 160-61, pl. 333 and repr. in colour on cover.

Armstrong refers to this as a companion picture to the *Giudecca* exhibited in 1841 (No. 391) and states that both were painted for Bicknell. However, when during the course of the exhibition, a Mr Collard enquired the price of *Bellini depositing his Pictures* (No. 393), Turner replied quoting a price also for the *Giudecca* which refutes the theory that it was painted on commission. It seems more likely that Bicknell acquired both pictures in the normal way at the R.A. (although *The Times* report of the Bicknell sale, 27 April 1863, follows Christie's catalogue in stating that this picture was painted expressly for Bicknell) and their relationship as pendants seems unproven, even though Waagen also refers to them as such. Indeed, John Gage, in the catalogue of the 1972 exhibition at the Petit Palais, suggests rather that this picture is connected with *Sun of Venice* (No. 402), exhibited in 1843. He also points out that, as Ruskin realised, Venice held a special significance for Turner. As in the case of both Rome and Carthage, Venice represented for him a great city which had fallen into ruin through its own indulgence in supersition and luxury. The cemetery of the Campo Santo is thus treated by Turner as a symbol of the approaching end of Venice as a great imperial city.

At the R.A. this and Turner's other Venetian view *The Dogana* (see No. 396) were generally praised. *The Times*, 3 May, called them 'Two splendid pictures', while *The Spectator* for 7 May described them as 'two lovely visions of Venice, gorgeous in hue and atmospheric in tone.' In *Ainsworth's Magazine* for June 1842, Thackeray thought that 'when examined closely,' the

Campo Santo of Venice 'is scarcely less mysterious [than *The Exile and the Rock-Limpet*, No. 400]; at a little distance, however, it is a most brilliant, airy, beautiful picture.'

The *Literary Gazette* for 14 May was, however, sharply critical: '*The Dogano* and 73, *Campo Santo*, have a gorgeous *ensemble*, and produced by wonderful art, but they mean nothing. They are produced as if by throwing handfuls of white, and blue, and red, at the canvass, letting what chanced to stick, stick; and then shadowing in some forms to make the appearance of a picture.'

Further notices which mention this picture are given in the entry for No. 396.

Ruskin, who also refers to it as 'Murano and Cemetery', thought it 'the most perfect of all the late Venices' and 'the second most lovely picture he ever painted of Venice' (the *Approach to Venice* (No. 412) being the finest of all). Later, however, he wrote as if the picture's condition and colour had greatly deteriorated, which is surely wholly unjustified.

398. Snow Storm—Steam-Boat off a Harbour's Mouth making Signals in Shallow Water, and going by the Lead. The Author was in this Storm on the Night the Ariel left Harwich
Exh. 1842 (Plate 388)

THE TATE GALLERY, LONDON (530)

Canvas, 36 × 48 (91·5 × 122)

Coll. Turner Bequest 1856 (10, 'Steamer in a Snow Storm' 4′0″ × 3′0″); transferred to the Tate Gallery 1910, returned to the National Gallery 1952 and to the Tate Gallery 1968.

Exh. R.A. 1842 (182); Manchester 1887 (621); Amsterdam 1936 (163, repr.); Paris 1938 (146, repr.); New York, Chicago and Toronto 1946–7 (56, pl. 45); Venice and Rome 1948 (45); R.A. 1951–2 (163); New York, St Louis and San Francisco 1956–7 (115, repr. p. 16); New York 1966 (23, repr. in colour p. 44); R.A. 1974–5 (504, repr. in colour p. 504).

Lit. Ruskin 1843 and 1857 (1903–12, iii, pp. 297, 534, 569–71; xiii, pp. 161–3); Thornbury 1862, i, pp. 334–5, 347; ii, p. 207; 1877, pp. 407–8, 457–8, 466; Hamerton 1879, pp. 286–8; Monkhouse 1879, p. 128; Bell 1901, pp. 144–5 no. 233; Armstrong 1902, pp. 154–5, 231; Falk 1938, pp. 174–5; Clare 1951, pp. 106–7, repr. p. 108; Davies 1959, pp. 98, 185; Finberg 1961, pp. 390, 506 no. 547; Herrmann 1963, p. 35; Kitson 1964, pp. 79, 82, repr. p. 68; Rothenstein and Butlin 1964, pp. 52–62, colour pl. xxi; Gowing 1966, pp. 38, 45–8, repr. in colour p. 44; Lindsay 1966, pp. 191, 255; Brill 1969, pp. 21–2, repr. p. 22; Gage 1969, pp. 39–40, 91; Reynolds 1969, p. 190, colour pl. 160; Gaunt 1971, p. 11, colour pl. 46; Gage 1972, p. 45, pl. 3; Herrmann 1975, pp. 50, 234, colour pl. 173; Adele

Holcomb, 'John Sell Cotman's *Dismasted Brig* and the Motif of the Drifting Boat', *Studies in Romanticism* xiv 1975, p. 38.

The picture may recall a particularly bad storm in January 1842 though it has not been possible to tie down the exact incident. Adele Holcomb doubts the veracity of the story that Turner had himself tied to the mast for four hours during the storm; it does indeed bear a suspicious resemblance to accounts of the marine painter Joseph Vernet. However, in the fifth edition of his notes on the Turners on view at Marlborough House, Ruskin added a report of a conversation between the Rev. William Kingsley and Turner in which the artist stressed the truth of the incident and his interest in recording the experience: 'I had taken my mother and a cousin to see Turner's pictures, and, as my mother knows nothing about art, I was taking her down the gallery to look at the large "Richmond Park", but as we were passing the "Snowstorm" she stopped before it, and I could hardly get her to look at any other picture; she told me a great deal more about it than I had any notion of, though I have seen many sea storms. She had been in such a scene on the coast of Holland during the war. When, some time afterwards, I thanked Turner for his permission for her to see his pictures, I told him that he would not guess what had caught my mother's fancy, and then named the picture; and he then said, "I did not paint it to be understood, but I wished to show what such a scene was like; I got the sailors to lash me to the mast to observe it; I was lashed for four hours, and I did not expect to escape, but I felt bound to record it if I did. But no one had any business to like the picture." "But," said I, "my mother once went through just such a scene, and it brought it all back to her." "Is your mother a painter?" "No." "Then she ought to have been thinking of something else." These were nearly his words; I observed at the time he used "record" and "painting" as the title "author" had struck me before'—see Turner's sub-title in the R.A. catalogue; Ruskin himself wrote 'Note the significant use of this word, instead of "artist" '.

However, Ruskin records Turner's hurt reaction to the criticism (untraced) that the picture was nothing but a mass of 'soapsuds and whitewash': 'Turner was passing the evening at my father's house on the day this criticism came out: and after dinner, sitting in his arm-chair by the fire, I heard him muttering to himself at intervals, "soapsuds and whitewash! What would they have? I wonder what they think the sea's like? I wish they'd been in it." ' (Incidentally Frith, giving evidence at the Whistler versus Ruskin trial in 1878, attributed this criticism to Ruskin himself! See Ruskin, 1903–12, xxix, p. 584.) The *Athenaeum*'s review on 14 May was typical of this abuse: 'This gentleman has, on former occasions, chosen to paint with cream, or chocolate, yolk of egg, or currant jelly,—here he uses his whole array of kitchen stuff. Where the steam-boat is—where the harbour begins, or where it ends—which are the signals, and which the author in the *Ariel* ... are

matters past our finding out.' Or, as the *Art Union* for 1 June observed, 'Through the driving snow there are just perceptible portions of a steam-boat labouring on a rolling sea; but before any further account of the vessel can be given, it will be necessary to wait until the storm is cleared off a little. The sooner the better.'

In *Modern Painters* Ruskin described the *Snowstorm*, with two watercolours, as 'nothing more than passages of the most hopeless, desolate, uncontrasted greys, and yet . . . three of the very finest pieces of colour that have come from his hand'. Later, in a description of the effect of sea after prolonged storm he pointed out that 'There is indeed no distinction left between air and sea; that no object, nor horizon, nor any land-mark or natural evidence of position is left . . . Suppose the effect of the first sunbeam sent from above to show this annihilation to itself, and you have the sea picture of the Academy, 1842, the Snowstorm, one of the very grandest statements of sea-motion, mist, and light, that has ever been put on canvas, even by Turner. Of course it was not understood; his finest works never are . . .'

399. Peace—Burial at Sea Exh. 1842 (Plate 386)

THE TATE GALLERY, LONDON (528)

Canvas, $34\frac{1}{4} \times 34\frac{1}{8}$ ($87 \times 86 \cdot 5$); partly painted up to frame, approx $33\frac{1}{4} \times 34$ ($84 \cdot 5 \times 86 \cdot 5$), with corners cut across at approx. $8\frac{3}{4}$ (22) from corners of canvas.

Coll. Turner Bequest 1856 (42, 'Burial at Sea' 2′9″ × 2′9″); transferred to the Tate Gallery 1910.

Exh. R.A. 1842 (338); Manchester 1887 (623); Amsterdam 1936 (162, repr.); *Golden Gate Exhibition* San Francisco 1939; exchange loan to the Louvre, Paris, 1950–59; *Victorian Artists in England* National Gallery of Canada, Ottawa, March–April 1965 (150, repr.); New York 1966 (24, repr. p. 30); Edinburgh 1968 (18, repr.); Dresden (16, repr. in colour) and Berlin (26, colour pl. 13) 1972; Lisbon 1973 (18, repr. in colour); R.A. 1974–5 (521, repr.); Leningrad and Moscow 1975–6 (64, detail repr.).

Lit. Cunningham 1852, p. 26; Ruskin 1857 (1903–12, xiii, pp. 159–60); Thornbury 1862, i, p. 346; ii, pp. 182–3; 1877, pp. 171, 323–5, 465; Hamerton 1879, p. 292; Monkhouse 1879, p. 128; Bell 1901, p. 145 no. 234; Armstrong 1902, pp. 153–4, 226, repr. facing p. 154; MacColl 1920, p. 21; Falk 1938, p. 161; Davies 1946, p. 186; Clark 1949, p. 106; Clare 1951, 107, repr. p. 110; Finberg 1961, pp. 390–91, 507 no. 548; Rothenstein and Butlin 1964, pp. 68–70, pl. 120; Gowing 1966, pp. 27–31, 38, repr. p. 30; Lindsay 1966, pp. 202–3; 1966², p. 52; Brill 1969, pp. 241–31, repr. in colour at end and, detail, p. 31; Gage 1969, pp. 109, 186, 191, 260 n. 83, 269 n. 10; Reynolds 1969, p. 187, colour pl. 159; Gaunt 1971, p. 11, colour pl. 45; Herrmann 1975, pp. 50, 234, colour pl. 174.

Exhibited in 1842 with the following lines:

'The midnight torch gleamed o'er the steamer's side
And Merit's corse was yielded to the tide.'
 —*Fallacies of Hope*.

The painting is a memorial to Turner's friend and erstwhile rival Sir David Wilkie who died on board the *Oriental* on the way back from the Middle East on 1 June 1841; he was buried at sea off Gibraltar at 8.30 the same evening. Turner's picture was done in friendly rivalry with George Jones, who did a drawing of the burial as seen on deck. Jones reported that Clarkson Stanfield objected to the darkness of the sails; 'I only wish I had any colour to make them blacker', replied Turner, who may also have been alluding to Wilkie's marked use of black in his later pictures.

At the R.A. the painting was paired with *War. The Exile and the Rock Limpet*, a picture of Napoleon on St Helena (No. 400) and complementary in colour, being dominated by reds. Such pairings of works of contrasted colour were also to be a feature of Turner's Academy contributions in 1843 and 1845 (see Nos. 404 and 405, and 424 and 425). Both pictures, though painted to the full extent of the square canvas, were finished off, presumably on the R.A. walls, as octagons. No. 399 is now however framed to show the full extent of the painted surface.

As usual the critics, after praising in most instances Turner's Venetian exhibits, vented their fury on his more imaginative works. 'He is as successful as ever in caricaturing himself, in two round blotches of *rouge et noir*', wrote the *Spectator* for 7 May 1842. The *Athenaeum*, 14 May, felt embarrassed that foreign visitors should see such works and concluded, 'We will not endure the music of Berlioz, nor abide Hoffmann's fantasy-pieces. Yet the former is orderly, and the latter are commonplace, compared with these outbreaks.' A 'Supplement' to *The Times* for 6 May described the ship in *Peace* as 'an object resembling a burnt and blackened fish-kettle'. Both *Ainsworth's Magazine*, June 1842, and the *Art Union*, 1 June, came out with the suggestion that the pictures would look as well turned upside down.

Surprisingly even Ruskin, though finally spurred on to write the first volume of *Modern Painters* by the hostility of the critics in 1842, had little to say about *Peace* (though a considerable amount about *War*) and dismissed it as 'Spoiled by Turner's endeavour to give funereal and unnatural blackness to the sails.'

400. War. The Exile and the Rock Limpet
Exh. 1842 (Plate 387)

THE TATE GALLERY, LONDON (529)

Canvas, $31\frac{1}{4} \times 31\frac{1}{4}$ ($79 \cdot 5 \times 79 \cdot 5$)

Coll. Turner Bequest 1856 (43, 'The Sea Lympit' 2′7″ × 2′7″); transferred to the Tate Gallery 1905.

Exh. R.A. 1842 (353).

Lit. Ruskin 1843, 1860 and 1857 (1903–12, iii, pp. 273, 286, 297, 364, 474; vii, pp. 157–8, 438–9 n.; xiii, pp. 160–61); Thornbury 1862, i, pp. 346–7; ii, p. 196; 1877, pp. 127, 171, 399, 465–6; Hamerton 1879, pp. 292–3; Bell 1901, p. 145 no. 235; Armstrong 1902, pp. 153–4, 225; Davies 1946, p. 186; Clark 1949, p. 106; Finberg 1961, pp. 390, 507 no. 549; Rothenstein and Butlin 1964, pp. 68–70; Lindsay 1966, pp. 190, 202–3; 1966², p. 52; Brill 1969, pp. 24–30, repr. p. 24; Gage 1969, pp. 194, 260 n. 83; Reynolds 1969, p. 187, pl. 164.

Exhibited in 1842 with the lines:

'Ah! thy tent-formed shell is like
A soldier's nightly bivouac, alone
Amidst a sea of blood ————
———— but you can join your comrades.'
—Fallacies of Hope.

Ruskin, who seems to have valued this picture more highly than its companion *Peace—Burial at Sea* (No. 399), commented 'The lines which Turner gave with this picture are very important, being the only verbal expression of that association in his mind of sunset colour with blood . . . the conceit of Napoleon's seeing a resemblance in the limpet's shell to a tent was thought trivial by most people at the time; it may be so (though not to my mind); the second thought, that even this poor wave-washed disk had power and liberty, denied to *him*, will hardly, I think, be mocked at.' In *Modern Painters* Ruskin had expressed his particular liking for 'the glowing scarlet and gold of Napoleon and Slave Ship [No. 385]'.

The press was universal in its condemnation of this picture, even *Blackwood's Edinburgh Magazine* for July 1842, which found a general improvement in Turner's exhibits as compared with previous years, dismissing *War* as 'a greater absurdity than ever'. The figure of Napoleon was particularly criticised. 'He is in black military boots', wrote the critic in the *Literary Gazette*, 14 May, 'the continuous reflection of which from his toes in the water give him the appearance of being erected upon two long black stilts, and the whole thing is . . . truly ludicrous.' In a 'Supplement' to *The Times* for 6 May the picture was dismissed as 'an elongated Napoleon . . . running to seed in a redhot atmosphere of brimstone and brickdust.' The *Athenaeum*, 14 May, described Turner's *War* as 'yet odder than his "Peace"'. In the midst of a canvas smeared with every shade of rose colour, crimson, vermillion, and orange, is set up a *thing*—man it assuredly is not—', an 'effigy of Napoleon rolled out to a colossal height . . . Below the feet of the modern Prometheus lies something about the size of his cocked-hat, called in the Catalogue "a rock limpet".' For further criticism see under No. 399.

401. The Opening of the Wallhalla, 1842
Exh. 1843 (Plate 419)

THE TATE GALLERY, LONDON (533)

Mahogany, $44\frac{5}{16} \times 79$ ($112 \cdot 5 \times 200 \cdot 5$)

Coll. Turner Bequest 1856 (26, 'The Wallhalla' $6'5\frac{1}{2}'' \times 3'7\frac{1}{2}''$); transferred to the Tate Gallery 1929.

Exh. R.A. 1843 (14); Congress of European Art, Munich 1845; Whitechapel 1953 (96, repr.); *Age of Neo-Classicism* R.A., September–November 1972 (1186).

Lit. Ruskin 1843, and letter to Mrs John Simon, 28 November 1857 (1903–12, iii, p. 249 n.; xxxvi, p. 270); G. K. Nägler, *Neues Allgemeines Künstler-Lexicon* xix 1849, p. 163; Thornbury 1862, i, pp. 347–8; 1877, p. 466; Hamerton 1879, p. 294; Richard Owen, *The Life of Richard Owen* 1894, i, p. 263; Eastlake 1895, i, p. 189; Bell 1901, p. 146 no. 236; Armstrong 1902, pp. 157, 205, 236; MacColl 1920, p. 22; Falk 1938, p. 181; Davies 1946, p. 186; Finberg 1961, pp. 395–6, 404, 414–15, 507 no. 550; Rothenstein and Butlin 1964, p. 56; Lindsay 1966, p. 250 n. 11; 1966², p. 52; Robert Rosenblum, *Transformations in late Eighteenth Century Art* 1967, p. 139, pl. 161; Reynolds 1969, pp. 185–6, pl. 157.

Exhibited in 1843 with the following caption:

'*L'honneur au Roi de Baviere*':
'Who rode on thy relentless car, fallacious Hope?
He, though scathed at Ratisbon, poured on
The tide of war o'er all thy plain, Bavare,
Like the swollen Danube at the gates of Wien.
 But peace returns—the morning ray
Beams on the Wallhalla, reared to science, and the arts,
For men renowned, of German fatherland'.
—Fallacies of Hope, M.S.

The Walhalla is a temple in the Doric style on the Danube about five miles from Regensburg, designed by Leo von Klenze. The foundation stone was laid by Ludwig I of Bavaria in 1830 and it was finally opened in 1842. Turner had seen it on his return from Venice in 1840 and there is a drawing in the 'Venice, Bamburg and Coburg' sketchbook (CCCX-70). The picture was, as Turner's caption indicates, a tribute to the King of Bavaria and in 1845 he sent it to the 'Congress of European Art', the opening exhibition at the new 'Temple of Art and Industry' in Munich; the wife of Turner's friend, the anatomist and naturalist Sir Richard Owen, had translated part of the programme for the exhibition, as she recorded in her diary on 8 August 1845.

 The article on Turner in Nägler's *Künstler-Lexicon* gives a near-contemporary account of the German reaction to the picture. 'The painting caused a sensation because it was seen as a pure satire on this kind of celebration. One knew Turner from the lovely steel

engravings after his drawings and imagined, therefore, that one had been honoured with a lampoon by him. If the later works of this master show the same kind of treatment, they could be taken as proof of the worst and most ludicrous kind of confusion into which art can get. When looking at this picture, it was impossible to comprehend that the artist had once painted good pictures and knew how to produce beautiful effects of light and colour. Pictures of the above-mentioned kind show neither sense nor understanding. One would like to see these productions as a cheerful satire if only they were not, unfortunately, so patently meant to be taken seriously. For his contribution to the Munich art exhibition he goes down in history on page 198 of the Kunstblatt 1846, as a dauber. At the same time we note that in England too, the degeneration of such an outstanding talent is regretted. Some of his works are seen only as curiosities of the art of painting.'

The picture returned from Munich damaged and was seen by Elizabeth Rigby, later Lady Eastlake, when she visited Turner's studio on 20 May 1846. 'The old gentleman was great fun: his splendid picture of "Walhalla" had been sent to Munich, there ridiculed as might be expected, and returned to him with 7l[£] to pay, and sundry spots upon it: on this Turner laid his odd misshapen thumb in a pathetic way. Mr. Munro suggested they would rub out, and I offered my cambric handkerchief; but the old man edged us away, and stood before his picture like a hen in a fury.'

But Ruskin, discussing the poor technique of some of Turner's oil paintings, says that 'No picture of Turner's is seen in perfection a month after it is painted. The Walhalla cracked before it had been eight days in the Academy rooms . . .' In a letter to Mrs John Simon of 28 November 1857 he quotes the Walhalla, among other works, as an example of Turner's failure with human figures.

In England the Walhalla was generally well received by the press, if only in comparison with Turner's other works of recent years. For the Morning Chronicle of 9 May 1843, it was 'one of the most intelligible pictures he has exhibited for many years', a view echoed by the Athenaeum for 17 June and the Spectator for 13 May, which also described it as 'a superb landscape composition', though 'the group of figures and emblems . . . is one of those licences of art which Turner exercises to give effect to his pictures.' Even Blackwood's Magazine, August 1843, found the picture 'far the best' of Turner's exhibits; 'indeed it has its beauties; distances are happily given: most absurd are the figures, and the inconceivable foreground.' The Times for 9 May, however, dismissed the picture as 'One of Mr. Turner's clever perpetrations.'

The Illustrated London News for 20 May gave the picture a long eulogy, beginning 'This is a noble picture, full of the poetry of the art . . . Mr. Turner, in dealing with this great subject, appears to have soared beyond his besetting sins, and for once to have leapt within the limits of propriety.' The review continued by

recommending 'to the notice of artists — and especially young ones — the quality of Mr. Turner's colours, and his peculiar mode of applying them to the canvass. His pigments are generally very much diluted, and seem to be laid on the canvass, not in broad heavy flats of colour, but by a successive elaboration of touches, each one more delicate and slightly differing in tint from its predecessor. It is in this way, we believe, he has succeeded, beyond all other artists, in getting the atmosphere — the colour — the depth of nature itself into his pictures.'

More critical was the Art Union for June 1843. 'The landscape is by no means generally eligible, but this is of no moment, the object of the artist being to paint light and atmosphere; and how far he may be successful, will be better shown half a century hence than now. The admirers of Mr. Turner say, indeed, that Time will restore him to the high fame of which Time has deprived him. Yet those who see this picture, and here make a first acquaintance with the artist, will find it difficult to believe that he once painted pictures of chaste, delicate, and surpassing beauty — as true to nature as Nature is to herself . . . The picture is a whirlpool, or a whirlpool of colours; neither referring to fact, nor appealing to the imagination.'

402. The Sun of Venice going to Sea Exh. 1843

(Plate 389)

THE TATE GALLERY, LONDON (535)

Canvas, $24\frac{1}{4} \times 36\frac{1}{4}$ ($61 \cdot 5 \times 92$)

Inscribed on sail (damaged and retouched) 'Sol de VENEZA MI RAI.I . . .'

Coll. Turner Bequest 1856 (one of 18–21, 36–40; see No. 383); transferred to the Tate Gallery 1954.

Exh. R.A. 1843 (129); Manchester 1887 (619); Wildenstein's 1972 (55, repr.); R.A. 1974–5 (534, repr.); Leningrad and Moscow 1975–6 (67, repr.).

Lit. Ruskin 1843 and 1857 (1903–12, iii, pp. 250–51, 545–6; xiii, pp. 163–4); Thornbury 1862, i, p. 348; 1877, p. 466; Hamerton 1879, p. 266; Bell 1901, p. 146 no. 237; Armstrong 1902, pp. 155, 235; William T. Whitley, Artists and their Friends in England 1700–1799 1928, i, p. 283; Finberg 1930, pp. 140–44, 151, 157, colour pl. 26; Falk 1938, pp. 140–41, repr. facing p. 246; Davies 1946, pp. 151–2, 186; Finberg 1961, pp. 396, 400, 507 no. 551; Rothenstein and Butlin 1964, p. 64, pl. 117; Lindsay 1966, p. 193; 1966², pp. 25, 52; Gage 1969, p. 146, colour pl. 26; Gaunt 1971, p. 11; Hawes 1972, p. 42, repr. p. 46 fig. 13; Shapiro 1972, p. 202.

The pessimism that lies behind Turner's views of Venice is here made clear in the verses published in the R.A. catalogue:

'Fair Shines the morn, and soft the zephyrs blow,
Venezia's fisher spreads his painted sail so gay,
Nor heeds the demon that in grim repose
Expects his evening prey.'
 —*Fallacies of Hope, M.S.*

Based on part of Thomas Gray's 'The Bard', these lines appear slightly differently in different copies of the catalogue, as Ruskin explained in a footnote to his notes on the Turners shown at Marlborough House in 1856: 'Turner seems to have revised his own additions to Gray, in the catalogues, as he did his pictures on the walls, with much discomfiture to the printer and the public. He wanted afterwards to make the first lines of this legend rhyme with each other; and to read:

"Fair shines the moon, the Zephyr" (west wind)
 "blows a gale";
Venetia's fisher spreads his painted sail.

'The two readings got confused, and, if I remember right, some of the catalogues read "soft the Zephyr blows a gale" and "spreads his painted sail so gay"—to the great admiration of the collectors of the Sibylline leaves of the "Fallacies of Hope".'

The picture was one of Ruskin's favourites. He is even said to have been ejected by the police from the R.A. in 1843 for making a pencil sketch of it. The following year he noted in his diary on 29 April that 'Yesterday, when I called with my father on Turner, he was kinder than I ever remember. He shook hands most cordially with my father, wanted us to have a glass of wine, asked us to go upstairs into the gallery. When there, I went immediately in search of the "Sol di Venezia", saying it was my favourite. "I thought", said Turner, "it was the 'St. Benedetto'" [No. 406]. It was flattering that he remembered that I had told him this. I said the worst of his pictures was one could never see enough of them. "That's part of their quality", said Turner.' A year later, as Ruskin recorded in a letter to his father from Venice of 14 September 1845, he was delighted if 'a little taken aback when yesterday, at six in the morning, with the early sun-light just flushing its fold, out came a fishing boat with its painted sail full to the wind, the most gorgeous orange and red, in everything, form, colour and feeling, the very counterpart of the Sol di Venezia.'

When the picture was first exhibited at Marlborough House in 1856 Ruskin commented, at the end of a long description, on the condition of the painting: 'The sea in this picture was once exquisitely beautiful: is not very severely injured, but has lost much of its transparency in the green ripples. The sky was little more than flake white laid with the pallet-knife; it has got darker, and spotted, destroying the relief of the sails. The buildings in the distance are the ducal palace, dome of St Mark's, and on the extreme left, the tower of San Giorgio Maggiore. The ducal palace, as usual, is much too white, but with beautiful gradations in its relief against the morning mist. The marvellous brilliancy of the arrangement of colour in this picture renders it, to my mind, one of Turner's leading works in oil.'

The critics of the 1843 R.A. exhibition were less enthusiastic, being rather put off by the verses that give the picture its hidden note of doom. 'His style of dealing with quotations', wrote the *Athenaeum* for 17 June, 'is as unscrupulous as his style of treating nature and her attributes of form and colour', while the *Art Union* for June 1843 suggested that Turner's 'wretched verses may have had some deleterious influence on the painter's mind—may have cast a spell over a great genius. Oh! that he would go back to nature!' The critic went on, 'The most celebrated painters have been said to be "before their time", but the world has always, at some time, or other, come up with them. The author of the "Sun of Venice" is far out of sight; he leaves the world to turn round without him: at least in those of his works, of the light of which we have no glimmering, he cannot hope to be even overtaken by distant posterity; such extravagances all sensible people must condemn; nor

"is the winter of *our* discontent
Made glorious summer by this 'Sun of Venice'."'

The *Illustrated London News* for 27 May on the whole liked the picture but missed its pessimism entirely: 'A rich cluster of the scrapings of Mr. Turner's iridescent palette: for it is evidently more the work of the palette-knife than the pencil. Yet how glorious is the general effect! Looked at from a considerable distance, it is discovered to be a fisherman's vessel, under a lofty crowd of canvass . . . And like a thing of life she goes, so gay—so buoyant—so swift—that we almost feel the bright city to be lessening in the distance.' For *The Times* of 9 May 'The Sun appears to be a fishing vessel. It is a very silly sort of craft. The rest of the picture is fine.'

403. Dogana, and Madonna della Salute, Venice
Exh. 1843 (Plate 390)

NATIONAL GALLERY OF ART, WASHINGTON D.C.

Canvas, $24\frac{3}{4} \times 36\frac{5}{8}$ (63 × 93)

Signed 'J M W T' on wall in bottom right corner (Plate 539)

Coll. Edwin Bullock of Handsworth near Birmingham, who bought it at the R.A. Exhibition in 1843; his purchase is recorded in a letter from Turner to an unknown correspondent, written on 23 November 1843: 'I have no small picture in hand and indeed I have no wish to paint any smaller than Mr. Bullocks and those all of Venice 200 gns if painted by commission—250 gns afterwards. This is the offer made to Mr. B. who thought of a companion picture to his bought last year out of the exhibition' (Turner seems to have meant the last exhibition rather than last year. The idea of a companion picture evidently did not come to anything. It is interesting to note that

Turner reduced his charges for a picture painted on commission); Bullock sale Christie's 21 May 1870 (143) (not 1878 as stated by Bell and Armstrong) bought Agnew; sold to John Fowler—later Sir John Fowler, Bt; sale Christie's 6 May 1899 (79) bought Agnew for James Ross of Montreal; sale Christie's 8 July 1927 (28) bought Agnew for Alvan T. Fuller of Boston, Governor of Massachusetts; given to Washington in memory of Governor Alvan T. Fuller by the Fuller Foundation 1961 (Inventory no. 1604).

Exh. R.A. 1843 (144); Royal Birmingham Society of Artists 1843 (54); Agnew 1899 (19); Birmingham 1899 (7); Boston 1946 (17); Boston Museum of Fine Arts *Fuller Memorial Exhibition* 1959 (33); R.A. 1974–5 (533).

Lit. Ruskin 1843 (1903–12, iii, p. lv, pl. 5); Burnet and Cunningham 1852, p. 119 no. 222; Thornbury 1877, p. 580; Wedmore 1900, i, repr. facing p. 146; Bell 1901, pp. 146–7 no. 238; Armstrong 1902, p. 235; Finberg 1930, pp. 140, 148, 157; Falk 1938, p. 250; Finberg 1961, pp. 396, 507 no. 552.

At the R.A. the critics concentrated their attention on *The Opening of the Walhalla* (No. 401), *The Sun of Venice* (No. 402) and the two 'Deluge' pictures (Nos. 404 and 405).

The *Athenaeum*, 17 June, wrote that 'We have so often entered our protest against Mr. Turner's flagrant abuse of his genius, that we can find no new terms of reprehension' and, after criticising *The Sun of Venice* and *Walhalla* concluded with 'the others we forbear to particularize'. The *Spectator*, however, on 13 May wrote of the three Venetian views (see also Nos. 402 and 406) that they 'are beaming with sunlight and gorgeous colour, and full of atmosphere; though, as usual, all forms and local hues are lost in the blaze of effect'. *The Times*, 9 May, wrote 'This is a splendid picture. It is divested of all absurdities and shows the great power of the artist, when he is content to copy nature as she is.'

Turner was to use substantially the same view again in a picture he exhibited at the R.A. in the following year, *Venice—Maria della Salute* (No. 411).

404. Shade and Darkness—The Evening of the Deluge Exh. 1843 (Plate 392)

THE TATE GALLERY, LONDON (531)

Canvas, 31 × 30¾ (78·5 × 78)

Coll. Turner Bequest 1856 (47, 'Eve of the Deluge' 2′6½″ by 2′6½″ in diameter); transferred to the Tate Gallery 1905.

Exh. R.A. 1843 (363); Cardiff 1951; Arts Council tour 1952–3 (20); Tate Gallery 1959 (360); New York 1966 (28, repr. in colour p. 40); Dresden (18, repr.) and Berlin (27, colour pl. 17) 1972; R.A. 1974–5 (522); Hamburg 1976 (130 and 156, repr. and colour pl. 18).

Lit. Thornbury 1862, i, p. 347; ii, pp. 332–3; 1877, p. 466, 531; Hamerton 1879, p. 295; Bell 1901, p. 147 no. 239; Armstrong 1902, pp. 156–7, 220; Davies 1946, p. 186; R. D. Gray, 'J. M. W. Turner and Goethe's Colour Theory', *German Studies presented to Walter Horace Bruford* 1962, pp. 112–16; Finberg 1961, pp. 396, 507 no. 553; Kitson 1964, p. 82, repr. in colour p. 72; Rothenstein and Butlin 1964, pp. 70–72, pl. 121; Gowing 1966, pp. 38, 51, repr. in colour p. 40; Lindsay 1966, pp. 212–13; 1966², pp. 52, 55–6; Gage 1968, p. 685; Gage 1967, pp. 173, 185–8, 190, 194, colour pl. 51; Reynolds 1969, pp. 150, 192–6, colour pl. 161; Herrmann 1975, pp. 50–51, 233, pl. 151.

Exhibited in 1843 with the following lines:

'The morn put forth her sign of woe unheeded;
But disobedience slept; the dark'ning Deluge
 closed around,
And the last token came: the giant framework
 floated,
The roused birds forsook their nightly shelters
 screaming
And the beasts waded to the ark'.
 —*Fallacies of Hope* M.S.

See under the companion *Light and Colour (Goethe's Theory)—The Morning after the Deluge—Moses writing the Book of Genesis* (No. 405). For what is almost certainly a first version of the composition see No. 443.

405. Light and Colour (Goethe's Theory)—The Morning after the Deluge—Moses writing the Book of Genesis Exh. 1843 (Plate 393)

THE TATE GALLERY, LONDON (532)

Canvas, 31 × 31 (78·5 × 78·5)

Coll. Turner Bequest 1856 (48, 'Moses writing the Book of Genesis' 2′6½″ × 2′6½″ in diameter); transferred to the Tate Gallery 1905.

Exh. R.A. 1843 (385); Arts Council tour 1952–3 (21); Tate Gallery 1959 (359); New York 1966 (29, repr. in colour p. 41); Dresden (17, repr.) and Berlin (28, colour pl. 18) 1972; R.A. 1974–5 (523); Hamburg 1976 (131 and 157, repr. and colour pl. 19).

Lit. Thornbury 1862, i, p. 347; 1877, p. 466; Hamerton 1879, p. 295; Bell 1901, pp. 147–8 no. 240; Armstrong 1902, p. 220; Davies 1946, p. 186; Clark 1949, pp. 105–6, 108; Finberg 1961, pp. 396, 508 no. 554; R. D. Gray, 'J. M. W. Turner and Goethe's Colour Theory', *German Studies presented to Walter Horace Bruford* 1962, pp. 112–16; Herrmann 1963, pp. 35–6; Kitson 1964, p. 82; Rothenstein and Butlin 1964, pp. 70–72; Gowing 1966, pp. 38, 51, repr. in colour p. 41; Lindsay 1966, pp. 212–13; 1966², pp. 52, 55–6; Gage 1968, p. 685; Gage 1969, pp. 113, 126, 132, 173, 185–8, 190, 194, colour pl. 52; Reynolds 1969, pp. 158, 192–7, colour pl. 163;

Holcomb 1970, pp. 27–8, pl. 14; Herrmann 1975, pp. 50–51, 233, colour pl. 150.

Exhibited in 1843 with the following lines:

'The ark stood firm on Ararat; th'returning sun
Exhaled earth's humid bubbles, and emulous of light,
Reflected her lost forms, each in prismatic guise
Hope's harbinger, ephemeral as the summer fly
Which rises, flits, expands, and dies.'
 —Fallacies of Hope, M.S.

A companion to Shade and Darkness—The Evening of the Deluge (No. 404). The choice of subjects may have been influenced by John Martin's Eve of the Deluge and The Assuagement, exhibited as companions at the R.A. in 1840.

The allusion to Goethe's Fahrbenlehre, of which Turner owned and annotated Eastlake's translation, parallels his allusion to Du Fresnoy in Watteau painting twelve years earlier (No. 340). It refers to Goethe's theory of a colour-circle divided into 'plus' and 'minus' colours: the former, reds, yellows and greens, were associated by Goethe with gaiety, warmth and happiness, while the latter, blues, blue-greens and purples, were seen as productive of 'restless, susceptible, anxious impressions'. R. D. Gray has suggested that Turner's opposition between 'Light and Colour' on the one hand and 'Shade and Darkness' on the other was also a criticism of Goethe's theory that colour was the product equally of Light and Dark: Turner's 'Dark' picture he sees as the negation of colour. Gage, however, sees Turner's intention as the restoration of the equality of Light and Dark as values in art and nature. To the sublimity of darkness he added a sublimity of light. But the verses given to Light and Colour, which demonstrates the 'plus' colours, make it as pessimistic as Shade and Darkness. Turner transformed the rainbow of the Covenant into scientifically-induced prismatic bubbles, each one an ephemeral harbinger of hope, born to die. In addition the Biblical concordance between Noah's Covenant and that of Moses writing the Book of Genesis apparently on the Tables of the Law, with the Brazen Serpent foreshadowing the Crucifixion before him, must be seen in the light of Turner's constant use of the serpent as a symbol of evil (see Gage 1969, pp. 185–7, for a fuller development of this theory).

The critics were universal in their condemnation of these pictures, though the Spectator for 13 May 1843 found them intelligible as illustrations 'of Goethe's Theory of Light and Colour . . . but further we cannot follow the painter. There may be some sublime meaning in all this . . . but . . . we see in these two octagon-shaped daubs only two brilliant problems—chromatic harmonies of cool and warm colours.' The Athenaeum for 17 June as usual regretted 'Mr. Turner's flagrant abuse of his genius' but admitted that 'there is a poetical idea dimly described through the prismatic chaos, which arrests the attention and excites the fancy.' For the Morning Chronicle, 9 May, they 'are perfectly

indescribable, and seem to consist of

——————— atoms casually together hurl'd'.

The Times for 11 May called Shade and Darkness a 'ridiculous daub' and its companion 'A wretched mixture of trumpery conceits, involving an anachronism that the meanest scholar at a parish school could rectify.' Blackwood's Edinburgh Magazine for August, spurred by the recent appearance of the first volume of Ruskin's Modern Painters, was even more scathing. From Shade and Darkness, wrote the critic, 'we learn . . . that, on the eve of the mighty Deluge, a Newfoundland dog was chained to a post, lest he should swim to the ark; that a pig had been drinking a bottle of wine . . . that men, women, and children (such we suppose they are meant to be) slept a purple sleep, with most gigantic arms round little bodies . . .' and so on.

Both pictures are painted up to the edge of the canvas but were finished, probably in their frames, as octagons, though it seems that Turner may have thought at one time of finishing No. 405 as a circle. Both were reframed in 1966 to show the full extent of the paint surface.

406. St. Benedetto, looking towards Fusina
Exh. 1843 (Plate 391)

THE TATE GALLERY, LONDON (534)

Canvas, $24\frac{1}{2} \times 36\frac{1}{2}$ (61·5 × 92)

Coll. Turner Bequest 1856 (one of 18–21, 36–40; see No. 383); transferred to the Tate Gallery 1968.

Exh. R.A. 1843 (554); Amsterdam, Berne, Paris (repr.), Brussels, Liege (39), Venice (repr.) and Rome (repr.) (48) 1947–8; R.A. 1974–5 (535).

Lit. Ruskin 1843, 1860, 1857 and Notes on his Drawings by Turner 1878 (1903–12, iii, pp. 250, 546; vii, pp. 157–8; xiii, pp. 164–6, 454); Thornbury 1862, i, p. 348; 1877, p. 466; Hamerton 1879, pp. 266–7; Bell 1901, p. 148 no. 241; Armstrong 1902, p. 235; Finberg 1930, pp. 140, 144–8, 151, 157, pl. 27; Davies 1946, pp. 151, 186; 1959, pp. 98–9; Finberg 1961, p. 508 no. 555; Herrmann 1975, p. 51, pl. 164.

As Ruskin pointed out, the title is partly imaginary, there being no church of San Benedetto visible in this view looking west along the Canal della Giudecca towards Fusina. 'The buildings on the right are also, for the most part, imaginary in their details, especially in the pretty bridge which connects two of their masses: and yet, without one single accurate detail, the picture is the likest thing to what it is meant for—the looking out of the Giudecca landwards, at sunset—of all that I have ever seen.' In a letter to his father of 5 January 1850 Ruskin reported delightedly how he had seen a covered boat with a great curving rudder in the very place where Turner had shown one in his picture (presumably on the right, in the middle distance), and how, though this was no longer a regular service, it had

been in Turner's day the regular cheap passage-boat to Padua via Fusina. 'So it was by mere accident, a most lucky one, that I got this little illustration of Turner's putting everything in its own place.' Thornbury, following the first official catalogue, calls it ' "Approach to Venice, looking towards Fusina", from a sketch made in 1839–40; sunset is approaching'. The sketch referred to is probably the watercolour of a similar view in the Turner Bequest, datable to 1840 (CCCXV-13).

This pictures does not seem to have attracted any individual comment in the press but it vied with *The Sun of Venice* (No. 402) for first place in Ruskin's estimation. In his notes on the Turners shown at Marlborough House in 1856 he wrote, 'Take it all in all, I think this is the best Venetian picture of Turner's which he has left to us.' In 1856 the condition of the picture was, according to Ruskin, 'tolerably safe. The writer of the notes in the published catalogue is mistaken in supposing that the upper clouds have changed in colour; they were always dark purple, edged with scarlet; but they have got chilled and opaque. The blue in the distance has altered slightly, making the sun too visible a spot; but the water is little injured, and I think it the best piece of surface painting which Turner has left in oil colours'. Ruskin would, of course, have remembered how the picture had looked in 1843, but his later description (in his notes on his own Turner drawings of 1878) of the decay and ruin through cleaning and retouching of this and other Venetian oils seems exaggerated when one looks at them today after more recent treatment.

A copy with variations by J. B. Pyne, signed and dated 1858, was sold at Christie's on 30 July 1959 (53; 27 × 35 in.). As in the case of other paintings by Turner exhibited in his lifetime or by the National Gallery from 1856, a number of other copies of various periods are known, usually by unidentifiable artists.

407. Ostend Exh. 1844 (Plate 394)

BAYERISCHE STAATSGEMÄLDESAMMLUNGEN, NEUE PIN-AKOTHEK, MUNICH

Canvas, $36\frac{1}{2} \times 48\frac{1}{2}$ (92·9 × 123·2)

Coll. H. A. J. Munro of Novar who may have bought it at the R.A. but in any case owned it in 1847 when it is recorded as hanging in his London house, 113 Grosvenor Square, by the *Art Union Journal* (p. 255); Munro sale Christie's, 24 March 1860 (151) bought Gambart; T. C. Farrer (?—see below); Cornelius Vanderbilt II (1843–1899); thence by descent to his daughter, Countess Szechenyi, Washington D.C., from whose heirs it was acquired by Agnew; bought by the Munich Gallery in 1975 (Inventory no. 14435).

Exh. R.A. 1844 (11); ?Whitechapel 1889 *Fine Art Exhibition* (97, see below); R.A. 1974–5 (506); Hamburg 1976 (132, repr.).

Lit. Ruskin 1843 (1903–12, iii, p. 568); Burnet and Cunningham 1852, p. 119 no. 226; Thornbury 1877, p. 580; Bell 1901, pp. 148–9 no. 242; Armstrong 1902, pp. 161, 226; Finberg 1961, pp. 400, 401, 508 no. 556; C. H. Heilmann, 'Ostende. Ein Bild aus Turners Spätzeit für München', *Pantheon* xxxiv 1976, pp. 221–30, repr. in colour.

Turner visited Ostend several times. Indeed, in 1826 there was an alarm raised, due to a misunderstanding, that Turner had been injured when a powder magazine exploded there, causing widespread damage to the city (Lindsay, pp. 165, 251, who, however, must be wrong in stating that Turner's father had been informed of the disaster by Fawkes because Fawkes had died in October 1825). Turner's father himself seems to have been responsible for furthering this rumour as Turner refers to his father having 'contrived to stir up others in the alarm' (letter to Holworthy of 4 December 1826 which is to be published by Gage).

In the 'Ostend, Rhine and Wurzburg' sketchbook (CCCIII), dated by Finberg 1837–1840, there are two or three rapid pencil drawings inscribed 'Ostend'. The drawings on pp. 6 verso, 17, 19 verso and 21 all contain features which have some connection with the oil although they are in so summary a shorthand style that it is difficult to be certain of a direct relationship. Similarly No. 310 of CCCXLIV, 'Miscellaneous Black and White Drawings 1830–41', which is inscribed 'Ostend', has two very slight sketches which show the two arms of the pier at the mouth of the harbour. Heilmann reproduces a number of these drawings in his *Pantheon* article and discusses their relationship to the finished picture.

Bell relates that this picture was bought by Cornelius Vanderbilt, without any provenance, as a view of Boulogne Harbour. It was the American painter, Thomas Moran (1837–1926), an ardent admirer of Turner's work, who identified it as the *Ostend* exhibited in 1844. The chances of an exhibited Turner losing its identity, after having been resold once with its correct title, must be extremely slight, but the picture is one of the late, vaporous compositions which would have been understood and appreciated by only a handful of collectors in the 1870s and '80s.

It is not known how soon after 1860 the picture went to America but Cornelius Vanderbilt cannot have bought the picture from Gambart, whom he knew, or the title would not have become mislaid. A possible clue may be that this picture is to be identified with one exhibited at Whitechapel in 1889 (97) lent by T. C. Farrer and entitled 'Fishing Boats in Boulogne Harbour, Storm coming on'. No size is given in the catalogue, but the description is as follows:

'The entrance to the harbour is narrow, and the lighthouse shows the bar of sand which makes the waves break. Turner has waited for a moment of a sudden squall, and has caught and fixed it on his canvas. The wind rushes, the scud hurries across the sky, the

waves rage and tumble, and we feel the power that lives and works in nature.'

Although it is difficult to recognize in the picture a sand bar where the waves break, the description fits *Ostend* in other respects. Cornelius Vanderbilt bought his Venetian oil by Turner (see No. 362) from Lord Dudley *c.* 1890 and also a large watercolour of *Bamburgh* at about the same time, so that the date of the Whitechapel exhibition coincides with what we know to be an active phase of Vanderbilt's interest in—and acquisition of—Turner's work. It seems highly likely, therefore, that the picture exhibited at Whitechapel was in fact *Ostend*.

At the R.A. most critics concentrated on *Rain, Steam and Speed* (No. 409) but the *Spectator*, 11 May, after qualifying Turner's works as 'slight and extravagant' despite 'the daring originality of his effects', considered that '*Ostend* and *Port Ruysdael* [No. 408] are two magnificent seapieces, without exaggeration and in these scenes the general effect is all sufficient . . .'

Ruskin, in *Modern Painters*, thought *Ostend* 'somewhat forced and affected', and he mistakenly reported the year of its exhibition as 1843.

408. Fishing Boats bringing a Disabled Ship into Port Ruysdael Exh. 1844 (Plate 420)

THE TATE GALLERY, LONDON (536)

Canvas, $36 \times 48\frac{1}{2}$ ($91 \cdot 5 \times 123$)

Coll. Turner Bequest 1856 (12, 'Port Ruysdael' $4'0'' \times 3'0''$); transferred to the Tate Gallery 1948.

Exh. R.A. 1844 (21); Paris 1965 (37, repr.); *Marine Paintings* Arts Council tour, October 1965–April 1966 (26, repr.).

Lit. Ruskin 1843 (1903–12, iii, pp. 568–9); Thornbury 1862, i, p. 348; 1877, p. 466; Hamerton 1879, p. 299; Bell 1901, p. 149 no. 243; Armstrong 1902, p. 230; Davies 1946, pp. 152, 185; Finberg 1961, pp. 397–8, 400–01, 508 no. 557; Rothenstein and Butlin 1964, p. 68.

In a rather surprising passage in a letter to his dealer Griffith of 1 February 1844 Turner asks, 'and Pray tell me if the new Port Ruysdael shall be with fish only', suggesting that the picture was then under way and was being painted on commission; it was never sold, however. For Turner's fictitious 'Port Ruysdael' see his 1827 exhibit of this title, No. 237.

This picture received little attention from the press compared to the more controversial of the year's exhibits. For a reference in the *Spectator* for 11 May 1844 see No. 407.

Ruskin described this as 'among the most perfect sea pictures he [Turner] has produced, and especially remarkable as being painted without one marked opposition either of colour or of shade, all quiet and simple even to an extreme, so that the picture was exceedingly unattractive at first sight.'

409. Rain, Steam, and Speed—the Great Western Railway Exh. 1844 (Plate 395)

THE NATIONAL GALLERY, LONDON (538)

Canvas, $35\frac{3}{4} \times 48$ (91×122)

Coll. Turner Bequest 1856 (33, 'Steam, Speed and Rain' $4'0'' \times 3'0''$).

Exh. R.A. 1844 (62); Manchester 1887 (612); New York, Chicago and Toronto 1946–7 (57, repr. pl. 47); R.A. 1951–2 (161); New York 1966 (33, repr. p, 48); *Art and the Industrial Revolution* Manchester City Art Gallery, May–July 1968 (64); Paris 1972 (274, repr.).

Lit. Thornbury 1862, i, p. 321; 1877, pp. 92, 535; Hamerton 1879, pp. 295–7; Monkhouse 1879, p. 128; Ruskin *Dilecta* ch. 3, 1900 (1903–12, xxxv, pp. 574–5, 598–601); Bell 1901, p. 149 no. 244; Armstrong 1902, pp. 158–60, 175, 191, 227; G. D. Leslie, *The Inner Life of the Royal Academy* 1914, pp. 144–5; A. M. W. Stirling, *The Richmond Papers* 1926, pp. 55–6; Falk 1938, pp. 183–5; Davies 1946, pp. 152, 186; Clark 1949, p. 102, pl. 88; Clare 1951, p. 109, repr. p. 112; Davies 1959, pp. 99–100; Finberg 1961, pp. 400–01, 508 no. 558, pl. 22; Herrmann 1963, p. 38, pl. 18; Kitson 1964, p. 82, repr. in colour p. 71; Rothenstein and Butlin 1964, p. 66, pl. 122; Gowing 1966, p. 38, repr. p. 48; Lindsay 1966, pp. 194, 201–2, 247 n. 11; 1966², p. 58; Gage 1969, pp. 190, 194, 265 n. 163, 269 nn. 9 and 10; Reynolds 1969, p. 197, colour pl. 162; Gaunt 1971, p. 11, colour pl. 47; John Gage, *Turner's Rain, Steam and Speed* 1972, repr. with details and in colour; John Gage, 'Gautier, Turner and John Martin', *Burlington Magazine* cxv 1973, p. 393, pl. 56; Herrmann 1975, pp. 53, 234, colour pl. 175.

An anecdote related by Lady Simon to both George Richmond and Ruskin and reported by them with variations (Stirling 1926 and, from Lady Simon's letter, in *Dilecta* 1900 respectively) may give one of the origins of this picture: a travelling-companion in a train (or coach) returning from Devonshire in a storm, later identified by her as Turner, put his head out of the window to observe the effect, getting drenched; she, encouraged by his example, did the same and recognised the effect in the next R.A. Exhibition. A more definite source of inspiration, as Gage points out (1972, pp. 11–13, 22–26), was the Railway Mania of the late 1830s and early 1840s. Davies has identified the site of the painting as the railway bridge over the Thames at Maidenhead looking east towards London. Turner probably chose the Great Western route to the west on account of its associations with both the Thames Valley and the West Country, sites long painted by him, besides which it was the most extensive system in the world; the section between Bristol and Exeter was actually opened in 1844. Maidenhead Bridge, built 1837–9 to Brunel's designs, had also aroused particular interest on account of its long elliptical arches.

George Leslie, who saw Turner at work on this picture during the R.A. Varnishing Days, says that Turner 'painted out the little hare running for its life in front of the locomotive . . . This hare, and not the train, I have no doubt he intended to represent the "Speed" of his title; the word must have been in his mind when he was painting the hare, for close to it, on the plain below the viaduct, he introduced the figure of a man ploughing, "Speed the plough" (the name of an old country dance) probably passing through his brain.' Gage (1972) points out the similar symbolic use of a hare in *Battle Abbey, the Spot where Harold fell*, engraved in 1819 (the engraving repr. pl. 8; see also Gage 1969, p. 134, engraving repr. pl. 29), and *Apollo and Daphne* (No. 369), and suggests that the painting is an allegory of the forces of nature using up-to-date imagery.

Wedderburn reports Ruskin as having answered the question why, if an engine was so ugly, Turner had used one in this picture, with the words 'To show what he could do even with an ugly subject' (Ruskin 1903-12, xxxv, p. 601 n. 1).

The newspapers were torn between amazement and admiration. *The Times* for 8 May 1844 wrote, 'The railways have furnished Turner with a new field for the exhibition of his eccentric style. His 'Rain, Steam, and Speed' (62) shows the Great Western in very sudden perspective, and the dark atmosphere, the bright sparkling fire of the engine, and the dusty smoke, form a very striking combination. Whether Turner's pictures are dazzling unrealities, or whether they are realities seized upon at a moment's glance, we leave his detractors and admirers to settle between them.' For the *Morning Chronicle* of the same date 'Speed, Steam, and Rain* is perhaps the most insane and the most magnificent of all these prodigious compositions'— Turner's works as a whole. In it Turner 'actually succeeds in placing a railroad engine and train before you, which are bearing down on the spectator at the rate of fifty miles an hour. How these wonderful effects are produced it is beyond the power of man to say. How men appear with vermillion shadows, and trees of salmon colour; how engine fires blaze where no one ever saw them blaze; and whirlwinds, cataracts, rainbows, are spattered over the incomprehensible canvass—all may imagine who are familiar with Mr. Turner's pictures'. Similarly *Fraser's Magazine* for June: Turner 'has out-prodied almost all former prodigies. He has made a picture with real rain, behind which is real sunshine, and you expect a rainbow every minute. Meanwhile, there comes a train down upon you, really moving at the rate of fifty miles an hour, and which the reader had best make haste to see, lest it should dash out of the picture, and be away up Charing Cross through the wall opposite [at this time the R.A. was in the present National Gallery building in Trafalgar Square]. All these wonders are performed with means not less wonderful than the effects are. The rain . . . is composed of dabs of dirty putty *slapped* on to the canvass with a trowel; the sunshine scintillates out

of very thick, smeary lumps of chrome yellow. The shadows are produced by cool tones of crimson lake, and quiet glazings of vermillion [;] although the fire in the steam-engine looks as if it were red I am not prepared to say that it is not painted with cobalt and pea-green. And as for the manner in which the "*Speed*" is done, of that the less said the better,—only it is a positive fact that there is a steamcoach going fifty miles an hour. The world has never seen anything like this picture.'

Only the *Spectator* for 11 May was completely negative in its criticism: 'when he [Turner] comes to represent a railway-train . . . the laxity of form and licence of effect are greater than people will allow.'

410. Van Tromp, going about to please his Masters, Ships a Sea, getting a Good Wetting
Exh. 1844 (Plate 396)

ROYAL HOLLOWAY COLLEGE, UNIVERSITY OF LONDON

Canvas, 36 × 48 (91·4 × 121·9)

Coll. It is probably this 'Van Tromp' picture which is recorded in Joseph Gillott's account book as being bought by Charles Birch for £400 on 12 March 1845 from George Pennell (who presumably had it on consignment from Gillott himself); John Miller of Liverpool by 1850; sale Christie's 22 May 1858 (248) bought Gambart; bought by Agnew in 1867 from Miller (it seems likely therefore that Miller bought this back from Gambart at some time between 1858 and 1867—see also No. 415) and sold to Henry Woods, M.P.; sale Christie's 5 May 1883 (147) (wrongly titled in the sale catalogue: 'Van Tromp's Shallop at the Entrance to the Scheldt') bought Martin, a *nom de vente* for Thomas Holloway (1800–December 1883); passed with the rest of Holloway's collection to Holloway College.

Exh. R.A. 1844 (253) with note—*vide Lives of the Dutch Painters*; Liverpool Academy 1850 (37 lent by John Miller); R.S.A. 1852 (21); Manchester 1857 (282); R.A. 1934 (158); R.A. 1951-2 (158); Cologne (61 repr.), Rome (62) and Warsaw (61) 1966-7; Agnew 1967 (33); Berlin 1972 (34).

Lit. Burnet and Cunningham 1852, p. 120 no. 229; Thornbury 1877, pp. 92 (with wrong title), 580, 606; C. W. Carey, *Catalogue of Pictures at Royal Holloway College* third edn 1896, p. 42 no. 43; *Art Journal* November 1897, pp. 336–7; Carey 1899, pp. 173–5; Wedmore 1900, i, repr. facing p. 132; Bell 1901, p. 150 no. 245; Armstrong 1902, pp. 161, 231; Cunningham 1952, pp. 322–9, repr.; Finberg 1961, pp. 400, 508 no. 559, 516 no. 593; Rothenstein and Butlin 1964, pp. 58, 68, pl. 123; Bachrach 1974, p. 20.

As noted under the entries for the other Van Tromp pictures (Nos. 339, 344 and 351), their titles have been a

good deal confused in the past until clarified by Cunningham's article. The other three were exhibited in consecutive years from 1831–3 and the gap of eleven years between them and this picture is not easy to explain, but the Dutch marine tradition was never far from Turner's mind and in 1844 it was to have a final flowering in his oeuvre with the exhibition of this picture and of the *Fishing Boats bringing a Disabled Ship into Port Ruysdael* (No. 408, which itself returned to a subject first exhibited in 1827). It is also possible that Turner's allusion in the title to *Lives of the Dutch Painters* meant that Turner had recently read this work, which had suggested this subject to him as a postscript to the series. However, no work of this title can be traced, so Turner may either have invented it or got the title wrong to such an extent that it is no longer possible to guess which book he meant.

I am indebted to Professor Bachrach for much assistance in preparing this entry, in particular for suggesting the incidents which may have been in Turner's mind when he chose this subject and for a number of perceptive ideas which help to clarify Turner's interpretation of it.

Tromp had been dismissed the service by Admiral de Ruyter, after failing to come to the aid of his superior because he insisted on pursuing his own tactics. It was William III who saw to it that the two admirals were later reconciled and Tromp was reinstated after making his submission to the Admiralty. Turner depicts Tromp as 'going about to please his masters', a sign that the admiral had swallowed his pride and come to terms with authority. 'Going about' or going onto a new tack can be interpreted as Tromp making a fresh start. Turner also alludes to Tromp's past troubles by placing his vessel in a turbulent trough of sea while the onlookers, 'his masters', although very close at hand, are shown in comparatively calm water. Turner reveals where his own sympathies lie, in choosing to symbolise Tromp's return to favour by showing him tackling a tricky manoeuvre, which the admiral executes with brilliant panache.

The burgee with 'VT' on it which Tromp is flying is in fact an anachronism as it was not until the nineteenth century that Dutch naval captains began to fly burgees bearing their initials. This practice was unknown in England, but Turner doubtless became aware of it when he visited Rotterdam either in 1841 or on a previous visit.

At the R.A. Turner's seven exhibits, his last great effort on such a scale, were treated by the critics with their usual mixture of admiration, exasperation and incomprehension. *The Times*, 8 May, summed it up thus: 'Turner comes out this year with all his wonted peculiarities so that he will neither lose a determined admirer nor win one vote from those who are accustomed to attack his extraordinary productions.' The reviewers concentrated, as might be expected, on *Rain, Steam and Speed* (No. 409) and to a lesser extent on the *Approach to Venice* (No. 412). The only review to mention this picture by name was the *Morning*

Chronicle of 8 May which considered that it was 'little inferior to it [*Rain, Steam and Speed*] either for their strangeness and extravagance, or for their extraordinary beauty and skill.'

411. Venice—Maria della Salute Exh. 1844
(Plate 421)

THE TATE GALLERY, LONDON (539)

Canvas, 24⅛ × 36¼ (61·5 × 92)

Coll. Turner Bequest 1856 (one of 18–21, 36–40; see No. 383); transferred to the Tate Gallery 1929.

Exh. R.A. 1844 (345).

Lit. Thornbury 1862, i, p. 348; 1877, pp. 466–7; Bell 1901, p. 150 no. 246; Armstrong 1902, p. 235; Finberg 1930, pp. 151, 157; Davies 1946, p. 186; Finberg 1961, pp. 400–01, 508 no. 560.

The view shows the Dogana with S. Maria della Salute behind it in the centre, the Canal della Giudecca on the left, and the Zecca and the Giardino Reale on the right; at one time the picture was known as 'Venice, Giudecca'. For another, unfinished view of the Salute see No. 502; c.f. also No. 403.

The critics gave this picture qualified admiration. The *Morning Chronicle* for 8 May 1844 held that this and the 'Van Tromp' picture (No. 410) were 'little inferior to it [*Rain, Steam, and Speed*, No. 409] either for their strangeness and extravagance, or for their extraordinary beauty and skill'. The *Spectator* for 11 May thought this and *Venice Quay, Ducal Palace* (No. 413) 'too evanescent for any thing but a fairy city'.

412. Approach to Venice Exh. 1844 (Plate 422)

NATIONAL GALLERY OF ART, WASHINGTON D.C.

Canvas, 24½ × 37 (62 × 94)

Coll. B. G. Windus of Tottenham; sale Christie's 20 June 1853 (5) bought Gambart; Charles Birch; sale Foster's 28 February 1856 (57); bought Wells(?); Joseph Gillott by 1860; bought in 1863 from Gambart by Agnew and sold to James Fallows; later in 1863 exchanged by Fallows (for pictures by Elmore and P. F. Poole!) with Agnew and sold to J. Smith; bought back from his executors in 1870 by Agnew and sold to W. Moir; bought from Mrs Moir in 1899 by Agnew; Sir Charles Tennant, Bt; bought by Knoedler from the second Lord Glenconner (Sir Charles Tennant's grandson) in 1923 and sold in the same year to Andrew Mellon who gave it to the National Gallery, Washington, in 1937 (Inventory no. 110).

Exh. R.A. 1844 (356); Royal Birmingham Society of Artists 1860 (64 lent by Joseph Gillott); Liverpool Art Club 1881 (133); Manchester 1887 (613); Agnew 1896 (5); R.A. 1903 (37).

Lit. Ruskin 1843, 1856, 1878 (1903–12, iii, p. 250; xiii, pp. 166, 409, 454); Burnet and Cunningham 1852, p. 120 no. 231; Thornbury 1877, p. 580; *Catalogue of the Tennant Collection* 1896, repr. (it seems impossible to reconcile the date of the catalogue with the fact that the picture was acquired in 1899); Bell 1901, pp. 150–51 no. 247; Armstrong 1902, pp. 112, 147, 155, 161, 235; Finberg 1930, pp. 147, 148–9, 157; 1961, pp. 400–01, 508 no. 561; James Dugdale 'Sir Charles Tennant' *Connoisseur* clxxviii, No. 715, Sept. 1971, p. 2, repr. in colour; Gage 1974, pp. 83–4.

Exhibited with the following quotations:

> 'The path lies o'er the sea invisible,
> And from the land we went
> As to a floating city, steering in,
> And gliding up her streets as in a dream,
> So smoothly, silently.'—*Rogers' Italy*

> 'The moon is up, and yet it is not night,
> The sun as yet disputes the day with her.'—*Byron*

(As noticed under the entry for No. 379, Turner here misquotes the second line of verse xxvii of Canto IV of *Childe Harold*.)

At the R.A. the picture did not receive much individual notice but the *Spectator* for 11 May used a phrase to describe it which sums up the ambivalent attitude of Turner's admirers at the time: 'beautiful as it is in colour it is but a vision of enchantment.' *The Times*, 8 May was on the whole laudatory: the *Approach to Venice* 'with its rich greens in the foreground and the tints of the clouds, and of the distant objects, all so delicately blended, present a beautiful and fantastic play of colours to the spectator, who will take his station amid the benches in the middle room, and be content with the general impression.'

Ruskin wrote that 'it was, I think, when I first saw it, the most perfectly *beautiful* piece of colour of all that I have seen produced by human hands, by any means, or at any period.' Later, however, he described it as 'now a miserable wreck of dead colours' while originally it had been 'beyond all comparison the best' view of Venice. Ruskin's view about the extent of the change in the picture's physical appearance is, as usual, overstated, but it is certainly true that the 'rich greens' noticed by the critic of *The Times* are now no longer nearly so prominent.

Gage suggests that there may be a link between this picture and Turner's early visits to Stourhead where, in the library, hung a portrait of a Doge attributed to Titian, and a series of ten Canaletto drawings of ceremonies connected with the Dogal office. The nearest barge in the left foreground in this picture is clearly inscribed 'DOGE', but, this apart, the connection seems tenuous.

413. Venice Quay, Ducal Palace Exh. 1844
(Plate 423)

THE TATE GALLERY, LONDON (540)

Canvas, $24\frac{1}{2} \times 36\frac{1}{2}$ ($62 \times 92 \cdot 5$)

Coll. Turner Bequest 1856 (one of 18–21, 36–40; see No. 383); transferred to the Tate Gallery 1920.

Exh. R.A. 1844 (430); Australian tour 1960 (13); Wildenstein's 1972 (56, repr.).

Lit. Thornbury 1862, i, p. 348; 1877, pp. 466–7; Bell 1901, p. 151 no. 248; Armstrong 1902, p. 235; Finberg 1930, pp. 151, 157; Davies 1946, p. 186; Finberg 1961, pp. 400–01, 508 no. 562; Herrmann 1975, p. 51, pl. 165.

The Doge's Palace is on the left, with the Campanile behind. The big church on the right is S. Zaccaria.

For the *Spectator*'s comment on this picture see No. 411.

414. Whalers Exh. 1845
(Plate 398)

THE TATE GALLERY, LONDON (545)

Canvas, $35\frac{7}{8} \times 48$ (91×122)

Coll. Turner Bequest 1856 (one of 76–78; see below); transferred to the Tate Gallery 1905.

Exh. R.A. 1845 (50); R.H.A. 1846 (253); Moscow and Leningrad 1960 (56); Edinburgh 1968 (14); on loan to National Maritime Museum since 1975.

Lit. Ruskin 1843 (1903–12, iii, pp. 250–51); Thornbury 1862, i, p. 349; 1877, p. 467; Bell 1901, p. 151 no. 249; Armstrong 1902, p. 236; Davies 1946, p. 187; Finberg 1961, pp. 407, 509 no. 563; Herrmann 1975, pp. 53–4, 234, colour pl. 176.

Exhibited in 1845 with the caption '*Vide Beale's Voyage*, p. 163.'

On the 1854 Schedule Nos. 414, 423 and 426 are listed as 76, 77 and 78, 'Whale fishing No. 1', ' ,, No. 2' and ' ,, No. 3', each $4'0'' \times 3'0''$.

Turner exhibited four pictures of 'Whalers', two in 1845 and two in 1846 (see Nos. 415, 423 and 426). Three, including this example, were given references in the R.A. catalogue to 'Beale's Voyage' by which Turner meant Thomas Beale's *The Natural History of the Sperm Whale . . . to which is added, a Sketch of a South-Sea Whaling Voyage*, first published in 1835 without the *Voyage* and again, as above, in 1839. In fact, the page references given for this picture and No. 415 both fall within the main body of the text, not the *Voyage*, and both refer to incidents retailed in ch. XIII, on the 'Chase and Capture of the Sperm Whale'.

This picture illustrates the first such account, on pp. 161–7, which is set in the North Pacific near Japan on a calm day, with 'the sun pouring its intense rays with dazzling brightness'. The whale is harpooned by the leading boat just as it is about to 'sound' (p. 163),

and then lashes the sea in its agony (pp. 163–4). It dives, and on resurfacing is lanced (p. 164). It breaks away but is pursued by two boats and again harpooned and fatally lanced (p. 166). It dies 'a victim to the tyranny and selfishness, as well as a wonderful proof of the great power of the *mind* of man'. The picture is probably a conflation of several episodes in this account, and is probably also indebted to the fourth story on pp. 176–83, in which Beale describes how the harpooners stand in the bows of their boats (pp. 180–81).

There are a number of sketches of whalers in the 'Whalers' sketchbook of *c.* 1844–5 (CCCLIII-6 to 14) and a watercolour of a whale aground, annotated 'I shall use this', in the 'Ambleteuse and Wimereux' sketchbook of May 1845 (CCCLVII-6; repr. in colour Butlin 1962, pl. 31); there is another similar watercolour, annotated 'He breaks away', in the Fitzwilliam Museum, Cambridge (see Cormack 1975, no. 52, repr.). None is specifically related to this picture.

The Times for 6 May 1845 recognised that Turner 'has found a new field for his peculiar style in the whale fishery . . . The greater portion of the picture is one mass of white spray, which so blends with the white clouds of the sky, that the spectator can hardly separate them, while the whiteness is still continued by the sails of the ship, which are placed in defiance of contrast.' The review goes on to talk of Turner's 'free, vigorous, fearless embodiment of a moment. To do justice to Turner, it should always be remembered that he is the painter, not of reflections, but of immediate sensations.' The *Morning Chronicle* for 7 May pointed out that 'The only warmth in either picture [this and No. 415] is produced by the red clothing of the sailors in the boats, a selection of colour which, on a close inspection, seems so obviously inconsistent with their vocation, that the spectator is tempted to cry "how absurd", and to walk away from the spot. But when he has got away some three yards, if he look back he will be astonished to find how these red tints become mellowed in their general effect, and how other rough patches of superfices seem to have melted into thin transparent air, and how in fact, by a wonderful combination of materials all his own, Mr. Turner has produced extraordinary aerial effects.' The *Athenaeum* for 17 May, on the other hand, found that 'no "distance" can "lend enchantment to the view", nor, by receding, do sky and water, or the whale at No. 50 (computed to be some six hundred feet long) or the craft in all the pictures, gain more clearness and intelligibility than they possess when we are close before them.' The *Literary Gazette* for the same date, after saying that 'It is whispered that Mr. Turner does not mean to exhibit any of his productions after this season', asserted that 'His scale of colour has never, so far as we know, been approached by any other man; and however wild it may be, it must still be felt that it is a development of elements essential in nature, carried far above her usual aspects.' The *Spectator*, after describing the two whaling pictures on 10 May as 'all light, spray, and clouds; beautiful as harmonies of colour', added on 24 May that 'the hues of light are of such

prismatic brilliancy, that the sailors are painted of the same bright orange colour that the palaces and gondolas of Venice are decked in' in Turner's Venetian exhibits of the same year. 'As light is light all the world over, there may be times when the Northern seas welter in a flood of radiance as dazzling as that which pours down from a Southern sky; but such is not their most characteristic effect.'

Ruskin, speaking of Turner's 1845 exhibits in the later editions of *Modern Painters* i, describes the two whaling subjects as 'altogether unworthy of him'.

415 Whalers Exh. 1845 (Plate 399)
also known as *The Whale Ship*

THE METROPOLITAN MUSEUM, NEW YORK

Canvas, 36⅛ × 48¼ (91·7 × 122·5)

Coll. Elhanan Bicknell (?) who may have originally commissioned the picture but also seems to have returned it to the artist soon after the R.A. Exhibition was over (see below); H. A. J. Munro of Novar (?); Joseph Hogarth; sale Christie's 13 June 1851 (48) bought Gambart; John Miller of Liverpool; sale Christie's 22 May 1858 (247) bought Gambart; bought by Agnew from Miller in 1867 and sold to F. R. Leyland (it seems likely, therefore, that Miller bought back both this and *Van Tromp going about* (No. 410) from Gambart at some time between 1858 and 1867); Leyland sale Christie's 13 June 1874 (115) bought in; Thomas Woolner, R.A..; sale Christie's 12 June 1875 (132) bought in; Charles Cooper; sale Christie's 21 April 1883 (151) bought Vokins; Francis Seymour Haden sale Christie's 23 May 1891 (110) bought in; bought by the Metropolitan Museum in 1896 (Wolfe Fund: Accession no. 96:26).

Exh. R.A. 1845 (77); R.A. 1892 (19, still the property of F. Seymour Haden); Indianapolis 1955 (49); R.A. 1968–9 (164).

Lit. Ruskin 1843 (1903–12, iii, pp. 251, 252 n.); Burnet and Cunningham 1852, p. 119 no. 233 or 234; Thornbury 1877, pp. 467(?), 581; Bell 1901, p. 152 no. 250; Armstrong 1902, pp. 158, 236; *Catalogue of the Paintings in the Metropolitan Museum* 1911, p. 173 no. 341; *ibid.* 1931, p. 366; Boase 1959, p. 344 and n., pl. 34d; Finberg 1961, pp. 407, 409, 509 no. 564; Lindsay 1966, p. 192; Shapiro 1972, pp. 82 n. 4, 230 n. 3, 248; Herrmann 1975, pp. 53, 234.

Exhibited in 1845 with the caption *Vide Beale's Voyage* p. 175.

In the past, the titles of this picture and of the Tate Gallery's '*Hurrah! for the Whaler Erebus!*' (see No. 423) have been confused: for instance in nearly all the nineteenth-century sale catalogues where the picture was correctly called 'Whalers' or 'The Whale Ship' but had appended the subtitle 'Hurrah! for the Whaler Erebus! Another Fish!'

Turner's interest in whaling subjects was probably aroused by a combination of circumstances: first, his patron Elhanan Bicknell was a whaling entrepreneur; second, he obviously read with keen interest Thomas Beale's *The Natural History of the Sperm Whale*, reissued in 1839; and third he may have been to view a $14\frac{1}{2}$ ft whale which appeared off Deptford in October 1842 and which was displayed to the public after being dispatched by four watermen. As noted in the entry for No. 414 Beale's book was to provide Turner with subjects for four whaling pictures, of which this picture, now generally known as *The Whale Ship*, was the only one to be sold; the remaining three are now in the Tate Gallery.

There seems to be some evidence that this picture, at any rate, was originally painted for Bicknell. A letter from Turner to Bicknell invites the latter to visit him as he has 'a whale or two on the canvas'. The date of this letter is given by Armstrong as 31 (*sic*) June 1845 by which time the 1845 pair would have already been on exhibition at the R.A. so that it seems probable that the date should read 31 Jan. and thus refers to the pictures which Turner was peparing for the 1845 exhibition.

In September 1845 Ruskin senior wrote to his son John, then on his way back from Italy: 'Bicknell is quarrelling with Turner on two points—he gave him 120 Gs for loan of Temeraire to engrave and Turner besides demands 50 proofs. Bicknell resists and sends 8. Then he found Water Colour in Whalers and rubbed out some with Handky. He went to Turner who looked Daggers and refused to do anything, but at last he has taken it back to alter. Roberts admires the picture but all say it is not finished. They account for his hurry and disregard for future fame by putting Water Colours by his stronger passion, love of money.' John Ruskin replied on 23 October that he was 'vexed at all the row with Bicknell'.

The upshot of this row is not known and the history of the picture over the next six years remains obscure. The catalogue of the Metropolitan Museum states that the picture was owned by Munro of Novar (but no other authorities mention him in the provenance) and it is possible that, if Bicknell returned the picture to Turner, Munro, who doubtless would have known of the disagreement, may have then bought it, wishing to do Turner a good turn. This is pure conjecture, as not one of the six catalogues when it was sold at Christie's in 1851, 1858, 1874, 1875, 1883, and 1891 mentions either Bicknell or Munro as a previous owner. However, as Bicknell financed Hogarth's publication of the engraving of the *Temeraire* in 1845 (as Dr Shapiro has discovered), and as Bicknell's name is give as the buyer of the other two pictures in the 1851 Hogarth sale, *Saltash* (No. 121) and *Windmill and Lock* (No. 101), it would seem likely that Bicknell may well have had an interest in all three pictures which are amongst those described as destined to be 'engraved in the Royal Gallery of British Art'. It seems probable, therefore, that in fact Munro of Novar never owned *The Whale Ship*.

The question of Bicknell's association with the whaling pictures is further obfuscated by Burnet who states that '*Hurrah! for the Whaler Erebus!*' was painted for Bicknell but there seems to be no evidence whatsoever that he ever owned it.

The reference cited by Turner in the R.A. catalogue, '*Vide Beale's Voyage* p. 175', occurs in fact in the third story related by Beale in his *Natural History of the Sperm Whale* (see under No. 414), an incident that took place on 18 June 1832 off Japan (pp. 173–6). In the morning an immense sperm whale was sighted and chased by three boats. It was unusually temperamental and steered an erratic course until well into the afternoon. At 4.30 pm it was harpooned by Captain Swain who also managed to inflict two lance wounds. It dived but re-emerged, bleeding from its blow-hole, and struck one of the boats with its forehead, overturning it. The whale swam round the men in the water but did not attack them, and they were picked up by another boat (p. 175). The whale was attacked again with the lance and died, but sank, never to be seen again. John McCoubrey, in an unpublished lecture given at Johns Hopkins University, Baltimore on 18 April 1975, sees this as a typical example of Turner's commentary on the hopelessness of man's endeavour.

The general composition of *The Whale Ship* bears some similarity to the description of the moment when the whale re-emerges in Beale's narrative (p. 173).

Although none of Turner's watercolours of whaling subjects can be considered to be a study for any of the exhibited oils, there is what may well be a preliminary idea for the series, drawn by Turner after his reading of Beale, in the Fitzwilliam Museum, Cambridge (see Cormack 1975, no. 52 repr.). This watercolour, which Turner inscribed 'He breaks away', shows a whale ship approaching while a whale, its tail high out of the water, thrashes away from the ship's course.

At the R.A. the two whaling pictures attracted a good deal of notice from the critics. Although some of them were hostile or merely facetious, others showed signs of looking at Turner's work with sympathy and with more understanding of his methods than they had shown recently. Naturally enough, most papers considered both whaling pictures together and their comments are noted under the entry for No. 414.

Of this picture, *Punch* (January–June, p. 233) wrote 'No. 77 embodies one of those singular effects which are only met with in lobster salads and in this artist's pictures.' However, the *Literary Gazette* for 17 May described it as 'a vision and unreality but the handling of the tints, and their harmony, allowing for the exalted pitch of their prismatic brightness, are astonishing. Splintered rainbows thrown against the canvass is a better comparison than the deteriorating one of lobster-sauce, which some crusty critic has applied as an accompaniment to the Leviathan. There are atmospheric effects of magical talent; but after all, we would rather possess one of Mr. Turner's earlier works, when he did not think of subliming truth, than three of the most brilliant of these imaginations, created with all his mastery of art.'

Thackeray, in *Fraser's Magazine* for June 1845, wrote that after studying a picture of Turner's for a while it begins 'to mesmerise you ... That is not a smear of purple you see yonder, but a beautiful whale, whose tail has just slipped a half-dozen whale-boats into perdition; and as for what you fancied to be a few ziz-zag lines spattered on the canvas at hap-hazard, look, they turn out to be a ship with all her sails.'

416. Venice, Evening, going to the Ball Exh. 1845
(Plate 424)

THE TATE GALLERY, LONDON (543)

Canvas, $24\frac{1}{4} \times 36\frac{3}{8}$ (61·5 × 92·5)

Coll. Painted for William Wethered, junior, of King's Lynn who, however, must have returned it to Turner before the artist's death (see below); Turner Bequest 1856 (one of 18–21, 36–40; see No. 383); transferred to the Tate Gallery 1921.

Exh. R.A. 1845 (117); Newcastle 1924 (160); Dresden (22, repr.) and Berlin (32) 1972; Lisbon 1973 (22, repr.); Hamburg 1976 (104, repr.).

Lit. Ruskin 1843 (1903–12, iii, pp. 250–51); Bell 1901, pp. 152–3 no. 251; Armstrong 1902, p. 235; Finberg 1930, pp. 151, 158; Davies 1946, p. 186; Finberg 1961, pp. 407–8, 509 no. 565; Rothenstein and Butlin 1964, p. 66.

Exhibited in 1845 with the caption '*MS. Fallacies of Hope*'; see Nos. 355 for a possible explanation of the absence of any actual verses.

As the critic of the *Spectator* implied, 24 May, Turner's four Venetian scenes exhibited this year, two in the East Room and two in the Middle Room, cover the four 'effects of morning and evening, noon and sunset' (see Nos. 417, 418 and 419); however, 'there may have been times when these different periods assimilated in nature as closely as they do in these pictures; only such must be exceptional cases!' Earlier, on 10 May, the *Spectator* had written of the first two 'with their magical effects of light and colour: the watery floor and aërial sky meet at the horizon in a gorgeous mass of orange and golden tints ... the intervening space being filled with the glowing atmosphere.' Similarly, *The Times* for 6 May spoke of 'a play of brilliant colours, sparkling as they vanish above smooth waters.' Unfortunately, today one has to take most of these qualities on trust. The *Morning Chronicle* for 7 May returned to the way in which Turner's late pictures made sense at a distance. In this picture 'the rising moon ... with its long gleam of light coming across the waters, is really a curiosity worthy of study. Stuck on with the palette knife, or the thumb, who would think it would give the soft cool light it does? ... Regretting his apparently incurable mannerism, we cannot but admit that in the present instance he has somewhat cured it of its extravagance.'

Ruskin, in the later editions of *Modern Painters* i, writes 'Of the Exhibition of 1845, I have only seen a small Venice (still, I believe, in the artist's possession) and the two Whaling subjects. The Venice is a second-rate work . . .' He could be referring to this picture or to any one of Nos. 417, 418 and 419.

The early histories of the two pairs of *Going to* and *Returning from the Ball* exhibits of 1845 and 1846 are greatly entwined. For an attempt to disentangle them, see the entry for Nos. 421 and 422.

417. Morning, returning from the Ball, St. Martino Exh. 1845
(Plate 425)

THE TATE GALLERY, LONDON (544)

Canvas, $24\frac{1}{2} \times 36\frac{1}{2}$ (62 × 92·5)

Coll. Painted for Francis McCracken of Belfast but returned to the artist almost certainly by the autumn of 1846 at the latest (see below); Turner Bequest 1856 (one of 18–21, 36–40; see No. 383); transferred to the Tate Gallery 1912.

Exh. R.A. 1845 (162); Whitechapel 1953 (98); on loan to Yale University Art Museum, New Haven 1964–7; Dresden (23, repr.) and Berlin (33) 1972; Lisbon 1973 (23, repr.); Hamburg 1976 (105, repr. and colour pl. 24).

Lit. Thornbury 1862, ii, p. 195; 1877, p. 399; Bell 1901, p. 153 no. 252; Armstrong 1902, p. 235; Finberg 1930, pp. 151, 158; Davies 1946, p. 186; Finberg 1961, pp. 407–8, 509 no. 566; Rothenstein and Butlin 1964, p. 66.

Exhibited in 1845 with the caption '*MS. Fallacies of Hope*'. *Punch* (January–June 1845, p. 236) decided to make good the lack of any actual quotation from the *Fallacies of Hope* in this instance', as the picture 'really seems to need a little explanation'; as Turner 'is too modest to quote the *Fallacies of Hope*, we will quote it for him:

> 'Oh! what a scene!—Can this be Venice? No.
> And yet methinks it is—because I see
> Amid the lumps of yellow, red, and blue,
> Something which looks like a Venetian spire.
> That dash of orange in the background there
> Bespeaks 'tis Morning! And that little boat
> (Almost the colour of Tomata sauce,)
> Proclaims them now returning from the ball!
> This is my picture, I would fain convey,
> I hope I do. Alas! *what* FALLACY!'

Punch (*ibid.*, p. 233) also commented on the two pictures with two near-featureless drawings entitled 'Venice by Gaslight—Going to the Ball' and 'Venice by Daylight—Returning from the Ball', both subtitled '*MS. Fallacies of Hope* (*An unpublished Poem.*)'

See the entry for No. 416 for other press criticism of the 1845 pair, and the entry for Nos. 421 and 422 for the early histories of the four Venetian *Ball* subjects. 'St.

Martino' seems to have been an invention of Turner's; see Nos. 421–2.

418. Venice—Noon Exh. 1845 (Plate 426)

THE TATE GALLERY, LONDON (541)

Canvas, 24 × 36⅛ (61 × 91·5)

Coll. Turner Bequest 1856 (one of 18–21, 36–40; see No. 383); transferred to the Tate Gallery 1929.

Exh. R.A. 1845 (396); Cardiff 1951.

Lit. Thornbury 1862, i, 348–9; 1877, p. 467; Bell 1901, p. 153 no. 253; Armstrong 1902, p. 235; MacColl 1920, p. 24; Finberg 1930, pp. 151, 158; Davies 1946, p. 186; Finberg 1961, pp. 407, 509 no. 567; Rothenstein and Butlin 1964, p. 66.

Exhibited in 1845 with the caption '*MS. Fallacies of Hope*'. Thornbury adds the subtitle, 'from the Canal of St. Mark', also found in early National Gallery catalogues. MacColl identifies the view as seen 'from a point off the Public Gardens; in the distance to left the Church of San Giorgio, to right the Doge's palace'. For the possible interest of a 'Mr. P.' in this picture and No. 419 see the entry for Nos. 421–2.

The *Spectator* for 10 May 1845 spoke of the two Venetian scenes in the Middle Room, this picture and No. 419, as 'another pair of gorgeous visions of *Venice*, blazing with sunlight that floods sea and sky', which makes one regret the present state of this picture. The *Athenaeum* for 17 May, after claiming that most of Turner's exhibits in 1845 did not make sense even at a distance, went on, 'But the Venice, Noon (396), beheld from one particular point, is a beautiful dream, full of Italy, and poetry, and summer'.

The paint and, probably, the ground were transferred from the original canvas in 1926.

419. Venice—Sunset, a Fisher Exh. 1845
 (Plate 427)

THE TATE GALLERY, LONDON (542)

Canvas, 24⅛ × 36¼ (61 × 92)

Coll. Turner Bequest 1856 (one of 18–21; 36–40; see No. 383); transferred to the Tate Gallery 1954.

Exh. R.A. 1845 (422).

Lit. Thornbury 1862, i, p. 349; 1877, p. 467; Bell 1901, p. 153 no. 254; Armstrong 1902, p. 235; MacColl 1920, p. 24; Finberg 1930, pp. 151, 158; Davies 1946, pp. 152, 186; Finberg 1961, pp. 407, 509 no. 568; Rothenstein and Butlin 1964, p. 66.

Exhibited in 1845 with the caption '*MS. Fallacies of Hope*'. MacColl describes this as a 'View of the Giudecca and Grand Canals from a point near their junction; in the centre of the picture the domes of the

Salute are seen in the middle distance.' For contemporary criticism see No. 418.

Transferred from the original canvas in 1908.

420. Queen Mab's Cave Exh. 1846 (Plate 397)

THE TATE GALLERY, LONDON (548)

Canvas, 36¼ × 48¼ (92 × 122·5)

Coll. Turner Bequest 1856 (28, 'Queen Mab's Grotto' 4′0″ × 3′0″); transferred to the Tate Gallery 1954.

Exh. B.I. 1846 (57); Australian tour 1960 (15); Victoria and Albert Museum *Berlioz* 1969 (111, repr.); R.A. 1974–5 (B42).

Lit. Ruskin 1846 (1903–12, iv, p. 342); Thornbury 1862, i, p. 349; 1877, p. 467; Edward T. Cook, *A Popular Handbook to the National Gallery* 1888, pp. 659–60; Lionel Cust, 'The Portraits of J. M. W. Turner', *Magazine of Art* 1895, pp. 248–9; Bell 1901, p. 156 no. 261; Armstrong 1902, p. 227; Falk 1938, pp. 74, 150 n. 1; Davies 1946, pp. 152, 186; Finberg 1961, pp. 413, 509 no. 572; Gage 1969, pp. 146–7, 264–5 n. 152.

Exhibited at the British Institution in 1846 with the lines:

'Frisk it, frisk it, by the Moonlight beam'.
 Midsummer's Night's Dream.

'Thy Orgies, Mab, are manifold'.—MSS *Fallacies of Hope*

Davies suggests that the apparent reference to Shakespeare's *Midsummer Night's Dream* might have been intended to form part of a three-line quotation from the *Fallacies of Hope*, and that the form in which the lines appear in the catalogue is the result of Turner's, or the printer's, carelessness.

The picture was possibly painted in part in response to Francis Danby's *An Enchanted Island*, first exhibited and engraved in 1825 but G. H. Phillips' mezzotint of which was republished in 1841 (repr. Eric Adams, *Francis Danby: Varieties of Poetic Landscape* 1973, pl. 35). The earlier 1840s saw Danby's attempt to reestablish his reputation in London after nearly ten years' exile abroad. In its turn Danby's picture, painted after he settled in London in 1824, reflects Turner's feeling for light.

For the *Art Union*, March 1846, the picture 'admits of more than a usual employment of the vague, illusive, and fanciful; and full advantage is taken by the artist to play with the means he commands to produce a daylight dream in all the wantoness of gorgeous, bright, and positive colour, not painted but apparently flung upon the canvas in kaleidoscopic confusion.

Ruskin, in an Addendum to the first edition of *Modern Painters* ii, 1846, reviewing the British Institution exhibition of that year, also criticises the work: 'Among the various failures, I am sorry to have to

note the prominent one of Turner's; a strange example of the way in which the greatest men may at times lose themselves, from causes it is impossible to trace.' 'Nothing . . . could be more unfortunate than the central portion of the picture in the Institution, a heavy mass of hot colour being employed in the principal shade, and a strange meaningless green spread over the delicate hues of the distance, while the shadows on the right were executed with pure and crude blue, such as I believe cannot be shown in any other work whatsoever of the great painter.'

This picture is, perhaps surprisingly, one of the most frequently imitated of Turner's works, one such version being in the Cleveland Museum (ex. Earl of Arran Collection; repr. *Twentieth Anniversary Exhibition* Cleveland 1936, pl. 60). One reason could be the special facilities given, it seems, by the British Institution for the copy of selected works after the closure of their exhibitions; see No. 210.

Lionel Cust identified this picture as the one for which there is an eye-witness account of Turner's activity in finishing it on the British Institution's walls, but John Gage has identified this as *Regulus* (No. 294, *q.v.*).

421. Going to the Ball (San Martino) (Plate 402)
422. Returning from the Ball (St. Martha)
Exh. 1846 (Plate 403)

PRIVATE COLLECTION, U.S.A.

Canvas, each 24 × 36 (61 × 91·4)

Note: All references in sale and exhibition catalogues and in literature give *Going to the Ball* first.

Coll. The early histories of the two pairs of Venetian subjects *Going to* and *Returning from the Ball*, exhibited in 1845 (Nos. 416–7) and 1846, are extremely confused and are dealt with in detail below. After a number of vicissitudes the 1846 pair were bought by B. G. Windus and their subsequent history is as follows: Windus sale Christie's 20 June 1853 (1) bought Gambart and (2) bought Wallis; both pictures were bought by Joseph Gillott from Henry Wallis on 23 March 1854 (for £1,800 which Gillott paid for with £200 cash and two pictures by Callcott); Joseph Gillott sale Christie's 20 April 1872 (159) and (160) both bought by the Earl of Bective; sale Christie's 4 May 1878 (62) and (63) bought in; James Price by 1887; sale, Christie's 15 June 1895 (62) and (63) both bought Agnew; Sir Donald Currie; by descent to his grandson, Major F. D. Mirrielees for whom sold by Agnew in 1937 to Knoedler who sold them to the present owner.

Exh. R.A. 1846 (74 and 59); Manchester 1887 (620 and 614 lent by James Price); Guildhall 1897 (63 and 67); Copenhagen 1908 (42 and 43); Agnew 1922 (9 and 11); R.A. 1934 (673 and 677).

Lit. Burnet and Cunningham 1852, p. 120 nos. 240 and 239; Thornbury 1862, i, p. 349; 1877, pp. 467, 581; Bell 1901, pp. 154–5 nos. 256 and 255; Armstrong 1902, pp. 147, 235; Finberg 1930, pp. 151, 158; 1961, pp. 413, 509 nos. 573 and 574.

As noted above, the early history of these pictures and Nos. 416–7 is very obscure. Although a number of letters have survived from Turner, written to Francis McCracken of Belfast and William Wethered of King's Lynn who each owned one of the 1845 pair, these letters pose almost as many problems as they solve.

The correspondence begins in October 1844 when Wethered evidently asked Turner to paint him another *Approach to Venice* (see No. 412), although in his reply Turner thanks him for allowing him 'to make some change'. This is followed by a letter in November to McCracken, who had apparently enquired after a picture of the Rigi (presumably a watercolour) and a Venetian subject, to which Turner replies that he has 'commenced one of Venice.'

In May 1845 Turner wrote to McCracken, regretting that the latter would not be in London during the R.A. Exhibition and asking him how he wishes his picture to be sent, and whether he wants a frame or not. The letter continues:

'The subject is returning from the Ball—the dawn of Day when the moon withdraws her light and rosy morn begins—the Company Pause' (R.A. 162, *Morning returning from the Ball, St. Martino*, now in the Tate Gallery, see No. 417).

'Going to the Ball—sun setting and the moon rising—over Venice [is] painted for a gentleman of King's Lynn: the Campo Santo with Boats and masqueraders proceeding towards the City [R.A. 117, *Venice, Evening, going to the Ball* now in the Tate Gallery, see No. 416]—Yours returning to St. Martino, an island on the Adriatic.'

On 31 July 1845 Turner wrote to Wethered, 'I must beg to say that I do not understand by your last (In regard to the Pictures) . . .' This reference to pictures in the plural is significant but, later on in the letter, it appears as if Wethered was hesitating over his purchase(s), as Turner mentions returning to him 'the £160 paid' and continues 'I requested your Sheffield friend Mr. P. to let his choice of two Venice pictures [presumably *Venice—Noon*, R.A. 396, and *Venice— Sunset, a Fisher*, R.A. 422, Nos. 418–9] to stand over until you had decided.' Presumably, Wethered was contemplating buying a second Venetian picture as well as *Going to the Ball*, but he appears not to have done so, nor does Mr. P. of Sheffield as both the other pictures are now in the Turner Bequest. However, as Turner mentions that 'the frame and packing case [will be] ready by tomorrow or Saturday', there seems no reason to doubt that *Going to the Ball* was sent to Wethered after the close of the exhibition.

Until recently it has been believed that the 1846 pair was also painted for McCracken and Wethered, as will appear from Turner's letters to them quoted below.

However, just as this catalogue was going to press, John Gage obtained the text of a letter from Turner to Sheepshanks, written on 4 May 1846. Gage has very kindly sent me a note of the relevant passage which asks 'Which of the two Pictures (you will find at the Royal Academy on the North side of the East Room) you like the best to consider as yours.'

The only other picture in the East Room that year was *Hurrah! for the Whaler Erebus* (No. 423) which was No. 237 at the R.A. and therefore cannot have hung on the same wall as the two Venetian pictures which were nos. 59 and 74.

John Gage also informs me that it appears from this letter that Sheepshanks had already paid 250 gns for a picture, without having first seen it. As Turner's letter (quoted above) to Wethered of 31 July 1845 states 'I meant to have 300 gns for all the Venice Pictures returned from the Ex', it appears that Turner had raised his prices since 1843 (see No. 403) when he quoted 250 gns for Venetian subjects or 200 gns if painted on commission.

Therefore, a price of 250 guineas in 1846 suggests that Turner was prepared to sell to an old customer like Sheepshanks at favourable terms, as a commission seems to be ruled out in this case by Turner offering Sheepshanks his choice of either picture, thereby clearly implying that both were still available in early May.

Why Sheepshanks chose neither is a mystery, unless he found that he did not like the changes in Turner's style which had taken place since 1840, when Turner had painted No. 384 for him. Whatever the reason, Turner went back to his clients for the 1845 pair, writing to both McCracken and Wethered on 14 June 1846 but, just to add to the confusion put the letters in the wrong envelopes! The letter to McCracken asks him if he is to 'get a frame ready by the end of the Exhibition, like last year but it appears unseasonable at the present time' (the meaning of 'unseasonable' here seems unclear but may possibly imply that McCracken had expressed doubts or dissatisfaction about a picture he had bought or that Turner had painted for him). The letter to Wethered says 'the subject of your picture being (St. Martino) returning from the Ball—and not (St. Martha) going to the Ball which is for Mr. F. McCracken of Belfast.' Here Turner further obscures the problem by muddling the titles as well as the letters, but the reference to St. Martha as well as the date of the letter, makes it clear that Turner is referring to the 1846 pair. The question is, therefore, whether Turner confused the churches or 'Going to' and 'Returning from'. There are at least two possible explanations and these conflict:—

1. If the 1845 pair had both been deemed unsatisfactory by McCracken and Wethered quite soon after being painted, and had already been returned to the artist by the time of the 1846 exhibition, then it would seem that the 1846 pair must be considered as a second attempt on Turner's part to treat the same—or almost the same—subjects. In this case it would seem logical that Wethered should still wish to have *Going to* so that R.A. 74 must be considered his, while *Returning from* R.A. 59 was McCracken's.

2. However, if McCracken and Wethered still had their 1845 pictures, and if Turner had finally failed to sell either of the 1846 pair to Sheepshanks, Turner may have thought the best solution to a sticky situation was that McCracken and Wethered should each add a companion to the pictures they already had. In this case R.A. 74 must have been intended for McCracken and 59 for Wethered.

On the available evidence it seems impossible to guess which solution is the more probable (or the less improbable), but perhaps it would seem more logical that both pictures with 'St. Martino' titles should go to the same patron (McCracken), especially as no such island exists in the area, and the name must therefore have been invented by Turner.

The problem is not made easier by the present appearance of the Tate pair, in which it is hard to recognize 'the sun setting and the moon rising' or the other aids to identification mentioned in Turner's letter to McCracken of May 1845. In either case it is difficult to understand why two pairs of pictures, obviously conceived as such, should have been divided in this way between two patrons—and not only once but twice. Such a bizarre arrangement was perhaps doomed to failure from the first, and accounts for all four pictures being returned to the artist.

The last minute incursion of Sheepshanks into the arena has only made a confused situation still more obscure. Further letters, which might disentangle the imbroglio, must surely be missing, and both text and context of the extant letters are often equally difficult to comprehend.

That the last word on the subject has not yet been written is emphasised by the 1845 pair, now in the Tate Gallery, having had 'Exhibited 1846' painted on their frames, presumably in about 1856 when they passed to the National Gallery. This suggests a possible confusion of identity and opens up further avenues for speculation almost too tortuous to contemplate.

Whether McCracken ever took delivery of his 1846 picture is not known but it seems likely that Wethered received his, for on the 29 August Turner wrote to him to tell him that a picture had been sent 'to King's Lynn by the Eastern Counties Railway'. However, on 23 October Turner wrote again to Wethered:

'On my return yesterday evening I found your letter wishing me to paint you a Landscape—(English scenery) size 3 feet by 4 feet—

The Subject must be fixed (for I have fail'd twice in my choice in the Venice commission) therefore I tremble about it and the price will be five hundred Guineas . . .'

This implies quite clearly that Wethered had rejected both his Venetian subjects (Turner's high fee quoted for a 3 ft by 4 ft landscape may reflect his exasperation over this), and presumably both were returned to the

artist. Turner's use of the word 'commission' in this
context seems impossible to reconcile with his earlier
letter to Sheepshanks already quoted.

McCracken must also have rejected his 1846 picture,
and the reunited 1846 pair were then bought by
Windus, as already noted, although Finberg is surely
wrong (nothing is quite certain, however, in this saga)
in stating that Windus bought them at the time of the
R.A. exhibition, although he may well have admired
them then.

As noticed in the entries for Nos. 416 and 417, the
earlier pair had been much ridiculed in *Punch*. In 1846
the critics tended to concentrate on the *Whaler*
pictures or *The Angel standing in the Sun* (No. 425) and
Undine (No. 424). *The Times*, 6 May, did not 'expect
that any but the ultra-Turnerites will admire the *Return
from the Ball* . . .' The *Spectator* for 9 May was more
complimentary: 'One of a pair of Venetian scenes,
where an expanse of sky and water is flooded with
golden atmosphere, called *Going to the Ball*, is in a blaze
of sunshine that dazzles the sight; the pendent picture,
Returning from the Ball, serving as a foil to the beaming
brilliancy of its companion.' The *Art Union* for June
1846 wrote of no. 59 'There is here less of the utter
absence of definition, which has of late years distin-
guished these works; the forms are more distinct, and it
is probable that an engraving of the work would be
more really agreeable than the picture itself . . .' and of
no. 73 (a mistake for 74) 'it is really much to be lamented
that an artist possessing the powers of Mr. Turner
should not exert them upon some subject worthy of
them.'

Although St Martino turns out to have been a
fictitious island, there was a Festa of Santa Marta
concerned with sole-fishing, a subject which would
surely have appealed to Turner. This involved bril-
liantly lit boats decorated with coloured balloons, and a
banquet on the Piazza S. Marta on the Giudecca which
lasted until dawn, so that Turner may well have had this
in mind when painting this *Returning from the Ball*
picture. I am grateful to John Gage for drawing my
attention to this Festa which is described in full by G.
Renier-Michiel, *Origine delle Feste Veneziane* 1829, ii,
pp. 219 ff.

423. 'Hurrah! for the Whaler Erebus! Another Fish!' Exh 1846 (Plate 400)

THE TATE GALLERY, LONDON (546)

Canvas, $35\frac{1}{2} \times 47\frac{1}{2}$ (90 × 121)

Coll. Turner Bequest 1856 (one of 76–8; see No. 414);
transferred to the Tate Gallery 1929.

Exh. R.A. 1846 (237); Amsterdam, Berne, Paris (repr.),
Brussels, Liege (41), Venice (repr.) and Rome (repr.)
(50) 1947–8; Whitechapel 1953 (99); Paris 1965 (36,
repr.); Edinburgh 1968 (15).

Lit. Thornbury 1862, i, p. 349; 1877, p. 467; Bell 1901,

p. 155 no. 257; Armstrong 1902, p. 237; Falk 1938,
p. 185; Davies 1946, p. 187; Finberg 1961, p. 413,
510 no. 575; Rothenstein and Butlin 1964, p. 72,
pl. 125.

Exhibited in 1846 with the reference '—*Beale's
Voyage*'. Despite this reference the picture is much less
closely tied to the text than are the two whaling pictures
of the previous year, Nos. 414 and 415. As John
McCoubrey pointed out in his lecture on 'Turner's
Whaling Pictures' given at Johns Hopkins University,
Baltimore, on 18 April 1975, there is no record of a
whaler called the *Erebus*. In fact Turner seems to have
been cashing in on the interest in the voyage of the
Erebus and the *Terror* in search of the North-West
passage. The ships set out in 1845, were still away in
1846, and were finally abandoned as lost in 1847.
However, it is possible that the title of this picture also
echoes two passages in Thomas Beale's *Natural History
of the Sperm Whale*. The first, in the chapter on the
'Chase and Capture of the Sperm Whale', comes in the
fourth episode when nine boats from three different
whalers pursue a whale; on p. 179 there is a description
of shouted exchanges between the men in the boats,
invoking the names of their parent ships much like the
title of this picture. The second, in the appended *Sketch
of a South-Sea Whaling Voyage*, and thus, unlike the
1845 references, actually justifying the reference to
'*Beale's Voyage*', is the account of the cheers that
greeted the securing of the last whale of the voyage of
the *Sarah and Elizabeth* under Captain Swain.

Of the drawings in the 'Whalers' sketchbook one is
close in composition to this picture (CCCLIII-14).

Of the two whaling pictures exhibited in 1846, this
example mysteriously received by far the greatest
abuse. The *Art Union* for June 1846 used it as a peg on
which to hang a comparison with Turner's works of
twenty years earlier, summed up in the phrase, of his
recent works, that 'they only share the *prestige* of earlier
productions'. Of this picture the reviewer goes on, 'but
for the oracular catalogue, it is impossible to divine the
subject of the picture: there is no form for the eye to
dwell upon, save the topsails and ropes of the ship.'
Hours of examination of the picture had passed without
the critic 'finding that severity of purpose which should
characterize it'. The *Almanack of the Month* showed a
cartoon of 'Turner painting one of his pictures' with a
large mop dipped in a bucket labelled 'YELLOW' and
wrote 'The subject is, "Hurrah for the whaler *Erebus*—
another fish", but it should be called "Hallo there!—the
oil and vinegar,—another lobster salad."' The review
continued: 'Considerable discussion has arisen as to the
mode in which Turner goes to work to paint his
pictures. Some think he mixes a few colours on his
canvas, instead of on his palette, and sends the results to
be exhibited. Another ingenious theory is that he puts a
piece of canvas in a sort of pillory, and pelts it with eggs
and other missiles, when, appending to the mess some
outrageous title, he has it hung in a good position in the
Academy. Our own idea is, that he chooses four or five

good places, in which he hangs up some regularly framed squares of blank canvas. A day or so before the opening of the Exhibition, we believe he goes down to the Academy with a quantity of colours, and a nine-pound brush, with which he dabs away for a few minutes, and his work is finished.'

On the other hand *The Times* for 6 May wrote, 'But surely the "Hurrah for the Whaler" (237) should check all those who regard the pictures of this great colourist as mere themes for mirth. It is a sea-piece, the ships in the foreground being the usual indistinct combinations of red and yellow. The spectator looks full against the sun, and the treatment of this blaze of light, with the delicate etherial indications of the clouds in the "cirrus" region, is most magnificent.' Similarly the *Spectator* for 9 May wrote, 'Turner has also another couple of *Whalers*, wonderful compositions of light and colour.' The *Literary Gazette* of the same date found, of all Turner's exhibits of this year, that 'So entirely is the eye carried away by a sort of indistinct and harmonious magic, that we seem to consent to the abandonment of solid truth and real nature altogether, and allow dark ships to be chrome yellow, whales glittering pink, human beings sun or moon beams, and little thick dabs of paint ethereal clouds.'

424. Undine giving the Ring to Massaniello, Fisherman of Naples Exh. 1846 (Plate 404)

THE TATE GALLERY, LONDON (549)

Canvas, $31\frac{1}{8} \times 31\frac{1}{8}$ (79 × 79)

Coll. Turner Bequest 1856 (44, 'Masaniello' $2'6\frac{5}{8}'' \times 2'6\frac{5}{8}''$); transferred to the Tate Gallery 1905.

Exh. R.A. 1846 (384); Edinburgh 1968 (16).

Lit. Ruskin 1857 (1903–12, xiii, p. 167); Thornbury 1862, i, p. 349; ii, p. 196; 1877, pp. 399, 467; Bell 1901, p. 155 no. 258; Armstrong 1902, p. 234; MacColl 1920, p. 25; Davies 1946, p. 186; Clare 1951, p. 117; Finberg 1961, p. 413, 510 no. 576; Rothenstein and Butlin 1964, p. 72; Gage 1969, pp. 194, 259–60 n. 83; Reynolds 1969, pp. 198–200, pl. 173.

Almost certainly painted as the companion to *The Angel standing in the Sun* (No. 425, *q.v.*); the colours are complementary. *Undine* had no accompanying text in the R.A. catalogue, unless, as has been suggested, the second of the two texts given for the other work, that from Samuel Rogers' *Voyage of Columbus*, should in fact have applied to this one. The sources of the subject were probably two stage productions that Turner could have seen in London, a ballet version of Auber's opera *Masaniello*, which ran from 1829 to 1835, and Jules Perrot's ballet *Ondine*, which ran from 1843 to 1848. In the latter Ondine entices the revolutionary fisherman Matteo into the sea.

While some of the critics coupled the two pictures together (see under No. 425) others did not. The *Art Union* for June 1846 supports the identification of the sources of the subjects suggested above: 'On seeing the picture and the first word of the title we thought that this gentleman had worthily betaken himself to the charming romance of De la Motte Fouque; but Hulbrand's "wife and water" has nothing to do with Massaniello [*sic*]. We must, therefore, be content to refer the picture to some ignoble ballet'. The review concludes, 'In the picture of Undine we see a composition intended by its author only for a momentary sight'; whoever thinks it is 'to be dwelt upon falls into that vulgar error which leads to general condemnation' of Turner's works. The *Almanack of the Month*, in a review accompanied by a sketch apparently done from memory, put it rather differently: '"Undine" ... is a very fair specimen of this slap-dash school [already caricatured *apropos* "Hurrah! for the Whaler Erebus*", see No. 423], which we admire for its extreme boldness. The audacity of the thing is truly wonderful. We know the Doge of Venice used to marry the Adriatic, and throw a ring into it, but we were not aware that one of these rings had been picked up by Undine, and given to Masaniello.' *The Times* for 6 May did 'not expect that any but the ultra-Turnerites will admire' this picture, which it described as 'remarkable for that favourite white light of Turner's ... in vivid contrast to the dark blue sky, with its mass of red flame (probably Vesuvius).'

Turner seems to have been much more undecided on the final shape he wanted for this picture and No. 425 than he had been in similar cases in earlier years (see Nos. 382, 394–5, 399–400 and 404–5). The top-left corner of *Undine* seems to have been finished off with an octagonal format in mind but at the last minute he added a fish in the bottom right-hand corner, necessitating a square frame. Similarly at the last moment he added a flask in the bottom right-hand corner of No. 425, though the composition as a whole seems to have been envisaged as a circular one.

425. The Angel standing in the Sun Exh. 1846
(Plate 405)

THE TATE GALLERY, LONDON (550)

Canvas, 31 × 31 (78·5 × 78·5)

Coll. Turner Bequest 1856 (45, 'The Angel of the Sun' $2'6\frac{5}{8}'' \times 2'6\frac{5}{8}''$); transferred to the Tate Gallery 1905.

Exh. R.A. 1846 (411); New York 1966 (37, repr. p. 54); Edinburgh 1968 (17); R.A. 1974–5 (526, repr.).

Lit. Ruskin 1857 (1903–12, xiii, p. 167); Thornbury 1862, i, p. 349; 1877, p. 467; Bell 1901, pp. 155–6 no. 259; Armstrong 1902, p. 217; MacColl 1920, p. 25; Davies 1946, p. 186; Clare 1951, p. 117, repr.; Finberg 1961, pp. 413, 510 no. 577; Rothenstein and Butlin 1964, p. 72, pl. 128; Gowing 1966, p. 53, repr. p. 54; Lindsay 1966, pp. 180, 213; Gage 1969,

pp. 145–6, 187, pl. 70; Reynolds 1969, pp. 158, 200–03, pl. 172; Holcomb 1970, pp. 27–8, pl. 15; Herrmann 1975, pp. 54, 235, pl. 181.

Accompanied in the R.A. catalogue by the following passage from the *Book of Revelation*:

'And I saw an angel standing in the sun; and he cried with a loud voice, saying to all the fowls that fly in the midst of heaven, Come and gather yourselves together unto the supper of the great God;

That ye may eat the flesh of kings, and the flesh of captains and the flesh of mighty men, and the flesh of horses, and of them that sit on them, both free and bond, both small and great.'—*Revelation*, xix., 17, 18.

and also a quotation from Samuel Rogers' *Voyage of Columbus*:

'The morning march that flashes to the sun; The feast of vultures when the day is done'—*Rogers*.

In the foreground Adam and Eve lament over the dead body of Abel and Judith stands over the decapitated body of Holofernes, perhaps one of the captains mentioned in the quotation from *Revelation*.

The chained serpent derives from *Revelation* xx, 1–2. Gage suggests that Turner has conflated the Angel of the Apocalypse with the Cherubim with flaming sword at the Gate of Paradise, enforcing the Expulsion of Adam and Eve. The passage from Samuel Rogers' fragmentary *Voyage of Columbus* from which Turner took his second quotation bears the subtitle 'The Flight of an Angel of Darkness', a conception, as Gage points out, in accord with Turner's growing pessimism. Turner's choice of subject may have been partly suggested by Ruskin's reference to him as 'the great angel of the Apocalypse' in *Modern Painters* i 1843 (1903–12, iii, p. 254; the reference was omitted from the third edn of 1846 onwards). There is also a possibility that Turner, in declining health, saw the picture as a summing up of his career. Already, the previous year, there had been a suggestion that he might give up exhibiting (see No. 414).

This picture and *Undine* (No. 424) provoked the usual lament from the *Athenaeum* for 9 May 1846: 'That there is art in them, consummate art, in reconciling to the eye such effusions of all the strongest and most opposing colours of the palette, we freely admit: but we as freely declare our regret, that over such aberrations of talent no controlling influence exerts its genial restraint.' The *Spectator* for the same date had more, though qualified, praise, calling them 'tours de force that show how nearly the gross materials of the palette can be made to emulate the source of light—of the figures we can only say that Turner seems to have taken leave of form altogether.' For *The Times* of 6 May 'The "Angel standing in the Sun" is a truly gorgeous creation . . . It is all very well to treat Turner's pictures as jests; but things like these are too magnificent for jokes; and the readers of the *Oxford*

Graduate know that many of these obscurities are not altogether unaccountable'—the reference is to the first volume of Ruskin's *Modern Painters*, published anonymously in 1843. Ruskin, however, writing some twelve years later, passed over the two pictures as 'painted in the period of decline', with 'the *distinctive* characters in the execution, indicative of mental disease; though in reality these characters are so trenchant that the time of fatal change may be brought within a limit of three or four months, towards the close of the year 1845.'

426. Whalers (boiling Blubber) entangled in Flaw Ice, endeavouring to extricate themselves
Exh. 1846 (Plate 401)

THE TATE GALLERY, LONDON (547)

Canvas, $35\frac{3}{8} \times 47\frac{1}{4}$ (90 × 120)

Coll. Turner Bequest 1856 (one of 76–78; see No. 414); transferred to the Tate Gallery 1929.

Exh. R.A. 1946 (494); Newcastle 1924 (161); New York 1966 (38, repr. p. 60); Edinburgh 1968 (13); *Victorian Paintings 1837–1890* Mappin Art Gallery, Sheffield, September–November 1968 (1); Prague, Bratislava (149, repr.) and Vienna (57, repr.) 1969; *Discovery of Harmony* Expo Museum of Fine Arts, Osaka, March–October 1970 (IV-228, repr.); Paris 1972 (276, repr.); Dresden (24, repr. in colour on cover) and Berlin (35) 1972; Lisbon 1973 (24, repr.); R.A. 1974–5 (524, repr.); Leningrad and Moscow 1975–6 (65, repr.).

Lit. Thornbury 1862, i, p. 349; 1877, p. 467; Bell 1901, p. 156 no. 260; Armstrong 1902, p. 236; Falk 1938, p. 185; Davies 1946, p. 187; Finberg 1961, pp. 413, 510 no. 578.

As John McCoubrey has pointed out (in a lecture at Johns Hopkins University, Baltimore on 18 April 1975) Greenland whalers did not boil blubber on board ship, unlike the sperm whalers of the South Seas described by Thomas Beale in his chapter XIV on 'Of the "Cutting in" and "Trying out"' (*Natural History of the Sperm Whale* 1839, p. 187; for Beale as a source of Turner's whaling pictures see Nos. 414, 415 and 423). McCoubrey suggests that Turner's interest in the contrast between cold ice and the dramatic glow created by boiling blubber was inspired in part by the description of 'trying-out' in F. D. Bennett's *Narrative of a Whaling Voyage round the Globe . . . with an Account of Southern Wales, the Sperm Whale Fishery* 1840, pp. 211–12. The same book also contains a comparison between the sperm whale and the Arctic or Greenland whale (pp. 213–22). Turner's interest in the Arctic, which was also reflected in his reference to the 'Erebus' in the title to No. 423, may have been spurred by F. W. Beechey's *A Voyage of Discovery towards the North Pole . . . to which is added, a Summary of all the Early Attempts to Reach the Pacific by Way of the Pole* 1843.

This contains several descriptions of ships forcing their way through flaw and 'brush' ice and being trapped. John Gage (exh. cat., Paris 1972) has suggested a further possible source in the Rev. Thomas Gisborne's *Walks in a Forest* 1799, which includes a description of Monk's expedition of 1619 lighting fires on the ice to unfreeze barrels of gin. Indeed it is possible, as Judy Egerton has pointed out, that Turner's apparent inaccuracy in showing Greenland whalers boiling blubber was done deliberately, to show them using this means to thaw out the ice.

Of the sketches in the 'Whalers' sketchbook two seem to show the dramatic effect of boiling blubber, while a third shows the same general composition as the picture together with the detail of the anchor buried in the ice in the foreground (CCCLIII-6, 7 and 8).

After its abuse of '*Hurrah! for the Whaler Erebus*' (see No. 423) the *Art Union* for June 1846 was relatively kind to this picture. 'There is a charming association of colour here—the emerald green tells with exceeding freshness; but it would be impossible to define anything in the composition save the rigging of the ship'. The *Athenaeum* for 9 May, after mentioning Turner's usual 'congeries of yellows, reds, and blues, ticketed with strange titles having no apparent connexion with the heaps of colour before us', continued of this work that it presented 'something ... more tangible ... one *can* make forms out of those masses of beautiful, though almost chaotic colours. The sea-green hue of the ice, the flicker of the sunbeam on the waves, the boiling of the blubber, and the tall forms of the ice-bound vessels, make up an interesting picture.'

427. The Hero of a Hundred Fights *c.* 1800–10; reworked and exh. 1847 (Plate 406)

THE TATE GALLERY, LONDON (551)

Canvas, $35\frac{3}{4} \times 47\frac{3}{4}$ (91 × 121)

Coll. Turner Bequest 1856 (83, 'Tapping the Furnace' $4'0'' \times 3'0''$); transferred to the Tate Gallery 1929.

Exh. R.A. 1847 (180); Newcastle 1912 (53); *Art and the Industrial Revolution* Manchester City Art Gallery, May–July 1968 (65, repr.); R.A. 1974–5 (527 repr.); on loan to the Wellington Museum from 1975.

Lit. Ruskin, letter to Clarkson Stanfield 1847, and 1857 (1903–12, iv, p. 338 n. 1; xiii, p. 167); Thornbury 1862, i, p. 349; 1877, p. 467; Bell 1901, p. 157 no. 262; Armstrong 1902, p. 223; MacColl 1920, p. 25; Davies 1946, p. 187; Finberg 1961, pp. 416–17, 510 no. 580; Rothenstein and Butlin 1964, p. 72; Reynolds 1969, p. 204, pl. 175; Gage 1972, p. 36, pl. 18.

Exhibited in 1847 with the explanation:

'An idea suggested by the German invocation upon casting the bell: in England called tapping the furnace.—*MS Fallacies of Hope*.'

The attribution to the *Fallacies of Hope* suggests that some verses may have been omitted. The scene is the casting of M. C. Wyatt's bronze equestrian statue of the Duke of Wellington which had occurred in September 1845, but this was superimposed by Turner on a much earlier picture of an interior with large pieces of machinery, akin to, though not identical with, the drawing of the interior of a belfry in the 'Swans' sketchbook of *c.* 1789 (XLII-60 and 61). The original painting must have been done *c.* 1800–10. When Turner came to rework it he left much of the original untouched, adding the great burst of light on the left and highlighting the still-life in the foreground.

One suspects that most of the work on *The Hero of a Hundred Fights* was done on the Varnishing Days. That Turner was there is known from his having touched in a portion of the rainbow of Maclise's *Sacrifice of Noah* which hung next to it, causing Ruskin to complain in a letter to Clarkson Stanfield, commiserating with him over the poor position of one of his exhibits, that 'They have served Turner worse, however; there is nothing in his picture but even colour, and they must needs put Maclise's rainbow side by side with it—which takes part—and a very awkward and conclusive part too in its best melody.' The *Literary Gazette* for 8 May 1847 thought the opposite however, saying that the Turner was 'painted up to such a blaze as to extinguish Noah's rainbow. It is a marvellous piece of colouring. If Turner had been Phaeton, he must have succeeded in driving the chariot of the sun.' The critic of *The Times*, 1 May, after saying that it 'strikes the eye at first as a simple burst of inexplicable brightness,' claimed to have guessed the subject before referring to the catalogue.

Other reviews were less favourable. 'Fantastical absurdity' and 'dazzling obscurity' wrote the *Spectator* on 8 May, adding, on 19 June, that 'As a "vision", it is a burlesque on poetic licence.' 'Full of fine passages of chromatic arrangement,' said the *Athenaeum* for 8 May, 'it has so little foundation in fact that the sense is merely bewildered at the unsparing hand with which the painter has spread forth the glories of his palette'. The *Art Union* for June suggested that 'it pleases most when seen at various distances.' For the *Morning Chronicle*, 10 May, it was a 'pictorial rhapsody. Let the reader suppose a capricious syringe filled with unmixed masses of red, white, yellow and green, and the contents discharged upon the canvass.' Cruellest of all was the *Illustrated London News* for 8 May: 'This kind of painting is not the madness of genius—it is the folly and imbecility of old age.' Amazingly, no one seems to have noticed the stylistic dichotomy between the original painting and the superimposed glow that so dazzled them.

428. The Wreck Buoy *c.* 1807: reworked and exh. 1849 (Plate 407)

THE WALKER ART GALLERY, LIVERPOOL

Canvas, $36\frac{1}{2} \times 48\frac{1}{2}$ (92·7 × 123·2)

Coll. H. A. J. Munro of Novar; the date that he acquired it is not known but it was brought down from Scotland by Munro in order that Turner might send it to the R.A. in 1849; Munro sale Christie's 11 May 1867 (177) bought Agnew for John Graham; sale Christie's 30 April 1887 (91) bought Agnew; sold to George Holt of Liverpool in 1888; bequeathed by his daughter, Miss Emma Holt, to Liverpool on her death in December 1944.

Exh. R.A. 1849 (81); Glasgow 1878 (105); Birmingham 1899 (12); Guildhall 1899 (37); Glasgow 1901 (88); Brussels 1929 (182); R.A. 1934 (656); R.A. 1962 (185); Arts Council 1964 (111); Agnew 1967 (35).

Lit. Burnet and Cunningham 1852, p. 121 no. 246; Ruskin 1856 (1903–12, xiii, pp. 41, 43); Thornbury 1862, i, p. 232; ii, p. 400; 1877, pp. 105, 581, 597; Frost 1865, p. 95 no. 109; Wedmore 1900, ii, repr. facing p. 218; Bell 1901, p. 157 no. 263; Armstrong 1902, pp. 158, 168, 232, repr. facing p. 176; B. Webber, *James Orrock R.I.* 1903, i, p. 41; W. L. Wyllie, *J. M. W. Turner* 1905, p. 137; Boase 1959, p. 344; Finberg 1961, pp. 425, 510 no. 582; Rothenstein and Butlin 1964, pp. 72–3, pl. 126; Lindsay 1966, p. 248; Gage 1969, pp. 41, 187, 232–3; Reynolds 1969, p. 204; Bennett and Morris 1971, pp. 75–7, pl. 10; Herrmann 1975, pp. 55, 235, pl. 183.

Although the date of Munro's purchase is not known, it may quite possibly have been before his first recorded acquisition of a Turner oil: the *Venus and Adonis* bought in 1830. In Munro's account of the purchase of *Venus and Adonis* (see entry for No. 150) he states that 'Turner then knew I had bought any thing of his which had come to the hammer'. In fact very few Turner oils had been auctioned before 1830 apart from those in the de Tabley sale in 1827, at which Munro was not a buyer, but this does suggest that Munro owned a painting or paintings by Turner by 1830. In the Munro catalogue it says that it was 'Turner's own desire that this picture should belong to the Munro Collection' but it is unclear what exactly this means.

When Turner saw the picture again in 1849 he was dissatisfied with it and repainted it to a considerable extent. Thornbury records that Munro sat by Turner's side watching with horror as the artist spent six laborious days transforming the picture which, however, 'came out gloriously'.

Finberg suggests that the picture originally dated from about the same time as the *Pilot hailing a Whitstable Hoy* (No. 85) of 1809 but without giving any evidence for this. Wyllie believed that before the alterations, the picture showed a view of the mouth of the Thames, painted from Reculver. The *Athenaeum*, 14 April 1849, reported 'But of an early picture by him in the possession of Mr. Munro, which has been brought from Scotland for exhibition, we hear great things' (this could, however, refer to *Venus and Adonis*). The 1971 Liverpool catalogue suggests that another

possible reason why Turner repainted it was that the picture had already been exhibited and it was against the Academy rules to send it in again. No early seascape by Turner shown at the R.A. springs to mind as a candidate but a more likely source lies in the pictures Turner exhibited in his own gallery, particularly in 1807, a year in which we know from Farington's *Diary* that Turner showed a number of views on the Thames but know no details beyond this. The only picture which we can say with some confidence was shown this year is the *Junction of the Thames and Medway* now in Washington D.C. (No. 62) and it seems very possible that the 'original' *Wreck Buoy* was exhibited at about the same time.

Gage suggests that Turner may have used this opportunity to illustrate an idea that had been in his mind for some years as a page in the 'Dieppe and Kent' sketchbook (CCCLXI p. 108 verso) shows a drawing of ships at sea inscribed 'Bright light (?) on the wreck Buoy'. This sketchbook has two pages on which drawings are dated 11 September 45 but as the drawing in question is on the end page of the book it may possibly be a little later. Gage also sees this as essentially a pessimistic work, as were the two 'Deluge' pictures of 1843 (Nos. 404 and 405) and the last four 'Carthage' pictures, exhibited in 1850 (Nos. 429–32), showing that Turner had lost belief in the possibility of redemption. Gage associates the rainbows with the bubbles forming the rainbow in *Light and Colour* (No. 405) which are the emblems of fallacious hope, not of the covenant between God and Man.

James Orrock noticed that Turner had not inverted the colour sequence in the second reflected arc of the double rainbow, although it is now quite difficult to discern this, which confirms Gage's opinion that the picture has darkened considerably, despite being cleaned in 1967.

The extent of the repainting which the picture underwent in 1849 is not easy to determine. Thornbury was the first to record it (although the critic of the *Illustrated London News* evidently knew something of the truth—see below; Ruskin, on the other hand, does not mention it) and suggests that it was confined mainly to the sky and this is borne out by technical examination. Nevertheless, as the Sudley Hall catalogue points out, 'both the buoys are of a type not much in use before about 1850; green buoys had been used at least since the seventeenth century to mark the position of wrecks but even until 1854 they were shaped like a double cone, not spherical as depicted here.' Ruskin considered that it was 'the last oil picture that he painted, before his noble hand forgot its cunning.'

The picture received mixed notices at the R.A. despite the high hopes already noted in the *Athenaeum*. Indeed, this same journal, when confronted by the picture itself, called it merely 'one of the artist's recent unintelligible experiments upon colour' (12 May). *The Times* for 5 May wrote 'Viewed close, the whole appears a mass of confusion, but at a distance it resolves into a combination of warm and cold colours, in which the red

and green buoys appear as two *foci*.' The *Literary Gazette* for 12 May thought it 'A wonderful specimen of his power in colours. Rainbows, beacon-lights of fiery intensity, and the harmonizing of tints that seem more to belong to fire-works than oil-painting, are carried to an extent for which the eye hardly dares to vouch.' The *Spectator*, again for 12 May, called it 'one of Turner's sportings with the patience of the Hanging committee and the public' and was again critical at greater length in a later issue (23 June) describing the rainbow's arc as 'shaped no better than the vault of an ill-built wine cellar'. The *Illustrated London News*, 26 May, described it as 'Evidently a picture painted twenty years ago, left lumbering about, and then cleaned up, or intended to be so, by the insertion of two or three new bright rainbows'. The *Art Union* for June 1849 thought it 'certainly the best of his late productions' but criticised Turner for following Scott's example in selecting titles 'which shall, merely as titles, convey nothing to the "courteous" reader of the book or of the picture'.

429. Mercury sent to admonish Æneas Exh. 1850
(Plate 416)

THE TATE GALLERY, LONDON (553)

Canvas, $35\frac{1}{2} \times 47\frac{1}{2}$ (90.5×121)

Coll. Turner Bequest 1856 (30, 'Mercury sent to admonish Æneas' $4'0'' \times 3'0''$); transferred to the Tate Gallery 1905.

Exh. R.A. 1850 (174); New York 1966 (39, repr. in colour p. 49); Edinburgh 1968 (23); *From El Greco to Pollock: Early and Late Works by European and American Artists* Baltimore Museum of Art, October–December 1968 (88, repr.); R.A. 1974–5 (528).

Lit. Thornbury 1862, i, p. 349; 1877, p. 467; Hamerton 1879, pp. 297–8; Bell 1901, pp. 158–9 no. 265; Armstrong 1902, p. 255; MacColl 1920, p. 26; Davies 1946, p. 186; Finberg 1961, pp. 427, 511 no. 586; Rothenstein and Butlin 1964, p. 73; Gowing 1966, pp. 38, 53, repr. in colour p. 49; Gage 1969, pp. 98, 187, 244 n. 105; Reynolds 1969, pp. 204–5.

Exhibited with the verses:

'Beneath the morning mist,
Mercury waited to tell him of his neglected fleet.'
 —*MS Fallacies of Hope.*

It is difficult to identify Mercury with his wand and winged feet among the figures in this picture. The standing figure on the left seems to be Æneas in his cloak of Tyrian purple, working on the foundations of the citadel; with him stands Cupid, whom Venus had substituted for Æneas' son Ascanius. Perhaps Mercury has already melted into thin air, as Virgil describes him

doing after he delivers his message. Æneas' fleet is suggested on the right.

This is the first of four pictures on the theme of Æneas' stay at Carthage, tempted by love for Dido to resist the destiny that summoned him to Italy; for the others see Nos. 430–432. Several critics looked back regretfully at Turner's earlier style. For *The Times*, 4 May 1850, 'it would seem as if Mr. Turner had possessed in youth all the dignity of age to exchange it in age for the effervescence of youth. But to the more practical eyes which still trace through these eccentri-cities the hand of a great master and a matchless command over the materials of painting, careless of form and prodigal of light, these four pictures are not deficient in beauty and interest.' This picture and *The Departure of the Fleet*, No. 432, were distinguished for having 'the coolness of dawn, or twilight thrown, as it were, through the radiance of a southern sun, which gives the glow and the iridescence of the opal.' The *Athenaeum* for 18 May tried to steer a middle way between the extremes of enthusiasm and disparage-ment: 'Mr. Turner's works, amid their eccentricity of manner, exhibit the creative quality of Art, the suggestive powers of the artist, in as high a degree as the works of any painter who ever wielded pencil.' These four pictures 'are, each, full of combinations of forms of richest fancy and of colours of most dazzling hue.' They must be looked at from a distance for 'the general effect' and 'as great pictorial *schemes* abounding in rich stores of Nature and deductions from Art'. *Mercury sent to admonish Æneas* was described as 'exquisite for delicacy and refinement'. The *Illustrated London News* of 1 June was more uncompromisingly critical, talking of 'an excess of deviation from all everyday and anyday examination of nature'. Taking up the *Athenaeum*'s point about looking at the pictures from a distance, the critic went on, 'How far is this distance to be carried? till they are almost out of sight?' The critic of the *Spectator*, 4 May, only seems to have noticed three of the pictures: 'a splendid perplexity, respecting which the name would convey no information to the reader; with a companion, equally brilliant to the eye and dark to the understanding', and 'another picture from his "Fallacies of Hope",—the said fallacy being any hope of understanding what the picture means.'

430. Æneas relating his Story to Dido Exh. 1850

DESTROYED ?; FORMERLY THE TATE GALLERY, LONDON (552)

Canvas, approx. 36×48 (91.5×122)

Coll. Turner Bequest 1856 (29, 'Æneas relating his Story to Dido' $4'0'' \times 3'0''$); transferred to the Tate Gallery 1905.

Exh. R.A. 1850 (192).

Lit. Thornbury 1862, i, p. 349; 1877, p. 467; Hamer-ton 1879, pp. 297–8; Bell 1901, p. 159 no. 266;

Armstrong 1902, p. 217; MacColl 1920, p. 26; Davies 1946, p. 186; Finberg 1961, pp. 427, 511 no. 587; Lindsay 1966², p. 52; Gage 1969, pp. 98, 187, 244 n. 109; Reynolds 1969, pp. 204–5.

Exhibited in 1850 with the following verses:

'Fallacious Hope beneath the moon's pale crescent shone,
Dido listened to Troy being lost and won.'
—MS. *Fallacies of Hope*.

The picture was listed by MacColl in 1920 as being in the National Gallery, Millbank, now the Tate Gallery, but by 1936 the picture had been dropped from the catalogue, presumably having been destroyed at some earlier date; there is no record of how or when. Amazingly, no reproduction has been traced. MacColl's description reads, 'Dido and Æneas in a magnificent barge on the river attended by other barges; in the background a great city composed of recollections of the Castle of St. Angelo, in Rome, the Doge's Palace and Bridge of Sighs in Venice, and other noble buildings'.

The Times for 4 May 1850, discussing the four Carthage pictures (see No. 429), wrote that 'Even in the wilder pictures (192) in which the most definite object would seem to be a black cat, and, in 'The Visit to the Tomb' (373) [No. 431] (what tomb?), the confused and luminous mass subsides at a distance into an order of its own.' For the *Athenaeum*, 18 May, this picture was exquisite 'for wealth and power'. For further press criticisms see No. 429.

431. The Visit to the Tomb Exh. 1850 (Plate 417)

THE TATE GALLERY, LONDON (555)

Canvas, 36 × 48 (91·5 × 122)

Coll. Turner Bequest 1856 (32, 'The visit to the Tomb' 4′0″ × 3′0″); transferred to the Tate Gallery 1905.

Exh. R.A. 1850 (373); Whitechapel 1953 (101); Edinburgh 1968 (24, repr.).

Lit. Thornbury 1862, i, p. 349; 1877, p. 467; Hamerton 1879, pp. 297–8; Bell 1901, p. 159 no. 267; Armstrong 1902, p. 236; MacColl 1920, p. 26; Davies 1946, pp. 152–3, 186; Finberg 1961, pp. 427, 511 no. 588; Rothenstein and Butlin 1964, p. 73,

pl. 127; Lindsay 1966², pp. 52–3; Gage 1969, pp. 98, 187, 244 n. 105; Reynolds 1969, pp. 204–5, pl. 176; Herrmann 1975, pp. 55, pl. 182.

Exhibited in 1850 with the line:

'The sun went down in wrath at such deceit.'
—MS., *Fallacies of Hope*.

The Times for 4 May 1850 asked 'what tomb?' and indeed there is no description of such a visit in Virgil, though Dido does take Æneas to see how the building of Carthage is progressing. The reference is presumably to the tomb of Dido's husband. Sychaeus, in whose memory she tried to control her love for Æneas; Turner had shown the tomb in his picture of *Dido building Carthage*, exhibited in 1815 (see No. 131). The two figures of Dido and Æneas, on the left, are accompanied by Cupid, substituting for Ascanius as in No. 429. For contemporary reviews of this picture see No. 429.

432. The Departure of the Fleet Exh. 1850
(Plate 418)

THE TATE GALLERY, LONDON (554)

Canvas, 35⅜ × 47⅜ (89·5 × 120·5)

Coll. Turner Bequest 1856 (31, 'The departure of the Fleet' 4′0″ × 3′0″); transferred to the Tate Gallery 1905.

Exh. R.A. 1850 (482); Arts Council tour 1952 (24).

Lit. Thornbury 1862, i, p. 349; 1877, p. 467; Hamerton 1879, pp. 297–8; Bell 1901, p. 160 no. 268; Armstrong 1902, p. 233; MacColl 1920, p. 26; Davies 1946, p. 186; Finberg 1961, pp. 427, 511 no. 589; Rothenstein and Butlin 1964, p. 73; Lindsay 1966², p. 52; Gage 1969, pp. 98, 187, 244 n. 105; Reynolds 1969, pp. 204–5.

Exhibited in 1850 with the lines:

'The orient moon shone on the departing fleet,
Nemesis invoked, the priest held the poisoned cup.'
—MS. *Fallacies of Hope*.

Dido and her attendants, on the left, watch the departure of the fleet. For contemporary press criticisms of this picture see No. 429.

Nos. 433–532: Unexhibited Works
Nos. 433–86: Miscellaneous

433. Landscape: Christ and the Woman of Samaria *c.* 1830 (Plate 408)

THE TATE GALLERY, LONDON (1875)

Canvas, 57¼ × 93½ (145·5 × 237·5)

Coll. Turner Bequest 1856 (? 251, '1 (Scriptural subject)' 7′10″ × 4′10″); transferred to the Tate Gallery 1910.

Exh. On loan to the National Museum of Wales 1964–74; R.A. 1974–5 (486).

Lit. Armstrong 1902, p. 224; MacColl 1920, p. 28.

A large Italianate landscape of the kind exhibited by Turner from *Bay of Baiae* (No. 230) onwards, but here perhaps not carried quite to the degree of finish he deemed necessary for an exhibited work of this character. It is probably the 'Scriptural subject' listed as no. 251 in the Schedule of the Turner Bequest and seems to show Christ and the Woman of Samaria by Jacob's well (*John* iv, 6–7), set in a landscape with an Italian hill-town similar to but not the same as Tivoli (see No. 311). The composition, with a hill-town on the left and an avenue of trees on the right, is particularly close to *Palestrina*, begun in Rome in 1828 and exhibited at the R.A. in 1830 (No. 295).

434. Rocky Bay with Figures *c.* 1830 (Plate 409)

THE TATE GALLERY, LONDON (1989)

Canvas, 36 × 49 (91·5 × 124·5)

Coll. Turner Bequest 1856; transferred to the Tate Gallery 1906.

Exh. Paris 1938 (147, repr.); Amsterdam, Berne, Paris (repr. in colour), Brussels (repr. in colour), Liege (repr. in colour) (33), Venice (repr. in colour) and Rome (repr. in colour) (38) 1947–8; Tate Gallery 1959 (348; not shown); R.A. 1974–5 (483); Leningrad and Moscow 1975–6 (52, repr.).

Lit. MacColl 1920, p. 30; Rothenstein 1949, p. 18, colour pl. 10; Herrmann 1963, p. 27, pl. 11; Rothenstein and Butlin 1964, p. 39, pl. 76; Gaunt 1971, p. 7, colour pl. 21.

In composition this is a variation on the theme of a number of the sketches on coarse canvas probably painted in Rome in 1828 (see Nos. 302, 303 and 309), and also the finished *Ulysses deriding Polyphemus* exhibited in 1829 (No. 330). But it is very different in technique from the sketches, the paint being worked over, partly with the handle of the brush or even the fingers, to produce infinite gradations of tone; in addition the colouring is much subtler. The sky is as finished in its more delicate style as that of *Ulysses deriding Polyphemus* and this may be the beginning of another work for exhibition, in Turner's standard 3 ft by 4 ft size; indeed MacColl suggested that it was possibly another episode in the story of Ulysses. It is also related, in reverse, to one of the unpublished *Liber Studiorum* plates, *Glaucus and Scylla* (R. 73), but the figures in the painting are different and greater in number and there is a suggestion of long, low ships across the water on the right.

435. The Vision of Jacob's Ladder *c.* 1830?
 (Plate 428)
THE TATE GALLERY, LONDON (5507)

Canvas, 48½ × 74 (123 × 188)

Coll. Turner Bequest 1856 (256, '1 (Scriptural subject [)]' 6'2½" × 4'0'; identified 1946 by chalk number on back); transferred to the Tate Gallery 1951.

Exh. R.A. 1974–5 (484).

Lit. Davies 1946, pp. 162, 190.

Listed in the Schedule of the Turner Bequest, no. 266, merely as 'Scriptural Subject 6'2½" × 4'0", but almost certainly the Vision of Jacob's Ladder, *Genesis* xxviii, 10–12, though Jacob is accompanied by his family and is being addressed by an angel rather than by the Lord God. Martin Davies describes this as a very early work but in fact it seems to have been worked on over a considerable period. The basic forms, and particularly the craggy hill in the centre, are close to such paintings as *The Goddess of Discord choosing the Apple of Contention in the Garden of the Hesperides* and *Fall of the Rhine at Schaffhausen*, both exhibited in 1806 (Nos. 57 and 61) but the impressionistic technique and the way in which the whole picture is illuminated by the apparition suggest a much later date, probably close to the *Vision of Medea* which also reflects a return to earlier ideas and Venetian painting (No. 293). The general effect owes much to Titian but the flicked-in forms of the angels are still closer to Tintoretto.

This painting not only shared the general neglect of most of the works kept in Turner's studio but was even turned to the wall and used as an impromptu palette. The dabs of paint were only removed when the picture was recently restored at the Tate Gallery.

436. Christ driving the Traders from the Temple *c.* 1832 (Plate 412)

THE TATE GALLERY, LONDON (5474)

Mahogany, 36¼ × 27¾ (92 × 70·5)

Coll. Turner Bequest 1856 (153, one of '3 each (ditto [panel])' 3'0" × 2'3"; identified by chalk number on back); transferred to the Tate Gallery 1947.

Lit. Davies 1946, pp. 157, 188 n. 16.

Similar in style, though unfinished, to *Shadrach, Meshech and Abednego* (No. 346) which was exhibited in 1832, and painted on an identically labelled prepared panel by R. Davy. This may well have been intended as a complementary New Testament scene. The picture over the altar shows the parallel text of Moses breaking the Tables of the Law. Davies, pointing out that the architectural setting is very Romish, suggests that the picture reflects Turner's Anti-Catholicism.

The dark splash to the right of centre and other spots elsewhere, only partly removable during restoration

treatment in 1975, seem to be the result of an accident in Turner's studio and may account for his abandoning the picture.

437. Tivoli: Tobias and the Angel *c.* 1835
(Plate 410)

THE TATE GALLERY, LONDON (2067)

Canvas, $35\frac{5}{8} \times 47\frac{5}{8}$ (90·5 × 121)

Coll. Turner Bequest 1856; transferred to the Tate Gallery 1949.

Exh. Arts Council tour 1952 (14); on loan to the Municipal Gallery of Modern Art, Dublin, 1962–7; R.A. 1974–5 (488, repr. in colour p. 117); on loan to the National Museum of Wales since 1975.

Lit. MacColl 1920, p. 35; Davies 1946, p. 155.

This picture and No. 438, carried to the same degree of near-completion, probably arose out of Turner's second visit to Rome, developing compositions of the kind found among the sketches on coarse canvas of, probably, 1828 (see Nos. 302–17). The heavy impasto and rich colouring seem to parallel the treatment of various interior scenes associated with Petworth and thought to date from the mid 1830s (see Nos. 445–9) but the dating is very tentative (MacColl 1920, p. 34, dated them both 1840 or later).

Tivoli, a recurrent subject among Turner's Italian landscapes and one ultimately derived from Wilson (see Nos. 44 and 545), is here made the setting for a Biblical subject paralleling that of *Christ and the Woman of Samaria* (No. 433). For a discussion of the topography see Alfred Thornton in MacColl, *loc. cit.*

438. The Arch of Constantine, Rome *c.* 1835
(Plate 411)

THE TATE GALLERY, LONDON (2066)

Canvas, 36 × 48 (91 × 122)

Coll. Turner Bequest 1856; transferred to the Tate Gallery 1906.

Exh. New York, Chicago and Toronto 1946–7 (55, pl. 48); Venice and Rome 1948 (44); Edinburgh 1968 (7); R.A. 1974–5 (487); Leningrad and Moscow 1975–6 (54, repr.).

Lit. MacColl 1920, pp. 34–5.

Repr. Rothenstein and Butlin 1964, pl. 111.

Very close in style and degree of completion to No. 437, *q.v.* For the topography of the scene see the account by Alfred Thornton printed in MacColl, *loc. cit.*

439. Mountain Glen, perhaps with Diana and Actæon *c.* 1835–40
(Plate 430)

THE TATE GALLERY, LONDON (561)

Canvas, $58\frac{3}{4} \times 43\frac{3}{4}$ (149 × 111)

Coll. Turner Bequest 1856 (? 261, '1 (Upright Landscape)' $4'11\frac{1}{2}'' \times 3'8\frac{1}{2}''$); transferred to the Tate Gallery 1905.

Exh. Paris 1953 (71).

Lit. Thornbury 1862, i, pp. 349, 392–3; 1877, pp. 180–81, 467; Armstrong 1902, p. 225; MacColl 1920, p. 27.

In size and upright format the picture should probably been seen as a follow-up to *Mercury and Argus*, exhibited in 1836, and indeed it may be the companion commissioned from Turner by the long-suffering Mr 'Dives' (probably Joseph Gillott) but never completed as they had quarrelled (see No. 367 and Thornbury, *loc. cit.*). The forms, especially of the trees, are more curvilinear however and the picture is perhaps two or three years later, roughly contemporary with *Phryne going to the Public Bath as Venus*, exhibited in 1838 (see No. 373).

The tree on the left was originally painted further to the right. The picture seems to have been worked on in one campaign and left unfinished, rather than worked on over a period.

The composition is a free adaptation, upright rather than horizontal, of the *Liber Studiorum* plate 'From Spenser's Fairy Queen', R. 36, published June 1811 and classified as 'H' for Historical (repr. Finberg 1924, p. 143; the preliminary drawing (Vaughan Bequest), CXVII-L, and etching repr. p. 142). Here, however, the figures, though not completed, seem to represent Actæon, on the left, being attacked by dogs on surprising Diana, who seems to be shown further away in a depression below the tent-like form at the base of the stricken tree. There is a reclining nude on the left, but apart (perhaps) from this figure none of Diana's attendant nymphs can be seen. The composition is perhaps inspired, at a considerable remove, by Titian's two Actæon pictures. These came to England from the Orleans collection in 1798. *Diana surprised by Actæon* entered the Bridgewater collection and was exhibited at the British Institution in 1839 (see Harold E. Wethey *The Paintings of Titian* iii 1975, p. 140, repr. pl. 142); *The Death of Actæon* was lent to the British Institution in 1819 and 1845 by Sir Abraham Hume and his grandson Viscount Alford respectively and is now in the National Gallery (Cecil Gould, *National Gallery Catalogues: The Sixteenth Century Italian Schools* 1975, p. 296; repr. Wethey iii 1975, pl. 152).

440. Heidelberg *c*. 1840–5 (Plate 414)

THE TATE GALLERY, LONDON (518)

Canvas, $52 \times 79\frac{1}{2}$ (132×201)

Coll. Turner Bequest 1856 (255, '1 [picture] (Heidelburg)' 6'8" × 4'4"); transferred to the Tate Gallery 1929.

Exh. Newcastle 1912 (52); Newcastle 1924 (162); Whitechapel 1953 (88); *Heidelberg im Bild der Jahrhunderte* Ottheinrichbau des Schlosses, Heidelberg, May–October 1957; New York 1966 (18, repr. p. 60); R.A. 1974–5 (574, repr.).

Lit. Thornbury 1862, i, p. 326; 1877, p. 452; Armstrong 1902, p. 222; MacColl 1920, p. 18; Davies 1946, p. 190; Rothenstein and Butlin 1964, p. 56, pl. 106; Gowing 1966, p. 38, repr, p. 60; Max Schefold, 'William Turner im Heidelberg und am Neckar', *Jahrbuch der Staatlichen Kunstsammlungen in Baden-Württemberg* v 1968, pp. 136–7, repr. p. 131.

A large finished picture of the kind normally exhibited by Turner, but for some reason this particular work does not seem to have been shown at the R.A. or anywhere else during his lifetime. The German subject and general composition are similar to the *Opening of the Walhalla, 1842*, exhibited in 1843 (No. 401), there being the same rather hectic air of festivity. In this case the costumes suggest that Turner was alluding to the short-lived court of the 'Winter Queen', Elizabeth sister of Charles I, who married Frederick Elector Palatine but who spent most of her life in exile after the failure of his attempt to hold the crown of Bohemia. Turner has shown the castle, partly destroyed by the French in 1689, as undamaged. The picture was engraved by T. A. Prior and published in the *Turner Gallery* 1859–61, as 'Heidelberg Castle in the olden Time'.

There are a number of sketches of Heidelberg, Frederick's original capital, in the 'Spires and Heidelberg' sketchbook and the 'Heidelberg up to Salzburg' sketchbook of 1840 (CCXCVII and CCXCVIII).

441. Studies for 'Dawn of Christianity' *c*. 1841
 (Plate 431)

THE TATE GALLERY, LONDON (5508)

Canvas, $52\frac{5}{8} \times 25\frac{5}{8}$ (133.5×65)

Coll. Turner Bequest 1856 (? 298ˣ, '1 — Canvas with beginnings of pictures'; identified 1946 by number '298' on back); transferred to the Tate Gallery 1951.

Lit. Davies 1946, pp. 163, 191 n. 27.

Only the 1856 Schedule included no. 298ˣ, which was referred to as an extra picture found at Turner's studio in Queen Anne Street; for 298 see No. 45.

The canvas seems originally to have been prepared for one of the Petworth landscapes, being similar in size and shape (see Nos. 283–91). Spoilt by water, it was subsequently used for six rough monochrome sketches in grey paint, most if not all working towards the composition of *Dawn of Christianity (Flight into Egypt)*, exhibited in 1841 (No. 394). With the canvas used as an upright there is across the top a single landscape, flanked by trees. Below this are three related compositions, circular in composition like the exhibited picture. That on the left has a part-outline, following a circle, in the same grey paint as the sketch itself; the other two seem to have been circumscribed by scratching into the white ground. A further circular sketch, roughly framed in the same grey paint, was painted below but with the canvas the other way up; this contains a pyramidal feature that connects it more closely with the Egyptian setting of the finished oil, though in other respects it is less close in composition than are the sketches already mentioned. Finally, adjacent to this, there are rough indications of foliage, particularly close to the large tree on the left of the finished oil, with another feature further to the left.

442. Rosenau *c*. 1841–4 (Plate 429)

YALE CENTER FOR BRITISH ART, PAUL MELLON COLLECTION

Canvas, 38×49 (96.5×124.5)

Signed 'J M W Turner' lower left

Coll. Colonel E. F. W. Barker; G. Barker-Harland; bought in 1965 from Oscar and Peter Johnson Ltd. by Mr and Mrs Paul Mellon.

Exh. R.A. 1968–9 (161).

An unrecorded version of No. 392, exhibited at the R.A. in 1841 and now in the Walker Art Gallery, Liverpool. The Liverpool Catalogue (1971) states: 'A sketchier version is in the collection of Paul Mellon. It has been catalogued as by Turner but autograph copies or versions of his work are very rare.' This is certainly true and in only three instances is there general agreement that both versions are by Turner's own hand. In two other cases—the two versions of *Neapolitan Fisher-Girls* (Nos. 388 and 389) and of *Rosenau*—opinion is divided. Although Mr and Mrs Mellon's *Rosenau* apparently raised no doubts, or at least none that were published, at the time it was shown at Burlington House in 1968–9, such doubts have been raised since, in particular by Martin Butlin, although I still consider it genuine. This question should be solved now that the picture is on public exhibition at Yale.

The three subjects of which it is agreed that two authentic versions exist are:
1. *Bonneville* (Nos. 46 and 124).
2. *Æneas and the Sybil* (Nos. 34 and 226).
3. *The Evening of the Deluge* (Nos. 404 and 443).
In the case of 1, the two versions were exhibited at the R.A. in 1803 and 1812 respectively and it is not known

why this interval elapsed, unless the success which Turner had had in selling 'Bonneville' subjects in 1803–4 may have encouraged him to explore the vein further at a time when criticism of his exhibited work, led by Sir George Beaumont, was increasing.

In the case of 2, about sixteen years separate the two versions and the reasons for Turner painting the second are explored in the entry for No. 226; while, with 3, the differences between the two versions are sufficiently marked to warrant a second being painted, as explained in the entry for No. 443.

The interval which separates the two versions of *Rosenau* can only be brief, so far as one can judge from examining the handling, although the rather more free brushwork of this version tempts one to date it certainly after the exhibited picture.

Unfortunately, there is no clue which might provide a reason why Turner painted a second version of this subject and the lack of any early history of this picture is a further stumbling block to enquiry. As already suggested under No. 392, one cannot help speculating that, since Turner seems to have gone out of his way to visit Coburg in September 1840, he may have had at the back of his mind the hope that a picture of Prince Albert's birthplace might find its way into the Royal Collection, thus making up for the loss of the *Battle of Trafalgar* (No. 252), and perhaps lead to further royal favour and eventually to the knighthood which he coveted. This theory is only tenable if we assume that this version was painted *c.* 1844 at the time that Gillott bought the exhibited version and that Turner was prompted to paint it as a result of the renewed interest in his work, occasioned by the publication of the first volume of *Modern Painters* in 1843, which led to collectors like Gillott and Elhanan Bicknell buying Turner's work in bulk in 1844. Encouraged by this, Turner may have felt it prudent to have a version of the royal subject to hand, in case of any enquiry from royal circles, but it must be admitted that there is no evidence to support this theory.

It seems just possible that it was this picture that appeared in Phillips' catalogue of 22 April 1856 (136) as 'Prince Albert's Villa in Saxe Gotha', the property of John Fairrie of Clapham Common who also owned No. 134. If so, it would appear, from the copy of Phillips' catalogue in the British Museum, to have been either bought in or withdrawn from the sale.

443. The Evening of the Deluge *c.* 1843
(Plate 413)

NATIONAL GALLERY OF ART, WASHINGTON D.C.

Canvas, $29\frac{7}{8} \times 29\frac{7}{8}$ (76 × 76)

Coll. The Rev. T. J. Judkin; Mrs Judkin sale Christie's 13 January 1872 (35) as 'The Animals going into the ark—circle' bought White; William Houldsworth by 1878; sale Christie's 23 May 1891 (59) bought in; sale Christie's 16 May 1896 (54) bought Shepherd; Maurice Kahn from whom bought by Agnew in 1900

and sold to H. Darell-Brown 1901; sale Christie's 23 May 1924 (41) bought Carroll; with Howard Young Galleries, New York, 1928; Mrs Lilian Timken by 1933; bequeathed by her to Washington in 1959 (Inventory no. 1592).

Exh. Glasgow 1878 (13 lent by W. Houldsworth); Agnew 1901 (17); Art Institute of Chicago *A Century of Progress* 1933 (206 lent by Mrs Timken).

Lit. Armstrong 1902, p. 220, repr. facing p. 180.

The Rev. Judkin was a friend of Constable's and also certainly known to Turner as he features in a number of anecdotes recounted by Thornbury (e.g., 1862, i, pp. 223, 316–7).

This must presumably be an earlier version of the exhibited *Shade and Darkness—The Evening of the Deluge* (No. 404), which was superseded by the latter because it did not provide such an effective contrast to *Light and Colour* (No. 405). The explanation of this must lie in the very different tonality and colours of the two versions: the Washington picture has a grey-green tonality, with some reds and yellows in the bottom left-hand corner, which in no way 'restates the sublimity of black' which Gage suggests was Turner's chief concern in painting the subject and which is emphasised in the Tate version, in order to illustrate Goethe's table of polarities. Indeed the Washington picture contains some of the 'plus' colours which belong to *Morning* rather than to *Evening* and this must be the reason why Turner painted the second and considerably darker version. Turner was also anxious, according to Gage, to restore the equality of light and darkness as values both in nature and in art, which he felt Goethe had unduly neglected.

In the spiral of birds, illustrating the line 'The roused birds forsook their nightly shelters screaming' (which was appended to the Tate version when shown at the R.A.), Turner employs the same compositional device that he used with the flock of gulls in *Quille-Boeuf* (No. 353), although it is given greater emphasis here than in the Tate version.

444. A Lady in Van Dyck Costume *c.* 1830–35
(Plate 432)

THE TATE GALLERY, LONDON (5511)

Canvas, $47\frac{3}{4} \times 35\frac{7}{8}$ (121 × 91)

Coll. Turner Bequest 1856; transferred to the Tate Gallery 1947.

Exh. Arts Council tour 1952 (15); Antwerp 1953–4.

Lit. Davies 1946, p. 163; Rothenstein and Butlin 1964, p. 45; Gage 1969, p. 244 n. 109; Reynolds 1969, pp. 137–8.

The three-quarter-length format, the figure's pose, and particularly the placing of her arms, the richly-coloured loose sleeves and the opening onto a view of a landscape

are all based on portraits by or attributed to Van Dyck at Petworth, and this picture probably dates from about the same time as *Lord Percy under Attainder* (No. 338), exhibited in 1831, which is based on the same portraits (see Plates 552, 553 and 554). It also forms one of the series of paintings of the figure on much the same relatively large scale, that, beginning with *Rembrandt's Daughter* exhibited at the R.A. in 1827 (No. 238), includes the *Reclining Venus* painted at Rome in 1828 (No. 296), *Jessica*, R.A. 1830 (No. 333), and *Two Women with a Letter* of c. 1835 (No. 448).

An area along the bottom, reaching up almost to the bottom of the sleeve, was repainted at the National Gallery in 1944 to replace losses.

445. Dinner in a Great Room with Figures in Costume c. 1830–35 (Plate 415)

THE TATE GALLERY, LONDON (5502)

Canvas, 35¾ × 48 (91 × 122)

Coll. Turner Bequest 1856; transferred to the Tate Gallery 1947.

Exh. Cardiff 1951; Tate Gallery 1959 (349); Australian tour 1960 (9); New York 1966 (13, repr. p. 59); Paris 1972 (269, repr.); R.A. 1974–5 (338); Leningrad and Moscow 1975–6 (32).

Lit. Davies 1946, p. 161.

Formerly called 'A Costume Piece'; the present title was given by Lawrence Gowing. Like Nos. 446 and 447 this seems to have been inspired by the informal social life, with an element of dressing up, at Petworth under the third Earl of Egremont; see also No. 449. It is also one of the works most strongly influenced by Rembrandt, and therefore probably to be dated to the early or mid 1830s. In particular the figure silhouetted against a shaft of light on the left seems to reflect the early painting by Rembrandt formerly called 'The Philosopher' which seems to have passed through the London sale rooms twice in the 1790s and perhaps again in 1821 (National Gallery, London, no. 3214; see Neil Maclaren *National Gallery Catalogues: The Dutch School* 1960, p. 332).

446. Figures in a Building c. 1830–35 (Plate 450)

THE TATE GALLERY, LONDON (5496)

Canvas, 36 × 48 (91·5 × 122)

Coll. Turner Bequest 1856; transferred to the Tate Gallery 1947.

Exh. Agnew 1967 (20); Dresden (13, repr.) and Berlin (13, pl. 33) 1972.

Lit. Davies 1946, p. 160.

Very close in character to No. 445, though the setting

with its heavy vaults may be a subterranean one. The figures are even more Rembrandtesque.

The existing picture was painted over a completely unrelated landscape composition with brown foreground and blue sky, thinly painted, and strongly defined buildings on the sky line, painted with considerable impasto; the buildings were level with the waists of the figures on the left and are still discernible. This composition had fully dried before the present one was added on top. The lack of adhesion produced considerable losses, particularly along the edges top right and in an area below the figures on the left; these losses, though touched in, can still be detected as depressions in the surface of the picture.

447. Music Party, Petworth c. 1835 (Plate 434)

THE TATE GALLERY, LONDON (3550)

Canvas, 47¾ × 35⅝ (121 × 90·5)

Coll. Turner Bequest 1856; transferred to the Tate Gallery 1919.

Exh. Amsterdam (repr. in colour), Berne, Paris (repr. in colour), Brussels (repr. in colour), Liege (repr. in colour) (35), Venice (repr. in colour) and Rome (repr. in colour) (41) 1947–8; New York 1966 (11, repr. p. 36); R.A. 1974–5 (336); Leningrad and Moscow 1975–6 (31, repr.).

Lit. MacColl 1920, p. 44; Falk 1938, p. 97; Herrmann 1963, p. 27, pl. 12; Rothenstein and Butlin 1964, p. 45, pl. 92; Gowing 1966, p. 36, repr.; Lindsay 1966, p. 179; Gaunt 1971, p. 8; Herrmann 1975, p. 37, pl. 137.

Like *Two Women and a Letter* (No. 448) this picture develops on a large scale the interior scenes of the informal social life at Petworth found in the series of drawings in bodycolour on blue paper (CCXLIV). No actual room at Petworth can be identified however. The relatively thick paint and virtuoso handling seem to be characteristic of a stage in Turner's development in the early and mid 1830s under the influence of Rembrandt.

448. Two Women with a Letter c. 1835 (Plate 435)

THE TATE GALLERY, LONDON (5501)

Canvas, 48 × 36 (122 × 91·5)

Coll. Turner Bequest 1856; transferred to the Tate Gallery 1947.

Lit. Davies 1946, p. 161; Rothenstein 1949, p. 22, colour pl. 12; Rothenstein and Butlin 1964, pp. 45, 76, pl. 93; Lindsay 1966, p. 179.

As in the case of *Music Party, Petworth* (No. 447) this is a development of the theme of the drawings in bodycolour of life at Petworth, though no actual room

there can be identified. The handling, bolder and with thicker paint than in *Music Party*, suggests a slightly later date. The concentration on the back of the neck and the high-swept hair-style of the foremost girl suggests a possible influence from Fuseli. The subject, a bit difficult to make out, seems to be of a girl seated in a high leather-backed chair while her companion teases her by concealing a letter behind her back.

449. Interior at Petworth *c.* 1837 (Plate 433)

THE TATE GALLERY, LONDON (1988)

Canvas, 35¾ × 48 (91 × 122)

Coll. Turner Bequest 1856; transferred to the Tate Gallery 1906, returned to the National Gallery 1956, and to the Tate Gallery 1961.

Exh. New York, Chicago and Toronto 1946–7 (51, pl. 43); New York, St Louis and San Francisco 1956–7 (113, repr. in colour p. 18); R.A. 1974–5 (339, repr.).

Lit. MacColl 1920, p. 30; Falk 1938, pp. 97–8, 143; Davies 1946, p. 154; Clark 1949, p. 103; Clare 1951, p. 79, repr. p. 74; Davies 1959, p. 100; Rothenstein and Butlin 1964, p. 45, colour pl. xviii; Reynolds 1969, pp. 135–7, colour pl. 114; Gaunt 1971, p. 8, colour pl. 35; Herrmann 1975, pp. 37, 233, colour pl. 134.

Although identified as Petworth when first listed in the National Gallery inventory in 1905 the picture depicts no recognisable room. It is however the culmination of a series of oil paintings of interiors associated with Petworth (see 445–8). David Thomas, in an unpublished lecture, has suggested that this picture represents Turner's reaction to the news of his friend and patron Lord Egremont's death in 1837. The suggestion of a catafalque with coat-of-arms, surrounded by dogs, and the sculptures that possibly allude to Lord Egremont's collection of antique and contemporary examples, support this. All is in a state of dissolution, above all from the power of light flooding in from the right.

The heavy drying-crackle in the foreground, rare in Turner's work, indicates his haste. Before restoration in 1974 the gaps left by the shrinking of the top layers of paint revealed a layer of bright red underlying much of the foreground.

450. A Vaulted Hall *c.* 1835 (Plate 451)

THE TATE GALLERY, LONDON (5539)

Mahogany, 29½ × 36 (75 × 91·5)

Coll. Turner Bequest 1856 (150, one of '3 each (panel)' 3′0″ × 2′6″; identified 1946 by chalk number on back); transferred to the Tate Gallery 1947.

Exh. New York 1966 (16).

Lit. Davies 1946, pp. 167, 188 n. 15; Gowing 1966, p. 36.

Distinct in size and the relative lack of colour from the Petworth interiors, Nos. 445–9, but probably of about the same date. Gowing sees its sombre tonality, handling and massive design as paralleling *Snow-Storm, Avalanche and Inundation* exhibited in 1837 (No. 371).

451. The Cave of Despair, from Spenser's 'Faery Queen' (?) *c.* 1835 (Plate 452)

THE TATE GALLERY, LONDON (5522)

Mahogany, 20 × 32 (51 × 81)

Coll. Turner Bequest 1856 (159, 1 unidentified 2′8½″ × 1′8½″; identified 1946 by chalk number on back); transferred to the Tate Gallery 1947.

Lit. Davies 1946, pp. 165, 188; Gage 1968, p. 681, repr. p. 676, fig. 48.

Martin Davies catalogued this picture as 'A Visit to the Underworld (?)', old Tate Gallery catalogues as 'Unidentified Subject', and Lawrence Gowing as 'An Allegory of Time' on account of the hour-glass held by the child-like figure in the centre. More recently, however, John Gage has identified the subject as an illustration to Spenser's *Faery Queene*. Charles Eastlake was painting an illustration to the same poem for Sir John Soane while Turner was with him in Rome in 1828–9 (repr. Gage, *op. cit.*, fig. 47), and in a letter to Eastlake of 11 August 1829 Turner writes that he would have liked to have bought Benjamin West's *Cave of Despair*, sold with the contents of West's studio in May of that year, 'and lament I did not' (repr. Gage, *op. cit.*, fig. 49). According to Gage, Turner, rather than illustrate any one passage, conflates elements from Cantos VIII and IX: Despair, seen in a cave inhabited by an owl, as in Canto IX, is urging the Red Cross Knight to kill himself with a dagger, partly because he has deserted Una and transferred his allegiance to the witch Duessa, whom Una is shown revealing in the right foreground as a 'loathly, wrinckeled hag', an incident which takes place in a different cave in Canto VIII; the hour-glasses illustrate the lines in Canto XI, verse 46, when Despair tries to persuade the Knight that it is 'better to die willinglie, Then linger till the glas be all out-ronne'. Turner had already illustrated Spenser in one of the *Liber Studiorum* plates, R. 36, 'From Spenser's Fairy Queen', published in June 1811 (repr. Finberg 1924, p. 143; see also No. 439). However, the central figure identified by Gage as the Red Cross Knight is remarkably difficult to make out.

452. Head of a Person asleep *c.* 1835 (Plate 453)

THE TATE GALLERY, LONDON (5494)

Canvas, $9\frac{5}{8} \times 11\frac{7}{8}$ (24·5 × 30)

Coll. Turner Bequest 1856 (? 273, 1 unidentified
',, $10\frac{1}{2}''\times,,9\frac{3}{4}'''$, presumably meaning 'o ft $10\frac{1}{2}$ in by
o ft $9\frac{3}{4}$ in'); transferred to the Tate Gallery 1947.

Lit. Davies 1946, p. 190.

Similar to two watercolours of heads traditionally said
to have been done from figures lying on the beach at
Margate when Turner was staying there with Mrs
Booth at some time between 1827 and 1846, when Mrs
Booth moved to a house in Cheyne Walk, Chelsea. The
first is the *Head of a Fishwife lying in the Sun*, repr.
Connoisseur lxix 1924, p. 137, formerly in the collection
of Archibald G. B. Russell and with Roland, Browse and
Delbanco in 1972. The other, sold at Sotheby's 10
March 1965 (36), now belongs to W. Wood Prince,
Chicago. What is probably another version of the same
story is John Pye's account of Turner drawing the head
of a drowned girl at Chelsea (Falk 1938, p. 220).
However, the oil head, with its relatively dark
colouring, may be an indoor scene, reflecting the
bedroom studies done at Petworth and elsewhere.

453. The Evening Star *c.* 1830 (Plate 436)

THE NATIONAL GALLERY, LONDON (1991)

Canvas, $36\frac{1}{4} \times 48\frac{1}{4}$ (92·5 × 123)

Coll. Turner Bequest 1856 (117, one of 36 each
$4'0'' \times 3'0''$; identified 1946 by chalk number).

Exh. Paris 1938 (144, repr.); Arts Council tour 1947
(25); Whitechapel 1953 (86); Rotterdam 1955 (56,
repr.); New York, St Louis and San Francisco
1956–7 (114, repr. p. 15); Tate Gallery 1959 (352);
Berlin 1972 (11, repr. in colour pl. 12).

Lit. Finberg 1909, ii, p. 736; MacColl 1920, p. 31; Falk
1938, pp. 144–5; Davies 1946, pp. 154, 188 n. 14;
Clare 1951, p. 106, repr. p. 104; Davies 1959, p. 100;
Rothenstein and Butlin 1964, pp. 12, 48, pl. 82;
Lindsay 1966, p. 172; 1966², p. 58; Brill 1969,
pp. 17–18, repr. p. 17; Gage 1969, p. 144; Gaunt
1971, pp. 8–9, colour pl. 26.

For MacColl this is 'Perhaps of the same date as "The
New Moon" ', exhibited in 1840 (No. 386), but stylisti-
cally it seems earlier, as had already been suggested by
Finberg, who associated it with some draft verses about
'The first pale Star of Eve ere Twylight comes' in the
'Worcester and Shrewsbury' sketchbook of *c.* 1829–30
(CCXXXIX-70). It is just possible that the subject was
suggested by Etty's *Venus, the Evening Star*, exhibited at
the R.A. in 1828, but this was a figure subject. More likely
is the influence of Bonington, as in the case of the
comparable painting exhibited in 1830, *Calais Sands*
(No. 334, *q.v.*).

454. Hastings *c.* 1830–35 (Plate 437)

THE TATE GALLERY, LONDON (1986)

Canvas, $35\frac{1}{2} \times 48$ (91 × 122)

Coll. Turner Bequest 1856; transferred to the Tate
Gallery 1906.

Exh. Amsterdam, Berne, Paris, Brussels, Liege (32),
Venice and Rome (36) 1947–8; on loan to the
National Gallery of Scotland 1964–8; Edinburgh
1968 (9); R.A. 1974–5 (493).

Lit. Rothenstein 1949, p. 12, colour pl. 6.

A variation of the theme of *The Chain Pier,
Brighton* (Nos. 286 and 291) but more worked up in sea
and sky, paralleling the development seen in *Staffa—
Fingal's Cave*, exhibited in 1832, in the subservience of
solid forms to the forces of nature (see No. 347). The
sky seems to represent a later stage in the development
of the composition than the rest of the picture.

455. Rough Sea with Wreckage *c.* 1830–35
(Plate 438)

THE TATE GALLERY, LONDON (1980)

Canvas, $36\frac{1}{4} \times 48\frac{1}{4}$ (92 × 122·5); formerly on a larger
stretcher approx. $41\frac{7}{8} \times 50\frac{1}{4}$ (106 × 127·5)

Coll. Turner Bequest 1845 (109, one of 36 each 4'0'' by
3'0''; identified 1946 by chalk number); transferred
to the Tate Gallery 1954.

Exh. New York 1966 (8, repr. in colour p. 20); Paris
1972 (270, repr.); Dresden (11, repr.) and Berlin (15)
1972; Lisbon 1973 (12, repr.); R.A. 1974–5 (492);
Leningrad and Moscow 1975–6 (57, repr.).

Lit. MacColl 1920, p. 29; Davies 1946, pp. 153–4, 188
n. 14; Rothenstein and Butlin 1964, p. 62, pl. 96;
Gowing 1966, p. 36, repr. in colour p. 20.

MacColl's statement that this picture and No. 456 are
'founded upon two smaller pictures, "The Storm" and
"The Day after the Storm", said to have been
suggested by the gale of November 21, 1840' (Nos. 480
and 481) is incorrect, nor is the suggested dating at all
likely. Turner's series of paintings of stormy seas seems
to have been produced over a considerable period. This
example, with its relatively solidly modelled clouds and
waves making a disciplined composition notwithstand-
ing the energy of the forces involved, can be tentatively
dated to the early 1830s. It can in particular be related
to *Mouth of the Seine, Quille-Boeuf*, exhibited in 1833
(No. 353, *q.v.* for a contrary view; to my mind the sky in
Ostend (No. 407) completely lacks the body of the
clouds in both *Quille-Boeuf* and *Rough Sea with
Wreckage*).

456. Breakers on a Flat Beach *c.* 1830–35

(Plate 454)

THE TATE GALLERY, LONDON (1987)

Canvas, 35½ × 47⅝ (90 × 121)

Coll. Turner Bequest 1856; transferred to the Tate Gallery 1906.

Exh. *The Romantic Era* Herron Museum of Art, Indianapolis, February–April 1965 (41, repr. in colour); Hague (48, repr.) and Tate Gallery (46, repr.) 1970–71; on loan to National Maritime Museum from 1975.

Lit. MacColl 1920, pp. 29–30; Herrmann 1975, p. 43, pl. 170.

Close in style and colour to No. 455, and probably to be similarly dated to the early 1830s. MacColl's likening of the composition to two smaller pictures (Nos. 480 and 481) is again impossible to accept.

457. Waves breaking against the Wind *c.* 1835

(Plate 440)

THE TATE GALLERY, LONDON (2881)

Canvas, 23 × 35 (58·5 × 89)

Coll. Turner Bequest 1856; transferred to the Tate Gallery 1919.

Exh. Antwerp 1953–4.

Lit. Herrmann 1963, p. 38, colour pl. 19.

Smaller than Turner's standard 3 ft by 4 ft format and companion to No. 458, balancing it in composition. Both probably date from the mid 1830s.

Tack holes and tension lines at the extreme edges suggest that the picture was at one time pinned to a board, perhaps during execution. Flattened impasto and ingrained dirt (now removed or reduced by retouching) suggest that the picture was laid flat on the ground or against a wall before the paint had fully dried.

458. Waves Breaking on a Lee Shore *c.* 1835

(Plate 441)

THE TATE GALLERY, LONDON (2882)

Canvas, 23½ × 37½ (60 × 95)

Coll. Turner Bequest 1856; transferred to the Tate Gallery 1919.

Exh. Liverpool 1933 (65); Cardiff 1951; Rotterdam 1955 (57); *English Landscape Painters* Phoenix Art Museum, December 1961–January 1962 (27); *Man and his World* Expo 67, Montreal, April–October 1967 (85, repr. in colour); Prague, Bratislava (147, repr.) and Vienna (56, repr.) 1969; Tokyo and Kyoto 1970–71 (43, repr. in colour); Dresden (12, repr.) and Berlin (20) 1972; Lisbon 1973 (15, repr. in colour); Milan 1975 (153, repr.); Leningrad and Moscow

1975–6 (61, repr.); Hamburg 1976 (127 repr. and colour pl. 20).

Lit. Clark 1973, p. 107, pl. 84a; Herrmann 1975, p. 43, colour pl. 145.

Companion to No. 457 and probably painted in the mid 1830s. The motive of waves breaking on a shore with a central burst of spray was one that Turner had already used in a wash drawing from the 'Studies for the Liber' sketchbook (not engraved; CXV-7, repr. exh. cat., B.M. 1975, p. 42 no. 40, and Wilkinson 1974, p. 100 in colour); the sketchbook is watermarked 1807 but at least one of the designs from it is for the unpublished plate of 'Ploughing, Eton' which presumably dates from nearer 1819 when the publication of the *Liber Studiorum* was abandoned.

459. Waves breaking on a Shore *c.* 1835

(Plate 455)

THE TATE GALLERY, LONDON (5495)

Canvas, 18¼ × 23⅞ (46·5 × 60·5)

Coll. Turner Bequest 1856 (? 167, one of 2 each 2′0″ × 1′6¼″ with ? No. 275); transferred to the Tate Gallery 1947.

Exh. Arts Council tour 1952 (18); *A Hundred Years of British Landscape Painting 1750–1850* Leicester Museums and Art Gallery, October–November 1956 (33); on loan to National Maritime Museum from 1975.

Lit. Davies 1946, p. 160.

460. Fire at Sea *c.* 1835

(Plate 439)

THE TATE GALLERY, LONDON (558)

Canvas, 67½ × 86¾ (171·5 × 120·5)

Coll. Turner Bequest 1856 (254, '1 (Fire at Sea)' 7′3¾″ × 5′8½″); transferred to the Tate Gallery 1910, returned to the National Gallery 1956, and to the Tate Gallery 1968.

Exh. New York, Chicago and Toronto 1946–7 (53, pl. 44); R.A. 1974–5 (496).

Lit. Ruskin 1860 (1903–12, vii, p. 246 n.); ?Thornbury 1862, i, p. 325; ?1877, p. 451; Armstrong 1902, p. 229; MacColl 1920, p. 27; Davies 1946, p. 190; Clark 1949, pp. 108–9, pl. 86; Rothenstein 1949, p. 20, colour pl. 11; Davies 1959, p. 100; Herrmann 1963, p. 32, pl. 16; Rothenstein and Butlin 1964, pp. 19, 52–3; Lindsay 1966, p. 162, 179, 249 n. 48; Brill 1969, p. 19, repr.; Gaunt 1971, p. 8, colour pl. 29; Herrmann 1975, pp. 43, 233, colour pl. 144.

Despite its relatively 'unfinished' state this was given an inventory number immediately on entering the National Gallery in 1856, like the works exhibited in

Turner's lifetime. Thornbury probably refers to this picture when he speaks of Turner 'studying a burning ship at sunset (unfinished oil picture)'. There are three sketches of a ship on fire in the 'Fire at Sea' sketchbook, dated by Finberg *c.* 1834 (CCLXXXII-3, 4 and 5) and the painting probably also dates from about this time as is suggested by MacColl in his remarkably specific 'painted about 1834'; it may well have reflected Turner's renewed interest in fire subjects following the burning of the Houses of Parliament in October 1834 (see Nos. 359 and 364). Ruskin suggests that the picture 'has had its distance destroyed' by the loss of its upper glazes through cleaning in the same way as *Hero and Leander* (No. 370).

461. Yacht approaching the Coast *c.* 1835–40
(Plate 448)

THE TATE GALLERY, LONDON (4662)

Canvas, 40¼ × 56 (102 × 142)

Coll. Turner Bequest 1856 (? 266, 1 unidentified 4′8½″ × 3′4½″); transferred to the Tate Gallery 1938.

Exh. Amsterdam, Berne, Paris (repr.), Brussels, Liege (38), Venice (repr.) and Rome (repr.) (47) 1947–8; Paris 1953 (87); Rotterdam 1955 (61, repr.); New York 1966 (22, repr. in colour p. 34); R.A. 1974–5 (494, repr. in colour p. 118).

Lit. Rothenstein and Butlin 1964, pp. 60–62, pl. 118; Gowing 1966, pp. 27, 31, 38, repr. in colour p. 34.

The rather unusual size is shared by *Stormy Sea with Blazing Wreck* (No. 462) to which this picture is perhaps the counterpart, light against dark. The composition, though not the mood, is remarkably similar to *Slavers*, exhibited in 1840 (No. 385), though *Yacht approaching the Coast* can perhaps be dated a few years earlier. It has been suggested that the heavily worked surface covers forms of gondolas, and that the town on the left was originally conceived as Venice; the underlying composition would have been something like that of *Procession of Boats with Distant Smoke, Venice* (No. 505), though that is usually dated rather later.

The impasto has been flattened during relining.

462. Stormy Sea with Blazing Wreck *c.* 1835–40
(Plate 449)

THE TATE GALLERY, LONDON (4658)

Canvas, 39⅛ × 55¾ (99·5 × 141·5)

Coll. Turner Bequest 1856 (? 267, 1 unidentified 4′8½″ × 3′3¾″); transferred to the Tate Gallery 1938.

Exh. R.A. 1974–5 (495).

One of Turner's relatively rare night scenes; perhaps, on account of its unusual size, to be seen as a companion to *Yacht approaching the Coast* (No. 461). The figures on the shore and the skeletal fragments of the wrecked ship echo the finished picture *Wreckers—Coast of Northumberland*, exhibited in 1834 (No. 357), but the Tate picture is more dramatic and probably a bit later.

As in the case of No. 461, the crispness of the impasto has been lost, apparently during relining.

463. Stormy Sea with Dolphins *c.* 1835–40
(Plate 442)

THE TATE GALLERY, LONDON (4664)

Canvas, 35¾ × 48 (91 × 102)

Coll. Turner Bequest 1856 (? 119, one of 36 each 4′0″ × 3′0″; identified 1946 by probable number on back); transferred to the Tate Gallery 1948.

Exh. New York 1966 (35); Cologne (60, repr.), Rome (61, repr.) and Warsaw (60, repr.) 1966–7; R.A. 1974–5 (501).

Lit. Davies 1946, pp. 157, 188 n. 14; Gowing 1966, p. 45.

Martin Davies suggests that this may be a sunrise scene, though a fire at sea, brighter than but analogous to *Stormy Sea with Blazing Wreck* (No. 462), is another possibility. The colour is much stronger than in most of Turner's stormy seas, as is also the case with *Slavers*, exhibited in 1840 (No. 385), but the dating is very uncertain.

464. Margate (?) from the Sea *c.* 1835–40
(Plate 443)

THE NATIONAL GALLERY, LONDON (1984)

Canvas, 36⅛ × 48¼ (91·5 × 122·5)

Coll. Turner Bequest 1856; transferred to the Tate Gallery 1949, returned to the National Gallery 1968.

Exh. Exchange loan to the Louvre, Paris, 1950–59; New York 1966 (17, repr. p. 50).

Lit. MacColl 1920, p. 29; Davies 1946, p. 154; Gowing 1966, p. 37, repr. p. 50.

The identification of the scene is likely but not definite.

465. Seascape *c.* 1835–40
(Plate 456)

THE TATE GALLERY, LONDON (5515)

Canvas, 35½ × 47⅝ (90 × 121)

Coll. Turner Bequest 1856; transferred to the Tate Gallery 1947.

Lit. Davies 1946, p. 164.

The sky was painted at two distinct periods, a largish area along the horizon (save at the right) and extending

diagonally upwards towards the top left-hand corner, with a smaller area on the right, having been added after the first layer had suffered some discoloration; the later work was probably done with a palette knife. Some of the original paint has been lost along the right-hand edge.

466. Seascape with Storm coming on *c.* 1840
(Plate 444)

THE TATE GALLERY, LONDON (4445)

Canvas, 36 × 47⅞ (91·5 × 121·5)

Coll. Turner Bequest 1856; transferred to the Tate Gallery 1938.

Exh. Amsterdam, Berne, Paris, Brussels, Liege (37), Venice and Rome (46) 1947–8; Moscow and Leningrad 1960 (54); New York 1966 (26, repr. p. 57); Paris 1972 (271, repr.); Dresden (20) and Berlin (30) 1972; Lisbon 1973 (20, repr.); R.A. 1974–5 (502); Hamburg 1976 (128, repr. and colour pl. 21).

Lit. Kitson 1964, p. 84, repr. in colour p. 69; Gowing 1966, pp. 27, 39, repr. p. 57.

As John Gage has suggested (exh. cat., Paris 1972), the centrifugal composition, with the strongest contrast of light and dark in the centre, was developed in such works as *Snow Storm: Steam-Boat off a Harbour's Mouth*, exhibited at the R.A. in 1842 (No. 398).

467. Seascape with Distant Coast *c.* 1840
(Plate 457)

THE TATE GALLERY, LONDON (5516)

Canvas, 36 × 48 (91·5 × 122)

Inscribed. 'M M N Ns T Ts' upper right. (Plate 556)
c

Coll. Turner Bequest 1856 (106, one of 36 each 4′0″ × 3′0″; identified 1946 and 1973 by chalk number on back); transferred to the Tate Gallery 1947.

Exh. R.A. 1974–5 (503).

Lit. Davies 1946, pp. 164, 188.

Cleaning in 1973 revealed that this is particularly close in style and handling to No. 466, tentatively dated *c.* 1840. The significance of the painted inscription (see Plate 556), which seems to have been done before the paint finally dried (i.e., in Turner's studio), is unclear; the nearest parallel is the set of letters inscribed down the left-hand edge of *Forum Romanum* (No. 233).
 There are some losses of paint down the right-hand edge. Traces of watercolour can be detected in the middle of the sky, and possibly in the sea as well.

468. Seascape with Buoy *c.* 1840
(Plate 458)

THE TATE GALLERY, LONDON (5477)

Canvas, 36 × 48 (91·5 × 122)

Coll. Turner Bequest 1856 (123, one of 36 each 4′0″ × 3′0″; identified 1946 by chalk number on back); transferred to the Tate Gallery 1947.

Exh. *Out of this World* Fine Arts Gallery, University of St Thomas, Houston, Texas, March–April 1964 (32); on loan to the Albright-Knox Museum, Buffalo, 1964–72.

Lit. Davies 1946, pp. 157, 188 no. 14.

Tentatively datable to *c.* 1840. The buoy was added in water-soluble paint.

469. Sun setting over a Lake *c.* 1840
(Plate 445)

THE TATE GALLERY, LONDON (4665)

Canvas, 35⅞ × 48¼ (91 × 122·5)

Coll. Turner Bequest 1856; transferred to the Tate Gallery 1947.

Exh. New York 1966 (34, repr. in colour p. 46); Dresden (19) and Berlin (29, colour pl. 16) 1972; Lisbon 1973 (19, repr. in colour).

Lit. Gowing 1966, p. 38, repr. in colour p. 46; Herrmann 1975, p. 55, colour pl. 178.

Whether the picture shows the sun setting over a lake or the sea is difficult to determine, but the presence of what appear to be mountains on the right suggests the former. If so, the picture could be a rather more dramatic and colourful variant of the theme of *Monte Rosa* (No. 519) and perhaps, like that picture, the result of a visit to Lake Maggiore in 1840 or 1841.

470. A Wreck, with Fishing Boats *c.* 1840–5
(Plate 459)

THE TATE GALLERY, LONDON (2425)

Canvas, 36 × 48⅛ (91·5 × 122)

Coll. Turner Bequest 1856 (116, one of 36 each 4′0″ × 3′0″; identified 1946 by chalk number on back); transferred to the Tate Gallery 1948.

Exh. Antwerp 1953–4; Moscow and Leningrad 1960 (55); New York 1966 (30, repr. p. 51); Paris 1972 (272).

Lit. Davies 1946, pp. 155, 188 n. 14; Gowing 1966, p. 38, repr. p. 51.

In so far as one can judge one of the later of the unexhibited paintings of stormy seas, though not quite as bold as No. 471.

471. Rough Sea *c.* 1840–45 (Plate 446)

THE TATE GALLERY, LONDON (5479)

Canvas, 36 × 48 (91·5 × 122)

Coll. Turner Bequest 1856 (104, one of 36 each
 4′0″ × 3′0″; identified by chalk number on back);
 transferred to the Tate Gallery 1947.

Exh. R.A. 1974–5 (505).

Lit. Davies 1946, pp. 158, 188 n. 14.

The original paint is missing along most of a strip about
1 in. wide down the left-hand edge. In addition, much
of the red and white in the foreground has flaked off.
Even allowing for these losses this is probably the
boldest of all the unexhibited oils of stormy seas in the
Turner Bequest; it is tempting to place it last in the
series.

472. Seascape: Folkestone *c.* 1845 (Plate 447)

LORD CLARK OF SALTWOOD, O.M., C.H.

Canvas, 34¾ × 46¼ (88·3 × 117·5)

Coll. Sir Donald Currie by 1894; by descent to his
 grandson D. J. Molteno from whom bought by
 Agnew in 1950 and sold to the present owner in 1951.

Exh. R.A. 1894 (19); Whitechapel 1953 (97); Rot-
 terdam 1955 (59); Leggatt 1960 (30); Agnew 1967
 (34).

Lit. Armstrong 1902, p. 221 where it is described as an
 unfinished canvas taken from Turner's studio.

Formerly called 'Storm off the Forelands', the sug-
gestion was made in the catalogue of Leggatt's 1960
exhibition that it may derive from studies made in the
'Folkestone' and 'Dieppe' sketchbooks (CCCLXII and
CCCLX) of *c.* 1845. Although no drawings in these
books seem to connect directly with this oil, it must
certainly date from around this time. It has con-
siderably more colour than most of the seapieces in the
Turner Bequest (e.g., Nos. 455 and 470) and the closest
picture stylistically among Turner's exhibited works is
the *Ostend* of 1844 (No. 407). A feature shared by both
pictures is the markedly green colour (reputedly
Turner's least favourite colour) of the water. News-
paper critics of the 1844 R.A. exhibition also drew
attention to the bright greens in the foreground of
Approach to Venice (No. 412) which would seem to
confirm that Turner used this colour more freely at this
time.

The absence of any history before 1894 is puzzling.
Although the type of late canvas that is usually
associated with a provenance stemming from Mrs
Booth and John Pound there is no trace of it in the
Pound sale of 1865 or any other clue to connect it with
such an origin. Although by the mid 1840s the
distinction between Turner's exhibited and un-

exhibited work had lessened to a considerable degree,
this canvas does not have the characteristics of a late
exhibited work. If, therefore, it was sold during
Turner's lifetime, it must have been bought direct from
the studio by a collector such as Gillott or Bicknell, who
were both buying Turner's work in bulk *c.* 1844. It
seems still more likely, however, that it was in some way
disposed of after Turner's death. Although we have no
record of any Turners sold in this way, that such
transactions took place is highly probable and, indeed,
the number of pictures of this general type, for which
no early records of sale exist, is now sufficiently
large to make it seem virtually certain that a group
of canvases were either stolen or sold before the
inventory of the Turner Bequest was made (see No.
509).

473. Sunrise with Sea Monsters *c.* 1845 (Plate 481)

THE TATE GALLERY, LONDON (1990)

Canvas, 36 × 48 (91·5 × 122)

Coll. Turner Bequest 1856; transferred to the Tate
 Gallery 1906.

Exh. Amsterdam, Berne, Paris, Brussels, Liege (40),
 Venice and Rome (49) 1947–8; New York 1966 (36,
 repr. in colour p. 47); Paris 1972 (275, repr.); R.A.
 1974–5 (507); Leningrad and Moscow 1975–6 (81).

Lit. MacColl 1920, p. 30; Gowing 1966, pp. 38, 48,
 repr. in colour p. 47; Brill 1969, p. 23; Reynolds
 1969, p. 198.

Nearer to the *Whalers* pictures of 1845 and 1846 (see
Nos. 414–5, 423 and 426) than to the *Slavers* of 1840
(No. 385) and therefore probably to be dated *c.* 1845.
There is a drawing of a fairly similar composition in the
'Whalers' sketchbook (CCCLIII-21) and the group of
sea monsters is also related to Turner's various studies
of fish, such as that in the Victoria and Albert Museum
(repr. in colour Butlin 1962, pl. 24). John Gage has
suggested (exh. cat., Paris 1972) that Turner's interest
in the fantastic and monstrous aspects of fish was
further suggested by 'Walk the Third: Summer—
Moonlight' in the Rev. Thomas Gisborne's *Walks in a
Forest*, published in 1795 but quoted by Turner in
connection with his *Dawn of Christianity*, exhibited in
1841 (No. 394).

474. The Beacon Light *c.* 1835–40 (Plate 460)

THE NATIONAL MUSEUM OF WALES, CARDIFF (Inventory
no. 807)

Canvas, 23½ × 36½ (59·7 × 92·7)

Coll. Mrs Booth; to her son John Pound; sale
 Christie's 25 March 1865 (197) bought Agnew; sold
 to Abel Buckley; bought back from him by Agnew in
 1868 and sold to R. Brocklebank, Haughton Hall,

Cheshire; Ralph Brocklebank sale Christie's 7 July 1922 (72) bought Blaker for Miss Gwendoline Davies who bequeathed it to Cardiff in 1952.

Exh. Liverpool 1886 (79); Guildhall 1899 (24); Arts Council 1946 (67); National Library of Wales 1946 (67); 1947 (28); 1951 (31).

Lit. Wedmore 1900, i, repr. facing p. 130; Armstrong 1902, pp. 147, 218; R. Brocklebank junior, *Pictures and Engravings at Haughton Hall, Tarporley* 1904, no. 46, repr.; Steegman 1952, p. 24 no. 89; N.M.W. catalogue 1955, p. 91 no. 807; 'Extracts from the Blaker Diary', *Apollo* 78, 1963, p. 296 (7 July 1922).

The curiously unauthentic appearance of this picture is explained if one accepts the suggestion, first proposed by Martin Butlin, that it is a fragment of a canvas which was originally 36 × 48 in., the size most frequently used by Turner. This theory is borne out by the fact that there is paint on the turnover portion of the canvas on all four sides, although to a lesser extent on the left-hand edge. In addition the picture has certainly been worked on by a hand other than Turner's, particularly in the areas of the left-hand part of the sky, falsifying the shade of blue, and around the fire which may be in the main a later addition. Finally, in the sea below and slightly to the right of the sun, a dollop of impasto has been put on in a way which is quite uncharacteristic of Turner's work. In the Pound sale of 1865 the size is given as 38 × 23 (in all cases in this catalogue the width is given first) so the truncation must have occurred early on in the picture's history.

The scene has been identified as a view of the south-east side of the Needles, near Freshwater in the Isle of Wight. This seems possible although it is difficult to be certain about it. If so, it may be based on watercolours and drawings done as early as 1795 on Turner's visit to the Isle of Wight in that year (e.g., p. 39 of the 'Isle of Wight' sketchbook (XXIV) which shows Freshwater Bay), or Turner may have had the idea for this picture on his later visit when he stayed with John Nash at Cowes in 1827 and may very well have revisited the western end of the island.

It is not easy to suggest the date of a partly reworked fragment with any certainty. Armstrong proposes *c.* 1840 which seems rather too late, although the handling suggests a dating of certainly not before 1835. The late 1830s is probably as close as one can reasonably get. As far as one can judge from its present appearance, it seems unlikely that the picture was ever of high quality.

475. Margate Harbour *c.* 1835–40 (Plate 461)

WALKER ART GALLERY, LIVERPOOL (Sudley Hall)

Canvas, $18\frac{1}{16} \times 24\frac{1}{16}$ (45.8 × 61)

Coll. Possibly Lot 198 in John Pound's sale at Christie's on 25 March 1865 as 'Off Margate Pier' 24 × 18 (the sizes were given width before height throughout the catalogue) bought Agnew; H. T.

Broadhurst; F. R. Leyland sale Christie's 9 March 1872 (72) as 'Margate Harbour' bought in; James Polak, the dealer, from whom bought in March 1872 by George Holt (1825–1896); by descent to his daughter Miss Emma Holt, who bequeathed this picture with the rest of her collection to the City of Liverpool on her death in December 1944.

Exh. R.A. 1974–5 (497).

Lit. Bennett 1964, p. 21 no. 312; Bennett and Morris 1971, pp. 72–3 no. 312, pl. 12.

As with all Turner's small pictures with titles connected with Margate, much doubt and confusion exists about its early provenance and correct title. In particular, the titles of this picture and No. 556, also at Sudley, *Emigrants embarking at Margate*, may have become transposed. Their histories are certainly far from easy to disentangle. A further complication is suggested in Christie's own catalogue of the Leyland sale in 1874 where lot 117 'Emigrants embarking at Margate' has a note added, 'cost 231 guineas at Pound's sale'. None of the pictures in the Pound sale fetched this sum but Broadhurst did pay Agnew's £231 (200 guineas + 10 per cent) for this picture (as 'Off Margate Pier') immediately after the Pound sale.

It is perhaps worth noting that this canvas has the same dimensions as Lot 200 in the Pound sale at Christie's in 1865: 'Kingsgate Pier near Margate, Emigrants landing'. The latter, which is at present untraced, would seem to be a self-contradictory title unless it can be connected with a shipwreck off Margate which occurred in 1843. If such a connection could be established, then the remote chance that it might be identified with this picture, which is just hinted at in the 1971 Holt Bequest catalogue, is diminished because a dating for this picture of before rather than after 1840 seems more convincing on stylistic grounds. The catalogue of the Turner Bicentenary Exhibition suggested *c.* 1835. However, it must be admitted that it is foolhardy to attempt too precise a dating for this kind of Turner.

None of the drawings or sketches of Margate in the Turner Bequest can be connected with the composition although the Liverpool catalogue suggests that it may have been among the works Turner painted from his Margate lodgings; the identification of the scene rests on the traditional title. Turner seems to have stayed at Margate with the Booths from the time they settled there in 1827. Mr Booth died in 1833 or 1834 but Mrs Booth stayed on at Margate until Turner took a house in Chelsea for her in 1846.

Cleaning in 1969 confirmed the authenticity of the picture, which has close affinities with *Wreckers on the Coast* (No. 477), which may also very well have been painted at Margate.

476. Off the Nore: Wind and Water *c.* 1840?

(Plate 462)

PRESENT WHEREABOUTS UNKNOWN

Canvas, 12 × 18 (30·5 × 46)

Coll. Possibly to be identified with Lot 201 in the Pound sale at Christie's 24 March 1865 as 'Squally Weather' 18 × 12 in. (sizes are given width before height throughout) bought Bicknell; H. S. Bicknell sale Christie's 9 April 1881 (460 as 'Squally Weather') bought Johnston; anon. sale (but Christie's own catalogue identifies the vendor as Johnston) 12 December 1898 (137) bought Leggatt; bought from Leggatt by Agnew in 1899 and sold to P. Westmacott from whom repurchased by Agnew in 1901; James Orrock; sale Christie's 4 June 1904 (141) bought R. Smith; no subsequent history is known.

Exh. Guildhall 1899 (29).

Lit. Armstrong 1902, p. 230, repr. facing p. 161; Charles Holme, 'The Genius of J. M. W. Turner R.A.', *Studio* 1903, colour pl. facing p. o xii as 'A Seapiece' and dated *c.* 1842.

From the illustrations in Armstrong and Holme, it is not possible to judge the quality and authenticity of this picture, but if it can be traced with certainty back to Pound's collection its chances of being genuine are much enhanced. A final answer will only be forthcoming when and if the painting itself reappears.

Similarly, the absence of a recent photograph makes it very hard to suggest a date with certainty, but stylistic affinities with Mr and Mrs Paul Mellon's *Waves breaking on the Shore* (No. 482) at least make Armstrong's suggestion of *c.* 1840 seem reasonably convincing.

477. Wreckers on the Coast: Sun rising through Mist *c.* 1835–40 (Plate 482)

PRIVATE COLLECTION

Canvas, 14 × 21¾ (35·5 × 52·25)

Coll. Mrs Booth; John Pound (her son by her first marriage); sale Christie's 24 March 1865 (202) described as 'WRECKERS—early morning' 21½ × 14 (all sizes are given width before height in this sale catalogue) bought Vokins; Sir Donald Currie (1825–1909); by descent to his granddaughter Mrs M. D. Fergusson from whom bought by Agnew's 1971; Mr and Mrs Patrick Gibson 1972; sold on their behalf by Agnew to the present owner 1974.

Exh. Agnew 1967 (26).

The identification of this unpublished picture with Lot 202 in the Pound sale of 1862 seems reasonably certain and the scene may very well be the coast in the vicinity of Margate as the sale contained a number of Margate subjects. This was presumably one of the canvases given by the artist to Mrs Booth and was perhaps painted while he was lodging with her at Margate, before she and her son moved to Chelsea in 1846, where she kept house for Turner at 119 Cheyne Walk.

The problem of dating is similar to *Margate Harbour* No. 475, with which it has close stylistic connections. Dated *c.* 1840 in the 1967 Agnew exhibition catalogue, this still seems reasonably convincing although it is possible that it may be a year or two earlier. The catalogue of the Turner Bicentenary Exhibition dated *Margate Harbour c.* 1835. It is certainly foolhardly to attempt to date these canvases too exactly and therefore probably *c.* 1835–40 for both pictures is the most acceptable suggestion.

478. Morning after the Wreck *c.* 1835–40

(Plate 483)

THE NATIONAL MUSEUM OF WALES, CARDIFF (Inventory no. 806)

Canvas, 15 × 24 (38 × 61)

Coll. Mrs Booth to her son by her first marriage, John Pound (? sale Christie's 24 March 1865, 204 as 'Off Margate—Hazy Morning'); M. T. Shaw; sale Christie's 20 March 1880 (102) bought Vokins; bought from Messrs. Dowdeswell in 1910 by Miss Gwendoline Davies and bequeathed by her to the National Museum of Wales in 1952.

Exh. National Museum of Wales 1913 (24); National Library of Wales 1947 (27) and 1951 (34); Whitechapel 1953 (92); Agnew 1967 (22); R.A. 1974–5 (323).

Lit. Steegman 1952, p. 24 no. 88; N.M.W. catalogue 1955, p. 91 no. 806.

The provenance given above is partly conjectural; the early history is uncertain as with so many of the pictures with the Mrs Booth–John Pound provenance because titles and sizes (where given) have become inextricably confused.

In John Pound's sale at Christie's on 24 March 1865 Lot 199, entitled 'Morning after the Wreck' (incorrectly described as a drawing by Graves, *Art Sales* iii 1921, p. 224) was bought by Shaw but the measurements are given as 19 × 13 in. The only picture in the Pound sale with the same dimensions as this picture was called 'Off Margate—Hazy Morning' but it was bought by Bicknell and not by Shaw. This was not resold again until the H. S. Bicknell sale at Christie's 9 April 1881 (461) where it was (again incorrectly) described by Graves as a drawing 15 × 24 and was bought by J. Lloyd for 130 guineas (see also No. 555, also now at Cardiff). Unfortunately, no measurements are given in the catalogue of the Shaw sale in 1880 but according to Graves Lot 102 came from Mrs Pounds' (*sic*) sale.

The dating also presents problems. In the catalogue of the Agnew 1967 exhibition, I proposed a date of 'perhaps not much before 1840'. In the Turner Bicentenary Exhibition catalogue, however, it was dated 1827–30 and a comparison suggested with the Cowes sketches of 1827. However, when hung on the same wall in the exhibition as the Cowes sketches, the Cardiff picture was clearly seen to be later and the dating on the exhibition label was altered to *c.* 1835. Certainly this picture has close affinities stylistically to the *Margate Harbour* at Liverpool (see No. 475) which hung beside it at the Bicentenary Exhibition and which was dated there *c.* 1835. Although it is the kind of Turner that is most difficult to date with precision, I believe both this and the Liverpool picture to have been painted *c.* 1835–40.

479. Off Ramsgate (?) *c.* 1840 (Plate 484)

THE GOVERNING BODY OF RUGBY SCHOOL

Canvas, 12¼ × 19 (31·1 × 48·3)

Coll. Mrs Booth, and from her to her son by her first marriage, John Pound; sale Christie's 25 March 1865 (205) as 'View off Margate—Evening' (18 × 12 in. but sizes are given width before height throughout this catalogue), bought Agnew; sold to W. J. Holdsworth in 1866; bought back from him by Agnew in January 1881 and sold to Dr T. W. Jex Blake in December as 'Breeze off Margate'; Dr Jex Blake (1832–1915) became headmaster of Rugby in 1874 and founded the Rugby School Art Museum in 1878. Although there is no evidence as to the date that he gave the picture to the school, it seems likely that he did so on leaving Rugby in 1887.

Unpublished and never publicly exhibited, this picture belongs to the same group of coast scenes as No. 478 in Cardiff and No. 475 in Liverpool, although its extreme freedom of handling suggests that it may be rather later in date, perhaps *c.* 1840.

There is no evidence as to when the title was altered from *Margate* to *Off Ramsgate* which is now inscribed on the gold flat inside the frame, but presumably there was good reason for this, although positive identification of such a sketchy view seems difficult. A former Curator of the Rugby School pictures pointed out that if the hulk in the distance is on the Goodwin Sands, as seems possible, these are visible from Ramsgate but not from Margate. No doubt Margate titles were attached to all the Booth/Pound pictures of this kind because Mrs Booth lived in Margate.

480. The Storm *c.* 1840–45 (Plate 463)

THE NATIONAL MUSEUM OF WALES, CARDIFF (Inventory no. 972)

Canvas, 12¾ × 21½ (32·4 × 54·5)

Coll. A label on the back states that this and the companion picture (see No. 481) were given by the artist to Mrs Pounds (*sic*) (i.e., Mrs Booth) and that it was bought from her daughter by Agnew for S. G. Holland (Agnew's stock-book records this transaction on 13 July 1897 and repeats the spelling as 'Pounds'. She must have been either John Pound's widow or daughter-in-law, and may possibly be identified with the Mrs M. A. Pound who gave Turner's palette to Alfred Austin according to an annotated copy, at present on loan to the Tate Gallery, of Christie's catalogue for 11 June 1909, when Nos. 483 and 484 were also sold); S. G. Holland sale 25 June 1908 (112) bought Knoedler presumably jointly with Colnaghi who sold it to Miss Margaret Davies in November 1908 (Hugh Blaker, who was the Misses Davies' adviser about their collection, underbid the picture at the sale); bequeathed by her to the National Museum of Wales 1963.

Exh. Birmingham 1899 (3); Guildhall 1899 (27); National Museum of Wales 1913 (26); National Library of Wales 1951 (32).

Lit. Armstrong 1902, pp. 147, 150–51, 231, repr. p. 213; Holmes 1908, pp. 17–25, pl. 1; Falk 1938, pp. 237, 238, repr.; J. A. S. Ingamells, *Catalogue of the Margaret S. Davies Bequest* 1963, p. 7 no. 7.

Another label on the back states 'Said to have been painted by Turner during the great storm which raged on the day on which the Princess Royal was born, Nov. 21 1840.' It is impossible to know how much this story can be relied upon but it is certainly a theme which would have appealed to Turner and, even if he was not himself on the coast (at Margate?) on the night of the storm, he may easily have painted these two pictures from eye-witness accounts.

Although the two 'Storm' pictures are not considered genuine by some authorities, including Lawrence Gowing and Martin Butlin, but rather to be pastiches of motifs from Turner's exhibited pictures such as *The Slave Ship* (No. 385) or *Wreckers* (No. 357), over-full of incident and displaying a technique unlike Turner's, especially in the painting of the sky, the compiler accepts them as by Turner. A careful study of them reveals a number of similarities with other Turners of the 1840s—with the whaling pictures, No. 426 for instance, but more particularly with the *Yacht approaching the Coast* (No. 461), and the *Stormy Sea with Blazing Wreck* (No. 462), both of *c.* 1835–40. In the latter, the painting of the water, the wreckage and the approaching fishing boat come close to this picture, allowing for the difference in scale, and the overall surface texture is also markedly similar.

Both these pictures have suffered from being flattened by too harsh a relining in the past but it also seems possible that Turner worked on the canvases again very late in his life if, indeed, they were originally painted as early as 1840. They show some evidence of a rather dry, unspontaneous handling which may be

characteristic of Turner's last years. There is little firm evidence for analysing this style but these two oils have something in common with the very late watercolour *The Descent of the St Gothard* (private collection, England; exhibited Agnew 1967 (96)) which is almost certainly the drawing made for Ruskin and, if so, is documented to 1848 (repr. in John Russell and Andrew Wilton *Turner in Switzerland* p. 129).

481. The Day after the Storm *c.* 1840–45 (Plate 485)

THE NATIONAL MUSEUM OF WALES, CARDIFF
(Inventory no. 810)

Canvas, 12 × 21 (30·5 × 53·3)

Coll. Identical history to No. 480 until 1908 when it was sold by S. G. Holland at Christie's 25 June (113) bought Colnaghi who sold it in the same year to Miss Gwendoline Davies (Hugh Blaker, who helped the Davies sisters form their collection, underbid both the 'Storm' pictures at the Holland sale and was no doubt acting on their behalf at the time); bequeathed by Gwendoline Davies to the National Museum of Wales, 1952.

Exh. Birmingham 1899 (4); Guildhall 1899 (28); National Museum of Wales 1913 (28); National Library of Wales 1951 (30).

Lit. Armstrong 1902, pp. 147, 231, repr. facing p. 121; Holmes 1908, pp. 17–25, pl. 2; Falk 1938, pp. 237, 238, repr.; Steegman 1952, p. 24 no. 92; N.M.W. catalogue 1955, p. 92 no. 810.

For the storm which is said to have inspired this and the companion picture, and for the dating and authenticity of the two pictures, see the entry for No. 480.

482. Waves breaking on the Shore *c.* 1840

(Plate 464)

YALE CENTER FOR BRITISH ART, PAUL MELLON COLLECTION

Canvas, 17½ × 25 (44·5 × 63·5)

Coll. Mr and Mrs Franklin MacVeagh of Chicago, who bought the picture in England in 1889; bought from Mrs MacVeagh's daughter-in-law in Washington in 1961 by Agnew; sold to Mr Paul Mellon in 1962.

Exh. Richmond 1963 (136, colour pl. 192); R.A. 1964–5 (163); Yale 1965 (192); Agnew 1967 (23); Washington 1968–9 (15).

Lit. Amelia Gere Mason, *Memoirs of a Friend* Chicago 1918, which quotes a letter written to the author from Mrs MacVeagh in August 1889: 'I found some fine old things for the house, too, in England. We bought two beautiful pictures, one a coast scene in oil by J. M. W. Turner . . . wasn't that a find?'

No history for this picture can be discovered before 1889, although it is the kind of canvas which has come to be associated with the Mrs Booth and John Pound collection. As it was certainly not in the Pound sale at Christie's in March 1865, it seems possible that Pound disposed of a group of Turners privately either before or after this date and that this picture was among them, but so far there is no evidence to support this theory.

This is a subject which had a special fascination for Turner for he painted it in oil and watercolour throughout his life. Therefore a precise dating is not easy but the rather more adventurous colouring suggests that it is later than the Tate Gallery's *Waves breaking against the Wind* and *Waves breaking on a Lee Shore* (Nos. 457 and 458) now dated *c.* 1835.

There are close parallels with *Waves breaking on a Shore* (No. 459), of similar size in the Tate Gallery which is now dated *c.* 1835—but was formerly dated *c.* 1840—and certain affinities in colouring, especially in the greens, with Lord Clark's late seascape *Folkestone* (No. 472) suggest that a dating of close to 1840 is the most likely. The painting of the water is also close to that in *Europa and the Bull* (No. 514) which almost certainly dates from 1835–40.

483. Off Deal *c.* 1835 (Plate 465)

NATIONALMUSEUM, STOCKHOLM

Millboard, 8½ × 11¾ (21·5 × 29·8)

Coll. As with No. 484 said to have been given by Turner to Mrs Booth, and by her son by her first marriage, John Pound, to Mrs M. A. Pound who in turn gave it to A. Austin, who sent it anonymously for sale at Christie's, 11 June 1909 (190) bought Dowdeswell, from whom bought by Miss Margaret Davies probably in 1910 at the same time that her sister Gwendoline bought No. 484; Miss Margaret Davies sale, Sotheby's 24 February 1960 (93) bought Matthiessen Gallery from whom bought by the Nationalmuseum, Stockholm, 1960 (inventory no. 5526).

Exh. National Museum of Wales 1913 (29); National Library of Wales, 1951 (36).

Lit. Nationalmuseum Stockholm *Annual Report* 1961, no. 85.

It seems reasonable to infer that this was considered at any rate not certainly authentic when it appeared in the saleroom in 1960 as it brought a very low price (£800). The compiler certainly had doubts about it at that time and these doubts were shared by Martin Butlin when he saw the sketch in Stockholm in the early 1960s.

However, *Off Deal* was sold at auction before the discovery among the Turner Bequest in the British Museum of a group of oil-sketches on cardboard or millboard, two of which are of similar dimensions to this sketch (Nos. 485–6). The British Museum sketches were exhibited in the Print Room in 1962 and close stylistic affinities were revealed between some of them

and the sketches in Cardiff and Stockholm. Although No. 484 in Cardiff is perhaps of slightly higher quality, a recent visit to Stockholm by the compiler has confirmed that the two pictures are clearly by the same hand. The Stockholm picture can therefore be accepted as genuine without reservations. For the question of its dating, see the entry for No. 484.

484. A Sailing Boat off Deal *c.* 1835 (Plate 486)

THE NATIONAL MUSEUM OF WALES, CARDIFF (Inventory no. 811)

Millboard, 9 × 12 (23 × 30·5)

Coll. Identical history to No. 483 until sold at Christie's, 11 June 1909 (191) bought Dowdeswell, from whom bought by Gwendoline Davies 1910; bequeathed by her to the National Museum of Wales in 1952.

Exh. National Museum of Wales 1913 (25); National Library of Wales 1951 (35); Whitechapel 1953 (95); R.A. 1974–5 (324).

Lit. *Connoisseur* xxiv 1903, p. 259; Steegman 1952, p. 25 no. 93; N.M.W. catalogue 1955, p. 92 no. 811.

On the same type of millboard and the same size as Nos. 485 and 486.

In the catalogue of the Turner Bicentenary Exhibition this picture was dated 1827–30 and compared to the oil sketches on millboard discovered in the 1950s in the British Museum (see Nos. 485–500). Comparison with the examples shown at the exhibition, however, seemed to show only superficial similarities, but as this picture was hung in the same room as the sketches of yachts in the Solent of 1827 (Nos. 260–2) comparison with them was easy. This seemed to me to show that this picture was definitely later in date: the technique was looser and the horizon was obscured by mist and spray in a way that was quite different either to the

Cowes sketches or to the way in which the distance was painted in the 1827 exhibited pictures such as '*Now for the Painter*' (No. 236) or *East Cowes Castle: the Regatta bearing to Windward* (No. 242). In the same room in the exhibition hung the *Margate Harbour* from Liverpool (No. 475), there dated *c.* 1835, and this seemed to have a good deal in common with the *Sailing Boat off Deal* which also, I would suggest, belongs to the mid 1830s. This approximate dating is now accepted by Martin Butlin.

485. Riders on a Beach *c.* 1835 (Plate 466)

THE BRITISH MUSEUM, LONDON (1972.U.745)

Millboard, 9 × 12 (23 × 30·5)

Coll. Turner Bequest 1856.

Exh. Tokyo and Osaka (repr.) and Hong Kong 1973–4 (9).

This painting and No. 486 are from the parcel of oils on millboard found unnumbered among the works from the Turner Bequest transferred from the Tate Gallery to the British Museum in 1931, but differ from the fourteen other sketches from that parcel, Nos. 487–500, in being executed on a smoother, thicker type of millboard. In this way they resemble *A Sailing Boat off Deal* (No. 484), which is also of the same size, and they presumably date from the same time, though perhaps slightly earlier than the *c.* 1835 proposed by Evelyn Joll.

486. Shore Scene with Waves and Breakwater
c. 1835 (Plate 467)

THE BRITISH MUSEUM, LONDON (1974.U.850)

Millboard, 9 × 12 (23 × 30·5)

Coll. Turner Bequest 1856.

See No. 485.

Nos. 487–500: Sketches of Coast and other Scenes, *c.* 1840–45?

THESE fourteen sketches on millboard were discovered in the early 1960s in a parcel among the works from the Turner Bequest transferred from the Tate Gallery to the British Museum in 1931; they had not been numbered or included in Finberg's 1909 *Inventory*. They fall into three groups according to size, approx. $10\frac{1}{2}$ × 12 in., $9\frac{3}{4}$ × $13\frac{1}{2}$ in. and 12 × 19 in., but form a homogeneous group technically and stylistically. Two further sketches from the same parcel are distinct in style, technique and the type of millboard used (see Nos. 485 and 486). *Ship in a Storm* (No. 489) is close in composition to *Snow Storm—Steam-Boat off a Harbour Mouth*, exhibited in 1842 (see No. 398), while others from the group such as *Sunset seen from a Beach with Breakwater* (No. 497) are the equivalent in oils of very late watercolours such as those in the 'Ambleteuse and Wimereux'

sketchbook of 1845 (CCCLVII). However, compositional resemblances help very little in dating Turner's late works and comparison between works in different media is equally fruitless.

Thirteen unspecified sketches from Nos 485–500 were first exhibited at the British Museum in 1962 (see under 'Lit.' below).

Lit. *Sketch Books and Albums of Drawings, German Gothic and Renaissance Prints: Oil Sketches by J.M.W. Turner. Exhibition held in the Department of Prints and Drawings* 1962; 'British Museum: Rediscovered Oil Sketches by J.M.W. Turner', *Illustrated London News* 10 March 1962, p. 371.

487. Coast Scene with Buildings *c.* 1840–45?
(Plate 487)

THE BRITISH MUSEUM, LONDON (1972.U.738)

Millboard, irregular, 12 × 18¾ (30·5 × 47·5)

Coll. Turner Bequest 1856.

Exh. R.A. 1974–5 (469, repr.).

Similar in technique and support to the rest of this group and, though dated rather earlier than the rest when exhibited in 1974–5, almost certainly contemporary with them. Although the composition, with its architectural features, is comparable to some of the sketches on coarse canvas probably painted at Rome in 1828 (see Nos. 302–17), the paler tonality supports a later dating.

488. Red Sky over a Beach *c.* 1840–45? (Plate 488)

THE BRITISH MUSEUM, LONDON (1972.U.746)

Millboard, irregular, 11¹⁵⁄₁₆ × 18⅞ (30·5 × 48)

Coll. Turner Bequest 1856.

Exh. Tokyo and Osaka (repr.) and Hong Kong 1963–4 (11).

489. Ship in a Storm *c.* 1840–45? (Plate 468)

THE BRITISH MUSEUM, LONDON (1972.U.739)

Millboard, irregular, 11⅞ × 18¾ (30 × 47·5)

Coll. Turner Bequest 1856.

Exh. Tokyo and Osaka (repr.) and Hong Kong 1963–4 (10); R.A. 1974–5 (498).

Similar in composition to *Snow Storm—Steam-Boat off a Harbour's Mouth*, exhibited in 1842 (see No. 398) but not necessarily actually used as a sketch for that picture.

490. Calm Sea with Distant Grey Clouds
c. 1840–45? (Plate 469)

THE BRITISH MUSEUM, LONDON (1972.U.743)

Millboard, irregular, 11⅞ × 19 (30 × 48)

Coll. Turner Bequest 1856.

491. Coast Scene with Breaking Waves
c. 1840–45? (Plate 470)

THE BRITISH MUSEUM, LONDON (1972.U.741)

Millboard, irregular, 11⅝ × 19⅛ (29·5 × 48·5)

Coll. Turner Bequest 1856.

492. Sea and Sky? *c.* 1840–45? (Plate 471)

THE BRITISH MUSEUM, LONDON (1972.U.740)

Millboard, irregular, 11¾ × 18⅛ (30 × 46)

Coll. Turner Bequest 1856.

The supposed sea is a yellowish cream colour and there are patches of blue and grey in the sky.

493. Sand and Sky? *c.* 1840–45? (Plate 472)

THE BRITISH MUSEUM, LONDON (1972.U.742)

Millboard, irregular, 11¹³⁄₁₆ × 18⅞ (30 × 48)

Coll. Turner Bequest 1856.

The presumed sky is off-white, while the foreground consists of two shades of a warm buff.

494. Yellow Sky? *c.* 1840–45? (Plate 473)

THE BRITISH MUSEUM, LONDON (1972.U.744)

Millboard, irregular, 11⅞ × 18¾ (30 × 47·5)

Coll. Turner Bequest 1856.

This picture consists of bands of varying yellow tones and may be just a study in colour relationship or a lay-in for further development, perhaps as a sketch of sand and sky like No. 493.

495. Coast Scene *c.* 1840–45? (Plate 474)

THE BRITISH MUSEUM, LONDON (1974.U.851)

Millboard, irregular, 10⅝ × 11¹⁵⁄₁₆ (27 × 30·5)

Coll. Turner Bequest 1856.

496. Figures on a Beach *c*. 1840–45? (Plate 475)

THE BRITISH MUSEUM, LONDON (1974.U.852)

Millboard, irregular, 10-3/16 × 11-3/4 (26 × 30)

Coll. Turner Bequest 1856.

497. Sunset seen from a Beach with Breakwater
c. 1840–45? (Plate 489)

THE BRITISH MUSEUM, LONDON (1974.U.848)

Millboard, irregular, 9-3/4 × 11-7/8 (25·8 × 30)

Coll. Turner Bequest 1856.

Exh. R.A. 1974–5 (500).

498. Sailing Boat in a Rough Sea *c*. 1840–45?
 (Plate 476)

THE BRITISH MUSEUM, LONDON (1972.U.748)

Millboard, irregular, 10-1/2 × 11-15/16 (26·5 × 30·5)

Coll. Turner Bequest 1856.

499. Two Figures on a Beach with a Boat
c. 1840–45? (Plate 477)

THE BRITISH MUSEUM, LONDON (1972.U.747)

Millboard, irregular, 9-5/8 × 13-5/8 (24·5 × 34·5)

Coll. Turner Bequest 1856.

Exh. Tokyo, Osaka and Hong Kong 1963–4 (8, repr. in
colour); R.A. 1974–5 (499).

500. Waves breaking on a Beach *c*. 1840–45?
 (Plate 478)

THE BRITISH MUSEUM, LONDON (1974.U.849)

Millboard, irregular, 9-3/4 × 13-1/2 (25 × 34·5)

Coll. Turner Bequest 1856.

Nos. 501–32: Miscellaneous

**501. Venice, the Piazzetta with the Ceremony of
the Doge marrying the Sea** *c*. 1835 (Plate 490)

THE TATE GALLERY, LONDON (4446)

Canvas, 36 × 48 (91·5 × 122)

Coll. Turner Bequest 1856 (136, one of 36 each
4′0″ × 3′0″; identified 1946 by chalk number on
back); transferred to the Tate Gallery 1948.

Exh. Rotterdam 1955 (58); New York 1966 (12, repr.
p. 36); Edinburgh 1968 (8).

Lit. Davies 1946, pp. 156, 188 n. 14; Gowing 1966,
p. 36, repr.; Herrmann 1975, p. 47, pl. 156.

Formerly given a solely topographical title, this picture
has been identified by Lawrence Gowing as a work in
progress on the subject of the Doge symbolically
marrying the Adriatic, which Turner could have known
from sixteenth- and seventeenth-century Venetian
examples. Turner seems to have abandoned the picture
at the moment of drastically altering the roof-line of the
Doge's Palace on the right.

Tentatively datable to the mid 1830s on account of its
relatively strong colouring and thickly applied paint. In
addition, Turner seems to have abandoned his standard
3 ft by 4 ft format for Venetian exhibits after 1836, but
see Nos. 505 and 506.

502. Venice with the Salute *c*. 1840–45 (Plate 491)

THE TATE GALLERY, LONDON (5487)

Canvas, 24-1/2 × 36-1/2 (62 × 92·5)

Coll. Turner Bequest 1856 (145, one of 2 each
3′0-1/2″ × 2′0-1/2‴ with No. 503; identified 1946 by chalk
number on back); transferred to the Tate Gallery
1947.

Exh. R.A. 1974–5 (536); Leningrad and Moscow
1975–6 (68).

Lit. Davies 1946, pp. 159, 188.

Turner exhibited no fewer than eighteen small
Venetian scenes of this size at the R.A. between 1840
and 1846. Nos. 502 and 503, both from the Turner
Bequest and only recently revealed by cleaning, are
presumably lay-ins for further works for exhibition.
No. 502 seems to show S. Maria della Salute seen along
the Grand Canal from near the present Academia
bridge; another view of the Salute, from the opposite
direction, was one of the 1844 exhibits (No. 411).

There are losses, now restored, about 1 in. wide
down the left-hand side and about 1/4 in. along parts of
the bottom edge.

503. Scene in Venice *c*. 1840–45 (Plate 479)

THE TATE GALLERY, LONDON (5488)

Canvas, 24-1/2 × 36-1/2 (62 × 92·5)

Coll. Turner Bequest 1856 (144, one of 2 each
3′0-1/2″ × 2′0-1/2‴ with No. 502; identified by chalk
number on back); transferred to the Tate Gallery
1947.

Exh. R.A. 1974–5 (537); Leningrad and Moscow
1975–6 (69).

Lit. Davies 1946, pp. 159, 188.

Repr. *Connoisseur* clxxxvii 1974, p. 192 in colour,
before and after cleaning and with detail.

See No. 502. The scene appears to be a view on the

Grand Canal but it has not been possible to identify the view precisely.

There are irregular paint losses down the left-hand edge, now restored. Impressed rectilinear lines of dirt, also now removed or concealed by restoration, show that other pictures were leant against this one while the paint was still wet.

504. Venetian Scene *c.* 1840–45 (Plate 492)

THE TATE GALLERY, LONDON (5482)

Canvas, $31\frac{1}{4} \times 31$ (79·5 × 79)

Coll. Turner Bequest 1856 (158, one of 2 each $2'7\frac{1}{4}'' \times 2'7''$ with No. 532; identified 1946, ?by chalk number on back); transferred to the Tate Gallery 1947.

Lit. Davies 1946, pp. 158, 188.

An unfinished Venetian scene with the square format and vortex-like composition of a number of Turner's works of the 1840s (e.g. Nos. 404–5), similar in its impression of a procession of boats to No. 505. For what was possibly a projected companion see No. 532.

There are paint losses, now restored, all down the right-hand edge, though mainly only in a narrow strip.

505. Procession of Boats with Distant Smoke, Venice *c.* 1845 (Plate 493)

THE TATE GALLERY, LONDON (2068)

Canvas, $35\frac{1}{2} \times 47\frac{1}{2}$ (90 × 120·5)

Coll. Turner Bequest 1856; transferred to the Tate Gallery 1906.

Exh. Hamburg, Oslo, Stockholm and Copenhagen 1949–50 (101); Toronto and Ottawa 1951 (11); Australian tour 1960 (14, repr. in colour); New York 1966 (31); Dresden (3) and Berlin (4) 1972.

Lit. MacColl 1920, p. 36; Davies 1946, p. 185; Rothenstein and Butlin 1964, p. 64, pl. 119.

This was formerly called 'The Burning of Ships', and was identified by MacColl as possibly 'Some historical scene of naval warfare ... or a vague recollection of the incident in the Iliad, which was the subject of a picture by Claude, or again, of the burning of Æneas' ships by Turnes ... In the foreground to the left are galleys crowded with men.' However, the subject is more likely to be a Venetian one; *c.f.* particularly the clusters of boats and gondolas in some of the exhibits of 1844 and 1845 (e.g. Nos. 411, 417, 421 and 422). The picture seems to date from the mid 1840s and is in Turner's standard 3 ft by 4 ft size, which, however, he abandoned for his exhibited Venetian oils after 1836.

506. Festive Lagoon Scene, Venice? *c.* 1845
 (Plate 480)

THE TATE GALLERY, LONDON (4660)

Canvas, $35\frac{3}{4} \times 47\frac{3}{4}$ (91 × 121)

Coll. Turner Bequest 1856; transferred to the Tate Gallery 1938.

Exh. New York 1966 (32, repr. in colour p. 35); Wildenstein's 1972 (57, repr.); R.A. 1974–5 (538).

Lit. Herrmann 1975, p. 47, colour pl. 147.

Similar to No. 505. This example is typical of a number of Turner's later works in the way in which the spectator is drawn into the picture between serried rows of staring faces, running the gauntlet, as it were, of the frenzied inhabitants of Turner's imaginative world. It was formerly called 'After the Ball(?)'.

507. Riva degli Schiavone, Venice: Water Fete *c.* 1845 (Plate 494)

THE TATE GALLERY, LONDON (4661)

Canvas, $28\frac{3}{8} \times 44\frac{1}{4}$ (72 × 112·5)

Coll. Turner Bequest 1856 (? 138 or 139, 2 each $3'9'' \times 2'4\frac{1}{2}''$); transferred to the Tate Gallery 1938.

Exh. Paris 1953 (86).

Companion to No. 508 and like it similar in style to the rather larger Nos. 505 and 506.

This picture is so thickly painted that it may have been executed over another composition.

508. Venetian Festival *c.* 1845 (Plate 513)

THE TATE GALLERY, LONDON (4659)

Canvas, $28\frac{1}{2} \times 44\frac{5}{8}$ (72·5 × 113·5)

Coll. Turner Bequest 1856 (? 138 or 139, 2 each $3'9'' \times 2'4\frac{1}{2}''$), transferred to the Tate Gallery 1938.

Exh. Australian tour 1960 (16); Tokyo and Kyoto 1970–71 (46, repr.); Dresden (21) and Berlin (31, colour pl. 22) 1972; Lisbon 1973 (21, repr. in colour).

Lit. Rothenstein and Butlin 1964, p. 64.

Companion to No. 507, *q.v.* Formerly called 'Venice, after the Ball'.

509. Landscape with a River and a Bay in the Distance *c.* 1835–40 (Plate 495)

MUSÉE DU LOUVRE, PARIS

Canvas, $37 \times 48\frac{1}{2}$ (94 × 123)

Coll. Camille Groult (*d.* 1907), Paris by 1890; by

descent to his grandson, M. Pierre Bordeaux-Groult, from whom purchased by the Louvre in 1967 (Accession no. RF 1967-2).

Exh. Paris 1894 (?); Paris, *Vingt ans d'acquisitions au Musée du Louvre* 1967–8 (387); Paris 1972 (267); R.A. 1974–5 (620).

Lit. E. de Goncourt *Journal* 18 January 1890; Gage 1969, p. 192; Kitson 1969, pp. 247–56, repr. in colour; Kitson 1971, pp. 89–94.

Without any reasonable doubt to be identified with the picture enthusiastically described by Edmond de Goncourt in his *Journal* when he spent 'Un après-midi devant les tableaux anglais de Groult'.

This may be one of the Turners mentioned by Camille Pissarro, in a letter to his son written in June 1894, as being in an exhibition in Paris ... 'an exhibition of the English School is being held; some superb Reynolds, several very beautiful Gainsboroughs, two Turners belonging to Groult which are quite beautiful ...' (see also No. 520). For the exhibition in Paris, see No. 375.

This picture belongs to a series of canvases, probably painted about 1835 or shortly afterwards, most of which are connected—some more closely than others—with engravings published in the *Liber Studiorum* many years before. In this case, the 'Junction of the Severn and the Wye' (Rawlinson 28), published in 1811, has served as the basis for this oil, although Chepstow Castle has been omitted from the picture and the composition has in general been very much simplified. Turner's purpose in painting this series (none of which was exhibited during his lifetime) is unclear, but it seems possible that, having made up his mind to leave his pictures to the nation, Turner wished to include a cross-section of examples of his late style in his bequest, and that this series formed a part of a project which (like the *Liber Studiorum*) he never completed.

A suggestion, made by Professor Lawrence Gowing, that Turner painted this series as a trial run to see if such 'sketchy' pictures were marketable, opens up another avenue of speculation about the whole group but, if this was Turner's purpose, it would seem to have failed, as not a single picture in the series is known to have been sold during the artist's lifetime. Another and perhaps rather more plausible explanation has been proposed by Professor Jerrold Ziff in a paper he read to the Turner Symposium held at Johns Hopkins University, Baltimore in April 1975. Professor Ziff suggested that, although towards the end of his life Turner appeared to become increasingly preoccupied with images of disaster such as fire, avalanche and storm, this group of oils, mostly based on subjects classified as 'EP' (which probably stands for 'Elevated Pastoral') in the *Liber*, shows that Turner still felt that there was a place for the idyllic in the repertoire of a landscape painter. Thus Turner may have intended the group to stand as a reaffirmation of his faith in Nature in her more tranquil moods.

How the pictures left Turner's studio is another unsolved mystery. Two of the series (Nos. 511 and 513) were sold at Christie's in 1865 from the collection of John Pound, the son by her first marriage of Mrs Sophia Caroline Booth, Turner's mistress and housekeeper in Chelsea. Turner had presumably given these pictures either to her or to her son, but none of the others in the series can be traced to the Booth/Pound collection. There remains the possibility that they were among approximately eighty pictures which were rejected from the Turner Bequest by the National Gallery in 1856 on the grounds that they were not genuine. Against this suggestion must be weighed both the fact that these exclusions were made by Sir Charles Eastlake, a friend of Turner's who knew his work well, and also that he accepted as part of the Bequest a number of canvases which were still less 'finished' than those in this series. Nor can these works be identified in the Inventories of 1854 and 1856, which listed all the works in Turner's possession when he died, whether by him or not. They may simply have remained as a parcel of unstretched canvases, perhaps rolled up together, and have been removed from Turner's studio (Stefan Slabczynski, former Keeper of Conservation at the Tate Gallery, who cleaned this picture for the Louvre, reported that it had formerly been rolled as had others of the group). A letter written by Effie Ruskin to her mother on 24 August 1852, telling her that Ruskin had renounced the executorship of Turner's Will as he was sickened by all the dispute over it, continued ' ... Certain it is that already Turner's lawyer has *stolen* a bag of drawings', which makes it sound as if the studio was open to pilfering of this kind.

510. The Falls of the Clyde *c.* 1835–40 (Plate 496)
THE LADY LEVER ART GALLERY, PORT SUNLIGHT, CHESHIRE

Canvas, 35 × 47 (89 × 119·5)

Coll. The Rev. Thomas Prater; sale Christie's 6 May 1871 (128) bought Campbell; Sir Hugh H. Campbell sale Christie's 2 May 1874 (125) bought Agnew from whom bought by William Houldsworth; sale Christie's 23 May 1891 (58) bought Agnew for Joseph Ruston of Monk's Manor, Lincoln; sale Christie's 21 May 1898 (53) bought Wallis; Sir Joseph Robinson, Bt; sale Christie's 6 July 1923 (29) bought Tooth from whom bought by Lord Leverhulme in September 1923.

Exh. Glasgow 1888 (335); Leggatt 1960 (not in catalogue); Tate Gallery 1973–4 (218); R.A. 1974–5 (621).

Lit. Bell 1901, p. 43; Armstrong 1902, p. 220; Gage 1969, pp. 41, 126, 143 ff., 254 n. 250, colour pl. 17; Kitson 1971, pp. 91 ff., fig. 3; Clark 1973, p. 246, pl. 187.

There has been a good deal of confusion over the

provenance of this picture due to the fact that both Bell and Armstrong state that there are two oil paintings of the subject:

> 1. Prater sale 1871 bought Sir H. Campbell; Campbell sale 1874 bought Agnew (35 × 47 in.);
>
> 2. Mrs Booth sale 1864 bought Vokins; William Houldsworth sale 1891 bought Agnew; Joseph Ruston sale 1898 bought Wallis; H. C. Frick of Pittsburgh (33 × 47 in.).

As the Campbell picture sold in 1874 passed via Agnew's into the Houldsworth collection, it appears that the provenance has got split into two and that in fact only one picture exists. Due to the kindness of Mr Edgar Munhall of the Frick Collection, New York, who has searched through the records of H. C. Frick's collection without finding a trace of any such picture, it appears that Armstrong must have been in error in cataloguing a version in Frick's collection, and this, in turn, has misled later writers.

There is no trace of the picture in the Booth/Pound sale of 1865 (not 1864 as stated by Bell). Bell's authority for this part of the provenance is unconfirmed, although the picture does belong with a group of canvases usually associated with Mrs Booth's ownership. Moreover, this canvas has vertical cracking, the result of having been rolled at some time, which links it to the group discussed in the entry for No. 509.

This canvas owes its origins to a large early watercolour, exhibited R.A. 1802 (366) and now in the Walker Art Gallery, Liverpool (29¼ × 41⅝ in., repr. Gage pl. 16). The subject was naturally one to appeal to Turner, and he may have felt especially drawn to it by his study of watercolours by Louis Ducros at Stourhead, as is suggested by Kenneth Woodbridge in his chapter on Turner in *Landscape and Antiquity* (1970; Ducros' watercolour of *The Falls at Tivoli* is reproduced by Woodbridge, pl. 29b). In the R.A. catalogue in 1802, Turner added 'vide Akenside's Hymn to the Naiads' to the title. As Gage has pointed out, the earlier watercolour 'was scarcely able to show that it was about the elemental forces of nature, the effect of sun on water, without a reference to Akenside's poem; in the prismatic colour of the later oil version at Port Sunlight this content is immediately clear, once we recognise the direction of Turner's mind.'

The early watercolour was engraved in the *Liber Studiorum* (Rawlinson 18), published in 1809, and was used by Turner as an illustration to one of his Perspective Lectures in 1818. But Turner sketched the scene again on his trip to Scotland in 1831 in a dozen or so drawings at the beginning of the 'Stirling and Edinburgh' sketchbook (CCLXIX, especially pp. 2 verso, 3 verso, 4 verso and 8 verso). Gage plausibly suggests that it was no coincidence that Turner returned to former subjects such as this and Norham Castle in 1831 after his contact in Edinburgh with Sir David Brewster in order that he could reassess them in terms of Brewster's theories about light and colour.

Dated 1840–45 by Armstrong, this is certainly too late. For a general discussion of the canvases based on engravings in the *Liber Studiorum* series, see the entry for the Louvre picture No. 509. The dating of *c.* 1835 for this group, proposed by Kitson and Gage, seems plausible although they would surely be the last people to be dogmatic about this difficult problem. It may be that, if the Melbourne *Val d'Aosta* (No. 520) is correctly titled and is connected with the 1836 visit, and if *Monte Rosa* (No. 519) stems from the journey to Venice in 1840, then the whole series may be nearer 1840 than 1835 in date but, in the absence of any firm evidence, it seems wiser to stick to *c.* 1835–40.

The Turner Bicentenary Exhibition catalogue pointed out that Turner employed watercolour in certain areas and this is still visible in the form of little droplets where the oil paint has rejected total assimilation.

511. Landscape with Walton Bridges *c.* 1835–40
(Plate 497)

MR H. S. MORGAN, NEW YORK

Canvas, 34 × 46¼ (86·3 × 117·5)

Coll. Mrs Booth; John Pound (Mrs Booth's son by her first marriage); sale Christie's 25 March 1865 (195) bought Agnew; John Smith; bought back from Smith's executors in 1870 by Agnew and sold in 1871 to John Graham of Skelmorlie Castle, Ayrshire; sale Christie's 30 April, 1887 (90) bought Agnew; sold in May 1887 to J. S. Morgan; by descent to his great-grandson, the present owner.

Exh. Agnew 1913 (15).

Lit. Armstrong 1902, p. 223; Falk 1938, p. 237; Kitson 1969, pp. 254–5.

Listed by Armstrong simply under the title 'Italy'; the connection with the scenery of Walton Bridges was first noticed by Martin Butlin and there seems no doubt that this is one of the group of canvases of the later 1830s based on engravings in the *Liber Studiorum* series, in this case no. 13 published in 1808, under the title 'The Bridge in the Middle Distance'. As Kitson points out, the composition is so close to that of an Italian landscape that it is not surprising that the true identity of the subject went unrecognised for so long.

For a full discussion of the group, see the entry for No. 509 and also for No. 513. Armstrong makes the same mistake about the Bicknell provenance as he did in the case of No. 513.

512. Norham Castle, Sunrise *c.* 1835–40
(Plate 498)

THE TATE GALLERY, LONDON (1981)

Canvas, 35¾ × 48 (91 × 122)

Coll. Turner Bequest 1856; transferred to the Tate Gallery 1914.

Exh. Paris 1938 (145); New York, Chicago and Toronto 1946–7 (54, pl. 46); Amsterdam, Berne, Paris, Brussels, Liege (34), Venice and Rome (39) 1947–8; Paris 1953 (82); New York, St. Louis and San Francisco 1956–7 (112, pl. 13); Tate Gallery 1959 (354); R.A. 1974–5 (650, repr. in colour p. 184).

Lit. MacColl 1920, p. 29; Clark 1949, p. 107, pl. 87; Rothenstein 1949, p. 24, colour pl. 2; Clare 1951, p. 102; Herrmann 1963, p. 38; Rothenstein and Butlin 1964, pp. 50, 62–4, pl. 124; Lindsay 1966, p. 203; Gage 1969, pp. 40–41, 126, 254 n. 250, pl. 35; Holcomb 1974, p. 47, pl. 10; Andrew Wilton, 'Retrospect: Norham Castle 1798–1840' in exh. cat., R.A. 1974–5, pp. 172–4, repr. in colour p. 184; Herrmann 1975, pp. 54, 234–5, colour pl. 177.

This is one of the examples of a later development of a plate from the *Liber Studiorum*, in this case published on 1 January 1816 under the catagory 'P' for 'Pastoral' (R. 57, repr. Finberg 1924, p. 227 and Herrmann 1975, pl. 188; the preliminary pen and sepia drawing, CXVIII-D, repr. Finberg 1924, p. 226 and Herrmann 1975, pl. 187, and the underlying etching repr. Finberg 1924, p. 226). The plate is inscribed as being from 'the Drawing in the Possession of the late Lord Lascells', the watercolour from the Harewood Collection that is one of two closely related compositions, one of which was exhibited at the R.A. in 1798 as 'Norham Castle on the Tweed, Summer's Morn' with a quotation from Thomson's *Seasons* (both versions are in private collections, one ex. Laundy Walters, the other ex. Mrs Thwaites; the first repr. Armstrong 1902, pl. 16 and Gage *op. cit.*, pl. 33, the second exh. R.A. 1974–5 (640)). Two large watercolour studies for the 1798 exhibit are in the British Museum (L-B and C, the first repr. Herrmann 1975, pl. 186). Turner had sketched this view in 1797 in his 'North of England' sketchbook (XXXIV-57, repr. Herrmann 1975, pl. 184) and again in his 'Helmsley' sketchbook on his way to Scotland in 1801 (LIII-42 verso–50, especially 44 verso and 45, repr. Herrmann 1975, pl. 185).

In its turn the somewhat revised *Liber* composition led on to a number of later versions. A finished watercolour in the British Museum (Turner Bequest CCVIII-O; repr. Rawlinson and Finberg 1909, colour pl. 14, Gage 1969, pl. 34 and Herrmann 1975, pl. 189) formed the basis for two further engravings, one done by Charles Turner in 1824 for the *Rivers of England* Part ii, pl. 1 (repr. Herrmann 1975, pl. 190), the other by Percy Heath in 1827, perhaps for the *Literary Souvenir*. A further engraving, done by William Miller in 1834 for Scott's *Provincial Antiquities of Scotland*, was based on new on-the-spot pencil sketches made in the 'Abbotsford' sketchbook in 1831 (CCLXVII-59 verso) and on another finished watercolour formerly in the collection of Munro of Novar and now in the United States. Armstrong lists three further finished watercolours, dating them 1800–02, *c.* 1820 and 1820–25 (*op. cit.*, p. 268).

Of two colour beginnings in the British Museum, one (CCLXIII-22) probably dates from *c.* 1817 while the other (CCLXIII-72) may date from as late as the oil painting. Nevertheless, the oil is closer in general composition and in the presence of cattle in the water to the *Liber* plate. The mass of the castle is however assimilated with the central bluff rather than standing above it silhouetted against the sky, and the other forms, including the barely-sensed hut on the left, are much more impressionistically defined. (For Turner's preoccupation with this subject, and its development, see in particular Wilton, *op. cit.*)

513. Landscape: Woman with Tambourine
c. 1835–40 (Plate 499)

MRS M. D. FERGUSSON

Canvas, $34\frac{3}{4} \times 46\frac{1}{2}$ ($88 \cdot 5 \times 118$)

Coll. Mrs Booth; John Pound (Mrs Booth's son by her first marriage); sale Christie's 25 March 1865 (196) bought Agnew; John Smith; bought back from Smith's executors by Agnew in 1870 and sold in 1871 to James Price; sale Christie's 18 June 1895 (61) bought Agnew; Sir Donald Currie; by descent to the present owner.

Exh. Manchester 1887 (611); Agnew 1967 (25); R.A. 1974–5 (623); on loan to the National Gallery of Scotland since 1976.

Lit. Armstrong 1902, p. 223 (where it is incorrectly stated that the picture had belonged to Bicknell. This mistake arose because Armstrong believed that the vendor in 1865 was Bicknell); Falk 1938, p. 237; Kitson 1969, p. 254.

This landscape is based on the engraving in the *Liber Studiorum* (Rawlinson 3), published in 1807 and entitled 'The Woman and Tambourine'. For a more detailed discussion of the canvases, painted in the 1830s, but based on engravings from the *Liber Studiorum*, see No. 509. So far as the provenance of the group goes, it has been suggested in general terms that they must have originated with Mrs Booth. However, in fact only this picture and No. 511 can with certainty be traced back to the Booth/Pound collection.

This was dated 1838–40 in the catalogue of the 1967 Agnew's exhibition but the Turner Bicentenary Exhibition catalogue dated the whole group *c.* 1835–40; this wider bracket is perhaps more acceptable in view of the lack of any precise evidence to support an exact dating.

Both this and No. 511 are given titles by Armstrong connecting them with Italy (in this case 'Dream of Italy: Woman with Tambourine') but, whereas the landscape here appears to be classical, No. 511 depicts Walton Bridges as Martin Butlin has pointed out. The fact that they make an admirable pair compositionally and both have bridges as their most prominent features, misled Armstrong into describing them as pendants.

514. Europa and the Bull *c.* 1835–40 (Plate 500)

THE TAFT MUSEUM, CINCINNATI, OHIO

Canvas, $35\frac{7}{8} \times 47\frac{7}{8}$ (90·8 × 121·6)

Coll. The Rev. Thomas Prater; sale Christie's 6 May 1871 (127) bought Cassels; W. R. Cassels sale Christie's 30 June 1906 (63) bought Colnaghi; C. P. Taft, Cincinnati, 1907; bequeathed by him to Cincinnati in 1931 (Accession no. 1931:422).

Exh. Guildhall 1899 (25, where it was incorrectly described as having been in the collection of Mr. Thomas Agnew; this confusion arose because Christie's sale of 6 May 1871 included a great proportion of Thomas Agnew's collection as well as pictures belonging to the Rev. Thomas Prater); Boston 1946 (13).

Lit. Armstrong 1902, p. 221; M. W. Brockwell, *Catalogue of the Taft Museum* 1939, p. 50 no. 162; Kitson 1971, p. 94, fig. 4.

The subject, inset in a scrolled frame, occurs in the frontispiece to the *Liber Studiorum* (Rawlinson 1), published in May 1812, although the background of the print shows a seaport with classical temples etc. The subject was very likely suggested to Turner by Titian's great picture of *The Rape of Europa* (now in the Gardner Museum, Boston) which was exhibited in London as part of the Orleans Collection 1798–9 and again at the British Institution in 1816, lent by Lord Darnley.

This picture belongs to a series which is discussed more fully under the entry for No. 509, canvases dating from *c.* 1835 or perhaps a little later which have some connection with engravings in the *Liber Studiorum* series. While Turner's purpose in painting them is not clear, their provenance is positively murky. While traditionally connected with Mrs Booth's collection and then with that of her son by her first marriage, John Pound, only two (Nos. 511 and 513) can be with certainty traced to John Pound's sale at Christie's in 1865. Of the rest, this picture and *The Falls of the Clyde* at Port Sunlight (No. 510), which also belonged to the Rev. Thomas Prater, have a history which stretches back further than that of any of the others but, even so, nothing is known about them before their appearance at Christie's in 1871.

515. Sunrise, a Castle on a Bay: 'Solitude'
c. 1835–40 (Plate 501)

THE TATE GALLERY, LONDON (1985)

Canvas, $35\frac{3}{4} \times 48$ (91 × 122)

Coll. Turner Bequest 1856; transferred to the Tate Gallery 1938.

Exh. New York 1966 (27); R.A. 1974–5 (622).

Lit. Herrmann 1963, p. 38, colour pl. 17; Rothenstein

and Butlin 1964, p. 50, colour pl. xx; Gowing 1966, p. 45.

The composition is one of those developed from the *Liber Studiorum*, in this case 'Solitude', R. 53, published 12 May 1814 (repr. Finberg 1924, p. 211; the preliminary pen and sepia drawing, CXVIII-A, and etching are repr. p. 210). The plate was one of those classified as 'E.P.', probably Epic, Elegant or Elevated Pastoral (see Finberg *op. cit.*, p. xxxviii). The plate is much more detailed and sharply defined, and includes a figure of the Magdalen reclining in meditation under the group of trees on the left; it seems to be included in a list of *Liber* subjects in the 'Liber Notes (2)' Sketchbook, CLIV(a)-26 verso, under the heading 'EP', as 'Says [the engraver of this plate, W. Say] Castle & Mⁿ [Magdalen]'—the title is difficult to read.

516. Sunrise, with a Boat between Headlands
c. 1835–40 (Plate 502)

THE TATE GALLERY, LONDON (2002)

Canvas, 36 × 48 (91·5 × 122)

Coll. Turner Bequest 1856; transferred to the Tate Gallery 1906.

Exh. Arts Council tour 1947 (26); Lisbon and Madrid 1949 (47); Hamburg, Oslo, Stockholm and Copenhagen 1949–50 (102); *La Peinture sur la Signe de la Mer* Galeries Royales, Ostend, August–September 1951 (98); Cape Town 1952 (30); Arts Council tour 1952 (23); New York 1966 (19, repr. in colour p. 37); Paris 1972 (268); Lisbon 1973 (17, repr.); R.A. 1974 (22); R.A. 1974–5 (625); Leningrad and Moscow 1975–6 (80).

Lit. MacColl 1920, p. 33; Rothenstein and Butlin 1964, pp. 50, 62–4, colour pl. xxiv; Gowing 1966, pp. 38, 45, repr. in colour p. 37; Gage 1969, p. 254 n. 250.

This is one of the unfinished oil paintings in which Turner approaches closest to his late watercolour style, though in many respects it is similar to the oils derived from the *Liber Studiorum* subjects, particularly to *Norham Castle* (No. 512). MacColl relates it to a watercolour *The Lake of Lucerne*, formerly in the collection of Sir James Knowles, but this seems unlikely. In general character, however, the scene, with its headlands, that on the right apparently surmounted by a tower, with another tower lower down on the left and shipping between, does resemble late watercolours of Swiss lakes; alternatively the composition could hark back to the Rhine watercolours of 1817.

517. Landscape with River and Distant Mountains *c.* 1835–40 (Plate 503)

WALKER ART GALLERY, LIVERPOOL

Canvas, 36¼ × 48¼ (92 × 122·5)

Coll. Robert Durning Holt, who acquired it 'perhaps not long after 1876' according to his grand-daughter, the Hon. Mrs Methuen, who remembered the picture hanging in the dining-room at Holt's house, 54 Ullet Road, Liverpool, throughout the 1890s; given by Lady Holt (R. D. Holt's daughter) to the Walker Art Gallery, Liverpool in 1945.

Exh. Walker Art Gallery, Liverpool, *The Taste of Yesterday* 1970 (44); R.A. 1974–5 (624).

Lit. Armstrong 1902, p. 224 (with dimensions 39 × 48 in. and dated 1840–45); Kitson 1971, pp. 89 ff., fig. 2.

This picture was not much regarded at Liverpool until cleaning in 1969 revealed its beauty and undoubted authenticity. It comes closest to the Louvre *Landscape* (No. 509) amongst the group of canvases which are discussed more fully under the entry for that picture. The Liverpool picture, however, does not appear to have any connection with any engraving in the *Liber Studiorum* series, unlike most of the others in the same group. Like the Louvre picture, it has been rolled up at some time and may have formed part of a bundle removed in this way from Turner's studio. There is perhaps some confirmation of this theory in the fact that none of the series has any history traceable to before the 1870s with the exception of the two included in the Pound sale at Christie's in 1865 (Nos. 511 and 513). Kitson suggests that the view is a generalised one based on scenery in the British Isles rather than on the Continent.

518. The Ponte delle Torri, Spoleto *c.* 1835–40
(Plate 504)

THE TATE GALLERY, LONDON (2424)

Canvas, 36 × 48 (91 × 122)

Coll. Turner Bequest 1856; transferred to the Tate Gallery 1909.

Exh. Amsterdam 1936 (165); Venice 1938 (10); British Council tour, Cologne, Rome and Warsaw 1966–7 (59, repr.); Agnew 1967 (24); Prague, Bratislava (144, repr.) and Vienna (55) 1969; Tokyo and Kyoto 1970–71 (45, repr. in colour); Dresden (15) and Berlin (22, colour pl. 32) 1972; Milan 1975 (152, colour pl. 8); Leningrad and Moscow 1975–6 (79).

Lit. Rothenstein and Butlin 1964, p. 50, pl. 110; Giovanni Carandente, 'Un Viaggio di Turner in Umbria' in *Spoletium* xi 13, April 1968, pp. 20–21, repr. in colour p. 13; Herrmann 1975, pp. 47, 234, pl. 155.

Known until Carandente's identification (first made in the Italian language exhibition catalogue for the British Council's tour of 1966–7) as 'Bridge and Tower'. Based on two sketches in the 'Ancona to Roma' sketchbook, drawn in the autumn of 1819 on Turner's first visit to Italy (CLXXVII-40 and 41, repr. Carandente, *op. cit.*, pp. 17 and 16 respectively), but, it would seem, considerably later, *c.* 1835–40 like the similar oils Nos. 509–17.

519. Monte Rosa *c.* 1835–40 (Plate 505)

YALE CENTER FOR BRITISH ART, PAUL MELLON COLLECTION

Canvas, 36 × 48 (91·5 × 122)

Coll. Sir Donald Currie by 1894; by descent to his grand-daughter Mrs L. B. Murray from whom bought by Agnew in 1960 and sold to Mr and Mrs Paul Mellon.

Exh. R.A. 1894 (25); Richmond 1963 (137); R.A. 1964–5 (169); Yale 1965 (197); Washington 1968–9 (14); R.A. 1974–5 (619).

Lit. Armstrong 1902, p. 225.

The view is taken from near Stresa and Pallanza looking across Lake Maggiore towards Monte Rosa.

Armstrong describes it as 'an unfinished canvas taken from Turner's studio'. This is true only in so far as the same description could also apply to the whole series of canvases discussed under the entry for No. 509.

In the catalogue of the R.A. exhibition 1964–5, it is suggested that this may have been a product of Turner's journey through the Dolomites to Venice in 1840. In fact, the red in the left foreground is similar to the red pen work in some watercolours of the early 1840s and it seems possible that a dating of *c.* 1840 is in fact correct. The catalogue of the Turner Bicentenary exhibition dated all this series *c.* 1835–40 and it is certainly not easy to be more precise than this. There is, of course, a possibility that a distinction may exist between those pictures in the series which are connected with *Liber Studiorum* subjects and those which are not, but they seem to form such a homogeneous group stylistically that it is perhaps splitting hairs to try to subdivide them into two categories. In this case, if *Monte Rosa* is the product of the 1840 journey to Venice, then it would seem to provide an argument for assigning the whole group to around this date.

520. The Val d'Aosta *c.* 1835–40 (Plate 508)

THE NATIONAL GALLERY OF VICTORIA, MELBOURNE

Canvas, 36 × 48 (91·4 × 121·9)

Coll. Camille Groult, Paris (*d.* 1907) by 1894; by descent to his grandson M. Pierre Bordeaux-Groult from whom bought by Agnew and Wildenstein in

1971; bought by the National Gallery of Victoria from Agnew in 1973.

Exh. Paris 1894 (?); David Jones Art Gallery, Sydney, 1973 (17); R.A. 1974–5 (568, repr. in colour) as 'Mountain Scene, perhaps the Val d'Aosta'; Zurich 1976–7 (38).

Lit. Martin Butlin, 'A newly-discovered masterpiece by J. M. W. Turner', *Art Bulletin of Victoria* 1975, pp. 2–10, repr. in colour on cover.

A recently discovered picture which may have been referred to in a letter by Camille Pissarro written in June 1894 to his son, Lucien, describing an exhibition of English pictures then being held in Paris, which included 'two Turners belonging to Groult, which are quite beautiful'. As noted in the entry for No. 375, no catalogue of this exhibition can now be traced. At that time Groult owned only two genuine Turners, the Louvre *Landscape* (see No. 509) and this picture, although he was soon to acquire *Ancient Italy* (No. 375).

Although very difficult to identify topographically, there seems no reason to doubt the traditional title, which connects the picture with Turner's tour of the Val d'Aosta, undertaken in the summer of 1836 with his friend and patron H. A. J. Munro of Novar. This journey resulted in Turner exhibiting the *Snow-Storm, Avalanche and Inundation—a Scene in the Upper Part of the Val D'Aouste, Piedmont* at the R.A. in 1837 (No. 371) but this canvas, although extremely difficult to date exactly, may have been painted slightly later, possibly at about the same time as the *Monte Rosa* (No. 519).

Both this and the *Monte Rosa*, although unconnected with *Liber Studiorum* engravings, may also be part of the same projected scheme whereby Turner may have intended to leave, as part of his bequest to the nation, a group of canvases which displayed the full range of his late style. (For a further discussion of this series, see No. 509.)

In the Turner Bicentenary exhibition two smaller canvases from the Tate Gallery (see Nos. 521 and 522) were exhibited for the first time and the suggestion was made that they were also connected with the 1836 journey.

The further suggestion, put forward tentatively in the catalogue of the Turner Bicentenary exhibition, that the composition may after all derive from a *Liber Studiorum* subject, the 'Ben Arthur' (Rawlinson 69, published June 1819) seems implausible as the connection is surely too tenuous to sustain, even allowing for the fact that the other canvases of this date which stem from *Liber Studiorum* subjects do not follow them all that closely.

521. Mountain Scene with Lake and Hut
c. 1835–40 (Plate 506)

THE TATE GALLERY, LONDON (5476)

Oil and pencil on canvas, 28 × 38 (71 × 96·5)

Coll. Turner Bequest 1856 (141, one of 2 each 3′2″ × 2′4″ with No. 522; identified 1946 and 1973 by chalk number on back); transferred to the Tate Gallery 1947.

Exh. R.A. 1974–5 (569).

Lit. Davies 1946, pp. 157, 188.

Correctly grouped with No. 522 in the schedule of the Turner Bequest as similar not only in size but also in style, handling and subject. The scene may well be a Swiss lake, being similar to those depicted by Turner in a number of watercolours of the 1840s. The date of these two pictures may however be slightly earlier, as they are akin in style and subject to the National Gallery of Victoria's *Val d'Aosta* (No. 520).

A rectilinear pattern of lines of dirt impressed into the paint when it was still wet, and a similarly impressed texture from canvas in the lower right-hand corner, show that other pictures were leant against this one while it was fresh in Turner's studio; the lines have been minimised by conservation treatment. The original paint is missing down the left-hand edge.

522. Mountain Landscape *c.* 1835–40 (Plate 507)

THE TATE GALLERY, LONDON (5486)

Canvas, 28 × 38 (71 × 96·5)

Coll. Turner Bequest 1856 (140, one of 2 each 3′2″ × 2′4″ with No. 521; identified 1946 by a chalk number on back); transferred to the Tate Gallery 1947.

Exh. R.A. 1974–5 (570, repr.).

Lit. Davies 1946, pp. 159, 188.

Companion to No. 521. The viewpoint of this picture, apparently looking down over a valley that runs in diagonally from the lower right-hand corner, is close to that of the National Gallery of Victoria's *Val d'Aosta* (No. 520).

As in the case of the companion picture, there are signs that other pictures were leant against it in Turner's studio while the paint was still not completely dry. There are paint-losses down the left-hand edge, now restored.

523. The Thames above Waterloo Bridge
c. 1830–35 (Plate 509)

THE TATE GALLERY, LONDON (1992)

Canvas, 35⅝ × 47⅝ (90·5 × 121)

Coll. Turner Bequest 1856; transferred to the Tate Gallery 1906.

Exh. Venice and Rome 1948 (43); Rotterdam 1955 (60); Edinburgh 1968 (3); R.A. 1974–5 (435).

Lit. MacColl 1920, p. 31.

Datable for stylistic reasons to the early 1830s, it is just possible that this was projected as Turner's answer to Constable's picture of *Waterloo Bridge from Whitehall Stairs, June 18th, 1817*, exhibited at the R.A. in 1832. The effect of smoke-belching industry contrasts with the sparkling clear atmosphere of the Constable, and a large twin-funnelled steam-boat replaces the royal yacht. The possibility of Turner setting out to rival this particular Constable is reinforced by the incident that took place during the 1832 Varnishing Days, when Turner's *Helvoetsluys*, a relatively subdued picture, was hung next to Constable's painting (see No. 345).

524. Abbotsford 1834–6 (Plate 514)

THE INDIANAPOLIS MUSEUM OF ART, INDIANA

Japanned metal tray, oval, 20 × 25 (50·8 × 63·5)

Coll. Presented by Turner to Sir Walter Scott's daughter, Sophia Lockhart (*d.* 1837); ?bequeathed by her to Scott's butler, William Dalgleish; Henry Wright who, on leaving Edinburgh *c.* 1856, presented it to John Renton, from whose family it was bought in 1896 by Thomas Craig-Brown; Trustees of E. T. Craig-Brown deceased, sale Sotheby's 1 December 1954 (151) bought Mitchell for Mrs Katherine Conroy who presented it to the John Herron Art Museum in memory of Evan F. Lilly (Accession no. 55.22. The John Herron Museum was rechristened the Indianapolis Museum of Art when the new museum was built in 1970).

Exh. Glasgow 1901 (37, lent by Thomas Craig-Brown); Indianapolis 1955 (27, repr. in colour on cover).

Lit. Armstrong 1902, p. 217; Indianapolis Museum of Art, *A Catalogue of European Paintings* 1970, pp. 157–8; Adele M. Holcomb, 'Turner and Scott', *Journal of the Warburg and Courtauld Institutes* xxxiv 1971, pp. 386–97, pl. 68(d); Gerald E. Finley, 'J. M. W. Turner and Sir Walter Scott: Iconography of a Tour', *Journal of the Warburg and Courtauld Institutes* xxxv 1972, pp. 359–85.

Turner's visit to stay with Sir Walter Scott at Abbotsford, made with the intention of first choosing and then sketching subjects to be engraved for an illustrated edition of Scott's *Poetical Works*, lasted from 4–9 August 1831. It is discussed fully by Holcomb and Finley in the articles cited above. Professor Finley also publishes the 'Abbotsford Diary' of Robert Cadell, Scott's publisher, who was present throughout the visit.

The provenance of the tray is given in a letter (now in the possession of Mr Kurt Pantzer of Indianapolis) written by Thomas Craig-Brown in May 1905. Henry Wright was a traveller with Blackwood's, the publishers, and John Renton, a music seller in Edinburgh. Craig-Brown's letter states that it was on a picnic which took place during Turner's visit, that 'Turner, seizing a tray, commenced on it a view of the house which he afterwards presented to Sir Walter's daughter at the close of his visit.' This tradition is followed by Dr Holcomb but Cadell's diary, which documents the events of each day very fully (and indeed proves how very full they were), mentions no such picnic and it seems inconceivable that the gift of the tray, had it occurred at this time, should have gone unrecorded by Cadell.

The tray must therefore have been painted after this and I owe much of the rest of this entry to the kindness of Professor Gerald Finley, who has most generously allowed me to read the typescript of his forthcoming book on Turner's illustrations to Scott. This book is largely based on new material among the Scott and Cadell papers in the National Library of Scotland.

Turner certainly had some contacts with the Lockharts through Cadell on his visit to Scotland in 1834 and Professor Finley has also discovered a reference in Sophia Lockhart's diary (in reality more of a book of appointments) for 29 February 1836 to a proposed visit from a 'Mr. Turner'; if this refers to the artist, as seems possible, then it may have been on this occasion that Turner presented her with the tray—a commemorative gift similar to the watercolour of *Smailholm* which Turner had given to her father in 1832.

Pencil views of Abbotsford occur in the 'Abbotsford' sketchbook (CCLXVII); among them is a drawing on pp. 15 verso–16, showing the house across the Tweed, which has quite a close relationship with the oil. However, Professor Finley considers that the true source for the composition on the tray is a watercolour in the collection of Sir Edmund Bacon, Bt, identified by Professor Finley as a view of Abbotsford by moonlight which, in his opinion, may have been drawn to illustrate the *Dramas of the Poetry* in 1832 but was then discarded. The tray design in turn served as the basis for the watercolour of Abbotsford, engraved for Lockhart's *Life of Scott* in 1839 (frontispiece to vol. viii; this watercolour was sold at Christie's 20 March 1959 (60) bought Leggatt).

If the tray belonged to Sophia Lockhart, as is stated by Thomas Craig-Brown, then it must have preceded the watercolour for the *Life*, as Sophia died in 1837 and Cadell refers to Turner preparing the watercolour for the *Life* in 1838. The presence of pentimenti in the tray also reinforces the argument that it was executed before the illustration in the *Life*. Moreover, the fact that the figures in the tray are identifiable as Scott and his family, whereas, for reasons of scale alone, in the *Life* watercolour they are not, attests the especial commemorative significance of such a gift for Sophia. As

Professor Finley points out, in the tray Scott is shown wearing the same light-coloured suit in which he appears in the watercolour of *Smailholm* (Finley, pl. 56(d)), which Turner had earlier given to Scott. The other figures in the tray are identified by Professor Finley as Scott's two daughters, Anne (*d.* 1834) and Sophia, and probably also their brothers, Walter and Charles, although it is possible that the second male figure may portray John Gibson Lockhart.

The warm evening glow of the setting sun, in which the scene is bathed, can be interpreted not only as a symbol of Scott's declining years, but also as an allusion to a most fruitful and harmonious visit.

On stylistic grounds a dating for the tray of 1834–6 would seem perfectly acceptable although the fact that it is painted on metal has undoubtedly had an effect on the handling, which makes dogmatic assertions about date unwise. As might be expected the painting has more qualities in common with Turner's illustrative work than with his exhibited oil paintings, and was perhaps painted thus intentionally by Turner to serve not only as a memento of Scott and his family but also of the kind of work he had been engaged in during his visit.

If the tray was not given to Mrs Lockhart until 1834–6, then the tradition that she gave it to William Dalgleish at the time of the sale of Abbotsford and its contents, which followed closely on Scott's death in September 1832, must be incorrect. However, it seems possible that Mrs Lockhart left the tray to her father's faithful servant in her will. It was Dalgleish who had remained with Scott during the dreadful days after the author's financial crash, weeping that 'he cared not how much his wages were reduced but go he would not'.

525. Sunset *c.* 1830–35?　　　　　(Plate 510)

THE TATE GALLERY, LONDON (1876)

Canvas, $26\frac{1}{4} \times 32\frac{1}{4}$ (67 × 82)

Coll. Turner Bequest 1856; transferred to the Tate Gallery 1928.

Exh. Newcastle 1912 (55).

Lit. Burnet 1852, p. 58; Thornbury 1862, i, p. 169; 1877, p. 121; Armstrong 1902, p. 232; Gage 1969, pp. 36–7, 231 n. 92 (mistakenly as No. 469).

Possibly the work referred to by the younger Trimmer as being among the rolled canvases in the Turner Bequest (Thornbury, *loc cit.*,; see p. 104): 'There is a red sunset (simply the sky) among these rolls, the finest sky, to my mind, ever put on canvas.' The other works mentioned by Trimmer are the larger Thames sketches of *c.* 1806–7 but this painting was probably painted considerably later, perhaps in the early 1830s. It is however darkened by discoloured megilp which makes assessment difficult.

It may also be the subject of the story told to Burnet

by the dealer Woodburn: 'Driving down to his house at Hendon, a beautiful sunset burst forth; Turner asked to stop the carriage, and remained a long time in silent contemplation. Some weeks afterwards, when Woodburn called on him in Queen Anne Street, he saw this identical sky in his gallery, and wished to have a landscape added to it: Turner refused the commission—he would not part with it.'

526. A Mountain Lake at Sunset *c.* 1830–35

(Plate 515)

MR WILLIAM WOOD PRINCE, CHICAGO

Panel (painted on the lid of a box), arched top, $9\frac{1}{4} \times 6\frac{1}{8}$ (23.5 × 15.5)

Coll. The Earl of Arran whose ancestor the fourth Earl (1801–84) was certainly acquainted with Turner; bought from Leggatt by Agnew in 1960 and sold to the present owner.

Exh. Leggatt 1960 (36, lent by the Earl of Arran).

An unpublished picture which does not, however, belong to the series of oil sketches on paper or card which also came from the Arran Collection, and most of which are now in the collection of Mr and Mrs Paul Mellon. These sketches, which were originally discovered by the late Paul Oppé in 1952, were exhibited at Leggatt's in 1958. The majority of them were shown again at the Virginia Museum of Fine Arts, Richmond, in 1963 (139a–139n) but are now no longer accepted as being by Turner by most Turner scholars. They nearly all contain pencil work and the general impression which they give is strongly calligraphic.

This sketch is, however, more painterly and is characteristic of Turner in being painted looking straight into the declining sun. The small size and the fact that it is painted on a box lid suggest that it was painted out of doors—in order to record an effect which appealed to Turner—although this is a rare occurrence in Turner's oeuvre after the tour in Devonshire in 1813. There are, however, the sketches of yachts racing in the Solent painted on the spot in 1827 (Nos. 260–5) and the possibility that some sketches connected with Turner's visit to Rome in 1828–9 were painted out of doors (see p. 163), which provide evidence that he did not entirely abandon *plein air* painting in oils. Turner told Munro of Novar that he experienced difficulties in managing oils in the open air and that 'he always got his colour too brown'. This conversation may date from the tour of the Val d'Aosta in 1836 which Turner and Munro made together, although, as Gage (1969, p. 39) notes, it does not provide evidence that Turner was still sketching in oil at that date. It does, however, remain a possibility that this sketch may date from this journey although, on stylistic grounds, a dating of 1830–35 would seem rather more likely. Martin Butlin noted that he felt doubts about its authenticity when he saw it in 1960.

527. Harbour with Town and Fortress *c.* 1830?

(Plate 511)

THE TATE GALLERY, LONDON (5514)

Canvas, 68 × 88 (172·5 × 223·5)

Coll. Turner Bequest 1856 (? 253, 1 unidentified 7′4½″ × 5′8½″); transferred to the Tate Gallery 1947.

Exh. Edinburgh 1968 (20).

Lit. Davies 1946, p. 164.

This large unfinished harbour scene seems to continue the theme of *Harbour of Dieppe (Changement de Domicile)* and *Cologne, the Arrival of a Packet Boat. Evening*, exhibited in 1825 and 1826 respectively (Nos. 231 and 232). The similarity to these works, which are of exactly the same size, is an argument for dating the Tate Gallery picture rather earlier than has hitherto been thought likely, *c.* 1830 rather than the later 1830s.

528. Estuary with Rocks and Buildings *c.* 1830–40

(Plate 516)

THE TATE GALLERY, LONDON (5518)

Canvas, 68 × 95¾ (173 × 243·5)

Coll. Turner Bequest 1856; transferred to the Tate Gallery 1947.

Lit. Davies 1946, p. 164.

Various architectural forms are suggested, particularly on the left, and the picture, though rather larger, is perhaps to be seen as a variant of *A Harbour with a Town and Fortress*, No. 527.

Four small punctures in the canvas have been temporarily secured, but the picture awaits full conservation treatment and is covered with surface dirt.

529. Seaport in the Grand Style *c.* 1830–40?

(Plate 517)

THE TATE GALLERY, LONDON (5544)

Canvas, 68 × 95¾ (172·5 × 243·5)

Coll. Turner Bequest 1856 (250, 1 unidentified 8′0″ × 5′8½″; identified 1975 by chalk number on back; see below); transferred to the Tate Gallery 1947.

Lit. Davies 1946, pp. 168, 190 nn. 23 and 26.

In the 1854 Schedule no. 250 is annotated in pencil 'marked 270 (bis)'. The confusion was the subject of a note in the revised Schedule of 1856 as follows: 'Among the pictures removed to the National Gallery in pursuance of the Agreement dated 21 June 1854, two pictures were found numbered 270; one only, of small dimensions, being included in Schedule A [i.e., that of 1854; see No. 281]. That picture is now numbered 270*, the other of larger dimensions, being numbered

270. An unfinished picture of large dimensions, numbered 250 in Schedule A, was not found among the pictures transferred to the National Gallery, but was found, so numbered, in Queen Anne S̲t̲ [Turner's studio] and, together with the other works found there has now been removed to the National Gallery'. This large picture was No. 529.

There is a hole in the canvas near the top right-hand corner and two small tears bottom left; these have been provisionally secured. The picture is still very dirty and is in need of further treatment.

Most of the ground was left uncovered, but where Turner has begun work he has shown ships and architectural forms in considerable detail, those on the right being drawn with the brush rather than painted however. These features suggest that Turner was planning another Carthaginian port scene. The date could be any time between 1815 and 1840, probably more towards the latter.

530. Extensive Landscape with River or Estuary and a Distant Mountain *c.* 1830–40? (Plate 518)

THE TATE GALLERY, LONDON (5542)

Canvas, original size approx. 55½ × 99 (141 × 251·5); the picture has been restretched on a different sized stretcher, 58¼ × 94 (148 × 238·5), with the result that approx. 3½ (9), 1 (2·5) and 1½ (4) of painted canvas is turned over the left, top and right edges while 3¾ (9·5) of unpainted canvas is exposed within the stretcher area at the bottom

Coll. Turner Bequest 1856 (249, 1 unidentified 8′1″ × 4′10½″; identified 1946 by chalk number on back); transferred to the Tate Gallery 1947.

Lit. Davies 1946, pp. 168, 190.

The canvas is a double one, typical of many of Turner's paintings, and the fact that the double canvas has survived suggests that the canvas was at least removed from the original stretcher, if not restretched, by Turner himself.

The picture has not yet been cleaned and the forms are barely laid in, but the rectangular shapes in the foreground suggest that Turner had some architectural features in mind.

531. Landscape with Water *c.* 1835–40 (Plate 519)

THE TATE GALLERY, LONDON (5513)

Canvas, 48 × 71¾ (122 × 182)

Coll. Turner Bequest 1856 (262, '1 (Lake Scene)' 6′0″ × 4′0¼″; identified 1946 by chalk number on back); transferred to the Tate Gallery 1947.

Exh. New York 1966 (21, repr. p. 11); Edinburgh 1968 (21); Prague, Bratislava (148) and Vienna (58) 1969; Tokyo and Kyoto 1970–71 (44, repr. in colour);

Dresden (14) and Berlin (23) 1972; Lisbon 1973 (16, repr.).

Lit. Davies 1946, pp. 163–4, 190; Rothenstein and Butlin 1964, p. 50, colour pl. xix; Gowing 1966, p. 45, repr. p. 11.

Dated *c.* 1840–45 by Gowing but probably a bit earlier. The composition is similar to many of Turner's Italianate landscapes of the 1830s or even earlier (*c.f.* among watercolours the sketch for the large water-colour *Landscape: Composition of Tivoli*, exhibited at the R.A. in 1818 (474); repr. exh. cat., R.A. 1974–5, p. 87 nos. 182 and 181 respectively). In style and handling, though larger, it is comparable to the unfinished oils of *Liber Studiorum* subjects here dated *c.* 1835–40 (Nos. 509–15).

532. A River Seen from a Hill *c.* 1840–45

(Plate 512)

THE TATE GALLERY, LONDON (5475)

Canvas, 31 × 31¼ (79 × 79·5)

Coll. Turner Bequest 1856 (157, one of 2 each 2′7¼″ × 2′7″ with No. 504); transferred to the Tate Gallery 1947.

Exh. Arts Council tour 1952 (22).

Lit. Davies 1946, pp. 157, 188.

An oil beginning, square in shape and probably done in the early 1840s when Turner was experimenting with such formats; *c.f.* especially No. 504. The scene, with a bridge and twin poplars, may be Italian but is not necessarily so.

The original paint has been lost all down the left-hand edge.

6. Untraced Works of Unknown Date

533. Fishing Boats in a Stiff Breeze

PRESENT WHEREABOUTS UNKNOWN

Size unknown

Coll. Painted for Turner's close friend and executor Henry S. Trimmer (c. 1780–1859) whom Turner met about 1805–6; Trimmer sale Christie's 17 March 1860 (42) bought Hooper; bought in September 1860 by Agnew from Holmes and sold to John Heugh; no subsequent history is known (although Agnew's repurchased two 'Marine views' from John Heugh in May 1863; both were sold to Thomas Rought) and it seems probable that the picture was later known by another title, e.g., possibly *The Mouth of the Thames* (No. 67). In the catalogue of the Trimmer sale the picture is described as an early work.

534. Coast Scene

PRESENT WHEREABOUTS UNKNOWN

Size unknown but possibly $12\frac{1}{2} \times 17\frac{1}{2}$ ($31 \cdot 7 \times 44 \cdot 4$)

Coll. (?) Joseph Gillott sale Christie's 27 April 1872 (299) as 'Coast Scene—stranded Boat and Old Capstan' bought Betts; (?) Thomas and Betteridge sale, Birmingham 8 April 1892 (120) as 'Stranded Boats and Capstan' $17\frac{1}{2} \times 12\frac{1}{2}$ (but presumably $12\frac{1}{2} \times 17\frac{1}{2}$ as the size of the watercolour of *Brinkburn Priory* in the same sale is given width before height) bought Wigzell; no subsequent history is known.

Exh. Birmingham Society of Artists 1830 (136).

Lit. Finberg 1961, p. 490 no. 354.

The only clue we have about this picture is the following description which appeared in *Aris's Birmingham Gazette* for Monday 25 October 1830:

'No. 136 'Coast Scene' J. M. W. *Turner* R.A.—

A flat beach, quiet sea, and moderately clouded sky. Such are the simple elements of this picture, but they are so skilfully treated as to form a picturesque and scientific as well as a very pleasing combination. An old ricketty capstan in the foreground becomes a dignified mass of form and colour, and the deep browns of the nearer portion harmonize with the gradations in the water and sky.'

The medium and the lender's name were not given but Finberg conjectures that the picture was probably an oil. The only other Turner in the exhibition was a watercolour of *Florence* (300) but it is difficult to identify this from among several possibilities. In any case, there is no certainty that both loans came from the same collection. The 'old, ricketty capstan in the foreground' seems the only major aid to identification, and this suggests that it may very well be the same picture as that sold by Joseph Gillott in 1872 as the 'old capstan' again features prominently in the description in the catalogue, despite the fact that the stranded boat mentioned in Christie's catalogue is not referred to in the exhibition notice of 1830. As Gillott came from Birmingham, he may well have bought it from whichever local collector lent it to the 1830 exhibition, although Gillott does not seem to have begun buying Turner's work until 1843, and therefore this purchase seems almost certain to have been made after this date.

535. Distant View of Margate Cliffs, from the Sea

PRESENT WHEREABOUTS UNKNOWN

Size unknown

Coll. J. Carpenter by 1833.

Exh. S.B.A. 1833 (84 lent by J. Carpenter).

Lit. *Magazine of Fine Arts* iii November 1833, p. 71: Finberg 1961, pp. 345, 498 no. 433

Nothing is known of this picture beyond its appearance in the Society of British Artists Exhibition in 1833, nor of its owner, J. Carpenter, who does not appear to have owned other works by Turner. He did, however, lend a Hogarth and a Morland to this exhibition besides the Turner, but this is his only appearance as a lender according to Graves' index (1913–15, p. 2469). In the *Magazine of Fine Arts* it is described as 'a beautiful little picture' but that is the only clue we have about its appearance. Turner painted Margate subjects throughout his life as we know, from the early picture which he gave to Samuel Dobree in 1804 (No. 51; this still belonged to the Dobree family in 1833) to a number of late canvases from Mrs Booth's collection which appeared in the John Pound sale in 1865 with Margate titles attached to them, as well as the National Gallery's *Margate from the Sea* (No. 464) of *c.* 1840.

536. View in Savoy

PRESENT WHEREABOUTS UNKNOWN

Size unknown

Coll. Oakley by 1834; no subsequent history is known.

Exh. S.B.A. 1834 (63).

Lit. Finberg 1961, pp. 351, 499 no. 456.

The only record of this picture is its appearance at the third Winter Exhibition of the Society of British Artists which opened in December 1834. Four early pictures by Turner were loaned to the exhibition: two by Lord Egremont (Nos. 108, 149), one by James Wadmore (No. 91) and this picture which was entitled 'View in Savoy' and lent by '—Oakley'. The other three pictures were painted around 1810, if that provides a clue in suggesting the date of this picture. The name 'Oakley' does not occur again as a collector of Turner's work so far as I know. Indeed this exhibition marks his only appearance as a lender, according to Graves' index (1913–15, p. 2553), but he also lent paintings by Rembrandt, Reynolds and Salvator Rosa on this occasion. One possibility is that the 'View in Savoy', if it is not a lost picture but merely, a mistitled one, may mask one of the oils of *Bonneville*. If so, the most likely candidate is the version now in Philadelphia (No. 124), the first known owner of which was John Gibbons. He died in 1851 but seems to have been active as a collector almost until his death as he did not acquire his other Turner oil, the *Seascape with a Squall coming up* (No. 143), until 1849, so he could have bought this picture from Oakley at some time after 1834.

537. Landscape

PRESENT WHEREABOUTS UNKNOWN

Size unknown

Exh. Birmingham Society of Artists 1834 (9).

Lit. Bell 1901, p. 169; Finberg 1961, p. 498 no. 451.

No trace of this picture has been found and the only reference to it, quoted below, is too vague for one to be certain of anything save that it was an early work and predominantly brown. It seems clear also that it was an oil, but whether it was sent by Turner from among his unsold canvases or lent by a collector is uncertain, although the only other Turner in the exhibition, a watercolour *View of Rye* (248), is definitely stated in the catalogue to have been lent by Charles Birch, a local collector who lived at Harborne. On the whole Turner does not seem to have exhibited much outside London, so that it seems most likely that it was lent by a local collector, but that this was not mentioned in the catalogue.

The picture is described in the *Birmingham Advertiser*, 25 September, as follows:

'9. *Landscape*—TURNER— Those who are accustomed to know this eminent artist, in his later style of colouring, whether in water or in oil, will be surprised at the subdued and sombre tone of the present picture, which has evidently been painted many years ago, and has suffered from age. The prevailing tints are dark and obscure browns, and it might be mistaken for an old landscape of the Italian School. There is, however, a gradation and mellowness in the effect which still render the picture valuable.'

538. Landscape

PRESENT WHEREABOUTS UNKNOWN

Size unknown

Coll. J. Allnutt by 1835.

Exh. Birmingham Society of Artists 1835 (17, lent by J. Allnutt).

Lit. Bell 1901, p. 169; Finberg 1961, p. 500 no. 464.

The only description we have of this picture comes from the *Birmingham Journal*, 19 September 1835, which does at least confirm Finberg's supposition that this loan probably referred to an oil. Unfortunately, the description is so lacking in details that positive identification seems almost impossible. The only concrete information supplied in the review is, 'here we have a picture—an Italian—alpine landscape, in oil, an exhibition of his genius under a former *avatar*; differing in every quality from the characteristics of his present works . . .'. This description makes it appear as if the picture was more likely to be a mountain landscape deriving from the 1802 trip to the continent rather than from the visit to Italy in 1819. On the whole, pictures such as this one which were lent to exhibitions under a generalised title such as 'Landscape' seem less likely to be 'new' works than pictures already known but which had become shorn of their original titles. Possible contenders are either one of the *St Gothard* pair (Nos.

146 and 147) which belonged to Allnutt, or a version of *Bonneville* recorded by Ruskin in the first volume of *Modern Painters* (1903–12, iii, p. 245) as 'in the collection of Abel Allnutt Esq,' but, as already noted under No. 46, it seems clear that Ruskin really meant John Allnutt.

539. A Storm

PRESENT WHEREABOUTS UNKNOWN

Size unknown

Coll. Sarah Rogers (*b.* 1772), the sister of Samuel and Henry Rogers; she inherited her collection from her brother Henry with whom she shared a house until his death in 1832; she then moved to Hanover Terrace where her collection was viewed by Waagen in 1854; there has been no subsequent trace of her Turner.

Lit. Mrs A. Jameson, *Companion to the Most Celebrated Private Galleries of Art in London* 1844, p. 412, lists a picture by Turner in Miss Rogers' collection but gives no details; Waagen 1854, ii, p. 268 as '*A Storm, treated almost entirely in brown. A spirited but very mannered sketch.*'

540. Seapiece, with Fishing Boats off a Wooden Pier, a Gale coming on

PRESENT WHEREABOUTS UNKNOWN

Size unknown

Coll. Samuel Rogers (1763–1855), the poet whose *Italy* and *Poems* were both illustrated by Turner; Rogers sale Christie's 2 May 1856 (528) bought Ratcliffe. The catalogue stated that it was 'an early work'. No subsequent history is known and no Turner seapiece now in existence fits the description at all closely.

Not mentioned by Mrs Jameson in her description of Rogers' collection (1844) although she does list a Turner watercolour of *Stonehenge* in his possession (no. 71) and also refers to a Turner oil belonging to his sister, Sarah (No. 539). It seems likely, therefore, that Rogers did not acquire his oil until after 1844. It may even possibly have been a gift from Turner in return for the poet agreeing to be one of his executors.

541. Cilgerran Castle *c.* 1799?

PRESENT WHEREABOUTS UNKNOWN

Panel, 9½ × 13½ (24 × 34·2)

Coll. John Miller of Liverpool; sale Christie's 22 May 1858 (250) bought Agnew; sold 24 May to Colnaghi; Sidney Castle by 1899 and until at least 1902; no further history is known.

Exh. Guildhall 1899 (5 lent by Sidney Castle).

Lit. Bell 1901, p. 76; Armstrong 1902, p. 223.

Bell noted that this picture differed in composition from all other versions of the subject, while Armstrong describes it thus: 'Looking over woods and river to castle. Sun setting in stormy sky.' For Turner's other pictures of Cilgerran, see Nos. 11, 36 and 37.

7. Works No Longer Attributed to Turner

Nos. 542–4: Copies after Turner

Nos. 542–3: Sir Augustus Wall Callcott (1779–1844)

542. Copy of 'Sheerness and the Isle of Sheppey'
c. 1807–8 (Plate 520)

THE TATE GALLERY, LONDON (813)

Canvas, $27\frac{1}{2} \times 35\frac{1}{4}$ (70 × 89·5)

Coll. . . .; John Meeson Parsons, bequeathed 1870 to the National Gallery; transferred to the Tate Gallery 1912.

Lit. *Catalogue of the Pictures in the National Gallery; . . . British School* 1878, p. 168; MacColl 1920, p. 28; Mary Chamot, *The Tate Gallery: British School, A Concise Catalogue* 1953, p. 261; Brown 1975, pp. 721–2, repr. p. 719, fig. 40.

A copy of the picture now in the National Gallery of Art, Washington (No. 62); there is a still smaller, more freely handled version in the Ashmolean Museum, Oxford (No. 543). Accepted in 1878 as a genuine Turner of about 1801 and retained as such by MacColl, though by then the relationship with the Washington and Oxford pictures had been noticed, the date amended to about 1808, and a note added that 'Doubts have been cast on the authenticity of the picture, because of the construction of one of the sails.' Mary Chamot, in 1953, relegated the picture to 'ascribed to J. M. W. Turner', and it was recognised as a copy in the Tate Gallery catalogues from 1967. David Brown was the first to attribute this and the Oxford version to Callcott, as works done for his own instruction a little before he painted the life-size replica

still at Browsholme Hall, the home of Thomas Lister Parker, who bought the original in 1807.

543. Copy of 'Sheerness and the Isle of Sheppey'
c. 1807–8 (Plate 521)

ASHMOLEAN MUSEUM, OXFORD

Canvas, $14\frac{1}{8} \times 18$ (36 × 46)

Coll. Bequeathed by the Rev. Thomas Penrose in 1851 to the Oxford University Galleries (now the Ashmolean Museum).

Exh. Leeds 1868 (1144 as 'Stormy Weather at Sea').

Lit. Armstrong 1902, pp. 53, 231 (where 'Penrose' is called 'Primrose'); *Catalogue of Paintings in the Ashmolean Museum* 1951, p. 103 no. 438; Brown 1975, repr. p. 722, fig. 38.

Although this picture was bequeathed to Oxford as a Turner during the artist's lifetime and was catalogued as such in 1951, doubts about its authenticity were expressed soon afterwards. In 1963 Luke Herrmann, then an Assistant Keeper at the Ashmolean, told the compiler that in the next edition of the Ashmolean catalogue it was to be listed as a copy. It was not, however, until the appearance of David Brown's article that Callcott's name was convincingly suggested as the painter of both this picture and No. 542. Mr Brown notes that the Ashmolean picture is 'the most freely handled' of the small versions, although at present the surface is both dry and somewhat discoloured.

No. 544: British School, Nineteenth Century

544. A Fresh Breeze, part Copy of 'Sheerness and the Isle of Sheppey' (Plate 522)

THE TATE GALLERY, LONDON (2642)

Canvas, $15\frac{1}{2} \times 19$ (39.5×48)

Coll. . . .; George Salting, bequeathed 1910 to the National Gallery; transferred to the Tate Gallery 1919.

Lit. Brown 1975, pp. 721–2, repr. p. 718, fig. 39.

First catalogued by the National Gallery as by Crome, and by the Tate Gallery as School of Crome, this picture is in fact a part copy of Turner's *View off Sheerness* in the National Gallery of Art, Washington (No. 62); for two complete copies of that picture see Nos. 542–3. This picture is based on the left half of Turner's original, spacing out and altering the proportions of the distant shipping, omitting the large buoy in the left foreground, and weakening the dramatic sky.

Nos. 545–60: Works Formerly Attributed to Turner

Nos. 545–7: Richard Wilson (1713 or 1714–1782) or his Studio

545. Tivoli (Plate 523)

THE TATE GALLERY, LONDON (5538)

Canvas, 29×38 (73.5×96.5)

Coll. Turner Bequest 1856 (296, with marginal note '(copy from Wilson)'; identified 1946 by chalk number on back); transferred to the Tate Gallery 1947.

Lit. Davies 1946, pp. 167, 191; Gage 1965, p. 23 n. 54; Gage 1969, p. 36.

A close replica of the painting by Wilson in the Dulwich College Gallery which passed from the Desenfans to the Bourgeois collection in 1807 ($28\frac{3}{4} \times 38$; repr. W. G. Constable, *Richard Wilson* 1953, pl. 117a). To judge by the style and tonality, the replica is almost certainly by Wilson or from his studio rather than by Turner.

546. Valley with a Bridge over a River (Plate 524)

THE TATE GALLERY, LONDON (1890)

Canvas, $39\frac{3}{4} \times 53\frac{3}{4}$ (101×136.5)

Coll. ?Garnons Bequest 1854 *or* Turner Bequest 1856 (see below); transferred to the Tate Gallery 1947.

Lit. Davies 1946, pp. 153, 177; W. G. Constable, *Richard Wilson* 1953, p. 130.

A plaque formerly attached to the face of the picture bore the number '1890', a National Gallery inventory

number allocated in about 1900–01 and identifying the picture as being from the Garnons Bequest. This bequest consisted of a group of sixteen pictures from Colommendy House near Mold in Wales, and were traditionally held to have been taken there in an unfinished state by Richard Wilson when he retired from London in about 1780. Unfortunately only one of the pictures was given an inventory number when the pictures entered the National Gallery in 1854, no. 267, now in the Tate Gallery and accepted as by Wilson. The others were numbered in two batches, *c.* 1900–01 (1859, 1880, 1889–91) and *c.* 1919 (2977–89). One further work was not numbered until 1944 (5560). A number of these works are no longer attributed to Wilson and they may not all in fact be Garnons pictures. (For the Garnons Bequest see Davies 1946, p. 177.)

This picture was catalogued as School of Richard Wilson until 1946, when Martin Davies reattributed it as an early Turner, and for this reason suggested that it was in fact a hitherto unidentified Turner Bequest picture. In the comparable case of No. 547, a version of Wilson's *Niagara Falls* the same size as this picture, Davies' similar reattribution has since been reversed, and it is tempting to do the same in this case, despite W. G. Constable's verdict, 'Very improbably by Wilson'. Certainly the size is unusual for Turner (the nearest are Nos. 89 and 107 of approx $40 \times 51\frac{1}{4}$ in. and Nos 461–2, approx 40×56 in.) while being close to a common Wilson format. It is difficult to find parallels among equally unfinished works by Turner; it is nearest to the rather further advanced *Valley with a*

Distant Bridge and Tower (No. 256), probably done in the 1820s, rather than to any early work. On the other hand, there are parallels among unfinished Wilson or Wilson school pictures of the kind found among the Garnons Bequest (e.g., Constable *op. cit.*, pls. 57b, 126c (*Niagara Falls*, see No. 547) and, outside the Bequest, pls. 129a—a picture which actually belonged to Turner—and 129b).

547. Niagara Falls (Plate 525)

THE TATE GALLERY, LONDON (1891)

Canvas, $39\frac{1}{2} \times 53\frac{3}{4}$ (100 × 136·5)

Coll. ?Garnons Bequest 1854 *or* Turner Bequest 1856 (see No. 546); transferred to the Tate gallery 1953.

Lit. Davies 1946, pp. 153, 177; W. G. Constable, *Richard Wilson* 1953, pp. 95, 130, 230–31, rep. pl. 126c.

For the possible mix-up between pictures from the Garnons Bequest and those from the Turner Bequest see No. 546. In this case Davies was again responsible for the reattribution to Turner and his Bequest, entitling the picture 'Common with Sandpit (?)', but Constable and other experts have much more decisively returned it to Wilson or his studio. It is a version of the larger picture now in the Wolverhampton Art Gallery, engraved by William Byrne in 1774 as by Richard Wilson from a drawing made on the spot by Lieutenant William Pierie of the Royal Artillery in 1768.

No. 548: Sir Joshua Reynolds (1723–1792) or his Studio

548. Portrait of a Lady (Plate 526)

THE TATE GALLERY, LONDON (5564)

Canvas, $29\frac{3}{4} \times 24\frac{1}{2}$ (75·5 × 62), of which an irregular strip down the left-hand side approx. $6\frac{3}{4}$ (17) wide is a later addition

Coll. ?Sir Joshua Reynolds; ? his niece the Marchioness of Thomond, sold Christie's 26 May 1821 (in lot 10 with another; see below) bought 'Turner, R.A.'; by descent to Miss M. H. Turner, by whom presented to the Tate Gallery 1944.

The original canvas has been cut irregularly down the left-hand side; the addition was presumably made to balance the composition. At the same time, a large part of the chair was overpainted and the line of the lady's bosom strengthened; there are touchings-up to her eyes and elsewhere. It may well be that these extensive retouchings were in part designed to turn an unfinished sketch into a more finished picture.

The picture was accepted as a gift from Miss M. H. Turner, a collateral descendant of the artist, as the work of J. M. W. Turner, in the manner of, or a copy of, Reynolds. However, in 1974 the compiler, with the help of Miss Elizabeth Einberg, reattributed the picture to Reynolds or his school.

That it was in Turner's collection is nevertheless probable, as the artist's relations were allocated those works in his studio not by Turner himself. In addition, Turner is known to have bought three works by Reynolds at the sale of the latters's niece, the Marchioness of Thomond, one of which, in a single lot (10) with *Admiral Lord Keppel, a sketch* and described as 'the late Duchess of Devonshire, the latter not strained', may be this picture: the fact that it was described as not being on a stretcher fits with the present state of the canvas.

'Admiral Keppell' is listed in the Inventory of the Turner Bequest as no. 313, among the works not by Turner. In the same section, no. 354, 'Portrait—Sir J. Reynolds', could be either this female portrait or the 'Portrait of Sir Joshua, unfinished', which was also bought by Turner at the Thomond sale, lot 11B. There is also an unattributed 'Portrait of a Lady', no. 335. (Two other lots, 13 and 27, were bought by 'Turner', but the absence of the qualifying 'R.A.' found by the name of the purchaser of lots 10 and 11B suggests that this was someone different.)

Nos. 549–60: Miscellaneous

549. Bath Abbey: West Front (Plate 527)

YALE CENTER FOR BRITISH ART, PAUL MELLON COLLECTION

Canvas, 42 × 50 (106·6 × 127)

Coll. C. Lyne-Stephens; R. Hall McCormick of Chicago by 1902; sale New York 15 April 1920 (40)

bought Scott and Fowles from whom bought by Knoedler in May 1920 and sold in 1929 to James Carstairs; repurchased by Knoedler in 1936 and sold in 1938 to Hugh J. Chisholm Jr; with Durlacher Bros. by 1951 from whom acquired Mr and Mrs Paul Mellon in 1953.

Exh. Copley Hall, Boston *Loan Collection of Pictures by Old Masters and other Painters* 1903 (21); Toronto and Ottawa 1951 (1); Durlacher Bros, New York *Romanticism in 18th Century England* 1953 (12); Indianapolis 1955 (5).

Lit. Wedmore 1900, i, repr. facing p. 12; Armstrong 1902, p. 218; Mauclair 1939, p. 125, repr.

Armstrong suggests that this may possibly be identified with the work Turner exhibited at the R.A. in 1796 (715) but this was almost certainly the watercolour, at present untraced, which was sold by Agnew in 1900 to James Gresham.

In the compiler's opinion, this is certainly not by Turner but is an independent work of 1790–1800 by an artist whose style resembles that of William Marlow (1740–1813). In the Mellon collection it is no longer given to Turner and is listed simply as 'English School'.

550. Cilgerran Castle (Plate 528)

PRIVATE COLLECTION, ENGLAND

Canvas, 35 × 46½ (88·9 × 118·2)

Coll. H. A. J. Munro of Novar; sale Christie's 6 April 1878 (104) bought Agnew for Sir William (later Lord) Armstrong; Armstrong heirlooms sale Christie's 24 June 1910 (93) bought in; by descent to the present owner.

Exh. Guildhall 1892 (93) and 1899 (3).

Lit. Bell 1901, pp. 74–6; Armstrong 1902, p. 53 n.; Beckett 1947, pp. 10–15.

When exhibited at the Guildhall in 1899, alongside the version now belonging to the National Trust (No. 11), this picture was denounced as a copy in a letter to *The Times*, 1 May, from the artist J. McWhirter, R.A. (1839–1911). When challenged, McWhirter replied that he had 'eminent opinion' on his side, but declined to be more specific. Bell seems to have considered it genuine, although he notes that it was distinguished from the version exhibited at the R.A. in 1799 by 'great freshness of tone and colour'. On the other hand, Sir Walter Armstrong seems to have agreed with McWhirter as he omitted it from his Catalogue Raisonné, referring to it only in a footnote where he implies that it is a copy. Beckett records that Finberg suggested that it might be a copy by William Muller (1812–45). Turner's watercolour *Tivoli* (exh. R.A. 1818) was certainly copied in oils by Muller when in the Allnutt collection, as both appeared in the Allnutt sale in 1863, but no link is known between Muller and either Butterworth or Cave who owned No. 11 between 1827 and the time of Muller's death, and Muller was surely too young to make such an able copy while No. 11 was still in the de Tabley Collection.

The low price the picture fetched at auction in 1910, compared with the very high figure in the Munro sale,

would seem to suggest that McWhirter's doubts were generally shared. Furthermore, the circumstances in which the picture entered the Munro collection are far from clear. The statement in the catalogue of the exhition held at the Guildhall in 1892, that it was painted in 1799 and acquired directly from Turner by Munro, seems very suspect. In 1799 Munro was only three, so presumably can only have acquired this picture many years later, and lack of stylistic differences between the two versions argue against it having been ordered later by Munro. It seems much more likely, therefore, that Munro bought the picture from someone other than Turner and possibly after Turner's death. (The picture exhibited at Greenock in 1861 seems a possible candidate, see No. 11.) It is also puzzling that there is no mention of this picture in the 1865 catalogue of Munro's collection, compiled by Frost and Reeve shortly after Munro's death; nor does Thornbury list it among Munro's Turner oils.

Nevertheless, notes in Turner's hand in both the 'Hereford Court' (XXXVIII) and 'Academies' (LXXXIV) sketchbooks suggest that he had a number of orders for 'Kilgarrons', both in oil and watercolour. However, the compiler inclines to the view that this picture is an extremely able copy of No. 11, probably done soon after the latter was painted. It may even be that William Delamotte, who seems to have owned No. 11, copied it himself, but this is pure speculation. The handling of the paint in this version has a heavy and opaque quality about it, especially in the water in the foreground, which is difficult to reconcile with Turner's work. Furthermore the copyist does not seem to have understood fully the relationship between the figures, nor is the sense of recession wholly convincing and the overall impression is of a less adventurous picture than No. 11. However, it must be admitted that this is one of the most puzzling of Turner problems, and that the possibility that this is a second version of No. 11, painted by Turner himself, certainly cannot be ruled out. The definitive answer may emerge only if the two versions are brought together again for direct comparison as happened in 1899.

551. A Stream between High Banks, with Cattle and Sheep (Plate 529)

HARRIS MUSEUM AND ART GALLERY, PRESTON (Inventory no. 598)

Panel, 17⅜ × 12¾ (44·1 × 32·4)

Coll. Bought from Thomas Griffith, Turner's dealer and one of his executors by Richard Newsham (1798–1883) who bequeathed his collection to the Corporation of Preston.

Lit. James Hibbert (ed.), *Catalogue of the Pictures and Drawings of the Newsham Bequest to the Corporation of Preston* 1884, p. 37 no. 62, repr.; Sidney H. Paviere, *The Principal Pictures in the Harris Museum and Art Gallery, Preston* 1949, pl. 94 as 'Pastoral Landscape'.

Despite the provenance going back to Griffith, this cannot be accepted as genuine. It is a fairly close imitation of Turner's work of *c.* 1806–7 but comparison with a Turner of roughly the same date and of similar subject matter such as *The Quiet Ruin, Cattle in Water; a Sketch, Evening* in the Tate Gallery (No. 83), also on panel, reveals weaknesses throughout the Preston picture. In particular, the sense of recession where the bank curves into the distance is conveyed unconvincingly and the cows and sheep lack solidity. The foliage is also treated in a muddled way without any clear delineation. Finally the stream is painted in a lifeless manner that is unthinkable in Turner's work.

552. The Fight on the Bridge (Plate 530)

ROYAL ALBERT MEMORIAL MUSEUM AND ART GALLERY, EXETER

Canvas, $17 \times 23\frac{3}{4}$ ($43 \cdot 2 \times 60 \cdot 3$)

Inscribed and dated 'J M W Turner 1814' lower left

Coll. Presented to the Exeter Museum in 1947 by Percy Moore Turner and others 'in memory of the late Robert Worthington F.R.C.S.'

Exh. Whitechapel 1953 (78).

Lit. Roger Fry, *French, Flemish and British Art* 1952, p. 201, pl. 71; T. S. R. Boase, 'English Artists and the Val d'Aosta', *Journal of the Warburg and Courtauld Institutes* xix 1956, pp. 285–6, pl. 58(c).

When exhibited at Whitechapel, this picture was entitled 'The Battle of Fort Rock, Val d'Aosta, Piedmont', the title of a watercolour exhibited at the R.A. in 1815 (192) and now in the Turner Bequest (LXXX-G). The Turner Bequest watercolour is based on a watercolour sketch in the Fitzwilliam Museum, Cambridge (Inventory no. 1585; Cormack 1975, no. 10 repr.), which was originally a page in the 'St. Gothard and Mont Blanc' sketchbook of 1802 (LXXV). The composition of this oil is not, however, the same as the exhibited watercolour and no doubt that was the reason for the subsequent change of title.

This picture is definitely not by Turner, and Professor Boase was wrong in stating that the artist exhibited it in 1814. The signature and date are in a small neat script wholly unlike Turner's writing and the X-ray shows that they were added later. The inference from this is that the picture is probably a deliberate forgery, perhaps based on a Turner drawing. In the 'Schaffhausen etc. Folio Drawings' (LXXIX) nos. N to S are pencil and white chalk drawings on grey paper of virtually identical dimensions to this picture which suggests that there may have existed a genuine Turner drawing, made in 1802, which was copied in oil by an unknown hand and falsely signed and dated.

553. Old London Bridge (Plate 531)

THE TAFT MUSEUM, CINCINNATI, OHIO

Canvas, $40\frac{1}{8} \times 49\frac{1}{2}$ ($102 \times 125 \cdot 7$)

Inscribed 'Port of London 1825' on buoy in left foreground

Coll. Bought from Dalton by Agnew in 1872 and sold to John Heugh; sale Christie's 24 April 1874 (186) bought Agnew for H. W. F. Bolckow of Marton Hall, Middlesborough; sale Christie's 5 May 1888 (68) bought Colnaghi; acquired by Charles P. Taft, 1910; bequeathed by him to Cincinnati in 1931 (Accession no. 1931·444).

Exh. R.A. 1885 (194); Boston 1946 (8); Toronto and Ottawa 1951 (7); Indianapolis 1955 (20).

Lit. *Art Journal* 1888, p. 342; Armstrong 1902, p. 224; M. W. Brockwell, *Catalogue of the Taft Museum* 1939, p. 155 no. 505.

Despite the facts that this picture has been accepted as genuine in a number of exhibitions in the U.S.A. and Canada since the war, and fetched high prices on its two appearances in the saleroom in London in the nineteenth century, it is in fact a close copy (with very minor differences in the foreground and extending slightly on the left) of the watercolour in the Victoria and Albert Museum (no. 522:1882, Jones Bequest; $11\frac{1}{2} \times 17\frac{1}{2}$ in., signed and dated 1824), or of the engraving after it by E. Goodall, published in 1827. The handling throughout is quite unlike Turner's, as also is the colour, while details like the fish in the right foreground, a favourite motif of Turner's, are painted in a lifeless way unimaginable in Turner's work.

554. Edinburgh and Calton Hill from St Anthony's Chapel (Plate 532)

HENRY E. HUNTINGTON LIBRARY AND ART GALLERY, SAN MARINO, CALIFORNIA

Canvas, $33\frac{1}{4} \times 44$ ($84 \cdot 5 \times 111 \cdot 8$)

Coll. Colonel Grant (?); bought from Percy Moore Turner by C. H. Collins Baker for the Huntington in 1937.

Lit. C. H. Collins Baker 'Turner's *Edinburgh from St. Anthony's Chapel*', *Burlington Magazine* lxxv 1939, p. 28, pl. 11B.

The picture is unrecorded in Turner literature except for the notice in the *Burlington Magazine* written by the purchaser. Nor is any early history known, although a picture entitled 'Edinburgh from the Carlton Hill' was sold at Christie's 16 April 1853 (95) bought Cubitt. The vendor was the dealer Vokins but it fetched only 30 guineas, whereas on the same day another oil by Turner (No. 16) fetched 1,250 guineas.

The article by Collins Baker shows by reference to a

number of buildings which appear in the picture—in particular the Burns Monument which was erected in 1830 (and there are other topographical features cited which confirm a dating after 1829)—that the picture cannot have been painted until after Turner's visit to Edinburgh in 1831, which surely rules it out as being by Turner as the palette in no way resembles Turner's by that date. Indeed, the painting of the buildings, figures and foliage do not reveal Turner's hand, while the confused way in which the planes recede in some areas is wholly uncharacteristic of Turner. Whoever painted it chose a viewpoint which was clearly a popular one among artists at the time, for substantially the same composition is shown in an engraving by George Cooke, published in 1819, after a watercolour by Callcott and again in one of the series of lithographs by Bonington, entitled *Picturesque Views in Scotland*, published in 1826 and based on drawings by Pernot.

The only connection I can trace in Turner's work is with two drawings on pp. 164 and 166 of the 'Calais Pier' sketchbook (LXXXI) in use from 1801–3, which are inscribed 'Study for Edinburgh'. Although extremely rubbed and indistinct, they do approximate quite closely to the general scheme of composition even if few details are discernible, although the tower on the hill right of centre appears to have a flat top in the drawings, whereas in the oil it has an extra turret added on top. The drawings are also taken from a viewpoint closer to the city than that of the Huntington oil. The fact that the drawings are inscribed in Turner's hand suggest that, when he went through the sketchbook in 1805 (the evidence for this is given in the entry for No. 16), he had already made use of these drawings for a finished composition, most likely in this case to have been a watercolour.

555. Off Margate (Plate 533)

THE NATIONAL MUSEUM OF WALES, CARDIFF (Inventory no. 808)

Canvas, $11\frac{1}{2} \times 17\frac{1}{2}$ (29.2 × 44.4)

Coll. The histories of these small canvases with 'Margate' titles attached to them are very confused and almost impossible to sort out with certainty. This is the kind of picture that one would connect with a Mrs Booth/John Pound provenance as is suggested in the National Museum of Wales catalogue. Lot 205 in the Pound sale of 25 March 1865 was described as 'View off Margate—Evening' 18 × 12 (but all sizes were given width before height in this catalogue) but it seems more likely that this was the picture now at Rugby School (No. 479). The Cardiff picture was definitely Lot 64 in the Theodore Lloyd sale at Christie's on 4 February 1911 as 'Off Margate—a Hazy Morning' bought Vicars and with a note that it came from the collection of H. S. Bicknell, 1881; bought from Vicars in 1912 by Agnew jointly with Wallis and Son and sold by the latter in the same year to Miss Gwendoline Davies;

bequeathed by her to the National Museum of Wales, 1952.

However in the Bicknell sale catalogue of 9 April 1881 at Christie's:

Lot 460 'Squally Weather', 12 × 18, fetched 55 guineas, no buyer's name given; this may possibly be identified with No. 476: *Off the Nore: Wind and Water*.

Lot 461 'Off Margate—a Hazy Morning', 15 × 24, fetched 130 guineas, bought James Lloyd (see No. 478).

If James and Theodore Lloyd were connected there is still the problem of the confusion over the sizes and the titles; furthermore, there is no mention made in the Bicknell sale catalogue of a connection between either Lot 460 or 461 and the Pound sale of 1865.

Exh. National Museum of Wales 1913 (30).

Lit. Steegman 1952, p. 24 no. 90; N.M.W. catalogue 1955, p. 91 no. 808.

Despite the very faint possibility that this picture may share a common provenance with genuine Turners at Cardiff and elsewhere, it cannot be accepted as authentic. The colour, the lack of recession, the painting of the sky and the strange way in which patches of impasto seem to float in a detached way over areas of barely covered ground, all argue conclusively against it being Turner's work. It must therefore be regarded as a deliberate attempt to imitate Turner's style.

556. Emigrants embarking at Margate (Plate 534)

WALKER ART GALLERY, LIVERPOOL (Sudley Hall)

Canvas, $17\frac{1}{16} \times 21\frac{1}{16}$ (43.3 × 53.4)

Coll. The provenance is uncertain, but the Sudley catalogue (see below) suggests the following:

? D. J. Pound sale Christie's 25 March 1865 (200) as 'Kingsgate Pier, near Margate, Emigrants Landing' 24 × 18 in. bought White: ? F. R. Leyland sale Christie's 9 March 1872 (73) 'Emigrants Embarking at Margate, a Sketch' (no size given) bought Polak; ? F. R. Leyland sale Christie's 13 June 1874 (117) 'Emigrants Embarking at Margate' bought White; bought from James Polak by George Holt January 1875 with this provenance on the bill, 'Mrs. Pound for whom it was painted, thence to Vokins, Agnew, Leyland'; by descent to George Holt's daughter, Emma, who bequeathed the picture with the rest of her collection to the City of Liverpool on her death in 1944.

By way of comment on the provenance as supplied to George Holt when he bought the picture: Vokins only bought one picture at the Pound sale in 1865: lot 202—'Wreckers—Early Morning' which measured 14 × 21½ in. and is to be identified with No. 477. Furthermore there is no trace at all of a picture of this title in Agnew's records between 1865 and 1875.

Lit. ?Armstrong 1902, p. 225; Bennett 1964, no. 311 as by an imitator of J. M. W. Turner; Bennett and Morris 1971, pp. 77–79, no. 311, pl. 13 as by Turner.

In the opinion of the compiler, which Martin Butlin shares, this picture cannot be accepted as by Turner and it is perhaps relevant to emphasise that the dimensions do not correspond with any picture in the Pound sale catalogue of 1865 and that, where pictures from this sale have been positively identified, the dimensions given in the catalogue are generally accurate, despite the fact that the width is given before the height. This point is in fact noted by Mr. Morris in his catalogue entry for the picture but it is perhaps justifiable comment that one does well to emerge from reading this detailed entry without becoming confused. This is not to disparage the entry but to commiserate with anyone who tries to clarify the enormous number of problems and ambiguities connected with Turner's 'Margate' pictures, particularly in connection with early sale catalogues, in many of which no sizes are given. In this case the alteration of title and the alternation between White and Polak as buyers become wholly bewildering. Mr Morris sets out all the possible hypotheses with great fairness, including the theory that this picture may have been bought in as 'Margate Harbour' in the 1872 Leyland sale (see No. 475) and then rechristened 'Emigrants Embarking at Margate' in the 1874 sale, but he wisely refrains from putting forward too positive a solution. He does, however, suggest that, as both this and No. 475 share a common Leyland provenance, they may well also have been together in the Pound Collection, thereby strengthening the chances of this picture being authentic.

In the event, in this instance, the number of possible alternatives is so great and the number of certainties so few that the only satisfactory procedure seems to be to concentrate on the picture itself. Once this is done, the number of clear dissimilarities with Turner's style becomes overwhelming and the picture must be rejected from Turner's oeuvre. To be more specific: the colour is too sweet, the form overall is too flaccid and the sun's rays trail off into the bottom left-hand corner in a meaningless way. The flecks of pink in the sky do not seem to have any real significance — and the painting of both the figures and of the trees on the left is quite untypical of Turner. It is surely closer to J. B. Pyne (1800–70) although not close enough to make a positive attribution to him convincing.

557. Margate Jetty (Plate 535)

THE NATIONAL MUSEUM OF WALES, CARDIFF (Inventory no. 809)

Canvas, 15 × 11 (38·1 × 27·9)

Coll. As with Nos. 483 and 484, said to have been given by Turner to Mrs Booth, and by descent through her son by her first marriage, John Pound, to Mrs M. A.

Pound who gave it to A. Austin, who sent it anonymously for sale at Christie's 11 June 1909 (189) bought Dowdeswell, from whom bought by Gwendoline E. Davies, 1910; bequeathed by her to the National Museum of Wales, 1952.

Exh. National Museum of Wales 1913 (23); National Library of Wales 1945 (11) and 1951 (33); Whitechapel 1953 (93).

Lit. Connoisseur xxiv, p. 259; Steegman 1952, p. 24 no. 91; N.M.W. catalogue 1955, p. 91 no. 809.

One of the most puzzling of Turner problems in that the provenance, if correct, would seem to establish its authenticity. Yet the quality is poor and the lack of underlying structure, the touchstone by which Turners of this kind must be judged, very noticeable. A theory put forward by Martin Butlin that it is a genuine fragment of the left-hand side of a 15 × 24 in. canvas, badly worn round the jetty and with the 'fluffy' effect of the handling due to retouching by Dowdeswell, is ingenious and may conceivably be correct. Yet in the final analysis there is no single feature of the picture which causes one to say 'No one but Turner could have painted that' and, on balance, there seems to be no real justification for including it in Turner's oeuvre. It may even have been painted considerably after Turner's death, for there is a very faint Whistlerian aura about it which would support a later dating.

558. The Shipwreck (Plate 536)

THE NATIONAL GALLERY OF CANADA, OTTAWA

Canvas, 46 × 56¼ (116·8 × 142·8)

Coll. Baroness Burdett-Coutts (1814–1906) (this is the traditional provenance although the picture does not appear in any of the Burdett-Coutts sales); acquired by the National Gallery of Canada in 1926 from the dealer Nico Jungman (Accession no. 3455).

Exh. Toronto and Ottawa 1951 (15); Winnipeg Art Gallery Turner 1952.

Lit. H. Teitze 'Die Öffentlichen Gemäldesammlungen in Kanada', Pantheon xvii 1936, p. 184; Catalogue of the National Gallery, Ottawa 1948, p. 121 no. 3455; R. H. Hubbard, European Paintings in Canadian Collections (i) 1956, p. 154; Boase 1959, p. 344.

According to the Ottawa catalogue, 1948, to be identified with the 'Wreck of a Transport Ship' exhibited at the British Institution 1849 (38), but this is incorrect as this was a much earlier picture of c. 1810 (see No. 210). This picture, which Hubbard dates to the 1840s but which seems closer to Turner's work of c. 1835–40, is virtually unmentioned in Turner literature and has received almost no attention from Turner scholars. The canvas size is unusual but is not very different from the Yacht approaching the Coast (No. 461) and Stormy Sea with

Blazing Wreck (No. 462) in the Tate Gallery (each approx. 40 × 56 in.).

In trying to determine the authenticity of a picture of this kind which has no early history, an obvious line of enquiry is to search for related material in the Turner Bequest, although the absence of such material in the case of a picture of this date provides evidence of a negative rather than a condemnatory nature.

In this case, although I cannot discover anything which has a close connection with the Ottawa picture, there are certainly affinities between it and the *Ship in a Storm* (No. 489, millboard, 11⅛ × 18¾ in.), one of the group of oil sketches discovered in the Turner Bequest in the 1950s, and added to the inventory only in 1972. This sketch was dated *c.* 1835–45 in the catalogue of the Turner Bicentenary Exhibition (498).

However, a number of un-Turneresque features about the canvas raised the question of its authenticity and it was decided to send the picture over to London in the summer of 1975 for examination at the Tate Gallery.

Careful study showed that there were disturbing weaknesses throughout the picture even after making allowances for the areas of repaint in both the water and the sky. The passage which comes closest to Turner's work is the dark cloud which rises like a pall of smoke to the right of the boat, but even here its relationship to the water and to the horizon is not clearly defined, and the cloud itself is covered with thin parallel cracks quite untypical of the craquelure in other Turner canvases. The painting of the sea itself lacks the cohesive vigour of Turner's work and the object in the right foreground (a figure clinging to a spar?) has areas of impasto on it which suggests that it is virtually 'finished' in contrast to other far more summarily painted parts, which seems quite out of keeping with the way that Turner built up his pictures. The colour is also untypical of Turner both in the light part of the sky and in the right foreground, although more may be discovered about this when the pigments in this area have been analysed.

At present it seems likely that this is a skilful and deliberate imitation although perhaps it is fair to add that there remains an element of doubt about this.

559. Caernarvon Castle (Plate 537)

MUSEU DE ARTE DE SÃO PAULO, BRAZIL

Canvas, 38 × 55 (96·5 × 139·7)

Coll. According to an article by Mrs Finberg in the *Connoisseur*, the picture 'was probably purchased direct from the artist' by Sir Thomas Liddell (1775–1855) who was created Baron Ravensworth in 1821; on his death the picture passed to his son, Henry Thomas, who was later created Earl of Ravensworth; the picture hung originally at Ravensworth Castle but was later transferred to another of the family seats, Eslington Park, Whittingham, Northumberland, where it remained until it was

acquired *c.* 1951 by the Matthiessen Gallery, London, from whom it was bought by the São Paulo Museum in 1952.

Exh. Tate Gallery, Arts Council *Masterpieces from the Sao Paolo Museum of Art* 1954 (31 repr.).

Lit. Hilda F. Finberg, 'Turner's Views of Caernarvon Castle', *Connoisseur* cxxv 1952, pp. 32, 58, repr. in colour.

The viewpoint is virtually identical to that in a slightly larger picture (38 × 59 in.) by Muller in the Tate Gallery (no. 1565) which is signed and dated 1837. There are, however, considerable differences in detail especially in the right foreground and also on the extreme left. It has already been noted that Muller is known to have copied in oils Turner's watercolour of *Tivoli* and also possibly one of Turner's views of *Cilgerran Castle* (see No. 550). In this case, however, it would seem that Muller's view of Caernarvon was the original which served as the basis for the São Paulo picture. This cannot be by Turner but must be a deliberate attempt to reinterpret the Muller in the very much brighter colours which were thought to resemble those found in Turner's work of the 1830s.

560. Venice: Santa Maria della Salute from the Giudecca

THE BEAVERBROOK FOUNDATIONS, ON LOAN TO THE BEAVERBROOK ART GALLERY, FREDERICTON, NEW BRUNS-WICK

Canvas, 28 × 36 (71·1 × 91·4)

Coll. J. Elmassian, London by 1954; bought by Lord Beaverbrook in 1955; placed on loan to the Beaverbrook Art Gallery by the Beaverbrook Foundations in 1959 (Inventory no. 1959 260).

Lit. Jonathan Mayne, 'Two unrecorded Turners', *Burlington Magazine* xcvi, 1954, p. 18, fig. 19.

Quite unknown before being published in the *Burlington Magazine*, this picture cannot withstand careful scrutiny and is clearly not genuine. The paint is smeared on in a clumsy manner throughout, wholly unlike Turner's work, and the clouds and architecture are modelled in an inept and coarse fashion. The recession fails to work convincingly and the whole effect recalls that in the picture of *Old London Bridge* (No. 553) in the Taft Museum, Cincinnati so that it seems possible that they may be by the same imitator. It is also worth pointing out that the canvas size differs from the measurements of 24 × 36 in. which Turner employed most usually in the 1840s for his Venetian subjects. In Turner's letter referring to the Washington *Dogana and Salute* (No. 403) he states 'Venice size being best 2 feet 3 feet'.

Unfortunately no illustration appears in the volume of plates, as the owners would only permit it to be reproduced if it was listed as being by Turner.

Concordance of National Gallery, Tate Gallery and British Museum Inventory Numbers with this Catalogue

The Tate Gallery shared the National Gallery's sequence of inventory numbers until 1955; no distinction of ownership is therefore made in the following list, particularly as paintings continue to be exchanged between the two institutions. From 1955 the Tate Gallery started a new numerical sequence, the figures being preceded by the letter 'T'. Works now at the British Museum are numbered according to Finberg's *Inventory* of 1909 (see p. 21) with the exception of a group of works discovered more recently and numbered in 1972 and 1974. Works not from the Turner Bequest are marked with a *.

National Gallery and Tate Gallery

Inventory No.	Catalogue No.	Inventory No.	Catalogue No.	Inventory No.	Catalogue No.
369*	343	488	115	522	373
370*	349	489	109	523	378
371*	355	490	126	524	377
372*	396	491	90	525	382
458	25	492	127	526	386
459	2	493	55	527	383
460	7	494	129	528	399
461	5	495	128	529	400
462	70	496	87	530	398
463	34	497	130	531	404
464	79	498	131	532	405
465	30	499	135	533	401
466	29	500	138	534	406
467	82	501	139	535	402
468	42	502	140	536	408
469	33	503	228	537	351
470	17	504	233	538	409
471	19	505	230	539	411
472	48	506	241	540	413
473	49	507	244	541	418
474	56	508	330	542	419
475	31	509	331	543	416
476	54	510	332	544	417
477	57	511	292	545	414
478	69	512	337	546	423
479	68	513	293	547	426
480	58	514	340	548	420
481	80	515	338	549	424
482	100	516	342	550	425
483	97	517	346	551	427
484	123	518	440	552	430
485	107	519	294	553	429
486	89	520	369	554	432
487	83	521	370	555	431

Inventory No.	Catalogue No.	Inventory No.	Catalogue No.	Inventory No.	Catalogue No.
556	251	2677	192	4665	469
557	73	2678	178	5473	301
558	460	2679	182	5474	436
559	283	2680	184	5475	532
560	285	2681	185	5476	521
561	439	2691	163	5477	468
561a	212	2692	169	5478	279
562	209	2693	164	5479	471
813*	542	2694	166	5480	250
1180*	66	2695	170	5481	327
1857	84	2696	160	5482	504
1867	28	2697	162	5483	246
1875	433	2698	176	5484	281
1876	525	2699	173	5485	274
1890*(?)	546	2700	174	5486	522
1891*(?)	547	2701	284	5487	502
1980	455	2702	175	5488	503
1981	512	2703	171	5489	45
1984	464	2704	161	5490	43
1985	515	2705	167	5491	271
1986	454	2706	172	5492	249
1987	456	2707	168	5493	151
1988	449	2857	247	5494	452
1989	434	2858	248	5495	459
1990	473	2879	277	5496	446
1991	453	2880	278	5497	153
1992	523	2881	457	5498	296
1993	262	2882	458	5499	273
1994	261	2958	302	5500	152
1995	260	2959	303	5501	448
1996	266	2988	255	5502	445
1997	265	2990	305	5503	207
1998	263	2991	306	5504	259
1999	267	2992	307	5505	256
2000	264	3026	308	5506	300
2001	268	3027	304	5507	435
2002	516	3048	203	5508	441
2055	258	3133	253	5509	298
2064	286	3380	309	5510	299
2065	287	3381	310	5511	444
2066	438	3382	313	5512	44
2067	437	3383	314	5513	531
2068	505	3384	315	5514	527
2302	191	3385	316	5515	465
2303	189	3386	317	5516	467
2304	190	3387	312	5517	297
2305	183	3388	311	5518	528
2306	180	3550	447	5519	165
2307	193	3557	39	5520	275
2308	179	4445	466	5521	272
2309	186	4446	501	5522	451
2310	188	4657	196	5523	257
2311	194	4658	462	5524	326
2312	177	4659	508	5525	276
2313	181	4660	506	5526	318
2424	518	4661	507	5527	320
2425	470	4662	461	5528	321
2642*	544	4663	202	5529	23
2676	187	4664	463	5530	319

Inventory No.	Catalogue No.	Inventory No.	Catalogue No.	Inventory No.	Catalogue No.
5531	322	5538	545	5544	529
5532	323	5539	450	5545	324
5533	280	5540	328	5546	227
5534	200	5541	195	5563*	282
5535	325	5542	530	5564*	548
5536	24	5543	245	6283*	295
				T.1585*	1

British Museum

Inventory No.	Catalogue No.		
XCV(a)—A	154	K	223
B	157	Add L	224
C	155	1972.U.738	487
D	156	739	489
E	158	740	492
F	159	741	491
G	35	742	493
CIII—18	208	743	490
CXXX—A	213	744	494
B	214	745	485
C	215	746	488
D	216	747	499
E	217	748	498
F	218	1974.U.848	497
G	219	849	500
H	220	850	486
I	221	851	495
J	222	852	496

Index of Titles

THIS index is confined to titles given to the pictures included in this catalogue. Titles of watercolours and other works by Turner, and of works by other artists, are included in the General Index under the name of the artist.

References are to Catalogue Numbers save where otherwise stated. **Bold numbers** indicate the catalogue entry dealing with the picture in question.

General Index

REFERENCES are to Catalogue Numbers unless otherwise stated. **Bold numbers** indicate ownership, past or present, of a work treated in this catalogue. Museums and other public institutions are listed under the name of the town in which they are situated, private collectors and dealers under their names.